BERNARD LEACH

BERNARD LEACH

LIFE AND WORK

Emmanuel Cooper

Published for the Paul Mellon Centre for Studies in British Art by
Yale University Press, New Haven and London

For information about this and other Yale University Press publications, please contact:
U.S. Office: sales.press@yale.edu yalebooks.com
Europe Office: sales@yaleup.co.uk www.yaleup.co.uk

Designed by Kate Gallimore
Typeset in Perpetua by SNP Best-set Typeset Ltd., Hong Kong
Printed in Great Britain by St. Edmundsbury Press Ltd., Suffolk

Library of Congress Cataloging-in-Publication Data
Cooper, Emmanuel.
 Bernard Leach : life and work / by Emmanuel Cooper.
 p. cm.
 Includes bibliographical references and index.
 1. Leach, Bernard, 1887- . 2. Potters—England—Biography.
 I. Title.
 NK4210.L35C66 2003
 738'.092—dc21
 [B]

2002153119

A catalogue record is available for this book from the British Library

10 9 8 7 6 5 4 3 2 1

CONTENTS

ACKNOWLEDGEMENTS

Many people have helped with this biography, giving freely of their time by answering questions and searching for letters and photographs. Of the Leach family I am greatly indebted to David and Elizabeth Leach, Jessamine Kendall, Betty Leach, John Leach, Jeremy Leach, Myra Leach, Philip Leach, Joy Leach and Janet Leach, all of whom produced invaluable documents and gave me long interviews. Special thanks also to Warren MacKenzie, Donna Balma, Gwyn Hanssen Pigott, Glenn Lewis, Jeff Oestreich, Margaret Heron, Christopher Reed, Mirek Smísek and Byron Temple. Barley Roscoe, the director, and the staff of the Craft Study Centre, formerly at the Holburne Museum in Bath and now at the West Surrey Insitute of Art and Design, were tireless in facilitating my study of the Leach archive, as were Pamela Griffen, the Arts Council archivist; Anna Hale of the Craft Potters Association archive at Aberystwyth Arts Centre; Moira Vincentelli of the Ceramic Collection at the University of Wales, Aberystwyth; Sara Kinsey and Helen Swinnerton, HSBC Group archives; and Margaret Dewey, Society of the Sacred Mission. Many individuals provided information and insight and I would like to mention in particular David Horbury, Dr Frederick Grubb, Dr Yūku Kikuchi, Julia Pitts, Edmund de Waal and Takeshi Yasuda who kindly read all or parts of the manuscript and made invaluable and much appreciated comments.

In addition I would like to thank Shigeyoshi Takagi (Abiko), National Museum of Wales; Oliver Watson, Ceramics Department and Rupert Faulkner, Far Eastern Department, of the Victoria and Albert Museum; Hilary Williams, High Cross House, Dartington; Hitoshi Morita, Ohara Museum of Art; Lois Moran, *American Craft* magazine; Peter Nochles, the John Rylands University Library, University of Manchester; Marty Gross, Marty Gross Film Productions; Gerry Williams, *The Studio Potter*; Teiko Otsumi and Kyoko Mimura (Nihon Mingeikan); Archie Bray Foundation, Alfred University, New York; Kiichiro Shimha, Doshisha University, Japan; Keizo Zushi, the Hitomi Museum of Art; Father McCoog, Mount Street Jesuit archives, London; Cyril Frankel, Rie archives; Father I. St Lawrence JC, St John's Beaumont; Richard Green, York City Art Gallery; Stephen Chaplin, Slade School of Art; Dr Harold

Blum, Freud archives; Kathy Niblett, Potteries Museum, Stoke-on-Trent; Dr Malcolm Vale, St John's College, Oxford; Tate Gallery library; Thomas Cook archives; Toshiro Kuwahara (Japan Publications).

Others who offered much practical help include Dr Chiaki Ajioka, Michael Arditti, Lyn Atkinson, Wilhelmina Barns-Graham, Richard Bawden, Sven Berlin, Hans and Brigitte Borjeson, Sally Boyle, Mary Boys-Adams, Barry Brickell, Alan Caiger-Smith, Ara Cardew, Seth Cardew, Len Castle, Jeremy Clark, Michael Clough, Margo Coatts, Elizabeth Collins, Ellen P. Conant, Trevor Corser, John Drummond, Derek Emms, Gutte Eriksen, Murray Field-house, Robin Fletcher, Robert Fournier, Professor Christopher Frayling, Bret Guthrie, Philip Hainsworth, Tanya Harrod, Patrick Heron, Philip C. Hills, Carol Hogben, Michael Hunt, Alyn Giles Jones, Dorothy Kemp, Peter Kinnear, Dermod Knox, Eileen Lewenstein, Adrian Lewis-Evans, Martha Drexler Lynn, Victor Margrie, Scott Marshall, Nan McKinnell, Dicon Nance, William Newland, Kiko Noda, Michael O'Connor, Nimala Patwardhan, Susan Peterson, Helen Pincombe, Shirley Pippin, Valerie Prescott, Bryan Robertson, Henry Rothschild, Monica Sacret, Peyton Skipwith, Dr Roger Slack, Julian Stair, Peter Stichbury, Louise Taylor, Mark Tooby, Simon Watney, Dr Jeffrey Weeks, David Wicks, Marion Whybrow, Richard L. Wilson, Irene Winsby, Nigel Young, Douglas Zadek.

I owe a debt of thanks to the Crafts Council and the Writers' Guild who generously gave financial support for the project.

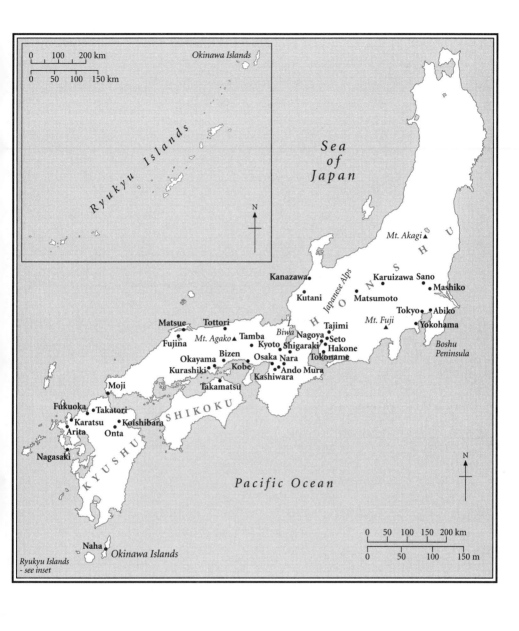

Bernard Leach, potter, artist, writer, poet and one of the great figures of twentieth-century art, played a crucial pioneering role in creating an identity for artist potters in Britain and around the world. Born in the East and educated in the West, Leach saw himself as a conduit between the two cultures, constantly searching for wider understanding and acceptance of civilizations that seemed so different. In his long life he spent some twenty years in Japan where he came to know and love the old and respect the new, and to appreciate the central role of pottery within Japanese society. His life was a fascinating blend of the practical and theoretical.

Adopting John Ruskin's concept of head, heart and hand, Leach sought to create work that was fulfilling intellectually, aesthetically and practically. 'Pots and all other artefacts serve the mind as well as the body,' he believed. 'They are born of a marriage between use and beauty. They are an extension of people striving to make human products with as much wholeness and naturalness as a sea shell or the wings of a butterfly.'[1] In a life of making pots, spanning a period of over sixty years, Leach developed a distinctive and characteristic style. Unlike his early contemporaries, he adopted an ideology more closely based on that of the Arts and Crafts movement, which sought to provide pots for everyday use as well as create individual 'works of art'.

Following his initial study with the sixth Kenzan, a traditional Japanese potter,[2] Leach sought to combine eastern and western influences in his ceramics, and was admired by the Japanese for successfully incorporating historical ideas in work that was modern and forward looking. While in Japan Leach kept in touch with contemporary radical ideas on modern art in Europe, such as theories of abstraction, Clive Bell's concept of 'significant form', and the writings of the French philosopher Henri Bergson, whose concept of 'vital spirit' (élan vital) was close to Leach's ideas about 'vitality'. Leach saw his work with ceramics as reflecting such radical change. In England he was part of the great flowering of craft activity in the decade following the First World War, part of a move away from the prevailing oppressive academicism and narrow concerns of much fine art towards other, more tactile forms of expression. In addition to pottery this included hand-block printing, textile design

and production, and stone carving. He quickly became a central figure, writing articles, encouraging debate and acknowledging the need to educate and inform.

Almost subconsciously Leach responded to many of the basic tenets associated with modernism – truth to materials, the importance of function in determining form and the simplicity of decoration – interpreting such concerns to produce work that was both good to use and to look at. For Leach, a sound understanding of clay and making, glazing and firing methods, as well as the purpose for which a piece was intended, were crucial to its production, though his initial antipathy to the machine was at odds with other aspects of modernist thought. As an advocate of the humanistic qualities of handwork he was suspicious of what he saw as the dehumanizing qualities of machine production, identifying himself with the ideas of William Morris 'against the materialism of industry and insensibility to beauty'.[3] Despite this aversion he was well aware that his work should not be concerned with the past but reflect a 'deepening consciousness' and 'a new wholeness'.[4] Leach's ambiguous position in relation to modernism and its role within the wider concerns of the craft movement can be well summed up in Tanya Harrod's pertinent phrase 'eclectic modernism'.[5]

Although artists as diverse as Matisse, the architect Le Corbusier and the critic and painter Roger Fry had been attracted by the expressive possibilities of clay before the First World War,[6] their involvement was as artists or designers working with skilled ceramists. This was in contrast to the artist potters who emerged in the 1920s and virtually created a new art form. The prevailing aesthetic of these potters was dominated by early Chinese ceramics, in particular those of the Sung dynasty,[7] which were being seen in the West in large quantities for the first time.[8] With their powerful sense of form, minimal decoration and simplicity of glaze, Sung-dynasty ceramics became part of the modernist principles of greatness in art. The formal, austere beauty of the wares proved a major inspiration, with critics comparing the work of modern potters to progressive sculpture and modern music. 'A finely proportioned pot', argued the potter William Staite Murray 'is an abstraction',[9] a view echoed by the budding art critic Herbert Read who proclaimed pottery was 'plastic art in its most abstract form'.[10] With his experience in Japan and visits to China and Korea, Leach was able to claim first-hand knowledge of the East, frequently contrasting the wide appreciation of ceramics of these countries with the superficiality and materialism of the West.

In Japan, Leach was respected, admired, even revered, his pots, drawings, textiles and furniture selling almost as soon as they were shown. Towering a foot above his Japanese friends, Leach was literally and metaphorically seen as a giant. He learnt a decent smattering of Japanese and though able to read very little of the language he studied the history and culture of his adopted country and spoke knowledgeably about its traditions. One of his enduring

attractions for the Japanese was that he sought to understand the country and its culture while retaining his basic Englishness. The British ambassador, Sir Francis Rundall, made this point cogently when opening a major retrospective exhibition of the potter's work in Japan. While Leach had identified 'himself with so much in the life of Japan', the ambassador pointed out, he 'remained essentially and characteristically English'.[11] The horrifying war between his two beloved nations was a source of great anguish for Leach, but he never lost sight of the unity and understanding he sought to foster.

After the Second World War Leach began to attain in England the sort of recognition he received in Japan. With his elder son, David, as manager, the Leach Pottery started to achieve financial viability. In addition to individual pieces made by Leach and other members of the 'crew', the Pottery produced a range of well designed and crafted high-fired tableware that made sensitive use of deep, rich glaze contrasted with the toasted unglazed clay on forms that were both practical and attractive. All were slowly fired to a high temperature in a wood- or oil-burning kiln to bring out the inherent qualities of clay and glaze. In producing reasonably priced tableware and individual pots, the Leach Pottery established a model for studio potters around the world.

Broadly, Leach's pots fall into those inspired by the West and those by the East. Western influences include English medieval jugs, eighteenth-century slipware dishes and occasionally German salt-glaze wares. Leach's earthenware dishes, with their characteristic honey-coloured glaze and slip-trailed or combed decoration, are modern interpretations of pieces produced by Thomas Toft and his contemporaries in Staffordshire.[12] The decoration of the handsome large dishes, expressed with minimal line and strong sense of composition, offered much scope for Leach's graphic skills. Eastern motifs such as well-heads and stylized landscapes were used on some, on others he opted for quintessentially western designs including mermaids, hares and griffins. Yanagi Sōetsu, the leader of the Japanese Folkcraft Movement, memorably described these pots as 'born not made'.

The other, larger group derives almost exclusively from the East and embraces low-fired wares such as raku, but more significantly high-fired stoneware and porcelain. Contact with China, Korea and Japan (the descending order in which Leach ranked their importance) was crucial in helping him create shape and decoration. His stoneware and porcelain (other than the handled jugs based on thirteenth-century English pitchers) in both form and glaze seem to western eyes almost exclusively inspired by the East. Yet to the Japanese, Leach's ceramics appear totally western, the shapes and decoration transformed by a European understanding while retaining oriental sensitivities.

In addition to making pots, Leach was a skilled and imaginative draughtsman. During his time as a student at the London School of Art he discovered that etching rather than painting was his *métier*, a medium in which he was

able to explore his love of line, with drawing becoming a way of thinking. Whenever an opportunity arose he drew using pen and wash to depict landscape. Occasionally these drawings reflect eastern influences and conventions but most are essentially European in character, the finest embodying the speed and confidence with which they were produced. Before making pots Leach sketched the shapes, often including the decoration. These may be detailed studies or sketches on newsprint or scrap paper, but all indicate that Leach saw himself as much as a designer as a maker. His graphic skill was also evident on pots and tiles, whether using brush, slip-trailer or incised designs.

Alongside drawing and potting Leach was a prolific writer of essays and books. He was also an engaging conversationalist and an enthusiastic, vivacious and entertaining speaker, able to engage audiences whatever their size, often improvising from headings jotted on the back of an envelope. A prodigious letter writer, his correspondence includes some of his most inspired writing. Much of this has survived, including important letters between Leach and Yanagi that touch on philosophical issues, and those to the American artist Mark Tobey, who was instrumental in Leach accepting the Bahá'í faith, which are more intimate and personal. All trace the broad development of his ideas and emotions as well as his responses to major events in his life. The vivid, powerful and intensely personal correspondence between Leach and his third wife, the American-born potter Janet Darnell, has also come to light. These long letters, with their unique insight into Leach's thoughts on England and Japan in the postwar world not only illuminate his work as a potter but also his attitude to love, sex and relationships.

Throughout most of his life Leach wrote poetry. These often highly personal lines, though rarely directly autobiographical, reflect mood and feeling, often addressing complex emotions through wistful and melancholic imagery. Some early poems take a broad humanistic approach to the horrors of war and the importance of identity, while later ones are more religious and mystical. Although few rise above the standard of a gifted amateur, they provide valuable insight into his inner thoughts and feelings. Some of the finest are sensitive translations of Japanese haiku. As his sight began to fail in old age Leach redefined himself as a writer rather than a potter.

Leach's first serious book *A Review* was issued in 1914. Others were to follow, most notably *A Potter's Outlook* in 1928, in which he took a critical but passionate look at his work in England and the wider role of the studio potter in western society. But his most significant publication came in 1940 with *A Potter's Book*, a personal, technical and aesthetic account of the life of a potter. Its blend of opinion, advice and practical instruction evoked a way of life that seemed both highly attractive and attainable in an age becoming more materialistic and consumer orientated. So convincingly did Leach write, offering 'values' at a time of rapid change and uncertainty that in the 1960s and 1970s it became a blueprint among many potters for the counter-cultural search for

a more meaningful, self-sufficient way of life. An enduring success, the book was translated into many languages and remains in print. Leach's book on the great Japanese calligrapher and potter the first Kenzan introduced the work of the artist to the West; his adaptation of Yanagi's philosophical writings, *The Unknown Craftsman*, forms a unique body of essays on Buddhist concepts of beauty, which made these ideas accessible to a new audience. In *Beyond East and West: Memoirs, Portraits and Essays*, published at the end of his life, Leach is at his most readable and engaging, placing his work as a potter and writer in the broad context of his involvement with East and West.

The importance of *A Potter's Book* in helping shape understanding of studio ceramics has, almost inevitably, given rise to a debate about whether it is his writing or his work as a potter that has stood the test of time. In fact they are intimately bound together. His writing came out of his practical experience of potting in both Japan and England and is rooted in the studio as much as the study. Whether dealing with accounts of how to prepare clay bodies, mix glazes, fire kilns or contemplate the implications of the 'Sung standard', Leach brought to *A Potter's Book* an eloquence that is challenging, illuminating and inspiring.

Given Leach's eminent status within the applied arts, it is surprising that there has hitherto been no full biographical study in the West. Although there are many excellent essays on his pots[13] and an important critical study,[14] none has attempted to examine the full span of his life and work and the often intimate relationship between them. Such a lapse reflects the uncertainty of Leach's status within the visual arts in the years immediately following his death. To a post-modern generation in search of colour and free expression his pots appeared conventional and prescribed, the intense blacks, muted sombre browns, greys and creams too restrained and limiting. A younger generation of potters also questioned his role within the studio pottery movement, some seeing his influence as unrelated to modern needs. As the years have passed his pots have been 'rediscovered', their quiet, thoughtful qualities have been reappraised, while his philosophy of unity and wholeness continues to catch the imagination.

The Japanese psychologist Dr Shikiba Ryūzaburō compiled a comprehensive study of Leach's life and work published in 1934. This brought together much existing material in addition to a biographical account provided by Leach in which he wrote passionately about his early life. This gives details of his childhood, the difficult relationship with his stepmother, his love for but distance from his father and his troubled teenage years before moving to Japan in 1909.

It is nearly seventy years since that autobiographical sketch was written and over twenty since Leach died. Now is the time to take a more distanced look at the fascinating and often paradoxical life of an artist in continual search of what he called 'the still centre', to consider his often turbulent relationships

and to ponder the significance of his oft-repeated mantra 'the pot is the man'. In *A Review* he observed that just as 'artists paint their bodies and souls into their pictures' so potters made pots that reflected their own character. Pots, he believed, were best assessed in human terms using the analogy of the body to consider lip, neck, shoulder, belly and foot. Despite the attraction of the intimate relationship between makers and the vessels they produce, the maxim 'the pot is the man, his virtues and vices are contained therein' often proved difficult for Leach to follow. With great honesty he could describe his friend Hamada Shōji and his pots as standing four square, but other close and dear friends such as Lucie Rie and the potter Tomimoto Kenkichi caused him bother as he rarely liked their pots.

Making use of the vast wealth of documents Leach collected over his lifetime and personal accounts from his family and those who knew him well, I have sought to produce a 'full and searching' biography in which a central concern is the relationship between his life and his pots. At their best his vessels are magnificently self-contained with a convincing unity of form, glaze and decoration. With a few small balls of clay applied to the outside Leach could transform a pot, sometimes thrown by someone else to his design, into something rich and special that celebrates the qualities of the material. With a pointed tool he could inscribe fluid, incisive designs of trees, birds or foliage that perfectly matched the form. At ease with the brush, he was able to suggest the essence of a fish or landscape with a few elegant and evocative brushstrokes. In such pieces Leach did capture the still centre, a centre that was often to elude him in life. To use his own words Bernard the potter and Bernard the husband and father were not necessarily the same. Within the often profound turmoil of his emotional relationships pots were a way of exploring an inner quiet that expresses none of these uncertainties, and in this sense the pot represents only a part of Bernard the man, who was neither saintly nor bloodless, and could be arrogant, charming, insightful, astute, selfish and charismatic.

In the early 1970s I spent a memorable afternoon with Leach in his flat in St Ives, the panoramic view of the rolling Atlantic waves and what seemed like miles of blue sky seen through the huge windows formed a dramatic backdrop to an enlightening conversation. Then in his late eighties and partially blind, Leach was alert, provocative and engrossing, moving from subjects such as education and pottery to politics and belief. Sometimes quiet and confidential, at other times angry and excited, he was especially vehement when recalling his school days and the sadistic attitudes of his teachers who would administer beatings for a badly learnt Latin grammar. He spoke about his early years in Japan and his growing belief that an essential ingredient of pots was what he called 'vitality', pointing out such qualities in a medieval pitcher, a Chinese Sung bowl and a small lidded pot by the French potter Francine del Pierre, caressing the forms as he talked movingly about the pots and the

potters who made them. As a pacifist he praised what he saw as the courage of United States President John F. Kennedy, 'a brave young man', who he saw as standing up to the Soviet Union and thereby saving the western world from destruction. He was equally passionate in deploring inequality, citing with outrage the sign on a bench in Shanghai, 'No dogs or Chinese'. I left with a powerful sense of someone with a clear view of himself and his work as a potter and writer.

We met briefly several other times, most notably in the early 1960s during my first visit to the Leach Pottery. Having recently left art school, where I had read *A Potter's Book* and learnt of his reputation as a distinguished potter, I was curious to visit the studio and see the work for myself. To my amazement we were directed to the showroom by a tall, gangly, lanky, mustachioed figure with flying hair wearing a collar and tie, sports coat, flannels and polished brown shoes who turned out to be the great man himself. In the showroom I gazed in admiration at the strong, sure forms and fluid decoration, their easy qualities belying the skill and thought involved in their production, the quietness of the pieces, their muted colours and general sense of restraint capturing a sense of wholeness and unity.

This biography will I hope add to an understanding of this complex and contradictory but always engaging figure whose work was part of a wider search for 'truth and beauty'[15] – an idea little discussed today, but one that formed a central part of his art and life.

Following convention, Japanese names are given in traditional form, with the family name first. Old spellings of such names as Peking (rather than Beijing) and Sung for Song have been retained throughout to reflect the time at which they were used.

AMBITION, ENERGY, STRENGTH AND PERSEVERANCE

Hong Kong Japan England

1887–1903

As the aeroplane circled above Hong Kong preparing to make its descent, eighty-two-year-old Bernard Leach looked out at the spectacular beauty of the vast jaw-like harbour between Kowloon and Hong Kong Island. Huge buildings stood along the edge like 'big white teeth',[1] while the then recently constructed delicate spur of land forming the runway of Kai Tak Airport seemed to protrude into the sea 'like a tongue'.[2] The sight of the harbour, the ships at anchor and the closely packed buildings revived childhood memories. It also underlined the huge changes that had taken place both in his own life, and in the city laid out below him, since his birth in the colony on 5 January 1887.

In that year Queen Victoria had celebrated her Golden Jubilee, a half-century which had seen Britain emerge as a leading international power and ruler of a quarter of the globe. The British flag fluttered over Hong Kong just as proudly as it did over many other distant parts of the world, where the idea of duty and colonial responsibility was an accepted and unquestioned part of imperial might. Hong Kong, meaning 'fragrant harbour' in Cantonese, was a crown colony established by Britain following the Opium Wars.[3] It comprised the island of Hong Kong, Stonecutter's Island, Kowloon and the New Territories, and included one of the largest, busiest and most prosperous harbours in the world. The geographical position on the belly of Asia was the focus for Britain's military, commercial and financial strength in the Far East.

Many of Leach's ancestors had held office within government administration or the military, either at home or in the British Empire overseas, and the Leach family were particularly proud of their long association with the legal profession.[4] One of the most notable, Sir John Leach,[5] served as Master of the Rolls and Chancellor of the Duchy of Cornwall. Bernard's great-grandfather was Senior Registrar Supreme Court of Justice, Chancery Division, his grandfather had served as Secretary of the Rolls and Keeper of the Records, while his father was a High Court Judge. Although a source of great pride, none offered any precedent for Leach's artistic ambitions.

Leach's first memory of Hong Kong was of the harbour packed with hundreds of small vessels of diverse shape and size, their flags and streamers presenting a fluttering mass of colour in the sunlight. At night the ships' lamps formed a starry galaxy full of excitement and adventure. Half a century later the Chinese junks had all but disappeared, the smaller sampans were now tucked away in small inlets and served as homes to the thousands of families who 'hardly put their feet ashore'.[6] Hillsides that he remembered as sparsely dotted with houses were now covered by towering, high-rise buildings, which, if not architecturally outstanding, seemed to have 'a sort of unity and a fulfilment of sheer need which was unexpectedly impressive'.[7] The colony teemed with activity, its population having increased to some four million, transforming it into a leading international manufacturing, trading and financial centre.

Deep in thought as he gazed out of the aircraft window, Leach contemplated his long connection with the East. Dealing with the past, absorbing and eliminating, deciding what to keep and what to reject was a constant concern. Although fond of quoting William Blake,[8] to 'Drive your cart and horse over the bones of the dead', it was not advice Leach himself found easy to follow given his interest in family history. With age he had become more attentive to his ancestry, actively helping to construct complex family trees and was overjoyed when distant relatives were identified. Both his parents, he was proud to say, were of 'middle-class Anglo-Celtic stock' and at one point he had a family tree, which was later lost, tracing his Welsh ancestry.

The year was 1969. On this journey Leach and Janet, his often formidable third wife who was also a potter, were *en route* for Japan, the country he regarded as his second home, to set up an exhibition of Janet's pots at Osaka Daimoru department store. Although Leach had revisited Hong Kong many times before, on this occasion he had decided to search out the grave of his mother who had died so tragically at his birth. The enquiry was a combination of an increasing concern with family history and a growing awareness of his own mortality. The vast changes that were transforming the colony helped add distance to his recollections, but he was glad that his friend the Japanese potter Hamada Shōji and his wife, Kazue, were to meet them.

As he thought about his mother further prophetic words of Blake came to mind, 'Man has no Body distinct from his Soul',[9] reminding him yet again of the need for unity and coherence within individuals and nations. His own desire, formulated fifty years earlier, was for people of vision who could trust their feelings as well as their intellect. Despite his own and his family's colonial responsibilities he wrote of how he longed 'for men of genius to come out of Europe instead of the average men of commerce, of statecraft and of church craft!'[10]

Although in his eighties Leach still nursed the idea of writing a book, with the provisional title, *The Bible of East and West*, something even more necessary, he thought, than Blake's *Marriage of Heaven and Hell*.

A love union of the two hemispheres, a mystic ring on the finger of the world. This is the picture of East and West which is before my eyes: The East living in the spirit till the walls and roof fall about its ears, as in Peking: The West living for things till it hurts itself as in this great slaughter. The real meeting which only commences now, the meeting of extremes, whether it takes place in Japan, America, Russia, or China, come soon, come late, holds out the promise of the first complete, round, human society.[11]

Such global, concerns were unlikely to have disturbed the legal mind of Bernard's father, Andrew John Leach, who had arrived in the colony nearly a hundred years earlier fully believing in Victorian concepts of service and duty that neatly reflected the family motto *At spes non fracta* (Hope is not lost), a legend combining both optimism and tenacity. Andrew Leach was born on 16 September 1851, the seventh of twelve children to Richard Howell Leach and Frances Mary, née Walker, at 44 Cambridge Terrace, a respectable and leafy part of Paddington, London. Like many of his brothers Andrew Leach was sent to the highly respected Sir Roger Cholmeley's School, Highgate, north London,[12] now known as Highgate School, which had a reputation for educating boys for the army and legal profession. At St John's College, Oxford,[13] he excelled in sports, rowing and running for his college and, following in his father's footsteps, he was called to the bar at the age of twenty-five. In the intrepid pioneering family tradition he travelled to Shanghai to join the legal practice of a celebrated Mr Drummond, though anecdote suggests that this may also have been to escape an unsuitable emotional entanglement.

From Shanghai the young lawyer transferred to the rapidly expanding colony of Hong Kong, and the Far East was to remain his base for nearly twenty-five years until ill health forced his early retirement in 1903. Intelligent, disciplined and quick witted, Andrew Leach proved an efficient legal administrator. Under his direction successful measures were taken to deal with an outbreak of bubonic plague, 'the terrible scourge', and an ordinance submitted defining the powers of the government to instigate drastic remedial measures. Later he wrote on the role of government and the legal service in Hong Kong, all of which further helped reinforce the strength and proficiency of colonial rule. Efficient and sometimes ruthless he managed a legal practice, served in different official posts and acted at various times as attorney general.

By the middle of the 1880s and professionally well established, the thirty-four-year-old lawyer met Eleanor Massey Sharp, called Nellie, a small, delicate, pretty woman with a neat rounded face, ten years younger than himself. One of four children born to a schoolmaster, Edmund Hamilton Sharp, known as Hamilton, and Elizabeth Massey of Manchester, she was in Hong Kong visiting her uncle and aunt, Granville and Matilda Sharp. Although Nellie was

a Baptist and Andrew at this time had inclinations towards the Roman Catholic faith they married and set up home at Rose Villas, quickly settling into the social life of the colony.

In March 1885 Nellie Leach wrote excitedly to her mother detailing her life and the way it reflected her status within the community.[14] After complaining about the oppressive heat of the summer months she gave descriptions of her clothes, the friends entertained at tiffin[15] and of the invitation to present prizes at the Athletic Sports Day, where she made a speech appropriate to the occasion 'as there is some talk of war'. She also held successful conversazione, helped at exhibitions and took part in 'renderings by our quartet'. Maintaining the family interest in literature, she had, she told her mother, read and been greatly impressed by Shelley's *Prometheus Unbound*.

Like Andrew Leach, Nellie was part of a large extended family with many connections with the Far East. Their neighbours, Uncle Granville and Aunt Matilda, were sufficiently wealthy to maintain two large houses and several servants. After working first as a banker in India and in Hong Kong, Granville Sharp had set up a thriving trading business in the colony, subsequently becoming a bill and bullion broker and property owner. When he died, at the age of seventy-four in 1899, his vast fortune was estimated to be two million dollars,[16] the bulk of which was left to set up a new hospital, named the Matilda, in memory of his wife.[17] A legacy of £300 was left to Bernard, invested 'in ample security' at 7½ per cent, to be paid when he reached the age of twenty-one.

The families were active within the local social and religious communities. Although staunch Anglicans the Sharps accepted that cremation was an alternative to burial, a practice generally regarded as pagan and unChristian, partly because it would leave no corporeal remains to ascend into heaven on Judgement Day.[18] But in the crowded conditions of Hong Kong it seemed healthy and appropriate, so following Matilda's death in 1893, and in accordance with her wishes, her husband arranged a cremation. In the absence of a crematorium or professional helpers Indians were employed, but unfortunately, rather than winding the body in the customary sheet it was encased in a coffin, which proved resistant to the flame. When the sides eventually fell away the charred body was clearly visible and further quantities of fuel had to be thrown onto the funeral pyre, which still burnt bright after one and half hours, a spectacle that seemed particularly unedifying.[19]

The news that Nellie was expecting a child early in 1887 delighted her parents, who were particularly pleased that the birth coincided with their own plans to travel east. With their family of three girls and one boy now grown up Hamilton and Elizabeth Sharp had sold the Old Trafford School, Seymour Grove, Manchester, which they had run for thirty years, and were in the process of moving to Japan. Hamilton was to lecture in English at one of the first Christian universities, the Doshisha in Kyoto, and had travelled in advance

leaving Elizabeth to follow after saying unhurried farewells to members of the family and touring the beauty spots of Europe with her children. With her youngest daughter Marion, she went to see her eldest daughter Edith Isabel in Edinburgh who was married to William Evans Hoyle, a surgeon and scientist now working on classifying the shells acquired during the pioneering *Challenger* expedition.[20] They had one child, Muriel, four years old, who later was to marry Elizabeth's grandson, Bernard.

From Tilbury Elizabeth and Marion sailed to Naples, and as the heat of the south became more oppressive they moved north, breaking their journey at Rome, Florence and Como before arriving at Lucerne, intending to remain for three months. In October her son Ernest, who was shortly to enter Oxford, joined his mother and sister. Family life was important to Elizabeth, and despite doubts at leaving her children she saw the move to Japan as part of her Christian duty. A letter from Hong Kong bringing news that Nellie was ill threw her plans into disarray, and stirred sad memories of her own first-born and the dangers of childbirth. The infant, a daughter, had survived eleven painful, distressing weeks before dying of 'Asphyxia and Convulsions',[21] and Elizabeth prayed that her daughter's child would be spared a similar tragedy. She immediately booked a berth, spending the final few days buying gifts for both her daughter and the expected grandchild.

The long slow voyage allowed ample time for Elizabeth to observe the variety of sights, sounds and impressions of the different people she met and the countries she saw, all of which was duly recorded in beautiful copperplate script in her diary. On the afternoon of 18 November the vessel sailed into Hong Kong harbour, five weeks after leaving Italy, where she was met by her husband, who had travelled from Japan, and her son-in-law Andrew Leach. Quickly they made their way to his new house, The Falls, magnificently set on the hills above the town, pausing only to embrace Matilda at her house. After weeks of anxiety Elizabeth was at last able 'to fold my Nellie' in her arms, but even with her mother's care her daughter's condition showed little improvement and two fearful months were spent coaxing and nursing her and making preparations for the expected child.

Troubled and concerned Elizabeth provided as much comfort and reassurance as was possible. Despite the attendance of Dr Hartigan,[22] an Irish-born surgeon connected to and often employed by the highly influential Hong Kong and Shanghai Bank, the birth proved fatal, for while a healthy male child was born the mother died. 'Until January 5th I nursed her and the same hour that gave me her baby took her from our ministry. Dear dear child, I shall go to her but she shall not return to me',[23] wrote Nellie's mother. Two days later in a sad procession 'the precious casket' was carried down the steep winding paths and taken to Happy Valley cemetery where foreign, mainly British, merchants, missionaries and military adventurers lay buried. The cortège, wrote Elizabeth, was 'accompanied by many who loved her, following our precious

burden on the sunny afternoon. We reached the Quiet Valley after the sun had gone behind the hills and as we turned round from the place we had had her the silver moon shone down upon the scene and dear Andrew whispered "Is it not beautiful"'.[24]

Heartbroken at their loss the family nevertheless welcomed the infant who was named and baptized Bernard Howell, the latter after his paternal grandfather. For Hamilton and Elizabeth the sad and emotional event was not a favourable beginning to what was intended to be the start of a new life in the East, while for Andrew Leach it marked the tragic end of a happy marriage. Legal matters involving business in Shanghai helped keep him busy, and the baby was left in charge of his mother-in-law who employed the help of a competent Chinese amah. Shortly afterwards, Hamilton left to visit missionaries in the country beyond Canton, and Elizabeth, feeling it was now safe to leave the child for a short time, joined him sixteen days later. The voyage brought sad reminders of her journey east and the hope of 'meeting my beloved and seeing her in her own home; now all that has become a memory, all sacred, loving completed'.[25]

The family decided that the infant could best be cared for by his grandparents in Japan and that Hamilton should go ahead leaving Elizabeth to follow with the child and the amah. 'Tuesday 29th March 1887. Left The Falls at 4 o'clock with Bernard in my arms in my dear Nellie's chair. Annette following. Amah next. Three chairs, proceeded by coolies carrying luggage',[26] finally leaving Hong Kong on 7 April. 'On Piddar's Wharf, Andrew awaited us looking very pale and tired. He had had a long fatiguing day on the Bench, "his first".' Despite the sadness of the parting Elizabeth found time to admire

> the beauty of the night, full moon, and dear little Hong Kong lighting up the hillside with the outline of the Peak range clear and dark against the blue sky, whose peaks and gaps and winding paths have become so familiar to me, so filled with ineffable memories. And there in the shaded recess to which that descending track down the mountain (Manchai) Gap is the Valley where my treasure is awaiting the Resurrection call, when we shall meet again.[27]

Five days later their ship anchored in Nagasaki Bay, the international port on Kyūshū. Full of curiosity Elizabeth went ashore to meet a Mrs Hutchinson who had sent a note with a 'few lines from my husband', and to visit a Japanese church. Unlike the densely packed thoroughfares of Hong Kong she found the Japanese streets 'clean and airy'. In the afternoon they returned to their ship, the *Thibet*, laden with gifts of peach blossom boughs and white and red camellias. Two days later after sailing through the Inland Sea, Elizabeth awoke to find the steamer quietly resting by Kobe pier. The Sharps were part of a substantial number of missionaries and teachers flooding into the country, the Tokyo directory listing thirty-one different societies and sects or denominations, with an aggregate of three hundred male and female missionaries.[28]

Although foreigners were permitted to live, trade, buy or sell property or engage in industrial enterprise they were limited to certain areas, and travel or movement required a passport. Such restrictions presented few problems to the Sharps but it did to the amah who was half Chinese, entailing a wait while papers were prepared and checked. Elizabeth and Hamilton left for Osaka, 'an hours pleasant ride . . . Dear Bernard's first in a train. He was so good. Precious precious babe',[29] her husband to continue to Hikone, where they were to live, she to follow the next morning leaving the child in the capable hands of a Mrs Pole and the amah.

While waiting for the settlement papers Elizabeth found herself over-whelmed by anxiety about 'the strange future', but a visit to Hikone eased her mind, convincing her that they could make 'a loving and happy home'. For a time they stayed at the Kakoo Kakoo Hotel, an experience that gave them a first-hand taste of the strangeness and minimalism of Japanese life, which in comparison with the fashionable clutter of western homes seemed austere and plain. 'We literally find nothing but pretty rooms and a matted floor, beauti-fully clean and airy, and for beauty of scenery and situation no one could not desire more',[30] noted Elizabeth cheerfully. At the beginning of May with the necessary documents secured they took possession of a 'pretty house', and entered it with Elizabeth 'carrying a lamp and a flower' with the amah by her side holding the child. Gradually she turned the house into a home. To help, a boy, Batani, was employed and was thought 'a nice fellow'.

In their new life they sought to combine aspects of English and Japanese customs, seeing their adopted country as exotic and quaint. The Japanese they regarded with a patronizing combination of arrogance and mild contempt tinged with a measure of admiration. Few British residents bothered to learn more than the rudiments of the language, preferring to communicate by the use of gestures and a kind of pidgin Japanese, which, surprisingly, enabled ser-vants and the local shopkeepers to fathom their needs. In pioneering colonial fashion many for-eigners enjoyed the challenge of deciphering the English learned and used by the Japanese, the British scholar Basil Hall Chamberlain describing this as 'English as she is Japped'.[31] Visiting the country in 1889 the artist Sir Alfred East was amused to find on a western menu such strange dishes as 'mouton with red currant dam' and 'sluffle'.[32]

News that their daughter Marion had reached Colombo on her voyage east, and was to visit Hong Kong before arriving in Japan in June, added to their happiness. Despite feeling settled, the heat and mosquitoes proved a challenge. Plagued from time to time by ill health Elizabeth was thankful when in July at the start of the university holidays they were able to leave Hikone to spend a week at Otsu before moving to Kyoto. They were away until the middle of September 'when the cool came and the mosquitoes went'. In February 1888 Hamilton was in touch with Joseph Hardy Neesima, known as Neesima Joe (Nijima Jō),[33] founder of the Doshisha (literally one-purpose-institution), the

first Christian university in Kyoto, about his appointment as a teacher of English. Although the proposed salary of 150 yen was less than expected he accepted the post and the family moved to Kyoto.[34] In their new home Elizabeth sought to create a welcoming and relaxed atmosphere. 'Our little drawing room looked very inviting. The flickering flames reflected on the walls the shaded lamp and flowers, and prettily spread table and comfortable meal – for which the cool evening air had prepared us'.[35] Readings in the evenings included uplifting texts such as a life of Harriet Beecher Stowe or John Ruskin's *Two Paths* as well as *Nicholas Nickleby* by Charles Dickens. 'A great treat' was hearing the poet and writer Sir Edwin Arnold[36] read from his new book *Light of the World*. The habit of reading aloud was one Leach was to enjoy throughout his life, both as a schoolboy and with his own family in Japan twenty years later.

Under the care of his devoted amah and his loving if distant grandparents, the child thrived and on 9 March 1888 he delighted them by walking across the drawing-room, described by him as their 'likle room', an event Elizabeth duly noted in her diary. Their satisfaction with his steady progress was cut short when in April he developed an attack of whooping cough and was taken to Kobe to recover. Although their experiences on that journey 'were contrary' the break appeared to do him good. In July they escaped to Osaka and then for two months to the hot spring resort of Arema (Arima), adopting the established Europeans' pattern of retreating from the humid heat of the summer months to either the seaside or the mountain. The diary entries, often effusive about the strange beauty of the country and its tradition, reflect contemporary attitudes to Japan, and the Japanese. 'The veneration of these people, their love of Nature. She is their hand maid, and thro' and by her their most sacred offerings are made,' trilled Elizabeth, adding 'I have seen much to admire and impress in Japan but Nara stands alone, a witness of the antiquity and reverence of this people.' Taking up themes that her grandson would address twenty-two years later, she observed 'They have to "let alone" not desecrate their temples nor their lovely lands by ruthless changes.'

Leach's childhood memories of life with his grandparents in Kyoto included seeing fresh fish swimming in wooden tubs in the market-place, long icicles hanging from a bamboo aqueduct in the winter, the glorious sight of cherry blossom, and the smell of wild flowers and the taste of *takuan* (a pickle made from *daikon*, white long radish). This regular, ordered life changed drastically in the early 1890s[37] when his father met and married Jessie Maria Sharp,[38] and they came to take him back to Hong Kong. Jessie Sharp was a second cousin of his mother, but unlike Nellie, she was a devout Catholic. Andrew Leach, though born and brought up as a member of the Church of England, had become aware of the Catholic faith under the influence of Cardinal Newman and the Tractarians while a student at Oxford, and under Jessie's persuasion converted to Catholicism. Although Bernard's stay in Japan was little more

than three years it was sufficient to give him a few words of Japanese and to impress upon him the unique beauty of the landscape. When he returned in 1909 his memories were so powerful that the 'once-familiar sweet scent of blossoms carried me back to childhood'.[39]

The earliest recollection Leach had of his father was of him arriving in Kyoto with Jessie, whom he assumed was his mother, to take him to Hong Kong. Meeting his father again was an exciting adventure and Leach remembered 'standing with him at the age of 4 on the top of the Eastern Mountain called Hieizan (Mt Hiei) looking down on the waters of the lake far below'.[40] The impressionable child also recalled 'walking with him down to a monastery with a great pool of carp and of a priest coming down with food for them, calling them by beating perhaps a stone with a stick and clapping his hands. A large carp came swimming up to be fed with some cereal like puffed rice'. In Japan the carp was often seen as symbolizing the fighting spirit, 'Because of its strength, and its determination to overcome all obstacles it is held to be a fitting example to growing boys, typifying ambition, energy, strength, perseverance',[41] qualities that Bernard Leach was to possess in great measure.

Enthralled by his parent's house, which sat back to back with another on the hilltop of the island of Victoria upon which Hong Kong is built, the four-year-old child quickly adapted to life with his parents. Although he had the greatest regard and devotion for his father, who in his eyes could do no wrong, his feelings for his stepmother were more ambiguous. In later years he recalled his childhood as a time of formality and distance when 'It was only a half Irish half Chinese amah whose name I had never even heard who gave me any affection'.[42] It was from his amah that he eventually learnt that Jessie was not his birth mother but his stepmother, a fact that came as a great relief. 'She was,' he recalled, 'of a very different type and there was no natural sympathy between us, and this information came to me, even at an early age, as a kind of release.'[43] As he grew older Leach's relationship with his stepmother became even more difficult and tense, for they were in constant competition for his father's attention. Although he wrote several reminiscences of his father Leach recorded virtually nothing about his stepmother. Both, however, were united in their love and admiration for Andrew Leach, sharing his fondness for outdoor life, respecting his energy and applauding his professional success.

Life proved as well ordered and conventional as that with his grandparents, which meant that he saw very little of his father and not a great deal of his stepmother. But family life did have moments of relaxation. Occasionally his father made 'a special kind of mayonnaise' that so impressed his son that he continued to make it throughout his life. A keen shot Andrew Leach kept two spaniels, named Dash and Nemo, which he took on the mainland when shooting snipe. On weekdays the dogs were not allowed in the house but on Sundays this rule was waived and Bernard was always mystified to

find them waiting outside the door ready to come in on that day only. Also on Sundays his father would walk him 'down to the R. C. cathedral not far from the bottom station of the funicular railway. I loved the trembling notes of the first organ I ever heard. It made the hairs stand up on the nape of my neck!'[44]

In 1895 Andrew Leach was appointed a judge and the family moved to Singapore, settling first in Abbottsford, a building remembered by Bernard as 'a nice house'. A few days after their arrival his father gave a loud cry from the garden where, dressed only in a kimono, he had climbed a tree and found himself covered with a swarm of biting ants. Much to the astonishment and amusement of his son and his amah his father cast off his kimono and slipped down 'faster than he went up, stark naked'. On rare occasions the child was taken to the law courts, which were next door to the large cricket ground and the famous Raffles Hotel, to see his father in action, though the proceedings were far above his head. On a particularly hot summer's day, dressed in a smart, spotlessly white drill sailor suit, he was driven in the family carriage to hear his father. Emerging from the law courts and forgetting that Singapore is only one degree north of the Equator he sat down on the carriage seat that had been left open to the sun only to jump up smartly with a shout because it was so hot that it burnt his leg.

As a senior official Justice Leach was treated with great respect, and was generally regarded as someone to be esteemed and even feared. A police guard protected his house twenty-four hours a day, and one night apprehended a Chinese burglar attempting to break in, the noise waking the whole household including the curious child. Bernard gazed with awe on the intruder, whose hands had been tied behind his back, pinioned against one of the pillars of the covered way that led to the kitchen quarters, struggling to break free. Recklessly, when the policeman attempted to close in, the intruder had struck him with an iron opium pipe, adding to his list of offences. Alarmed by the unusual vigilance the burglar nervously inquired whose house it was and when told bewailed his bad fortune in having inadvertently selected 'the Lion Judge's home'.[45]

In court, like his ancestor Sir John Leach, Andrew was often both irritable and dictatorial, demanding the highest respect for his office and showing little patience with any litigant or counsel he thought ill-prepared or ignorant. His caustic remarks were legendary and anecdotes about his outbursts repeated with relish. One plaintiff, a young man, arrived in court accompanied by his mother, a large woman dressed in a fine satin dress and wearing a startling hat composed principally of red feathers, who took a seat near the front. Entering the witness box her son was totally overawed by the proceedings and when asked his name before being sworn in could only come up with his diminutive. On being asked what that stood for the judge was met with silence. 'Will you answer me?' boomed Justice Leach, glaring at the witness

through large spectacles. Desperate to help her son, in a stage whisper his mother urged him to repeat his name. Greatly irritated, the judge thundered that she should 'sit at the back of the court and keep her mouth shut, or I'll turn you out'. Calm appeared to be restored until, when about to take the oath, the luckless youth was only prevented from kissing the Bible by a roar from the judge causing the terrified lad to drop it. This was too much for the mother who, hiding her face behind a large fan, whispered loudly to her progeny 'Say you are a Roman Catholic, son!'[46]

Like many in his position Mr Justice Leach could be both genial and severe. To young men fresh from England he offered wise, sensible and friendly advice, acting as confidant and counsellor, keeping a watch on their tendency to over-drink and warning them of the various difficulties and temptations to avoid. Such conviviality was rarely extended to his son; they did, however, share a great interest in sport, most particularly cricket. Andrew Leach served as captain of both Hong Kong and Singapore cricket clubs, and inspired a great love of the game in his son. Bernard recalled looking admiringly at his father in action on the field where 'he bowled with a very curious bent arm action'.[47] Judge Leach was also a decent bat and a short-distance sprinter. For one special event he was persuaded to take part in the local veterans' race and his son recalled his determination when, after running well and but ten yards from the winning post, he 'heard a crack of a muscle and watched him hop the last ten yards and win!' adding 'I was so proud of him'.[48] With his growing professional acclaim the family celebrated his success, and were delighted when he was appointed a Queen's Counsel. Although he remained a remote figure whom Bernard felt he never really knew, he could recall no angry words throughout his childhood, and fifty years after his father's death wrote 'I really loved my father – always'.

No record survives of any schooling, or of any private tuition, and with no brothers or sisters Leach recalled that he was 'a lonely child'. His interest in drawing, a pursuit he could follow on his own, began at an early age, later observing 'I have drawn since I was a child of six'.[49] Among other subjects he drew boats at anchor in the harbour, though none has survived. Left to his own devices for much of the time Leach thought his interest in clay may have begun when, at the age of nine, he recalled 'picking up worm casts before they could harden and playing with them in my fingers. It is the primitive first tactile contact with earth and all children experience it as they play in mud puddles'.[50]

As he approached the age of ten his parents decided that he should be educated in England, selecting the Jesuit school Beaumont College, 'the Catholic Eton', at Old Windsor. His father's old school in Highgate, a traditional choice for the Leach family, was rejected in favour of the religious discipline offered by the Jesuits. His Great-Uncle Granville, then aged seventy-two and still mourning the loss of his wife, accompanied the child to England, choosing to

sail to the west coast of America, cross to New York by train and then by ship to England. The more complicated journey was a little faster than the sea passage and may have been the particular choice of his uncle, who was thought eccentric.

The only recorded memory of the long rail journey for the ten year old was the fear that at some point his great-uncle would step off the train to stretch his legs and would leave him stranded and all alone. For a child such a trip halfway round the world must have been both an exciting and daunting prospect. He was leaving behind his beloved father and the security of a familiar routine for a way of life that was strange and uncertain and many thousands of miles from home. England, though regarded as his natural home, with its very different way of life was totally alien to him. Fortunately, being part of the vast Leach family, there were many uncles and aunts and distant cousins to take care of him and with whom he could stay. Letters from his father indicate the extent of the family, with constant inquiries after the well being of relatives such as Uncle Fred, Uncle Henry, Hilda, Aunt Minnie, Uncle Walter, Roland, Monica and Sir Joseph and Lady Savoy. There was little chance, however, of seeing his father for several years unless he came home on leave.

Beaumont College, like most public schools, was strict and conventional. It was founded in 1861 by the Society for Jesus to educate Catholic boys from the upper classes as part of the Jesuit response to the ramifications of the Oxford Movement. One of its aims was to turn the thoughts of English Catholics to centres of official national life from which their religion had so long cut them off. Although the Jesuits already had a boys' school, Stoneyhurst, their 'windy Lancashire fortress', they were keen to have access to a bigger share of the Establishment and Beaumont offered an ideal opportunity. Magnificently placed, situated some twenty miles from London between Windsor and Staines, the school stood on the slope of a beautifully wooded hill rising gradually from the banks of the Thames; its finely timbered grounds, covering nearly 200 acres, had once been a part of Windsor Great Park.

At its centre was The White House, an elegant eighteenth-century building with a graceful formal colonnade of thirty-six-feet-high pillars, topped with exotic elaborate capitals fashioned out of the artificial material known as Coade Stone. The building and estate had been bought from the executors of Lord Ashbrook in 1854 and had been extended to create the schoolrooms. It attracted Catholic boys from noble and rich Continental families, sons of peers and important squires, claimants to the thrones of France, and above all members of the Spanish royal family, the last collectively dubbed 'The Sherry Trade'. The school opened with fewer than a hundred boys and remained around this size until the early decades of the twentieth century. In 1888, a preparatory school, St John's,[51] was constructed in the extensive grounds about a third of a mile from the college.

Eager to gain royal approval, the school was greatly honoured when Queen Victoria visited in 1882, and again as part of the Diamond Jubilee celebrations on 5 July 1897 accompanied by her daughter Princess Henry of Battenberg and her granddaughters Princess Henry of Prussia and Princess Louis of Battenberg. Gifts to the monarch included a loyal address written on vellum with gilt and coloured decorations presented in an envelope of watered silk, and a bouquet of pink and white orchids. In all the excitement the boys got rather out of hand and no one went to bed before midnight. Leach later recalled how, when walking in Windsor Home Park, he often saw the queen in old age and 'duly doffed my hat'.[52]

When Leach entered Beaumont on 1 September 1897, the school, under the rectorship of Father Tarleton, was not at its best. There were beatings and expulsions, the boiler burst, part of the roof fell in and a servant was sacked for selling the boys spirits and keys. In 1901[53] the more extrovert and ambitious Father Joseph Bampton was appointed rector and he immediately inaugurated a campaign to improve the school. Beaumont was widely advertised and visitors were entertained on a grand scale. To add a sense of gravitas to what was still a recently established institution, study windows were fitted with heraldic stained glass made up of coats of arms of old boys, and the captain system, derived from that in use at Rugby, was introduced.

To extend their military connections Father Bampton succeeded in persuading the Navy League to award two annual prizes that necessitated organizing special classes in mathematics and English, so enabling the school to advertise that it could get Catholic boys into the Navy as officers. This possibility was of particular interest to Andrew Leach for he knew that his son sometimes designed 'battleships and those kinds of things'[54] and suggested that he might consider a naval career. Although he attempted mechanical drawing Bernard quickly realized that such a career would not suit his talents, commenting 'it wasn't my game'.

Under Father Bampton's guidance the Jesuit system of strict supervision was modified by the introduction of a slightly more liberal regime and a wider range of activities that allowed a degree of freedom to move about the grounds, and for the older boys to use bicycles. Smoking was allowed at set times. A small zoo encouraged an awareness of and involvement with animals, and at various times the school owned a bullmastiff and a Great Dane, which were allowed to roam the grounds.

There is no record of Leach's response to the newly decorated chapel or of its effect on his own artistic ambitions, his memories centring on the superb singing rather than the splendour of the setting. Later in life during visits to other religious institutions he was constantly reminded of the ethereal quality of the music at Beaumont. Religion made a profound mark on him and in 1900 he was confirmed Edmundus Andreas, taking the name of his maternal grandfather and father. Writing about his time at Beaumont,

Leach's recollections were a combination of respect and awe for 'although the discipline was grim, the boys were taught a faith which was based on the worship of God through the teachings of Jesus Christ and His Church. Belief amongst us was absolute'.[55]

Daily life followed the pattern of many other public schools; it was tightly ordered and heavily timetabled with little opportunity for the boys to be alone. 'At Beaumont any boy can be found at any time of the day within two minutes,' the school boasted.

Latin was compulsory, with the addition of Greek for the brighter pupils. Studies of history made much use of *Green's History of England*, a book that later proved useful to Leach for the patterns it illustrated on prehistoric English burial urns. Letters from home were collected during a half-hour break, 'First Rec', after which came more lessons for all but the unfortunate individuals who had to submit to corporal punishment for their misdeeds at the hands of the prefect. This punishment often took the form of a leather paddle, known as a tolly or ferule, given on the hands. To the impressionable pupil the beatings seemed needlessly cruel and sadistic, deterring rather than encouraging interest.

Like his near contemporary, the Irish writer James Joyce, who underwent a similar education in a Jesuit school in Ireland, his school days were a combination of fear, bullying and intimidation by both boys and masters. Joyce vividly describes a beating on both hands administered with a 'pandybat', an instrument made of whale bone, leather and lead, given to a boy for 'a bad Latin theme'.[56] Although he enjoyed sport Leach appears to have been withdrawn rather than outgoing, keen on such solitary pursuits as drawing and reading and academically undistinguished. Being several thousand miles from his parents did not help and he dreamt regularly about and prayed for the mother he had never known.

Like many schools across the Empire, Beaumont took every opportunity to celebrate royal occasions. For Queen Victoria's funeral in 1901 the King of Spain[57] was invited but declined to lay the school wreath made up of flowers reflecting the school colours – white blossoms of arum lilies, lilies of the valley, and white tulips, with violets as the only colour. Two boys who were first cousin to the king laid the wreath. For the delayed coronation of King Edward VII on 9 August 1902 elaborate celebrations were planned, but the postponement dampened enthusiasm. Writing to his son from Penang his father complained that for 'the coronation festivities things are very dull here and the go seems to have gone out of things and bodies'.[58] As part of the festivities Beaumont boys were taken to view the procession from the roof of the presbytery attached to St George's Cathedral, Southwark. College celebrations included a bonfire that 'burned grandly' and a much admired display of fireworks, though the event was overshadowed by an accident to one boy, Johnson, whose face was burnt by a large firework exploding with great violence.[59]

A severe outbreak of influenza the following January not only filled the infirmary but overflowed into a twelve-bedded dormitory. The sanatorium was at the top of several long and steep flights of stairs, and on one occasion Leach was discovered leaning over the edge of the banister gazing into the abyss below. In later life he recorded a recurring vivid nightmare in which he was looking over the top, terrified that he would fall into the well below.

One of the few pleasures at Beaumont was reading aloud and Leach took elocution classes, winning a prize virtually every year for his recitations. Favourites were classics such as Tennyson's 'The Captain' – 'a time honoured piece' – whose opening lines, 'He that only rules by terror/Doeth grievous wrong', may have carried more than a resonance of his perception of life at Beaumont, and 'The Brand Excalibur'. Play acting also appealed and Leach appeared as Faulkland in a scene from Sheridan's *The Rivals*, and in *Monsieur Tonson* by W. T. Moncrieff, 'a bright little play' that kept 'the house uproariously amused for over an hour and a half'.[60] Leach played the part of Jack Ardourly, while his friend Prince Alfonso of Spain took that of Monsieur Bellegarde.

Keen on public speaking Leach was also a regular attendee at the Debating Society. This was formally set up with a structure based on that of parliament with members representing different constituencies following a comprehensive book of rules detailing procedures such as who may speak and for how long. The prime minister maintained order, a position held by Francis Patmore,[61] who was also captain of the school. Subjects discussed included such controversial issues as the abolition of the House of Lords.[62] To loud applause Patmore warned that the 'Lords was the only barrier between us and government by the democracy, and he objected to be governed by the shopkeepers, pork butchers and others who held sway in the lower house'.[63] Appropriately, Leach represented Hong Kong.

One of the most challenging debates was the proposition that 'The Empire of China should be divided amongst the Powers of the World'. This topical debate referred to the fate of the country following the Boxer Rebellion of 1900 when missionary settlements in the north of China were burnt and looted and thousands of Chinese Christians slaughtered. An allied force of foreign powers entered the county and marched on Peking to free the foreign legation. Extravagant proposals included dividing up the country and the West running it as a colony. In the debate Leach stressed the uniqueness of the country and the value of its cultural tradition. 'It has its own customs, and own way of looking at things, its own ideals, and even if it were conquered, and parcelled out, it would never assimilate with the nations of Europe',[64] he reasoned. His inspired defence was a foretaste of his later respect for, and admiration of, Chinese tradition and culture. To his gratification the motion was roundly defeated by 27 to 6.

Great emphasis was placed on sport, and afternoons were devoted to football in winter and cricket in summer. Other games included tennis and rowing on the Thames. Boys were encouraged to learn to swim in a large, indoor steam-heated swimming pool, though there were no formal lessons; only boys who could swim four lengths fully clothed were allowed to row. Following in the footsteps of his grandfather and father Leach headed for the cricket pitch, and in his final year was rewarded with a place in the first eleven. Fixtures were arranged with, among others, St George's Hospital, Beaumont Union, and the Newman Society, Oxford. In his final match, played against Eton College, Beaumont were roundly defeated by three wickets and sixty-four runs, Leach managing to score six before being bowled out. A photograph of the team shows him to be slight of build, a timid looking sixteen year old.

Apart from sport and elocution, art was the only subject at which Leach did well, taking extra drawing classes from Mr T. E. Friday and his brother Mr J. A. Friday, the aged professors of drawing who taught part-time at the school for many years. In addition to geometrical and perspectival drawing they also encouraged, without much direction, freehand and model drawing, subjects in which Leach excelled and for which he was awarded several prizes. Less to his taste was the tedium of having to 'laboriously copy reproductions of academic pictures such as those by Alma-Tadema or Lord Leighton, PRA, with Conté crayon, stump and rubber, almost with the end of his nose'.[65] Stumping, a technique devised as a means of depicting form without the use of line to create a solid effect by using carbon dust in spiral cones of paper, was highly favoured by the State Art Education Authorities. Through a process of prolonged dabbing, rubbing and stippling, the form had to be represented by shading based on the observation that 'there are no lines in nature'.[66] Leach's graphic skills came in useful in an evening of topical talks and discussion in the Modern Side Academy when, for an item on geography, he 'drew on the blackboard with bewildering rapidity a map of the world'.[67] Making use of the visual aid his partner Wilfred Glyn 'pointed out in an imaginary tour the principal coaling stations on which England depends for defence in time of war'.

At Beaumont Leach made few friends and none with whom he subsequently kept in touch. His nickname, 'Chink', awarded because of his oriental background, did not endear the other boys to him, many of whom he thought rough and uncouth. A friendship was struck up with Prince Alfonso D'Orléans Bourbon, known to his family as Ali; they appeared in the same school plays and both were active members of the debating society. On one occasion they commiserated with each other while waiting in line to receive punishment. When an opportunity arose later in life to renew contact Leach declined, doubting he would be remembered.

Like many parents his father often complained that he heard too infrequently from his son. Andrew Leach's letters, short and fatherly rather than

intimate, were likely to include reports about the absence of rain and conse-
quent shortages of water, his activities on the bench with references to com-
plicated murder trials, his success at shooting snipe and his prowess at golf.
Stamps for his son's album were often included. A never-ending source of
interest for both were the activities of members of the family, and his father
liked news of any visitors. For one speech day Bernard's cousin Hilda[68] and
his Aunt Minnie came to see him receive a prize, prompting his father to
complain about his failure to write a full account. One much discussed event
was the marriage of his father's younger brother Alfred, a Church of England
minister, to Hilda Mullens. 'I hear Uncle Alfred's wedding is fixed for the
16th April – the date is a nuisance as it cuts into your holidays,' wrote his
father. 'However I suppose it cannot be helped – though his reverence has not
written to us for ages & we only hear through others. You must do exactly as
you like about giving him a wedding present. – & let me know how you are
off for pocket money.'[69] No record survives of whether Bernard attended the
funeral of his paternal grandmother Frances Mary Leach, who died on 1
November 1900 at the age of eighty-three. She was buried in Shamley Green,
Worcestershire, where Alfred, her son and Bernard's uncle, was vicar.

The question of where to stay in the holidays was always pressing, and at
times Leach must have felt rather like a parcel passed from one relation to the
other. Holidays were usually spent with his Uncle Walter, a solicitor, in
the company of his cousins Roland and Hilda, at Ealing in west London. In
the summer they liked to go to the seaside and his father was greatly put out
when told that 'Uncle Walter is vacation Registrar & will not be able to take
you to the sea this August. It is a great trouble to me for I am sure you ought
to go somewhere every year. However something may turn up'.[70] Christmas
could be equally problematic, but these were usually spent happily with Uncle
Walter and his family.

With the approach of his sixteenth birthday Leach's future had to be
decided. Having shown no inclination for a career in law, colonial adminis-
tration or banking, there seemed little point to him in remaining at Beaumont,
but his parents were more cautious. The intensity of their discussion was tren-
chantly expressed in long anguished letters from his stepmother written at the
beginning of his final term. 'Put your heart and soul into your studies . . . and
make up your mind to do something that will please your father,' she urged,
adding, 'You could not have a better father and you are his only child.' She
would, she said, feel 'fearful disappointment' if he did not 'make a good choice
of a career'. Increasing the emotional pressure she implored him to be 'more
sociable & more active & less dreamy', and rubbed salt in the wound by
reporting feeling 'quite sad' when she heard of his cousin's success at Win-
chester. Above all she hoped that he would 'turn out a pleasure and a delight
to your dear father'.[71] With such overwhelming demands there was little
wonder that dreaming seemed the only available option.

During what was to be his final year the earnest schoolboy came across John Ruskin's *Modern Painters*[72] and read it avidly 'without prompting from any masters, or anything except my own heart. I allocated the whole of it'.[73] Ruskin's impassioned words stoutly defending and elucidating the works of Turner and putting forward ideas about the moral and uplifting qualities of art opened his eyes to the glories of painting, succeeding in making him 'mad keen about the world of art'.[74] Although Ruskin's writings were for a time later rejected by Leach, he continued to be influenced by many of his ideas, in particular Ruskin's belief that good architecture and art, though not necessarily ecclesiastical, must be religious in spirit, and his firm conviction that education should be a matter of the head, the heart and the hand.

In the face of the powerful family tradition and parental pressure to follow a respectable profession the young Leach, insisting that he wanted to be an artist, consulted Father Bampton and Uncle Walter, both of whom independently affirmed his artistic talent. Despite such positive support his father was cautious. 'I got your letter this morning about what the Rector says about your vocation in life. But there is much to be considered before you select such a life's work. First you must ascertain not only that you have a liking and taste but also the qualifications for an artist. The Rector is not I imagine qualified to give a sound opinion as to this nor is Uncle Walter.'[75] When further requests for details about his son's career failed to materialize he complained about his lack of response. 'I have not heard for several mails & you have never yet answered my letter about your vocation as an artist.'[76]

Despite his professional acclaim, growing ill health, which included persistent indigestion, marred Andrew Leach's success, and doctors were endlessly consulted, but with no particular cause diagnosed he thought it not serious. 'Tomorrow I am off to Singapore for the trip to see Dr Kerr,' he wrote. 'My heart or the muscles around it are giving me trouble but you need not be anxious as Dr K declares the heart itself is alright.'[77] Hoping against hope, his father thought his troubles could be put down to 'the beginning of what is known as a smokers heart and of course I shall have to give up my beloved tobacco. I am reduced to 2 again a day'.[78] Doctor Kerr, reported his father, gave him 'a good medical character and says with care I shall soon be alright again. My heart is all sound but irritated by dyspepsia which may be troublesome to get rid of'.[79] With plans to visit England he thought any decisions about his son's future could be postponed.

Early in 1903 Andrew and Jessie Leach sailed for Europe for a six-week tour of Italy before arriving in England to see their son and discuss his future. His father was somewhat relieved 'to hear through Muriel that you . . . do not intend to make your mind up until I go home – when we will think the matter out together', adding as an afterthought the suggestion that he might like to consider becoming 'an architect?'[80] Italy appeared to have a beneficial effect

with Andrew Leach reporting 'I am glad to say we are both well & I am feeling much better. To tell you all we have done in detail would be to fill a volume'.[81]

Unfortunately Andrew Leach's old troubles flared up and he and Jessie were forced to cut short their tour and seek specialist advice in London. After a gap of six years Leach's delight in seeing his parents was offset by anxieties about his father's health and the impending discussions about his own future. At sixteen Bernard was far below the usual leaving age. When his father visited the school in March he was greatly surprised by the rector's genuine support for his son's artistic ambitions, applauding his success in winning drawing prizes and pointing out the absence of any academic ambition. These arguments finally persuaded Andrew Leach to allow his son to enter the Slade School of Art in London in September. 'Home on leave towards the end of my schooling, he came to see me at Beaumont to consult the Rector about my future. I had excelled only in drawing, elocution and cricket. It was with some anxiety that my father sent me to the Slade School of Art.' To the budding artist 'this was sheer joy. I had found my vocation . . . Life began to take on meaning.'[82]

'I ALWAYS WANTED TO BE AN ARTIST'

England

1903–1909

Quite how Andrew Leach was persuaded that his only child should be allowed to leave school at sixteen to become an art student, even at such a relatively respectable institution as the Slade School of Art, remains a mystery. The rector's adamant support must have helped to convince him of his son's ability, and he may have reasoned that his interest in art would pass and that he would eventually embark on a more conventional career. In any case Bernard was only sixteen and there seemed no urgency to make a final decision. Although the exact cause of Andrew Leach's ill health remained undiagnosed, it was not thought sufficiently serious to hinder his planned return to the Far East.

Apart from being able to pay the not insubstantial fees, potential Slade students were required to present a folder of work for the approval of Henry Tonks,[1] the artist in charge of drawing. Despite his relatively young age Leach was accepted at once. Although at the time the Slade's youngest student, Leach was following in the footsteps of his great hero the painter Augustus John[2] who had also enrolled at the age of sixteen. The basic fee of eighteen guineas covered full-time tuition for three terms. An additional payment of £1 11s 6d enabled Leach to attend the fine art and anatomy classes.

By the early years of the twentieth century the Slade had established a reputation for offering a solidly grounded education based on the atelier system. Part of the University of London the school had opened in 1871 with an endowment from Felix Slade who bequeathed funds to support the study and practice of art. In contrast to the academic courses set up at Oxford and Cambridge, the University of London established a Faculty of Fine Art to provide an enlightened, modern practical education with practising artists as lecturers. A purpose-designed building formed the north-west wing of the imposing neoclassical quadrangle of University House, the green lawns and relative peace creating a quiet oasis in the midst of the bustling city.

Frederick Brown was professor, a remote figure who later won Leach's approval when he discovered that he had taught the artist and illustrator Aubrey Beardsley at the old Westminster School of Art,[3] with Philip Wilson

Steer in charge of painting. Tonks, however, although only assistant was regarded as 'the ruling spirit', his powerful personality and command of drawing was then considered the most important aspect of an artist's training. Having abandoned his career as a successful surgeon to become an artist and teacher he was thought to be as incisive with his criticism as he had been with the scalpel. 'Physically, he was a towering, dominating figure, about 6′ 4″ tall, lean and ascetic looking, with large ears, hooded eyes, a nose dropping vertically from the bridge like an eagle's beak and a quivering, camel-like mouth,' recorded one student, adding 'There was about him an aura of incorruptible nobility of purpose . . . respected by all the students and feared by many.' Leach saw Tonks as 'a great teacher' and likened him to 'Squarcione,[4] the founder of the Renaissance in Venice and the comparison is excellent. Trained as a surgeon he retains the severe and cuttingly exact character of one of his manner and method. He is the only man I have ever met who says exactly what he thinks to the verge of brutality.[5] Like Ingres, who said it took thirty years to learn to draw but only three to acquire the skills of painting, Tonks believed that 'drawing is an explanation of form',[6] and that the 'drawings of great men are like lines in Shakespeare the beauty of which are beyond explanation'.[7]

The Slade attracted a wide range of students who generally remained for two to three years, though some longer. With no set course as such the staff advised students which particular classes to attend. There were no formal examinations, the university status bestowing respectability. The professor gave subjects for composition once a month. Great emphasis was placed on working from the figure, usually posed in the handsome studios lit by an even north light, but the rooms could be rather chilly and in the winter months models complained endlessly. Studios were allocated to a specific subject, with the men, who were far outnumbered by the female students,[8] given the best spaces.

The rules insisted that 'All students will be required to draw from the Antique until judged sufficiently advanced to draw from the life'. No matter what their experience, Tonks was adamant that this rule be followed, insisting that students draw plaster casts of Greek, Roman and Renaissance heads, and sculptures such as *Discobolus* and *Dancing Fawn* until he permitted them to move to the life class. Tonks's rigidity met with resistance, particularly from those who had enjoyed the freer atmosphere of Paris, but no exceptions were made. Along with other new students, Leach had to stand, 'drawing at arm's length with charcoal on Michelet paper, from plaster casts of Greek sculpture, from morn till night',[9] which for him was 'sheer agony', reminiscent of the drudgery of stump work he had endured at school. In a few 'painful months' Tonks succeeded in exorcising 'the false standards and habits' that he had acquired at Beaumont in 'learning to copy microscopically photographs of well-known paintings by academicians'.[10]

Like Augustus John, Leach was pleased to pass to the life room, although it was here that Tonks was at his most cutting, with 'a sarcastic wit and a biting utterance which, when so moved, did not hesitate to employ without distinction of the sexes'.[11] Ruthlessly critical, Tonks prowled round 'with a deepening sardonic frown on his surgeon's face, stopped, and in silence said "Well – I want to know when any of you are going to show signs of becoming artists"',[12] and with that swept from the room. Leach often related the anecdote to illustrate the discipline required. Clearly intimidated by Tonks, Leach respected his incisive comments, even if he felt he did not get the support from him that he deserved. In later life he looked back more generously, reflecting that Tonks's 'surgery having changed our skins – saved our lives maybe'. Tonks's mantra 'action, construction, proportion', enunciated as 'the flaming guardians of the paradise of art', made an enduring impression, which though intended for drawing, later seemed equally applicable to making pots. Tonks did once pay the young Leach a grudging compliment saying 'You may be able to draw one day'.[13]

After the discipline of Beaumont, where the students were kept in the dark about 'all matters relating to the world outside the boundary walls',[14] Leach found the freedom and excitement of the Slade and the life of a student 'sheer joy'. The bound register in which students signed to record attendance indicates that he was a regular, even on Saturdays.

Almost at once he met Reggie Turvey,[15] a handsome, mustachioed South African five years his senior. 'On my own, for the first time in my life, and feeling very shy and lost, the youngest student in the school, fresh from Beaumont, I must have sensed a similar shyness in him, also the sincere desire for truth and beauty which tempered both our lives.'[16] Engrossed in conversation they walked to Turvey's 'boarding house'[17] in Bayswater and later they shared rooms. With a generous monthly allowance Turvey was comfortably off and remained at the Slade for three years. Some years later Leach was particularly pleased to discover that the two were distantly related for both had ancestors from Bedfordshire where a branch of the Leach family had intermarried with the Turveys before going to South Africa. Through Turvey, Leach became friends with another South African, Gordon Leith,[18] a student at the Architectural Association, with whom he later shared rooms in Chelsea. They maintained contact when Leith returned to South Africa, where he became a leading architect.

In an effort to find Bernard somewhere suitable to live Andrew Leach arranged for him and Turvey to take rooms in Hampstead, and sent a cheque for £4 towards the cost. Still concerned he later recommended a Mrs Burt in Lancaster Place, Belsize Park, at a cost of twenty-five shillings a week, pointing out that this had the added attraction for a cricketing buff like his son of being 'about 7 minutes from the Hampstead cricket ground'.[19] Leach and Turvey became great friends with Reginald Brundrit,[20] a student from Skipton

in Yorkshire. Brundrit showed early promise as an artist having already attended Bradford Art School and after only a year won second prize for figure painting as well as certificates for perspective and painting.

Feeling 'alive and flying for the first time',[21] for Leach his time at the Slade was full of discovery and excitement. One of Leach's few surviving water-colours is a testament to his youthful endeavours. The study, of a view of London seen from Hampstead Heath[22] rendered in a flowing style reminiscent of Turner, captures the smoky atmosphere of the distant city, effectively con-trasting it with the leafy open ground of Hampstead. Leach explored the city, visiting galleries and museums and investigated the sights and sounds of the bustling metropolis. Such strange, evocative spectacles as the billowing sul-phurous smoke given off by the steam trains from what is now the Circle and Metropolitan Underground lines that served Great Portland Street and Gower Street stations near the Slade,[23] never failed to amaze him. The sounds of 'horse-buses, growlers and handsomes' added to the thrills, as did the street sellers cry 'meat, meat, cat meat', thought by the naive youth to be the flesh of that domestic animal rather than meat for the animal to eat.[24]

The idyll of art school was brought to a sudden end by his father's wors-ening health, a prolonged medical consultation causing him to miss one of their meetings, indicating the severity of his illness. 'Very sorry to see so little of you yesterday but the doctor kept me so late I couldn't help it,' wrote his father apologetically. The eminent London doctor, Sir Patrick Manson,[25] pop-ularly known as 'Mosquito Manson' from his pioneering malarial research, diagnosed cancer of the liver, advising that he had probably only a year to live. Bernard was given the news in a room in Maddox Street, near Oxford Circus, to the plaintiff sounds of a barrel organ drifting up from the street below. With Andrew Leach's return to the East now out of the question he and Jessie settled in a new house, Belle Retiro, in Branksome, Bournemouth.

The blow for Leach was twofold. Not only had he to come to terms with the impending death of a father he barely knew but for whom he had great love and respect, he had to face increasing opposition to his art studies and pressure to take up a 'respectable' career. Andrew Leach was suspicious of the life of an artist, believing it to be financially insecure and potentially immoral, especially life classes, which he associated with unrestrained licen-tiousness. His son was still impressionable and naive, with little experience outside institutional life, an unworldliness his father recognized by taking him into a public house to show him where he could order a decent lunch at reasonable cost.

In view of his failing health, limited finances and real concern about his son's artistic career, Andrew Leach consulted Tonks about his son's future. While Tonks had earlier given muted praise, he did not, as Leach was bitterly to recall, support him continuing at the Slade, saying that he 'was too young for him to judge' and felt unable to 'advise my father to let me be an artist

with only one hundred pounds per annum to live on'.[26] The only consolation after Tonks's demeaning assessment was the award to Bernard of certificates in perspective and drawing of first-class merit, given for proficiency rather than mere attendance.

With no alternative but to live with his parents in 'the horrid stark new house'[27] in Bournemouth, Bernard managed to get permission to spend two weeks on a painting holiday with his chums Turvey and Brundrit in Yorkshire, staying in Skipton with Brundrit's mother and aunt.[28] Set amid the Yorkshire Dales the town was an ideal base from which to explore the expanse of the moors and the rolling beauty of the dales. Each day the three 'walked miles and painted assiduously', returning to fill themselves with magnificent high teas and 'the best traditional English food'. Tonks's maxim 'action, construction, proportion' continued to ring in his ears but Leach found it too mechanical and hard, believing that painting required 'natural expression, feeling and imagination'.[29] In this he had more in common with the ideas of Whistler, who, in the words of his pupil Walter Sickert, had 'no wish to record anything merely because it exists. It is not occupied in a struggle to make intensely real and solid the sordid or superficial details of the subject it selects. It accepts, as the aim of the picture, what Edgar Allan Poe asserts to be the sole legitimate province of the poem, beauty'.[30]

In Yorkshire Leach concluded that he 'did not paint a single picture . . . of any real merit . . . I was interested in line, and Reggie in colour and texture. He loved painting in itself and was a born colourist'.[31] It was not until two years later that he began to feel he had achieved 'genuine conviction' and 'living expression' in his work, but never felt that he made real progress with painting. Nevertheless, during their two weeks in the north, the open exchange of views and the mutual criticism came as a welcome relief after the highly academic atmosphere of the drawing classes of the Slade. Despite Leach's self-confessed lack of success with paint the days passed all too quickly and it was with great reluctance that he left for the sombre and sickly atmosphere of his parents' home in Bournemouth.

Set on the south coast in a pine-covered area of Hampshire,[32] with ready access to sandy beaches and open countryside, Branksome formed one of the suburbs of the rapidly growing Bournemouth conurbation. The luxurious setting of wide, tree-lined roads, the proximity of the sea and the clement weather did little to soften the difficulties of living with his parents. Taking on the role of dutiful son did not come easily after seventeen years of mostly living in a school or staying with relatives. For the first time as a young adult Leach had to find a way of relating to his father and stepmother that permitted him to maintain at least some degree of independence, while being ever conscious of his father's worsening condition and the suffering he must bear. Although ready to acknowledge his stepmother's devotion to his father, relations between them were strained and difficult, Bernard finding that they

'hardly agreed about anything'. In later life he concluded that 'My stepmother never gave me love, nor I her',[33] as each in their own way continued to vie for Andrew Leach's affection.

Realizing the imminence of his death Andrew Leach asked his son to select a site for his grave at the new cemetery at Parkston. A spot at the edge of the cemetery was chosen overlooking open countryside[34] for which Leach designed an elegant, five-foot-tall headstone in the form of a cross with a carved Celtic design in relief. Anxious about his son's future and knowing he was able to make only limited financial provision for him, Andrew Leach implored Bernard to pursue a professional and reliable career and seek admission to the Hong Kong and Shanghai Bank with which the family had some connections. With a sinking heart, Bernard felt he had little choice and reluctantly gave a deathbed promise to his father to try.

Andrew Leach died of liver cancer and a heart attack on 7 November 1904, barely ten months after the initial medical diagnosis.[35]

> I watched him die. Sickness made him irritable and prevented him breaking through that strange barrier of blood which so often and so unfortunately lies between fathers and sons, mothers and daughters. I know he wanted to reach and touch me, and I who loved him in return wanted so much to understand and be understood. It never came – a dumb love on both sides – but no understanding.[36]

Discovering that he was too young to sit the bank's entrance exams and all too ready to escape from his stepmother, Leach accepted an invitation to stay with his Uncle Will Hoyle and Aunt Edith, now living in Manchester. Bearing in mind his bank application, he enrolled at Owen's College, one of the constituent colleges of the Victoria University of Manchester.[37] After the stimulation and excitement of London, Leach did not immediately take to the dour environment of the industrial and commercial manufacturing capital of the north, finding its architecture severe and disliking its apparently everlasting wet climate. If, after the south, the atmosphere seemed provincial and dull, Leach responded positively to the friendliness and genuineness of the people, finding them 'more real, if grim . . . whether of town or university'.[38] He particularly responded to the good humour of his Uncle Will, Aunt Edith and their daughter, Muriel, who was four years his senior, experiencing in the warmth of the family home 'the nearest thing to a mother's love'.[39] His Aunt Edith, sister to his own mother, took a genuine interest in him and he responded to her sincerity and sympathetic insight. From her he heard about his mother, the details helping to bring her to life. Uncle Will, an intriguing combination of scientist and artist, was 'a most loveable and admirable man – a good scientist, an admirably balanced person'.[40] Appointed the first director of the Victoria Museum (now the Manchester Museum), part of the university, Dr Hoyle was responsible for collecting natural history

exhibits, which included zoological, geological, botanic and entomological specimens.

Like his Sharp grandparents, the Hoyles were a literary and cultured family and Leach enjoyed the group readings of the classics. 'It was', he recalled, 'his Aunt Edith's voice reading Shakespeare and Robert Louis Stevenson . . . which first took me "behind the scenes" of literature to the men and women whose thoughts make books . . . For the first time I was with relations in whose sea of understanding of life I knew by nature how to swim in'.[41]

Through the Hoyles' connections with the university, Leach became friendly with the young would-be painter Henry Lamb, who was studying to be a doctor. Lamb's father was a distinguished professor of mathematics at Owen's College and instrumental in its conversion into what was then known as Victoria University of Manchester. A reluctant student at the medical faculty of Owen's College, Lamb's real interest lay in art, and like Leach was following a career in response to parental pressure. He duly hatched a plan whereby he would first devote himself to qualify medically – and so avoid accusations of waste and fecklessness – before becoming an artist. After gaining top marks in his finals he fled to London in the summer of 1905 taking with him the 'alluringly attractive Nina Forrest', whom he rechristened Euphemia after Mantegna's saint.[42] The boldness of the plan greatly impressed Leach.

The biggest attraction of Manchester, however, proved to be his cousin Muriel, whose charms won his heart. One day, walking from Edale to Hatfield, along part of the Pennine Way known as Jacob's Ladder in the Peak District, they 'became aware of a shared love',[43] the first experience of such deep feeling for them both. Dr and Mrs Hoyle were shocked, and gently but firmly said it could not be. Still in his teens, inexperienced with as yet no career prospects, Leach had little security to offer Muriel, but her parents' greatest concern was that as first cousins they were too closely related to contemplate marriage.

Reluctantly Leach felt he had no alternative but to accept his uncle's verdict. Although tempted by Henry Lamb's example to move to London, he was mindful of his limited income and dutifully returned to his stepmother's home at Bournemouth. Following an examination and an interview at the Hong Kong and Shanghai Bank in the City of London, he was offered, much to his amazement, a position as junior clerk at the Lombard Street headquarters. Junior staff tended to be recruited from minor public schools, the interview intending to ensure that they had the right sort of background with questions centring on sporting abilities rather than financial acumen. The Hong Kong and Shanghai Bank's reputation was as a rugby-playing company but Leach's cricketing skills held him in good stead and he was soon selected to play in the first eleven.

While the sporting opportunities might be enjoyable, the daily routine of junior clerks was everything Leach dreaded. Tasks included running the post desk, mundane checking of figures or splitting bills of loading, which had to be separated and attached to their relevant documentation and then forwarded to the appropriate department or branch of the bank. The modest salary of about £70 per year underlined their menial position at the bottom of the career ladder. P. G. Wodehouse, who worked as a junior clerk at the bank some six years earlier, wrote several accounts describing the tedium of this life.[44] He was, he said 'the most inefficient clerk whose trouser seat ever polished the surface of a high stool'[45] who never mastered the mysteries of Fixed Deposits, Inward Bills and Outward Bills. The monotony of the work, with its exasperating balancing of seemingly endless rows of figures, drove Leach to near desperation. 'I hated the look, I hated the smell,' he fumed, 'I hated the routine and the deadly series of "smutty stories" with which the tedium was relieved.'[46]

Metropolitan life did, however, have compensations. Contact was reestablished with Turvey and Brundrit and he lodged in Chelsea,[47] the nearest the city had to what could be called an artists' colony. He liked the narrow, unassuming streets that ran from the King's Road down to the quiet beauty of Cheyne Walk by the side of the Thames, then an undeveloped riverbank. The ghost of Whistler[48] still seemed to haunt the area and like him Leach became fascinated by the river in twilight, when the daily activity of a materialist world was softened by a veiled light, imbued with the mystery of shadows. Friends and literature also offered escape. Henry Lamb and Euphemia occupied cheap lodgings in Paultons Square off the King's Road, and Leach became a regular visitor, although their abject poverty caused him to observe 'What the couple lived on I do not know'.[49] Despite poverty, Lamb attended Augustus John's night classes at the Chelsea School of Art,[50] set up in Rossetti's old 'fine studios' in nearby Flood Street.

Lively evenings were spent in Lamb's rooms discussing art and literature, and either Augustus John or Lamb introduced Leach to the writing of Henrik Ibsen and George Borrow. In Ibsen's *Brand* Leach found echoes of his own search for some sort of contemporary meaning in art when the line 'He has been sick a hundred years is dead and must be buried' caught his attention. 'This,' he commented, 'is true of the last centuries ideas of Beauty.' Such concepts gave rise to the idea that 'the Idealism of the century came to an end by means of the realism of the Impressionists. At the beginning it was to most onlookers sheer ugliness, as is the case with the Post-Impressionists. As a group they brought a general blessing of clear sight, eyes for the light, individually they gave us more than mere realism'.[51]

The writings of Borrow, 'the prince among vagabonds', struck a particular chord with Leach, for like John he saw them as 'a dream, partly of study, partly of adventure'.[52] In Borrow's *Lavengro* he found the prospect of a bohemian life of freedom that was in great contrast to his own grindingly bourgeois

existence. 'How George Borrow's taught me to love the roads of England! The people he met on them and their racy speech . . . I read and reread. I even emulated Borrow in walking down to Bournemouth.[53] *En route* he paired up with a couple of tramps and unable to find a haystack to lie in for warmth they slept beside each other with only a thin overcoat to keep them warm. In the middle of the night they woke and ran a mile to get the circulation going, resumed their walk at dawn, but fell asleep in the sun on the chalk downs above Winchester before being disturbed by the feet of people walking to church. The visit was no doubt to see his stepmother, now living with her unmarried sister Eve Sharp. Both later moved to Brighton.

Despite the compensations of friends and literature, Leach felt his life to be meaningless. One of the people to whom he could try to communicate some of his unhappiness was his Aunt Edith, but a reminder of Muriel's birthday on 24 November only served to highlight his feelings of loss. Whilst acknowledging his 'uneasiness', she urged him to stick with his work at the bank, seeing it like his father as the start of a settled and ordered career. Even in literature they were unable to find common ground, each looking to poetry for different views of life. Attracted by the inspirational verve and more pagan assertions of Omar Khayyám, lines such as 'Waste not your Hour'[54] seemed particularly apt to his current state and he urged his aunt to read the verses. She, however, preferred instead to recommend the work of Robert Browning, 'so much more healthy', and such reassuring lines as 'Burrow awhile and build, broad on the roots of things'.[55]

Looking back on this period he described it as 'very dark', a time when he seemed 'to have lost all that I cared for, my faith, my love, my art'. At Beaumont, Leach's religious belief had been 'absolute' but feeling utterly disillusioned by the death of his father, the absence of art, the forbidden love for Muriel, he lost his belief in God. In his struggle to retain his faith he even contemplated entering a monastery. 'The opening of horizons of art from the first month at the Slade, and the bitter experiences which I went through after my father's death broke down that frank and too simple acceptance. I gradually became an agnostic who read Blake and Whitman, and got flashes of insight through the experiences of art,' he recorded. Reflecting on this unhappy period he later wrote 'I knew even then that religion and art were eventually one.'[56] Significantly, Leach saw himself as agnostic rather than atheist. The grim picture was made worse by a sense of desperation and sexual licence. 'For a time I did not care for what happened and I let go of restraint and so only added to my shame and sorrow,'[57] he noted.

Serious and thoughtful but confused Leach was troubled not only by his material existence but his need for some sort of central belief, some truth that was both meaningful and relevant. A poem written at this time on the back of one of his aunt's letters[58] suggests his sense of confusion, and his feeling of helplessness:

The way is long
The path is narrow
The clouds fly overhead
But ever upwards Duwende
And God will guide your feet
Which way to tread.

A recurring nightmare, first experienced at this time, which 'waking did not dispel', gives some indication of the depth of his anxieties. Fortunately Gordon Leith, with whom he was sharing rooms in Redcliffe Gardens, Chelsea, helped him through the horror. 'I was in the Great Night of Space, the last of living things', he recalled

> The world was gone and with it the last vestige of humanity, and love, and mercy, and in their place the dark Immensity was filled with machinery, soulless, insatiable, silent, which defied the bounds of space and time and whose work was the destruction of all living organisms.
>
> My turn had come, the last food for the maw of that awful Minatour.
>
> Like a bird held by the beady eye of the leisurely snake, body paralysed, mind struggling and ranging wildly for escape amidst the cogs and wheels of clock-work vast as light-years, I waited a long age in deadly terror and awoke'.[59]

The deeply disturbing dream caused Leach to arouse Leith and tell him that he was 'either going mad or was about to die', and at 2 a.m. they went looking for the red light of a doctor. 'For half an hour we searched and the terror held and then I was given bromide and gradually recovered.' So awful was the dream and so vivid the fear that Leach claimed that he 'would have preferred to have had a leg cut off without anaesthetics rather than go through that experience again'. The highly wrought dream seemed to the unhappy young man 'a symbol of my life'.

At the bank life became more intolerable. 'I loathed the heartless repetition – balancing to a penny three million or so pounds of duplicate exchange bills per week. This dogs body routine was generally finished alone in the vaults as late as 10 o'clock at night,'[60] he wrote. Unlike his unnamed predecessor, who also had artistic leanings, Leach did not take the dramatic step of dumping the bag full of accounts into the Thames from London Bridge, but after nearly a year he decided he could no longer continue, believing 'I would be happier with £100 a year and art than with £1,000 without'.[61] In consequence he handed in his notice and moved into cheaper lodgings. 'My promise to my father to try the Hong Kong and Shanghai Bank . . . and my dependence upon my step-mother financially, finally made me save every possible penny, in case she refused help until I came of age, held me to my task.'[62] Charles Addis, the

bluff, Scottish-born manager angrily accused Leach of using the bank as a stepping stone, though to what he did not make clear.

The news of his resignation so alarmed and horrified his stepmother that she feared her stepson had lost his reason and spoke of this to Dr Hartigan, who was now serving as the bank's doctor in London, and asked him to investigate. Over dinner he told Leach of his stepmother's concern and her request to ascertain whether he was 'quite normal'. Having delivered the earnest young man into the world, Hartigan felt more inclined to be sympathetic to him than his stepmother, although Jessie Leach, despite her disapproval, continued to provide her stepson with funds. Yet whatever was to happen his decision to leave was final, and Leach calculated accordingly.

Still smarting from the rejection of his love for Muriel, but now free of the routine and boredom of bank life, Leach decided he must escape from the city. Feeling the need for a companion and remembering the dogs his father had kept, as well as the ones at Beaumont, he went 'to Chelsea Bridge under whose arches on the south side of the Thames, lost dogs were kept'.[63] Despite the confusion and the terrific noise of yapping, barking and howling, he finally selected a brown Irish terrier that cost the not inconsiderable sum of ten shillings. The dog quickly proved something of a liability. Securely fastened on a rope but full of energy and excited to be free, it dragged its proud new owner along the street. The ravenous hound succeeded in getting hold of the end of six penny worth of butcher's scraps, refusing to relinquish it until the entire piece had been consumed, a process that took the best part of an hour.

With the dog, now named Pan, Leach stayed in North Wales with Tom and Anne Jones, who had worked as general help and nanny to the Hoyles, at their beautifully situated cottage on the old sea road between Prestatyn and Rhyl. Boisterous and energetic, the dog appeared to have an insatiable appetite. To their utter amazement, despite being securely tied up during the night, it succeeded in reaching and consuming 'two pounds of good fresh butter' in the larder. They had not calculated on the length of its body or its tenacity when within possible reach of food. The dog proved equally challenging when taken for a walk on the Welsh hills as, once off the lead, it leapt over a stone wall and began chasing sheep. Alarmed, Leach hastily followed and seeing blood on the ground put on such a spurt that the braces supporting his trousers snapped, forcing him to run clutching his pants only to find the dog facing the flock herded into a semicircle. Horrified, Leach gave the dog 'the beating of a lifetime'.[64] Rightly or not he decided against reporting the incident and wisely avoided the hills for some time, though to his relief whenever they passed a flock of sheep the dog showed no interest. Pan eventually met a tragic end when it was accidentally run over by a goods wagon in Dorset.

In addition to exercising and controlling his dog Leach continued to paint, draw and write poetry. One poem, 'April Dawn', dated 1907, was a pastoral

response to the countryside, evoking with its reference to 'calm light', 'hushed fields', and 'grey mists', a gentle yearning for peace and order, an anticipation of the ending to 'the long night'. Its tone of muted hope reflected Leach's uncertainties and doubts and is the theme of one of his surviving paintings from this period, a water-colour known as *Prestatyn Mines*.[65] Carefully observed and handled, the sombre, unfussy study of the buildings silhouetted against a brooding sky has a monumental quality, an impression enhanced by the solid feeling of the structure and of an industry that stretched back over two thousand years, a potent reminder of his own Welsh ancestry.[66] Leach was later to write to a relative bewailing the loss of the Massey family tree that traced his Welsh ancestry, which had been accidentally thrown away.[67]

For a time Leach settled at Northmore Farm,[68] Wareham, Dorset, situated by the River Piddle, from where he explored the countryside by foot and bicycle. The picture-postcard town with its neat square, ancient buildings and peaceful air is well captured in a pencil drawing, now in the collection of the Victoria and Albert Museum, showing the Rising Sun Inn. As he 'walked, rowed, caught a few fish and gradually rid myself of the grubby memories of Lombard Street',[69] Leach was able to stand back from frustrated emotional entanglements and through his art began to feel that he was at last 'searching for truth and beauty'.

Although beginning to regain a sense of purpose, a frightening event occurred, which, like his earlier nightmare, reflected deep anxieties. It happened when he and Reggie Turvey were renting a house in Bournemouth, where a steep cliff led down to the sea. Walking on the beach with the dog that belonged to the house they decided to return by taking what appeared to be a short cut by climbing up the cliff.

> We got to a point where I couldn't go up any further, and couldn't go down. The sandy surface of the cliff offered little foothold, or grip. The dog had given up long ago and returned home the long way. I tried to use my penknife to dig into the surface, but it was crumbly and gave no grip. Reggie did it and managed to go ahead. I don't know how he did it. I eventually got to the top, we lay on our backs, and thanked god.[70]

The reckless action seemed symbolic, a risk worth taking, an effort worth making, and remained in Leach's memory.

After two years of uncertainty, indecision and restlessness, 1908 proved a major turning point. On 5 January, his twenty-first birthday, he had access to his inheritance, securely invested at $7\frac{1}{2}$ per cent, to provide a reasonable if modest income of around £140 to £200 a year. Writing in his diary on 1 January he wrote 'I want to draw some pictures of human life, something real and unaffected',[71] implying both a growing understanding of his work and a realization of its limitations. With a restored sense of direction and

independent means, following the example of Turvey and Brundrit, Leach enrolled[72] at the London School of Art, an institution similar to Augustus John's Chelsea School of Art. With many American and quite a few Japanese students, it may have appeared solid, reliable and respectable in contrast to John's more flamboyant institution, and the teaching more regular and thorough. The school, in Stratford Studios, Stratford Road, off Kensington High Street, had been opened in 1904 by the muralist and painter Frank Brangwyn[73] in collaboration with the sculptor and renowned painter of landscape and animals John M. Swan. William Nicholson and Niels M. Lund assisted them. The idea of teaching the young and influencing their work appealed to Brangwyn's extrovert, energetic and vain nature, and students were encouraged to slavishly copy his own style. Brangwyn also hoped the school would make money to meet increasing expenses, particularly in helping furnish and maintain Temple Lodge, the large Georgian house in Queen Street, Hammersmith, he had recently purchased. The comprehensive programme outlined in the prospectus listed classes in oil and watercolour painting, life drawing, portraiture, costumed models, illustration, still life, composition, and sketching along with regular criticisms of work.[74]

There is little doubt of Brangwyn's impact on the highly impressionable student. Despite limited references to him in Leach's writing, they had much in common. Like Leach, Brangwyn had Welsh ancestry of which he was proud and like him he was born overseas.[75] Brangwyn was also a great enthusiast for the art of Japan having studied and become enamoured of Japanese work partly through his friendship with the distinguished artist and Royal Academician Alfred East. East had spent six months in Japan, where he had been made an honorary member of the Meiji Bijutsu Kai (Meiji Fine Arts Society), and in Britain he helped found the Japan Society.[76] Both he and Brangwyn served as members of the art committee for the Anglo-Japanese exhibition that opened at White City, west London, in 1910,[77] an exhibition reflecting widespread fascination with Japanese culture as well as increasing respect for the country's growing military and economic power.

Brangwyn had other connections with Japan. In 1896 he married Lucy Ray,[78] a woman whom Leach was later to describe as Japanese. Many of Brangwyn's Japanese friends were involved in painting and pottery, either as collectors or connoisseurs, several of whom he met through renting a room in his house to a Japanese man with links to the Japanese embassy. Through him Brangwyn came to know Matsukata Shosaku, whose father was twice prime minister of Japan and a leading collector of traditional Japanese art, and his brother the Japanese industrialist Matsukata Kojiro, a collector of modern western art.[79] The London School of Art gained a reputation for taking Japanese students.

From an early age Brangwyn had been directly involved in the ideas and practice of the Arts and Crafts movement. As a youth, when drawing

in the South Kensington Museum (now the Victoria and Albert Museum) Brangwyn met and was encouraged by the architect and designer Arthur H. Mackmurdo, and at the age of fifteen served a four-year apprenticeship in the workshop of the artist and craftsman William Morris. In the 1890s Morris became increasingly interested in the orient and Japanese design, infusing Brangwyn with his enthusiasm. At the same time Brangwyn fell under the spell of Whistler, who had evolved his own interpretation of 'arrangement of line, form and colour',[80] with its limited tonal range of muted shades and the successful juxtaposition of simple masses to create more than a hint of Japonaiserie. In addition to accepting commissions for large-scale murals, Brangwyn was an accomplished designer, carrying out schemes that included furniture as well as complete interiors. Leach admired rather than liked the physical and technical mastery of Brangwyn's work, seeing the murals as combining a deft awareness of structure and composition with an acute understanding of tradition.

As an avid collector Brangwyn often went to great lengths to obtain pieces he could ill afford, sometimes bartering and swapping in pursuit of his trophy. Among other objects acquired for Temple Lodge was an impressive collection of pots of various ages and styles, including pieces from China and the Middle East, arranged on every available shelf throughout the house. On one occasion he exchanged the dining-room furniture for a dozen Persian pots. He also had a number of Japanese tea-bowls that were of sufficient note to be mentioned in a letter to Leach from a friend of Reggie Turvey in South Africa.[81] Whether Leach ever saw Brangwyn's collection is not known, but it is difficult to believe that he did not respond to his enthusiasm.

At the school Swan, an established, reliable, solid and respectable artist, conducted drawing and painting classes 'from the nude' in the morning, and in the afternoon Brangwyn figure and still-life classes. Although conscientious, Brangwyn was so preoccupied with commissions that he was rarely able to give the students much time, and was a nervous and tense teacher, even with those eager to learn. While stressing again and again the importance of sound technique, he lead his pupils to believe that there was only one way to build a composition and that this was in his own grand and flamboyant manner. Yet, despite his shortcomings, his students had nothing but respect and admiration for him, Turvey thinking his work 'interesting because it carries personality. It is absolutely free. He has an excellent sense of design'.[82]

From Swan, who gave meticulous practical advice, Leach learned about paint and tone 'in a long traditional descent from Velasquez'. Among other tips, Turvey recorded in his notebook details of eight flesh-colour combinations recommended by Swan who also passed on Whistler's medium recipe.[83] William Nicholson, who 'was persuaded with difficulty to come in one day', appeared looking immaculate, wearing suede gloves and waving a swagger cane. Leach was treated to a memorable *tour de force* demonstration and useful

advice when the painter, after delicately peeling off one glove 'sat down on my donkey, with two strokes drew me an elbow and said "Simplify" '.[84]

Keen though Leach was, he never felt completely at ease with colour and composition, and discovering that Brangwyn had set up a small etching studio joined the class, sensing that line rather than paint was his strength.[85] Few other students showed interest in etching and he was able to wallow in the luxury of having Brangwyn to himself for an hour or two each week. At this time Brangwyn's fame as an etcher was at its height. Initially Brangwyn had been enthralled by Whistler's small-scale, atmospheric, semi-abstract etchings, responding to their delicacy of touch and feeling, but rejected this approach as unnecessarily narrow and limiting. By the early years of the century Brangwyn had abandoned small scale in favour of large plates, often immersing them several times in acid and inking them with painstaking care to create complex effects. Unlike Whistler's ethereal work, Brangwyn's was often graphically representational, including scenes of everyday life such as steelworkers, blacksmiths, plate-layers, dockers and agricultural labourers, a range of subject matter that initially influenced Leach.

One early etching *West India Docks*, 1909, inscribed in pencil 'My first etching', (6 × 6 ½ in, 15 × 16 cm) depicts a sailing ship in harbour in front of buildings, and may have been struck a year after the plate was cut. Others include *The Coal Heavers*[86] (8 × 6 ½ in, 21.5 × 16.5 cm), an urban scene showing a horse and cart with two men carrying sacks of coal in front of a building, observed in nearby Earl's Court. The powerful sense of human endeavour and the understated but implied glorification of human labour were in the humanist spirit of Brangwyn's work. In contrast, a monumental but gaunt study of a church, probably St Luke's, Chelsea, entitled *The Gothic Spirit*[87] (11 ¾ × 8 ¾ in, 30 × 22 cm), suggests a search for something more light and transitory, the architecture both real and symbolic. Either side of the huge soaring building floats a winged figure, a symbol of belief and devotion. Much to Leach's disgust, Brangwyn, ever the teacher and feeling he could improve on his efforts, attempted to draw on the plate, only refraining after protest. In etching Leach had found a technique that ideally suited his linear skills, discovering that he was able draw freely but precisely and create his own style.

Within the school's liberal, encouraging regime Leach found the support and stimulus to nurture his ideas, his fellow students proving as invigorating as the teaching. On his first day he was overjoyed to meet a highly talented young Japanese sculptor and poet, Takamura Kōtarō.[88] 'Tall, dignified, with friendly aloofness',[89] Takamura sat quietly drawing in the life room where Leach admired his work. In the process of pursuing an international education, Takamura had first learned under his father Takamura Kōun at the Tokyo Bijutsu Gakkō[90] (Tokyo School of Fine Art) before attending the Art Students League in New York. After the London School he planned to work with Rodin

in Paris before returning to Japan. Puzzled by his interest in the West, Leach asked 'Why don't you paint Japanese style?' only to be told that he had come to Europe to 'understand what the Europeans feel',[91] but added that he would try it in the future. In long and heated discussions about modern art Takamura took the view that Cézanne was a heretic, while Leach argued that John was 'the only anti-academical authorized new painter in London'.[92] Since being 'set at liberty from the fetters and handcuffs of strict catholic education' Takamura thought Leach 'eagerly opposed to all orthodoxy'.[93] Takamura responded to the 'tall, skiny [sic] student', finding his drawings had 'specific line and somewhat twisting inclination . . . more of an etcher than a painter', and they became good friends.

At the time Leach was formulating the idea of moving to Japan to practise as an artist and teacher, partly inspired by the return to England of his grand-parents Elizabeth and Hamilton Sharp after twenty years in Japan. Leach pestered them with questions about Japan, their first-hand accounts stirring memories of a haven where change was slow and old values still intact.[94] Such impressions were confirmed by the writings of the highly popular if sentimen-tal writer on Japanese life and mythology Lafcadio Hearn, which Leach read avidly. Hearn's recently published *Glimpses of Old Japan*[95] and the earlier *Glimpses of Unfamiliar Japan*[96] evoked a rich, harmonious and mysterious world that suc-ceeded in awakening in Leach 'childhood memories of Japan besides desires for the strange and little known'. The author's earlier books on the West Indies aroused his sympathies for 'the black and brown and the yellow races'.[97]

Hearn, an American of Greek-Irish parents who after a journalistic training in the United States settled in Japan in 1890, took up citizenship, adopted a Japanese name, and set up home with a Japanese woman. He explored parts of the country few foreigners visited and wrote sensitively on the inner life of the Japanese, on religions, superstitions, customs, rituals and ways of thought, finding within them great meaning and power. The Japanese language, however, defeated him and he reflected that 'you would not make yourself understood in speaking unless you learned to think like a Japanese – that is to say, to think backwards, to think upside-down and inside out'.[98] The poetic and visionary quality of Hearn's writing and the vivid picture he painted of a society apparently unspoilt by rampant commercialism, added to Leach's desire to know more about the country.

In his quest for further information Leach visited Takamura's house off the King's Road next to Chelsea Town Hall, and receiving no reply knocked louder. Eventually 'I heard footsteps slowly coming down the corridor towards me. The door half opened: very quietly he said: "Forgive me, I am meditating. I shall explain tomorrow"'.[99] In Takamura Leach found 'a dignity and delicacy and great integrity, and an aroma of the East which entered my bloodstream . . . he told me about Zen and with that came the first hint of a deep contact and meaning'.[100]

Sitting by the fire in Takamura's room, talking about Japan and listening to him play Japanese tunes on his mandolin brought the country to life, and as Leach heard about a society in which belief, art and life seemed so harmoniously combined he became keener than ever to return to the country of his early childhood. Leach explained his plan of earning a living in Japan by teaching etching, but Takamura, aware of Leach's inability to speak Japanese and his ignorance of the customs of the country, was apprehensive of the scheme's financial success. Generously Takamura provided the names of prominent members of the art world in Tokyo, an invaluable aid in a country where formal introductions were expected. In addition to his father, the impressive list included Masaki Naohiko, president of the Tokyo School of Fine Arts, Mr T. Iwamura, professor of history of European art at the Tokyo School of Fine Arts, and Mr M. Midzuno, a young novelist. All spoke English and could help Leach deal with the subtleties of Japanese etiquette.

In London exhibition possibilities were investigated. Through his friendship with the artist Vanessa Stephen, Henry Lamb had become involved with the Friday Club and persuaded Leach to take part. The club was an attempt by Vanessa Stephen 'to create a cultural milieu not unlike that she had observed in certain Parisian cafés'.[101] At first she had envisaged a modest, intimate group, meeting more to talk about art than to practise it. Here, she said, 'we can get to the point of calling each other prigs and adulators quite happily when the company is small and select, but it's rather a question of whether we could do it with a larger number of people who might not feel they were quite on neutral ground'.[102] In fact the Friday Club proved a great success, holding exhibitions in major London galleries and becoming 'one of the liveliest exhibiting groups [in Britain] before the First World War'.[103] Leach continued to send work regularly until the club finally ceased in the early 1920s.

Leach's increased confidence and sense of artistic identity were reflected in his emotional life. By sheer chance while visiting his grandparents he met his cousin Muriel again and to his delight discovered that their feelings for each other remained unchanged. 'The joy of this day no words of mine can describe'[104] enthused Leach. Pursuing the idea of marriage, they consulted a doctor who assured them that cousinship was no hindrance, and Muriel's parents, convinced of their devotion and sincerity, finally agreed. They became engaged and 'Joy returned'.

With his relationship with Muriel now official, and his plans to go to Japan slowly taking shape Leach felt the need before leaving Europe for direct contact with the great art of the Renaissance and drew up his own version of the Grand Tour. Intending to be away for only a modest three or four months, he planned to travel around Italy before spending time in Paris. The tour began on a distinctly domestic note with two weeks on the French Riviera with Muriel and her parents. Around this time Leach began to keep a diary, a practice he maintained for most of his life. In his later years these amounted to

little more than engagement books, with pages left blank, but the earlier diaries were often desk sized, listing appointments as well as a variety of personal reminiscences. Over the years these included drafts of letters, articles, responses to current events, records of thoughts and feelings, and lists of points for and against a particular course of action, the entries often written with great force and directness.

His 1908 diary[105] gives details of his tour, his impressions of the art, his musings on various philosophical issues and speculation on his planned move to Japan. Occasionally Muriel made entries. In addition to serving as an engaging travelogue, the diary throws light on Leach's attitude to religion, his love for Muriel, and his apprehension about their future life together. Part descriptive and part reminiscence, the diary is the record of a young man's search for a voice. Sometimes he is arrogant and opinionated, at others naive and unworldly, whether in assessing the qualities of fellow travellers, appraising the art or in standing up to hotel managers.

In *Beyond East and West* Leach mentions setting off in the summer, yet his diary specifically refers to March, suggesting that this was more likely to be the start of his tour. His arrival in Genoa[106] was unpromising. After depositing his luggage he strolled into town where a pleasant Scotsman, claiming to speak no Italian, asked for help in finding a Cook's office as he needed to exchange money. Pleased to have struck up a friendship Leach accepted an invitation to have lunch with the Scotsman and his companion, who was travelling on to Asia. As agreed Leach turned up at their hotel and waited downstairs. 'Presently he came and asked me if I could change 100 Fr note as they could not so I lent him 29 Fr & £3.10 instead & he went to pay.' Much to Leach's horror he 'never came back'.

After this inauspicious start he moved to Pisa, then to Perugia where he luckily secured the last available room in the Hôtel de la Poste, feeling pleased to have just beaten a group of tourists. The city he thought 'delightful', and he walked energetically to the top of a hill 'overlooking all Umbra', the city striking him as 'star shaped'. Around the middle of April he arrived in Venice but again accommodation proved difficult, the hotel was not 'what I want', though in the morning he awoke to 'the sound of oars dipping in the canal below my window. It was delightful. The gondolier sang sometimes'. However, after an altercation with the manager, 'The kind of brute that always gets the upper hand over me', he moved on 'to humble but cheap and satisfactory quarters with a cheap restaurant. Expenses came to about 4/– a day.' He could not resist the tourist attraction of a hired gondola. He also made excursions to the island of Burano where he admired the lace-making still practised in small fishing villages.

In Rome, keen to experience 'where foreigners seldom penetrate', he abandoned the guidebook and after a walk of several miles in the *campagna* along the Appian Way plunged into the narrow backstreets. Enthralled by

shops with all manner of smells, his attention was riveted by the plaintiff voice of 'a blind singer, who seemed to know what singing was about'. In the open space of the piazza of St Peter's, enjoying a cup of coffee he fell into a day-dream until suddenly becoming aware of 'the fixed gaze of a pair of brown eyes belonging to a small boy' who scrambled unsuccessfully for a piece of cake that had fallen on the floor. Aware of 'an element of pride at stake', Leach's modest offering of two sous was accepted and 'did not disturb his equanimity'.

A similar mood of adventure in Florence led him to climb the hills outside the city to enjoy its 'glorious expanse'. Sitting in a shady spot in the ordered symmetry of the Boboli Gardens he was mesmerized not only by the splen-dour of the surroundings but by a colony of ants and a group of lizards darting across the rocks. The hot afternoons were usually given over to reading, his books including *Romola*, a tale that he decided was not to his taste, finding it 'clever, true in detail, witty, amusing, but no, as a whole I don't like it, and feel I should not have liked George Eliot'. No comment is recorded for another book *The Thousand and One Nights*. Seven happy days were spent in the city, which was 'a joy'.

For the art in general Leach's response was mixed, finding much 'utterly mediocre', but at other times finding that the sight of a particular work jus-tified an artist's reputation. Raphael, he declared, 'was the greatest surprise all his best works were clean and pure, simple and altogether worthy of his reputation'. Michelangelo's *David* he thought impressive and the Uffizzi full of treasures. Again he found Raphael to be 'first rank' while Leonardo da Vinci's unfinished picture *The Adoration of the Magi* was 'one of the most mag-nificent conceptions', and his drawings 'of supreme merit'. Giotto's Arena Chapel, Padua, more than surpassed his expectations; 'If I ever had doubts about this artist', he noted, 'they are now finally dispelled'. He enthused on the Byzantine cathedral in Venice, commenting 'This strange building. The Byzantine period is so amazing: its suggestion of Egypt and the East, its influ-ence on Giotto and Angelico Cimabue . . . The Byzantine spirit again made strong hold upon me – splendid invigorating angularities.'

Despite the constant cultural experience of great art and magnificent architecture, as well as the opportunity to draw, at times Leach felt restless and lonely. 'I have had enough sightseeing & long for good fellowship & company,' he wrote, prompting him to contemplate his future plans. 'I wonder if I will get heavily smitten with this state of mind in Japan – I hope not.' Regular communication with Muriel, who was travelling on the Continent with her parents, did not always quell the doubts he felt about their marriage.

This evening there is a heavy spirit upon me. Muriel's happiness as well as my own centres so largely around the Japanese scheme. Apart from cir-cumstances unforeseen I think I have the ability but have I the strength,

grit, experience for the task? Will I be able to acquire sufficient in time? God help me! I shall try and help myself.

With a sense of reality he added 'It will be an uphill fight all within & alone.' The self-searching and uncertainty were reflected in a note about the difficulty of 'the very act of expressing ones feelings', which he found puzzling. 'There is something unnatural about it. It seems to recall the superstition of knocking under the table,' continuing 'I don't mean the relief which often comes after one has given vent to the pent up feeling.'

Questions of faith also continued to trouble him, for while he wrote that he had disentangled himself 'from Christianity as well as Catholicism',[107] he was often moved by experiences of profound belief. Outside St Peter's, after marvelling at Michelangelo's magnificent façade, he entered the building and walked slowly towards the altar. Leaning against a pillar his attention was caught by 'the seated iron figures of himself, legs crossed' and was greatly moved by the fact that one half-foot of the bronze statue of St Peter[108] had been 'kissed away over the centuries'. The spell was broken by 'a fussy, bespectacled German (surely!) measuring the immeasurable with a foot rule', an action that contrasted with 'a simple country woman [who] knelt on the hard floor, patient with her burning candle of faith, which she placed in an empty socket, and then went and kissed the same iron foot once more'.[109] Through both the sight of the faithful at prayer and the resonant church music he found meaningful expression of belief. Drawn by the sound of music he entered a church where he 'found Benediction drawing to a close. It so humble – only poor folk & only a few dim lights . . . so I knelt & prayed hard for Muriel and myself'. During several visits to St Mark's the 'vespers and solemn chants brought back memories of Chapel at Beaumont – beautiful memories'. Although his 'allegiance to Rome was gone', his 'respect for her faith'[110] remained.

The final leg of his tour was four weeks in Paris[111] where he planned to look at art with Reggie Turvey. In the city's experimental atmosphere the two earnest young artists found much to discuss, for each sought a way forward not only for their own work as artists but in attempting to deal with the often radical changes taking place within art. Van Gogh, Leach thought, had signalled Expressionism, a style characterized by simplified forms and a distortion of line and colour, and now, in its wake, a new rebellious generation was rejecting many of Van Gogh's ideas. It was to be another two years before Roger Fry mounted his first sensational exhibition of modern French work 'Manet and the Post-Impressionists', which included ceramics, at the Grafton Galleries,[112] introducing contemporary French art to London.

Diligently they searched out the work of artists they thought explored more direct ways of representing nature, such as the Barbizon painters, all of whom worked directly from nature to prepare studies in the open air before

completing them in the studio. Fascinated by the depiction of landscape as a subject in its own right, Leach and Turvey also hunted out the work of the Impressionists, many of whom not only painted out of doors but were also experimental in their use of paint and subject matter.

Art, as well as life, seemed full of questions with few apparent answers.

> Question: – Which is the greater – the artist (Raphael) who appeals to all, the multitude – or the artist (Blake) who appeals only to the highest minds? What the devil has the 'mob' to do with art? What is the ratio between art & humanity? Is Art any use? To live happily one must take it for granted it is! – Turvey and I agree with Blake that Ability and Vision in an artist go hand in hand & are essentially equal.

This was a typical summary of their soul-searching discussions. Deep, probing and complex, in many ways their conversations reflected the doubts, aspirations and fears of any serious art student, but for Leach their questioning also touched on the conflict between intellect and feeling. They did find time to visit the Moulin Rouge, a nightclub with a reputation for all that was saucy and seductive in the French capital. On this occasion it failed to live up to expectations and was judged to be 'beastly'. They arrived back at Southampton on 15 June.

On his return one ghost from his past was partially laid to rest when Leach discovered Henry Tonks to be a fellow guest at a country house tea party. Impressed by Tonks eating a spring onion with his sandwich he did likewise and found that far from disliking the pungent taste he relished it, and from thenceforth was a convert. The chance meeting offered an opportunity to redress what he thought had been Tonks's short-sightedness in refusing to acknowledge his artistic capabilities. 'Mr Tonks, you turned me down on three successive occasions,' said Leach. 'Nevertheless, I am going to be an artist I'm going to Japan.'[113] With good grace Tonks 'put his cup down, shook me by the hand and wished me farewell and good luck'.[114] They never met again.

Throughout 1908 Leach wooed Muriel, continued at the London School of Art and pursued plans to go to Japan 'in order to try to understand Eastern art and the life behind it'.[115] Leach's reasons for going to Japan were complex. Japan not only embodied fond childhood memories, but was a land of opportunity and promise; it was also far from the reproachful eye of his stepmother and his failure to establish a career in the bank. Despite lingering doubts he felt emotionally settled and artistically more confident having been greatly helped by Brangwyn's meaningful recognition of the maturity of his work. 'How long have you been in art school?' asked Brangwyn when looking at his work. 'Including the Slade, altogether five terms,' Leach replied. 'Enough, get out! Go to Nature!' was Brangwyn's decisive reply, suggesting that Leach had progressed to the point where he needed to break free of institutional protection and find his voice in the wider world.

In the spring of 1909 Leach set out on board a German liner, the passage costing £28. Some years later Henry Lamb asked why he went to Japan. Although 'unable to give an answer which satisfied him', Leach was adamant that 'not for one moment did he regret the step'.[116]

A STRANGE LAND

Japan

1909–1911

'Artist' was how Leach defined himself in his passport, issued on 17 February 1909, accurately spelling out his ambition in his adopted country. Barely twenty-two, Leach wanted to construct a life that reflected his own desires rather than those of friends or family. From the Continent Takamura continued to send further useful contacts along with practical advice, recommending for example that it would be better to arrive at Yokohama rather than Kobe as the customs house was less strict. He also suggested taking plenty of paintings 'much more there than we expect here',[1] for Leach to demonstrate his artistic credentials and to avoid the possibility of customs officers confusing tubes of oil paint with 'paint for toilette',[2] and his etching press, which he thought 'would be a fountain for a thirsty'.[3] This large machine, with a twenty-four-inch bed operated by a huge cartwheel, was purchased from Kimbers,[4] suppliers of artists' materials in London.

Although never clearly stated, what Leach hoped for in Japan was as much a search for spiritual fulfilment – which he thought lacking in the West – as it was for artistic success. Even Henry Lamb's perfectly reasonable question about his decision had elicited only a vague reply, partly because his aims were probably more emotional than practical. Since his father's death and his loss of faith, England had proved far from rewarding, with the abiding presence of his stepmother a reminder of his failure to live up to his father's expectations, however unrealistic and unsuitable. In some respects he was also responding to the colonial, pioneering spirit of adventure within the Leach family in setting out to explore a foreign, 'exotic' and still little known distant country. The prospect of introducing and teaching etching in Japan was also exciting.[5] His naive understanding of this complex and rapidly developing country acknowledged little cultural exchange, but was conceived as part of a pioneering plan from a youthful artist travelling as educator and enlightener rather than as a student to study and learn.

'Japan,' observed Sir Rutherford Alcock, head of the first British legation, 'is essentially a country of paradoxes and anomalies, where all – even familiar things – put on new faces, and are curiously reversed. Except that they do not walk on their heads instead of their feet, there are few things in

which they do not seem, by some occult law, to have been impelled in a perfectly opposite direction and a reverse order.'[6] Lafcardio Hearn's evocative description that 'everything Japanese is delicate, exquisite, admirable – even a pair of common wooden chopsticks in a paper bag with a little drawing upon it; even a package of toothpicks in cherry-wood, bound with a paper wrapper wonderfully lettered in three different colours',[7] caught the beauty and promise of the country.

By 1909 Japan was on the verge of establishing itself as a major economic and military force. The self-preservatory efforts and isolationist instincts of the Japanese had been profoundly challenged in 1854 by the arrival of the Black Ships of the American naval commander, Commodore Perry, which forcibly opened up the country to international trade. Following the 1868 Meiji Restoration and the setting up of a new constitution twenty years later, Japan had moved rapidly from relative medievalism into the nineteenth-century capitalist-dominated world of modern commerce. Recognizing that a predominantly agrarian economy and handicraft production with its use of traditional hand skills could not compete with machine power and the precision of western industries the Japanese invited European and American industrialists to establish western-type factories to produce goods that could compete in the international market. In addition a new legal system was introduced, a parliament set up and a well-equipped and efficient military force organized, focusing attention on armed strength and science rather than on spiritual life. By the turn of the century one visitor was convinced that 'Tokio's and Osaka's large firms will be the great competitors of Birmingham and Manchester, and the European trade in the East will be mostly secured by Japan'.[8]

A policy of international expansion included the economic domination of Korea, which to all intents and purposes was incorporated into the Japanese Empire in 1910, while Formosa (Taiwan) was acquired from China in 1895. The spectacular military victory over Russia in the 1904–5 war gained Japan the admiration of the West. Japan's expansive colonial policy and the expenditure of money were as nothing compared to the energy spent absorbing the ideology and methods behind the West. Students were sent to England to acquire naval skills and financial management, Germany for scientific and military knowledge, and France to study art. Yet in many ways Japan remained a country that owed as much to the old and traditional as it did to new western-orientated influences. Tokyo, a city loathed by Hearn as a symbol of 'New Japan', was full of contrasts. In the centre electric light, automatic trams and western suits vied with rickshaws, palanquins and people wearing Nō costume. Leach was later to ascribe Japan's obsession with acquiring western technology and culture to Shinto, the native religion of Japan, quoting the words of J. W. T. Mason from *The Meaning of Shinto*: 'The creative activities of the Japanese, individualised and co-ordinated afresh, moved forth from

mediaevalism into the modern world, showing the same eager desires as in the past for new knowledge and accomplishments, while retaining many aspects of the ancient ways of the race.'⁹

On board the German liner slowly making its way east Leach shared a third-class cabin, but despite the lack of privacy the voyage did have its compensations. In the Indian Ocean a light breath of air rippled the gently heaving water bringing 'the fragrant breath of Ceylon four hours before we caught sight of the first dark rim of flowering trees low down the horizon'.'⁰ In the hot nights Leach slept on deck in the bows, waking in the early morning light to the sight of flying fish skimming the deck. During a brief trip ashore in Hong Kong childhood memories were confounded when he revisited the Peak to see his old home. Instead of the expected mountain and palace he found 'hillocks and a small semi-detached'.''

The sight of the industrious and prosperous harbour of Nagasaki with its picturesque sailing vessels and rowing boats, described by an earlier visitor as 'second to none perhaps in its loveliness','² was welcome and enticing. Despite the gap of eighteen years the sight of the country vividly rekindled early experiences, Leach's response echoing that of Commodore Perry's officers and men in their Black Ships some forty-five years earlier. When surveying the terrain through binoculars they 'were in rapture with the beauty of the country; nothing could be more picturesque than the landscapes wherever the eye was directed . . . a scene of beauty, abundance, and happiness, which everyone delighted to contemplate'.'³

Like his paternal grandmother twenty-two years earlier, Leach had four hours to explore the town. Seeing through the eyes of Hearn he felt 'indescribably towards Japan'. Neither the evidence of new industry nor the incursion of foreign investment impinged on his pleasure as he strode past the grey-tiled houses, eager to take in sights and sample the town. Leaving the streets behind he strolled into the hills and was captivated by the patchwork of open fields, enchanted by the brilliant yellow colour and sweet scent of *na no hana*, the sight of cherry blossom and the indigo-blue cotton garments of the farmers. Everything appeared to be made by hand on a human scale, living proof that the ideals as espoused by writers such as William Morris were both possible and practical.

With little knowledge of the language or customs but needing to eat, he gesticulated and mimed his requirements to a curious passer-by who, with dawning realization, pointed him in the direction of a wayside inn. Further pantomime resulted in nods of understanding before he was finally admitted, only to find that traditional Japanese inns rarely had a restaurant or dining-room but served meals in private seclusion. After removing his shoes he was taken up a flight of steep stairs to 'a quiet, unfurnished room' on the first floor where he sat cross-legged on a flat cushion, and as no menu was presented, waited to be served. A maid brought a small, low table and after kneeling

bowed deeply and set out a substantial meal of clear fish soup in a lacquer bowl with a large fish's eyeball floating in it, reckoned to be the daintiest of morsels, a sweet omelette roll, a pink half-curled *tai* (sea bream), stalks of raw pink ginger, some pickles and a small dish of *takuan* (pickled long white radish), that to his western eyes resembled chopped boiled cabbage. At least this dish seemed recognizable and not quite knowing how to tackle such unfamiliar food, he successfully manipulated the *hashi*, or chopsticks, and took a large mouthful. 'I do not know who was more surprised, the maid or me, for it was hotter than mustard! She could not restrain her laughter behind her chubby hand — but I was in pain!'[14] Chubby hand or not the maid showed him how to remove the bones from the sea bream and brought three bowls of rice. With the help of tea Leach consumed everything except the poached fish eye, which even his spirit of adventure could not stomach. By convention the bill stated a price rather than details of the food eaten, and a suitable tip, or *chadai*, was added. It was the start of a great adventure.

The following morning, as the liner approached Yokohama, the port serving Tokyo, echoing the experience of many visitors before and since, Leach was astonished by the breathtaking beauty of Mount Fuji. Soaring 12,397 feet above the clouds, it seemed 'purer than the very sky into which it towered, and more perfect in form than any mortal hands could model'.[15] Hearn's words, 'higher still and higher', flooded back to him, a sentiment capturing both the physical and emblematic power of the sacred mountain. To get to his hotel Leach took the purser's advice and hired one of the *jinriki-sha*, or rickshaws, from a row that stood at the edge of the town, a two-wheeled hooded carriage pulled by the owner. The driver's traditional outfits were reassuringly authentic, the characteristic winter costume consisting of pale-blue shirt with hanging sleeves tucked in at the waist and tight-fitting breeches of the same colour reaching just below the knee. Legs and feet were bare, with the exception of straw sandals secured by straw cords.

At the hotel further complexities of Japanese custom had to be negotiated, for not only was he unfamiliar with the etiquette but also was constantly stared at as an object of novelty. Fortunately a young English-speaking manager helped to allay his embarrassment and confusion. This did not, however, prevent the maids from finding numerous excuses to visit his room, plying him with endless questions about his age, children and profession and to fuss over his needs. On returning from a visit to Tokyo he was offered tea and cakes and asked if he would like a bath, an offer he accepted with pleasure, little realizing that the concept was vastly different to the western idea of privacy and solitude. When told his tub was ready Leach tried to explain that in England men did not disrobe in mixed company and indicated that the maids should retire. Confused, they withdrew, tittering about the peculiar habits of foreigners. After donning the kimono supplied by the hotel he was led down the corridor to the bathroom by the helpful assistant. The assistant

slid open a flimsy door, showed me where to put my kimono, gave me a small blue-and-white cotton runner for a towel, opened another door and handed me over to *bantô san* (the backwasher), who planted me on a very low stool on the wet floor, sluiced me with hot water and then attacked my back with a piece of hair cloth and deep massage, winding up with sharp blows on either side of my neck and further sluicing of hot water. Then he led me to the large, built-in wooden bath. By this time I could see through the steam the heads of those inquisitive girls – in the bath – awaiting my arrival! This was too much for my English modesty: I turned tail and fled to my room.[16]

The hotel's assistant manager pointed out that 'no impropriety was intended', adding 'that in his country people saw the naked body but that he had been told that foreigners looked at it',[17] a subtle but significant distinction.

However intrigued he was by the country's novelty and strangeness, he was keen to begin the process of establishing himself and, armed with an impressive list of introductions he set off to Tokyo to visit Takamura Kōun.[18] While the twenty-mile rail journey from Yokohama could easily be undertaken, the difficulty lay in finding Takamura's house. Leach could neither speak nor read Japanese, few streets had names, and on maps, under the *banchi* system, numbers related to the lots on which houses stood. Often, in a large city, hundreds of dwellings bore the same number and were numbered as they were built rather than consecutively, the numeration rarely shown in front of the building but only on documents.

At the Shinbashi terminus Leach showed the address to a policeman. Sabred and wearing a white uniform the officer quickly realized that instructions would be of little use and after telephoning for a replacement beckoned Leach to follow as he boarded one of the trams that rattled across the city and finally delivered him to Takamura's gateway with a polite bow. The aspiring artist could only nod his thanks. Further problems cropped up as Leach tried to make sense of the notice by the outer gate. While casting an approving eye over the enclosing functional and beautiful solid fence of split bamboo and wood, ingeniously constructed in a hundred patterns, he noticed that there was no visible bell. A polite cough brought a maid to the door; she took his card and signalled for him to enter. After removing his shoes Leach was conducted to the guest room, its beautifully proportioned space epitomizing refinement and fastidiousness. The wooden surfaces, he noted, were left plain to bring out the quality of the grain while the floor was covered with *tatami*, taut matting fashioned out of rice straw woven over a wooden frame with a mat sewn on top, each measuring three by six feet and at least two inches thick.

Shortly after Takamura Kōun entered with Kōtarō's younger brother who could speak a little English and sitting cross-legged on cushions they were

served green tea and tiny cakes. Takamura Kōun, then nearly sixty, was a court artist and distinguished figurative sculptor known for his perceptive response to western influences, his wooden carvings combining both traditional and modern ideas. In addition to serving on many powerful committees, he was professor in the department of sculpture at the Tokyo School of Fine Arts (Tokyo Bijutsu Gakkō). This had largely been set up in response to the influence of western art in Japan in the late 1880s to replace the Technical Art School. It was a useful introduction to someone virtually at the peak of official power and an important contact in a country still highly respectful of custom and convention.

For forty minutes they engaged in polite conversation, aided by the younger son's broken English, and Leach showed them his etchings, which they greatly admired, until, sensing it was time to leave, Leach attempted to stand up. Unlike his hosts who 'showed a wonderful elasticity of muscle and suppleness of joint which could only have been acquired by long practice',[19] he discovered that his long legs crossed in an unfamiliar position had gone to sleep and, much to their amusement he promptly fell over. A chair was placed on the veranda and there the tall gangling westerner sat until the use of his limbs returned. The pleasure of the conversation, the Japanese etiquette and the beauty of the house combined with the discomfort of sitting in an unfamiliar pose brought out once again the complex and contradictory nature of the country.

Following useful introductions from Takamura, Leach was invited to write an article grandiosely entitled 'The Introduction of Etching to the Japanese Art World',[20] to be published in translation in a Japanese art magazine. In it he propounded his views on Japanese art as essentially decorative 'not dynamism, but the development of the exquisite decorative art', and put forward the view that 'etching, basically an art of appreciation of various lines – must be of great interest for young talented artists to learn'.

Leach's introduction to Baron Iwamura, who taught English at the Imperial Art School in Ueno Park in northern Tokyo, was equally useful. His arrival coincided with increased interest in the field of print-making,[21] and on the strength of his association with Brangwyn and his etching skills he was invited to give a lecture-demonstration at Tokyo Bijutsu Gakkō (now Tokyo National University of Fine Arts and Music). Aware of the foreigner's practical needs Baron Iwamura introduced him to his assistant Morita Kamenosuke who taught English at the Tokyo Bijutsu Gakkō and lived in a house below Ueno Hill in what was once the village of Iriya, also known as Uguisudani or Warbler Valley.[22]

On Morita's suggestion Leach moved into a small, two-roomed self-contained annexe by the side of Morita's house, his first property in any country, and though modest he was 'inordinately proud of it'.[23] Paddy-fields interspersed with narrow paths surrounded the building and in the distance

stretched the great plain of Tokyo. Towards evening the landscape was punc-
tuated by eight-foot-high piles of washed white radish, or *daikon*, the vegetable
that when grated raw could be terrifically hot, as he had discovered to his
horror, but when pickled (*takuan*) was both sweet and salty. *Daikon* in its
various forms was a substantial part of the Japanese diet and Leach soon devel-
oped a taste for it and its cheesy sort of smell, finding that it had a chemically
useful effect in helping digest the rather hard white rice that was served to
him at virtually every meal.

Japanese cuisine was renowned for its careful preparation and stylish
presentation. Traditionally each part of the meal was offered on a separate
plate that could be round, square, triangular and polygonal, or even shaped to
resemble leaves or fans, coloured in a variety of glazes and tints. To most
Japanese a meal without rice was no meal at all, a point borne out by the
word *gohan* meaning both a meal and boiled rice. Unfortunately the old
woman looking after him seemed ignorant of the subtleties of the ancient
cuisine, providing dishes that not only lacked variety but were also indi-
gestible, for the most part consisting of small fish and undercooked rice. Like
Commander Perry, Leach gained an 'unfavourable impression in their skill of
cookery'.[24] After suffering for several weeks he consulted a doctor, who when
told proudly that he was eating 'Japanese food only' instructed him to 'go back
to bread quickly'. This was bought from a street-seller shouting '*Pan, pan
haikara pan, Rossia pan*' (Bread, bread, high collar [very up-to-date] bread,
Russian bread). Although a far cry from the crisp, wholesome bread he was
used to, it helped his digestion. A happy compromise was reached, though the
old woman's cooking remained a trial.

Problems of communication were mostly solved by a complex system of
gestures and mime but he attempted to learn the language asking basic ques-
tions such as *Nan desu ka?* (what is that?). To extend his vocabulary he set
himself the task of acquiring a hundred useful words. The fact that some
derivations seemed slightly familiar, particularly objects encountered around
the house, encouraged a false sense of security. *Teburu, rampu* and *shabon* –
table, lamp and soap – all dutifully repeated by the old women, appeared to
make the learning easy. But as he quickly discovered Japanese was like 'being
led blindfold through a maze without a stick to guide his steps'.[25] In the
evenings Morita took Leach round the city to purchase furnishings for his
'simple life' and answered numerous questions about Japan.

As spring moved into summer the wet season brought hard, regular and
persistent rain, the intensity and humidity of which Leach had never before
experienced. Leather shoes grew mould, everything dripped endlessly. The
rain did bring compensations. In the flooded fields frogs croaked melodiously,
while the inhabitants of the surrounding houses seemed imbued with a mood
of reflection and melancholy. The soft notes of an eighteen-inch-long bamboo
flute seemed in harmony with the season. From a neighbour's house the

daughter plucked plaintiff sounds from a thirteen-stringed horizontal harp, a *koto*, adding to the meditative mood. At night a group of men sang the choruses of Nō drama, the sonorous sound reminding him of plainsong and liturgical music. All seemed to capture the essence of a haiku by Sampū, 'In the summer rains,/The frogs are swimming/At the door'. The economy and rhythmic structure of the ancient art form caught Leach's interest and he began to enjoy it in translation.

The warm summer sun helped to dispel any lingering doubts about his new life and its direction. As the thatched roofs began to steam so any apprehension about his move to the country evaporated as he literally witnessed the rebirth of life. On the rich black volcanic soil he seemed to almost hear the bamboo grow as it attained an astonishing twelve inches in twenty-four hours. He did, however, experience periods of loneliness. With his marriage to Muriel in mind he thought that a more permanent residence was needed, discovering from Morita that a traditional wooden house could be built for less than £200. His Uncle Will and Aunt Edith agreed that he should realize part of his capital for such a property before Muriel travelled to Japan, where they would marry. A suitable plot of land was purchased from one of the Buddhist temples nearby on Ueno Hill and a team of country craftsmen engaged.

Traditionally, Japanese houses were single storey and built mostly of wood, a structure that in areas prone to earthquakes and tremors presented less danger to the inhabitants. No concrete foundations were used, partly because of cost but mostly because of the unstable nature of the area. To support the heavily tiled slate roof load-bearing posts were sunk into holes containing three stones, one placed on top of the other, one always horizontal with the nose of the last just protruding from the ground. Tools were handled with skill and accuracy, with a third of the time spent on keeping them sharp. Saws, planes and other tools were often used in the opposite way to the West with the adze cutting alarmingly towards the toes. Wood was left unpainted to reveal its natural qualities. After careful preparations the skeleton of the house was erected in a single day and supported without the use of nails. When the heavy roof-tiles were put in place a flag was placed on the top, an event celebrated by an uproarious meal of beer and macaroni.

Although committed to many aspects of the Japanese way of life Leach decided that he and Muriel needed greater comfort than was offered by the more minimal interiors of traditional Japanese homes. Discussion with the master builder was a delicate matter as modifications had to be subtly negotiated. However, to a westerner with firm ideas, such decisions could not be left to others, like his forebear Sir John Leach, who had started out as an architect, building design appealed to Leach. The idea of removing the shoes before entering and the logic of keeping dirt out rather than bringing it in then cleaning it out, seemed sensible. *Tatami* were both practical and attractive and in addition to providing a springy floor covering could serve as mattresses and

seats. In the living-room he had a *kotatsu* (or *horigotatsu*) built that consisted of a well within which stood a table with short legs that could be raised or set flush to the floor. Westerners could sit comfortably on the edge and place their legs beneath the table while anyone who wished to sit cross-legged could do so. This arrangement proved particularly useful when Leach and later Muriel gave English classes to Japanese university students who sat round the table. In winter a charcoal brazier helped keep feet warm.

Fascinated by the skill of the craftsmen and their knowledge and respect for their materials, Leach visited the site daily to observe progress. Despite his inability to speak Japanese and his demands for modifications, friendly terms were established, helped by regularly sending in shaved ice sweetened with various flavours. The installation of sliding doors finally made the house ready for occupation. It was a modest structure, consisting of two twelve-foot-square rooms, two smaller rooms, a kitchen and bathroom, and most importantly a fair-sized studio.[26] The building, a blend of traditional Japanese and western style, symbolized his hopes for his life in Japan.

With Muriel not due to arrive until November Morita proposed that they move to the cool, fresh mountains to escape the oppressively hot summer months. Adventurously Leach put forward the more challenging idea of a boat trip up the Sumida River, camping along the way. A vessel, eighteen-feet long with a long stern oar was hired, loaded with supplies of food, and on a glorious sunny afternoon they slowly set off enjoying the sight of river barges with their great sails. Despite his inexperience, Morita propelled the boat forward with neat figures of eight and all seemed to be going well until the pivot holding the oar fell overboard. Taking off his jacket Morita dived into the slowly moving water to retrieve the vital part but some fifteen yards away he raised an arm, gave a cry and disappeared below the surface. Recognizing help was required Leach dived in but realizing that his companion was in danger of panicking and putting both their lives in danger he hit him hard under the jaw, and called for help. A man fishing nearby pulled Morita into his boat, recovered the peg and secured their boat. It was not a promising start.

With an aching jaw it was some time before Morita felt anything but anger towards his friend and only gradually came to see the necessity of Leach's action. Other troubles followed. Despite anchoring in the middle of the river at night they were prevented from sleeping by ferocious swarms of mosquitoes and had to hire a net from a riverside inn to protect themselves. When the river became too shallow to row they had to resort to pushing the boat.

Finding the landscape attractive Leach did some painting in an attempt to represent 'nature as it is'. Although working outdoors was a practice well established in the West, both as a means of producing finished works of art as well as for making preparatory sketches, it was virtually unknown in Japan. Traditionally Japanese artists abstracted and synthesized their impressions of landscape according to accepted conventions.[27] Any Japanese seeing Leach

must have found the sight mystifying. With no concept of the bohemian, either as aesthete or artist, the image of the outdoor artist must have seemed bizarre, a figure of curiosity and amusement. Quite apart from Leach's great physical height, lanky figure and obvious foreignness his artistic activity must have excited much comment. Leach's few paintings that survive from this time are impressionist in style with a broad use of paint thickly applied to create an impasto effect with rich bright colour. While the canvases capture the heat and freshness of trees and the movement of the water, their curious flat effect never quite evokes the drama or depth of the landscape.

Sitting round their fire smoking after supper one evening the two friends were approached by a group of people holding aloft lanterns from the local village who invited them to be their guests for a hot bath the following evening. As Leach had by now realized, bathing in Japan was an important social and symbolic ritual in which the cleaning of the body was carried out before entering the tub so enabling the water to be hygienically shared, either communally or in strict rotation of importance. Immersion in the usually scalding hot water was not so much to wash the body but to relax and refresh the muscles, as much a social as a cleansing occasion. As such it was often offered to guests before a meal and was thought impolite to refuse. Strict protocol determined that the head of the household entered first followed by the male then the female members, with the servants last, but honoured guests had priority.

Duly prepared the following evening, Leach and Morita were conducted in the twilight to a clearing out of doors and felt rather than saw a large wooden tub of hot water at least three feet deep. As an esteemed foreign visitor Leach had precedence and as required by convention sluiced, soaped and washed twice before entering the water and squatted up to his shoulders. As the moon rose and the surroundings became visible he realized the bath was in the centre of the space between the houses and that his every movement was being watched avidly. This time he did not panic but enjoyed the experience. After Morita had bathed, fully relaxed and cleansed they made their way to their camp and under the light of the harvest moon took it in turns to row the boat all night.

During his absence the house was made ready. With the help of Sakya, an English-speaking Japanese friend, the foster-son of the abbot at the temple on whose land Leach's house was built, a maid and a cook were engaged. It was a proud moment. He had had the property built incorporating his own ideas, but more importantly he had become a part of traditional Japan.

In early November Leach met Muriel and her mother at Kobe, one of the largest and oldest ports of Japan. Little more than six months after his arrival they were married[28] in the British consulate and the Doshisha, the Christian university at Kyoto. Aunt Edith stayed in a traditional Japanese inn which, as an intrepid traveller, she quickly began to appreciate. Shortly afterwards the

newly-weds left for Tokyo to settle into their new home and for Leach 'another dream began'.[29] The two servants had decorated the house to give them a warm welcome, and Sakya was there to add his good wishes. 'We were,' wrote Leach 'very happy.'[30]

With an income of roughly £140 to £200 derived from a legacy of £2,300 from his father, and the sum of £1,000 each from his grandparents plus various sums from Muriel's parents, they were comfortably off. They were able to hire two servants, the maids receiving less than a pound per month in addition to their food and clothing, and live in reasonable comfort. Living expenses for the first year totalled around £100. Women servants were regarded as members of the family and became dependent on the mistress for advice and support, respecting her as their teacher and friend. In return they gave absolute and often touching loyalty. Leach was particularly impressed by such commitment when the maid O Mya San[31] flew into a rage at a boy who had flung a stone over the house that had broken a pane of glass. Her anger was especially surprising given that the Japanese thought children could do virtually no wrong, were rarely chastised and allowed to do more or less as they pleased until the age of about twelve when they were regarded as adult.

Devising menus proved to be as challenging for the Leaches as it had for the old woman. While they did not subscribe to Pierre Loti's view that 'Japanese cuisine can at best serve as an amusement',[32] they wanted to create a home that successfully blended English domesticity with aspects of Japanese culture. Much direction was needed if the cook was to prepare English dishes with specially purchased ingredients, but as neither Bernard nor Muriel had ever learnt how to cook they were often at a loss. After consulting recipe books, experiments produced a few favourite dishes. The staple of rice and not very good bread was added to with luxury shopping of European goods, which included an ounce or two of 'always tender' beef, excellent varieties of fish, plus eggs and milk. All were used sparingly but with repetition became monotonous. Occasionally Leach cooked a Yorkshire pudding, an event sufficiently noteworthy to record in his dairy. One pudding, caramel custard, was eaten every day for months on end. Most mornings they had porridge.

Regular routines were soon established, including readings of popular classics, with Leach detailing his responses in his diary. Books included Dickens's entertaining but loving account of Victorian life in *Pickwick Papers*, where the characterization caught his attention, Leach declaring that it was good if it carried conviction. 'The Wellers & Pickwick & the fat boy are loveable and in a way permanent though I opine Dickens swelling heart of sentiment almost outweighs his sharp eye for character, humour grotesque.'[33] Other books included J. M. Synge's tale of a husband feigning death to test the fidelity of his wife, *In the Shadow of the Glen*, which was judged 'beautiful, nice balance

of realism and private thought. Something of folk spirit',[34] H. G. Wells's *Wheels of Chance* was thought 'very observant and humorous',[35] while Emily Brontë's *Wuthering Heights* was reread for its evocation of the supernatural.

The move to the other side of the world, to a country fundamentally different from her own, with only her husband as friend and confidant was, to say the least, unsettling for Muriel. With no knowledge of the language she organized the household and dealt with the servants. As mistress of the house she was competent and careful, wary of displacing one problem with another, writing 'I hate a disorderly home because it expresses a[n] . . . unhappy . . . state of mind. Trying to alter the cause by attacking its effects. By keeping our habitation tidy we can deceive those who enter into thinking that we who dwell there are people of orderly mind, perhaps as we deceive ourselves by appearance'.[36] Whether it was her marriage, caring for the home or the strangeness of life in Japan that was disturbing her 'orderly mind' is not clear. 'Can one', she pondered, 'make a friend of an Oriental (Japanese)? That depends on what to you are the essential qualities of friendship. I do not know anyone of them well enough to call him my friend in the fullest sense.'[37] It was a plaintive cry, wanting to make friends while being cautious of people who seemed so different in virtually every respect.

Although they were cousins and had known each other for five years, establishing a profoundly different physical, emotional and sexual basis for their relationship was a challenge Muriel found easier than Bernard. Both were an only child and had great love and respect for their families, but whereas she had been cherished within a nurturing home he had limited experience of the intimacy of family life. Furthermore he was highly conventional, even Victorian in many of his attitudes, accepting without question that it was the wife who took charge of the home leaving the husband free to conduct his own life, usually away from home. This freedom enabled him to establish contact with artists and writers and pursue his career, often leaving Muriel with no one to call on for advice and guidance. Through their grandparents' contacts they were soon integrated into the small but well-established English community, many members of which were involved in missionary work. For Muriel this offered the opportunity for a full social life around mutual interests of tea parties, suppers, regular entertaining and weekly 'at homes'. Later this became a source of irritation between her and Bernard as he became critical of the notion of missionaries 'saving' Japan and more involved in making contact with the artistic milieu of Tokyo.

To supplement their income Leach taught English in a girls' high school, Muriel later taking over the class. She also helped with evening conversation classes for a group of students at the Imperial University who had responded to a small notice written in Japanese announcing that such teaching was available. Polite but voluble, the young men caused Leach to observe 'We talked about everything and learnt as much as we gave.'[38] The sixteen- to seventeen-

year-old high-school girls in contrast could hardly be persuaded to utter a single syllable. 'I was forced to talk interminably and it looked as if all I said was taken down in long hand,'[39] he noted. Nevertheless he did make a lasting impression, many of his students coming to see him forty years later when his pots were on exhibition in Tokyo.

Regular correspondence brought news of friends and family and details of events in London. When the murderer Dr Crippen[40] was hanged in 1910 Leach speculated that, in line with his pacifist views, if he had been a member of a jury he could not consent to condemn a prisoner to death. From Reggie Turvey came details of Leith and Brundrit, and accounts of current shows of the New English Art Club[41] where Augustus John had 'a portrait of Nicholson. Extremely good. Much character'.[42] Their correspondence reflected a typical Edwardian sense of fun with its mixture of familiarity and formality. Turvey would address Leach as 'old Smeerlap', 'old Clatterbucket' or even 'nose-in-the-pie', and sign off with 'Turvey' or even more properly 'Reg E. G. Turvey'.[43] His letters, mostly written from Bramerton Street, were relaxed and gossipy.

Although the greater part of the year was spent in Tokyo, excursions were made to mountain resorts to explore the beauties of the country. In the spring of 1910 Bernard and Muriel made their first expedition, choosing the relatively unspoilt wildness of Mount Akagi about a hundred miles north of Tokyo. It was a complicated trek involving a train journey followed by a horse-drawn coach. Sitting amidst live chickens and piles of foodstuffs they circum-navigated the narrow roads and precipitous bends before toiling up the rocky slopes on foot towards a pass on the mountain all the while fighting off a 'persistent young peasant' demanding 'Please teach English',[44] reminding them how widespread was the urge to learn western ways.

The pass was reached just as the sun was setting rapidly, a distant light proving to be a traditional Japanese mountain inn where, after a relaxing bath and supper, they enjoyed a sound sleep. They awoke to a breakfast of green tea and salted wild plums, an unusual but, they discovered, refreshing combination. Idyllic days were spent walking miles over what had been an ancient volcanic crater amidst woods largely untouched by human activity, stepping over fallen trees and listening to the rattle of thousands of cicadas and the sweet sound of nightingales. In the tranquil lake they swam naked in warm and trusting intimacy.

Liking nothing more than to be surrounded by friends and feeling the need for a kindred artistic spirit, Turvey, at Leach's urging, sailed to Japan with a view to settling in the country, planning to arrive in the spring of 1910. Despite being continually beset by financial problems in South Africa, Turvey's father supplied him with the necessary funds. During the voyage, aboard the Japanese mail liner *Mishima Nippon*, Turvey became friendly with a talented young Japanese architect and designer Tomimoto Kenkichi,[45] who was to

figure significantly in Leach's life. After hearing Turvey's friends on the quay at Tilbury animatedly discussing his intention of joining his friend the artist Bernard Leach in Japan, Tomimoto introduced himself as a fellow artist. During the voyage Tomimoto spoke about his interest in the art of the West, explaining that after graduating from Tokyo School of Fine Arts,[46] he had travelled to London where he had been greatly influenced by English Arts and Crafts ideas. Amongst other subjects he studied Gothic architecture and the work of William Morris and Whistler, and learnt how to make stained glass, possibly at Goldsmiths' College and at the Central School of Arts and Crafts.[47] At the South Kensington Museum he sketched metalwork, ceramics and glass and also visited the Red House.[48] A warm friendship was struck up, and Turvey invited him to visit Leach's house.

Turvey was welcomed enthusiastically by Leach. He slept in the nearby temple for the time he stayed with the Leaches, using the studio and helping teach English to the university students. At last Leach had someone with whom he could share ideas and talk about art, and he delighted in showing his friend around the city. As the summer heat became more oppressive Leach hired large rooms in a Zen temple near a fishing village on the large Boshu (Bōsō) Peninsula forming the south side of Tokyo bay. It proved a poor choice for although the valley setting was beautiful and ideal for drawing and painting there appeared to be little food available. The best of the fishing catch was dispatched to the city in the early hours of the morning, there were few vegetables, almost no fruit or meat and even eggs were scarce. Their inability to speak Japanese did not help. In Tokyo European food supplemented their diet but here such provisions were virtually impossible to obtain and any sent from the city took so long to arrive that they became inedible. Inexplicably they ordered French sticks of bread, which not surprisingly were mouldy and even after the green parts had been shaved away the remaining thin cigar-shaped insides were barely palatable let alone substantial. Integration with Japan seemed a long way off.

Working out of doors proved impractical. Either they were savagely attacked by the *buyo*, a vicious little black flying gnat or mosquito the size of a flea that settled on any area of bare flesh, took a bite and was gone leaving a stream of blood and furious irritation, or pestered by curious children who refused to be driven away. Finally the much needed but endless rain added to their problems. For eleven days and nights the non-stop downpour forced them indoors where they had to fight off the prolific insect life that took refuge under their thatched roof. To avoid being bitten mercilessly they sheltered beneath a room-sized mosquito net, playing cards and dreaming of sumptuous meals in Tokyo. Even when the weather cleared bathing proved unpleasant as the sea was coloured yellow by landslides brought on by the rain.

As a devoted and loving wife Muriel endured the holiday and its ordeals with fortitude but for Turvey it was the last straw. He found the language

impenetrable, the damp climate oppressive and he longed for the dry heat of South Africa. Most importantly the prospect of making a living as an artist seemed remote. In October 1910 he wrote to his parents about his lack of empathy with the country. 'People always get a wonderful idea of Japan. They dont see it as we do. They dont *live* here.'[49] In response to his parent's curiosity about the customs of the country he confirmed many of their stereotypical ideas. 'Jinrikishas . . . as they are called here . . . are numerous. It is the only mode of conveyance except by train, and electric tram.' With regard to their enquiries about the semi-naked body he assured them that 'Yes, you may see the stripped figures of men almost anywhere in Japan. They always wear a loin cloth though, and the figure is not considered as a profane thing here as in Europe and especially in England.'[50]

For relaxation Leach and Turvey walked in the peace and quiet of the nearby Buddhist cemetery, took rides on bicycles, and occasionally Tomimoto came round to talk, play games and read. Rounds of battledore and shuttlecock were played with Turvey and the servants, and games such as Up Jenkins[51] were deemed 'good fun'. They even made visits to the cinema seeing, among other films 'Tribulations of Thelos'[52] a silent feature with a heroic theme. But Leach felt a sense of aimlessness, a feeling not helped when plans to travel to China and Hong Kong as an artist were cancelled when his patron, a Mr N. Meane, decided he was not required.

With a view to attracting students Leach set up his etching press and placed notices in the newspapers promoting a small exhibition of prints as well as advertising the availability of Cambridge artists' materials that included tubes of oil paint and art equipment, using his European status as a guarantee of quality. A long account of the exhibition appeared in the Japanese equivalent of *Art News* in 1909, with a photograph of Leach in his very European-looking studio sitting behind his desk surrounded by many framed etchings showing him looking serious, thoughtful and bespectacled. It is indicative of someone who had a clear image of himself as very much a westerner in Japan. To entice the public during the three days of the exhibition Leach demonstrated etching techniques. To a culture based on the sophisticated use of the brush rather than the scribe, it is difficult to assess the impact of a process that makes use of finely incised line and delicate shading. Japanese visitors, curious to see the demonstration, duly came, and one, a university professor, only grasped the process when it was explained in French. The following day he wrote Leach a perplexing letter;

Dear Mr. Leach, B.,
I wish to send you my thanks for the show me method; but I like velly much to say more – thank for the taste of putrid mildness I find in your work . . .[53]

Was it, Leach wondered, some inscrutable veiled insult or highly coded praise? Sakya, his English-speaking friend, was equally dumbfounded, and consulted a priest at the temple who eventually fathomed the riddle, recognizing in the surprising description a classic Chinese compliment. 'The taste of putrid mildness' was a reference to the qualities of certain foods that were usually considered delicacies such as notorious Chinese seven-year eggs, the equivalent in Britain to high game or well-ripened Stilton cheese.

Following the exhibition Leach was visited by a thirteen-year-old Japanese boy, Mori Kamenosuke, known as Kame-chan[54] who had seen a review illustrating one of Leach's etchings and in hesitant English asked to work for him. Coming from a poor family he was, he said, prepared to do anything for he wished to be an artist. In a variation of the apprenticeship system Leach discovered that in Japan it was not unusual for a school-leaver to live with a family and help with any jobs in return for food, clothing and pocket money. After consulting the family and headmaster, in a combination of philanthropy and vanity Leach accepted the youth, who to all intents and purposes lived as a member of the family. Within a few months he was recording that he 'chased and tickled Kame-chan'[55] suggesting that he rapidly became an intimate and accepted member of the household. The youth immersed himself deeply in Leach's way of life, rapidly acquiring a thorough knowledge of English, reading art books, appreciating poets such as Whitman and Blake, translating books for his mentor and drawing competently in a western style.

So intensely did Kame-chan cling, so great was his obsession to embrace anything western that he lived virtually as a foreigner in his own country and Leach became concerned that he appeared to be loosing sight of his own culture. In a well intentioned but perhaps misguided act of charity, Leach felt he had lost control and was concerned how the youth would fare in the future. Following further discussions with his family and headmaster Kame-chan returned to his family and for about twelve months there was no contact until by chance Leach met him on the top deck of a tram. Hearing about the drudgery of his life as a worker in a brass factory he felt something should be done and a compromise was reached whereby he worked as an apprentice in a pottery workshop[56] but lived with the Leaches.

Although popular, Kame-chan began displaying odd and alarming symptoms including endlessly biting his lips and constantly spitting. A doctor diagnosed a form of dementia praecox, a loss of intellectual powers and schizophrenia. Inevitably Leach felt responsible thinking that if he had not taken the boy but had left him to a regular upbringing instead of the exotic and stimulating excitement of a foreign household things might have been different. For a time Kame-chan languished in a mental institution but Leach again intervened to take him away, appalled by the awfulness of the diet and the conditions, having to spend all but half an hour of the day in a darkened room applying glue to envelopes. With the help of Japanese friends

Kame-chan worked for short periods in shops. Although his behaviour caused anxiety he remained with the family until 1918.

The etching exhibition, although not a commercial success, attracted the interest of a radical group of students who welcomed direct contact with a European artist and were curious to learn as much as possible about the West. Affluent and privileged, they were members of the upper class, of the old Kyoto nobility, Samurai aristocracy, or sons of government officials, all from families whose wealth and social and political power made it possible for their sons to pursue literary and artistic careers. The group included artists, intellectuals and poets from the Gakushūin (Peer's School) and the Imperial University whose main objective was the understanding of western culture through the study of literature, art and philosophy. This stood outside mainstream society in opposing militarism and aristocratic feudalism, and as such they were at odds with the Gakushūin authorities. Inspired by the ideas and mysticism of Tolstoy and Maeterlinck, they formed a group known as Shirakaba (Silver Birch, or White Birch), declaring their belief in idealistic humanism, equality and freedom among individuals, whilst also seeking to come to terms with their own nobility and privilege. In many ways they were 'a blend of old fashioned libertarianism, self-motivated idealism, and a fundamental cultural conservatism'.[57]

Alerted by Leach's notices announcing his exhibition, four future members of the Shirakaba group visited him, though only two – Satomi Ton[58] and Kojima Kikuo[59] – became students. They produced self-portraits, Kojima after the style of Rembrandt, Satomi a brooding image in which his face was cast in dramatic shadow. Although amateurs with no professional art training, their proficiency so astonished Leach that for the first time it caused him to consider the idea of abandoning 'the idea of teaching Western Art in favour of learning more about the Arts of the East',[60] a defining moment in opening his eyes to the cultural richness of his adopted country.

During his etching demonstrations, Leach's enthusiasm for the work of Blake as well as John, Brangwyn and Tonks gave the impression that these were the most important artists in Britain. One young art student who responded positively both to the process and to Leach's enthusiasm, though not a member of Shirakaba until later, was the artist Kishida Ryūsei.[61] Inspired by Leach's work, in 1914 he produced a series of powerful etchings entitled *Tenchi Sozo* (Creation), complex compositions of tortured naked biblical figures, which, though heavily influenced by Blake, were depicted with an oriental sensibility. Kishida's portraits of Leach included one as a typical Edwardian gentleman wearing a high formal stiff white collar and necktie, a tight-fitting buttoned-up jacket, a generous moustache and gold-rimmed pince-nez. Leach's thin face was cast half in shadow by a large European wide brimmed hat, a combination of country gentleman and artistic bohemian.

Japanese artists, Leach hoped, would find the etching technique 'a means of expression suitable to their temperaments',[62] but he was in too small and specialized a circle to attract either sufficient numbers of students or a sufficiently broad audience. Although the idea 'never caught on',[63] through contact with the students Leach met a young writer and critic on art and literature Yanagi Sōetsu,[64] who was to have a profound influence on his thinking both as an artist and in his quest for spiritual fulfilment. Slight of build, two years Leach's junior, with an endlessly inquiring mind and a quick, sharp intellect, Yanagi had enjoyed a liberal education in a scholarly family. At Gakushūin, Yanagi was taught English by Suzuki Daisetz,[65] the distinguished Buddhist scholar, and German by the philosopher Kitaro Nishida. In 1910 he graduated as top scholar and was honoured to lecture on traditional Japanese poetry before the future Emperor of Japan, Hirohito. Yanagi's spoken and written English were excellent and he was anxious to acquire first-hand knowledge of the West.

The two men met first either through Leach's etching students or at an exhibition arranged by the Shirakaba of prints by modern German and French artists. Much to Leach's irritation Yanagi insisted on taking him by the arm and conducting him round, when each forcefully expressed their points of view, edging around each other nervously. It was not a good start. 'At first candidly I doubted him, for I felt that he in turn tried to lead me by the nose', noted Leach, who insisted that 'the French were better artists than the German'.[66] After this cautious beginning Leach 'began to take his measure' and accepted an invitation to visit Yanagi on Christmas Day 1911 to see three small original sculptures by Rodin, an artist revered by the Shirakaba as the supreme creator of humanitarian art. These had been sent in return for a gift of thirty nishikie prints sent to Rodin for his seventieth birthday. During Leach's visit Yanagi produced a series of reproductions by leading Post-Impressionists such as Cézanne, an artist he regarded as 'a doorway between East and West', together with work by 'Van Gogh, Gauguin and Signat'.[67] So powerful and challenging were the images that Leach felt both 'fear that it will completely upset my own output' and delight in having 'found living art'.[68]

A friendship slowly developed that was to deepen throughout their lives, a source of spiritual and intellectual support that was warm, rigorous and mutually understanding. Topics for discussion included art, philosophy, religion, literature and mysticism. Leach introduced Yanagi to the work of the American poet Walt Whitman and the English mystical artist and poet William Blake. So impressed was Yanagi by Blake's writing, regarding him as prophetic, intimate and mystical that in 1914 he published a 770-page book, *William Blake: His Life, Work and Philosophy*, the first in Japan, which he dedicated to Leach. In their often breathless letters they exchanged views on the Impressionists as well as contemporary writing on art. Post-Impressionism, Leach wrote, continued

Blake's idea in proclaiming a 'new Antidote' in freeing art from its historical constraints and its classical approach to education, and replacing this with 'purity simplicity & form'.

'We dealt authors and artists like playing cards: Sotatsu for Botticelli, Rembrandt for Sesshu,'[69] noted Leach, a cultural exchange that nurtured his philosophical leanings. Yanagi continued to extol the virtues of the 'God-intoxicated' nature of Blake's work as compared to the 'nature-intoxicated' Van Gogh. They applauded Frank Rutter's critical writing on art and studied the writing of the critic George Moore, which Leach was alarmed to discover was vehemently 'against the artist who travels', a view that caused him to think further about his work in Japan. Eastern mystics such as Lao Tze,[70] Confucius[71] and Chuang Tse[72] were also discussed. Given Leach's concern with the ideas and work of John Ruskin and William Morris and the Arts and Crafts movement, it is more than likely that he spoke about them to Yanagi who was later to develop ideas about Japanese folk art and Mingei theory.

Although Yanagi was not an artist, Leach believed that he had the ability to respond directly to beauty in all its manifestations, possessing the extraordinary 'seeing eye',[73] an ability to recognize 'significant loveliness'[74] or 'direct insight' (chokkan),[75] qualities he saw as inherent in the best masters of tea.[76] Abstract concepts of beauty and their relationship with spiritual elements were for Leach a part of Renaissance humanism. 'The only source of beauty was the Absolute,' he wrote. 'We in "image and likeness", therefore contain an innate capacity to recognise truth.'[77] In later years Leach was to claim that it was Yanagi, the creative critic, who 'lit my lamp', opening his eyes to the intrinsic beauty of traditional art and the work of the anonymous craftsman with its unconscious expression of the human soul.

Questions about 'truth and beauty', discussed at length with Yanagi, included such issues as What are the fundamental concerns of art? What does art 'mean'? and What constitutes the concept of the ideal? The breadth and scope of Yanagi's thought and ideas set Leach's mind racing, and they became the basis of much of Leach's own understanding of what constituted beauty. Their conversations may have prompted him to record in his diary 'In the train the thought came to me that the standard of Beauty is Absolute – by which all things are beautiful. The Absolute is incomprehensible quite inapplicable – There is a perpetual movement towards the Absolute'.[78] Further abstract thoughts were prompted by a private pupil, Mr Tasui, who drew Leach's attention to Leonardo da Vinci's idea that the soul knows instinctively that it is helpless without the body, hence the fear of death.

However much Leach was stimulated by Yanagi's ideas, he could not always follow his council of perfection whether in his own work or in adhering to traditional techniques and processes. Although keen to design textiles, Leach thought that only a purist method employing the 'warm, gentle nature'[79] of vegetable dyes would be appropriate, but discovered that although

the process seemed straightforward great skill was required to manage the technique successfully. Only later did he learn that aniline or chemical dyes were much simpler to use and if handled carefully could achieve similar sorts of qualities.

Their friendship matured intellectually and socially, and they even took a short holiday together[80] on Mount Akagi, a venue that had significance for each of them. Here Leach spent his first Japanese holiday with Muriel, and Yanagi had walked with Hattori Tanosuke, one of his most influential teachers. They talked enthusiastically about the work of the English writer Emily Brontë, Leach sharing Yanagi's view that 'she is one of the great mystic writers of the 19th century. I am thirsty for Wuthering Heights. Is she not better than Charlotte? I have just read some short account about Emily through the pen of Maeterlinck, which brings tears to my eyes. I love her at first glance'.[81] On one occasion a furious argument over art arose, but before going to bed they apologized, Leach for having been too emotional, Yanagi for his use of vulgar English. The following day, apparently forgetting their disagreement, Leach remarked on their brilliant discussion the previous evening and never recorded the episode.[82] Yet in daring to disagree with someone from the West the row was sufficiently significant for Yanagi to relate the story several times, disturbed by his audacity in stating his views, while also wanting to convey both his preoccupation with and commitment to western art.

At Yanagi's invitation Leach contributed to the monthly journal *Shirakaba*, and established close contact with the group, often being included in exhibitions they organized.[83] For over fourteen years, until the devastating Kantō earthquake in 1923 brought it to a close, *Shirakaba* was published with Yanagi as unofficial editor,[84] making him a central member of the group. Through a wide range of articles it introduced progressive literary and artistic ideas from the West to a small but important Japanese readership; it discussed the work of leading Impressionist and Post-Impressionist painters such as Van Gogh, Cézanne and Gauguin, and major western artists including Giotto, Leonardo da Vinci, Michelangelo, Goya, Rodin and Beardsley. Aspects of mysticism were also debated, and the writings of Tolstoy, Whitman, Blake and Strindberg analysed. Notably, *Shirakaba* carried few articles on oriental art.[85] As early as 1911 Leach wrote an article on etching that Yanagi translated for the journal, thereby introducing the technique and his own work to an influential readership.[86]

Leach also designed covers for all issues of the magazine published in 1913. For one that included a long feature on Blake, in which Yanagi favourably compared him with Michelangelo and Dürer, Leach produced a strikingly effective cover taking as his starting point two famous lines from the poem 'The Tyger' from *Songs of Innocence and Experience*. Curiously, on this occasion, he chose the conventional spelling of tiger rather than Blake's more idiosyncratic and graphic 'tyger':

Tiger, Tiger Burning Bright
In the Forests of the Night

The woodcut depicts an enchanting scene of a sylvan glade within a forest in which a naked figure of a child, 'innocence', stands beside a huge tree. A tiger lying in quiet contentment beneath the branches further evokes the mood of blissful harmony and calm.[87] The vast sensuous tree is reminiscent of one of Leach's most popular designs, the tree of life, a pattern that had mystical significance and was to recur throughout his career in a variety of interpretations both on pots and tiles. Cover designs for later editions continued the same bold approach. A 1918 woodcut depicted a Japanese landscape of a long road leading to a fine house set against dramatic, sharply pointed mountains, an early rendition of a theme that was also to recur in Leach's work.

Although contact with members of the Shirakaba was intellectually stimulating, establishing a reputation as an artist proved neither straightforward nor simple. Practically, Leach produced etchings, drew life models and worked on an oil portrait of Muriel based on a sensitive drawing that suggests a spirited and lively woman. In spring 1910 Leach exhibited etchings together with textiles and furniture he had designed, and some of which he had made himself, indicating the broad range of his concerns and his involvement in decorative art. Etchings were sent to a Friday Club exhibition in London for which a hanging fee of 10s 6d was paid. Paintings submitted to the annual salon in Tokyo were less successful, their rejection by the hanging committee prompting Takamura to write sympathetically but ironically 'what nice eyes they have'.[88]

Classes, travel, drawing and a new interest, photography, whiled away Leach's time, but he was plagued by doubts about his work on canvas. 'Is painting my metier?' he asked. 'I doubt it. It does not flow. No sense of touch, no sense of colour and no sense of tone – three weaknesses. Worst of all I cannot see anything in essentials . . . The young artist, even more than the old must paint Nature amorously. Love is the best teacher.'[89] His cryptic remark about love was a hint of growing emotional anxieties for, deeply ambitious both as an artist and as a lover, he desired satisfaction in both areas of his life. Throughout his early years in Japan the conflicts of love and sexual pleasure and their relationship to art continued to surface as part of a broader questioning of the direction and meaning in his work.

Within his marriage there were tensions, which, though not spelt out in detail, concerned fundamental issues about sex and love. Always searching for the mother he never had, it was inevitable that he should place Muriel at least partially in that role, thus leading to difficulties over sexual desire. As a solution Muriel suggested prayer, but as a non-believer Leach thought this unlikely to help, and succeeded only in adding further strain to their marriage. 'Muriel wishes me to pray, but I am sure it is unnecessary to pray in order to be in

tune with nature. I must begin to make my life *Me* religion. By this I mean I must begin to form definite opinions on all important questions and by so doing to make strong and sure the foundation of my house',[90] he recorded in his diary.

As a sort of hoping against hope he and others experimented with a planchette, a small heart-shaped board supported by two castors and a vertical pencil, which traced letters apparently without any means of volition when fingers were placed lightly on it. Even this proved something of a disappointment. 'I dont know what the possibilities are under some hands but when I get mine near it wont work,'[91] he complained. Throughout his life aspects of the supernatural were to intrigue Leach, a concern that was certainly influenced by Yanagi's investigation into such phenomena as telepathy, clairvoyance, premonition and automatic writing in trance. These Yanagi saw as part of human spirituality, a 'new science' as an alternative to 'dry science' to which the modern world was increasingly turning, and he devoted his first book to the supernatural.[92] Although prayer at Beaumont had had profound meaning it no longer offered solace. Clairvoyance and the occult may have seemed a possible alternative.

Still feeling his life lacked any shape or direction, Leach began to experience a growing disillusionment with Japan. Even the Japanese attitude to animals seemed wilful and cruel. 'How little sympathy the Japanese have with animals. Our cat was scared to death of Kame-chan, yet he was not deliberately unkind. Then the bus horses at Hota – they had to be run with and tempted on with mouthfuls of roadside grass.'[93] After seeing the wrestling at Ryogoku he declared it 'clear and clean and the exponents extraordinary fellows', but the hour's wait for the verdict caused him to observe how 'dreadfully servile the Japanese crowd is and how devoid of strong individuals. This is a strange land and I do not respect the people in many things. I cannot speak their language and their thought and emotion is very alien and mediaeval. As a whole I hate them . . . But I have a home . . . I have to grasp something of the old art and I must try to make and save'.

Leach found himself living in two very different worlds. One centred on the thrilling but elusive world of art that revolved around the exclusivity of Shirakaba, with its intense friendships, stimulating intellectual discussions and exploration of shared ideas and feelings about visionaries such as Blake and Whitman. There was also a growing friendship with Tomimoto, 'Reggie's legacy', which was to particularly blossom and flourish after Turvey's departure. In contrast there was the domesticity of his home which, while pleasant and as much like an English interior as was possible in a foreign country, seemed stifling and restricting. Although devoted, Muriel either chose against or was dissuaded from involvement in his artistic life, so emphasizing the separation between them. Tied in with home was the endless socializing of the English community and visits to Japanese beauty spots almost exclusively

visited by foreigners. Domestic matters, however, took a new turn for, by the end of the year, Muriel was four months pregnant and plans had to be made for an addition to the family.

With his artistic life uncertain, Leach opened his 1911 diary in thoughtful mood. 'On New Year's Eve, we sat round the fire & saw the Old Year out read the XCI Psalm . . . Some day in England I shall look back to the memory of this little house & studio & garden, the first of my very own, with an ache may be, it is difficult to realise.'[94] Pondering what the year would bring, 'Pray God it may be increase of activity',[95] he wrote, reflecting his absence of direction. Sometimes he dreamt of escaping, perhaps from his family responsibilities, or even from Japan. Part of him still felt the need to finish his education 'to develop my body by much natural training and exercise and the same with mind and will'. The reflective mood was taken up on his birthday on 5 January. 'How solemn and sad an anniversary this was to father,' he mused. 'I wonder how our lives would have run if mother had not died. Whilst at school my dear mothers spirit was often near me and I used to pray for her help in all trouble. I used also to pray to God and the Virgin Mary that I might see Mother.' The forthcoming birth of his child and the fear of any complications fuelled his anxious thoughts.

Pools of enlightenment included visits to museums where both paintings and pottery caught his attention, causing him to speculate on 'why should not a porcelain vase be as beautiful as a picture. Many in the museum are finer than any painting I have seen produced by westernised art in Japan. There are 50 perfect pieces there, such lovely shapes and colours'. Slowly his senses were being tuned to the qualities of objects made in clay, and this was to be his next discovery in a country that, while continuing to amaze and astonish, remained another world.

A WILD FLAME OF LIFE

Japan

1911–1914

To mark Turvey's departure for South Africa[1] Tomimoto, Morita and Leach held a farewell supper at which Leach presented him with a set of pastels, but the jolly atmosphere did little to dispel the sadness of the parting and Turvey predicted that the next time he saw Leach he would find him 'silly, toothless and inarticulate in an armchair'.[2] His friend was soon missed. 'How lonely it seems today without Turvey, I wonder when & how we shall meet again,' wrote Leach in his diary the following day. 'My thoughts go out to Turvey often – How does he do? We have seen eye to eye so long, though of course we squinted at first, when we next meet our eyes are bound to diverge, I dont like the idea at all.'[3]

With the baby expected in early May there were many distracting domestic duties, including the installation of electric lighting. The whole household was disrupted by the six electricians who displayed the universal problems of workmen, though these were exacerbated by the fact that the Japanese were unused to seeing westerners, let alone entering their houses. After spending a morning fitting two lights and a switch, none of which worked, they 'did not clear up their mess nor had manners. One of them came and stared at us for $2\frac{1}{2}$ minutes without explanation. Very Japanese',[4] complained Leach. Nevertheless lunch guests were well entertained with reassuringly English fare, one menu consisting of 'roast wild duck, soup, salad, cold tongue, cold pudding'.

Baby clothes arrived from Muriel's parents and Dr Hayata visited regularly and often stayed to tea. Leach thought him polite 'in the Japanese flowery style. He dances instead of walks. I dislike him though I daresay he is quite inoffensive even proficient in his own way'.[5] At St Luke's Hospital Muriel consulted Dr Kubo 'about certain little matters of hers', and purchased weighing scales for the baby. Accompanying her Leach took the opportunity to ask about 'mild ringworm (mild sort of irritation) & mild piles. Not serious. The latter I don't like as the tendency must be hereditary as Japan has an unfortunate climate for that kind of thing'.[6]

With preparations apparently well in hand for the forthcoming birth the maid O Mya San suddenly announced that she was getting married, a prospect

Leach viewed both as a great inconvenience and distasteful as the marriage arrangements seemed to him crude and insensitive.

> The whole idea of Japanese marriage is primitive and repugnant. Today they saw each other for a few minutes and eyed each other quietly. Mya san was obviously uncomfortable poor girl. Yet he seems a decent sort. They have no concept of our idea of love. The go-between and parents determine the suitability of the marriage in question and in most cases the principle is never ever see one another before they're plighted.[7]

A decision to delay the marriage until the autumn led to bad feeling on both sides. 'Mya San was exceedingly rude. It was partly a misunderstanding, but she is selfish and conceited',[8] noted Leach pompously.

Excursions to the theatre revealed yet more of the complexities of Japanese culture, with the performance often lasting for most of the day and a different play during the long interval. This, to Leach, seemed old-fashioned 'quite beyond me. Burlesque, grotesque and tragedy combined'.[9] The main performance, *Shosbara Tasute*, he enjoyed, maybe because the drama of a wicked stepmother and a heroic son reflected something of his own experience. A visit to a Nō play proved to be 'almost out of my range and very difficult to understand but the music and movement was fascinating'.[10]

At dawn on 6 May 1911 Muriel, or Snig as Leach referred to her when he felt affectionate, woke and quietly announced that the birth had started. Although there seemed no cause for anxiety it was the start of a twenty-four-hours ordeal, with Leach in almost constant attendance.

> During the day the pain came more and more frequently till by the evening they were almost continuous. O Mya-San telephoned the doctor, Muriel was put to bed. Awful night. Stayed up with Dr Kubo and Dr Harada till 1.30, going in now and then to see Snig. Poor lassie she suffered a great deal, I can hardly bear to think about it. About 2am I thought she slept from exhaustion, so I lay down on some cushions by the bed and slept for 2–3 hours.[11]

Muriel's 'groaning and tossing' woke Leach who was still terrified lest there should be a repeat of his mother's tragic fate, but 'the morning air, damp and rainy' seemed a good omen. Banished from the bedroom, he listened with increasing anxiety; 'With each sound that came from the room, I felt more desperate. After half hour Mya-San came to me on the veranda and said Muriel was asking for me so I went quickly. Did not mind what the doctors were doing as I thought I would, it was obviously necessary.'[12] After a further hour the baby was born. 'Never will I forget the first cry of the babe, and the first sight of him. I feared for a few minutes he was dead, but soon he made it clear

that he was not. Then came Muriel's relief. They made her comfortable, and gave baby a bath in the next room. Poor little chap, he's not so handsome. About 8 lbs with a big head and fairly fat.'[13]

For a short time Leach entered a dream world, partly from exhaustion and partly in adjusting to his role as father. One of his greatest pleasures was dandling the child on his knee and watching Muriel, 'dear little mother' with the baby, the birth bringing a new domesticity into their lives. The infant thrived, weighing a robust 10 lb 12 oz at six weeks. Whether or not to have the child baptized was much discussed, for having rejected his faith Leach was at best ambivalent. As a Christian, Muriel naturally pressed for a christening. David Leach cannot recall ever being told whether he had in fact been baptized, and presumed he had not.

At home Leach read to Muriel, choosing amongst others Keats's poems 'Ode on a Grecian Urn',[14] and 'Ode to a Nightingale', declaring them 'amazing'. Popular classics included *Marie Clare*. 'The first portion recalls the first portion of Jane Eyre . . . she constantly leaves deduction to the reader in a delightful, subtle, simple and uncomplicated way', and *The Caravanners* by 'Elizabeth' summed up as 'nasty, out of taste in parts, not even clever', but also 'amusing in parts'. *Simon the Jester* by William John Locke was thought to be 'not inspired in a fine sense, and yet he is artistic' and Thomas Hardy's *Jude the Obscure*, 'What an awful tragic book, how beautiful the country, it stinks Oxford dons like a cloud of malarial mosquitoes.'[15] Other books included *Rebecca of Sunnybrook Farm*, Rudyard Kipling's *The Jungle Book* and R. D. Blackmore's celebrated historical adventure *Lorna Doone*.

As Muriel felt stronger they went for little walks, either to the zoo, where Leach had developed a passion for parrots, or 'the beautiful Buddhist cemetery' near their home, both bringing memories of Turvey. 'Each time I revisit some spot last seen with Turvey it makes me sad to think that his memories must be so unpleasant. What a mistake I made in asking him to come out. The Fates, damn them, owe him a big debt of happiness.'[16] From England Uncle Will sent photographs of the recently completed but controversial memorial for Oscar Wilde by Jacob Epstein,[17] which Leach liked, thinking the sculpture 'vital despite strong Egyptian influence'.[18] Trips were also made to museums where, drawing from Chinese bronzes, he noticed the similarity between old Chinese and Ainu designs, the indigenous people of Japan who live mainly in Hokkaido, an observation later borne out by anthropologists.

In June the Leaches were invited to a special dinner at the Imperial Hotel to celebrate the coronation of King George V and Queen Mary,[19] a patriotic occasion that Leach enjoyed and thought 'very well managed', though a surprise visit from family relations was seen as an unwelcome intrusion. Charles Ure, Leach's uncle, who had married his Aunt Marion, one of his mother's sisters, came with his brother, but Leach, preoccupied with artistic activities, declared that he could spare them only limited time.

After visiting Gahosha, in central Tokyo, the first independent small art gallery, which showed the work of young artists, Leach was invited to exhibit etchings, textile designs and woodcuts, a welcome indication that his work was slowly being accepted into Japanese cultural life.[20] This impression was reinforced when shortly afterwards he and Tomimoto were invited to a raku party where pre-fired pots, known as biscuit-ware were decorated by guests. After being glazed these were fired again until the glaze melted when they were removed and cooled rapidly, so dramatically speeding up the firing process. Raku, a type of low-fired earthenware, uniquely Japanese, had been made since the sixteenth century, part of a collaboration between tea master Sen no Rikyū and Chōjirō, son of a tile-maker, probably in Kyoto.[21] Raku parties were, essentially, social occasions combining an element of creativity with the dramatic spectacle of firing and cooling. Decorating raku was comparable in the West to water-colour painting or playing the piano, and seen as an agreeable pastime.

Although Leach had become aware of pots through his interest in the decorative arts, until this point he had not thought of working with clay, but the experience of the raku party was eventually to change forever his perception of himself as an artist. Their host was the artist Hiraoka and Leach was struck by the fine traditional architecture of his property.

> The house was not of uncommon exterior but the interior reached the high water mark of anything I have seen [he noted]. Not elaborate but thoroughly Japanese & in excellent taste – in character. The ceiling in one room was made of broad laths of partially planed wood & wood shelving. The quality of the grain and in various places the interstices were closed with well chosen pieces of brocade and silk. The walls were delightful in colour with borders of white and every single detail in keeping.[22]

Given the tremendous significance of the event in shaping Leach's future it is perhaps inevitable that his several accounts of the occasion vary in detail, but all indicate its importance. In some he records that the visitors numbered about a 'dozen people, who included actors and painters',[23] though in others he mentions some 'thirty young artists'[24] as being present. In the relaxed and informal atmosphere of the beautifully proportioned tea ceremony room, guests, sitting on the floor 'as they do in Japan – or as they did then', painted designs or wrote verses on small pots. Noticing Leach's curiosity one invited him to 'come and write a poem on one of these pots'.[25] At first he was put off by the sticky, long brushes and the syrupy pigments, but fascinated and intrigued, he began to consider an appropriate design. 'Landscapes won't do. Portraits won't do. Patterns – what is a pattern?'[26] he asked himself. Recalling a Ming porcelain dish decorated with a parrot balancing on one foot on a stand, at one end a small seed container and a water pot at the other, Leach thought it would fit well in the centre of the plate.

When complete the dish was dipped into glaze, the opaque liquid obscuring the painting causing him to wonder if this was an indication that his pattern was not thought appropriate. After drying the dish on top of the kiln in the garden Kato, the raku potter conducting the firing, lifted the kiln lid to reveal an inner chamber surrounded by glowing hot charcoals and placed it inside with long tongs and replaced the lid. After about an hour, when the glaze had melted and formed a smooth glass-like covering, the pot was taken out and either stood on tiles or plunged while still glowing hot into a bucket of water where it bubbled and hissed. As it cooled the design slowly appeared, the colours bearing little relationship to the original pigment. To Leach's amazement the pot withstood this treatment and, still pinging as the glaze contracted, it was wrapped in a cloth and handed to him.

Mesmerized, Leach stayed on.

As it got darker the scene was both romantic and artistic. Most of us sat in the tea room, beautiful, and watched a few standing round the growling kiln from which cascades of sparks emitted with curious wriggling movements. The cups, removed with care, found most of the colours had altered and in one or two cases almost vanished. Mine was fairly successful. We then drew lots and each took someone elses . . . Morita and I and some dozen others stayed to a jolly supper and returned at 9.30.[27]

Decorating pots and seeing them transformed by fire into something colourful and expressive seemed magical 'the direct and primitive treatment of clay',[28] a means of creating something beautiful and useful. The experience caught Leach's imagination leading him to declare 'By this, to me a miracle, I was carried into a new world, something dormant awoke'.[29] 'Enthralled, I was on the spot seized with the desire to take up this craft.'[30]

With this new awareness of pottery he visited the national colonial exhibition in Uneo Park where he discovered 'a shop where visitors could buy unglazed biscuit wares, decorate them with their own hands, and have them glazed in raku'.[31] Captivated, Leach regularly tried out designs, assessing how they were changed by the action of the fire. Already the ceramic critic, he cast a discerning eye over the work of the potter running the stand judging it not very good.

He is the lineal successor of a famous ceramist, and is now about 45. He works for position and money. He has 'push'. He went to a workman at the A J exhibition with a fair conceit of himself, he is now unbearable. He hardly retains any of the old excellence in his products. He substitutes gas for coal, and coal for pine wood in his kilns. His work is very clean, highly finished (so called) but without quality.'[32]

Inspired, Leach began 'to search Tokyo for a teacher', but finding one sympathetic proved difficult. Several potters were visited, including Horikawa

Mitsuzan who specialized in raku and with whom Leach studied for a short time, even showing him the raku pots he made. However, Leach felt more at ease with Urano Shigekichi,[33] who bore the title the sixth Kenzan, whom he probably met through the intervention of the painter Ishii Hakutei.[34] Urano's curious but complicated lineage placed great importance on tradition, with an emphasis on decoration rather than form. Born in Tokyo of impoverished parents Urano learnt how to make glazed earthenware and later studied the technique of slip-casting. At the age of twenty-two he worked for the elderly but highly gifted potter Miura Ken'ya,[35] whose studio was equipped with different types of kilns and who had acquired the secret recipes of the great sevententh–eighteenth-century Japanese potter Ogata Kenzan.[36] Although generally considered to be 'the best potter in the Kenzan tradition',[37] Miura Ken'ya declined the title and hence could not pass it to Urano. In 1900 Urano was adopted by another potter Ogata Keisuke who claimed familial descent from Ogata Kenzan so enabling him to take the title 'Sixth-generation Kenzan'.[38] Urano set up his studio in Shin Sakamoto (Iriya) near Ueno Park, building a small earthenware kiln and a three-chamber climbing kiln for high-temperature firings. After a serious flood this was replaced by a western-style single-chamber kiln with two fireboxes.

With his daughter Nami, Urano dwelt in 'a little house in the northern slums of Tokyo',[39] eking out a living producing figurines, decorative objects and food dishes as well as tea utensils in the style of Kenzan, which in Leach's view had 'far less originality and power . . . [and] somewhat less vigour'.[40] Serious potters had all but abandoned the raku tradition, but Urano continued to produce it. Although skilled at handling the brush following the distinctly old-fashioned Rimpa style[41] associated with Kenzan, Urano's pots even to Leach's untutored eye seemed to lack energy and invention, but he was prepared to offer guidance and instruction and Leach liked him. Despite Urano's limited aesthetic understanding, he taught Leach an appreciation of form and how to handle the brush for ceramic decoration, a skill he honed throughout his life.

A financial agreement was made under which Leach spent two days a week for two years with the potter with, initially, Tomimoto serving as interpreter. Clay would be supplied, and, as Urano did not throw, a man hired to turn the wheel. Throwing, regarded as a profession in its own right, was not thought a necessary skill for an artist potter, but it was one Leach wanted to acquire. Entranced, he could not take his eyes off the pots made to his design. 'I watched the shapes taking form and often, though the walls of the pot were still too thick, I would stop the thrower because the clay was taking on such lovely shapes. So my first pots were largely shapes that were realised on the way towards those I had planned.'[42] Leach learnt the basic skills of throwing and trimming pots on the Japanese wheel, which, unlike western wheels, was pushed round with a stick and revolved clockwise. From

Urano, he 'learned how to look at a finished pot, how to examine its foot as well as its general shape, to see if the foot was cut in a harmonious relationship with the pot as a whole'.[43] Experts, he was assured, could often tell from what kiln or district a pot had come by studying the marks left by the twisted thread with which the pots had been cut from the wheel head. Leach also helped fire Urano's kiln, stoking it with wood, his 'first lessons in the ways of the fire'.[44]

With little knowledge of, or interest in, the scientific or technical aspects, Urano complained that Leach's endless questions made his head ache and told him to 'do what I show you, which is how my master taught me'.[45] With a view to finding out more about the craft's technical aspects, Leach asked his uncle to send copies of classic texts such as Emile Bourry's *A Treatise on Ceramic Industries*, which had been recommended by a Mr Burton, possibly William or his brother Joseph, associated with the Lancashire-based firm of Pilkington's Tile and Pottery Company, a contact his uncle may have suggested.

For nearly two years Leach studied with Urano taking bottles of Ebisu beer to share at lunch time. Urano was always referred to with respect as 'his master' and described with a mixture of admiration and fondness as a man 'of a quiet, friendly, honest and quiet disposition'[46] who was 'old, kindly, and poor, pushed aside by the new commercialism of the Meiji era'.[47] In 1913 Leach made a fine pencil character study of the potter, portraying a gently smiling figure looking content and genial.[48] Following Urano's death in the 1923 Tokyo earthquake he produced a mirror image, a soft ground etching based on the drawing.

While making no attempt to copy Urano's pots, Leach responded to the qualities of brush decoration within the convention of decorative rather than functional ceramics. Although aware that he himself 'wasn't an oriental . . . and didn't think I should be working in a direct oriental style',[49] he, like other potters seeking to establish their own style, scrutinized existing pots and looked at illustrations in books and examples in museums. He also consulted Charles J. Lomax's recently published *Quaint Old English Pottery*,[50] a well illustrated volume on eighteenth-century English slip-decorated wares. In *Beyond East and West* Leach credits Tomimoto with purchasing a copy at the Maruzen bookshop, noted for its imported English books, but at other times Leach claimed not to have seen it until 1917 when he discovered it on Yanagi's bookshelves after setting up his pottery at Abiko. The fact that many of his early pieces used devices and decorative treatments characteristic of English slipware suggests that he was familiar with such wares very early on. In addition, a Toft dish 'The Pelican in her Piety' was illustrated in 'Art and Commerce',[51] an article published in 1913.

After about a year Urano suggested that Leach set up a small pottery studio in the corner of his garden, indicating that Leach had made good progress. A room was built and after overcoming what seemed insurmountable official

obstacles a small raku kiln constructed. Writing to his Uncle Will, Leach described the problems in getting a permit to use the kiln:

> Incredible red-tape and nonsense. I honestly must have spent a week of days over their formalities & delays & all for a little affair a foot square inside and no more dangerous than my studio stove! For example after I had given them complete duplicate sets of plans & information (in Japanese) & had been to their head office & local branch several times & their officials had been to see my building operations four or five times & my roof was finished they calmly said it must be made of tin, but that if I had put it over the wooden roof it would do.[52]

It was an exasperating experience, but given that Leach's workshop was later to burn down, Japanese caution, albeit frustrating, was not altogether unwarranted. Nevertheless, such bureaucratic attitudes fuelled Leach's burgeoning antipathy towards aspects of new Japan.

In the studio Tomimoto, who was feeling depressed, tried his hand at the wheel and threw a bowl nine inches in diameter. As decoration Tomimoto chose a traditional design of plum blossoms and the text of a popular spring song 'The nightingale sings amongst plum blossoms once again, hokekkyo! hokekkyo!' (*Ume ni uguisu, hokekkyo! hokekkyo! to saezuru . . .*)[53] Later Leach discovered that the first Kenzan had quoted from the same spring ballad on one of his pots decorated two hundred years earlier.[54] The successfully raku-fired bowl was given to and greatly treasured by Leach.[55] It was the start of Tomimoto's career as a potter, and he immediately began to study with Urano, going on to establish a reputation for delicate and lively decoration on porcelain.

A year later, in recognition of their study with him, Urano presented Leach and Tomimoto with the Densho, the certificate of succession handed down from the first Kenzan, which contained the list of recipes of traditional colours and glazes, in effect acknowledging them as his successors. The specially drawn Densho was attractively coloured and decorated with a pattern of dots, with a translation in English. In the past such treasured documents were presented in a secret ceremony usually in the dead of night, the recipients agreeing only to divulge the contents to the next Kenzan.[56] Within traditional arts such as flower arranging, the acknowledgement of apprenticeship was common practice, ensuring the continuance of the craft and the protection of its secrets. While not following the Kenzan style, Leach was both moved and flattered at the gesture, and though he later resigned the inheritance and published the technical information in his book on Kenzan, he did use the title when speaking on the artist.

By early 1913 Leach was regularly making and firing pots, producing ninety pieces in six firings. Before exhibiting them he often sketched the forms in

his diary, on one occasion alongside a drawing of a potter preparing clay, bearing the caption 'potters thumping your wet clay, what are you thinking of today?'[57] In the same year he experimented with porcelain, packing eighty pieces in one kiln load. Like all potters he was eager to see the result and frustrated by the delay but recognized that 'I have no patience to wait for the opening in two more days'.[58] At this time his pots were small in size, the shapes and decoration derived mainly from historical styles such as eighteenth-century English slip-decorated red earthenware fired by the raku method, Delft maiolica painted earthenware, and Chinese porcelains. A porcelain ginger jar of conventional shape was enlivened with painted blue landscape decoration, while his raku was usually more brightly coloured, freer and often more inventive.

Pots were shown at, among other galleries, the Taibun Sha with a Mr Oka, who asked a modest 15 per cent commission and agreed that Leach could arrange his pieces so they 'should not be confused with other people's work'.[59] Still seeing himself as artist, potter and designer, he sent an application to join the American Etchers' Society in New York. Ever alert to fund-raising possibilities Leach considered the idea of exporting Japanese craft to England and when he 'saw some nice pottery', he purchased it at Tomimoto's suggestion with a view to resale in London. At one point, when considering the idea of returning to London, he proposed acquiring a property in Chelsea where the family could live and where he would have a studio and a shop-gallery. 'House in Kings Road selling Japanese and Chinese ware. Income – Muriel £25, BL £130, Grannie £50–£200; Total £350, expenditure £287 . . . shop front, studio, workshop, Kame Chan's room, own bedroom, maids bedroom, living room, kitchen, bathroom and lavatory.'[60] Despite Kame-chan's odd behaviour, the Leaches had virtually adopted him, and planned accordingly.

Two important but contrasting friendships – one with Yanagi and the other with Tomimoto – dominated Leach's life at this time. With Yanagi, conversation was ascetic, high-minded, probing, exclusive and intellectually challenging, and forced Leach to further consider the role of art within society. The links with Shirakaba continued to develop. A large international show organized by the group included his European etchings, drawings, oil paintings, plates, teasets, cups, jugs, bottles, vases of porcelain and pottery, and toys alongside work by Rodin, Renoir, John, Heindrich Vogeler and Yamawaki.[61]

Leach's friendship with Tomimoto was different but equally intense. They endlessly discussed their art, Leach finding Tomimoto sensitive, intuitive, impressionable and stimulating. They had much in common. Tomimoto or Tomi as he was invariably known, was born on a country estate at Ando, Nara Prefecture, into an old and well established family; Leach described Tomimoto's father as the equivalent of an English squire. Both were devoted

to their respective countries but were not uncritical, particularly at the growth of militarism in Japan. Tomimoto's background in architecture and art and his travels in England, where he learnt fluent English, removed many boundaries. Inspired by the ideas of Morris, Tomimoto set up a progressive architectural and interior design practice that offered services such as wallpaper creation, furniture, interior decoration, pottery, textiles, embroidery and metalwork.[62] He also wrote the first extensive biographical account of Morris in Japanese, *Wiriamu Morisu no Hanashi* (A Story of William Morris), published in *Bijutsu Shinpō* (Art News) in which he discussed the relevance of Morris's ideas to various crafts including pottery.

'I like him very much,' wrote Leach of Tomimoto, 'he has a strong sense of humour and loves the piquant. He is nearer the English temperament than any Japanese I have met hitherto.'[63] Aesthetically they had similar tastes. 'He again has the peculiar Japanese artist character – slight, delicate, fastidious – Cherry blossoms,'[64] commented Leach. Just as he and Turvey used affectionate nicknames so Leach and Tomimoto invented empathetic names, calling one another Kappa (water-sprite). They met frequently, visiting exhibitions and taking excursions to museums and galleries. Tomimoto became a regular guest at Leach's home, often staying the night, 'Tomi spent last night here. naked am', noted Leach ambiguously. 'It was nice having him. He is very good company.'[65] Their many expeditions in 1912 included a visit to the Takushoku Colonial Exhibition[66] where they were excited to see and purchase 'savage' art made by the Ainu, and crafts by the mountain people of Taiwan. They also visited Tomimoto's family home and toured the 'gentle countryside in the spring-flowering of cherry, peach, and pear trees, sketch books in constant very brief use'.[67] From these quick sketches of flowers and ferns, landscape, clouds and birds, they evolved patterns for their pots.

In response to what both saw as the dearth of exhibitions of progressive art they planned a large show that would feature their own work and that of young Japanese artists for the *Bijutsu Shinpō* exhibition at the Gorakuden (Palace of Comfort).[68] Ambitiously they decided not only to select the work but also design and install the exhibition. The phoenix was chosen as a motif, which Leach discovered was a universal symbol originating in ancient Egypt. A Chinese phoenix (*hōō*) was used for the exhibition sign board. All was going well until Tomimoto was rushed into the Red Cross hospital with typhoid fever. Industriously Leach continued to design wall decorations and invitation cards, but neglected his family.

Two weeks before the opening Tomimoto was discharged 'thin and white but on the high road to bodily and mental health'. In discussion about the exhibition he revealed, to Leach's amazement, that he had some five hundred drawings of various crafts, mainly pots, carried out during his stay in England, which they decided should be included in the exhibition. With Tomimoto still weak, Takamura, Leach's sculptor friend from the London School of Art,

helped hang the show. 'What a magnetism there is about him, his personality compels me. A most loveable character – sensitive, brooding, intuitive, refined, unexpected,'[69] enthused Leach.

Like Tomimoto, Takamura was horrified by what he saw as the aggressive nationalism and militarism of Japan, and reluctant to be part of this he withdrew, first from the city then from his family and friends. In the spirit of the English independent thinker and socialist Edward Carpenter[70] he left Tokyo for Hokkaido 'for freedom and thought, to live on the land to till the soil, to study, to be independent, to found his life'.[71] The sincerity and intensity of Takamura's views reminded Leach of Lenin, the revolutionary who had visited London several times in the 1900s and whose passion and commitment caught Leach's imagination. Intrigued by Russia and Shirakaba's respect for Tolstoy, Leach thought 'there are qualities about the people and the literature that are curiously attractive'.[72]

The Gorakuden exhibition, reflecting both western and eastern tastes, enabled Leach to maintain his independent identity.[73] The show included etchings, prints, drawings, paintings and pots by Leach and Tomimoto, and Morris-inspired rush chairs designed by Tomimoto. Reviews were positive, some even claiming it to be the first to feature 'modern artists' drawings in Japan'.[74] Leach sold a hundred items including forty small prints and ten raku pots, seven etchings, and two oil paintings on paper resulting in a profit of 54.50 yen, which was thought a modest success. This added to his sales at the Friday Club's Alpine Club exhibition where his etchings were shown alongside the work of the French caricaturist and painter Honoré Daumier. One of Leach's etchings, *Beggar and Bird*, sold for £5, his work receiving a laudatory mention in the *Morning Post*.

The challenge of finding a way forward for Japanese artists that took account of but neither merely followed fashion nor thoughtlessly aped western art, continued to vex Leach. He was horrified by the way that many traditional artists, often aided and abetted by official bodies, were swamped by what he saw as crude interpretations of western ideas. He was appalled by the paintings and sculptures selected for the Monbushō Bitjutsu Terrankai, the Ministry of Education's annual fine art exhibition,[75] writing that 'the standard set is pretentious and false, manual dexterity being rewarded and not the expression of sincere emotion'.[76] He also castigated both the police and the art establishment for censoring a 'straightforward nude painting' by Viscount Kouroda Seiki,[77] senior professor in the department of western art at Tokyo Art School, by insisting that a curtain be placed across the lower half. Further anger was expressed in the draft of a letter to an unnamed newspaper disagreeing with Kuwabara Yojiro's review 'Japanese painters owe debt to West'. In his diary, after bemoaning the lack of life in Japanese art, Leach wondered whether it would ever again 'form a national style and ideal'.[78]

Still keen to learn various techniques, Leach experimented further with photography, developing and printing with the help of someone called Leo Maseseoe. The images he regarded as 'failures except for one of a group of girls at Enoshima', though whether this was because of the faulty processing, incorrect exposure or poor composition is not recorded. Eager to practise the 'tricks of the stencil trade', a traditional craftsman, Mr Adachi, taught him the old-fashioned way to cut stencils and print them on calico, a long process that involved soaking and washing the calico, washing in ground colour, beating and soaking in starch and drying with a preparation of gum. Each sheet was damped on the underside, colours prepared with hot water and print steamed for twenty minutes before washing and ironing. Laborious and complicated, the process was soon abandoned as unworkable. Leach's uncertain artistic identity led him to demonstrate pottery decoration at an exhibition at Ikeno-hata, in Ueno Park, where he wrote the buyers' names in English on vases or sake cups as souvenirs. He later regretted its suggestion of frivolity and super-ficiality.

Although 'seized by the desire' to take up pottery, Leach continued to see himself as a designer and artist rather than a potter, and looked for ways to develop this. Inspired by the way Morris had marketed his designs, Leach pro-posed the idea of artists jointly opening a shop-gallery selling fine and applied art objects for interiors in a modern idiom. 'I am always thinking out a plan for the combined spreading of Art-love & the making of a living. My present idea is a W Morris movement by Takamura, Tomi, self & a few others. Paint-ing, sculpture, bronze, mats, porcelain, lacquer etc. to be exhibited in a club – shop.'[79] The idea did not materialize, partly because of cost, estimated at 5,000 yen, and because on reflection Leach saw it as distracting from his major artistic concerns.

Despite abandoning the idea of the shop-gallery, Leach still hoped to form a supportive community of artists, designers and writers, but this was seri-ously threatened by an unstated but evident rivalry between Yanagi and Tomimoto. Accounts of exhibitions by contemporary artists appeared in *Shi-rakaba*, but Tomimoto's were intentionally ignored. It made no reference to an entire room devoted to more than 150 of his designs and drawings in the 1912 *Bijutsu Shinpō* exhibition, then at the centre of the art world. Similar slights occurred at the opening shows of the Venus Club Gallery in 1913 and at the Mikasa Gallery when *Shirakaba* reported on all the artists except Tomimoto.[80] This deliberate exclusion of Tomimoto by Yanagi, who wrote most of the reviews, was less to do with the quality of his work than a per-sonal decision following publication of a magazine article in which Tomimoto had been harshly critical of Rodin,[81] an artist revered by Yanagi and *Shirakaba*. There were other rivalries. Yanagi may have been envious of Tomimoto's first-hand experience of England, in particular his knowledge of the work of Morris, and of his close relationship with Leach.

Like many other Europeans, the Leach family continued to escape to the cooler mountains in the hot sticky summer months. A favourite spot were the picturesque and unspoilt mountains and lakes of Hakone, about a hundred miles from Tokyo, the result of volcanic action that culminated in 'the matchless, solitary, 14,000 foot Fuji-san . . . this peak . . . in all Japan has a uniqueness of beauty amongst its volcanic peers right round the fringes of the Pacific'.[82] The area was acclaimed for its hot springs, invigorating air and places of historic interest. One year they rented a thatched cottage by Lake Hakone, a magnificent stretch of water six miles long and one and half wide renowned for its shimmering reflection of Fuji. To help care for David, 'not a crying child', they took with them 'nice, responsible maids', which allowed Bernard and Muriel the freedom to explore the countryside, and enjoy invigorating walks, climbing hills and rowing on the lake.

The summers of 1914, 1917 and 1918 were spent at the mountain resort of Karuizawa, about a hundred miles north of Tokyo, near the Asama active volcano, staying in houses set among fir trees overlooking the village. Situated on a plateau about 2,500 feet above sea level, where 'the air is clean and fresh', the resort, although little visited by Japanese, was popular with English and American visitors. The wild uplands offered the opportunity for long walks and for cooling showers in the refreshing mountain streams without fear of being disturbed. It was an idyllic spot,

> miles and miles of grasses, flowers, and lilies, ringed with distant valleys and mountains − tiger-lilies by day, pale yellow primroses throng the evening dusk and in September the white feathered seed of a kind of pampas-grass flows under the mountain airs and eddies, revealing every ridge and curve of unhampered hills and plains as the winds blow over it, silver on green.[83]

It was also 'a lovely place to dream and draw', and during these holidays Leach did most of his work on paper, often simplifying the landscape and combining line with washes of muted colour. Favourite subjects were the mountains, their peaks an endless source of fascination as the light cast them in different moods, a dreamland often drawn and incorporated into designs on pots. A good time was between sundown and dark when, amid the intense and deep shadows, 'intuition and emotions were released'[84] that seemed to take on symbolic meaning. Closely observed but loosely carried out, the drawings are among some of Leach's most expressionistic, and were the foundation for such dramatic etchings as *Mountain Gorge in Mist − Myōgi*.[85] Generally he preferred to work on Japanese grey absorbent paper, enjoying its soft texture, and was influenced by careful observation of the way the Chinese use the brush in writing characters and in drawings of mountains and water known as 'sansui'.[86] The 'three friends' of ink, brush, and paper were to be used throughout his life.

However blissful were the visits to the mountains it was the city that offered the possibilities and challenges for his career. Not only was there his work as an artist, but his desire to keep abreast and make sense of wider developments within the art world. His hero Augustus John, he felt, had to be constantly defended against critics who failed to understand him, for although such a distinguished portrait painter as John Singer Sargent regarded John as 'the greatest draughtsman of the age',[87] this did not prevent him receiving 'more inches of expert opprobrium than any artist of his generation in England'. Indignantly Leach argued that this was due primarily to a misunderstanding because John 'was a Celt – primitive, sharp, powerful and rugged as nature'.[88] With ancestral Celtic blood, the qualities Leach ascribed to John were much like those he wished for himself, particularly when beauty and refinement were seen to signify loss of vitality and life.

The unfettered qualities in John's work, which Leach described as 'a wild flame of life',[89] he also saw in the paintings of the French painter Paul Gauguin whose work he found inspirational, even revolutionary. 'The natural savage did that which I have been dimly groping over in theory only. So must all sincere men act according to their light,'[90] wrote Leach, an indication of his need to get in touch with that part of his creative spirit in which intuition was united with conscious expression. 'The only source of beauty was the Absolute,' he thought. 'We in "image and likeness", therefore contain an innate capacity to recognise truth.'[91] Leach also continued his involvement with mysticism.

Gauguin's observation that 'There are only two kinds of artists – revolutionaries and plagiarists', were aspects Leach was acutely conscious of in his own work, reminding him how fearless artists must be in pursuing their own ideas rather than staying safely within the known and secure. 'A creator, stripping himself nude, must plunge into the ocean of life and swim out and out. It were better for him to drown than to sit on the sand gazing wistfully at the white crested waves. Oh for some courage! He is a poor artist who keeps in his depth.'[92]

The critical dilemma was knowing which way to plunge. Despite experiments with oils on Japanese paper that involved replacing the linseed oil and turpentine with the far more volatile benzine saturated with ordinary candle wax, which Leach claimed as an original technique,[93] painting remained elusive. 'They say it is difficult to put a camel through eye of needle,' he wrote, 'I haven't tried, but I have attempted to force myself to paint.'[94] Pottery was more promising but he was yet to reach the point where he identified himself primarily as a potter, and he was also aware of the limitations of his pots. 'Not only does my work smell of the museum and the past (musty) but it has no unity. It is not enough,' he wrote in his dairy, 'for the artist to belong to the present, less still to reflect and repeat the past however remote and exquisite. He must also be a prophet. He must in true freedom search the past and

present for his own soul and then boldly on that foundation alone build towers of far shining light.'[95]

Unlike Leach, Tomimoto responded with great enthusiasm to life as a potter. Feeling thoroughly disillusioned with the city, distressed by Yanagi's antagonism, and following the failure of his architectural design office he left to set up a studio on family land four hundred miles away in Ando, taking with him Kame-chan, who had by now become a proficient potter, to help build a raku kiln. Like Takamura, Tomimoto felt the need to escape 'the beastliness of Tokyo officialdom'[96] for the relative quiet of the countryside. Here he intended to explore the simple life, living as close to nature as possible, and designing a house that reflected Arts and Crafts values.

In comparison with Tomimoto's clear decision, throughout 1913 Leach felt a growing sense of disillusionment – with his work, with life in the city and also increasingly with his marriage. Far from having a meaningful sense of direction as an artist he still hovered between etching, painting, pottery and any other craft that took his fancy, including textile printing and fan decoration. Looking back on this period, he wrote about his unhappiness with Japan, saying that

> the spring dream was over. Only the bad things about the Japanese came into my eyes. I was almost disgusted with the Japanese food. All the Japanese geology was bad. The music and the Shamisen which only sound chiri chiri did not impress me. The Japanese like beautiful things, they can find more if they tried. Although they thoroughly wash their bodies in the bath until their skin were peeled, the corridor of houses were with the unbearable smell of sewer.[97]

One reason for moving to Japan was the belief that the country was still steeped in traditional culture. Instead, in a mood of rapid and profound change, he found long-established values and old ways of working being rejected. 'One came out here filled with exotic dreams, and is confronted with the extremely ugly transition of an essentially primitive people. They are primitive and it must never be forgotten in judging them.' Even friends could be perplexing. During a visit to Tomimoto's family with Muriel and David, his friend's mother and grandmother were enchanted with the baby, but watching Muriel bathe him they were concerned that, contrary to Japanese custom and feeling, she did not protect his ears. The greatest astonishment, however, came with the 'old grandmother's frank and open remark "What charming testicles". No false modesty involved'.[98]

The growing problems in his relationship with Muriel centred around his desire for wider sexual experiment outside of his marriage, a desire that held no interest for Muriel. The constraints of family life were also frustrating. While he loved and enjoyed the children (their second child, William Michael was born on 12 May 1913, fortunately with no recorded complication) he

found the commitment required in conflict with his yearning for sexual adventure, experiment he saw as a natural stimulant to creativity. Some of these anxieties were reflected in a terrifying nightmare in which after killing Muriel, his son and Kame-chan no one would offer him shelter, not even Takamura, neither would the court put him on trial for murder even though he begged, and he saw this as a sign of his madness.[99]

As early as October 1911 he contemplated the importance of sexual fulfilment as an essential part of creative activity. 'On a certain occasion the whole art of living may be explained as the art of completely happy sexual relations. Surely the male bee is to be envied. What is death after such a self expression. This alone must the artist feel after the creation of beauty.'[100] Leach believed that 'The arts have all sprung from sexual relationships. Dancing and fighting, acting, painting and sculpture for the representation of sex, poetry, sexual emotions . . . The nearer one approaches the primitive the clearer this becomes. The female organ is the source of the first pattern.'[101] This idea was taken literally in his article 'Art and Commerce',[102] which addressed the now familiar theme of the way Japan was throwing away its cultural heritage, and the 'blunting of the spiritual senses' by the negative impact of western ideas. One of his unlikely illustrations was a design that to all intents and purposes represented a vagina surrounded by stylized flowers, innocently captioned 'A simple decorative pattern, but with as much character as I have seen expressed with means so simple'.

Art, he thought, was a statement of emotion and the more this was disguised and buried the more hypocritical society became. 'Today we cover the body and are doubly suggestive. The expression *double entendre* would be incomprehensible to a Zulu. We have invented marriage and discovered love in our defence.'[103] All of which brought him to one of his abiding concerns, 'the unification of physical desire and love',[104] which seemed even more urgent and demanding.

Some of the problems with art, sex and desire were dramatically highlighted when Nagahara Kōtarō told him about drawings he had seen at Nara, Kōriyama and Kyoto of male and female organs placed side by side. Nagahara also showed him pictures depicting 'vigourous direct exaggerated drawings of men and women at the white heat of sexual passion', which Leach found 'Terrible!' When told 'that 100 to 50 years ago such pictures were displayed for all to see, young and old, and that the standard of morality at the time was higher than that today', he saw this as 'the most convincing proof I have yet found of the primitiveness of the Japanese. Rodin and Aubrey Beardsley are modern European artists of the same species.'[105] With a combination of prudery, curiosity and excitement, Leach's conventional western sensibility was outraged by such blatant sexual expression, and perturbed that it did not fit with his image of the country even though an accepted part of traditional Japanese culture. Most disturbing was the feeling that the

'primitiveness of the Japanese'[106] reflected his own thoughts about sexual pleasure and desire.

Thoroughly out of sorts with Japan as well as his family and in search of a central, all-embracing belief, Leach was in regular correspondence with Dr Alfred Westharp, a Prussian Jew five years his senior and a doctor of philosophy and music, and was seriously contemplating a move to Peking to join him. Westharp wrote pamphlets and contributed articles to various magazines and journals, including *The Far East*, and they started to correspond. It seemed to Leach that Westharp offered 'a deep and wide perception in art, education and philosophy to focus my own groping thoughts between the Occident and the Orient'.[107] Their association, for Leach a complex combination of idolatry and scepticism, was based more on hope than reality. For nearly four years Westharp's influence was profound, with the young artist adopting many of his concepts, resulting in Leach virtually giving up his way of life to study and be with his new mentor. Westharp's apparently penetrating insights into the nature of belief, the essence of spirituality and the significance of the inner life corresponded with Leach's quest for fundamental meaning. At the same time Zoe Penlington, involved in editing *The Far East*, became a follower of Westharp and a rival to Leach's own discipleship.

The basis for much of Westharp's blend of idealism, authoritarianism, neo-fascism and libertarian concepts of individual freedom lay in his enthusiasm for the educational theories of the Italian doctor Maria Montessori[108] and his interpretation of the teachings of K'ung Fu-tzu (Latinized as Confucius), finding in them 'a basis for a deep interchange between contemporary science, education and the ancient wisdoms of the East'.[109] Such mystical philosophical thoughts as 'Truth means the realisation of our being', and 'Truth is not only the realisation of our *own* being: It is that by which things outside of us have a[n] existence',[110] appeared to reflect Blakian ideas about truth lying within, and became the basis of Leach's views on personal relationships, art and education. Westharp's advocacy of 'moral laws' as an intrinsic part of the natural world 'by which the seasons succeed each other and the sun and moon appear with the alternations of day and night',[111] seemed to carry an impressive mystical logic.

At Westharp's suggestion, Leach read and contemplated Confucius's volume of central thought, the *Chung Yung* (Middle Way), translated by the contemporary scholar Ku Hung-ming, which emphasized remembrance and reverence. He also became engrossed by Lao Tze's 'more spiritual and imaginative concepts',[112] finding in both 'some sense of a central belief upon which to base my thought and life'.[113] Both Leach and Westharp thought that contemporary Japan was in the process of losing its inner life and, given the downfall of dynastic rule in favour of a republic and the consequent political turmoil in China, did not want the country to move in the same direction. To recover, they argued, it must return 'to her Chinese traditions'.[114]

'Regeneration Through Education',[115] one of Westharp's pamphlets, was a polemic urging China to reject outright 'foreign goodwill' that sought to 'modernise' the country by introducing a new language, new system of writing, new dress and new concepts of the family. Instead Westharp argued that China must look at the ideas of her own teachers such as K'ung Fu-tzu. He espoused a startling mixture of dogmatism about the fundamental nature of men and women, and utopian liberalism derived in part from the ideas and practices of Dr Montessori. 'The child', she believed, 'has to be followed rather than be led',[116] and proposed a child-centred education that would take into account all the senses. Comparing his own stifling school days such freedom and understanding greatly appealed to Leach, who felt that 'the new education and schools seem to belong to another and a happier century'.[117] In his heavily annotated copy of Westharp's text Leach scribbled 'Yes, Yes' next to this paragraph.

The theories of Dr Montessori were also discussed in Westharp's pamphlet 'Education through Freedom'.[118] While critical of some of her methods,[119] Westharp applauded her principle of 'self-activity', agreeing that children could decide many things for themselves. On his copy of Westharp's article Leach responded enthusiastically scribbling 'wonderful', and 'yes indeed' by various paragraphs. The pamphlet also outlined Westharp's argument for the need to separate spiritual love from passionate or conscious love, 'the sexual love of our parents, which endeavours to suppress and to possess and wishes to reproduce themselves in the children',[120] particularly intrigued Leach. Progressive education did, however, have its limits. Both Westharp and Leach were appalled by the current trend within western progressive education to teach 'children in liberal schools the anatomy of sexual organs and of generation', the latter noting 'I never heard of this it sounds disgusting'.

In contrast to his progressive educational ideas, Westharp held deeply reactionary views about the fundamental nature of men and women, believing that 'the man is essentially conscious; the woman essentially unconscious. The man is concentrated in his intellect, the woman in her senses . . . the European way of mixing the sexes is deadly poison for the race'. In response to Westharp's observation that the 'union of man and woman is the union between consciousness and unconsciousness',[121] Leach scribbled in the margin 'male – active, female – passive'. Behind Westharp's views lay the belief that the 'girl must remain for the man as mysterious as his own inner instincts. She is the source of his inner life', ready to inspire and service the opposite sex. Paradoxically, while Westharp claimed to have the 'greatest esteem' for the European suffragettes because of their status being reduced to questions of finance, he did not believe that a Chinese woman should enter 'similar war-like proceedings'.

Westharp's misogynistic autocratic views extended into conventional male–female relationships, grandly proclaiming that 'marriage is the enemy',[122]

principally because women seemed reluctant to 'acquiesce in sexual freedom for men [as] they seem to desire it so much less themselves'.[123] Rather, he was a strong advocate of polygamy, which he practised, having several wives. Such a convention was 'misunderstood' in Europe, claiming that for women the harem was 'a sanctuary', and that 'well-understood polygamy is preferable to a hypocritical monogamy',[124] a view that set Leach's thoughts racing.

As part of his qualifications, Westharp claimed to have spent several years in medical study with sexual psychopathology as his 'special hobby', and to have been analysed by Sigmund Freud[125] who, he said, 'conceives suppression of sexual activity and emotion as being the principal of neurosis (ie mental indisposition)'. This he contrasted with the East where there was 'no religion conceiving sexual life as a sin', and wrote to urge Leach to come to China while advising that it would 'be better to come without your wife if you wish to undergo a psychoanalytical treatment à la Freud'. Although Westharp had 'little time for any system evolved in Europe', psychoanalysis and the ideas of Montessori were clearly exceptions.

One of Westharp's most provocative if ambiguous concepts was his idea of 'sense experience', which Leach saw as 'the realisation of spiritual energy or imagination. It is the body without which no action can arise from imagination alone, and vice-versa',[126] and which would in some way liberate his creative energy. 'Consciousness does not come from God but from sense experience,' he noted, adding 'It is all important that the sex relation should be practised for the sake of self study.'[127] Self-denial seemed to Leach an obstruction to creative activity, provoking the aphorism 'Sin is born of restraint'.[128]

Sexual experiment, or 'sense experience', held little or no interest for Muriel, and Leach's overwhelming desire to 'experiment, try, experience, that which intuition suggests'[129] was tempered with an awareness of the need to avoid damaging his marriage.

> I dread causing her pain for I cannot separate her sorrow from mine. Yet if I experiment in order to find the solutions for these problems I cannot, absolutely cannot afford to divide over side issues. In other words I must be as selfish as is necessary and know full well that this is liable to cause acute pain to Muriel unless she is as enthusiastic for my objective as I am. She cannot be so unless she lose her personality in mine and becomes the depository of my ideals and this is not the case.

It was a terrible dilemma, for Leach longed for Muriel's permission to take other lovers, which she was not prepared to give. As an example he looked to the 'relationship of Blake and his wife . . . I think such a relationship is often found in East in marriages. So I ask what is the European ideal of relationship

between men and women?'[130] Muriel was not impressed. Citing Blake as a 'freethinker' who desired to explore relationships outside of marriage is a tribute to the artist's power over Leach. In fact, although Blake proposed his own version of sexual radicalism, and at different times made thumbnail sketches of various hetero- and homosexual sexual acts,[131] there is little evidence that the poet experimented sexually outside of his marriage.

Ever since arriving in the East, Leach was attracted to China as the centre of eastern art. Despite its current economic, social and political turmoil, and in comparison with the relative geographical smallness of Japan, the country seemed to have retained many of its traditional ways. Whether 'Japan would regain a soul through a renaissance of Eastern thought or through the individualistic study of truth and morality which Western science offers'[132] was an issue that Leach continued to debate. Under Westharp's persistent and manipulative arguments he decided that 'the real option for me is of one or two years of new experience in China'.[133]

Such thoughts occupied Leach when, taking Kame-chan as his companion, he rented a small house in Yokohama early in 1914. Ostensibly he was there to study pottery and extend his technique by working with the potter Makuzu Kōzan,[134] who although skilled seemed to Leach to be insufficiently 'aesthetically conscious in the international and contemporary sense',[135] thereby reinforcing his sense of isolation and confusion. Yokohama was also an opportunity to escape the domesticity of the family and contemplate his work, telling Kame-chan that he 'must stop using old designs for motives on pottery'. Kame-chan's vivid and uncompromising reply 'that they were in the belly of a snake and unless we could cut our way out we ran the risk of becoming ordure than which it were better that we had never entered in' struck Leach as an apt metaphor. Echoing Blake's line 'I must Create a System or be enslav'd by another Man's',[136] he wrote 'I must digest or be digested'.[137]

The declaration of war by Britain on Germany and the advent of the First World War[138] added to Leach's uncertain and restless mood. As a pacifist he stood against war and bloodshed yet at the same time thought that bullies and aggressors had to be challenged. Paradoxically he took great exception to the views expressed by Norman Angell[139] who in *The Great Illusion* argued that any war must prove ruinous to the victors as well as the vanquished. The book, wrote Leach, 'seems quietly and simply to have taken hold of Europe. I don't think wars will be shelved. I am not altogether sure that I would want them to be. Surely they stir up slimes and eventually purify'.[140] Japan joining the Allied powers partly resolved Leach's pacifist dilemma, and when a young Englishman, appropriately while playing cricket in the grounds of the British embassy, asked if he was returning to England, Leach's reply was an emphatic no, for though he 'did not like the Kaiser and his upturned moustache'[141] he did not see himself with the task of stopping

him. His melancholy at the outbreak of war and its resulting sorrow was reflected in his diary written on the last day of summer at Karuizawa: 'There was a cold mist and rain for 2 days . . . All was very sad and as always I became heavy in spirit.'[142]

As a farewell artistic statement before leaving for a four-week exploratory visit to China, Leach held a show of etchings, drawings, paintings and pottery at both the Mikasa and Tanaka galleries.[143] Extolling the exhibition in The Far East,[144] Yanagi divined in the work aspects of 'the Greek spirit . . . [and] . . . the expression of perfect beauty', and the 'Gothic spirit which advocates the power of the shadow', seeing them both as informed by an awareness of oriental art. Perceptively Yanagi saw Leach's work as in a 'transitional period', his art nevertheless involving 'some risk . . . the search for something in a future world and the effort to express it in concrete form'. Singled out for special mention were etchings of St Luke's Church, Chelsea, views of Hakone, a self-portrait, an expressive interpretation of The Headlands of Negishi, an oil The Woodcutter, sketches of Karuizawa, and a drawing of Muriel.[145] Yanagi also identified as important Leach's 'contact with the old ceramics of China, Korea, and Japan',[146] an aspect of cultural history neglected by progressive Japanese artists, and 'the naive power' of the work. This latter quality, ambiguously described, was probably a reference to the absence of technical sophistication rather than to the folk tradition. The uneven technical quality of the early pieces was a characteristic the Japanese greatly admired.

Accompanying the exhibition was a sixteen-page booklet, A Review 1909–1914, prepared by Leach and illustrated with his drawings and etchings, which was in effect a personal credo and a statement about his past and future life. In addition to aphorisms, reminiscences and poems, Leach took the opportunity to assess his emotional, spiritual and artistic life, writing that although he went to the 'best-art school' he had not 'reached that stage of freedom which enables an artist to take part in contemporary movements of European art as a whole, much less to plunge headlong into such an alien atmosphere as old Japanese and Chinese art', but after six years he felt 'ready to enjoy old Chinese and Japanese art with a feeling of security [and] contemporary art through and with progressive Japanese artists'. Referring to his decision to leave Japan he wrote that he did not think 'he would return to work' but would repay his debt 'by attempting to introduce contemporary Japanese art in London'.

The combination of Blakian ideas: 'Every atom, every drop of water, leaf, insect, animal, man is the outward form of the spirit'; of Zen Buddhism: 'Zen meditations are an Eastern way of opening the store-house of the sub-conscious mind'; and the all-pervading importance of sexual desire 'the arts radiate from sex', though deeply felt, fused elements of fancy and idealism. Throughout A Review the voice of Westharp can be heard helping shape Leach's thoughts, whether in advocating Montessorian educational theories on the

importance in 'the awakening of latent talent', or his passionate belief that 'sex relation is the highest form of sense experience'. What also emerges is Leach's long-term commitment to the meeting of East and West, a concern that was to shape much of his life.

SENSE EXPERIENCE

Japan China Japan
1914–1917

In addition to setting up his exhibition, much of Leach's time was occupied preparing for his trip to China. Fortunately exhibition sales realized a total of 276.50 yen, with all but thirty-eight pots sold, and this business had to be settled. As usual lists were drawn up, not only as a way of identifying the tasks to be done but also as a means of considering the implications of his visit. Books, labels and slippers had to be purchased, pots sent to buyers, letters written to Westharp and his friends the Spackmans, and a passage booked to Tientsin. Luggage included camera, drawing materials, etching plates, two sketch books, diary, letter paper, pen, ink, addresses, dray, long-coated suit, frock-coat, trousers, Harris tweed, futons, slippers and guide book. Taking Westharp's advice, Leach acquired 'Japanese bedding, warm clothes – warmest you have'.¹ All suggested a long stay rather than the four weeks planned.

With a combination of excitement and apprehension, Leach saw his visit to China as part of a pilgrimage to a country he had long held in reverence, but with the country in political, social and economic disarray, it was not a propitious time. The overthrow of the Qing dynasty in 1911 brought to an end over 2,000 years of dynastic rule, and although the emperors had had absolute power, they adopted the Confucian philosophy of obeying the Mandate of Heaven that acknowledged to some extent the will of the people. The new Republic of China, more anti-dynastic than republican, elected Yüan Shik-K'ai as the first president in 1912, but the country remained divided north and south, and economically was in great difficulties. Following centuries of prosperity China had become one of the poorest nations, and after attacks from the West and Japan, territory had been ceded to foreign powers. Shortly after the outbreak of the First World War, Japan seized the opportunity to occupy the former German-leased territory of Kiaochow, and in 1915 presented the notorious 'Twenty One Demands', which in effect would have meant China losing control to Japan. Following Yüan's death in 1916, China split into semi-independent military states, beginning the warlord era, characterized by indecisive military campaigns and politico-military manoeuvres between the tenuous governments. Like Japan, China was seeking to come

to terms with its ancient tradition, and its role within the modern world but on a vast scale.

Despite, or perhaps because of, the current upheavals, Leach was eager to visit the country and make contact with a figure he saw as an influential leader offering not only a way of life but also outlining a mission that would shape his future. There was no intention to make pots, either because this presented too many practical problems or, more likely, because it did not seem relevant to his plans. The inclusion of drawing and etching materials made clear his continuing involvement with fine rather than applied art. For a time the journey would release him from family pressures and marital tensions, and possibly the complications of a clandestine love affair, for, regardless of his concern not to upset Muriel, his often expressed desire for freedom to experiment sexually with other women may have overcome any reservations. No record survives of Muriel's feelings at his impending move, but with much of her time occupied by two small children, one little more than eighteen months old, it may have seemed wisest to allow him to follow his head, even if his decision seemed ill judged.

Following Westharp's advice that he 'take *Osk Osaka Shoren Kaisha* from Osaka as it has smaller steamers which can go directly to Tientsin (not NYK from Kobe) which only goes to Taku', at 10 a.m. on 8 November 1914[2] Leach set sale from Kobe in a small steamer. Feeling optimistic but also lonely and confused, he pondered probably for the first time, the reason for his visit, his deliberations making it 'impossible to settle to any reading or writing'.[3] He was leaving behind a modest but growing reputation as an artist and a loving wife and children to sit at the feet of a teacher he had never met whose wisdom was interspersed with wild and often inaccurate generalizations about Japanese culture and about whom Yanagi had severe misgivings.[4]

The dark, tremendously swelling sea and the scudding clouds seemed to reflect his uncertain mood, while the smoke from the funnels was 'mesmeric, melancholy on grey days and meditative'.[5] As the weather improved and the sun shone so Leach began to relax, bringing a familiar desire 'to play and possibly make love'. Despite being served 'too much fish', there were generous portions of Japanese food, and to help pass the time he made a chess board and a set of cardboard men, discovering in conversation that European, Chinese and Japanese chess stem from the same origin.

The ship's arrival at Moji, a 'dirty, smoky factory town spoiling a lovely landscape', coincided with fireworks and raised flags in celebration of the anticipated fall of Tsingtan. Before being allowed ashore the water police insisted on interrogating Leach at length, probably because he was so obviously a foreigner, reflecting the increasingly strained relations between China and Japan. Prices on shore, he discovered, were cheaper than in Tokyo and he bought two trays, a pair of Chinese slippers and fruit for the voyage. At a shop selling reasonably priced red Chinese rugs, and 'red little teapots'[6] he was

again stopped and questioned, this time by plain-clothes detectives and he rapidly decided that the sooner the ship set sail the better. Even on board there were further warnings from the captain who advised him 'not to sketch' because in the tense atmosphere this could be misconstrued. Women, he noted in his diary, did the coaling.

As the ship crossed the Yellow Sea, past the Korean islands, it pitched and tossed in the rough weather, rendering virtually all the passengers seasick save Leach who although feeling a 'bit green' was sufficiently recovered after a two-hour sleep to enjoy a decent meal. As they passed the south coast of Korea he noticed a 'village a mile away, very different in character from Japan'. His buoyant mood was helped by the 'most beautiful sad sunset, the sun going straight down into the sea. No cloud visible. The sea a glistening swell. Some sea birds skimming towards the fading light. Great fish leaped and curved near the ship'.[7]

Entering the Gulf of Chihli, Leach read and reread Westharp's letters, puzzling over the sort of man he was going to meet and the life he was to lead. For a year Westharp had both inspired and confused him with his endless debates about whether to move to Japan or remain in China where Leach could join him. Yet, despite Westharp's contradictory thoughts, his radical ideas about society, education and sexual desire thrilled and excited Leach. Sexual relations, thought Leach, were 'the most perfectly mutual relation, equal in joy and pain, simultaneously spiritual and sensuous and for these reasons so important in Confucian teaching'.[8] Paradoxically, while acknowledging the importance of 'sex relations', Westharp adamantly rejected emotional involvement in favour of physical contact, arguing that 'sexual life' produced 'the most perfect, perhaps the only perfect consciousness. Consciousness produced through sense-experience',[9] a phrase that captured Leach's imagination, summing up his need for sexual and emotional experiment. Despite the fanaticism of Westharp's ideas, within them Leach found echoes of his own growing sexual and philosophical ambitions, and his continued disillusion with Christian teachings, which he thought only grudgingly accepted sex 'as a concession to human weakness'.[10]

Little that Westharp wrote deterred Leach from his adulatory attitude, whether it was his dismissive and reductionist views on European art in arguing that 'Michelangelo and Rodin never digests [sic] the body of the female which serves as their model',[11] and were 'only a sign of repressed sexuality', or startling personal confessions concerning his relationships with women and his polygamous household. Far from being discreet Westharp revelled in detailing his intimate involvement with various female members of the Tokyo community, in particular with a lady 'called before Mrs Sakurai' who he wrote 'has become my wife', and was now considering 'whether to come to Japan to "allow that lady to become in fact what she is ideally"'.[12] Zoe Penlington, another of Westharp's admirers in Tokyo, was intensely jealous of Leach.

Shamelessly Westharp encouraged her devotion, dismissing her marriage as 'purely financial', declaring that she had 'become a Westharpian' and was planning to travel to China using as a pretext *The Far East* magazine, of which she was editor. Such immodest boasting of his seductive success and sexual prowess suggests that Westharp wanted to shock and astonish, while hinting at similar opportunities for Leach.

First impressions of China were good. There was no delay crossing the mud-bar at Taku, the wharf of the river-port city of Tientsin about twenty-seven miles from the city itself, which was notorious for delaying ships. Without problem they steamed between the steep embankments up the river about the width of the narrow portions of the Suez Canal, yet sufficiently deep for about 2,000–3,000-ton steamers. At Taku, Leach admired the combination of physical strength and manual dexterity of the blue-clad dock workers as they 'stuck their iron hooks into a long bulk of timber, and, rope over their shoulders, all together inched its weight over the wharf edge'[13] so that a gangway could be placed in position. The operation flowed so smoothly and appeared so effortless that it seemed to be a metaphor for the entire stability of Chinese life.

The countryside, Leach recorded, was

> perfectly flat as far as one could see . . . earth light brown, a tenacious solid looking earth of vast extent. Villages and burial mounds were excrescences the one little pointed knolls in thousands. The other ochre mud dwellings huddled together in low groups. Small windows and mud roofs. Square set mud plaster work fulfilling the elemental needs of the blue clad inhabitants. It seems a hard life but not evil in the way our great mechanical cities are evil. It looks natural, the people, their work, (save the new from Europe) and the nature around them in unity and at unity in a soldier of more that way than any other eastern place I have seen.[14]

At Tientsin, in contrast to the 'ugly . . . foreign streets', the people appeared 'tall and strongly built' and were compared favourably with the Japanese. In both the upper-class men and those of the lower classes Leach found a 'surprising' dignity, 'the same dignity which I found in the Chinese pots which I revere'. A brutal incident involving a policeman seizing a coolie by the hair and kicking him did little to disillusion him on the rightness of the interaction, such aggression affirming his view of the accepting and philosophical Chinese nature. 'The coolies face expressed endurance of pain and seemed to say "I can't help it & this is life – I must take the punishment if I take the risk and fail but I shall do it again",'[15] he noted. This view was reinforced by the action of the police who controlled the rickshaw runners by beating them mercilessly with truncheon blows to the head. Undaunted, the runners persisted, appearing to accept such treatment with equanimity.

There was more than an element of romanticism in Leach's observations, for in opting for a new life in a strange country he wanted to see it in as favourable a light as possible. Despite finding the country plain, even 'stern', with 'a grey wet sky',[16] it seemed to him a relief after the prettiness and lusciousness of the Japanese landscape. However, like many travellers since, he found the roads 'terrible' and the people in general had an alarming 'disregard of dirt and smell'. Perceptively, it occurred to him 'that these people may become great commercial people of the future. Their practicality and substance point to it'. He did wonder about 'the other side . . . the spiritual side', but deemed it too early to have an opinion.

Built principally as a working port to serve Peking, Tientsin made few claims to architectural splendour but it was cosmopolitan. After booking into a hotel, dispatching telegrams and writing letters, Leach explored the Chinese quarter by *karuna* (rickshaw), finding four or five curio shops of interest and, although quoting 'ridiculous' tourist prices, he bought two pots 'for $2'.[17] Strolling after supper, aware of his unaccustomed freedom and in search of 'sense experience', his attention was caught by two young French women standing outside a cinema. One he thought 'quite pretty' and although she glanced at him occasionally he 'was not sure if she was a prostitute or not'. Despite the fleeting contact the incident 'was sufficient to arouse my passions terribly and if she had made me further advances I should certainly have succumbed. What am I to do? I returned and paid the price alone – the miserable anguish after and yet the next morning I still hankered after that girl'.[18]

Alone, away from home and in a foreign country Leach's eagerness to investigate 'sense experience' was not only a search for sexual satisfaction but for the ideal, the unity of love and sexual desire.

I am not a ladies man for my habit has quenched that possibly, but I have loved and can love deep. Still I desire strongly and with variety and this cannot be satisfied really without love. Am I fated to quench their fire with the physical satisfaction of prostitutes as so many artists and passionate yet sincere men do. I have never had my passion so strongly stirred by Eastern Women as by that French girl. Restraint is the father & mother of sin, how can I loose the bonds of delight? Even my habit has given me self-consciousness in measure but fraught with pain.[19]

As an afterthought, and rubbing salt in his wounded pride, he noted that the 'French girl and her companion went off with two young English soldiers'.

Arriving late at night in Peking there was no one at the railway station to meet him as agreed, and the rickshaw runner had problems deciphering Westharp's address written in Chinese on a card. It was not a promising beginning. Eventually the location was identified and after what seemed like miles they reached Westharp's house, which stood within the walls of a monastery,

where Leach was ushered into a room with walls covered with white paper patterned with mica, and filled with 'sternly-noble' furniture. To keep out the cold a handsome brass three-legged stove burnt fuel balls made out of a mixture of coal dust and wet clay. A Chinese servant served tea and eventually Westharp appeared, the 'formidable man' Leach had travelled so far to see offering only lame excuses for his distant and unreliable behaviour. Contact was finally made.

The architecture, the decoration and the food were all observed with enthusiasm by the serious young pilgrim. Breakfast of rice gruel, half a salted goose egg and some pickled vegetable, the quality of the egg depending on what the bird had fed upon, with fish producing the least attractive taste, was 'not British, but quite healthy and filling for all that',[20] purred Leach. Within a week he was flattered to be greeted by the children outside the temple with shouts of 'Hou de', a welcome always given to Westharp and seen as a sign of acceptance. The days were spent in earnest conversation, each getting a measure of the other. Taking up ideas expressed in his letters, Westharp further outlined the breathtaking scope of his plans, which sought to bring home the 'importance of Western science to the Eastern world', while decrying 'the formalism into which Confucian profundity had decayed'. The former, he thought, could restore the latter and his ambition was 'to persuade the government, such as it was at that time, to adopt the progressive educational concepts of Dr Montessori'.[21]

As part of Leach's education Westharp introduced him to various aspects of Chinese culture taking him to a supper party given by Mr Cheng, 'a fine young Chinese gentleman, speaking English well . . . who nevertheless strongly preserves his Chinese character and tastes'.[22] A guest house formed the front portion of the residence, and the buildings in the rear were occupied by women who were never introduced to male guests. Despite the fact that Mr Cheng was 'an official of good family', by western standards his house seemed to Leach quite small and 'not too clean', and in late November, 'fearfully cold, especially underfoot'. It was only by the obvious discomfort of the visitors that stoves were brought in. The frank, easy and free manner of the thirty male guests was in great contrast to the formality of the Japanese, and Leach was struck by their evident friendship, unselfconsciously 'walking hand in hand, & camaraderie & with all this solid dignity'.[23] One of the chief guests was a Chinese actor who trained the amateur dramatic society of which Mr Cheng was a star.

Supper was an exotic combination of 'lotus seed and apricot seeds, sugared walnuts, fish, chicken, meat balls stewed and of course rice',[24] with their host continually encouraging guests to help themselves from communal dishes in the centre of the table. The wine was 'strong like whiskey'.[25] During the meal Leach noticed that like the Japanese the Chinese did not talk much while eating, but unlike Japan there was little suppression of facial expression and

natural feeling. After the meal a small cup of water and a spittoon stand were brought to each guest for him to rinse out his mouth.

In a few short weeks Leach became captivated by China. The customs and ingenuity of the people were delightfully demonstrated when over breakfast one morning Westharp announced that he had to move from the temple to a house on the north side of the Manachu city, six or seven miles away. 'Some forty indigo-clad "coolies" – more or less casual workers'[26] arrived and after being served pastry-like dumplings and hot tea they carefully packed the crockery, luggage and furniture, and carried them on their backs without mishap, amazing Leach by their efficiency. Hiring transport in the city involved intriguing negotiations, for selecting a rickshaw entailed assessing the strength of the runner and the state of the machine before a price was agreed. Leach took to the whole procedure with relish, finding 'in such ways life was full of entertainment of an unexpected kind'.[27] Just as he had romanticized the workers' role when he first arrived in Japan, so the Chinese were seen as being in close harmony with nature. When returning at sundown from a hard day in the fields, he noted, workers 'often carried a song-bird tethered to a stick which when it sang entranced the labourer and his friend'. The sight and sound of shopkeepers sitting outside in the cool of the evening making music with a flute or other instrument was equally engaging, all refreshingly different to the 'quiet of a Japanese temple or Tea-room'.[28]

Some of his observations on the differences between the two countries were captured in a poem written in his diary: 'China is slow and Japan is quick./Japan is shallow and China is deep/The quickness of Japan sees the slowness of China and the deepness of China despises the shallowness of Japan.' By the side of the poem Westharp added 'Japan is excitable and China is powerful'. Despite his admiration for China and its people he had less enthusiasm for the Chinese capital where 'the hungry winds howl down from the bleak northern wastes and lay icy hands upon one's very bones'.[29]

In early December Leach agonized over whether to return to his family in Tokyo in time for Christmas as arranged or remain in Peking with Westharp. It was a formidable choice for he was engrossed by the city and greatly stimulated by Westharp's ambitious projects. The idea of returning to the tensions of his marriage and the uncertainties of Japan seemed a poor alternative. In an attempt to make a detached, even cold-blooded decision characteristically he listed the pros and cons, taking little account of Muriel's feelings or needs. A 'closed policy' of staying in Peking and writing a letter to arrive on 12 December was contrasted with the 'open policy' of going back as promised. Returning, he reasoned, would inevitably involve long explanations, possibly 'endanger seriously our married life by stupid attempts to explain things a woman could only feel', involve loss of a month's work in China and in addition cost 100 yen. Writing 'a calm and mature letter' to Muriel saying he would not be home for Christmas and New Year would, he knew, cause

disappointment, but was also an opportunity to propose 'a separation of some months'. This too would inevitably 'arouse suspicions of unfaithfulness, consequent loss of confidence and trust in my honesty. Produce a continuous feeling of uncertainty and anxiety or violent letters'. While recognizing that Muriel would be suspicious of his motives in wanting a separation, he saw himself as achieving a 'growing clearness' in his thinking. In Japan while there would inevitably be endless household affairs and money to sort out, he would be able to see friends such as Yanagi, though this would also involve questioning his decisions and hence was less attractive than staying in Peking. The third, and most irresponsible course was not to inform her at all and 'run risk of discovery mitigated by maturity on my part'.[30] Meanwhile Westharp asked for a loan of $12 to add to earlier sums, explaining that the war had disrupted his finances.

A compromise delaying his departure was decided. Writing to Muriel on 10 December, addressing her by the affectionate Snig, he promised to be in Tokyo for Christmas but stressed the urgency of his work in China, indicating that he would return as soon as possible. He and Westharp, he explained, were putting together a petition to be presented to the education ministry and were seeking an audience with the president. In response to an accusation by Muriel of pandering to his mentor, he emphasized that he was 'not dominated by Alfred Westharp', pointing out that Westharp's experience 'saves me time and money for he has been through the West. I know the West sufficiently to follow him now', concluding apologetically 'I have treated you stupidly but now I grow up'.[31]

Leach arrived in Tokyo three days before Christmas. No diary entries were made of the reception he was given or the welcome that he received from Muriel, but clearly they resolved some of their difficulties for in his diary across the top of the page for 1 January 1915 he wrote in large capital letters the word 'conception', a note added later when he discovered Muriel was pregnant. Visits were made to friends but much of the time was occupied preparing for a speedy return to China, including obtaining a passport for Kame-chan whom he decided should accompany him. Correspondence from Westharp[32] as usual offered contradictory advice about future plans, dithering over whether he should come 'to Tokyo or do you come to Peking', and whether Leach should bring Mrs Leach or travel alone. He also again outlined his financial difficulties and gave his views on the current political situation. With its combination of mild hysteria, over-enthusiasm and ambitious but unrealistic strategies for success, Westharp's letter was so muddled that only a devoted disciple would find encouragement within it.

In January, Leach returned to China with Kame-chan, quickly taking up from where he had left off, writing enthusiastically to Muriel about his work and the possibility of settling the family in China. Kame-chan proved to be a cheerful and helpful companion and assistant, writing to Leach's friends about

their life in China, including a forty-page letter to Turvey and one of twenty pages to Takamura. With his excellent English he was able to translate the Japanese books sent by Yanagi, indicating Leach's sketchy grasp of the language.[33] But the change of environment, which Leach hoped would help improve the youth's condition, had little effect and his behaviour continued to cause anxiety. At one point Leach thought Kame-chan was 'near a breakdown, and had a bad fainting fit'.[34] However, when not ill the youth was a loyal and devoted companion, whom Leach liked and appreciated.

With his plans appearing to go well, Leach decided to settle in China, writing to his cousin Ralph, who was a solicitor in the City of London, requesting him to arrange the transfer of bonds to Hong Kong to provide the necessary funds and to Muriel asking her to pursue without pushing any possible introductions to friends in the country. His plans were thrown into confusion by the news of Muriel's pregnancy. Having hoped for a period of freedom from additional family responsibilities his initial response was far from enthusiastic but he tried to deal with it as calmly as possible:

> I am prepared for the inevitable, & with good grace, if indeed it must be so. If the child comes it will probably mean that 1). I shall come to you after the educational meetings in April either alone or perhaps better with AW. 2). We would pack everything & give up the house & go to Karuizawa in June. 3). Then I would come here again till the autumn (September) by which time my ideas will I believe be much clearer in general & particularly with regard to A.W. & China. Then I can come for you & pick up our main luggage (meanwhile stored) & either come here or return home together with you & the kiddies – to China before the birth if feasible, to England after,[35]

none of which made any reference to his work as an artist. The impending birth did not alter his decision to leave Japan.

Closer contact with Westharp brought a growing realization that their relationship may be more complicated than Leach had previously thought, and that to retain his own identity he needed to establish himself independently, feeling 'there must be a barrier between him & me',[36] thoughts that did not deter him from believing in Westharp's powers. With a view to setting up his own home he duly applied for the necessary permit from the police, hoping to move as soon as possible. While drawn intellectually to what he saw as a clear, strong thinker, he doubted 'if it will eventually be possible to really collaborate with A.W.: there is something in him with which I sometimes doubt if I can ever harmonise but which I must more clearly and deeply understand',[37] he wrote to Muriel, adding 'I beg you to be patient and forbearing as indeed you have been till now my own darling'.[38] The tensions of his marriage, the decisions to be made and the problems with Westharp brought on an almost hallucinatory state in which he felt Muriel had

been present to me on several occasions so vividly that I almost felt I could open my eyes and see you as I sat in my room – something outside the ordinary . . . I had also the presence of father with me twice, accompanied by quiet involuntary tremor & slowing of the pulses. Very strange! I did not feel fear exactly so much as intensity and seriousness.[39]

In the light of Muriel's pregnancy he became more determined 'to find a suitable house for us all as soon as may be'[40] although this would involve a rent of about $35 instead of the $15 he had originally planned for. His grand scheme was to first find a property and then fetch Muriel and the family from Tokyo. Acquiring suitable premises proved far from easy. One relatively cheap house, though not large enough for a family but ideally suited to his immediate needs, was lost and he had to start a new search.

One task Leach willingly undertook was to type out Westharp's book 'China Anti-Christ', which as an amateur typist proved a labour of love. Typing with one finger was slow and Westharp was a prodigious writer. 'We work at the book – finishing it – revising it – correcting the typewritten proofs', reported Leach. 'Sometimes A.W. dictates to me and we discuss each obscure point in itself, as it will appear to the European, American & Eastern reader, looking up references, making comparisons with Blake, Whitman (RR). When A.W. begins to write he will produce as much as 20 pp of print in six hours, eating enormously. About 250–300 pp of the book are typed (five copies) & it is nearly through.'[41] At the time Leach had nothing but praise for the writing, describing it as 'astonishing – not easy no – for it does what no other book has attempted, (uniting natural science and the deepest psychology) but far clearer than Blake for example – nothing is ungetatable or really obscure – only unfamiliar and too compressed'.[42] Zoe Penlington was roped in to help, further stoking the jealousies between them. Later Leach changed his mind about the book saying that he found it distasteful and expressed satisfaction that it was never published, for though not a Christian, it expressed sentiments he did not like.

Despite a growing awareness of the social difficulties posed by Westharp's behaviour and his often disagreeable manner, Leach continued to see him as someone with whom he could work effectively. 'Poor Dr Westharp! He has suffered much in his life and not a living soul understands him. But oh the pity of it! It has left him a gaunt spirit',[43] was his sympathetic view. The problems Westharp had in establishing loving relationships were not helped by what Leach perceived as his 'scorn of human love & kindliness . . . Bitterness is in his face & in his thought. Not the serene peace of Shaka, or the compassion of Christ, or the warm embracing humanity of Whitman'. Nevertheless Leach thought him 'deep in life and a great forerunner'.[44]

The importance of sexual and emotional fulfilment, one of the abiding issues raised by Westharp, was dramatically highlighted when Leach attended

a meal at the Shoshinte with Westharp and another friend Chen Fu Ching at which geisha were present. Despite growing desire Leach felt unable to abandon himself to the pleasures on offer and was horrified by the way Westharp played 'quite lightheartedly with the Geisha & easily and most passionately'.[45] Chen Fu Ching was also 'mildly passionate with first one and then another'.[46] As the evening wore on Leach found himself more and more abashed and deeply uncomfortable.

> I longed to cast aside all the barriers & be easy and yes passionate at the end but naturally not crudely or in any forced way & with beauty and taste, yes & love. I need a serious beauty in it all. I thought of that exquisite Malay dance where beauty and passion welded into a lovely whole and how I longed to be the main dancer. I must have this love which holds all together. I cannot obtain my freedom without it.[47]

The final hour was for him a torture of body and spirit, a feeling that was increased by Westharp's attempt to find him a suitable companion when Shigoni, maybe a regular companion, was ill. 'I cut him short abruptly for I felt forced and knew that it was against the Japanese custom and spirit and felt it would spoil my relationship with Shigoni, besides being an offence against my own feelings'.[48]

In despair Leach eventually left and went to 'a foreign house' where he spent his 'money and passion freely with an Austrian girl who gave me passion for passion',[49] not arriving home until 1 a.m. Feeling mentally exhausted and despite wanting to sleep Westharp insisted on talking to him, evidently surprised at Leach's reluctance to explore his sexual needs, and suggested that his 'cure'[50] was far from accomplished. Kame-chan followed Westharp for a chat, but feeling emotionally and physically worn out Leach sent him away.

Leach's reluctance to accept Westharp's direction in the question of sexual fulfilment was also evident in his modest plans to set up a 'business plan for exporting Chinese furniture, carpets, toys, brass, enamel to foreign firms like Liberty'.[51] The scheme not only had the advantage of giving him and Kame-chan a practical task, but also served as a focus for studying aspects of Chinese culture. Westharp firmly brushed aside Leach's enthusiasm arguing that it was a diversion from their central task of providing 'the first real meeting of the East and West',[52] fierce opposition that Leach found difficult to deal with. Despite Westharp's disapproval, Leach continued to develop the export business of buying antiques to ship abroad and, fascinated by the quality and beauty of the objects, became an assiduous buyer. Impressed by the qualities of old and new pots he discovered that for a few pence he could buy modern Tz'u-chou ware 'almost as good as they were in those Sung days six hundred years earlier'.[53] Arrangements to sell the objects were made with Takuma Kuroda in San Francisco, and Adaline Emerson and Elizabeth Patten

in Hanover, New Hampshire, with agreements to share profits. Determined to study 'Chinese life and art', one of the reasons he came to the country in the first place, Leach engaged an English-speaking Chinese assistant at $15 per month for three hours every other day.

For all Westharp's unsympathetic criticism, Leach's admiration for his powers of analysis remained as strong as ever. Aware of the continuing tension between China and Japan, the horrors of war in Europe and the absence of any reference to the political situation between China and Japan during the Japanese elections 'only A.W. sees the full tragedy', wrote Leach. 'We wait to see if the disaster comes or not. Japan apparently waits to see how the wind blows from England Russia and America. She is not afraid of their threats and ships but of their refusal to provide cash now & later. She also waits for a plausible excuse to turn up for her to take active measures against China's dilatoriness in complying with her robber demands.'

In an attempt to put their ideas before a wider audience Leach gave a lecture with Mr Chen in the public gardens, which attracted some six hundred spectators, including representatives from all the provinces in China. He also organized an open meeting of about thirty people, where he and Westharp outlined the basic premise of Montessori educational methods and proposed setting up the first such school in the country. Shortly after the educational meetings Leach planned to return with Kame-chan to Tokyo, travelling either with or without Westharp who still had not made up his mind whether to accompany them, where he planned to close the Tokyo house and possibly spend the summer at Karuizawa before moving with the family to China.

Despite his yearning for 'sense experience', Leach missed his family and longed

> to see the kiddies whose photos I was examining half an hour since. Michael all sun & smiles & happy contentment, David so keen & sensitive & I repent it so thwarted. We will take that expression away by and by, that must be our main field of collaborative work. David has so much to spoil and so much to let grow, so much possibility. There is wistfulness & that divine spark of keen energy in his little face which I love. We must not waste it. God! I'd like to have him asleep in my arms this minute.[54]

This acceptance of family life and responsibilities was accompanied by a revealing confession that he would not be coming back 'to repress my own children any more, & you',[55] but to begin a new life for them both. Plans to settle with his family in China also involved a relationship with Muriel that he saw as more open and honest. In one letter he referred to the possibility of Muriel not travelling to China because of 'a certain object about which I wrote a short time back', either a reference to Westharp or a specific sexual relationship, but more likely to do with his demands for sexual freedom, demands for which Muriel continued to have little sympathy.

On 29 April Leach, with Kame-chan, but without Westharp, left for Japan, apprehensive but hopeful for the future. 'I wondered when I should return and when I should see you again and what changes these uncontrollable and yet not accidental events – war – death commences – would bring,'[56] Leach noted in his diary. On board the SS *Takeshima Maru-Yusu Kwaisha* as usual Leach took the opportunity to list his tasks, preparing a daunting agenda that included reading Westharp's books and Clive Bell's *Art*,[57] preparing a lecture on education with special regard for applied art and essays for 'my Japanese friends' on '(1) Art and Life, (2) Meeting of East and West, (3) European Civilization in Japan, and its effect upon art and life, (4) China'.[58] There were also letters to write and friends to visit, listing Sawada, Umehara, Nagahara, Awashima, Adachi, Arishima, Yamashita, Kenzan, Musha Nokōji, and Mrs Penlington. As a footnote he reminded himself of the need for tight control of money.

Selling his house in Tokyo, making arrangements to move to China and persuading Muriel of its importance, emotionally and intellectually proved 'a stormy chapter'. Muriel's pregnancy reminded him yet again of his family commitments, and though he wrote of feeling 'love & respect more clearly than at any previous time', there were still difficulties and differences to be sorted out. Although pleased to be with the family and at home for David's birthday on 7 May and Michael's on the 12th, Leach was soon planning their permanent move to China. In addition to all the business arrangements lectures were given to the Ladies' Club on pottery, which embraced not only Japanese, Chinese, Korean and European ceramics but also collecting and the unique qualities of Chinese ware. Embroideries, brass, amber, jewellery, lacquered goods, fans, furniture and toys purchased in Peking, Canton and Tientsin were shipped to Elizabeth Patten.

The tensions at home were not helped by the growing rivalry between himself and Zoe Penlington, and though he continued to contribute to *The Far East* he found Mrs Penlington's behaviour rude and intolerable. 'Her zealous venom speaks. I have made covers for her beastly magazine (8) and lettering (2) and illustrations (3). I have written for 4 or 5 numbers without payment . . . This kind of woman is disgusting because she is not even attractive,' he wrote in his diary. 'I have not given her the least grounds, she needs stamping on by spirited brutes.'[59] Adding insult to injury Mrs Penlington refused to reveal the contents of the letters she had received from Westharp or to show Leach the manuscript of the book, much of which he had typed out. More personally she was critical of his lecturing and, most damning of all, accused him of plagiarizing Westharp's ideas, a bitter accusation that hit home because he borrowed freely from Westharp's writings. 'Jealousy and thwarted ambition', he recognized, played a large part in influencing her behaviour, but as usual he saw himself as blameless.

Purchases included books that reflected a concern with weighty spiritual and supernatural issues as well as with philosophy. These ranged from Sir

Hiram Maxim's *Li Hung Chang's Scrap Book*, A. N. T. Stead's *After Death*, Dr Richard Bucke's *Cosmic Consciousness*, Euken's *The Problem of Human Life* (*Meaning and Value of Life*) and Denssen Vedanta's *Philosophy*, to the writings of Carpenter, Plato, Kant, Schopenhauer, Boyson and Nietzsche. Practical tasks involved dispatching eighteen cases of heavy baggage to Peking. An American friend, Miss Boynton, a Christian Scientist, gave him £50 towards his enterprise. Westharp's extensive shopping list included mosquito nets, WCs, lamps, porcelain, disinfectant and chlorodyne.

Although he intended to leave Japan, Leach still had great respect for Japanese culture and at his suggestion William Hoyle – Uncle Will – who had become director of the recently established National Museum of Wales in Cardiff, asked him to obtain a range of traditional tea ceremony objects. Leach purchased implements approved by the Cha-no-yu masters for the tea ceremony, acquiring in all fifty-one pieces together with explicit instructions how they were to be shown. 'I beg of you to follow this information . . . as nearly as possible for not only are the details minute & subtle even meticulous – but they are absolutely calculated to display each & all the things to the very best advantage.'[60] Sketches and drawings illustrated the exact layout. More significantly Leach wrote of the meaning of the objects and of the ceremony itself, 'to me and to the Japanese themselves, it is the high water mark of good taste in Eastern things', typifying 'Shibui – Japanese austerity in some thing apart & peculiar – beauty, lasting beauty and refinement, under an exterior rough, crude, simple even apparently clumsy', identifying some of the values that were to be important in his own ceramics.

After what seemed endless preparation Leach and family, 'leaving Japan for good',[61] departed on 4 July. Despite Muriel's seven months' pregnancy and two demanding young boys, Leach's excitement was undimmed. Friends from the English colony as well as Kenzan and Yanagi, whose wife, Kaneko, had given birth to a son two days earlier, gave them a warm send-off at Tokyo's Shimbashi station. On board the NYK *Keiko Maru* they travelled second class, Kame-chan third class, arriving in Peking feeling tired and disorientated after suffering sickness in the rough sea. To help restore their equilibrium they treated themselves to a good lunch at the Wagon Lits Hotel before setting out for Westharp's Gulow House[62] where they were to stay overnight. Unfortunately Michael felt ill and threw a tantrum, which continued unabated for some time, an indication of trouble ahead.

In early July the city was so sticky and humid that even Leach was forced to concede it was 'fearfully uncomfortable and hot',[63] conditions exacerbated by the smallness of Westharp's house. Situated in the north of the city halfway between the east and west walls, it was arranged in the conventional Chinese fashion with buildings on the north, east and west forming a central courtyard with a gateway on the south. It was far from commodious and even the long-suffering Muriel was critical:

Imagine a smallish larder with the temperature of a moderate oven & containing a couple of rather heavy black wood chairs (carved) & a massive table of the same & you have the first room. The two other rooms were practically all bed. The Chinese bed being simply a stone platform occupying about $\frac{1}{2}$ or $\frac{1}{3}$ of the room. We unpacked just the minimum amount but it really was rather awful, with the poor chicks crying out for drink all the time & having nothing to give them but boiled water which seemed very limited.[64]

To her surprise Muriel found Dr Westharp 'pleasant, helpful and natural' and 'nice with the children', an impression that was not to last. The following day as they prepared to leave Peking for Westharp's country house near the Summer Palace, Michael again 'was seized by one of his frenzies' and refused to eat, delaying their departure until early evening. Eventually the straggling party set off, two Peking carts carried the cook who had been employed the night before, and the luggage, with Bernard and Muriel and the children in two rickshaws. After the well maintained Japanese vehicles they seemed ramshackle though not uncomfortable. After travelling about an hour and a half on 'unspeakable' roads they arrived at the Summer Palace where Leach and David transferred to donkeys and Muriel to a type of Sedan chair, fortunately managing to avoid Boxer[65] trouble, which continued to rumble in the area.

At the country house the Leach household, established independently of Westharp, was extensive. It consisted of two cooks, one to take the orders, the other to do the cooking, an amah with tiny bound feet to look after the children and do the washing and a house coolie who laid the table and was a general help, in addition to a donkey coolie and a water carrier. None could speak English and communication through signs and a phrase book proved taxing. Fresh milk was obtained from a farm next door that had cows, but as finances were, as usual, tight this was considered ruinously expensive. Their income included an allowance of £100 a year from Muriel's parents, paid quarterly, other small amounts, the interest from Leach's investments and any modest profits from selling antiques to overseas dealers.

The layout of the house was similar to that in Peking, with buildings set around a courtyard. In the north lived Bernard and Muriel, the children and amah in the west and the coolies in the east. A veranda with an entrance gate formed the south side. In the middle of summer the heat was suffocating, and though the ceilings were high and the windows large with netting on the upper half, nothing seemed to stir the air. Unfortunately the farm attracted flies and no matter how hard they fought they were continually plagued. They were also attacked by hordes of mosquitoes, forcing them to sleep under a secure net. The children adjusted reasonably well, though their health was not good. David was dosed with Parishes food to improve his blood, and Michael continued to suffer from painful stomach cramps.

Westharp's own family household was complex. It included his wife who he referred to as the 'little Buddha', though he also boasted of his marriage to a Mrs Sakurai and was host to Zoe Penlington, accepting her as another unquestioning disciple and possible mistress. There was also another wife whom Westharp claimed to have met at the theatre. The presence of Mrs Penlington did not help relations between the Leaches and Westharp. She complained to Westharp of being criticized, though Muriel had said 'that there was no need for subterfuge', presumably about the nature of her relationship with Westharp, causing Leach to observe that Mrs Penlington's mind was 'unhealthy and distorted'.[66] The proximity of the Leach family provided Westharp with an opportunity to pontificate not only on Montessori methods of bringing up children but on relationships within marriage. Initially on his best behaviour, he offered advice on the need for a certain amount of separation between children and parents and the avoidance of fuss.

Together, Muriel and Bernard went on various short outings by chair, 'a heavy old-fashioned kitchen armchair',[67] the venues including the new Summer Palace and the old Summer Palace, and a Chinese theatre, which she found 'exhausting, excruciating and interesting'.[68] Michael's behaviour continued to cause anxiety, he constantly threw tantrums, demanded only Muriel's presence, refused to have anything to do with his amah and complained of terrible stomach pains. Westharp's advice to separate the children in another building some distance from their parents seemed unnecessarily cruel and although Muriel attempted to follow this and keep away from Michael it made the child so miserable that she thought it an 'unnatural arrangement',[69] good for neither child nor mother. David meanwhile had made friends with the local Chinese children, and though Muriel thought them 'working class' and 'smelly', she also saw them as 'natural ' and 'healthy'.

With a view to following Montessori ideas for bringing up their own children both parents read Carfield Fisher's *A Montessori Mother*, finding it 'inspiring and very charming'.[70] Muriel was finally put off when Dr Westharp, who she thought 'more Montessorian than Dr Montessori',[71] declared that the system could only be perfected in China, and that to be successful the children would have to spend their lives there 'to become Chinese in fact',[72] a proposition she found terrifying. While Bernard seemed content with their new life, Muriel thought Westharp 'an exceedingly forceful personality'[73] and was full of misgivings. 'I think,' she wrote to her parents, 'I must be like the man who put his hand to the plough and looked back.'[74] No matter how difficult she was determined to persevere.

Talks between Westharp and Muriel did little to further mutual understanding. Undaunted by her reluctance to accept his views, he continued to preach 'the abolition of suppression and the necessity of life in accordance with nature',[75] and would brook no argument or discussion saying that they did not 'begin to understand yet'.[76] Westharp made no secret of his disapproval

of the way the children were brought up, describing Michael as a 'little spoilt mothersboy'.[77] Their married life was not helped by Westharp complaining to Leach about Muriel, saying she 'must be taken care of in her own way and be considered absolutely independently from me and my ideas, principles etc because I am physically and psychically equally unable to bear the responsibility for anybody who has innerly no connection with me'.[78]

However much Leach found Westharp 'hard, selfish, bitter, cold, loveless'[79] and dismissive of his own interests, the doctor continued to exert great influence over him, persuading Leach to adopt full Chinese dress like himself and take the Chinese name of Li Chū-min. Together they went on excursions, including a thirty-mile trip by mule to the valley of the thirteen tombs of the Ming dynasty emperor, due north of Peking,[80] where they marvelled at its beauty and strength. To further their aim of setting up a Montessori school they were greatly excited by the arrival in Peking of a Mrs Harold Gould, a wealthy American, from whom Westharp hoped Leach would use his charm to extract funds to establish an Americo-European Montessori school. In this they were not successful, though Leach did try to make contact.

Given the increasingly difficult circumstances the Leaches decided it would be better to return to Peking and find their own accommodation as soon as possible. In the city they would also have easier access to medical advice as well as the European community, in particular the missionaries of whom Westharp strongly disapproved. Suitable premises were found but again at the last minute lost. As a temporary measure Westharp suggested that they move into Gulow House, which would be cheap and convenient for the hospital, and accordingly the Leach household, including cook, amah, washing amah and Wang the house boy were installed in the north, east and west houses, leaving the south house for Westharp's use. Michael's health continued to deteriorate. Chinese medicine was tried but failed to stop his diarrhoea, while western doctors found his complaint bewildering, one recommending chlorodyne. Even such drastic treatment had only a short-term beneficial effect. In despair the child was admitted to the French Hospital where inflammation of the intestines was diagnosed, effective treatment started and his health began slowly to improve.

The move of the Leach family to the capital coincided with a proposal to publish a monthly journal to further Leach and Westharp's aim of helping China, which if it was to succeed required financial and political help from the government. On several occasions Westharp, Zoe Penlington and Leach visited the foreign office to discuss the project and at first the scheme seemed as if it may receive support. Unfortunately, these negotiations necessitated Westharp and his entourage also moving to Peking where they found the south house too cramped and resented the presence of the Leach family, so adding a further strain on their relations. Although Leach continued to regard Westharp as

'divine'[81] accepting all he said, Muriel thought he brought only 'unhappiness into our life',[82] describing him as a 'very ruthless surgeon'.[83]

With Westharp pressing for Leach to leave his house and the birth of the baby imminent, the search for their own property became even more urgent. The pressure was increased by a series of recriminating letters from Westharp accusing them of occupying the house against his wishes, even though he had originally agreed that they could move into it. Despite Leach's assurances that they would leave as soon as other accommodation was found, events overtook them for on 19 September their third child arrived two weeks earlier than expected. After a day trudging round the city house-hunting, Leach returned at six to find a nurse attending his wife who was in labour. To relieve her pain he administered a little chloroform on a handkerchief and within a short time a baby girl was born bearing a mass of very dark hair and a striking resemblance to her brothers. Muriel found great pleasure in the child, named Edith Eleanor (known as Eleanor), commenting that motherhood succeeded in bringing 'one close to the big things of life'.[84]

Following a further three weeks' search suitable accommodation was found and the family moved into a corner, middle-class house, which 'as customary, faced north, south, east and west and consisted of a paved yard about twenty by thirty feet, surrounded by one-storied brick buildings, two or three rooms to each building',[85] previously occupied by a Mr Monastier.[86] While Westharp congratulated Leach on the property he had no respect for the departing tenant, hoping that 'he has gone to the devil, to whom he belongs' and advised Leach to 'not only disinfect the house but fumigate it also with a kind of Buddhist or better Taoul incense, in order to drive out the devil spirits and bad luck'.[87]

The birth of the child, Westharp's persistent interference with the way they brought up their children, his antagonism towards Muriel whom he felt totally resistant to his ideas, and the disagreement over their occupancy of Gulow House, signalled the start of a serious rift between Leach and his mentor. 'I cannot continue to work with you as hitherto that is to say compromising between complete following of your leadership and independence, and neither can I put aside compromise and be your Fidus Achates there remains independence,' wrote Leach. 'I am certain that as long as you live you will not find another man who will make an equal effort to follow and support you – closely and steadfastly, faithfully.'[88]

Yet however much Leach became disenchanted with Westharp's behaviour and his difficulties in conducting personal friendships, he still showed no sign of abandoning him as mentor. 'The spiritual ties which exist between you and me, and I wish to preserve by all means, can only be the basis for spiritual influence,'[89] he wrote. Wisely, Muriel retained an element of scepticism in her understanding of what her husband was seeking to do and what appeared realistic. Whilst applauding the general intention she saw that 'between the idea

and its' carrying out there's leagues and leagues'.[90] Yet despite her dislike and mistrust of Westharp, and even though she had severe doubts about the feasibility of his projects, Muriel remained loyal to her husband. Writing to her parents she reassured them of the importance of his work, saying that it was 'to help the future of China by giving her only those advantages of Western progress which are suited to her character & by bringing about a better understanding & appreciation of China in Europe'.[91] Unlike her husband, who thought that Westharp had 'penetrated the soul of China more deeply and truly than anyone else',[92] she was more doubtful, basing her observations on her own experience of Westharp, and of questioning 'the veracity of his penetration', concluding 'I feel he is not qualified to interpret any branch of human life & thought because his own nature is twisted and lacking in the only element which makes it possible to understand others'.[93]

Only in her letters to her parents, written as 'a secret between you and me' as she did not want her husband to think her in any sense critical, did she feel able to pour out her fears and doubts. Diplomatically she outlined some of Leach's difficulties with Westharp whilst trying to avoid direct criticism of her husband. Recognizing the power of Westharp's emotional hold over him she was aware of the dilemma in pointing out his weaknesses and the risk of being accused of a lack of understanding, and thereby enforcing his power over her husband. 'No one ever needed a religion – a something to put his faith in – more than B, he has none & the one aim of his life (partly unconscious) is to find one . . . He doesn't seem able to separate the spirit of it from all the forms and hypocrisies which he hates and so is always on the look out for something better.'[94] In addition to discussing Westharp, she vividly described their domestic arrangements, the problems and pleasures of dealing with five or more servants and the books they read and had enjoyed, which included *Ivan the Terrible*.

Paradoxically, a sense of freedom and 'a gradual loosening of the yoke' followed Westharp's recriminating letters, which graphically revealed his bitterness and inconsistencies, as Leach 'began to realise that his relationship with Dr W was not a satisfactory one: no reciprocity and on his side almost no independence of thought'.[95] With the family now in independent premises, and with five reasonably competent servants, Leach spent more time with them, taking the children for walks on the wall and exploring Peking and its surroundings for the first time. Both he and Muriel were enthralled by the ancient buildings. The traffic itself was

> quite fascinating especially going through some of the big gates like Chien Men; it is such a medley – quaint old Peking carts which are quite a feature, donkeys and occasional lumbering carriages with clanging bells and an endless stream of rickshaws with every possible variety of occupant & all these things shouting at all the others to get out of the way & none of them

taking the least notice of the other's shouts. The hubbub is all exaggerated too by gates which are like tunnels through the great thick walls. It is wonderful.[96]

They hired a rickshaw, fitted with pneumatic tyres, which made travelling both more comfortable and speedy. Rickshaws were still the principal means of transport but this was changing, and Leach was horrified to see parts of the double wall of the Tartar city around the gateways being demolished for an ugly but convenient tramline. Remarking on the hideousness of the new foreign buildings Muriel thought they looked as if they had just been 'dumped down among the Chinese'.[97] The age-old buildings and the urban environment inspired Leach to carry out soft-ground etchings of ancient temples and gateways, including Chen-mun Gate and The Temple of Heaven, in which he captured both their architectural detail and monumental character.

The children, in particular David, were soon integrated into the neighbourhood, making friends with, among others, Jung Hai, one of the coolies. In the courtyard David, happily wearing an elastic band around his head to stop his ears sticking out, pushed Michael about in a chair on wheels, which Leach had obtained for them to play with. Slowly Michael's health, though still sickly, began to improve, nourished with regular doses of cod-liver oil and malt, a concoction he relished. With their household well established Muriel followed up introductions to other British residents, detailing to her parents what seemed like a daunting list of visitors:

> Mrs Wenham, a young widow of whom I had heard, came to call a few days ago & asked us to go to Tea on Tuesday, she seemed nice. Her husband was a doctor. Then on Saturday a Mr & Mrs Gwynne called, Miss Boynton had told us of them & Bernard had met Mr Gwynne when he was here before. Yesterday we went out to the West City to the Anglican mission where Miss Foss lives & Miss Shebbeare and one or two others; it is quite a long way over there & they haven't any foreign neighbours but they are a fairly large community in themselves & their compound is very nice, much more Chinese than most of the mission.[98]

They even went to a concert at the Wagons Lits Hotel to hear Mirovitch and Piastro, pianist and violinist, perform during a world tour.

Lady Jordan invited Muriel to the British Legation, an enclosure three acres in size situated inside the Tartar city and once the palace of an imperial prince, whose entrance-archways had been adapted to the needs of European life. Inside there was a dispensary, armoury and tennis and fives courts, one of the more agreeable if less impressive compounds in the city. Muriel became a regular visitor, attending sewing afternoons and tea parties. Life was comfortable even if the climate was extreme with dust lying inches deep on the roads, disturbed by the slightest wind. In the cold winter, although everything

froze solid for three months, the dry atmosphere made it bearable. In summer, Peking, 'a city of walls', positively radiated heat at night and they left for a stay of a few weeks at Pei-tai Ho on the northern edge of the Gulf of Peichili.[99] In this small, largely foreign colony on the coast, Leach rented a bungalow, made sketches and etchings, and gave drawing lessons to the Lattimores, an English family.

Collaborations between Leach and Westharp continued, though their attempts to publish a journal were not successful, nor were their efforts to set up an East and West society, comprising a band of loyal followers and supporters intended to help spread their message. 'The object of the Society', wrote Leach, 'is to form a real continuing link between unprejudiced Westerners & thoroughgoing and active China. On the one hand to respectfully study Chinese Life and on the other an incentive to the rebuilding of National vigour and consciousness'.[100] A list of rules for membership drawn up by Leach included a deep respect for China, and a sincere desire to gain a deeper knowledge of Chinese psychology, history, moral teaching, art, method of life, production and tradition. The society had to be non-political, non-religious and racially equal. Meetings held weekly would be for discussion, exchange of information, debates, letters to press, yearly publication, memorandums on public questions by majority vote, excursions and investigations. However well intentioned, the society failed to capture the hearts of China lovers and few members were recruited.

Attempts by Leach to work independently in Peking were greeted largely with derision by Westharp who poured scorn on his ideas, dismissing his efforts to liaise with various official and semi-official bodies. He was also contemptuous of Leach's plans to open a shop 'for the sale of Chinese articles to Foreigners [and] for export',[101] or set up an art school. After writing an article about China, Leach was accused of self-aggrandizement. More sinister was Westharp's prediction that Leach would 'arrive at a complete breakdown',[102] and that the idea of self-realization had only carried him 'into the beginning of malignant egotism'.[103]

Regular meetings became more difficult when Westharp was appointed director of an orphanage at Pao Ting Fu, about a hundred miles from Peking, which he saw as an opportunity to put into practice some of his ideas about education. For a time Leach toyed with the idea of moving with him but perhaps wisely decided against it. They did try to meet often and though such occasions began reasonably they usually ended with Leach being given 'a long spiritual hammering'.[104] The ferocity of their emotional and intellectual struggle was powerfully captured in Leach's dairy:

Does not this wrestling equal in spiritual intensity what the men in the trenches go through physically. They cannot call me coward but who will understand? . . . AW is not disinterested. He seeks to dominate

instinctively. For him are blended selfishness and self realisation, bitterness and kindness, positive and negative with a Napoleonic force. I have partly deliberately but mainly inevitably submitted to him spiritually too weakly, playing negative but nature rebels and I cannot do it anymore. I understand too much. This is not an age to "following leader". I can see all the nervousness and pain of AW's life influencing his thoughts. I am not simple. I cannot submit to selfishness and bitterness and so much negative even when allied to such greatness. I have my own inner voice and my own self-realisations to obey. They will not submit any longer even to this master who has shaken and awoken them, but who continually oppresses them. He has a unique understanding of himself (Freud called him the most conscious man he had ever met).[105]

Perceptively, Leach added 'he has got a dominance over me which when I tried to throw it off in the least he has called rudeness. I fear that he will turn on me with a "malignant egotism"!'

Adept at needling Leach, Westharp often took up the vexing question of marital relationships and the way such commitment stood in the way of ideals, remarking that the 'enthraldom of man to his wife & her passion for him as something which claimed weak man. Unless wife had deep respect, no room for husband to work wholeheartedly towards such an ideal as mine'.[106] Although he enjoyed spending time with his family, Leach still felt the urge to look elsewhere for sexual satisfaction, and his diary hints at dalliance outside 'the marriage bed'.

> Sex is clean like the fresh mountain air
> It refreshes the soul
> A man needs this clean fresh sex as he needs the mountain air
> Pure sex is not for the marriage bed alone
> There are dangers to it
> When shall we get freedom?[107]

The theme of sexual desire was taken up in May the following year in a few lines entitled 'Thoughts on I.L.'

> Her budding breasts are beautiful
> And the promise of fountains
> If in the mountains
> At the break of this day.[108]

However much he still craved 'sense experience', the paramount task for Leach remained that of 'saving' China, and to this end he wrote at least two substantial papers, one on Confucius and another on Chinese education.[109] Having observed how Japan had embraced western ideas in modelling her

army and educational system after a German pattern, a navy after the British and a commercial system after the Americans, and in the process had 'sacrificed her very soul', China, he wrote

> seems to be blindly following her lead, particularly in copying all the faults of the education system. The China of tomorrow, conscious, active and in touch with the rest of the world, without undue loss of what is true and valuable in her tradition and spirit will be adopting the most advanced system of European education – which is in harmony with Chinese classical teachings . . . The Montessori system is demonstrating the fact that each individual, like each organ of the body has particular function and that only a lack of natural and healthy self-control produces disorganisation.[110]

Throughout, Leach dutifully acknowledged Westharp's ideas 'whose writings on the central problems raised by the meetings of Eastern spirit and modern Europe, brought me to China. He is the only man with anything approaching the necessary qualifications who has attempted to solve the problem from the roots'.[111]

The paper on Confucius,[112] again heavily influenced by Westharp's own views, was scattered with quotations from the sage, which reinforced Westharp's argument that in China Confucian ideas were in keeping with common practice. 'Truth means the realisation of our being. And moral law means the law of our being',[113] he quoted, commenting that 'the Chinese moral law is more clearly seen to be a natural law',[114] and 'if consciousness comes from sense experience, it goes without saying that the most complete sense experience must produce the most complete consciousness. This the Chinese sage calls realisation of our being'.[115] When considering questions of morality Leach compared the teachings of Christ with those of Confucius, 'If a man hurts me there are only three courses open: 1. to hurt him back, 2. to do him good 3. to retire. Christ taught to help at any cost. Confucius teaches help him if possible, if not retire',[116] observing that 'ignorance alone counsels revenge'.[117]

In his book *Beyond East and West* Leach devoted an entire chapter to a discussion of his concern with the teaching and ideas of Confucius[118] within the Chinese context, suggesting the depth and extent of his involvement at this time. The emphasis the teaching placed on 'the divine or most spiritual force within the individual' he found brought together into a single homogeneous whole the moral or religious law and natural law. In embracing and developing Westharp's ideas he saw parallels between old Chinese thought and contemporary European philosophy, educational theories and artistic development.

Perhaps naively Leach felt the need to speak up for Westharp and his ideas to the writer Ku Hung-ming whose recent translation of the *Chung Yung* both

he and Westharp agreed was by far the best either of them had come across. From it, he thought, it was possible to begin to 'comprehend why the religious philosophy it contained had had so profound and prolonged influence in the East'.[119] After some disagreement had sprung up between his guru and Ku Hung-ming, Leach was perturbed by what he saw as a misunderstanding and wrote unsuccessfully to the translator in an attempt to bring them together.[120] The exact nature of the disagreement was not clear, but given Westharp's difficult character, his rapid mood swings and generally unreliable behaviour suggests that he would intensely dislike any competition, and welcome only unquestioning followers and acolytes, a role that at this time Leach was prepared to accept.

Throughout Leach's time in China, Yanagi maintained regular contact while remaining deeply suspicious of Westharp's ideas and questioning Leach's wisdom in staying, even going so far as to express profound doubts about the enterprise. As early as July 1915[121] Yanagi suggested that Leach's work as an artist was far more important than that of social reformer, quoting from Turgenev who on his deathbed had written to Leo Tolstoy 'Great friend, listen to me again! Please return to your art'. Inspired partly by the study of Blake and the works of other writers Yanagi and Leach continued to share a growing interest in Christian mysticism. One of the issues which lay at the centre of Yanagi's thoughts was that of dualism, of the split between 'mind and the body, Heaven and Hell, God and man',[122] and how to unite or organize such divisions. To what extent God could be perceived as lying within or as a being quite separate from the self, were also profound issues touched on by Yanagi, concluding that Zen, or oriental mysticism, was the 'oil to the fire'[123] that offered 'the final emancipation from duality'.[124] These were challenging concepts and ones that at the time may have seemed far from Leach's concerns in China, but were to reverberate throughout his life.

In addition to looking at the philosophical aspects of religion, belief and spirituality, Yanagi also raised provocative questions about current developments within the European art world, asking for example whether Leach was 'entirely satisfied with Van Gogh's aesthetic?',[125] wondering if, like himself, he preferred the quietness of Cézanne. In fact in a comment added to the letter reproduced in Beyond East and West,[126] Leach responded more to the anguish and turbulence of Van Gogh, though he added that he was disinclined to give preference to either classicism or romanticism as 'Art lives by these contrasts'.[127]

The mood of indecision and drift that Leach was beginning to experience in China and in particular the growing sourness in his relations with Westharp was dramatically highlighted by news of Yanagi's proposed visit to China. This was to follow a tour of Korea to see his younger sister Chieko who was married to Immamura Takeshi, a senior civil servant who worked for the colonial government in Seoul, and to look at Korean art and craft. Yanagi's appetite

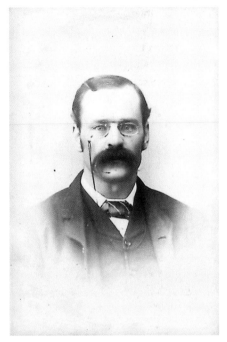

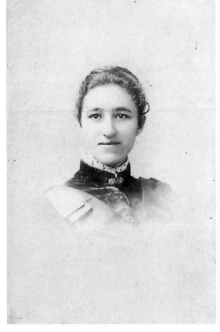

Andrew John Leach, Bernard's father, photographed in Hong Kong, *c.* 1885. (Family archive).

Eleanor Massey Sharp, called Nellie (or Nelly), Bernard's mother, photographed in Hong Kong, 1885. (Family archive).

Bernard Leach with his Sharp grandparents in a rickshaw, Japan, *c.* 1890. His half Chinese amah may be standing on the steps or more likely standing to the left of the picture. (Leach archive).

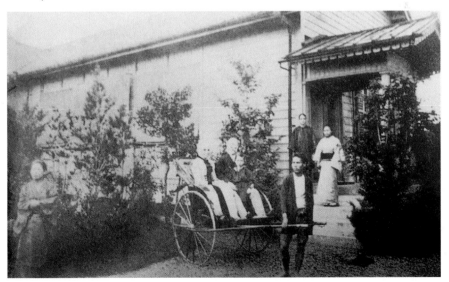

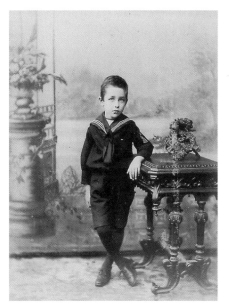

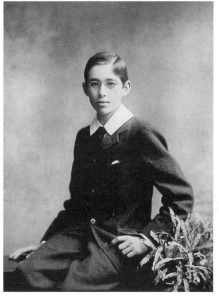

Bernard Leach aged about five. (Family archive).

Bernard Leach aged fourteen. (Family archive).

The Cricket First Eleven, Beaumont College, 1903. Bernard Leach is second from right, back row. (Jesuit Archives, London).

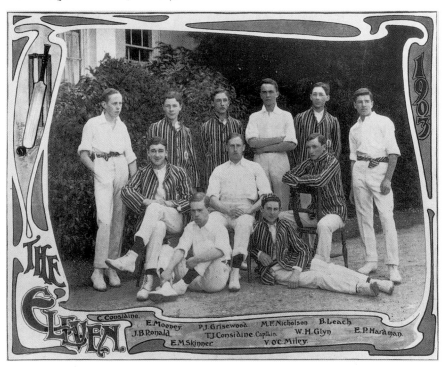

Bernard Leach, *Self-portrait* (detail), 1903. Oil on canvas; 30.3 × 40 cm. (Philip Leach Collection).

Bernard Leach, *Coal Heavers – Earls Court Road, London*, 1909. Etching; 20 × 16.3 cm.

Bernard Leach, *Mine, Prestatyn*, 1907. Watercolour; 53 × 42 cm. (Philip Leach Collection).

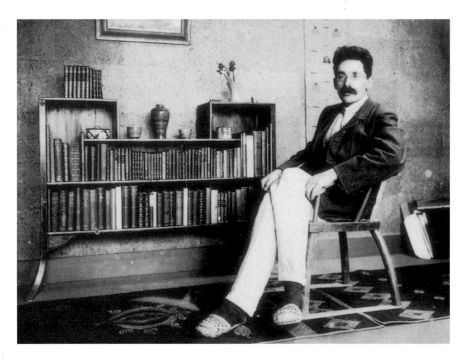

Bernard Leach in his house in Tokyo surrounded by furniture, carpet and pots he designed and/or made, *c.* 1914. (Leach archive).

Bernard Leach, set of three-legged chairs, *c.* 1918. Wood; h. 92 cm, w. 40 cm. The chairs were fashioned out of cedar wood to Leach's design, by a local carpenter. The wood was carefully chosen and cut to follow the natural curve of the grain, the decoration consisting of pierced holes, scrolled tops and cross-hatched patterns. Following local tradition the surface was darkened by singeing it in flame and ashes before being given a soft polish. (Leach archive).

Bernard Leach, plan of table, *c.* 1918. Each drawing 9 × 13 cm. The combination of western and eastern influences is typical of the furniture Leach designed in Japan. (Jessamine Kendall Collection).

Bernard Leach admiring one of his pots at an exhibition of his work in Tokyo, 1920. The table was designed by Leach, the textiles were probably also by Leach. (Leach archive).

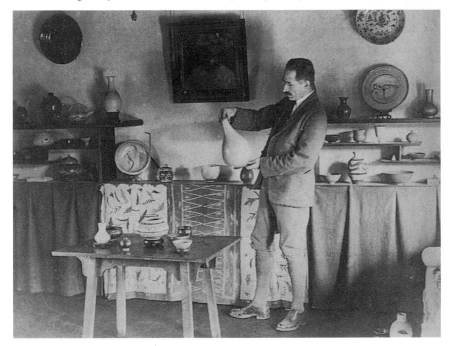

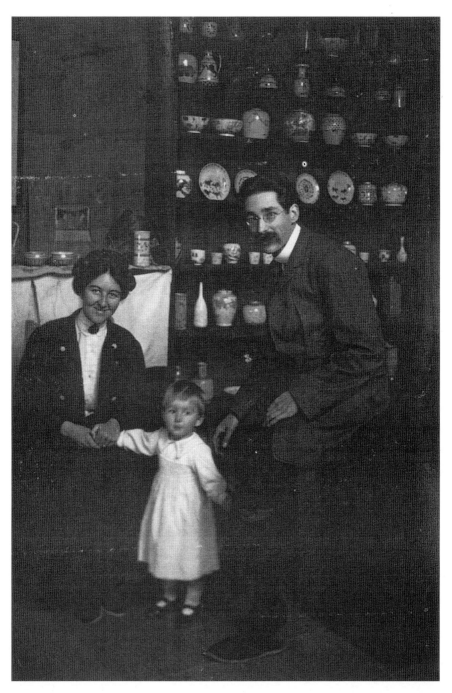

Bernard and Muriel Leach with David, aged about eighteen months, in their house in Tokyo, *c.* 1913. Leach's pots fill the shelves, giving a good indication of the range and styles of his work at this time. (Family archive).

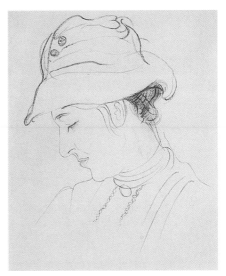

(Left) Bernard Leach, *Self-portrait*, 1914.
Etching; 14 × 9 cm. (Leach archive).

(Above) Bernard Leach, *Muriel*, 1912.
Pencil; 17 × 14 cm. (Jessamine Kendall
Collection).

Bernard and Muriel Leach with their
children David and Michael (as a baby), and
their two servants in their garden, Tokyo,
1913. (Family archive).

Bernard Leach, *Kame chan*, c. 1914. Pen and
ink; 18 × 13.6 cm. (Leach archive).

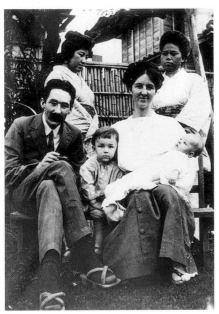

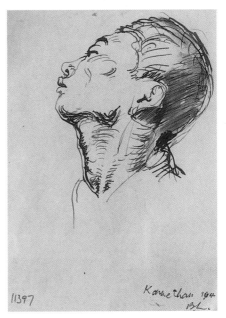

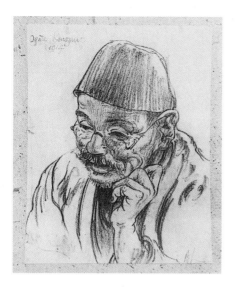

Bernard Leach, portrait of 'My Master Kenzan VI', 1924. Etching; 18 × 13 cm. The affectionate portrait was based on a 1913 drawing, and carried out after the death of Kenzan in the great Kantō earthquake of 1923. Leach archive.

Bernard Leach, right and Tomimoto Kenkichi, c. 1913, Leach holding a decorated pot, Tomimoto wearing a western-style tweed suit that included plus-fours. The fabrics behind were probably designed by Leach. (Private collection).

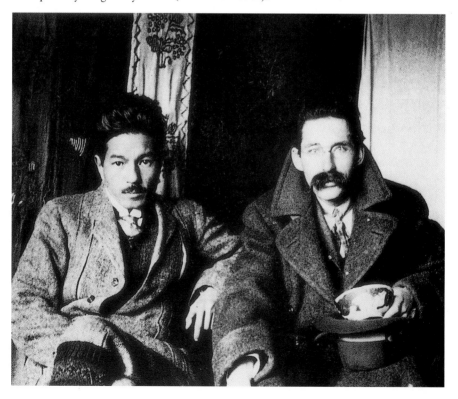

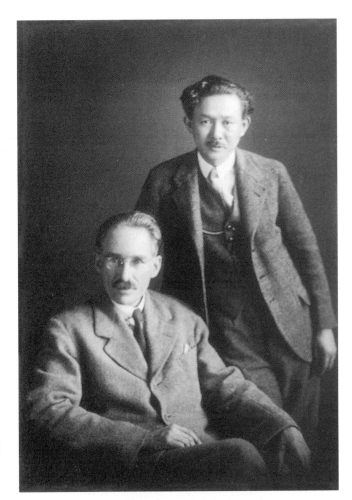

Bernard Leach,
seated, and Yanagi
Shōji, Tokyo, c.
1912, both wearing
conventional
European suits.
(Leach archive).

Dr Westharp and
group in Peking,
c. 1915. Dr
Westharp is
standing second
from the left, one
of his wives sits in
the centre holding
a child. (Leach
archive).

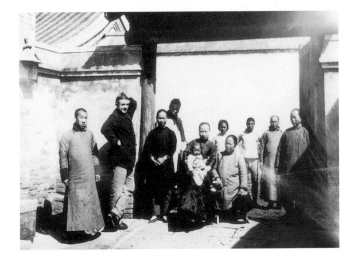

Bernard Leach at his pottery at Abiko, which faced onto the lagoon, showing the Chinese style roof and round window. Leach is sitting in front of the kiln to the right, c. 1918. (Leach archive).

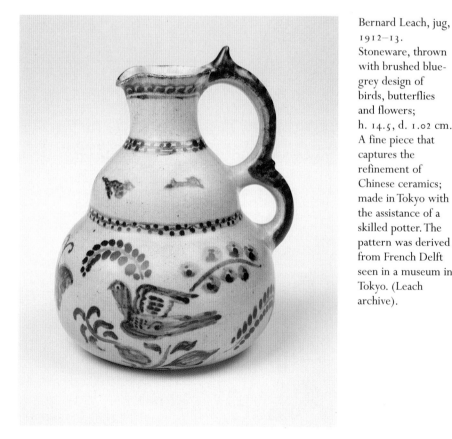

Bernard Leach, jug, 1912–13. Stoneware, thrown with brushed blue-grey design of birds, butterflies and flowers; h. 14.5, d. 1.02 cm. A fine piece that captures the refinement of Chinese ceramics; made in Tokyo with the assistance of a skilled potter. The pattern was derived from French Delft seen in a museum in Tokyo. (Leach archive).

Bernard Leach, wearing Japanese fireman's headgear and gloves, firing his stoneware kiln at Abiko, c. 1919, before the pottery burnt down. The roof is dangerously near the top of the kiln. (Leach archive).

Bernard Leach, jug, 1914. Stoneware, thrown with heraldic pattern in cobalt design; h. 23.7 cm, d. 16.5 cm. Both the form and decoration reflect Leach's search for his own style. (Courtesy Ohara Museum of Art, Japan).

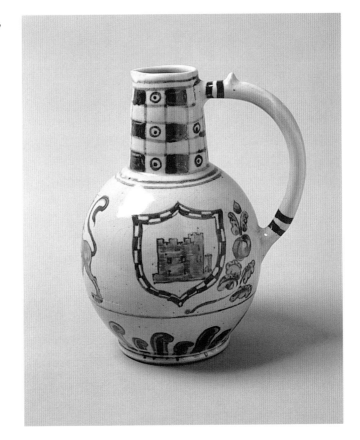

Bernard Leach, *The Temple of Heaven — Peking*, signed in plate, 1916. Etching; 28 × 30 cm. The slope of the roof later influenced the shape of some of Leach's lidded pots. (Private collection).

Bernard Leach with the potter Hayashi and his assistant at the pottery built for him on Viscount Kouroda's estate, at Kōgai-chō, Azabu, Tokyo, 1919. The photograph was used to illustrate the article 'An Art Pottery in Cornwall' in *Pottery Gazette* and *Glass Trade Review*, which was seen by Michael Cardew and inspired him to visit Leach in St Ives. (Leach archive).

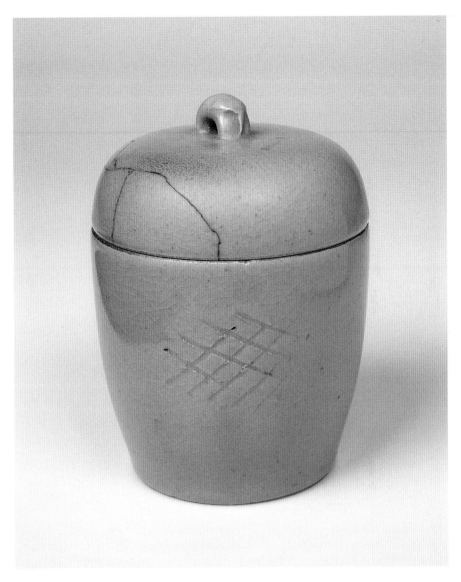

Bernard Leach, lidded pot, with knob in form of elephant, 1919. Porcelain, thrown with incised cross-hatch decoration, pale green glaze; h. 16.5 cm, d. 13 cm. With the assistance of a skilled potter, Leach achieved a high level of technical accomplishment in these early porcelain pieces that he was unable to obtain for many years in England. (Leach archive).

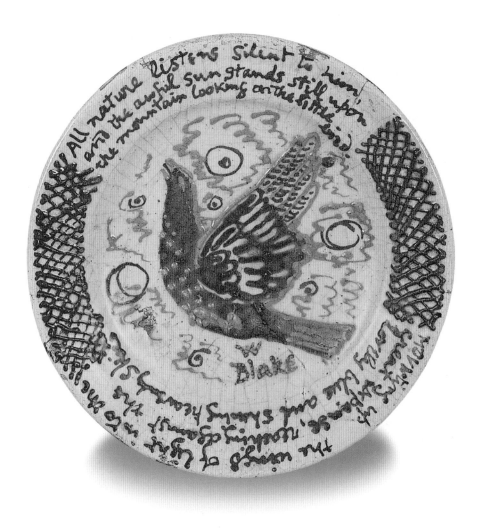

Bernard Leach, dish, 1917. Earthenware or raku with slip trailed decoration of bird, possibly dove, in centre, cross hatching and a quotation by William Blake on the rim; h. 4.4 cm, d. 20.9 cm. The design combines a free handling of the motif, cross-hatched pattern and text with a sure sense of composition. (Whereabouts unknown).

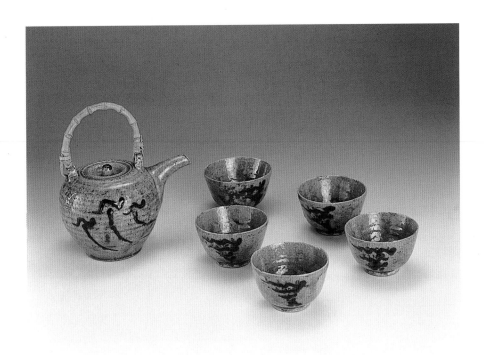

Bernard Leach, teapot and five tea bowls, 1919. Raku, thrown with pine tree decoration, green glaze; teapot h. 10.5 cm. d. 11 cm. The accomplished technical skill involved in making these pieces suggests that it was made by a professional potter to Leach's design. (Courtesy of the Nihon Mingeikan, Tokyo).

Bernard Leach, *Mountain Gorge in Mist*, illustrated in 'An English Artist in Japan', 1920. Etching; 24.8 × 20 cm. The etching, a powerful, expressionist interpretation of landscape, is in great contrast to earlier, more academic works. (Private collection).

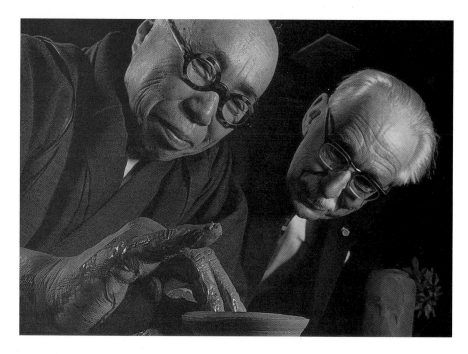

Bernard Leach watching Hamada Shōji throwing on the wheel, Japan, *c.* 1965. The two potters had not only been great friends since their meeting in 1918, but were also great admirers of each other's work. (Family archive).

for Korean art had been whetted by Asakawa Noritaka, a Japanese resident in Korea since 1913, who had carried out extensive research into Korean ceramics. Inspired by reading *Shirakaba*, Asakawa visited Yanagi at Abiko in 1914 to see the sculptures Rodin had presented to the group as a gift, and to give him a Chosōn faceted jar of white porcelain decorated in underglaze blue.[128] During his month in Korea, accompanied by Asakawa's younger brother Takumi who was also a pioneer researcher into Korean ceramics and folk craft, Yanagi travelled looking at pots, historic and archaeological sites, folk kilns and traditional craft shops. Korean nature, he thought, was 'rather solitary', but the people 'lovely and interesting. Their costume is graceful & their manners, especially of boys & girls are very charming'.[129] The first-hand experience of Korean art was to be a turning point for Yanagi in seriously questioning conventional theories of beauty, which were later to have a great influence on Leach.

In September Yanagi arrived in Peking to stay with the Leach family at Tung-tan Pai-low, full of his impressions of Korea, keen to talk about the fine pots he had seen, eager to explore China and exchange news and ideas. Together they toured the country by train and donkey visiting such sites as the Great Wall of China, which greatly impressed them by the way it 'curved about the bare Manchurian hills',[130] wondering at both the structure and the picture it made against the 'lowering sky and moving sunlight across it'.[131] In the capital they toured the great walls of the Tartar city and saw and admired the old imperial collection of pots, amazed by row after row of pieces from the twelfth-century Sung dynasty, observing the quality of the old glazes, the firing effects resulting from differences in temperature and the uneven colours caused by variations in the reduction atmosphere in the kiln. Other sights included the temple of Confucius, a vast, dusty hall raised upon a stone terrace containing dull red pillars that supported the lofty timbered roof, and the tablet of the sage together with those of other eminent sages.

During his two weeks[132] Yanagi rekindled Leach's appreciation and enjoyment of pots, each finding in them similar pleasure. Yanagi also generously acknowledged Leach's help in discovering that through him he could 'appreciate something of real Chinese art and spirit',[133] which helped him to 'a closer perception of the beauties of our great neighbour . . . [and] to enter into the wonderful national spirit of the Chinese people'.[134] They also searched antique shops, acquiring among other objects examples of Sung pottery, which stimulated great discussion that often continued into the night.

The visit was also an opportunity for Leach to make a calm assessment of his work in China and he 'poured out the conflict [he] had continually experienced with Dr Westharp',[135] conflict Yanagi had long suspected. Sensing that Leach's faith in Westharp was at a low ebb and that he was not happy with the whole Chinese project, Yanagi offered straightforward advice, putting into words perhaps what Leach felt. 'Come back to Japan, you have followed

a false leader – you do not need him. I have seen the intuition in your draw-
ings.'[136] Not only did he identify Leach's dilemma, but also offered practical
help. 'Come and build a kiln on my family land at Abiko and join our group
again.'[137] It was sensible and wise advice, for not only did it suggest a clear
direction for Leach but, in offering to provide suitable accommodation, paved
the way for him to again work with clay. Almost without hesitation Leach
decided to return to Japan before 'autumn turned to winter' and started to
plan accordingly. Yanagi departed taking with him a selection of Leach's draw-
ings, which he intended to squeeze into a show in Tokyo alongside the works
of Henri Matisse.

To reinforce his belief in Leach's creative abilities, Yanagi wrote from
Japan saying that his friends were keen to welcome him back, reminding
him that a room awaited him in Abiko and that there was land for building
kama (kiln) and studio. Although Yanagi's wife, Kaneko, was in Tokyo awaiting
the birth of their second child, he had engaged a country woman to cook
their meals. Acknowledging Leach's expensive European tastes he promised to
obtain 'bread and butter from Tokyo every day'.[138] Leach's drawings were well
received, and Yanagi sent details of a proposed new art gallery to be set up by
a Mr Tanaka, the son of a banker and a wealthy young man 'in some best part
of Tokyo'.[139] This would exhibit only those artists recommended by the Shi-
rakaba 'so that the gallery will remain always strictly artistic'.[140] Here, he said,
Leach could show on an exclusive basis, initially on consignment (i.e. sale or
return), and the work would be carefully and sensitively displayed. At Leach's
request Yanagi inquired, unsuccessfully, about a Montessori school in Tokyo.

Shortly before leaving China, Leach became enthralled by Chinese shadow
plays, discovering from Wang that players could be hired at reasonable cost
for a single performance. As a farewell celebration he employed six per-
formers who duly set up a stage covered with indigo cotton in the centre of
the courtyard, the shadows thrown onto a white screen illuminated from
behind to create a vivid and effective spectacle. The English audience watched
the performance spellbound, better able to appreciate the intricacies and sub-
tleties of the unfolding historical drama with the help of a commentary from
a Chinese-speaking friend. So impressed was Leach by the skill and ingenu-
ity of the performance that he wrote and illustrated an account of it, which
he sent to Edward Gordon Craig, the eminent theatre designer and son of
Ellen Terry.[141]

In preparation for their return 'cheap pots, embroideries, silk for Mrs
Yanagi, Cha No Yu bowl, toys . . . KC outfit – shoes, hat, suit'[142] were bought
for Japanese friends. In addition Yanagi sent a list of items requested by friends
who wanted pots, glass, toys and some special type of Chinese paint pill and
Chinese paint brushes, as well as porcelain, ceramics and embroideries. In
preparation for setting up his workshop Leach investigated suitable pottery
materials and arranged with his cousin for monies to be made available in

Japan. Still missing the companionship of Reggie Turvey he wrote with details of his plans and asked him to come to Abiko. Given Turvey's previous experience of the country it was an unlikely invitation but indicative of Leach enthusiastically taking up the threads of his previous life.

Disturbing news of the illness of his Aunt Edith, Muriel's mother, who they learnt had been ill in bed for five weeks cast a shadow over their preparations to return. Anxiously they cabled Cardiff to ascertain the severity of her illness and determine whether Muriel and the children should return to England. To their great sorrow, before any action could be taken, Edith died of heart failure, aged only sixty. It was a grave sadness to both Bernard and Muriel, and a particular disappointment that she had not seen any of their children. There was also the problem of Kame-chan's increasingly odd behaviour to be dealt with. Although he continued to live with the Leach family his frightening demeanour was distressing and Leach contacted a specialist in San Francisco who said that he may be able to help. Accordingly a passport was obtained to enable him to travel to the United States, but the journey never took place.

At a final leaving party Leach and eight friends sat round a circular table to consume a vast and memorable meal celebrating the best of northern Chinese cooking, confirming this as one of the finest cuisines in the world. Although anxious to return, delays continued to hamper their departure and at the port they were further put out by the late arrival of their steamer. Wang was left in charge of the luggage and, despite the freezing cold weather, slept on top of it causing Leach to observe cryptically that 'in China one could buy loyalty and love with money'.[143] The end of the China episode was unambiguously recorded in one of his final entries in his 1916 diary, 'Close connection with AW ended', concluding an involvement that had at first seemed so full of hope and spiritual reward. Although his time in China had not been successful in the way he had planned, it nevertheless played a crucial part in revealing his profound commitment to becoming a potter.

THE ISLES OF ENCHANTMENT

Japan

1917–1920

The uneventful journey to Japan left ample time for reflection. With a new sense of purpose Leach was preparing to rely more on his own efforts and abilities rather than seek out a new leader. The split with Westharp was so complete that his name was rarely mentioned save to say that the Leaches had given him permission to use their guest room for a meeting with Ku Hung-ming, though no record survives of this taking place. However noble Leach's intention had been in China, it had proved a costly and unrealistic quest, the return to Japan signalling both an acceptance of his destiny as a potter and the end of his crusading zeal to 'save China' from the worst aspects of western influence. Yet throughout his life he continued to be concerned with concepts such as 'developing the body and the intellect at the expense of the imprisoned spirit',[1] and 'developing the spirit and the imagination',[2] ideas Westharp forcefully put forward.

Although still intent on pursuing 'sense experience', there was also a recognition that Muriel and the children could not be treated casually. For Muriel Japan was a welcome return to a familiar way of life, when old and valued friendships could be re-established. For Leach it meant embarking on a career as a potter, exploring new challenges as a professional rather than amateur in his own fully equipped, purpose-built studio. Both looked forward to living in a country they knew and in which they had at least a minimal grasp of the language.

Following their arrival at Kobe, Muriel and the children went to stay with English friends and Leach to spend a few weeks with Tomimoto, keen to see how his pots and marriage were progressing. Born the eldest son into a distinguished landowning family whose father had died when he was eleven meant that Tomimoto was expected to inherit the family responsibilities as well as the Ando Mura estate, but having experienced life in the West it was a responsibility he did not want. In his late twenties family pressures to marry increased, and following convention a marriage broker was employed to arrange a suitable match. After discreet inquiries as to health and wealth the daughter of a local landowner was put forward as a suitable wife and Tomimoto was given her photograph. Appalled by the procedure he told

Leach 'I do not wish to marry in the old way – I have lived in your country, England. I am the eldest son and my family is distressed by my delay'.[3] To release himself from family obligations, Tomimoto resigned his position in favour of his younger brother.

Tomimoto's unconventionality was reflected in his choice of wife, Otake Kazue,[4] who worked for a leading women's journal in Tokyo, and who defined herself as a New Woman. A mutual attraction arose but Japanese custom made it difficult for them to meet without causing a scandal, so Bernard and Muriel invited them to spend time at their Tokyo house. 'I can beat her in anything except drinking', boasted Tomimoto, combining affection and admiration for someone whom he regarded as his equal. The marriage ceremony at the Seiyō-ken, a restaurant in the capital, was as unorthodox as their relationship. Japanese food was served one side of the table, European on the other, the principals sitting solemnly at the end. To Leach, the bride, the daughter of a well known painter, appeared 'rather swarthy, with a painted white face and old-fashioned hair style',[5] her black bridal kimono making a dramatic contrast with her white make-up. During the ceremony the chief speaker, a government official, droned on and Leach, understanding very little, was entertained by the range of bored expressions on the faces of the guests. At one point, observing two fellow artists tittering to each other, he was so overcome by giggles that in order to regain his composure he dropped beneath the table pretending to retrieve a fallen napkin.

The couple settled in Ando Muro where Tomimoto set up a pottery.[6] At the bottom of a pond near his home a suitable bed of clay was discovered that fired well and initially he produced low-fired raku, but this was soon abandoned in favour of more robust stoneware and, later, porcelain. Determined to demonstrate the progressive nature of their relationship the couple walked around hand in hand, greatly scandalizing the villagers by breaking the convention that the sexes do not touch in public, and the wife walks two steps behind her husband. The couple had two children, but eventually the marriage ended in separation. Remembering with affection his time in England Tomimoto evolved a lifestyle that combined aspects of Japanese and western culture.

During his stay Leach was invited to make use of the studio and work towards a joint firing of the kiln. Although initially cautious, recalling earlier experiences of Tomimoto's impatience when he could not bear to wait until the kiln had cooled, he agreed. For some four weeks they made pots and fired them in the two-chamber kiln. While the kiln was cooling they went on a fishing expedition, one of Tomimoto's favourite pursuits, which he saw as a form of meditation. Loaded with rods, bait and quantities of sushi[7] they set out early in the morning, Tomimoto marching ahead, weaving their way through the narrow paths in the paddy-fields for some three miles when he suddenly turned and without a word headed for home.

Intrigued, but at that point not alarmed, Leach duly followed. At the pottery Tomimoto removed a stopper in one of the spy holes into the kiln and inserted a roll of newspaper, which instantly burst into flames illuminating the shiny surfaces of the fired pots and indicating the great heat inside. Impatiently Tomimoto began hacking away the bricks forming the door of the kiln undeterred by the tremendous temperature and Leach's pleas to wait as he was putting the pots inside at risk, which if exposed to sudden draughts of cold air could crack. Deciding that he had no choice but to join in, Leach vowed never again to share his work with so impetuous a potter. Gingerly the still hot pots were picked up with thick cloths that quickly became singed, some even bursting into flames, and the firing was safely unpacked.

No quarrel ensued but when Leach commented admiringly on the quality of the glaze on one of Tomimoto's pots, which was stony and soft in feel rather than shiny and reflective, its maker snapped that he hated under-firing. The whole incident indicated the subtle but profound difference between them in terms of the qualities they sought in ceramics. In fact Leach appreciated rather than liked Tomimoto's pots thinking them technically well made, but he failed to respond to qualities he saw as 'clean, bright and hard',[8] preferring 'something warmer and gentler'.[9] Following Yanagi's interest in Korean ceramics Tomimoto took inspiration from the pots with brushed slip and slip-inlaid decoration of the Yi dynasty, developing forms in porcelain, some plain, others decorated with enamel designs, quite unlike Leach's work.

In Tokyo the Leach family settled in the residential and commercial suburb of Aoyama, in Harajuku,[10] a few hundred yards from the tramways and not far from English and American friends. The house, built to a traditional design, was raised from the ground and had a porch, a veranda, and windows fitted with paper shutters rather than glass, and was sufficiently large to accommodate a maid, a cook and the family of five. The large sitting-room had communicating sliding doors that led into the dining-room, the *tatami* matting adding to the traditional setting. David Leach, then a child of six, remembers it as having an upstairs though he slept downstairs as did the maid who helped look after the children. The house even had a garden and a separate tearoom where Leach slept. In the absence of suitable furniture Leach created his own, designing tables, chairs and a settee built by a carpenter.

Awaiting Leach was a reminder of the war in the form of a letter from the British vice-consulate, asking 'kindly let me know your age and also state whether, if under 42, you would be willing to serve in the army if called on'.[11] When Japan became an ally at the outbreak of war, Britain was fighting with a regular rather than conscript army, so sparing Leach difficult decisions about loyalty and commitment. The British government's introduction of conscription in 1916 raised the issue more urgently, but while firmly opposed to the German aggressor he still held pacifist views. A pencilled note

on the bottom of the letter records his unequivocal decision 'did not volunteer, will not serve'.

In China, Leach had kept in touch with events in Europe and was well aware of the appalling losses sustained by both sides, and his poems written on this theme were as much an expression of humanist feelings as they were anti-war:

> No life upon the street,
> No warmth in any home
> But death on every hand[12]

Another poem, 'Coffin of England', is a combination of despairing nationalism and alarm at the tragedy of war and destruction:

> England, my England
> Unconsciously you sleep.

With Leach away in Abiko designing and setting up his studio, Muriel was left to manage the home and care for the children. An early decision concerned David's education. Although initially favouring the Montessori system, away from Westharp's influence and in the absence of specialist opportunities the child was soon dispatched to a local kindergarten. Here he sang songs and quickly learnt to speak fluent Japanese to add to his English and Chinese. A year or so later he was sent to an American grammar school at Skiji, on the river, to study with other European children, travelling alone by fixed-wheel bicycle. The journey, which involved crossing the city, was quite an adventure for a young child, but his biggest fear was not the distance but getting his bicycle wheels caught in the tramlines. As the children went to sleep Muriel and Bernard often sang the traditional Japanese lullaby 'Nen nen Yo'.[13] On the whole the children were well behaved, but in a letter to Leach from the holiday mountain resort of Karuizawa Muriel indicated her anxieties and frustrations with regard to their offspring. 'I can't get any peace . . . and the children irritate me so dreadfully though I can't say they're naughty. Eleanor is the difficulty, I've nothing for her to do, the boys would be no trouble otherwise'.[14]

In the more ordered, calmer and purposeful life of Japan their marriage, though still rocky, seemed to settle, helped by spending a large part of the week apart, although doubts about the extent of their love and more precisely the depth of his feeling continued to trouble Leach. All his desire for sexual experiment, to seek out an ideal union of physical and spiritual love had been at his own rather than Muriel's instigation and he was aware that she had to deal with the emotional and painful process of discussion and reconciliation following Leach's adventures. On at least one occasion she wrote to him to affirm her love and desire. 'I want you just as much as you want me,' she wrote to Leach, adding 'I am happiest when I am most conscious of that want.'[15] In the same letter she reassured her husband that the old jealousies had passed, and was thankful 'at having got away from those days'.[16]

With his etching press set up, Leach printed plates he had made in China and cut new images based on sketches, including the Chen-mun Gate and Temple of Heaven in Peking. Experiments were also made with lithography, notably to create such evocative compositions as *Marble Rocks, Pei-tai Ho, China* in which the country took on surreal, almost nightmarish qualities. A more conventional print from this time was based on the sight of a fisherman stand-ing among the reeds on the banks of Lake Teganuma as seen from his studio at Abiko. The stooping figure is depicted leaning over the edge of his punt with basket in hand, pressing it down amongst the reeds to trap fish. The pastoral scene, with the setting sun, darkening sky and the vast spaces of the lake caught his eye and he rapidly sketched the scene, completing a soft-ground etching the following day. Its timeless, quiet mood encapsulated for Leach all that was vital about old Japan.

The tiny hamlet of Abiko, although barely twenty-five miles east of Tokyo, was an idyllic spot set in magnificent countryside. Yanagi's thatched house was picturesquely placed overlooking the six-mile-long, reed-bordered Lake Teganuma, noted for 'its frosty sunrises, red moon rises and apparitions of Fuji above the clouds seventy miles away'.[17] Not only was the setting outstanding but nearby lived several members of the Shirakaba group. These included the burgeoning novelists Shiga Naoya, whose writing was influenced by western rather than traditional Japanese literature, and Mushanokōji Saneatsu, another writer and educationalist who also looked to the West, whose New Village scheme of agricultural and educational reform was an attempt to provide a unified way of life. Regular visitors included the painter Kishida Ryūsei. The loose-knit group had echoes of a Tolstoy-inspired 'new village', a sort of rural community 'where high and low, young and old, rich and poor, would all live together in one large organic family'.[18] While it could not usefully be described as a commune it included a supportive group of like-minded artists and writers standing in opposition to contemporary materialist values.

The interior of Yanagi's house was arranged as precisely as a work of art. Strategically placed objects mirrored his enthusiasm for a marriage of eastern and western culture; scrolls with Sanskrit characters hung in alcoves, incense burners stood on furniture and large jars were placed in corners. A pen and ink sketch by Leach of Yanagi in his study captures its exotic mood and atmos-phere. Dressed in a kimono, Yanagi is shown sitting in a rocking chair by his desk on which stands a gas lamp, while on the shelves are Chinese pots and one of Rodin's sculptures, *Man Standing*, given to the Shirakaba by the artist. A visiting writer Robertson Scott, a friend of Leach and admirer of Yanagi, captured the cultural richness of the house:

> I found my prophet in a cottage . . . From the Japanese scene outdoors I
> passed indoors to a new Japan. Cézanne, Puvis de Chavannes, Beardsley,
> Van Gogh, Henry Lamb, Augustus John, Matisse and Blake . . . hung within

sight of a grand piano and a fine collection of European music. Chinese, Korean and Japanese pottery and paintings filled the places in the dwelling not occupied by Western pictures and the Western library of a man well advanced with an interpretative history of Eastern and Western mysticism.[19]

Meals were what might today be called fusion cuisine, likely to include delicacies such as *nattō* (bean cheese), often served in Leach's pots. In this rarefied, exclusive atmosphere Leach felt truly at home, as the art critic E. E. Speight observed 'happily dovetailing into such a delightful region of Japanese life', adding that only 'an artist could ever hope to have the privilege of such intimacy'.[20]

Leach designed an ingenious structure for his studio that reflected his own and Yanagi's cosmopolitan aesthetic views, its ornate roof a combination of Chinese, Japanese and European styles while the curious circular doorway was described as something only Leach could have invented. Kenzan's stoneware kiln was purchased and rebuilt. With a packing chamber of about a cubic yard and two fireboxes for stoking, Leach thought it was a size he could manage alone. A small raku kiln designed by Leach was duly erected next to the workshop and covered by a tin roof. Separating the workshop and Yanagi's house was a small, conical-shaped hill or mound enabling Leach and Yanagi to maintain a degree of independence.

During a visit to Abiko by Muriel and the children in the spring of 1917 the family experienced at first hand the power of oriental thought when a hornet painfully stung David. The village carpenter, Sako, who was building the workshop, reassured him that it could be cured. Taking the child on his knee he said, 'Be still', then repeated the words of a *sutra*, a Buddhist sacred text, and with one finger wrote its Chinese characters in the air. 'Now', he said, 'it's alright' and much to everyone's amazement, it was.[21] The incident recalled a similar event Leach had been told about by a Japanese purser. During a typhoon, passengers and crew had been thrown violently about the ship, many suffering severe seasickness. Noting the particular discomfort of a Zen priest the purser asked him why he did not meditate. Acknowledging the challenge the priest sat cross-legged, swayed with the movement of the ship and was sick no more.[22] Such examples of mind over matter caught Leach's imagination, stirring yet again his interest in the strength of oriental belief.

In contrast to the domesticity of family life, Abiko offered Leach a spiritual, intellectual and artistic home, free from parental responsibilities, where he could make, decorate and fire pots as well as discuss ideas and endlessly explore theories about art, religion and philosophy. Yanagi, his wife, Kaneko, and his children seemed content. She was a respected artist in her own right, acknowledged as having the finest contralto voice in Japan and a leading exponent of lieder. In addition to professional performances she gave many

fund-raising concerts to support Yanagi's work in Japan and Korea. From his workshop Leach not only had a spectacular view of the lagoon but could also hear Kaneko practise, the sweet sounds adding to his sense of place and purpose. It was, he said, 'the happiest year of my life'.[23]

During visits to Leach's studio Yanagi observed the development of form and decoration, and the effects of different glazes, deepening his knowledge of the technical and aesthetic qualities of the craft. Such first-hand insight stimulated him to consider the role of craftsmanship, especially in the transition from local crafts to individual, or artist craftsmanship. William Morris and the Arts and Crafts movement were again a favourite topic of conversation, with Yanagi wanting to know the equivalent English terms for peasant and folk art, or 'art of the people', as no precise Japanese term existed then or now.[24] Like Morris, who fifty years earlier had been horrified by the dehumanizing effects of industrialization, the loss of traditional techniques and of any genuine 'heartbeat' in the work and the alienation between work and worker, Yanagi was appalled by the rapid industrial changes in Japan. In his view a vital part of Japan's cultural heritage was being destroyed.

At the same time Yanagi was deeply fascinated by concepts of intuition, dualism and beauty, his ideas based on oriental spiritualism and philosophy drawn from a combination of Buddhism, Taoism, Sufism and Hinduism. All were different to western philosophy and religion, which often made use of the idea of contrast. Non-dualism he saw as evident in the finest craftwork in Korea and China, mostly made by unknown or anonymous craftsmen. The best Sung pots and Koryō celadons, widely acknowledged as superb works of art, had been created by potters unaware of producing such beautiful objects. Zen Buddhist ideas of beauty, primarily concerned with exploring meditative concepts through the austere, subdued or restrained qualities of *shibui* were intimately associated with the Japanese Way of Tea, or what was generally known as the tea ceremony. Quietness, depth, simplicity, austerity, restraint and purity were the antithesis of showy, gaudy, boastful. 'Silence like thunder'[25] was one way of expressing it. Objects used within the rituals of the tea ceremony were likely to be admired for their plainness of colour, simplicity of form and minimal decoration.

The Abiko studio, unlike Leach's earlier modest pottery, marked a more serious and thoughtful commitment in his work with clay, and in many ways was the start of his professional career as a potter. From conversations with Kame-chan he had become aware of the often overwhelming influence of traditional work, and of the need to assimilate rather than copy. As before he produced stoneware, porcelain, earthenware and raku, wide-ranging in both shape and decoration. With a growing understanding of the more austere qualities of Chinese Sung dynasty wares, with their concentration on form rather than decoration and the use of characteristic glazes such as pale green celadons and rich black-brown *temmokus*, Leach slowly began to evolve a style based on

such qualities. Typical forms included teasets, vases, dishes, bowls and plates, many with restrained brushwork decoration.

In addition to his admiration for oriental wares, following on from his earlier interest Leach was again fascinated with late seventeenth-century English slip-decorated ware, producing imaginative, highly decorated earthenware, much of it inspired by Lomax's well-illustrated *Quaint Old English Pottery*.[26] In the book's introduction, the respected ceramic historian M. L. Solon described the slipware possessing an 'essentially national character',[27] writing 'it is only in England that such attractive effects have been obtained by the use of such simple means'. Leach saw the large monumental dishes or chargers, with their vigorous slip-trailed decoration of stylized historical, mythological or biblical scenes by Toft and others, as unrivalled examples of English folk art. Their unselfconscious sense of pattern, inventive interpretation and the placing of bold designs struck him as a successful blend of skill and intuitive aesthetic understanding. These, together with the more abstract patterning of Wrotham ware, produced in Kent in the late seventeenth century, proved excellent starting points for his successful low-temperature earthenware pieces. Historical themes such as 'The Pelican in her Piety' and 'The Mermaid', were vigorously reinterpreted. Dishes, often given a border of cross-hatched lines of trailed slip that incorporated the date and even his name, included a variety of slip-trailed designs. One shows a ship with magnificent billowing sails surrounded by figure-like clouds on a blue background with 'Islands of Enchantment Bernard Leach Fecit'[28] trailed round the rim. Another carries a heraldic-like design of a lion.[29] One large dish bears a stylized flowing semi-abstract design of a running hare, its long ears virtually filling the top half of the plate, the composition evoking the animal's speed and movement. In the border amid cross-hatched slip trailing, Leach signed his own name in the Toft style.[30]

A pot in the traditional form of a tyg[31] was given four handles and a skilful design of trailed lines, with the date incorporated into the border pattern. One notable dish, about eight inches (20 cm) diameter brought together many of Leach's concerns; decorated in a trailed design of brown and blue slip on a cream ground, it depicts a skylark in the centre surrounded by a cross-hatched pattern with lines by Blake.[32] Such pieces, wrote Leach, were 'my first attempt after having started making pots in an alien country to get my feet on the ground of English tradition'.[33] Other, more whimsical pieces included a model of his kiln and workshop at Abiko, and a stoneware tea-bowl with incised decoration depicting the kiln.

Despite limited technical expertise, Leach worked alone. On his Japanese wheel he was able to throw only comparatively small pieces and had limited experience of kiln firing. While the relatively low temperatures required for raku posed few problems, the higher temperatures were far more challenging and troublesome. This inexperience revealed itself during his first

stoneware firing in August 1917. Following modest celebrations to mark the occasion, and having declined Kenzan's help, the fire was lit around sunset. Twenty-four hours later, after continuous stoking, it should have reached top heat but the glazes had not begun to melt and the store of specially split and dried pine was depleted. Other wood was used and throughout the hot night the fierce battle continued. Further frustration followed as the embers began to choke up the firemouths, the chimney became red-hot and a six-foot flame shot from its top. Covered with soot and sweat, and consuming endless cups of water to quench his thirst, Leach still found a moment to appreciate the beauty of the picturesque scene and the plume of smoke curling towards the moonlit sky.

Recklessly insistent on the kiln reaching the required temperature, in desperation friends split green wood and pulled down Yanagi's bamboo fence to throw onto the fire, creating a good deal of smoke. At one point the wooden beams supporting the roof over the kiln caught alight and were only extinguished by throwing on lumps of wet clay, adding to his despair. Eventually, after forty hours, the glazes began to shine, indicating that they had melted, and the kiln finally closed down. Exhausted, Leach was put into a bath from which he had to be rescued after promptly falling asleep. He then went to bed for a day and night. Despite his earlier experience with Tomimoto, Leach began to feverishly knock down the bricks forming the door of the still hot kiln. The results were perhaps inevitably disappointing. Over-enthusiastic stoking had caused wood ash to settle on the pots leaving rough and unpleasant surfaces; only the pale green celadons, or *seiji*, had worked, taking on a depth and richness he had not before achieved. It was a salutary lesson, demonstrating that not only was firing a skilled job but that a smoky flame, the result of using the damp wood, produced the richest greens.[34] Having stubbornly refused Kenzan's help and expended much effort and wasted a great deal of wood he was rewarded with barely half a dozen acceptable pieces. On Kenzan's advice he adjusted the kiln to increase the draught and gratefully accepted his offer to help with the next firing.

As soon as pots were fired Leach showed them in Tokyo where they received much attention, partly from curiosity as to what this Englishman produced, but also because of genuine admiration for them despite their technical limitations. Their combination of oriental and western qualities possessed an individual, living quality quite unlike work produced by most Japanese studio potters. This response was succinctly summed up by Takamura who, although still withdrawn from city life, wrote to Leach that his pots were 'full of science. Everyone is you. I couldn't help feel your presence. I recognise your eyes in some potteries, some smiling, some piercing, and I heard your voice'.[35] It was recognition that Leach was evolving a distinctive style.

In addition to making pots, Leach continued to work as a designer, handling a range of different materials to produce functional and aesthetically

pleasing objects that called on his sense of decoration and intuitive awareness of materials. Initially he designed items of furniture in response to practical need. 'I became tired of sitting on the floor and wanted support for my long legs . . . a little more comfort and a rest for my back,' wrote Leach.[36] A range of his work as designer and maker at the Ruisseau, or Ryuitsusō, Gallery, Kanda, in 1919, included both decorative and functional objects, which, according to Yanagi, were highly thought of to 'judge from the number of orders that he received for them'.[37] Bookcases, sofas, chairs, carpets, block-printed textile hangings and heads in raku and porcelain for women's hat pins were described as 'very close to life, to living, and very exotic and very unusual'.[38] Furthermore they were thought 'suitable to Japanese conditions of life . . . embodying . . . European as well as Oriental ideas of decoration'.[39] Perhaps the reviewer had in mind the upholstery of a sofa and chair, which were inspired by the stitched and quilted style used for Japanese firemen's coats, ingeniously designed so that as the material sagged it could be stretched taut by pulling it through the frame.

Characteristic pieces included a set of three-legged chairs fashioned out of cedar wood. Having discussed his design with a local carpenter, a length of suitable wood was chosen and cut to follow the natural curve of the grain, rather like the shape of the human back, to provide sufficient pieces for a number of chairs. The simple decoration consisted of pierced holes, scrolled tops and cross-hatched patterns. Following local tradition the surface was darkened by singeing it in flame and ashes before being given a soft polish. The natural qualities of the wood and joinery, which made no attempt to conceal its structure, can be seen as falling within the Arts and Crafts tradition, a curious hybrid of oriental and occidental design. One corner of the Kanda exhibition recreated a western domestic interior with three of the chairs placed around a table on which stood a white western-style teaset, complete with teapot and milk jug. Printed hangings decorated the wall, and on the floor was a patterned carpet.[40]

Keen to establish high-quality outlets for his work in Japan and overseas, Leach pursued the idea of joining the Artists' Guild, Chicago, to sell craft work and etchings. Contact was also made with a Mr Gurrey, an art dealer in Honolulu. Etchings were dispatched as was a quantity of porcelain, which included a celadon biscuit box and a blue and white cake dish. Earthenware items included a bottle, dish, and a coffee set. Other customers in Honolulu wrote asking for prices and availability of work, but America's entry into the First World War in 1917 depressed trade and resulted in slow sales.

As a natural showman and publicist Leach courted the press and media, shamelessly exploiting his status as a foreign artist, in giving public lectures, writing letters to newspapers, publishing provocative articles and broadcasting. As a western-educated artist he saw part of his responsibility as that of cultural commentator responding to current developments within the art

world and offering views on European art. He was at his most vehement and forthright when expounding on the iniquities of the Japanese artistic scene, its seeming willingness to herald the weak and imitative and its reluctance to embrace the inventive and challenging. In a six-page article, 'Living Art in Japan',[41] he accused Bijitsuin, the Fine Art Society, of having lost its way. 'Why have the Japanese abandoned their splendid heritage of eastern art? Why are they imitating the West?' he thundered. In tracing the influence of Post-Impressionism on Japanese art he picked his way through the various strands and exhibitions, lamenting the interference of the department of education 'who', he declared, 'did not hang the best work'. Shows organized by Shirakaba were praised, for they 'encouraged and voiced spontaneous and independent art in Japan', as was the work of the Sōdosha group, whose paintings he judged 'realistic and rhythmic'. What Japan required, Leach concluded, was 'the advent of a genius who shall have enough creative force to bridge the gulf between East and West',[42] a concern central to his own work and a subtle implication that he could create such links. In a long article on modern Japanese art for *Asia*, the journal of the American Asiatic Association in New York,[43] he took up a similar theme in outlining the complex politics of official art.

Lecturing on the astonishing Tang figures and animals produced in China from AD 618 to 905, many of which had come to light during the construction of the Peking–Hankow railway, he was full of praise for the skill and sensitivity of the stylized figures and animals. Leach did acknowledge that 'such facts I owe to Mr Takume Kuroda'. The objects, Leach suggested, indicated links between vastly different cultures. In his view the Tang horses were of pure Arab breed suggesting such creatures might have been specially imported, thereby implying a close relationship between the two cultures. Comparisons were also drawn between the Tang models and the Tanangra figurines made in ancient Greece and around the Mediterranean some one to two thousand years earlier, suggesting that there may have been a long-forgotten connection. Although scholars now discount such possibilities, the attempt to suggest ancient cultural links between East and West opened up discussions and intriguing possibilities.

When giving his first radio broadcast in his elegant but still limited Japanese in 1918, Leach went to great trouble to write out his talk in long hand to ensure that what he had to say was as correct as he could make it. To his horror he found that after thirty minutes he had finished his script, and alone in the studio and live on air he had to improvise for the remaining quarter of an hour.[44] In the future he decided that following a prepared series of headings was by far the best method, a system he successfully adopted for talks and lectures. As a speaker Leach had an innate ability of seeming to address each member of the audience, often capturing the right mood in combining seriousness with light-hearted good humour, a skill he carefully honed over time.

Having heard much about Korea, admired its art and architecture and become aware of its long history of ceramics, Leach fulfilled a long-held ambition to travel to the county with Yanagi some time in 1918.[45] While Yanagi felt a sense of loyalty to his brother-in-law, who held office within the colonial service in Korea, he did not approve of the Japanese occupation. Although the appointment of a Japanese governor-general had led to social, economic and political change resulting in the production of cotton, the development of the fishing industry and the establishment of international trade, the Japanese had also introduced profound changes in the cultural and spiritual life of the country. This resulted in Chinese classic and Confucian doctrine giving way to Shintoism, the indigenous religion of the Japanese, and the setting up of religious shrines against the wishes of the Koreans. Japanese control of Korea was brutally enforced, and in 1919 the country was declared to be an integral part of Japan. Korean protest was ruthlessly suppressed.

As Yanagi came to know and admire Korean folk art, he felt such changes threatened indigenous Korean culture, and put its inheritance at risk. It was not a popular view. The writer Tomitarō Suzuki, for example, believed that Japan's annexation of the country 'was not a curse . . . but a blessing',[46] and applauded the success of 'Japan's militarism'. Yanagi sought to demonstrate his disapproval of 'the heavy hand of Japanese militarism'[47] by supporting protest movements against the occupation of 'The Land of Morning Calm', and in 1919 published an article that expressed empathy and affection for the Korean people and respect for their culture. Acknowledging the beauty and quality of Korean art he argued that it should be properly collected,[48] and despite great difficulties he helped set up the Korean People's Folk Crafts Museum in Seoul in 1924, the first such institution in Asia.[49] Yanagi's pro-Korean stance brought him to the attention of the police, and he was put under observation for possible subversive activities.

The term 'the beauty of sadness', coined by Yanagi to suggest the flavour of Korean art and craft and the country's long dark history of successive foreign invasions, appealed to Leach's poetic imagination. Although having overtones of the 'aesthetic of colonialism', the term seemed to capture many of its qualities. These seemed especially evident in Korean pottery expressed in the 'sad and lonely' lines, insecure balance, passive and hidden inlay techniques and mournful designs such as 'willows and ducks' and 'flying cranes and clouds'. Such sadness could also be seen in the Korean preference for white, a colour associated with mourning, retreat and withdrawal.[50] The power of Korean ceramics on Yanagi was movingly brought home when one day Leach entered his study and found his host lost in a reverie, slowly moving from one Korean pot to another gently stroking each in turn. Awed by the intimate scene he stood in silence before Yanagi turned to him and said 'I am visiting my Korean friends'.[51] The incident reminded Leach yet again of the way the Japanese were able to 'find a unique language of aesthetic

communication in pottery',[52] and the accuracy of Yanagi's observation that 'Japan is a potter's Paradise'.[53]

The two Asakawa brothers, Noritaka and Takumi, directed Yanagi's investigations into Korean ceramics. The Chosōn faceted white porcelain jar decorated in underglaze blue, in what came to be known as the autumn grass style, presented to him by Noritaka in 1914, seemed to capture all the mystery, strength and delicacy of the ware. Both Yanagi and Leach benefited from Noritaka's first-hand knowledge and his fluency in the Korean language, and he corresponded with Leach, encouraging him to look afresh at the qualities of Korean pots.

The exact date of Leach's visit to Korea is not recorded but it may have been in autumn when the weather was warm by day and refreshingly cool at night, thereby avoiding the intense cold of the winter and the unpleasant sticky heat of the summer. As their ship sailed into the deep and sheltered bay of Pusan on the south-east coast, within sight of the Japanese island of Tsushima, Leach looked forward to the visit. Since the occupation the port had flourished. Post offices, schools, station houses and roads had been built, with Japanese owning shops, working in offices and teaching in schools, the rapidly expanding community including around 6,000 fishermen. From Pusan they made the ten-hour train journey of nearly three hundred miles to the capital, Seoul. Immediately Leach was struck by the monumental splendour of the ancient city surrounded by walls twenty feet high with battlements and loopholes built for archers and with eight great gates consisting of a tunnelled passage surmounted by a single- or double-storey projecting tiled pavilion.[54]

Leach's impressions were very different to an earlier traveller, who had little but contempt for the Koreans, describing them as a

> dirty people who insist upon dressing in white, wear cotton, padded in winter. Always wear hats, have headpiece accommodated to every situation and almost every incidence in life. Men wear hair long twisted into top knot. Women have a peculiar arrangement of dress by which a short white bodice covers the shoulders, but leaves the breasts entirely exposed; while voluminous petticoats, very full at the hips, descend from a waist just below the armpits, and all but conceal coarse white or brown pantaloons below'.[55]

By contrast, Leach was charmed by the habits and customs, marvelling at the 'strange horse hair hats of the married man – raised an inch above their heads on bamboo frames to provide a flow of cool hair in hot weather; the lilting shape of the foot gear; women beating washing on flat stones in the clear flowing water of river-beds, the lovely dark hair resting on the napes of their necks. In warm weather cool light linen clothing'.[56] He did, however, share the earlier traveller's profound reservations about the hotels and food.

Aware of Yanagi's complex political views on the occupation, Leach tended to draw back from commenting, seeing it as an issue for the people of Japan and Korea. Instead, he preferred to concentrate on the architecture, explore archaeological sites and investigate traditional crafts, many still practised as they had been for hundreds of years. What stuck him most was what he identified as the supreme beauty and grace of Korean line, 'whether in landscape, hats, shoes, pottery or poetry',[57] and also evident in the lines of the granite hills and the curved roofs of the buildings. To his eye this was characteristic of the country.

Korea and its art made a deep impression, with Leach responding as much to the atmosphere as to the beauty of the objects. 'I heard its rhythm on a Korean lute: I saw it in brass and iron and silver and gold; and in the pots of Korea it led me into the maze of heaven,'[58] was his enthusiastic response. So deeply did he identify with the country that on board the train back to Pusan he experienced an overwhelming sense of sadness, feeling that he had 'left a part of myself behind and the rest of me cries out with the pain of separation'.[59] As the train moved slowly south Leach watched the distant hills surrounding the city 'rise and fall in long beautiful lines',[60] the 'fingertips of those Northern hills rise over the horizon less frequently as we recede'.[61] He was, he thought, leaving something that was almost a part of himself. 'I have loved line all my life, why did I not go to Korea before?'[62] In his impressionistic and romantic memories there is the suggestion that he was not only leaving a country he had found fascinating but that in it he had recognized some of the spirit and awareness he himself was seeking, and which he had also experienced in China.

The conflict for artists between adopting modern western styles and the urge to follow traditional work, seemed to Leach to be a metaphor for deeper problems brewing on a national scale, between 'radical democracy and individualism on the one hand and military imperialism and communism on the other'. While full of opinions on most issues, Leach generally avoided national politics, but the ominous developments, inspired in part by growing militarism and nationalism within Japan, could not be totally ignored. Following Yanagi's openly expressed disapproval of the Japanese government's brutal involvement in Korea, the special police regularly tampered with his letters written to Leach and others, sinister signs of increasing state control that made him uneasy. Tomimoto, too, felt growing anxiety at the developing authoritarianism of his country. Writing to Leach he drew an analogy between art and modern life: 'I doubt to whom the message of quiet Chinese celadon and of the collection of Korean Pottery at South Kensington will deeply penetrate. If there be such a one who can perceive the spiritual content of such quiet loveliness he must begin to appraise the self-containedness behind the blood-shot excitability of his daily existence.'[63] Tomimoto's foreboding about current political developments was summed up in a terse but telling potter's analogy

'Half-baked modern Japan, under-fired great Japan'. In response to such destructive political and social developments he preferred to remain in the country for a life of quietness and contemplation. 'Nearly everyday I will come down to the Yamato river for the fishing. At the place I will sit down and will watch the water, as the old Chinese did, thinking by fishing'.[64]

The depressing political situation in Japan prompted Bernard and Muriel to consider their long-term plans, especially for the education of the children. Provoked in part by the death of Muriel's mother, which stirred a desire to see her father and introduce him to the children, the question was when rather if they would return to England. Both Muriel and Bernard were also beginning to feel the need for their own country and decided to return to England within two years.

One of the most significant meetings in Abiko was with the young ceramist Hamada Shōji.[65] Writing to say how much he admired Leach's work, Hamada's clear handwriting, good English and the directness of the message made a strong impression and he was invited to visit. It transpired that for some years Hamada had appreciated Leach's etchings, but most particularly his pots, seen in exhibitions at the Mikasa Gallery in Ginza, the Ruisseau Gallery and at the Sankaidō. Although he 'looked forward to seeing some changes in the display', he was undeterred by the fact that the 'works never seemed to sell; they were always dusty'.[66] Kishida Ryūsei's confident Post-Impressionist portrait of Leach had also impressed him by the way it seemed to capture both the strength and mystery of the artist. In Tokyo, Hamada rarely missed searching out Leach's work, and was particularly taken by the recycling of unsold drawings, noting that they would often make a reappearance, sometimes years later. This, he deduced, was not arrogance but the artist's confidence in his own work and the buyers' failure to recognize its quality.

Since childhood Hamada had been fascinated by the fine and applied arts of the West and, encouraged by his father, studied English as part of his appreciation of its culture. As a schoolboy he scoured second-hand shops dealing in western furniture sold by foreigners returning home, and later bought a few pieces that further stimulated his interest. Taking to heart Renoir's remark that 'If half the would-be painters in France were transformed into craftsmen, it would benefit both painting and crafts',[67] Hamada reasoned that 'even a bad pot has some use',[68] and duly enrolled at the Tokyo School of Technology (later Tokyo Institute of Technology), the only school then teaching ceramics. Here he was taught by Itaya Hazan,[69] a distinguished potter who was one of the leaders of the group of contemporary craft ceramists, who lived near the pottery town of Mashiko.[70] In the work of Leach and Tomimoto, the young would-be potter had seen the direction he wished to follow, but at the college emphasis was given to laboratory work. In the third year a measure of freedom allowed the students limited opportunity to follow their own ideas, but throwing was still only taught for two weeks and it was possible to graduate without

ever touching clay. For more practical experience, Hamada went regularly each Sunday to a ceramic workshop that sold clay and fired pots. A more senior student at the school, Kawai Kanjirō,[71] introduced himself to Hamada and with their shared interest in artist pottery forged a lifelong friendship. After graduating in 1914 Kawai worked at the Kyoto City Ceramic Research Institute where he helped Hamada get employment two years later.[72]

Although Hamada had first seen Leach's work in 1914 and spoken briefly to him at an exhibition, he had modestly refrained from introducing himself. The three-day meeting at Abiko was very different for they talked constantly. 'Here was someone who was obviously sensitive, who had a broad and easy flowing sort of mind,'[73] noted Leach approvingly. Not only did they discuss pots and the direction of the craft, but Hamada also answered his technical questions and provided sound explanations of reduction firings and the way glazes worked. Hamada also spoke of research into the reproduction of ancient Chinese glazes such as green celadons and rich black-brown *temmokus*. 'I had not met anyone with whom I could fully communicate as a potter,' purred Leach 'and here was a Japanese who spoke enough English, which combined with my Japanese such as it was, so that we could converse freely.'[74] In addition to Leach's pots, Hamada admired his sketches of swallows and pigeons with peculiar tails, and was enthralled by etchings of the Temple of Heaven, a church in Chelsea and Hakone. The visit to Abiko and further contact with Leach convinced Hamada to become a potter. During a visit to Hamada's studio Leach noted that he had made a pot so large that it was too big to carry through the door, leading him to conclude that acquiring skill was more important than producing completed pieces. Through Hamada, Leach also became a friend of Kawai.

Shortly after Hamada's visit a disastrous fire destroyed the Abiko workshop and all its contents, bringing the rural idyll to a dramatic end.[75] It was Leach's eleventh firing and though it had taken longer than usual appeared to be relatively uneventful. Exhausted, Leach had fallen into bed still covered with the grime and soot of the firing and was awoken by Yanagi Kaneko banging on the shutters in the early hours of the morning shouting 'uchi ga nakunatta' (your house has gone). Pulling on a few clothes Leach rushed to the studio and to his horror found a smouldering ruin. The radiant heat from the kiln's chimney had set the workshop roof alight and the entire building had been destroyed and with it his notebooks, glaze recipes, reference books, tools, old specimens, textiles for his exhibition, designs and drawings, jeopardizing a planned exhibition intended to raise funds for his return to England. In despair Leach took a fisherman's punt and poled to a quiet retreat among the reeds to contemplate his fate. Only the kiln and its load of pots survived, which ironically had been beautifully fired.

Hearing of the fire, Viscount Kouroda sent Naka Seigo, proprietor of a gallery in Tokyo, with a proposal to erect a new studio for Leach on his land

at Kōgai-chō, Azabu, in Tokyo. In an article some years earlier Leach had defended Kouroda's painting of a naked female figure after the police had insisted that a curtain be hung over the bottom half of the picture. Perhaps he recalled that support when he generously offered to finance a new studio on the condition that he would be able to use it when Leach left Japan. Such a gesture, Yanagi declared, was in keeping with old Japanese custom and Leach gratefully accepted.[76]

To be near the new studio Leach and his family moved to Komazawa[77] in Tokyo, and when detailed plans for the workshop were drawn up, during the hot months of July and August, Leach and family retired to the mountains at Karuizawa for 'drawing, making patterns, walking, sometimes playing tennis'.[78] Here, occasionally with Yanagi and Kaneko, they read, talked, walked and socialized with the established European community. On a more mundane level it was in Karuizawa that the boils from which Leach had suffered were finally cured. Whether it was the yeast treatment, the healing air of the resort or his more relaxed and purposeful life that did the trick is not clear.

Expeditions to the ringed crest of Asama were dramatic for they had to take care to avoid the belching sulphurous smoke of the live volcano. Nevertheless they enjoyed the novelty of burying and cooking eggs in the fragments of hot lava near the top. Large and luscious bilberries were picked from bushes planted by missionaries years earlier, and before breakfast Leach gathered chanterelles, the yellow funnel-shaped fungus growing in profusion at the foot of the tall trees. On their final visit, Leach and his son David, then ten, climbed one of the tallest trees, some fifty feet high, to admire the unspoilt landscape. The mountain holidays took on a golden glow, a safe refuge away from the stresses and anxieties of city life.

It was in the invigorating air and spectacular scenery of Karuizawa that Leach fell under the spell of the missionary teacher Father Herbert Kelly,[79] an Anglo-Catholic and 'thinker of the Church of England'. Among other achievements Father Kelly helped establish the Society of the Sacred Mission and Kelham Theological College (1903), Nottinghamshire, in buildings designed by Gilbert Scott. Tall and ascetic, Father Kelly, then in his fifties, was in Japan as a professor at the newly opened Central Theological College in Ikebukuro. He remained until 1919, establishing wide contacts, and many Japanese priests studied at Kelham until it closed in 1973. Despite not speaking the language, Father Kelly described his time in Japan as the happiest of his life.

What drew Leach to Father Kelly was not only his deep, unquestioning faith, but also his rejection of conventional expressions of religion. His belief that 'God is not the same as religion',[80] that 'life was part of a whole', and that 'God is part of every aspect of life', concepts evident in the work of Blake and to some extent Whitman and Carpenter, were close to Leach's ideas. In seeking to bring his students back to 'the plain issues of faith in the reality of God',[81] Father Kelly taught them to see the absurdity of the ornate but

seductive language of the church. His paradoxical style was reminiscent of the sages of Zen Buddhism who judged their followers by their response to difficult and often apparently contradictory questions. Father Kelly's desire for a faith that was unifying but undogmatic, fascinated Leach.

Other friends with whom they went on holiday included Harold and Winnie Spackman, an Anglican priest and his wife, also engaged on missionary work, who with Father Kelly and the Leaches went climbing at Karuizawa. A dedicated mountaineer, Father Kelly delighted in taking what to the ordinary eye were considerable risks, a trait Leach found both intimidating and exhilarating. Such self-imposed tasks were part of Father Kelly's religious belief, a means of testing courage and faith through physical stamina and the confrontation of fear. For the others, these difficult climbs were often a matter of dogged endurance, of taking a calculated gamble. During one climb, recalling the episode on the Bournemouth cliffs, Leach found himself stuck, unable to move forward or back, although when Muriel calmly stepped over his body his fear was dispelled. Later in life Leach recalled both incidents as having symbolic significance, each representing a state of terror and impotence and capturing doubts about his emotional and artistic direction.

In a world plagued with doubt, Father Kelly's steadfast belief and 'knowledge and wisdom' seemed rock-like, offering a type of spiritual guidance for which Leach craved. Serious climbing involved an element of danger, an acceptance of some sort of mental as well as physical challenge, and Father Kelly's testing of physical perseverance and steely resolve seemed a way of dealing with inner fears, of controlling the mind through control of the body. Through these mountain expeditions Leach gradually overcame his fear of heights to the point where he was able to look down 'onto the flat lands of Japan far below' without panic. So inspired was Leach by Father Kelly that he made a pencil sketch of him, which he subsequently gave to the Spackmans' daughter Katherine.[82] Still searching for a faith to fill the vacuum left by his rejection of Catholicism, Father Kelly's quiet strength and deep conviction seemed to Leach at least a partial solution.

By the end of the summer the new studio was completed and staffed by a young assistant and an experienced potter named Hayashi, a man of about forty, who in Leach's view was 'excellent . . . not only ready to work but able to keep a workshop in order and to deal with the lad, a young fellow who carried out such jobs as preparing glazes and clay . . . This was wonderful. I was able to get to work again'.[83] After Abiko it seemed like luxury. With the services of a skilled potter he designed and directed production, and as a result the shapes became more ambitious and accomplished. This is particularly evident on such complex forms as a green-glazed raku teapot fitted with a bamboo handle, which is assured and confident, its full swelling form decorated with a characteristic Leach design of a stylized and simplified pine tree. A stoneware teapot with a rounded bottom with three stub feet

recalling silverware, decorated with a painted design of a bird and leaves in grey-blue, reminiscent of Ming dynasty ware, is equally professional. Leach's broad range of shapes included vases and bottle forms, many derived from Korean ware, as well as bowls, dishes and lidded pots in earthenware, stoneware and porcelain.

With production underway, Leach commented with patriarchal insight that it was 'the right relationship between artist and artisan'.[84] To his surprise and pleasure the problem of acquiring suitable glazes and technical information was resolved by the generosity of his fellow potters who supplied recipes, disproving Tomimoto's remark 'Don't ask Japanese potters about potting because they won't tell you the truth'.[85] The most generous help came from Hamada who answered all Leach's many questions. Such generosity persuaded him of the benefit of open and free knowledge, and may have influenced his decision to later publish substantial practical information. Between January and April regular firings resulted in seven loads of pots.

By late 1919 plans to return to England were well advanced. A deciding factor was a letter from Edgar Skinner,[86] a friend of Muriel's father who had retired to St Ives, with details of a new enterprise, the St Ives Guild of Handicrafts. This was set up by a local philanthropist Frances Horne, a wealthy patron in her own right and the wife of a successful dealer in Far Eastern commodities such as rice and tea. The Hornes had settled in St Ives at Carbis Bay, built a large house, and acquired property for the Guild, which opened in April 1919 to provide a focus for hand-workers to 'stimulate and encourage the creation of handmade objects for use in the home, or for personal requirements'.[87] To add to hand-loom weaving, basket-making and embroidery, Skinner either discovered or more likely proposed that a potter would make a positive contribution to the venture. Knowing of Leach's intention to return to England Skinner spoke to Mrs Horne, a correspondence ensued and with the help of a capital loan and an assured income for three years Leach agreed to set up a studio pottery in St Ives.

The more Hamada saw Leach at work the more impressed he became. During a visit to Azabu he was enchanted by Leach's inventive designs, in particular one showing the three monkeys, see no evil, speak no evil, hear no evil, produced at Kouroda's request to mark the Japanese Year of the Monkey. Hamada saw Leach's pots as part of the modern movement, an artist who was aware of but not daunted or overwhelmed by tradition in seeking to identify and position the work of the artist craftsman within the wider concerns of contemporary visual art.

Hearing of Leach's plans to return to England to set up 'a semi-Oriental type of pottery',[88] Hamada immediately asked to accompany him, basing his request on his desire for practical experience and aesthetic development. Offers of ceramic work in China and Japan were turned down by Hamada as they conflicted with his intention of becoming a studio potter. Only Leach and

Tomimoto were producing the sort of pots he admired, and as Tomimoto had spent time in England he felt he too would benefit from similar experience. It was also an opportunity to stand back from Japan, to see it from afar, and to try and make sense of his own country.

The idea of Hamada accompanying him to England was not only flattering, but as Leach quickly realized would bring useful technical knowledge that would be a great asset. Mrs Horne duly gave permission to bring 'a good Japanese assistant',[89] though the three businessmen who had sponsored Hamada's education had yet to be convinced that Leach was a suitable person to guide and lead their protégé. One night, in the middle of a firing, Leach was visited by the three wise men backing and advising Hamada, all of whom had retired from their main activity in life.[90] The consensus was in Leach's favour and it was agreed that he work at St Ives for about three years. Shortly before leaving Japan, Hamada was handed the not inconsiderable sum of 1,000 yen.[91] This was an understood and accepted part of patronage requiring no acknowledgement other than that it should be used constructively. Again Hamada was reminded that 'on the journey, say at Hong Kong, if you think you have made a mistake, do not hesitate to come back at once, we shall cover your expenses'.[92] In preparation for the move, Hamada researched basic materials. While Leach intended to seek out Cornish materials he nevertheless proposed to take some from Japan. Hamada collected various glaze ingredients, investigated coloured pigments, acquired glaze recipes, and sketched potters' wheels.[93]

For his farewell exhibition Leach mounted an ambitious show at the Ryuitsusō Gallery in Kanda and the Takashimaya department store gallery in Nihonbashi, Tokyo,[94] of some 2,000 pieces of raku, stoneware and porcelain, plus drawings and etchings. Sales were good, resulting in a profit of £1,000, which provided funds for the journey to England and the St Ives venture. Notices in the press were favourable and respectful. In the *Japan Advertiser*[95] the reviewer, recognizing its significance in assessing Leach's achievement was generally enthusiastic. While acknowledging that not everyone would be attracted by all of the work, he thought that many would recognize in it 'the absolute sincerity of his art . . . an individual effort to express the spirit of beauty'. The new pieces, he observed, 'show marked development and the artist's technique has improved with the experience acquired by assiduous practice'. Given the services of a professional potter, such improvements were hardly surprising.

Writing in the same paper two days later the critic E. E. Speight[96] was more fulsome and complimentary, identifying aspects of the work that were particularly important to Leach and the reception of his work in Japan. 'In this pottery Old England and Old China meet, just as East and West meet in Norwegian folk-art,' he wrote. For Speight, Leach's true genius lay in the drawings and etchings, which he saw as visionary, 'teeming with mystic life just

passing into half-recognisable form . . . wonderful concourses of fantastic creatures for which we have no nearer words than dragon, centaur, goblin or wraith'.[97] He identified 'an outward movement, partly vertical, partly radiant, intensely symbolic, and ominous of great powers to be unfolded'.

Accompanying the exhibition was a hastily put together privately printed volume entitled *An English Artist in Japan*, carrying lithographic reproduction in facsimile on handmade paper and writings by Yanagi and Tomimoto, the artist Kishida and Leach himself, plus over thirty illustrations. Takamura's contribution arrived too late to be included. It was part catalogue in listing the drawings and etchings, but mostly an uncritical celebration of Leach's artistic achievements, which Kishida saw as 'produced by a pure spiritual sense under the domination of a strict aesthetic criticism'. It also expressed Leach's infatuation with, and the debt he owed to, the orient.

A contribution from Yanagi gave information about Leach's pottery at Abiko, and stressed the difficulties he had faced in handling such processes as firing the kiln. He also highlighted Leach's achievements and demystified the creative process by stressing the sheer hard work involved. Both Yanagi and Tomimoto touched on their close friendship with Leach, and the exchanges of ideas and experiences. In acknowledging his ability to get beneath the skin of both oriental and occidental culture, Yanagi wrote 'He is trying to knit the East and West together by art, and it seems likely that he will be remembered as the first to accomplish as an artist what for so long mankind has been dreaming of bringing about'. A subtle note of criticism came in Yanagi's somewhat over-modest observation that 'his present work is still far from the excellence of the ancient Sung or Korean masterpieces', and in view of such a remark rather needlessly pointed out 'that his technique leaves yet something to be desired'. However, he went on to say that despite such limitations Leach was a fine artist who 'knows what beauty is, and he knows the way he must tread'.

As part of his own writing Leach mused philosophical on the nature of existence, often expressed in crisp, short aphorisms on life, confessional writings in the form of dreams, almost apocalyptic in flavour, and a selection of poems written in the previous five years. Informing virtually all of his writing was recognition of a broad acceptance of religion and an unexplained but vital awareness of spiritual belief. 'Every work of art indicates an attitude towards God', he wrote, echoing Ruskin's view that good architecture and art must be religious in spirit. In assessing his eleven years in the East he acknowledged its abiding influence on his work and ideas. 'I bid farewell to two Japans with an equal heavy heart: the past like a fragrant bowl of tea whose lip I have caressed, and you young man of the future, earnest, striving, uncouth, whom I have lived among and loved like a brother. Farewell you isles of enchantment, You friendly home of Art!' His analysis of what he saw as the deep-seated differences between East and West were interpreted in terms of gender,

perceiving the East as intuitive, restful, inner and female, the West as male, concerned with reason, action and the outer. These ideas were reinforced by what he saw as a global need for societies and cultures to accept differences, and optimism that such understanding was possible. 'The meeting of extremes, whether it takes place in Japan, America, Russia, or China, come soon, come late, holds out the promise of the first complete round human society'.

Of the five poems, two were laments for the horror of the war, for example:

> Who will keep
> The flags of war
> Perpetually furled.

The others lyrical celebrations of the beauties and delights of Japan:

> Deep in my heart
> There flows a stream
> Of melody —
> Out in the garden
> There grows a tree
> Laden with flowers
> For the honey bee.

The three dreams are perhaps the most curious, most perplexing and most revealing in describing aspects of anxiety. In 'A Strange But Pleasant Dream', centred on Father Kelly, Leach felt he was letting the priest down in some way. This theme was also taken up in 'A Terrible Dream' in which he was unable to save his friend Reggie Turvey from being sucked into the slime of a swamp. The third dream, 'Nightmare', described his fear of being fed to a fantastic animal, which was so frightening that even when he woke up the terror stayed with him. To Leach the dreams were both revelatory and symbolic, relating both to his desire for artistic success and his involvement in the supernatural and spiritual. Far from suggesting someone at peace with himself, the dreams recall times in his life when he seemed about to be swamped by emotional catastrophe. The fact that he went to such lengths to record and disclose the dreams suggests their importance to him, and that by including them, in what was a valedictory publication, he was opening both himself and the dreams to a range of interpretations. From Westharp he was likely to have gained some understanding of the significance of dreams in Freudian analysis, though to what extent he submitted himself to such a procedure is unclear. The inclusion of the dreams in a book that was essentially a reflection on his life in the East implied a willingness to disclose inner fears and anxieties, even if in a highly coded form. Certainly the nightmare that he first recorded as a young man in London (discussed in detail in chapter three), suggests that he continued to be troubled by emotional and artistic insecurities.

In the Baron Iwamura lecture, given to the National Society of Fine Art,[98] Leach took as his title 'Ten Years in Japan'. Speaking movingly and honestly he referred first to the period when 'the spring dream was over', when he hated the food, the country's geological make-up, the music, and the 'unbearable smell of sewer' that pervaded the corridors of the houses. He was also critical of Japanese teaching methods based on imitation. However, he argued, great promise lay with younger artists who were able to assimilate and respond to western influences without losing a sense of their own national identity. Both in its command and confidence Leach saw himself as taking up the Ruskinian ideal. 'I thought of John Ruskin as my father . . . I thought he was beautiful and I still like him very much . . . he was very serious man.' For all its arrogance it was a *tour de force*, commanding in its sweep of art, society and education. Following his early disillusionment, Japan had been transformed into 'the isles of enchantment' where Leach had found direction and status as an artist. For the Japanese he was a European who had sought to understand eastern culture, and express this in his work; while remaining essentially western, Leach, like Hearn, was seen as having touched the soul of Japan. Artistically he was developing an identity of his own, associating on equal terms with progressive artists, writers and thinkers of the day, well aware that the pots that he, Tomimoto and Kawai were producing were different from contemporary Japanese studio potters.

In a magazine interview, Leach contrasted his position as an individual artist with that of Kōetsu Hanami, brother of the first Kenzan, a traditional artist craftsman whose main business was 'faithfully to carry on a tradition, to family, guild or craft', pointing out that no such reassuring structure existed for him. 'We have no traditions to carry on; factories, city life, science, education, travel have taken the old shelters from us . . . All the folk-law, the country traditions which determine the shape, size and pattern of all decorative objects is dying out.'[99] His final question, 'On what basis does a modern craftsman stand?' was one he continued to ask throughout his life.

Farewell preparations included a party at Abiko arranged by Yanagi and the disposal of furniture and goods. A cabin had been booked on the NYK *Kamo Maro* leaving Yokohama for London in June, where at the last minute a single cabin became available for Hamada. During the long voyage the family got to know Hamada, who proved to be affable and friendly with a gentle sense of humour, and a great success with the children. With endless patience he spent much time playing with them on deck, teaching David to swim in a makeshift canvas swimming pool by urging him to dog paddle from one side to the other. Such diversions were a particular relief for Muriel, for she was seven months pregnant and was suffering from the heat. The ship's doctor Dr Nishimura was on hand, but she was steadfast and uncomplaining. On board were their old friends Harold and Winnie Spackman.

During a stop in either Shanghai or Hong Kong Leach greatly admired the Chinese bowls of the Tz'u-chou type being used by coolies on the quayside. When he discovered they were modern he acquired a set for about a penny each, the bowls remaining in daily use at St Ives for many years. In Singapore, Leach and Hamada, anxious to taste a genuine Malay curry about which they had heard so much, rushed from one hotel to another in search of the real thing. To their surprise they were directed to a shabby-looking Arabic cafe, but in a true spirit of adventure explored what was available, randomly picking out dishes. Each proved to be hotter than the last giving them the impression that their lips were on fire and their faces burning. They cooled off by consuming copious amounts of delicious ice cream at Raffles Hotel. At Colombo they again wanted to sample the subtleties and flavours of genuine Indian curry and, accompanied by Muriel, went ashore. The brief visit included a trip of about five miles to Mount Lavinia, travelling in a *gharry*, a conveyance consisting of a box on four wheels pulled in this instance by a thin horse.

By inclination Leach was a planner and much time was spent on making lists and drawing up schemes. The task was daunting. Not only had he to establish a home for himself and his family but also create a studio workshop in a country of which he had only limited experience and only the vaguest notion of how his pots would be received. In leaving behind the potter's paradise of Japan he was opting for a future, which, if uncertain and unknown, was full of promise and hope.

AN ARTISTIC POTTERY

England

1920–1926

With Muriel heavily pregnant and three lively children to attend to, Leach was relieved when the ship sailed up the Thames to Tilbury docks, although the dirt and grime, the rows of 'mechanical, uniform, ugly'[1] suburban red brick houses, their chimneys emitting plumes of acrid grey coal smoke, seemed a depressing contrast to Japan. The bleak impression was compounded by the fact that while 'hundreds of Japanese had seen them off with tears in their eyes',[2] there was no one to meet them as they disembarked. Paradoxically, Hamada was met by two friends who whisked him off to his hotel. The low-key arrival eerily foretold the muted response his work was to receive in England. After settling into the comfortable Thackeray Hotel opposite the British Museum, recommended by Muriel's father, Leach felt heartened. The imposing sight of the building and its solid, neoclassical architecture reassured him that he was in the centre of all things English, bringing back happy memories of his days at the Slade. At a café in Museum Street, Muriel and Bernard re-established their Englishness by feasting on muffins, jam and tea and began to feel at home.

It was only a matter of weeks before the baby was due so they quickly moved on to Cardiff to stay with William Hoyle. They wanted to hear about the building of the National Museum of Wales in Cathays Park and of the extent of the collection, and also to meet William Hoyle's new wife, a widow, Florence Ethel Mabel Hallett, who had a family of four young children.[3] The Hoyles' house, Crowlands, at Llandaff proved too cramped for both families and the Leach children were farmed out to an aunt. The birth, which was premature, soon followed, but the labour went well except that instead of a single child twin girls were born on 28 August, named Ruth Jessamine, known as Jessamine and Elizabeth Massey, known as Betty.

With Muriel and the infants thriving, Leach was eager to move to St Ives. Before doing so he met up with Hamada in London, discovering that his friend had become a prodigious sightseer, taking bus routes from one end of the city to the other, and visiting museums and galleries, including the British Museum and the Victoria and Albert Museum, all of which he thought wonderful. While he considered the city 'dark and dim',[4] and the rooms of its houses dingy,

Hamada admired the brightly polished brasses and the gleaming windows. In Japan window glass was still unusual, the paper-covered windows, or *shoji*, admitting a limited amount of light.

St Ives, lying 'at the very toenail of England',[5] nearly three hundred miles from London, though accessible by train,[6] involved a journey of eight or nine hours, the single fare costing about twenty-five shillings. The two potters responded differently to the austere and dramatic Cornish landscape, the granite hills, windswept by Atlantic gales, creating an almost treeless terrain of moorland. To Hamada it appeared daunting, 'stone, stone everywhere, nothing but stone! As if all the skin and flesh were taken away and only the bones remained . . . How in heaven's name did I arrive in such a place where there was nothing soft to be found. The trees were bent and wind-blown. And the jutting rocks. Hard'.[7] Leach, in contrast, found that the land grew 'upon aliens like me with some Welsh ancestry',[8] and he was attracted to 'the bare landscape – folded hills and stern cliffs', recognizing that to some they 'may seem sad and lonesome, but to others with perhaps Celtic blood, fierce and grand in winter storm and cold; how tender the flowered paths of Cornish spring below granite bastions'.[9]

The small compact town of St Ives, surrounded by hills, had a timeless solidity. The tiny whitewashed fortress-like houses were built with thick walls and small windows, some with long flights of steps. The maze of narrow, winding streets had names such as Salubrious Place and Teetotal Street testifying to the town's Nonconformist traditions. The gaunt granite church dominated the centre, while the nearby Sloop Inn was a popular haunt for artists and fishermen. The town was more or less in two parts; the close-knit fishing community huddled around the harbour contrasting with the rows of terraces on the sides of the hills constructed for the tin-mine workers. By 1920 tin mining was in severe decline, while the age-old boat-building industry had moved elsewhere. Pilchard and herring fishing, for which St Ives was renowned, continued, though on a smaller scale and tourism had yet to develop.

With its magnificent landscape, dramatic seas and 'mystical' light, St Ives had become something of an artists' colony. Turner visited in 1811 and 1813 and admired the fishing lofts and narrow cobbled streets. Following an influx of artists in the 1880s[10] an art club was established. Unlike Newlyn on the south coast, which attracted such distinguished painters as Stanhope Forbes and Norman Garstin, St Ives had no well known resident artists but tended to be a centre for visitors including the painters James McNeill Whistler, Mortimer Menpes, Walter Sickert, Professor Frederick Brown and Philip Wilson Steer. The town was also a mecca for literary figures, most notably Leslie and Julia Stephen who returned for thirteen summers.[11] By 1920 the art community, though well established, had a reputation for old-fashioned land- and seascape painting, very different to its reputation as a centre for

progressive art that was to develop after the Second World War. In the town Leach's artistic status was uneasy, particularly in the early years, as artist potters were unknown and the rules of the various societies meant that he was only admitted for membership as an etcher.

Some time in September 1920[12] Leach and Hamada arrived to settle at 6 Draycott Terrace, a handsome late Victorian terrace house built originally for sea captains, overlooking Porthminster Beach, the harbour, Godrevy lighthouse and the station, from where trains ran to St Erth and Penzance. Their first visit was to Frances Horne at Tremorna at Carbis Bay. Arriving by the cliff path she rushed out to meet them shouting 'Has the baby arrived?' to learn that not one but two infants had been born.[13] 'Elderly, charming and enthusiastic'[14] and 'kind and sensitive',[15] she was far less intimidating than Leach feared. In addition to becoming a generous patron she became a family friend, acting as godmother to Jessamine[16] and acquiring many of Leach's pots, often buying them straight from the kiln. Brought up by two aunts, one in Germany the other in Holland, Frances Horne had seen the beneficial activities of handicraft guilds on the Continent and thought a similar venture would be of artistic and commercial value in St Ives. Accordingly she established the St Ives Handicraft Guild, with its headquarters in Hazelbury House, 1 Draycott Terrace, the most imposing property in the row. Here, a loom, usually operated by Florence Welsh 'a very energetic lady',[17] could be seen behind the large bay window, while the craft shop, open daily and run by the Horne family's former governess, offered an eclectic assortment of handmade goods that included 'tapestry weaving, Dorsetshire Ware, Peasant Pottery, baskets, toys, lace'[18] and embroidery designed by Mrs Horne and sewn by local women. Although sponsored by Mrs Horne, Leach had little contact with the Guild and little regard for the work, disapproving particularly of raffia dyed with chemical rather than vegetable dyes. As the 'sleeping partner' she loaned Leach £2,500 as capital to buy land and build the Pottery, and paid him the yearly sum of £250 for three years.

Muriel and the children, plus a Swedish au pair, soon joined Leach. The house proving cramped they moved a year later to number fourteen, which was a little larger. The boys were dispatched to a small local school run by Miss Shakerly, popularly known as Ma Shaps, and when David reached the age of eleven he was sent to XIV School, a prepatory school in Clifton, Bristol, though how or why this school was chosen David cannot now recall.

Family life tended to be demanding and sometimes troublesome. Betty did not thrive as she ought and after consultations with a London specialist was diagnosed as suffering from cerebral palsy, then known as spastic paralysis. The condition, characterized by jerky, uncontrolled movements, meant that she was able to do little for herself and needed a great deal of attention. It was a severe emotional blow to both Bernard and Muriel for, having disregarded

advice about the possible genetic dangers inherent in the marriage of first cousins, they had produced a child whose condition, it was then thought, might be the result of the close blood relationship of the parents.

With five growing children, 14 Draycott Terrace soon began to feel crowded. For some time Leach had been attracted by the gaunt beauty of an old granite building set back a hundred yards from the main road in Carbis Bay, a mile and half from St Ives. When it, together with an adjoining plot of land, came up for sale in late 1922 he acquired it for £1,100, reselling much of the land to realize funds for alterations and repairs. Divided into the Count House and Providence House, the property was turned into one, the dry rot dealt with and a gable added to the long sloping roof to provide four rooms extra to the ten that already existed. The roots of a eucalyptus tree planted by a previous tenant, which threatened to disturb the walls, also had to be seen to, though the family were convinced that the reek of eucalyptus kept them free of colds.

Slowly Providence House, usually referred to as the Count House, was turned into a home. The light and airy upstairs drawing-room had a wide window looking across the bay to Godrevy lighthouse, a huge, well-worn Chinese carpet covered the floor, its faded design of blue dragons adding to the slightly exotic atmosphere. A red hand-woven blanket by Ethel Mairet was draped across the back of the sofa, two large blue and white dishes hung on the wall and oriental pots stood on shelves. The furniture was a combination of traditional but comfortable English pieces with one or two from the East. Unfortunately the house tended to be damp and Leach waged a more or less continual battle with cockroaches, usually hitting them with his shoe.

Hamada was fond of the children and spent hours talking and playing games with them. One hot summer day he and Leach connived a bet that David and Michael could not swim round the headland from Porthminster Beach to Carbis Bay. From their rowing boat they watched as the boys floundered in the water, Michael giving up about three-quarters of the way, David just managing to swim the distance. Both were rewarded with half a crown for their effort. The whole family attended the opening of one of Leach's London exhibitions, celebrating afterwards with a meal in the Shanghai, one of the few Chinese restaurants in Soho, which David Leach recalls as memorable for the orders, in full or half portions, being shouted down the dumb waiter to the kitchen below.

Setting up the Pottery meant starting from scratch. A suitable site had to be acquired, workshops constructed, a kiln built and clays and raw materials found. It may have been Edgar and Edith Skinner[19] who drew Leach's attention to a strip of land about three-quarters of a mile up the hill from the centre of the town by the side of the main Land's End road, known as the Stennack. Some hundred yards long and twenty to thirty yards wide, the plot had a busy stream of the same name, the Stennack, which drained the redundant Consols

tin mine up the hill. Both Leach and Hamada thought its rapid flow could be harnessed in some way. The field, still cow pasture, had first to be cleared and prepared.

Leach decided on a small pottery, more studio than factory, capable of housing half a dozen potters and centred around the individuality of the artist. Rough proposals were drawn up and the town surveyor employed to put it into a form that would gain official approval. Although modest, the plans attracted much local curiosity and Leach felt it necessary to write to the *St Ives Times* dispelling rumours about the extent of his enterprise pointing out that he was not building a 'large industrial concern, employing local labour', but that the 'works are to be of a private nature and on quite a small scale' with the aim of turning out 'genuine handicraft of quality rather than machine-craft in quantity'.[20] This did not prevent the same paper reporting a month later that 'an interesting industrial experiment will shortly be made at St Ives in the nature of an industrial pottery, where it is proposed to combine old technique with the ideas of both East and West'.[21]

Although initially intending to do much of the building work, both Leach and Hamada were inexperienced and professionals were soon employed. George Dunn, one of the casual labourers, showed them how to use the long-handled Cornish shovel, using the left knee as a fulcrum, a more effective and less strenuous technique. In keeping with local tradition granite was used for the building, one of the last in the area to use the stone. A loft was constructed over part of the workshop-studio for storing and drying pots in the warm air from the room below. One side of the kiln shed was left open, the other covered. A room at the lowest end was reserved for Hamada to sleep in. Tables, benches, storage cupboards and damp rooms lined with asbestos for keeping pots moist, completed the workshop. Leach's Japanese wheel, 'a beautiful piece of nicely balanced wood spinning on a porcelain cup-bearing, which turned on a long spike of hardened wood or bamboo',[22] was installed. The wheel was spun by inserting the point of a stick into one of several holes set at an angle in the circumference of the wheel-head so that it could only be made to spin clockwise, the opposite direction to wheels used in the West. Hamada acquired 'a very small . . . very inefficient and inadequate kick wheel of the English type'.[23] Friendly throwing competitions to make large platters were usually won by Hamada, though occasionally each turned the wheel for the other to allow bigger pots to be made.

Building the kiln was more challenging. Finances were limited, few suitable materials were available locally, and neither potter had expert knowledge of kiln construction. The slight slope of the land was an asset but great consternation was caused when a hole of considerable size dug for the ash-pit and firebox filled with water seeping in from the Stennack. A climbing kiln of oriental style, constructed on a slope of about forty degrees to create a draught, was built either with two or three chambers, though no plans or

precise records survive. Each of its chambers probably measured about six feet in height and width, and four from front to back. The chamber nearest the firebox at the lowest end was fired first, with the flame and heat moving up a wall of saggars[24] round the roof and down the opposite wall and so into the following chamber. Hamada, in charge of the construction, ingeniously improvised from materials to hand, such as employing curved staves from the barrels used to pack salted herring to support the roof. Painstakingly Hamada chamfered by hand the roof bricks of the firebox to form a strong, self-supporting curve.[25]

With no high temperature refractory bricks readily available there was little alternative but to undertake the laborious task of making their own. A mixture of impure china clay, obtained for free from the first preliminary diggings of the newly opened Porthia China Clay Works, two miles away, mixed with a small amount of plastic ball clay to act as a binder was hammered into moulds. Saggars were made from a similar but even more coarse mixture. A small temporary kiln was constructed with second-hand fire-bricks obtained from an explosive factory at Hayle.

In addition to the climbing kiln a permanent round wood-fired kiln was built to fire raku and slip-decorated earthenware. Standing five feet high and about four in diameter, it had a firebox at the base, took around six hours to fire and technically was known as an updraught kiln because the flames passed up through the kiln. Pots were packed on perforated triangular shelves, layer on layer, leaving gaps through which the flame could rise. The top of the kiln, which was cooler, was fitted with a removable lid making it suitable for raku.[26]

Obtaining wood to fire the kilns in a landscape virtually denude of trees posed problems. For Leach wood evoked all the passion and romance of firing, the gentle flame yielding uniquely subtle effects on both glazes and clay body, particularly for high temperature wares and was 'by far the best of fuels'.[27] Coal, oil and gas were not deemed acceptable. Quick to spot a bargain Leach noticed that a memorial to a former mayor standing on nearby Steeple Hill was surrounded by pine trees and thick growths of rhododendron, both woods of which made suitable fuel. The Great Western Railway, the company owning the land, agreed to sell the dead trees for £20 and in the process of removing it and cutting the paths they were able to pick up a large amount of rhododendron resulting in a total of two hundred tons. Hamada was shocked to discover that carting the wood cost a staggering £100. He was even more astonished to find that it was cheaper to hire a machine to cut it up than employ skilled workers. Nevertheless the wood was a bargain, providing a three-year supply.

As neither potter had 'been thoroughly trained in wood-firing to a high temperature, or for that matter, in drying and cutting wood',[28] their inexperience was soon evident. They tended to pile too much wood into the firebox causing

large deposits of corrosive wood ash to build up on the inner walls. The hand-made bricks were soon eroded by the fierce flame; within a short time the kiln walls had started to bulge, developing cracks sufficiently large to accommodate Leach's hand. Pots split or cracked, glazes skipped, pieces were over-fired and became deformed, piles of saggars fell, and bits of brick dropped onto pots. Some could be re-fired, some sold as seconds, but those considered too poor were thrown in a fit of rage into the Stennack, while others served as targets and were duly smashed to pieces. Only 10 to 15 per cent of the pots came up to exhibition standard.

Finding suitable local ceramic materials was equally difficult. In addition to glaze ingredients two clay bodies were required, one for low- and one for high-temperature ware. Experiments with clay dug on their own land and clay from a local tin mine initially seemed promising but both were disappointing, as were their tests with candle clay.[29] In search of more suitable clay, Leach and Hamada, togged out in wellington boots, overcoats and carrying field glasses tramped the winter countryside on geological expeditions. Tall and with long legs Leach strode confidently down hill but found it more difficult to keep up with his shorter and more nimble companion going up. From a high point known as Trencrom they spied a streak of yellowish-red clay in a cutting behind St Erth, a village ten miles away, which after tests was found to fire to a good colour.

Following more detective work they found that a nearby factory used the clay for making metal casting moulds because of its ability to withstand sudden rises in temperature without cracking. A similar but smoother clay outcrop, employed as a waterproof layer to back up the granite harbour wall at Newlyn, was purchased from the local vicar at ten shillings a ton. When the yellowish clay was combined with a small percentage of china clay it yielded an earthenware body that worked well, and could also be used for slip-decorated ware. Unable to find local clays to make up a stoneware body, ball clays from Devon and Dorset were combined with fire-clay to give a smooth but subtly textured body, although it required much labour to prepare. A suitable local stoneware clay was not found until the late 1950s.

A source of wood ash, an ingredient of some high-temperature oriental glazes, also had to be identified. Kippering ash, collected from the herring smoking sheds, gave good results, while bracken ash produced an attractive creamy white matt glaze. One autumn they collected armfuls of dried bracken 'brown as the tobacco in a smoker's pouch' and after slowly burning it, washed, sieved and mixed it with feldspar and quartz to create a velvety-soft white crackle glaze. Its smooth quality may have been due to small amounts of salt picked up from the sea breeze. The glaze took pigment well and was used to great effect by Leach on simple bottle forms, about twelve inches (30.5 cm) in height, onto which he painted his famous Leaping Salmon design in iron black. With grace, elegance and great economy the design suggested

both the turbulence of the water and the twisting action of the fish. Later versions rarely equalled the success of the bracken ash glaze.[30]

Making use of local materials was not only more economical and a useful marketing ploy but also a commitment to a sense of place, a desire to establish roots, to produce work that was authentic and 'real'. Leach was able to claim in the *St Ives Times* that the Pottery sought to obtain materials

> as locally as possible, mostly within a radius of five miles, china clay and fire-clay from Towednack, and two or three red and blue plastic clays from the St Erth deposits. Besides these we get Cornish stone and feldspar from St Austell, and a white slip clay from Devon . . . I hope to depend more and more on local materials, not only because it saves expense, but because it enables one to choose on the spot exactly what one needs and to develop in the finished pottery a basic local character.[31]

When the building was complete, Leach was surprised to find George Dunn waiting for him, holding out his hand and declaring 'Cap'n, I'm staying put',[32] and he duly remained as general help until he retired in 1937. A native Cornishman, 'stocky, very short, indestructibly good-tempered and devoted to Bernard',[33] Dunn had formerly been a fisherman, miner and smuggler, though Leach suspected that he had not altogether relinquished his illegal activities. When he approved he said 'handsome, when he disapproved he spat'.[34] Unswervingly loyal, he offered to torch the Pottery to enable Leach to claim insurance when bankruptcy seemed a possibility in the late 1920s.[35] When he, his wife and a 'rabbit warren of young Dunns'[36] were threatened with homelessness after being evicted from their insanitary cottage in the town, Leach built Penbeagle Cottage[37] immediately adjacent to the Pottery, which the Dunns occupied at nominal rent. Edgar Skinner,[38] 'a painter of watercolours upon which Leach cast a baleful eye',[39] was taken on as bookkeeper, manager and general help; he wrote the business letters, often cooked lunch and attempted to maintain some sort of order.

With minimal creature comforts Hamada settled into his small room, some eight by ten feet, with an earth floor, furnishing it with a chest of drawers, a small table, a chair and bed. Constructed from rough wood from Steeple Hill held together with long pegs protruding from the frame, the bed took up a large amount of space. Its amalgam of traditional Japanese and English style seemed to capture all the qualities for which Hamada was looking, and was kept long after he left England until woodworm and age took their toll and it was finally burnt in the kiln. With the tap on the sink in the Pottery the only running water, Hamada visited the Leaches or the Skinners for a bath. Rudimentary sanitary arrangements consisted of an earth closet.

Following the model of the New Village, Hamada sought to be as self-sufficient as possible in an attempt to both eke out his meagre funds and to retain his independence. Although his lack of money restricted his ability to

travel, he did not regard this as a problem, preferring to have a fuller sense of where he was rather than seek too general a knowledge of the country. As part of his search to understand the land, Hamada went for solitary walks on the cliffs. Hamada's attitude was vindicated by Kawai who quoted a popular Japanese saying that the frog in the well does not know the great ocean, adding 'the frog knows heaven'.[40] Unlike Leach, who liked nothing more than an audience and endless talk, Hamada was quietly self-contained, a quality Leach attributed to his having been taught meditation, which 'affected the whole of his life'.[41]

Under Skinner's tutelage Hamada grew vegetables, some English some Japanese, which were cooked either on the fireplace or on a single gas ring. Although he ate bread he preferred rice and discovered that Javanese rice was acceptable if cooked with the lid held in place by a brick, the 'chink chink' sound given off by the rattling lid earning the dish its name. Many evening meals were shared with Old Basset, a local fisherman then in his late seventies, with whom Hamada was friendly. He usually arrived around 4.30 p.m. bearing gifts of fresh fish, crabs and lobsters to watch the potters in an admiring silence until work ended, before joining them for supper. Old Basset had many sons, some with boats of their own, and one night when the fleet was in, he took Hamada herring fishing, during which they netted about 5,000 fish.

The pattern of Leach's days was soon established. Mornings were spent writing letters, dealing with appointments, making arrangements, jotting down tasks and shopping in St Ives, where he could be seen 'holding a little notebook filled with lists and crossing out each item as he finished it'.[42] Around noon he arrived at the Pottery lamenting the fact that other duties prevented him from immersing himself in work earlier, and longing for the relative simplicity of life in Japan. As Hamada observed, there was not 'any overall organisation in the pottery, we did what we were enthusiastic about',[43] a revealing insight into its spirit of experiment and adventure, but not indicative of sound business.

As in Japan, Leach produced three types of ware – raku, lead-glazed earthenware, sometimes known as galena[44] because of the type of glaze used, and high-fired ware that included stoneware and porcelain – all of which fulfilled a different role at the Pottery. But unlike the luxury of Azabu, where he had a potter and assistant, at St Ives in the early years Leach threw all his own pots, which, given the problems with bodies and kilns, often seem uncertain when compared with pieces made in Japan. Some were slightly wobbly and uneven, though the forms were strong. Leach never claimed great throwing skill, writing 'I am better as a decorator than as a thrower. I am not, in my own opinion, a first-class thrower, and I have never achieved a complete mastery of throwing',[45] believing that it was a skill best left to others. Shapes were eclectic, many combining eastern and western influences. A lidded jam

pot was derived from the water jars used in the tea ceremony, while the incised decoration of abstracted foliage cut through a white slip echoed Chinese work. The tallest pieces were rarely more than eight inches (17 cm), and most were smaller.

Raku, colourful and often brightly decorated, was essentially decorative and not thought suitable for functional pots. The pieces, small in size, had to fit into the small chamber at the top of the earthenware kiln. Designs ranged from vases with floral decoration to dishes with patterns derived from early European tin-glazed earthenware. In the 1920s Leach produced limited amounts of raku, which often had wider appeal because of its brighter colours. Technically, the low-fired wares – raku and slip-decorated earthenware – were quicker and less demanding than stoneware, although craze-free glazes had to be devised to prevent liquid seeping through the porous clay body.

Both potters responded positively to the warm, homely qualities of traditional slip-decorated ware, seeing its evolution from medieval jugs and pitchers to country pottery as an indigenous aspect of English ceramics. They also saw it as indicating the way the social centre of working-class life moved from church to inn to home, each of which affected form and decoration. The eighteenth-century engraved motto 'Hail fellow well met, when this is down we'll have another',[46] was often quoted with slight disapproval as a perfect example of this change. Although not generally in favour of souvenirs, the Pottery did produce tankards, mugs and jugs with traditional sayings, partly to reflect this long tradition but also as a way of promoting sales. One tankard bears the motto 'Bring me my Rose-buds, Drawer; come/So while I sit thus crowned;/The drink the aged Cecubum/Until the roofe turne round'.[47] A small jug bears a quotation from Blake, 'A little flower is the labour of ages'.[48]

Although Leach had employed slipware techniques in Japan, both he and Hamada were keen to discover more about the different ways of using slip. In this respect they were following in the footsteps of potters such as Reginald Wells[49] who set up a studio pottery in the early years of the century near Wrotham, Kent, basing his style on the traditional wares of the area. Like Wells, Leach and Hamada were fascinated by the high level of skill and artistry of old pots but were mystified as to how such effects were achieved. They were particularly struck by the minimal beauty of a handsome dish about eighteen inches (46 cm) across with a simple design of black and white stripes with feathered or combed decoration. Only after examining shards picked up in a freshly ploughed field and seeing the different layers of slip did they deduce that it had been achieved by trailing lines onto a wet coating of slip of a different colour. According to a more fanciful account this realization came from seeing black treacle poured over Cornish cream spread on 'splits', a Cornish cake. By the time Hamada left to return to Japan at the end of 1923 Leach reckoned they had rediscovered about 80 per cent of slip-decorating techniques.

As part of their investigation into traditional country potteries, Hamada suggested a visit to Lake's, a country pottery twenty-five miles away at Truro, one of the few rural artisan workshops still operating,[50] a visit that Leach immediately appropriated as a social occasion for the family. Lake's pitchers, thrown in red clay with the rim dipped in white slip were sold in hardware shops and found in virtually every kitchen in Cornwall. Leach and Hamada were intrigued to see pots quickly thrown from soft clay lifted directly off the wheel and handles pulled from a stump of clay stuck to the side of the pot, a technique quickly adapted by Leach whose handles henceforth greatly improved. After being glazed with a simple mixture of clay and galena the pots were packed one on top of the other and quickly fired in a simple updraught kiln using bundles of gorse. Such directness and economy was in great contrast to Leach and Hamada's highly complex and conscious ways of working.

In addition to producing a range of tableware items such as jugs, teapots, tankards and jam pots, many covered with white slip through which designs and patterns were carved to reveal the red clay, Leach also made small models. These included a Cornish tin mine engine house, a Cornish Cottage[51] and spirited models of a horse and rider intended to be set on a house roof ridge as a good luck charm to ward off evil spirits.[52] By far the most significant earthenware pieces were the large, individually decorated dishes and chargers with powerful designs employing a limited range of earth colours such as yellow ochre, black, brown and white under a clear glaze. Some were moulded, others thrown on the wheel. More modest sized dishes were made by shaping a slab of clay over a hump mould, and for these Leach devised simple decorative motifs such as a willow tree, a frog, and trailed patterns. The large dishes were more special and time-consuming, with many bearing complex designs with a pattern of trellis lines around the rim. Recurring themes included oriental motifs such as a well-head, stylized mountain ranges and the tree of life, while more English designs ranged from 'The Pelican in her Piety', a deer with magnificent antlers and an owl, to a heraldic griffin. The dishes were usually fired upside down on stilts and placed one on top of the other to enable the glaze to form drips on the rim, an effect that Leach particularly liked. Occasionally one exploded, ruining others in the kiln. Their sense of bravura and confidence was in great contrast to the more modest tablewares, both in their aspirational vision and their command of the potter's art.

Although slip-decorated wares were an intrinsic part of English ceramics and technically less demanding than stoneware, Leach's main interest was with the high-fired pieces, which stylistically and culturally were quite separate. One of the few successful synthesizings of the two styles was stoneware jugs in the form of medieval pitchers. Well aware of the cultural conflicts inherent in making both stoneware and earthenware, of responding to oriental and

occidental influences, Leach decided that 'it was not a simple matter of mixing black and white into an international grey, but of preserving black and black and white as in endless interlacing patterns'.[53]

Like many other artist potters Leach took the view that high-fired stone-ware, because of its association with Chinese wares, was more 'noble' than earthenware, and capable of being profoundly expressive. Art galleries were more willing to exhibit stoneware, which in comparison with earthen-ware could command higher prices. Unlike other studio potters working at high temperature in the West, Leach had the advantage of having learnt his craft in the East. He knew what weight pots should be and had a sound under-standing of the processes involved, particularly with regard to the way the foot-ring finished off the base, giving the pot a sense of elevation. A bowl, derived from a Sung form, made in the mid-1920s, perfectly expresses the dynamic relationship of height to width, while the foot-ring is beautifully understood.[54] Other Sung-inspired techniques included a shallow bowl with a low-carved relief design under a pale celadon glaze. A lidded incense burner covered with a celadon glaze was derived from Han dynasty ware; its mod-elled, undulating 'mountain' lid was surmounted by a bird, and had an incised constellation on the side.

As a way of increasing sales and alerting public interest, raku sessions, fol-lowing the model of the Japanese raku party, were instigated at the Pottery on Thursday afternoons. Standing by the kiln after first explaining the history and technique of raku Leach encouraged visitors to buy biscuit-fired pots at prices from half a crown to a shilling and decorate them with ready-prepared pigments. The potters were on hand to advise on the thickness of the pigment and choice of design, though the commonest, of a 'cat drawn as a ball with a tail at one end and a small ball for the head with two ears and five whiskers . . . sitting on a wall',[55] was thought 'pretty ghastly'. The pots were fired in the top of the glowing hot earthenware kiln for about twenty to thirty minutes until the glaze had melted, at which point they were removed. Frances Horne's daughter, Margery, recalled being quite pleased with a pot she had decorated with a daisy design, but was horrified when Leach took it while still hot, covered it with black pigment to pick out the crackle, and in her view ruin it. As an added visitor attraction Muriel served excellent shilling teas. In addition to unlimited cups of tea, these included home-baked rock buns and scones, 'splits' served with cream and black treacle and the local delicacy of saffron buns baked by an old Cornish woman, Mrs Penberthy in Lower Stennack.

A visiting reporter was delighted by the 'Leach works' where the 'moor land air flows about it, and it is wrapped in the quietude so dear to the artist's soul'.[56] After watching Leach conduct a raku firing and lift 'white-hot tiles from a cylindrical kiln', they settled down to a meal during which Leach 'talked of his craft with the eloquence born of deep feeling'. Recognizing the

unique qualities of raku, which he introduced into the West, Leach made notes in preparation for 'a potter's notebook on the making of the simplest kind of oriental pottery',[57] which described the process as well as its history. The book was never completed, though Leach thought the technique ideal for use in schools. Support for this came from the American-born classical and oriental scholar, collector, amateur potter and enthusiastic supporter of artist potters, Henry Bergen,[58] 'a tall, powerful man with a rather square head and an athletic build',[59] with whom Leach became friendly in the early 1920s. Bergen commissioned pots from Leach and put him in touch with museum curators such as Bernard Rackham of the Victoria and Albert Museum and R. H. Hobson of the British Museum. Bergen also encouraged newly appointed museum staff to spend time at the Leach Pottery to add practical experience to their academic knowledge.

Almost as soon as there were pots to show Leach sought to exhibit them as widely as possible, though finding a market proved just as difficult as producing top quality pieces. An exhibition in St Ives was not a success, leading Yanagi to observe how the 'opposite would have been the case in Tokyo',[60] and suggested that Leach send the new work to Japan, which he eventually did two years later. Both Leach and Hamada contributed to the Friday Club exhibition[61] at the Mansard Gallery, Heal's in Tottenham Court Road, London, to which Leach also sent etchings. In his catalogue Leach recorded candid opinions of the work, describing C. R. W. Nevinson's paintings of London Bridge and Brooklyn Bridge as having 'no deep significance', Lucien Pissarro's work as 'awful', while engravings by Eric Gill were thought to be 'good'.[62] Raku pieces to the value of £2 10s were sold, realizing a total of £1 3s 9d after expenses.

In the 1921 autumn exhibition of the Home Arts and Industries Association Leach showed pots, 'both ornamental and useful, in porcelain, earthenware, and stoneware', described as displaying 'fine qualities of design, seen in the sound shapes and all over floral decorations, that are associated with Eastern and old English stoneware productions . . . which has resulted in the successful harmony both of line, form and pattern'.[63] The following year his etchings and pots at the Cotswold Gallery, London,[64] attracted notices in, amongst other publications the *Spectator*, *Westminster Gazette* and the *Glasgow Herald*. *Pottery Gazette* not only reported on the work but carried an illustration of twenty-eight pieces displayed on six shelves, the pots ranging from jugs and bottles to a variety of bowl forms. The *Daily Graphic*[65] gave a brief history of Leach's time in Japan and St Ives, concluding that it was in the 'Chinese Sung and early Korean stoneware that the Leach Pottery is concentrating . . . reproducing these beautiful glazes with our home materials. Bernard Leach stands alone'. In 1924 and 1925 his pots were exhibited in the Palace of Arts at the 'Empire Exhibition' at Wembley, for which he received certificates of participation.

It is a mark of Leach's exhibiting success throughout the 1920s and 1930s that he felt it necessary to subscribe to various press-cutting agencies,[66] amassing files of material from newspapers and magazines. It was also indicative of the willingness of newspapers and magazines to report on and review the work of what was still a small if rapidly developing art form. Potters as well as their pots made good copy, and when Leach demonstrated throwing on an English treadle wheel at the 'Applied Arts and Handicrafts Exhibition' at the 'Royal Horticultural Exhibition', Westminster, in December 1927, photographs appeared in the *Daily Sketch, Daily Chronicle* and *Daily Mirror*.[67]

In addition to seeking out galleries, Leach applied for membership of various arts organizations, though early applications to the Arts and Crafts Society and the Art Workers' Guild (closely allied with the ideas of Morris), were refused, in his view 'due to misunderstanding and ignorance'.[68] Later he was made a member of both and took part in various annual shows of the Arts and Crafts Exhibition Society[69] at Burlington House. He also became a member of the Red Rose Guild of Art Workers in Manchester[70] and regularly showed his pots in guild exhibitions at the Houldsworth Hall in the city. In a 1925 exhibition five small raku pots were bought by the architect and collector Sidney Greenslade[71] for the Arts and Crafts Gallery at the University of Wales, Aberystwyth, of which four were inspired by the shape and decoration of Delft drug jars, complete with white tin glaze and colourful painted patterns. He later became a member of the Arts and Crafts Bureau at 34 Bloomsbury Street, London, which in 1928 'opened a permanent centre for the exhibition and sale of the better sort of contemporary art, handicraft and machinecraft'. In addition to art-centred groups Leach became involved in more widely based organizations with broader political or artistic agendas such as the Arts League of Service, which aimed 'to bring the arts into everyday life'. Leach sought to ensure that the full spectrum of the visual arts was included. Politically the League was anti-war, believing that war memorials should honour the fallen not as victims of war but as makers of peace.

The erratic progress of the Pottery was greatly improved by the arrival in 1923 of Matsubayashi Tsurunoske, 'a precise little man',[72] engineer, chemist and craftsman-potter of a well known Nara pottery family that, he claimed, had been making pots for thirty-nine generations. He was known to all as Matsu. Although credited as 'thoroughly practical' who knew as much about the theoretical basis of ceramics as any western ceramist at that time, he was generally thought to make awful pots, which 'Bernard looked on . . . with a withering contempt which he was at no pains whatever to hide'.[73] Horrified by the state of the kiln, Matsubayashi insisted it should be pulled down and replaced with a professionally built, wood-firing three-chamber structure, technically known as a semi-continuous downdraught kiln.[74]

In January 1923 the Pottery was visited by Michael Cardew,[75] a 'young man . . . as handsome as a Greek god, with forehead and nose all in a straight line,

vivid eyes, golden curly hair, and a strong good jaw',[76] an eager would-be potter, described by Leach as a 'young Apollo'. Cardew was reading human- ities at Exeter College, Oxford, but an academic career held no interest for him and, having been introduced to traditional country pottery by W. Fishley Holland at Braunton Pottery, where he had learnt to throw, he was determined to become a potter. His attention was caught by an article on the Leach Pottery, 'An Art Pottery in Cornwall',[77] in *Pottery Gazette and Glass Trade Review*, probably written by Leach, which somewhat misleadingly was illustrated by photographs of Leach and his pottery assistants on Viscount Kuroda's estate and an image of a jug with an armourial design made in Japan. Intrigued, Cardew arrived in St Ives and was directed to the Stennack where as the houses came to an end and the fields began he found 'a sign board with a curly inscrip- tion just legible in the dusk The Leach Pottery'.[78] George Dunn greeted him and called Hamada who took him to Carbis Bay to meet Leach, both enthusing *en route* about Ethel Mairet's weaving.

The Count House, into which the family had recently moved, seemed to Cardew 'vast, cold and empty', noting that there were only a few 'very strange'[79] pots to be seen. Fifteen years his senior, Leach appeared as 'a per- fectly preserved example of an English Edwardian'.[80] Muriel, by contrast, Cardew thought 'a warm and charming person who looked rather like someone out of a Japanese colour print'.[81] A meal was served on 'grey stoneware, with decoration in a reserved blue'.[82] Wasting little time in testing Cardew's sensibility to pots, Leach asked his opinion on an eleventh- or twelfth-century Chinese bowl. Unsure how to respond Cardew wisely said little. The testing ceremony also included discussion about other wares and when Cardew spoke enthusiastically about English slipware and revealed his ability to throw reasonable sized pots his place was secured. Writing to offer the position Leach was alarmingly frank saying 'I want someone like yourself, young, strong and enthusiastic . . . I cannot afford to pay a salary we are pretty well at the end of our capital invested and must from now on depend on sales'.[83] Undeterred Cardew accepted.[84]

After completing his studies at Oxford, Cardew arrived at the Pottery to find, in addition to Leach, Hamada, George Dunn and Edgar Skinner (who arranged his lodgings at 2s 10d a night), Old Basset, the potter William Staite Murray in earnest conversation with Hamada, and Sidney Greenslade. Greenslade took Cardew to one side and told him how delighted he was that he was starting with a group 'so full of enthusiasm'.[85] Enthusiasm was not in short supply and at Cardew's suggestion he and Leach visited his father's house in Saunton, north Devon, to admire their collection of Edward Beer Fishley's pots. The two-day journey was made on Leach's recently acquired Martinside motor cycle and side-car,[86] on which, in George Dunn's phrase, he used to roar up the Stennack 'like a ball of fire'.[87] While appreciative of the green- glazed jugs and vases, in the kitchen Leach discovered plain water pitchers and

old oven dishes decorated with slip-trailing, which he preferred, cheerfully pointing out that they were part of the true English heritage.

An offer of a free Mediterranean tour with a first-class ticket took Cardew away from the Pottery until November and he returned to find both Leach and Hamada showing work in London. Throughout the three years he spent at St Ives, Hamada industriously made pots and despite the infrequent firings and high losses felt that before he returned to Japan he would show them in London. William Paterson, 'a fine old man'[88] and owner of the Paterson Gallery in Bond Street, London, was approached and although primarily concerned with fine art he liked the Japanese potter and his pots[89] and agreed to an exhibition. With the walls covered in 'velvet in a very beautiful shade of (faded) reddish-brown – a sort of dark fox with a dash of old rose',[90] the gallery was thought to look very handsome. Shortly before leaving for France *en route* for Japan, a further exhibition was held, Hamada having obtaining excellent glaze results in the final firing of the old kiln.[91] All but three pieces sold. Much of his income was spent on lengths of woven material and pieces of old slipware.

During a visit to the Paterson Gallery, Cardew was introduced to another would-be potter, Katharine Pleydell-Bouverie,[92] whom he found 'very beautiful and also very big, with a large frame like a French peasant's; and yet at the same time somehow petite, because her features were so curiously fine'.[93] Inspired by Roger Fry's pots on sale at the Omega Workshops[94] Pleydell-Bouverie had attended pottery classes at the Central School of Arts and Crafts in London but it was only seeing Leach's 'quiet-coloured, gentle-surfaced pots with a pleasant sense of peace about them'[95] that she thought seriously of taking up the craft. A contemporary notice, describing them as 'remarkable for dignity of shape, depth of colour, and quality of surface',[96] echoed her sentiments.

When she met Leach at the gallery, 'a long spidery man, giving a curious impression of shagginess in a Norfolk jacket and an extensive moustache',[97] she immediately asked to become a private pupil. Although at first reluctant he finally accepted her, impressed with her enthusiasm, not to mention her readiness to pay a £26 fee for six months.[98] Writing to her, Leach was brutally honest about the life of a potter:

> it is hard work of any woman not to say man, and she would have to be prepared to take the rough with the smooth. We do every thing with our hands from the wood splitting and mixing of clays to throwing and packing. That is to say the techniques of the East where no machinery is employed; we get dirty and tired, hot and cold, and unusual enthusiasm is the sole panacea.[99]

Undeterred, Beano, as she came to be known, after a two-week trial, joined the Pottery in January 1924. There she developed an interest in wood-ash glazes, a concern she was to continue throughout her career.

With a larger team of workers a more established routine slowly developed, though Cardew still thought it highly disorganized, particularly the clay-making arrangements, which he found 'chaotic and always inadequate for our needs'.[100] The treadle wheel Cardew had had built at Braunton Pottery[101] was installed, which he found easier and more efficient than anything at the Leach Pottery. Although he had mastered basic throwing skills there was still much to learn, such as the oriental technique of spiral wedging, a process of working the clay by hand to remove air bubbles and strengthen it prior to throwing; wedging in Leach's view was an essential process. He also had to learn to throw small pots off a clay hump, obviating the need to weigh out endless clay balls. Leach gave inspirational, evocative, if at times obscure advice. Holding up an old slipware dish he said 'Try to get that completeness of form – it is like a full moon'.[102] One of Cardew's tasks was to throw the souvenir mugs, jugs and tankards.

Despite Leach's obvious enthusiasm for oriental ware Cardew was less attracted and found himself instinctively drawn to the softness of English earthenware. In an attempt to further his understanding, Leach lent him his copy of Kakuzo Okakura's *The Book of Tea*, and though Cardew responded to the quietness and contemplative nature of the rituals, the objects left him cold. Following Hamada's return to Japan in late 1923, Cardew moved into his old room, slept in the curious bed and relished the spartan surroundings, even making a cult of them by taking a daily bath in the cold water of the Stennack. All went well until in the middle of winter he was stricken with pneumonia and spent six weeks in the St Ives cottage hospital. During his convalescence Leach brought books of early Chinese paintings of landscapes inscribed with Chinese characters, which Cardew thought were as wonderful as the images themselves. Despite their different temperaments, their diverse responses to pots and Cardew's fierce temper, which was quickly aroused and just as quickly subsided, a warm and enduring friendship developed. To Leach, Cardew was his first and best student, a 'good talker, illustrating his points with broad gestures, flashing eyes and a fine row of white teeth'.[103]

Meals were prepared with enthusiasm, good appetites making up for limited culinary skills. Leach concocted tasty dishes from limited ingredients while creating a minimum of washing up. All learnt to prepare 'chink chink' rice following Hamada's method and this was usually eaten with curry. Leach and Matsubayashi insisted on using chopsticks but Cardew claimed he was too hungry to learn the technique. A mainstay was what George Dunn dubbed Raw Fry. In the evenings their own version of the Japanese *giu-na-be* might include meat and spinach simmered in a frying pan, with Marmite substituted for *shoyu*. The Tzu-chou rice bowls and plates seemed to enhance the food, the delicate shape and lively brush decoration adding to the pleasure. Eating from these bowls often led to discussions about how they were made in a metaphysical as well as a technical sense. Admiring a turquoise coloured

Chinese pot one day Leach said 'I wish we could go to the place where it was made, and see what they use; it is sure to be something quite simple'.[104] After an intake of breath Matsubayashi did not agree, commenting after a pause 'I think – ah – rather complicated'.[105]

Under 'Bernard's erratic but mainly genial tutelage',[106] Pleydell-Bouverie said she learnt chiefly from observation and 'general stooging'. All the crew had to turn their hand to any job, and there was always plenty of 'donkey-work', despite Leach pontificating happily 'there is no drudgery in pottery',[107] a sentiment that was not generally shared. Cardew laboriously prepared the clay body, Matsubayashi fashioned handmade bricks for the kiln, Dunn endlessly sieved materials and Pleydell-Bouverie ground cobalt by hand, a task that in Japan was done traditionally 'for months on end by some old woman'.[108] Before returning to Japan, Matsubayashi, recognizing Cardew's more practical understanding, led him aside remarking 'I hope you will stay here with Mr Leach, and always help him with his work, because – ah – I think – ah – Mr Leach – ah – rather poetical'.[109]

Leach's unwillingness to consider the benefits of mechanical help and his determination to remain 'poetical' was brought home when he and Cardew travelled by motor cycle to Gordon Russell's[110] furniture workshop at Broadway in the Cotswolds in the spring of 1926 to take part in an Easter exhibition of rural crafts and industries, and where Cardew was to demonstrate throwing. The journey took three days and two nights, with the motor cycle and side-car packed full of luggage. It was a tense occasion as the two potters found themselves out of sympathy with Russell's move towards greater mechanization. Talking specifically of furniture and architecture Russell argued that the sensitive use of machines, together with intelligent design, could remove much of the donkey work, increasing production and reducing costs without loss of quality. Such impersonal mechanical processes had little appeal for purists such as Leach and Cardew who saw the machine as no substitute for individual skill and the fine judgement of hand-work.

With Matsubayashi's professional kiln complete, the first firing in May 1924 was greatly anticipated. After the ceremonial offering of salt on the fire arch and following a long day's stoking 'an atmosphere of tension developed that would have been quite suitable on a battlefield'.[111] As the rate of firing increased the kiln grew hotter; the stokers got progressively blacker as thick smoke billowed from the chimney filling the kiln shed with acrid fumes. In the flickering light of the flames and the crackle and flare of the logs in the fire mouth they 'moved about like creatures out of one of the more sinister creations of Hieronymus Bosch'.[112] In the grey light of dawn it became evident that something was wrong and peering through the spy holes into the kiln Matsubayashi saw a six-foot bung of saggars lean slowly forward and collapse against the front wall, blocking up the draught and bringing the firing to an end. Little in the firing was usable, the stoneware pieces were covered

with a rough coating of wood ash and underdone while the slipware in the second chamber was ruined as the damp atmosphere had caused the lead to volatilize leaving the surface starved and rough. Surveying the disaster, one of the team said 'Experience keeps a hard school, but fools will learn in no other'. 'Well', retorted Leach, 'they are fools who would ever think to learn in any other'.[113]

Firings improved but still tended to be erratic, some taking nearly twice as long as they should, all consuming wood at an alarming rate. On one occasion old railway sleepers, which proved to have been soaked in a solution of saltpetre, were used with disastrous results because of the 'pickle'. However, one cut-sided bowl Leach thought a great success. The glaze, intended to be a soft celadon green, 'came out with a matted surface and pleasant, warm decoration',[114] and though unexpected was one of his favourites. It was promptly purchased by the Victoria and Albert Museum for the princely sum of £12. To eke out the scarce supply of wood, coal was used for the low warming overnight, but wood remained the only acceptable fuel until the kiln was converted to oil firing in the late 1930s. Experiments were made with salt-glaze firing when common salt was introduced into the kiln at high temperature to create a characteristic thin orange-peel-like glaze surface. However, it was only tried a few times as it 'caused a dense white smoke to pour out of the kiln and down the Land's End road, to the alarm of passers-by falling in their tracks overcome by fumes'.[115] One salt-glaze pot was made in imitation of what was known as a German Bellarmine, a jug or bottle with a bearded face decoration.[116]

Like many of the small band of artist potters, Leach was most inspired by the qualities of Sung dynasty ceramics, which until the large quantities uncovered during the laying of railways in China in the late nineteenth century, were generally little known. In contrast to the highly sophisticated, technically dazzling porcelains of the later periods, which had hitherto been favoured by museums, the strong, simple forms, the plain, deep glazes and minimal decoration possessed qualities Leach described as having 'beauty and vitality'. Sung wares had featured in an exhibition of early Chinese pottery and porcelain in 1910 at the Burlington Fine Arts Club, and a series of articles in the *Burlington Magazine*[117] by R. L. Hobson[118] recognized their significance, their austerity inspiring potters and public alike. The profound effect of Sung pots was far reaching, bringing a new understanding of form and glaze that was the equivalent to contemporary reassessments in painting engendered by abstraction or in music by atonality.

Artist potters inspired by such wares to make high-fired individual pots included William Staite Murray,[119] W. B. Dalton,[120] Dora Lunn,[121] Charles and Nell Vyse,[122] and Reginald Wells.[123] After initially being inspired by English earthenware, Wells was so enthralled by Sung pots that he produced high-temperature pieces, naming them 'Soon ware', a punning title suggesting a

direct relationship with the Chinese pots. As a result of their shared interests in Sung and other historical wares, the short-lived Guild of Potters,[124] under the presidency of Gwendolen Parnell,[125] was set up in 1923. The twenty-five members of the guild met in Parnell's studio in Chelsea and mounted their first exhibition at the Gieves Art Gallery in Old Bond Street, where Leach's pots were described as 'sensuous'. Any rivalry between the members was usually around the price, a situation in which Leach rarely felt he did well, on one occasion complaining bitterly when Charles Vyse 'had a show . . . and sold £1,100 of pots which were really without life but technically wonderful'.[126] No one, however, could command Leach's unimpeachable authority of having learnt his skills in the East, which did not, however, prevent him from being dogged by technical failures or experiencing problems due to his commitment to using local materials and firing a large kiln.

Leach's greatest rival was William Staite Murray, a potter six years his senior who not only achieved higher prices[127] but had specific views on pots, believing that they should be regarded as sculpture, given titles and shown only in art galleries. By contrast Leach had more diverse ideas, torn as he was between making individual pots and more useful ware, both as a means of earning a living and also out of some as yet vague but undeveloped commitment to functional forms. Murray not only concentrated solely on one-off pieces but moved in fine art circles in London.[128] When both exhibited pots at the Artificers' Guild, Conduit Street, London, Sidney Greenslade described Leach's work as being 'just in the experimental stage – and clay and colours and glazes are uncertain', while Murray's hard-fired pots were judged as 'excellent, really of good quality . . . Murray should achieve something'.[129] Another critic,[130] reporting on Murray's first one-person show at the Paterson Gallery, thought that 'Mr Murray is now firmly installed as the most powerful potter in England. His work has not the same easy grace of line that Mr Bernard Leach obtains, but it has a greater potential energy'.

The two men had first met at the Artificers' Guild, when they 'stalked each other round a show-case in the middle of the room before making acquaintance'.[131] Despite what Leach perceived as 'Scottish dourness and seriousness of purpose',[132] a respectful friendship developed. In London Leach stayed with Murray, who tested his glazes and clay bodies in his gas-fired kiln, and Murray visited St Ives where he was shown how to turn a foot-ring,[133] handle a brush in the oriental manner and practise throwing on Leach's Japanese wheel, refusing to give up even when his face became 'as red as a turkey-cock'.[134] Thirsty for first-hand information of oriental methods, Hamada's knowledge of Chinese glazes was of particular interest.

Their friendship was severely strained by what came to be known as the 'London affair' when, much to Leach's disappointment, William Rothenstein, head of the Royal College of Art, appointed Murray as instructor in ceramics.[135] Rothenstein did not help matters by proposing, then withdrawing,

some sort of offer of a job share. Leach had wanted the prestigious position, not only for the fee of three guineas a day but also for the opportunity of influencing a younger generation of potters. While he was in many ways better qualified than Murray, Leach lived many miles away from London and he had none of Murray's fine art connections.[136] The decision to appoint Murray added to the growing rivalry between them, for while Hamada and Murray became good friends, the latter helping Hamada to install his final exhibition at the Paterson Gallery in 1923, Hamada was aware of 'a certain tension'[137] between the two men. Although Leach was somewhat mollified when Bergen, a friend of both potters, wrote to explain there were problems with funding, relations between Leach and Murray were never quite the same again. Murray later confessed to a friend that he found Leach's 'theorising on Pots and Art . . . a little tiresome'.[138] Despite their differences, Leach continued to respect Murray's pots.

Like Murray, Leach relied on a small number of discriminating collectors. Pots, still inexpensive in comparison with paintings, were rapidly acquiring a modest but discerning following. They were illustrated and written about in newspapers by a number of critics, with some such as Frank Rutter insisting that 'pottery is a phase of abstract sculpture free from representational bias'.[139] George Eumorfopoulos, a leading collector, 'a very quiet man, short of build, and with innate modesty and love for art',[140] was well known for his collection of historical wares. In his house in London, located between the Tate Gallery and the Chelsea Reach,[141] he built a two-storey museum for his collection of Chinese ceramics, thought to be one of the finest in the West. In the 1920s he became a passionate though not uncritical supporter of studio pottery. When Leach was invited to dinner in 1923, Mrs Eumorfopoulos took the opportunity to lift one of his pots standing on a grand piano to reveal the white mark where moisture had seeped through the piece. It was a conflict between technical skill and artistic expression for which Leach had no satisfactory answer. Eumorfopoulos encouraged guests to handle pieces, whether sculpture by artists such as Ivan Mestrovic, ancient Chinese pots or studio pottery. During Eumorfopoulos's visit to St Ives he tried to buy a twelfth-century fluted bowl given to Leach before leaving Japan, but his offer was declined.

An equally discerning collector was Eric Milner-White, Dean of King's College, Cambridge, and later Dean of York, described by Murray as 'the acknowledged Spiritual Father of the Studio Potters'.[142] He concentrated on the work of Murray, Leach and to a lesser extent Hamada, describing them as 'the three Master Potters of the Century'.[143] In the mid-1920s he acquired his first Leach pot, a bowl with a narrow foot, a black *temmoku* glaze and delicately painted iron-red decoration resembling the effects of fluting. In addition to individual pots Milner-White also admired Leach's tablewares, buying amongst other items a teapot, six egg cups and a number of ashtrays, which

he regarded quite separately from the one-off pots. Such functional pieces were seen by the *Times* critic Charles Marriott as representing Leach's willingness to engage with 'trade', rather than stand 'aloof with museum pieces'.[144] Marriott, an amateur painter from St Ives, often wrote about Leach's work for *The Times*.

In October 1921 Ethel and Philip (or Phillippe) Mairet,[145] a couple closely involved with the Arts and Crafts movement, invited Leach and Hamada to visit Ditchling, Sussex, a quiet village set among the undulating beauty of the Sussex countryside yet within easy reach of London. Residents of the village included the calligrapher Edward Johnston, the sculptor Eric Gill and Leach's old teacher Frank Brangwyn. While each pursued his own work, they shared a sense of unity and a commitment to the ethos of truth to materials and simplicity of form that greatly impressed Leach. Ethel was thought of as 'the mother of English hand-weaving'[146] for her pioneering work with hand weaving and vegetable dying. Philip, writer, pioneer ecologist and actor with Lillian Baylis's Old Vic company, was also involved with the journal *New Age*.[147]

For her purpose-built house and workshop, Gospels, Ethel Mairet had designed the building herself in conjunction with a local builder following the style of Sussex vernacular. With its tasteful furniture, minimal decoration and tranquil atmosphere all pervaded by the smell of freshly dyed wool, Gospels appeared like a living expression of ethical and artistic values. Such values were even expressed in the way of dining, with wholesome food served on slipware plates made by the Fishley Pottery in north Devon.[148] In Hamada's view these 'preserved the good traditions of England', meriting 'a perfect score'.[149] At nightfall they walked across Ditchling Common to see the Gills and were 'treated . . . with dinner in a merry atmosphere. In the long slender dining room, which might have been the kitchen of a farm house before, a big marble fireplace made by Gill was set, with fire burning bright. On the table were some cold meat on pewter plates and some bread on wooden plates'.[150] They may also have admired the hand-thrown dishes Gill had acquired from his friend Roger Fry at the Omega Workshop.

With its domestic cosiness, bohemian casualness and Arts and Crafts ethnicity informed by deeply felt but eccentric religious beliefs, Gill's life must have seemed a picture of untroubled harmony to Leach. Both he and the Gills shared a delight in the idea of plain living and high thinking. Visiting Gill's studio the following morning, Leach and Hamada noted the way the sculptor's tools were neatly maintained and how only good drawings by his children had been left on the white walls – the others having been erased. Gill borrowed some Chinese books he wanted to take a look at and Mairet wanted to copy out. Perhaps inspired by Ditchling, in the mid-1920s Leach tried to establish a similar artistic community in St Ives, which he named the Craft Guild.[151] Unlike the St Ives Handicraft Guild, whose work Leach considered of poor quality, the Craft Guild was intended be more professional and consist

of individual artists. Although letters were written and meetings arranged, the idea never materialized.

During one visit to Ditchling Hamada asked to buy a length of cloth from Ethel Mairet but as none was available he purchased instead a suit tailored from hand-woven cloth made for Mairet's first husband, from whom she had parted. Delighted, Hamada wore it for many years on special occasions, including his own wedding. A great admirer of Mairet, Hamada later helped arrange a mixed show of her textiles along with ceramics by Leach and Murray at the Kū-kyo-dō Gallery,[152] Tokyo, in late 1927. None of Murray's pieces sold, whether through Japanese loyalty to Leach or because his pots, in Yanagi's view, were 'quite imperfect both aesthetically and morally',[153] but Mairet's cloth sold well. So perfectly did Mairet's textiles reflect the ideals of designing and making following traditional methods that Leach shipped lengths of it to friends in Japan. When Yanagi's failed to arrive he asked for a replacement sufficient to make 'a suit also new breeches, and if possible another thick one for overcoat'.[154]

One evening at Ditchling was spent at the Mairets' in the company of Eric Gill and the hypnotic Serbian intellectual Dimitri Mitrinovic, 'an occultist with esoteric doctrines'[155] and intimate friend of the sculptor Mestrovic. At his headquarters at 55 Gower Street, London, Mitrinovic was to have a powerful influence on Leach in encouraging him to investigate the writings of amongst others Steiner and Adler, a study that combined psychical research, pacifism, socialism and the occult. The particularly English combination of agnosticism, pantheism and the idea of 'self-training and discipline . . . throwing light on cosmic ideas and symbolism' greatly appealed to Leach. Writing about Mitrinovic's New Europe Group in 1931 Leach was clearly enthralled. 'I regard it', he wrote, 'as the most significant and synthetic focus of thought which I have had the fortune to encounter in my life.'[156] During the evening Gill, feeling ignored and having an instinctive dislike of sages, pulled his hood over his head and left saying he had to go to bed.

Intrigued by all aspects of the occult and mystical systems, Leach corresponded for a time with someone called F. C. Thorpe in Bath, whom he had gone to visit but been unable to see. After correspondence, Thorpe sent a detailed numerology chart in which he plotted Leach's 'path of life', the numerological breakdown identifying major characteristics such as originality, humour, stubbornness, philandering, love of the opposite sex, and concern with spiritual and psychological subjects, a catch-all list that Leach found flattering and revealing.[157]

The numerologist was correct in identifying Leach's interest in philandering. Ever susceptible to female charm, Leach was constantly developing friendships with women that went beyond what was thought permissible. In the early 1920s there were several love affairs, one with a woman called Barbara Wood, the wife of a local doctor. Writing to Yanagi about his emotional

entanglements, his friend neither approved nor disapproved commenting that such affairs 'fall[s] often so naturally upon a man's life which walks up & down the vales of the world. It is something beyond the standard of good and evil . . . I believe what you loved and what you learnt will be reflected in the very glaze of your coming work which is the mirror of a potter'.[158] One of Leach's diary entries at this time was of a verse referring to passionate love as uniting sex and belief, finishing with the line 'God is the Climax'.

Closer to home, Leach developed a passion for Norah Braden,[159] a painting student from the Royal College of Art who arrived to work at the Pottery in 1925 on the glowing recommendation of William Rothenstein, who described her as 'a genius'. With Skinner having left the Pottery because of ill health she was taken on as secretary on a modest wage and as an unpaid pottery assistant. Attractive, vivacious, a gifted musician and artist with a strong sense of humour, Braden had piercingly blue eyes with which she could appear to detect the false and insincere. Outspoken, she had a way of standing up to Leach and questioning rather than merely accepting his pronouncements. Mercilessly she satirized his wearing of stiff collars and his general air of fogyism, accusing him of being sentimental about both his Japanese friends and English slipware. Like the child in the Hans Christian Andersen story, if she believed the emperor had no clothes she would say so. She was, said Michael Cardew, a 'big thing' for Leach who thought she had 'quite unusual qualities – a woman with one of the most discerning critical minds, equally critical of men and things'.[160] Despite or because of her sense of independence Leach fell for her, enthralled by her critical understanding of his pots and her ability and willingness to express and share her views. While Braden admired Leach, she did not reciprocate his feelings, and he wrote later how she had made him 'suffer a lot . . . I wish I could have been the right man, but you would have driven me out of my mind and so much of your nature would have been repulsed or unsatisfied of me'.[161] Despite this they respected each other's pots, enjoyed each other's company and remained lifelong friends.

Diligently Braden ordered materials, arranged for pots to be sent to exhibitions and sorted out carriage and packing with Kimbers in London, who virtually acted as Leach's agent. As a potter she developed her own strong but subtle style, going on to live and work with Pleydell-Bouverie at her pottery at Coleshill in 1928.

As the fame of the Pottery began to grow requests came from many students wanting to acquire practical experience. Private pupils included Ada Mason, who later helped Pleydell-Bouverie set up her pottery at Coleshill, and the highly talented but emotionally tense Sylvia Fox-Strangeways,[162] known as Jane, who had studied at the Central School of Art and the Royal College of Art. Much to Leach's delight both Braden and Fox-Strangeways were excellent saleswomen. Another gifted student, Dicon Nance, was apprenticed by his father, the writer Robert Morton Nance, at the princely

sum of ten shillings a week. He later married Leach's daughter Eleanor and made an important contribution to the Pottery by helping David Leach design and build what became known as the Leach kick wheel, a machine that was both functional and ergonomically efficient. Nance was so horrified by Dunn laboriously grinding fired clay between two metal plates that, harnessing the power of the fast-flowing Stennack, he devised and built a water-wheel to carry out such mechanical tasks.

A strong sense of community, jovial and club-like pervaded the Pottery. Practical jokes involved buckets balanced over doorways, and endless ribbing. Nicknames were freely given, Leach gaining the name Rik, Riketty or Rickety because of the shaky state of his Martinside motor cycle. Norah Braden was known as Lise, Ada Mason as Peter. Pleydell-Bouverie, or Beano, known as Bim by Braden, settled with a friend in a miner's cottage in the largely deserted village of Halsetown, a mile along the old Penzance road. Discussions about pots were often illustrated by Leach drawing on the blackboard, describing shapes in the air in a great miming act, or sometimes making pieces on his Japanese wheel. Occasionally the students were invited to the Count House where they talked endlessly about art and pottery, watched by the two Leach boys who 'stayed rather mute in the background, taking in something, not with our intellects for which we had no training, but with our intuition'.[163] In the summer months there were picnics on the heather-covered cliffs. On winter evenings Matsubayashi gave technical talks on ceramic materials, kiln construction, plasticity of clay and chemical formulas. Diligently Pleydell-Bouverie took notes, but Cardew, unsure of the value of Matsubayashi's knowledge or its relevance to his work, took virtually none and later borrowed hers. Leach attended 'rather as a critic posing questions', and was always 'interrupting with philosophical questionings such as whether all this theoretical stuff was really relevant to the quality of what you produced'.[164] Matsubayashi's idiosyncratic English, which confused the letters 'l' and 'r', did not help, but his knowledge and understanding of the needs of studio potters made his talks highly informative and useful.

With no sound business plan and despite free or low-cost labour, the Pottery was in constant financial trouble, requiring endless subsidy from Bernard and Muriel's private resources. Frances Horne's loan of £2,500 had long been exhausted and her three-year revenue funding ended in 1923. Business meetings with her were fraught as she was virtually stone deaf and her daughter, Margery, little more than a teenager, had to bellow often sensitive pieces of financial information in her ear. Further investment was curtailed by the illness and subsequent death of Mr Horne, at which point the St Ives Handicraft Guild was closed. Muriel's father would sometimes help out financially, but ill-health forced him to retire in 1924 and he and his family, including a new baby, Rosseter,[165] moved to Porthcawl, and had no spare capital to invest.[166]

From Japan came news of Kame-chan saying that despite the efforts of friends he was back in a 'lunatic asylum' with little that could be done to relieve his symptoms. With Yanagi and Tomimoto having resolved their differences, Yanagi gave mouth-watering descriptions of their visit to Korea. 'There are hardly any pots through which a people's life breathes as directly as Korean ones, specially Yi dynasty wares. Between pots and life, Japanese ones have "taste", Toft wares have "enjoyment", even the Sung pots have "beauty" . . . But the Yi dynasty pots have nothing in between; people's lives are directly behind the pots.'[167]

More disturbing was news of the great Kantō earthquake in 1923[168] when over 400 tremors and three days of fire resulted in the death of more than two million people. Tokyo, one of the largest cities in the world, was virtually wiped out, inevitably disrupting all communications and trade. One wild newspaper report claimed that Enoshima 'a picturesque island'[169] had disappeared. Eventually Hamada got news that his parents had survived by taking refuge on the only surviving bridge over the Sumida River. Yanagi's brother died as did Leach's teacher, Urano. Another friend lost virtually all his possessions. Tomimoto wrote to Leach about the ensuing turmoil, predicting that there was likely to be 'a revolution'[170] in which case he declared he would go to Shanghai and make a living as a motor mechanic or watch repairer, and advised Hamada to stay in England. A different view came from Kawai who thought that Hamada should return as soon as possible.[171] Appalled by the catastrophe Leach helped organize fund-raising events including benefit performances of Robert Morton Nance's *A Cornish Morality Play* to contribute to the Lord Mayor's Mansion House Japan Relief fund. The disappointing public response prompted Leach to write to the *St Ives Times*[172] deploring the fact that the houses had been only half full. Some £75 was raised from Cornwall as a whole, which Hamada thought would be recognized by friends in Japan.

The devastating earthquake brought a temporary end to the Japanese market for Leach's pots. Early in 1923, at Yanagi's suggestion, a large consignment of pots had been shipped and successfully exhibited at the Ruisseau Gallery[173] in Tokyo before the earthquake, where the finest pieces sold in the first two days. At the close of the exhibition Yanagi and Tanaka, acting as auctioneers, sold more pots including pieces left in Japan in 1920, some of which had 'cracks or big amendments or some deformation'.[174] Yanagi persuaded Naka Seigo to take no commission and after expenses and duty this resulted in a payment of 3,000 yen (about £300), a useful sum and far in excess of sales in Britain. The Japanese greatly appreciated the 'fresh' qualities of the galena or lead-glazed earthenware, not only because such work was not known in Japan but because it seemed more authentically European and helped satisfy an interest in anything western. With the exception of the raku, which sold immediately, buyers warmed to work evoking English rather than Japanese

culture, preferring tea or coffee sets which sold 'at once',[175] rather than tea-bowls or tea ceremony objects.

Reflecting on the finances of the Pottery in 1924 Leach noted 'We have but little cash in hand & this year there is my income to meet as well as the usual running expenses'.[176] In the first four years of operation the Pottery lost £2,534,[177] swallowing much of his and Muriel's inheritance. Income of £29 in 1921 rose to a peak of £1,030 in 1927 but fell back to £383 two years later, a situation not helped by the General Strike, anxieties about the international financial situation and the Depression, which at its peak saw some 3.75 million unemployed. Average sales for the period 1925–30 were a meagre £262. 'Neither Hamada nor I, nor Edgar Skinner, ever took more than one hundred pounds per year, and George Dunn, our clay-worker and wood-cutter, to within a year of his death was easily the best paid as an unskilled worker', wrote Leach in 1940. In an effort to raise funds in 1925 'shares' were sold in the Pottery, which among other benefits gave purchasers discounts on pots. Two years later bankruptcy again seemed a real possibility and Leach was forced to mortgage the property for £1,500, at 5 per cent interest. Shakily the Pottery reeled from one financial crisis to the next with Leach often writing to Yanagi about 'his multitudinous pottery problems'.[178]

To increase income Leach started producing tiles with hand-painted brush decoration, successfully blending function and artistry. Skilled labour was not required to make the tiles and Leach devised a range of decoration that included flowers, birds and animals in stylized form, kilns, well-heads and landscape in a combination of western and oriental themes. Fired to stoneware temperature, any distortion that occurred was thought to enhance the hand-made look. Initially tiles were made at the Pottery but later blanks were bought in more cheaply. The flat surface proved ideal for Leach's able and lively decoration. During firing the brush work softened and married with the creamy- or grey-coloured glaze to form a pleasing image. The tiles won the approval of the *Times* critic 'by their procession of what may be called "bread and butter" instead of "cake qualities" . . . Greys and olives are among them, but the general effect is that of designs in rust upon a ground of light buff'.[179] To promote sales a fully illustrated brochure was issued illustrating a tiled fireplace complete with grate.

Despite the tiles, overall sales remained low, causing Leach to write gloomily to Yanagi that 'everything is dominated by the damnable shop-minded and the commercial burgher of England . . . it is difficult to sell except to collectors and a small public. I shall have to limit myself to certain things and produce them more cheaply in order to keep going'.[180] Diligently pots were sent to various exhibitions in London and elsewhere, but were often ignored by critics and public alike. When, at Henry Bergen's instigation, Leach and Murray sent pots to New York and Boston in 1923 the enterprise proved disastrous with many pieces arriving broken and poor sales for those

exhibited. Offering to cover the losses incurred, Bergen described it as an 'edifying experience'.[181] America, they decided, was clearly not ready for their sort of pots. At the European arts and crafts show at Leipzig the Germans thought Leach's pots 'dull', an opinion shared by many visitors to the Pottery who preferred bright blue, nasturtium orange, or apple green.[182] 'It was years before we could get people to appreciate the quiet innate kind of colours of the raw materials themselves and of nature in its quieter moods',[183] protested Leach.

Following the Kantō earthquake Yanagi sold his home in Tokyo to enable him to care for his brother's large family and he and Kaneko moved to Kyoto, he to take up a professorship at Doshisha University, Kaneko to teach music in the girls' department. In spite of suffering financial problems Yanagi was soon urging Leach to send more pots and drawings, and with help from Hamada, Tomimoto and Tanaka, he arranged an exhibition of Leach's work at the newly refurbished Kū-Kyo-dō Gallery on Ginza.[184] The show did well and again the organizers refused to accept any kind of payment, but the poor exchange rate resulted in the modest net total of £136. Additional pieces were sold in Osaka where Yanagi took the liberty of charging half price for those shown two or three times before. Again Yanagi wrote stressing the popular enthusiasm for 'yellow galena of pure English quality',[185] which sold immediately, their 'pure Western quality . . . suited for the psychology of modern Japanese who live in Western buildings, manners and styles'.[186] The stoneware he thought was too 'black and grey in tone for the present psychology of Tokyo people after a disaster'.[187] Yanagi's description of the lead-glazed ware as 'born-pottery, not made-pottery'[188] hit home, reflecting Leach's aspirations as a potter and his relationship to his English inheritance. However, despite his good intentions, he continued to value it less than the oriental tradition. Hamada had now set up a pottery at Mashiko, and married Kazue, 'a pure Japanese girl both in spirit and manners',[189] who was now expecting a child.

From South Africa came news of Reggie Turvey's equally unsuccessful attempts to make a living as an artist, but he had finally sold his farm on the south coast of the Natal realizing his capital. Much to his mother's disapproval he fell in love with a married women whom she refused to welcome, where-upon Turvey moved his allegiance to her younger, unmarried, sister and announced his intention of returning to England to settle in St Ives, bringing his bride, Frances Waddell Gunn, twenty-two years his junior. Described by Leach as 'a young slip of a woman'[190] and nicknamed Topsy, she arrived at St Ives literally in Turvey's arms suffering from appendicitis and had to be rushed to hospital. Initially the Turveys moved into the Alison Studio in St Ives but eventually built a house and studio, Wheelspeed, opposite the Leaches in Carbis Bay, a property that Leach helped to design. For Turvey, Leach served as a role model, and he followed many of his ideas without question. They

planned a small white room for meditation 'a sanctuary of the spirit wherein the pursuits of truth and beauty meet'.[191]

Although often aligned with various progressive, broad political movements Leach never became identified with any one in particular. Following the General Strike in May 1926, Turvey raised topical political issues in a letter[192] asking if Leach had 'been shivering in the cold', adding 'you won't listen to the poor old "New Age" crying in the wilderness', reminding him of his own active support for Credit Power and the Social Credit Movement, a highly complex system devised by Major C. H. Douglas.[193] Philip Mairet saw Credit Reform as a means of stabilizing the economy, but the system was thought so uncertain that it was eventually vetoed by the government. Mairet expounded his pacifist beliefs to Leach, and deplored what he saw as the government's rejoicing at the ending of the General Strike.[194] For a time Leach subscribed to the weekly *New Age*, perhaps encouraged by Mairet, and even contributed a piece on the painter Stanley Spencer.[195] To a limited extent Leach did respond to Mairet's attempt to set up a 'Circle of Reformers', 'rekindled from Distributionists, Labourists, Craft Idealists, Ruralists and Credit Reformers',[196] and for a time he was in regular correspondence with Nellie Shaw, an advocate of community living.

At the age of thirteen David (and later Michael) was sent to Dauntsey's School, Wiltshire, a non-denominational institution established over 400 years earlier by William Dauntsey. Catering chiefly for the sons of farmers, it was less expensive than many others. Much to his father's relief, Michael won a school scholarship, which meant a reduction of a third in the fees. During the school holidays Michael, unlike David, spent time at the Pottery watching the potters at work and trying his hand, and for a school speech day constructed a small kiln and made pots, inspiring Leach to write proudly to Yanagi about his work with clay. Despite this practical interest Michael was more academically inclined and went on to specialize in the biological sciences, passing the Cambridge entrance examinations with flying colours long before he was eligible to attend. Eleanor and Jessamine were sent to Badminton School, and both later trained in dance. Betty remained at home and was in many ways the centre of Muriel's life. Later, Marion Ure, Muriel's great-aunt, one of her grandmother's sisters, came to live at the Count House, leading Leach to complain that he was always being run around like one of the children.

As the children grew, the pattern of family life was largely determined by school holidays when Leach set aside time to take the children for walks and play games with them. Indoors it was racing demon, Up Jenkins and head, body and legs. In the garden they enjoyed French cricket while in the nearby Tregenna rhododendron woods there was the hide-and-seek game of sardines. In the evenings Leach, often lying on his stomach, read aloud classics such as 'The Ancient Mariner'. Occasionally they gathered round the gramophone to listen to Harold Samuel play Bach, as well as Paul Robeson singing spirituals,

but a recording of a Japanese Nō play invariably reduced the girls to uncontrollable giggles.

Family outings involved long cliff-top walks and, in good weather, picnics, when a fire was built to boil the kettle. There were visits to old mines to scour for fool's gold or quartz crystals and long summer rambles gathering wild strawberries. In the autumn they went blackberrying and made jam. To Jessamine her father was warm and loving. During one walk she remembered how he stopped to admire the shape and form of a windswept hawthorn bush asking 'now how would you draw that – you can't include every twig you know'. It was memorable because walks alone with her father were rare, and were an introduction into an engrossing adult world. Both Eleanor and Jessamine, skilled folk-dancers, were watched with approval by their father. There was also the fascination of country lore involving itinerant tinkers who not only repaired household objects but ingeniously fashioned decorative lamps out of empty bottles and taught the boys ways of catching rabbits to ensure they remained tender. Their neighbours, the Grig family,[197] served them delicious Cornish food such as rabbit pie with a thick crust prepared in a slipware baking dish and cooked in a turf fire.

Aware of his Celtic blood, Leach sought to immerse himself in the local community. Attracted by the romanticism of the language he enrolled in Old Cornish classes given by Robert Morton Nance, an expert and author of books on the subject and founder of the Old Cornwall Society. As a decent batsman and bowler Leach was soon recruited to Lelant Cricket Club where his abilities were much admired. For a short time he attended evening meetings on socialism. Through Frances Horne, Leach met Dreolin Podmore[198] who drove about the area in a trap with two huge wheels. 'She was tiny: a cloud of pure-white hair over a head full of sensibilities, romantic Celtic dreams and enthusiasms,'[199] recalled Leach. At one of her tea parties they found the walls hung with clothes fashioned from Ethel Mairet cloth and their hostess wearing a dress made from Mairet's fabric; they 'talked about homespun furniture, food and the houses of England'.[200] She is credited with having suggested to Leach that he use the motif of the Mermaid of Zennor, a figure carved in the church of the nearby village, to decorate a large slipware dish. In a spirited and well organized composition the mythical creature was shown with long flowing hair holding up a mirror and a comb, against a background of waves with sailing ships on the horizon.[201]

Despite having ceased to be a Catholic, the church with its known and familiar rituals still had attractions. Discovering that Anne Foreign, a contemporary from the London School of Art, had married Bernard Walke,[202] a Church of England priest who worked at St Hilary, near Marazion, about ten miles from St Ives, the family became regular members of the congregation. Father Walke was a fine preacher and, much to Leach's approval, an open, committed and active pacifist. Leach found his approach a satisfying blend of

Catholic ritual and deep-felt passion and concern. The church itself was Catholic in all but name. The walls bore the Stations of the Cross, the lights in the sanctuary were permanently lit and incense burned. For occasions like Christmas and Harvest Festival dramatic decorations included branches placed in the church and silver balls, measuring some eighteen inches in diameter, hung in the arches flanking the aisle.

As with Father Kelly and others, Leach endowed Father Walke with almost mystical qualities, respecting him both for the clarity of his spiritual guidance and his practical work in supporting a home in the village which housed difficult children sent there by the magistrates' court. At one time the priest rode about on a donkey, lending him even more Christ-like qualities and prompting Leach to comment that Father Walke 'touched our hearts with Divine Love'.[203] The priest's courage was put to extreme test when he spoke persuasively on pacifism and the message of Christ at an open meeting in Penzance shortly after the end of the First World War. Enraged, his listeners leapt to their feet and he was saved only by the intervention of two soldiers, fresh from the trenches, jumping on the stage saying 'You will have to deal with us first'.[204] Eventually Father Walke's Catholic sympathies proved too much for his congregation and he was forced to abandon his parish and later formally entered the Roman Catholic Church.

Following Edwardian convention Leach was, at least outwardly, highly orthodox. Muriel and the children lived comfortably in a large house a mile and a half from the Pottery, quite separate from the many other aspects of his life. She rarely visited the Pottery except to serve Thursday teas, and although Leach had a studio at Count House most of his time was spent at the Pottery. With a full social diary, ambitious to make a career as a potter and drawn to the art and craft world of London, Leach was often absent, regularly spending several days in the capital, such outings doing little to ease the growing financial crisis facing the Pottery or the pressures of family life, or to help resolve his wish for a more fulfilling relationship.

HEAD, HAND AND MACHINE

England Japan

1927–1935

Against a background of increasing financial problems Leach decided to reorganize the Pottery to produce a more regular range of tableware in earthenware that could be sold relatively cheaply as 'bread and butter' lines. The steady stream of students wanting experience of a working pottery, he thought, could make this. Some remained for a year or more, others for less, but the able ones were encouraged to stay. 'They come to me year after year from the Royal College, or the Central School, or Camberwell, for longer or shorter, usually shorter, periods of apprenticeship,'[1] wrote Leach, reflecting the growing reputation of the Pottery. To meet demand, Leach set up short Easter and summer holiday courses.

The new tableware, of 'sound hand-made pottery in the English slipware tradition to suit those of limited income, who while loving beautiful things, also desire that they may be used for utilitarian purposes',[2] was shown at the Three Shields Gallery[3] in March 1927. The *Morning Post* was enthusiastic, though somewhat less so about the simultaneous exhibition of Leach's individual stoneware pieces at the Paterson Gallery, which, while admiring the 'charm, simplicity of shape and colour, and beautiful glazes', judged the decoration 'disappointing. His linear and floral designs frequently are out of keeping with the shape . . . and spoil the surface beauty of the glaze.'[4] Disappointingly exhibitions at the Mairet's short-lived New Handworkers' Gallery in Fitzrovia[5] met with only limited success. Located off the beaten track, it was accessible only by a steep flight of stairs and consisted of 'a back room on the first floor, too small to show the work to advantage'.[6]

The premises did serve as a useful *pied-à-terre* where Philip could write pieces for *New Age* and edit thoughtful pamphlets on the crafts, which were beautifully printed on handmade paper by Douglas Pepler at St Dominic's Press, Ditchling.[7] In 1930 the gallery moved to far superior premises at 6 Fitzroy Square, under the management of Ethel Mairet and Gwendoline Norsworthy.[8]

At Mairet's suggestion Leach wrote a pamphlet *A Potter's Outlook*[9] about the role of the studio potter. For Leach *A Potter's Outlook*, 'his first attempt in England to formulate faith and ideas',[10] was not only a review of his eight years

at St Ives and the world of studio pottery but also an examination of the uneasy relationship between the ceramic industry and the artist potter. Industry, he wrote, offered only 'crockery which is cheap, standardised, thin, white, hard and waterproof – good qualities all – but the shapes are wretched, the colours sharp and harsh'.[11] He bemoaned the limited understanding of collectors, and in a veiled attack, rebuked contemporaries such as Murray and Vyse for 'producing only limited experience pieces . . . they have not had the breath of reality in them'. In essence *A Potter's Outlook* was an outpouring of hope, disappointment and frustration. 'I thought that as in Japan, the work would speak for itself . . . this is not the case . . . we have been supported by collectors, purists, cranks or "arty" people rather than by the normal man or woman.'[12] 'Who are we?' he asked, 'What kind of person is the craftsman of our time? He is called individual, or artist – but how vague is the general understanding of the distinction even amongst educated people – and what is his relationship to the peasant, or the industrial worker?'[13]

Inspired by the left-wing politics of his friend Henry Bergen and recalling Morris's willingness to use some form of mechanical aid for 'donkey work', Leach proposed what was for him a radical notion: 'to get rid of the idea of the machine as an enemy. The machine is an extension of the tool; the tool of the hand; the hand of the brain; and it is only to *unfaithful* use of machinery which we can attack'.[14] He was, he claimed, investigating the possibility of changing from firing with wood to oil, replacing hand by power grinding even promising to install 'an electrically-driven potter's wheel as soon as I can find a silent and efficient one'.[15] Acknowledging the importance of function, his long-term intention, he wrote, was to produce semi-porcellaneous stoneware for household use 'with some of the qualities of the "Sung" or "Tang" ware of China – such pots would satisfy the finer taste and practical needs of today'. Finally, he outlined what amounted to a script for studio potters in the twentieth century in the West. His intention, he wrote, was to produce 'sound hand-made pots sufficiently inexpensive for people of moderate means to take in to daily use', while also making individual pieces that were 'very carefully selected from each firing and correspondingly valued'.

The division between one-off individual pots and tableware was further enshrined when Leach again held double exhibitions. At the New Handworkers' Gallery he showed 'utility pieces' and at the Beaux Arts Gallery[16] what were described as 'collector's specimen pots'. At the latter the highest priced piece was a 'Bottle with three small handles' priced at thirty guineas, clearly aimed at 'the collector of rare gems of the potter's craft'.[17] Extensive publicity included photographs of the tableware in the December issues of *The Studio* and *Pottery and Glassware*. The image of a breakfast setting of a cup and saucer, a plate laden with a boiled egg and croissants, a bowl filled with sugar lumps, with jugs for milk and lemonade placed on a crisp but homely checked tablecloth, had a whiff of Continental exoticism. With its mood of tasteful and

discerning living the photograph could easily have been taken forty or fifty years later. The rounded and friendly forms with comfortable handles still look fresh, uncluttered, practical and inviting.

By contrast two stoneware bottle forms, illustrated in *Drawing and Design*,[18] were self-consciously presented as art objects, their individual status empha-sized by each being placed on a carved wooden stand. The smaller was priced at nine guineas the other, 'a large grey and brown jar with four eared cord holes', at twenty guineas. Muted, restrained brushwork decoration enlivened the form. The *Observer* reviewer[19] found the pots 'interesting attempts to combine the best elements of Chinese glazing with a straightforward feeling for nature. All of them are extremely sober in colouring and simple in form'. The 'utility wares' were thought 'banal'.

Nevertheless, Leach's pots caught the attention of Leonard and Dorothy Elmhirst[20] and sometime around 1925 they approached him about their ambitious project of rural regeneration along liberal lines, which they were developing at their Dartington Hall estate situated in the beautiful landscape of south Devon. 'With the divine spirit of madness'[21] their intention was to create an almost utopian community that would include a progressive school in which art and craft had a prominent place. Leonard, the son of a Yorkshire clergyman, and Dorothy Whitney Straight, a wealthy American widow and heir to the Whitney fortune, were interested in forward-looking educational and social ideas inspired partly by the Nobel-prize-winning poet and educa-tionalist Rabindranath Tagore. His central philosophy was an intense faith in the power of love as the key to human fulfilment and freedom. Leonard had worked with Tagore and been deeply inspired by his pioneering work in India. Having previously heard something of Tagore's ideas from, among others, the art critic E. E. Speight in Japan, Leach responded positively to the Elmhirsts, believing they were the sort of patrons that could be of great help to the Pottery.

The Elmhirsts shared Leach's interest in a synthesis of eastern and western thought and like him were concerned with child-centred education. They were soon taking Leach's advice that they 'should have a small collection of pots by living British potters and some from China, Korea and Japan',[22] advice that for Leach combined educational zeal with a good measure of self-interest. Under his aesthetic supervision they purchased early Chinese pots, Leonard gradually acquiring the confidence to select modern Japanese work as well as pieces by Leach and Michael Cardew.

As guests of the Elmhirsts, Bernard and Muriel enjoyed what they described as 'a dream-like interlude'[23] when they discussed the idea of setting up a pottery on the estate. Reconstruction of the ancient buildings was still in progress and the Leaches warmed to the old architecture, the loving restora-tion and the spirit of enterprise and opportunity. In the same year the Elmhirsts purchased work from his exhibition at the Paterson Gallery and

despite Dorothy's irritating tendency to 'coo like a turtle'[24] when admiring his pots, they became good friends. During a tour of Cornwall the Elmhirsts and Tagore visited Leach to further discuss his involvement with the Dartington project. To the young David Leach, Tagore, with his long flowing beard, looked like the Old Testament prophet Abraham, commanding awesome respect.

With the financial situation at St Ives showing little signs of improvement Leach toyed with the Elmhirsts' invitation of becoming more involved with Dartington, estimating that setting up a minimal workshop would cost about £1,100, a figure that did not seem to them unreasonable, but still he remained cautious. Despite the Elmhirsts' enthusiasm and increasing financial problems, Leach was not willing to forfeit his artistic independence. Wanting to press ahead the Elmhirsts invited Michael Cardew then Muriel Bell to set up a pottery but both declined.

From Tomimoto came news that his two children Yo and To were doing well, and that he had moved to Tokyo. Following correspondence with Bergen, Tomimoto was reorganizing his life along Marxist lines and intended to use the machine to enable him to make pots more cheaply in order to achieve greater sales and reach a wider audience. From 1926 Tomimoto concentrated mainly on plain white porcelain instead of tea-bowls, inspired by eighteenth- and nineteenth-century Korean wares, some with blue and white decoration and over-glaze enamel. At his request Leach helped negotiate an exhibition of his pots at the Beaux Arts Gallery,[25] but as both Japanese and western taste tended to favour more elaborate decoration, there were few sales. The austere beauty of the pots seemed too minimalist and restrained for English taste, though the Victoria and Albert Museum was among the small number of buyers.

As part of a growing interest in traditional folk art Yanagi, Hamada and Tomimoto were collaborating in the collection of contemporary Japanese objects made by craftsmen for use rather than decoration, but after a violent disagreement about the role of artist craftsmen Tomimoto broke away leaving Yanagi more or less in charge. The traditional objects, handmade by anonymous makers to fulfil the needs of mainly rural communities, were chosen as part of an appreciation of the unselfconscious beauty of everyday household crafts, which gradually gave rise to the Mingei movement. In 1927 Yanagi published *Kōgei no Michi* (The Way of Crafts) setting out his aesthetic ideal, much of it incorporating the ideas of Morris and Ruskin, emphasizing the quiet qualities inherent in the work, its use of materials, skilled making and functional qualities creating a harmonious whole.[26] The text came to be regarded as the bible of Mingei thought.[27]

Such ideas were discussed when Yanagi and Hamada arrived in England for a four-month stay in May 1929. Langdon Warner, an American academic, whom Leach and Yanagi had known in Japan and who was now in charge of the Asian art collection at the Fogg Art Museum, Cambridge, Massachusetts,

had invited Yanagi to teach there, so enabling him to visit Europe *en route* for the United States. Their extensive itinerary in England included an exhibition of Hamada's pots at the Paterson Gallery (followed by a show of pots by Kawai at the Beaux Arts Gallery)[28] and tours round various counties, which included a visit to see Pleydell-Bouverie at Coleshill. There were trips to the Victoria and Albert Museum, to the Eumorfopoulos collection and the Guildhall Museum where the collection of medieval English jugs so impressed Yanagi that he proposed a loan exhibition in Japan. Thirty-two years later a group of English medieval pots was finally shown at the Folk Craft Museum in Tokyo.

After a trip to Ditchling they visited Eric Gill who had moved to the Chilterns in the heart of the Home Counties. Dressed in a light-grey blouse with nothing below his knees and bare-footed, Gill was at his most austere. As they talked their chairs seemed to draw closer together giving the meeting an almost alarming intimacy, but when Leach asked about the advisability of producing a small number of high-quality, expensive pieces or a large number of good quality ware at low prices Gill was evasive, telling Leach to produce the best works he could and leave the rest to others. At Dartington Yanagi was full of praise for the enterprise and its ideals, suggesting that a move to Devon would be beneficial for Leach. With his 'talent to produce beautiful things'[29] Yanagi thought that he would 'be able to do better work . . . than where he is now'[30] and that Leach's 'inborn sense of Art' would find new meaning. At Warner's suggestion they also took time to select objects for an exhibition of contemporary Japanese and English craft, including work by Leach, which was subsequently shown at the Fogg Art Museum and six other venues, but as with the earlier exhibition public response was muted and sales poor. In addition to lowered confidence as a result of the Wall Street Crash, Yanagi thought the American public not yet 'ripened to appreciate it'.[31]

With Bergen as host, Leach, Hamada and Yanagi flew to Paris in July, staying in an inexpensive but comfortable hotel in the colourful Latin Quarter. Taking a bus to Chartres they were overawed as the twin spires of the great medieval cathedral came into view over the rolling landscape. On arrival they stood in silence to marvel at the flying buttresses, the magnificent stained glass, the elegant arches and the soaring towers. To Yanagi the building was 'a physical expression of a common agreement about the meaning of life, of work, and of adoration',[32] uttering his prophetic words 'that is what you have lost. That is what you need, a new Gospel'.[33] Leach was in full agreement.[34]

At the Pottery, in an attempt to provide student accommodation, an office, a study and a showroom, what came to be known as Pottery Cottage was built in September 1927. This substantial building was a significant development in providing a much-needed home for the pots and quarters for Leach's own use as well as for the students. Around the same time Leach traded in his motor cycle for a Baby Austin, his first car. Increasingly Leach felt smothered by the demands of family life, feelings made more acute by his infatuation

with Norah Braden. While firmly discouraging his affections, she had urged him to try and make a go of his marriage primarily for the sake of the children, but if this were not possible to face up to the idea of separation. Now in his forties, Leach experienced anxiety about ageing, restlessness about his work as a potter and the need to make the business viable, which along with the financial and emotional demands of his family often threatened to overwhelm him. Although regular helpers were employed, Betty needed constant care and attention, the burden falling chiefly on Muriel. While he was respectful of the time, energy, love and commitment that Muriel gave to Betty, perhaps because so much of her time and resources were given to their daughter Leach felt she had less for her husband. Muriel knew better than anyone that Betty would always be dependent, always need her, and he may have felt excluded. Leach's desire to establish a loving and sharing sexually, emotionally and intellectually fulfilling relationship was additionally frustrated by his own devotion to Betty, and his wish not to abandon her. His not infrequent dalliances with other women were mostly short lived, and so far no woman had emerged who could seriously threatened his marriage, but it was perhaps inevitable that he would be constantly looking for someone with whom he hoped to share his ideals.

Visits to friends such as Havelock Ellis, then living in Wivelsfield, which could be combined with a trip to nearby Ditchling, were useful, as were a few days with Father Kelly at the Society of the Sacred Mission, Kelham, but proved to be of little lasting spiritual or practical help. At Kelham discussion ranged over fundamental issues of Christian faith such as the Trinity and Duality, as well as more personal concerns including celibacy versus free love, Christ and marriage, and discipline from within and without. All failed to convince Leach of the rightness of returning to the Christian faith or offered any lasting solace for his problems. Leonardo da Vinci's cryptic remark 'when imagination outruns performances this is the greatest evil'[35] seemed more accurately to reflect his feelings on art and life.

Following his nineteenth birthday, David, much to Leach's surprise, asked to join the Pottery, having abandoned the idea of becoming a doctor as he believed he was neither sufficiently talented to win a scholarship nor his father wealthy enough to cover the fees. Although his eldest son had previously shown little interest in pots and despite doubts about the Pottery's financial survival, Leach was overjoyed by David's decision. Income rarely exceeded expenditure, the profit of £126 for 1930 was the lowest for many years and followed a year that was nearly as poor, but Leach was still reluctant to risk his artistic independence by moving to Dartington.

At the Pottery assistants were tending to stay longer. Charlotte Epton, who arrived in 1927 and was later to marry the artist Edward Bawden, stayed for four years. As a competent thrower she passed on her skills to others, but left in 1931 following a dramatic fire when damp wood stacked on top of the kiln

to dry caught alight in the early hours of the morning, burning down the roof, an adjacent store and destroying much of her own work.[36] George Dunn, first on the scene, was reluctant to let the firemen through or allow them to hose water onto the kiln, but despite this the firing proved a success. A Canadian potter, Muriel Bell,[37] was also an excellent thrower who taught David basic pottery techniques and stayed for three years. Barbara Millard, 'a lovely South African girl' arrived in 1931 following a period at the Central School of Art, and stayed for a year.

Other able workers included John Coney who subsequently left to set up a pottery in Somerset. Kenneth Murray was also briefly at St Ives between stints as an enlightened education officer and pottery advisor in Nigeria. Troubled by marital problems Murray wrote to Leach giving him lengthy details, not only of traditional pottery making in Nigeria but also of his confused feelings for his wife, Phil. She was a member of Mitrinovic's group in London and in her own letters to Leach she spelt out her sexual and marital frustration. Experiencing much the same sort of feelings Leach found a measure of reassurance in knowing that others shared similar difficulties. Bernard Forrester[38] arrived after having served a seven-year apprenticeship at Minton's in Stoke-on-Trent before studying at Armstrong College, Newcastle upon Tyne, where Herbert Read introduced him to the qualities of Sung ware and suggested he contact the Leach Pottery to gain practical experience. Jubilant at having made a conquest from what he described as 'the industrial devil', Leach saw Forrester as 'just the sort of man one wants, keen and content with small pay'.[39]

The St Ives team[40] was joined in 1931 by Laurie Cookes.[41] Although employed primarily to assist with the secretarial work and to look after the showroom, she probably had some experience as a potter and an understanding of the craft and subsequently she lent a hand at whatever tasks were required. These included assisting in the workshop and helping to fire the large kiln. 'Student and secretary' was how Leach described her, though no known examples of her pots have yet come to light.

At thirty-seven, Laurie Cookes was tall and slender with a good figure, a sallow complexion, dark eyes and straight brown hair, later worn in a snood. With a penchant for long flowing dresses, often of hand-woven materials, and sandals, she embodied the sort of independence of thought and action that at one level greatly appealed to Leach. With Laurie he found himself able to talk about his work, ideas and ambitions, and she seemed to appreciate his artistic, aesthetic and emotional needs. Laurie, he felt, increasingly understood him, empathized with his ideas, and was a patient and understanding listener. She also seemed to have an intellectual grasp of what he was trying to achieve that enabled her fully to share his ideas and aspirations. Like Norah Braden before her, Leach quickly became emotionally attached. In Leach's view they met on three planes, the physical, intellectual and emotional. It is

difficult to know when Laurie was initially as smitten as Leach, but she responded without reserve to the charm and mindfulness of a successful, intelligent and engaging artist. They were soon on intimate terms.

Surviving letters testify to the growing intensity of their feelings in which both sought to embrace emotional and intellectual honesty with a desire to be open and trusting, discussing among other topics jealousies, rivalries and 'the self-indulgence of promiscuity'.[42] On Laurie's part there was, she said, a willingness to recognize that should Leach find another 'who attracts you more and can make you happier' he should not 'hold back because of me'.[43] They also agreed that without wishing to be selfish about other relationships new lovers must be discussed honestly and without duplicity. When Leach was away Laurie wrote saying how much she missed him and how different the Pottery was without him. In one sadly prophetic note she claimed 'never to have lost the feeling that your life and mine will only touch a little way'.[44] Yet, despite her infatuation, she was appalled by Leach's occasional pompous manner, witnessed when he was conducting a group round the show of Chinese ceramics at Burlington House in 1933.

Quite how or why Laurie came to the Pottery or what she had done before remains unclear, though a Leach family anecdote suggests she may have been a student at the Central School and worked for Lancelot Cayley Shadwell's Broadstone Pottery in Bournemouth. One of four children and the only girl, she was born into a solid middle-class family in Beaufort Street, a highly respectable part of Chelsea. Her father, Horace Cookes, who came from a family with a long and distinguished lineage[45] was an auctioneer and estate agent. After working in the city he had set up his own business in Kensington and owned extensive properties. As she explained to Leach, her upbringing was within a 'social, conventional morality'[46] that she now rejected in favour of 'strong instinctive feeling'.[47] Laurie Cookes's arrival was propitious not only emotionally but also practically as Leach certainly needed someone to take care of general administration and secretarial work. Frank Vibert, a local council employee, audited the accounts but there had been no regular day-to-day help since the illness and death of Edgar Skinner a year or two earlier and Leach neither enjoyed nor was efficient at such tasks. Laurie quickly became involved in all the complexities of the Pottery.

In sharp contrast to Muriel, Laurie offered excitement, adventure and passion, very different to the mothering concern Leach received at home. Bearing the responsibility of the family as they grew up, Muriel rarely had the time or indeed the encouragement to concern herself with the Pottery, save helping with teas and investing yet more of her financial capital in the enterprise. While continuing to support Bernard in all his endeavours she had gradually grown out of touch with his changing ambitions, and while perhaps vaguely aware of his philandering she saw herself as his wife and had no wish for this to change.

With the Pottery chalking up a record loss of £901 in 1931, and in response to the Elmhirsts' continuing encouragement, Leach proposed a new scheme, which he had briefly touched on in his pamphlet, *The Potter's Outlook*. This involved a sizeable team producing a range of pots 'of human quality for daily use'[48] roughly based on Sung forms. Made in fine porcellaneous stoneware with celadon glazes, though firmly rooted in tradition, they would address modern needs. 'Suitability for purpose', he pointed out, was interpreted differently in the East and West, the West tending 'towards suitability to bodily need, the Orientals to spiritual needs'.[49] The Elmhirsts thought that such pottery could 'find its natural place as an art, a science and a utility as well as in the educational scheme as an introduction to a sense of form and design',[50] and agreed to financial backing. They particularly responded to Leach's view that 'we must have pots made in mass by mechanical aid, and also pots made for intimate human delight by hand'.[51]

A major stumbling block was the appointment of William Slater as general manager to the Dartington estate. Scientist turned overseer, Slater diligently implemented Elmhirst policy that each scheme should be properly costed and economically run, insisting on the need to establish suitable markets along with efficient production. While the entire enterprise relied on the Whitney fortune, each of the activities on the estate, including the craft industries, was intended to be business-like and self-financing. Although filled with 'new courage' after a visit to Dartington in December 1931, discussions with Slater confirmed Leach's fears about the perceived separation of the roles of maker and designer. This, he declared, was a mistake as there could be no point in the 'fusion of hand and machine if he refuses the third step, head; hand; machine'.[52] Leach sent Leonard Elmhirst a copy of *A Potter's Outlook*, saying 'It is only by a return of the artist into normal life, into production, that on the one hand *he* may hope for normal health in his work, and on the other *we* may hope to buy and use furniture, textiles, pottery etc which will satisfy at one and the same time our bodies and souls.'[53] On Christmas Day, in a letter to Leonard, Leach reiterated the importance of education and of keeping the arts in touch with life for 'constant growth and renewal'.[54]

In the face of the worsening financial situation at the Pottery and recognizing that his relationship with Laurie Cookes made remaining in St Ives and living with his family impossible, Leach, despite Slater's caution, accepted the Elmhirsts' offer and in 1932 moved to Dartington. Cannily he negotiated good terms, securing a salary for himself, wages for two assistants at St Ives to offset any loss suffered by his own absence, plus a car allowance to enable him and David to travel between Cornwall and Devon. The move to Dartington also enabled Laurie to visit him away from the inquisitive eyes of the Pottery crew. While researching the new pottery he agreed to do some teaching at the newly built Foxhole School. A suitable site for the pottery was identified at Shinner's

Bridge[55] in the old quarry below the new junior school and a small studio was built, designed by Leach and Bob Henning the estate architect.

As close friends and neighbours, the Turveys were among the few that refused to be overawed by Leach's growing success, continuing to treat him as a chum. They spoke to Leach with often alarming candour, pointing out for instance that David should be allowed to find himself at the Pottery and 'be David Andrew and not Leach the second'.[56] Turvey was slowly establishing his own reputation, and in 1928 travelled to South Africa for a solo exhibition at the Durban Art Gallery. As a further sign of the Turveys' closeness to Leach, they followed him to Dartington, again choosing to design their own house in the village. Their architectural scheme was discussed with both Rex Gardner of the Dartington Hall estate and with Leach, though the resulting property with its experimental design required constant repair.

Motivated by a desire to distance himself from St Ives because of Laurie, and the need for some sort of financial security, Leach had moved to Dartington in preparation for setting up a substantial pottery workshop. He wanted to keep his options open with regard to his pottery at St Ives and therefore the more radical decision of closing St Ives was deferred until the position became clearer. Ultimately he wanted to retain his independence and if he had decided to close down St Ives completely and relocate everything to Dartington the history of the Leach Pottery would have been very different. Leach did persuade the Elmhirsts to buy his tile stock with a view to establishing production at Dartington, which also had the advantage of enabling him to display tile samples in their London showroom. To be profitable, the tiles needed a larger scale of production, a task St Ives was not geared up to do.

At Dartington, Harry Davis,[57] a highly energetic twenty-one-year-old potter came to Leach looking for work. After studying at Bournemouth Art School, Davis had worked at Broadstone Pottery, Bournemouth, where he became a highly skilled thrower, learning from an old industrial thrower.[58] At Broadstone, which had produced giftware decorated with enamels or multi-toned 'dribbly glazes', Leach Pottery wares were discussed, not because of their aesthetic qualities but because they were able to command what seemed enviably high prices. Recession forced Broadstone to reduce its labour force dramatically and the pottery closed in 1931. Shadwell advised Davis to apply to Leach for work and he duly cycled to Devon in August 1933, pitched a tent in the orchard and after demonstrating his throwing skills was offered a job at St Ives at a weekly wage of £1 10s. Sensing dangers in his more commercial training, Leach stressed that 'the quality and character of the throwing is more important than quantity'.[59] Davis's skills were greatly admired, and he not only threw some of Leach's exhibition pots but also taught David professional throwing techniques. Shadwell, with his own pottery closed, was also taken on, but plagued by domestic problems stayed only a few weeks.

Shaggy and long-limbed with a mass of auburn hair, a straggly beard and with a preference for loose shirts and baggy corduroys, Davis was industrious in his work and spartan in his material needs. In the opinion of May Scott, who was later to work at the Pottery and marry Davis, he did the work of three men. As a child, Davis had suffered from poor health and, determined to strengthen his body, forced himself to endure the hardest of conditions. For a time he lived above St Ives in a primitive shelter rigged up by rocks on Penbeagle Hill, an arrangement that also helped eke out his meagre wage. With Bernard Forrester he moved into Higher Ninnis Farm, Lelant, where, helped by Dicon Nance, he made plain, undecorated furniture.

The impact on Leach of 'the great experiment' at Dartington was profound. For the first time he was involved in education where emphasis was on experiment and self-discovery rather than on acquiring skills. Rubbing shoulders with dancers, painters, weavers and musicians brought together from around the world created an atmosphere of experiment and change and one that allowed Leach to throw himself 'heart and soul into his life and work'. His drawing changed dramatically as a result and he began producing a series of half life-size figures brimming with a new-found confidence. With the help of Bernard Forrester a small stoneware kiln employing an oil-drip system was built, though it never fired well. The small and inefficient electric kiln did not meet with Leach's approval and was sold. Unable to produce stoneware, Leach experimented with the local red clay before shipping in the more workable and attractive chocolate-coloured earthenware body from north Devon for the production of slipware. Eventually a range of tableware was developed with a covering of black slip patterned with spots of yellow under a clear glaze. New schemes included a well designed workshop and a tearoom furnished with estate-made furniture and pots.

Leach's most important encounter at Dartington was with Mark Tobey,[60] an American artist recruited by the Elmhirsts to be head of painting. Three years younger than Leach, he was a big, bear-like, jovial figure with a trim beard and dark, deep-set eyes, who was outgoing, warm, charismatic and fond of food. Dubbed 'the Sage of Seattle' because of the strong spiritual element in Tobey's work, Leach admired the artist's Cubist-inspired still lifes and landscapes, but was more suspicious of his later paintings, which he saw as 'intestinal'; gradually, however, he came to recognize that they were an attempt to express inner thoughts and feeling rather than outward appearance. The traditionalist in Leach was greatly struck by Tobey's innovative teaching skills, which encouraged students to free themselves of inhibitions. During one life-drawing class, Tobey, in a bravura display rendered the model in the manner of Leonardo, searching for light and shadow, before dusting off the charcoal and drawing in the style of El Greco and then Rembrandt to explore the effects of light on form.

A warm and enriching friendship developed; Leach described Tobey as

'more frank about himself than almost anybody I have known',[61] while Tobey found Leach intelligent, sensitive, and artistically aware. At the age of twenty-eight Tobey had become a Bahá'í[62] and he talked passionately about his commitment to this religious belief. Leach had first heard something about the Bahá'ís from Agnes Alexander, a leading member of the faith in Tokyo, but had never taken any interest in it. Tobey now brought the faith alive and made it more meaningful to him. It was, he said, a central part of his life in safeguarding the interests of and promoting 'the unity of the human race . . . the well-being of mankind, its peace and security . . . that it can illuminate the whole earth'.[63]

Moved by Tobey's persuasive powers Leach attended Bahá'í gatherings, greatly attracted by the openness, informality and the absence of rituals and official clergy, even going to a Bahá'í summer school. At the same time Leach remained an observer, aware of feeling 'pushed by propaganda and antipathetic to revelation and religious authority',[64] and so preferred to remain a supporter rather than a convert. Many of their long discussions on art and the Bahá'í faith were shared with Reggie and Topsy Turvey who had settled into Cott Cross, their new house in Dartington village. Under Tobey's convincing reasoning Turvey also became a convert and his painting moved away from landscapes to more abstract work inspired by the search for spiritual rather than material values.

Leach was so enthused by the power of Tobey's personality that he grew a short, neatly cropped beard in imitation of his newly found spiritual mentor. No doubt Tobey, who had been briefly married sometime earlier, had heard something of Leach's emotional troubles and offered sympathy, though there is no record of whether their 'frank' discussions touched on Tobey's own homosexual inclinations. While familiar and accepting of the close, passionate relationships between women such as Katharine Pleydell-Bouverie and Norah Braden, the designer Enid Marx and historian Margaret Lambert, and the textile designers Phyllis Barron and Dorothy Larcher, Leach's first-hand experience of male homosexuality was probably very limited. At this point Tobey's sexual identity may not have been entirely fixed, but whatever he told Leach it did not hinder the development of a warm, supportive and understanding friendship.

However enticing the atmosphere and radical the ideas at Dartington Leach remained deeply involved with St Ives. He continued to dodge back and forth, arriving in Devon more or less at the beginning of term, or slightly later, and rushing back to Cornwall when the school closed for the holidays. This allowed him to keep an eye on the Pottery, make a few stoneware pots and spend time with Laurie, which was just as attractive as the challenges of Dartington, particularly as there were limited opportunities to pursue his own work in Devon.

Further complications to what had become a highly complex emotional and working life came with the repeat of an earlier invitation from Yanagi

and the National Craft Society for Leach to make an extended visit to Japan. This, wrote Yanagi, was as 'a spiritual broker or rather a messenger from the West with whom we wish to discuss about theory and practice of future crafts, which we regard as one of the most serious and grand problems for the welfare of human beings in the future'.[65] The fulsome request, indicating Yanagi's profound respect for Leach, came with details of a retrospective exhibition planned at the Kū-kyo-dō Art Gallery,[66] and a special edition of *Kōgei* (Craft), no. 29, devoted to his work. There were also plans for an extensive biography edited by Dr Shikiba Ryūzaburō, a Japanese psychiatrist who wanted to include existing and new essays together with many illustrations of Leach's pots. In response to Shikiba's request for biographical details Leach sent a long account outlining his Hong Kong childhood, his school days, his year at the Slade, his unhappiness at the bank, and his time at the London School of Art. At the end he confessed that he was omitting 'the truly important private motivation which I am aware should not be done if an autobiography, or even a biography is to be of full human value. When I do see you', he added, 'I will put some of the matter in your hand for possible use after I am dead'.[67]

Some 200 pots and drawings, including slipware dishes, 'the most beautiful' according to Yanagi, were shown in the Kū-kyo-dō exhibition. About 700 people visited the show, two-thirds of the exhibits were sold, including nearly all the big and expensive pieces, resulting in a total of 3,900 yen. Cleverly, Yanagi proposed sending Leach only £100 and keeping the remainder in preparation for his visit to Japan. Given the exhibition's success and his increasing status, the attractions of Japan blossomed in comparison with the relatively lukewarm reception given to his pots in England and the ever-pressing problems of money, family and emotional relationships. Paradoxically, the Elmhirsts agreed to fund his visit. 'If I don't go, I feel that I shall never go,' he wrote to them, 'I have not sought it or struggled for it, it has come, and come twice.'[68]

In his application for a grant (later known as the Elmgrant) from the Dartington Research Grants Board Leach put forward perfectly rational reasons for a prolonged visit. It would, he said, enable him to investigate prototypes of domestic ware and acquire greater technical expertise 'prepatory to starting serious work at Dartington in the direction of making stoneware in larger quantities and in finer quality than I have been able to achieve under purely handmade conditions at St Ives'.[69] In addition he proposed to research a book on pottery that he had discussed with Richard de la Mare at Faber & Faber. With a nod towards Leonard, who was deeply interested in folk art, he pointed out that the visit would give him first-hand experience of the Mingei Undō, the name for the Japanese Folkcraft Movement set up by Yanagi. Leonard's response was unambiguous: 'The fact that you are regarded in Japan as the high priest of this movement is as strong a recommendation for you

going as any.'⁷⁰ Generously Dartington agreed to pay for his passage, living and travelling expenses, suitable clothes and a 16 mm cine-camera, as well as financially support Muriel and employ David to take over his teaching and research at Dartington in his absence. Major developments would be postponed until his return. It was a munificent package. Davis, Forrester and Laurie would run the Pottery at St Ives.

The decision to make an extended visit to Japan, however rational and potentially fulfilling, came at a particularly tense time, as the Turveys, clearly knowing of his affair with Laurie, were quick to point out. 'Somehow . . . I dont feel that you're being "true" . . . Is it really *you* that wants to go? To me it seems far more true for you to concentrate on Dartington and just a restless ambitious urge to go flying off before you've started doing what you intended at Dartington.'⁷¹ Rubbing salt in the wound they asked 'Are you taking Laurie with you? . . . It would be too much to expect her to be a "Grass-widow" for you', and turning the screw asked 'Tell me why you are running to Japan. Is it a running away or a chasing ambition or is [it] a real urge from your creativeness'.⁷² Part of the Turvey's frankness may have been a response to a brief affair between Topsy and Leach, but it carried more than a hint of truth.

Whatever their motives, the Turveys identified many of Leach's conflicting thoughts. For, just as he appeared to be on the point of embarking on an artistic project that may at last meet with some economic success, he intended to abandon it. Even more confusing was his decision to leave behind a woman he loved and for whom he was contemplating ending his long-standing marriage. In seeking to escape he was merely delaying the inevitable confrontation with Muriel who, far from knowing of his changed affections, had become quite friendly with Laurie. Perhaps hoping for a civilized friendship Laurie regularly visited the Count House during Leach's absence in Dartington. Although the children had mostly left home, Eleanor and Jessamine to school in Bristol and Michael to Cambridge, there was still the question of Betty and the constant care she required. Leach was well aware that leaving Muriel would also be seen as abandoning their daughter, issues he would have to face if he remained in England.

His affair with Laurie, who was living at Pottery Cottage, could not be concealed from the other workers and Leach either could not or would not make attempts at subterfuge, placing David, who was still living at home, in a particularly difficult position. While most of David's sympathies lay with his mother he respected and was fond of his father and was himself not entirely convinced that relationships had to be monogamous. On the one hand, if he told his mother about his father and Laurie he might hurt her needlessly, especially if the affair proved to be short lived, but on the other keeping silent involved him in a conspiracy of silence and deceit. David might have acted more decisively if he had known that Laurie was pregnant, and that despite

this Leach was pressing ahead with arrangements for his tour of Japan, leaving Laurie to shoulder the responsibility alone.

Determined to get away, no matter what the cost in terms of his family or his relationship with Laurie, Leach desperately felt the need for companionship on the journey to Japan. Discovering that Tobey was keen to travel east he approached the Elmhirsts for support. 'What we two could accomplish, in comparison with what I could achieve alone, seems to me deeper and broader than I thought when we last spoke',[73] he argued and the Elmhirsts subsequently agreed to sanction and fund a journey of some fifteen months for them both.

On 7 March 1934 Leach and Tobey left Victoria Station, London, for Dover and the cross-Channel steamer to France for a brief overland tour to Paris, Assisi, Florence and Rome, 'in order to take a last look at our own before plunging into that of the East', before sailing to Japan from Naples on board the *Terukumi Maru*. On the platform at Victoria, Bergen, Kin-ichi Ishikawa, a friend from Japan, and Mr Penny, a Jamaican friend of Tobey's, bid them a sombre farewell with Leach taking the opportunity to bring Bergen up-to-date on his domestic situation. Bergen advised Leach to say nothing to Muriel but rather to wait and see what developed.

For Leach the departure was an escape, a running away from problems with his family and Laurie that he found impossible to deal with. It was also deeply symbolic, signalling the end of his life centred on family and the Pottery for a future that was as yet uncertain. Not surprisingly, the boat and train journey were 'blank', according to Leach and he was 'exceedingly sad at the parting and stood alone in the stern of the cross-Channel boat saying farewell'.[74] To Michael he wrote of living 'through a dream, a sliding dream, train, chalk cliffs, ship, wake . . . numb pain'.[75] To Laurie he poured out all his sadness and confusion revealing yet more of the emotional turmoil he was leaving behind, 'Farewell land I love and people I love and have loved, wife, children, friends, farewell Laurie, farewell child in your womb. The cliffs fade – they are gone – I stand in the very stern watching to the last'.[76] In his diary Leach indicated that conception had probably taken place a month earlier (8 February) though no further references were made to the pregnancy or its outcome in surviving correspondence or in his diary. Only twenty years later, when reflecting on this turbulent period, did Leach question his decision to go to Japan, ignoring Laurie's condition. It is hardly surprising that, after receiving this letter, she assumed Leach would not return to England and felt abandoned and rejected. At some point Laurie went to Paris for an abortion, probably with Leach's approval; it must have been clear to her that he wanted a lover rather than a second family.

During his own three-day stay in Paris, Leach was in a profoundly emotional state, horrified by the implications of his actions yet feeling an overwhelming need to escape from his family and an open commitment to Laurie

and to investigate new opportunities in Japan. Late one night Leach's nerves were brought to near breaking point when Tobey returned to their hotel bedroom and switched on the light insisting that he wanted to talk. Leach, feeling tired and mentally exhausted, and fearing that he was on the verge of nervous collapse, pleaded to be left in peace and heated words were exchanged, but eventually they lay on the bed talking quietly about their suppressed feelings, and gently stroked each other's hand.

Tobey introduced Leach to an old friend Vera Milanova, a 'petite little woman', who 'looked rather like Edith Piaff, a little wry woman, smoked cigarettes incessantly, wore those long long woollen socks'.[77] Together they talked endlessly about the life and teaching of the Russian-Armenian mystic Gurdjieff,[78] of whom she was a devoted follower. They also went to the Musée Guimet to look at 'Chinese Thibettan painting and sculpture'. Leach sent Muriel a postcard of Rembrandt's painting *Femme au bain dite*,[79] of a naked woman holding a note and looking at a maidservant washing her feet. In its sense of solitariness it could almost have been an image of Leach, an impression confirmed by his melancholy message saying that he felt 'very tired and dead . . . Life is full just now & full too of adjustments & impressions . . . I leaned over the stern rail & watched Dover Cliffs recede until they were lost & thought & thought'.[80] He could have been referring to revisiting Japan after a gap of fourteen years and leaving his family and adjusting to a new way of life, but its heavy, sad, reflective tone also suggests his inner turmoil in abandoning Laurie and deceiving his wife.

As the incident in the hotel revealed, Leach and Tobey's respective temperaments made them uneasy travelling companions. Shortly after sailing from Naples the extent of their differences rapidly became apparent. 'We irritate each other intensely in a thousand daily mannerisms, rivalries, possessiveness & selfish habits,'[81] noted Leach. Impulsive and spontaneous, Tobey was a nightbird who became alive as darkness fell and insisted on talking into the early hours. In contrast Leach was more ordered and conventional, preferring to keep regular hours. Both were stubborn and determined to have their own way, resulting in tremendous rows. After a while they found they could be 'absolutely frank and truthful and open about one another and about our selves without breaking our friendship'.[82] The voyage proved to be not only a trip around the world, claimed Leach, but also a trip around each other. During long discussions to 'reach towards that which is more than ourselves'[83] they found that while agreeing on much in art, in life and in the Bahá'í faith, there were temperamental differences. They patched up their relationship, but when they docked at Colombo for a few hours, in pensive mood Leach went alone with a Christian missionary to a Buddhist funeral. Far from finding it depressing he felt calmed by the ritual of prayers and fire and the reassuring presence and conviction of the yellow-robed priests.

There were more sad reflections crossing the Indian Ocean, some of which were expressed in a letter to Norah Braden. Recalling his feelings for her he wrote of how she had made him suffer in not reciprocating his infatuation, but stressed that he was more able now to 'distinguish between subtle self-love and the genuine love of another'.[84] Although each agreed that they had gained a lifelong friend he still felt a sense of regret. Reflecting on his fragile emotional state he thought that he was stronger for 'having caught some disconcerting overshoulder glimpses of myself in several human mirrors during the last days in England and on the Continent'.[85] He did rue his promise to cast a great pile of her letters 'in the flat hard-horizoned sea'.[86]

Hong Kong, the city of his birth, struck him anew with its beauty and the way 'Victoria is hung on a hill which towers over the thronged streets and harbour', reminding him of the Chinese proverb 'Modesty loves the hills, Wisdom the sea'. Poignant childhood memories came flooding back as he observed the lean, hard-working Chinese and their ceaseless activity and industry. The population had now increased from one million to a staggering four million and to accommodate them the buildings soared upwards. They took a room in a Chinese hotel in Kowloon, cheaper than the city of Victoria opposite, spending a week sailing in sampans and sauntering round the streets. Among other places they went to see The Falls, his father's old house and the Matilda Hospital, built in memory of his Great-Aunt Matilda, finding them both surprisingly modest in size. Curiosity led them to visit the house of Aw Boon Haw, known as the Tiger Balm King, a Chinese self-made millionaire, a 'coolie comerich', who had made his fortune out of Tiger Balm, a widely used cure-all credited with almost magical properties. In a combination of generosity and ego boosting, visitors were welcomed to view his residence.[87] At the Amusement Park they rode on the rides and at the zoo played with the orang-outangs. In the crowded streets Tobey became fascinated by the vertical hanging sign boards covered with Chinese characters, black on white, red on white, red on black, red on gold, and occasionally emerald green. From these patterned and to him indecipherable marks – what he called 'secret writing' – he developed his 'white writing' style of non-representational painting that was to gain him international acclaim, acknowledged as one of the roots of Abstract Expressionism.

As their ship approached Shanghai, their next port, Tobey debated whether to continue with Leach and go on to Japan or remain and stay with a Chinese artist Teng Kwei, whom he had met in New York in 1923. A skilled calligrapher, Teng Kwei astonished Leach by painting on Chinese absorbent paper using his two-inch-long little fingernail dipped in ink, a technique only known in China. After disappearing with Teng, Tobey returned to the ship only to wave Leach farewell. Disappointment was tempered by relief because it meant no further disagreements and uninterrupted time in which to prepare for his forthcoming tour.

At Kobe, Leach scanned the crowds on the dockside for sight of old friends but was distracted by the ship's purser pressing into his hand a copy of Shikiba's biography. Flattered and slightly humbled by the weighty volume with its mixture of reprints of articles, appreciations and reminiscences by Japanese friends together with a hundred colour and black and white illustrations, Leach recognized the respect it gave to an artist still only in his mid-forties. It made Leach feel as if he 'should be dead'.[88] This was soon forgotten as friends surrounded him and members of the press took his photograph and sought his opinion, making him feel venerated and ancient as well as tickling his vanity.

The Japan he found in the mid-1930s was very different to the country he had left fourteen years earlier. It now bristled with a new-found confidence and was ready to compete commercially, economically, politically and militarily on the world stage. Ominous rumblings of undisguised militarism were difficult to miss. The government, led by a military bureaucracy, still controlled Korea, and in 1931 had occupied Manchuria setting up with great brutality the puppet state of Manchuko. They also gave notice of the termination of the Washington Treaty,[89] a step that seemed like provocative sabre-rattling diplomacy. In the urban centres western influence had become even stronger, many aping the American way of life, mostly culling the mode of dress and manner from the cinema, resulting in what seemed to Leach a parody of eastern and western cultures. Much to his disappointment many women had abandoned traditional costume in favour of western style clothes and cosmetics, which he thought had the effect of making them look, unknowingly, like 'Bond Street prostitutes'. During the walk to the house of a friend, Kawasaki, they passed cheap and ugly foreign-style buildings, poster-covered walls and a noisy street life with blaring radios. He was grateful to escape into a traditional Japanese interior 'with all its quiet inward refinement and beauty',[90] where he felt at home.

Leonard Elmhirst's description of Leach as 'The high priest of the movement' proved an accurate assessment of his standing in Japan and one that he accepted almost as a birthright. The visit, very much at Yanagi's instigation, was intended to introduce him to the rich variety of country crafts, many of which still followed traditional practice, work that formed the bedrock of Yanagi's theory around the concept of Mingei. Wherever he went Leach was given the status of *sensei*, or master, a mark of deep respect.

> I've only got to express the slightest desire and the way is made easy [he wrote] and as to this *sensei* business, besides being flattering and pleasant, I have no difficulty in accepting the role when it comes to craft itself simply because excepting two or three – Yanagi, Hamada, Tomi, and to some extent Kawai, who are also *sensai* – I feel able to teach, explain and show the way confidently to this younger generation and to the half-attached

world of connoisseurs and art-lovers who are mostly very confused by the complexities of intercontinental art and life.[91]

Throughout the fifteen-month tour Leach, usually accompanied by Yanagi and Hamada as well as various assistants or secretaries, stayed at beautiful and expensive traditional inns or as guests of wealthy businessmen. Days and weeks were spent at county potteries, where for the first time he saw traditional potters at work and became aware of the significance of the aesthetic of function. It was a grand, almost magisterial tour. Dressed in smart western clothes and carrying walking sticks, the visitors travelled almost like a presidential delegation, observing highly skilled artisan craftsmen, criticizing their work and advising them on changes. There was more than a little element of paternalism to their journey, of experts bestowing their opinion.

The full and ordered itinerary meant that hotels were reserved, special food prepared and fares and bills paid. Reporters and photographers followed them around, pestering for their views, on some occasions dispatching accounts on the legs of carrier pigeons for publication the following morning. During days or weeks in village pottery workshops Leach made pots but more usually directed potters to make them to his design, which he then decorated with painted or slip patterns. Most potteries produced traditional functional ware, which though beginning to be affected by changes in the market, retained its strength and vibrancy. It was a very different tradition to the urban raku and decorative stoneware in which he had been trained twenty years before and which, by comparison, appeared effete and old fashioned.

The first potting stop was at the pottery town of Mashiko, seventy miles north of Tokyo, where around sixty kilns produced a variety of kitchenware mostly for sale in the capital, regarded by Leach as 'rather plain, honest, not full of artistry or striving after beauty'.[92] One of the most fascinating Mashiko characters was Minagawa Masu who had worked as a teapot decorator for several decades, painting up to 1,000 patterns each day. Intrigued by her apparently effortless skill and dexterity in producing designs of greatly simplified landscape, Leach asked her to carry them out on paper but she complained that it did not feel right. To the visitors she represented the authentic voice of traditional pottery, the unaware artist practising a skill that simply seemed to flow, and they treated her with almost reverential zeal.

Responding to the simplicity and directness of the wares, Hamada had settled in the village almost ten years earlier, slowly learning how to handle the local clay and make the best use of available materials. Using only handwork and no mechanical help, the half dozen potters who worked for him filled a kiln, about ten times the size of that at St Ives, twice a month, underlining how uneconomic and amateur the Leach Pottery was by comparison.

Accommodated in the handsome thatched gatehouse on Hamada's estate, Leach slept and relaxed in one room and had a wheel in the other, with a young, strong, skilled potter at his disposal to make pots under his direction, which he later decorated. In the mornings 'it was his custom to take a pen even when he was enjoying a sweet flavour of morning smoking and to draw in the air with his unoccupied hand and rhythmical long stretched interaction, winding between a plain and a paddy field the slope of a hill'.[93] A small stoneware lidded box made at Mashiko was decorated with an incised design of the gatehouse.[94]

In the warmth of Hamada's family, which included Hamada's wife, Kazue, their two boys Ryū and Atsuya and Hamada's father, a pious and sincere Buddhist, Leach began to relax and feel at home. In his retirement Hamada's father spent much of his time illustrating a great 'pilgrim's progress' charting the broad and narrow path of Buddhist vices and virtues, reminiscent of Bunyan's *Pilgrim's Progress*. On one occasion when they were all listening to gramophone records of solemn Gregorian chants and Negro spirituals brought by Leach, the youngest child, Atsuya, did a curious little impromptu dance before planting himself on his lap, making him feel truly one of the family.[95] Through Hamada, Leach met 'Mr X' who, having been trained in the traditional ways of a spy, had learned how to control and use his body. His amazing if somewhat grotesque feats included holding his breath for long periods, sticking hatpins through his cheeks, chewing glass and climbing walls without foot or hand holds. 'Mr X' was part of the mysterious old Japan that fascinated Leach.

During several visits Leach worked on more than a thousand pots at Mashiko, a staggering amount both to make and market. At the unpacking of the first firing, which was shared with Hamada, they were surrounded by about a hundred people including businessmen and the governor of the prefecture, many indicating that they would like to purchase pieces by placing their card on them before they even knew the price. During one firing a great typhoon arose and the wind, blowing straight into the open shed in the direction of the flames, caused such a fierce draught that the glazes appeared to have melted hours earlier than usual. What at first had seemed a stroke of luck was later discovered to be the reverse as on the side of the pots away from the flame the glaze had hardly begun to melt and all had to be subsequently refired. Leach's Mashiko pots were shown at the Kū-kyo-dō Gallery, resulting in sales of 1,400 yen, the first of many exhibitions in Japan. The gallery invited Leach to select the best pots for repair that had arrived broken from England. No insurance claim had been made although he had received the full price, a further demonstration of the old-world honesty of traditional Japan and the esteem in which he and his work were held.

In Kyoto, Leach worked with Kawai who was establishing a reputation as a leading potter and lived in what was known colloquially as 'Tea-Pot Alley',

making among other objects lidded porcelain boxes by pressing clay in a mould. A design of two birds with a soft cobalt wash was used on one, successfully giving a traditional Japanese form a western interpretation. With Kawai, Leach designed moulded porcelain dishes, decorating them with minimal designs in enamel. As with Hamada, Leach enjoyed living as one of the family, though he was conscious of hurting the feelings of Kawai's loyal wife by failing to respond more positively to her husband's porcelain pieces. 'Despite the fact that I seldom liked his pots, I did admire the man',[96] wrote Leach, neatly contradicting his own often expressed view that the pot is the man. A family friend persuaded them to try acupuncture, a procedure about which Leach had only heard. Having watched the others he felt unable to refuse though he did find some of the needles 'rather like an electric shock'.[97]

At the Funaki family's Fujina Pottery on the shore of Lake Shinji he was welcomed as the high priest. It was in this area, near the old city of Matsue, on the north-west coast, that Hearn had written his first impressions of Japan. The Fujina Pottery was one of the few that used a lead glaze over slip decoration, firing the pots until the body was hard and non-porous, adapting a technique introduced by Hamada after he returned to Japan. Potters supplied Leach with clay, copied his shapes and assisted in any way they could. Leach showed the potters how to pull handles in the English fashion by 'milking' or stroking a wedge of clay attached to the pot. He also attended a private tea ceremony that involved the use of a travelling teaset, inscribed Chinese lanterns that were then floated away on the lake, investigated the mounting of *kakemono* (hanging scrolls) for his drawings, and watched a traditional paper maker prepare absorbent sheets from mulberry stems. It was all very tasteful and refined. At his accommodating inn there was the added bonus of a western-style breakfast of bacon, eggs, marmalade, toast and coffee.

In the three days at the Sakazu pottery near Kurashiki, Leach made seventy pots. His host, Mr Takeuchi, was curator of the excellent local art gallery that belonged to the millionaire Ōhara Magosaburō 'a sort of wise lord of the district, a man of great taste and ability'.[98] Leach was luxuriously accommodated in a house commissioned by Ōhara and built in an odd mixture of Chinese, Japanese and European styles. Although its character was not to Leach's taste he did appreciate its ample space. During supper at Takeuchi's house Leach was moved by the traditional way his wife silently attended on them and darned her husband's socks with various types of stitch using wool, cotton and silk. It was a domestic convention he admired and for which part of him secretly longed. Ōhara, well known for his contributions to various social welfare projects, agreed to donate funds for the construction of a folk craft museum. A plot of land was acquired in Meguro, Tokyo, and the building designed in traditional Japanese style, the foundations for which were laid in October of that year.[99]

At the nearby Okamoto family pottery everything he needed was, as usual, put at his disposal. Despite his 'comparative clumsiness on the wheel', his every movement was watched silently by the potters. At a packed dinner party he was invited to speak on a wide variety of topics including 'why even the best of modern pots fall far behind the standards of the past',[100] taking many questions from the audience. One wonders where he saw his own work as fitting into such an analysis. In the pottery village of Futagawa in the north of Kyūshū, Leach was again silenced by his own relative awkwardness. Admiringly he watched the potters use thick clay coils to build Ali Baba pots sufficiently large to fit a couple of men. 'I found myself constantly at a loss for a day or two', he observed and 'my own methods and habits finicky'.[101] Over the ten days he decorated a hundred large pots made to his design, some of which were freely covered in abstract patterns created by drawing his fingers through the wet slip. Dashes of brown and green completed designs far freer and more experimental than anything he produced in St Ives. Near disaster was just averted when fire threatened to consume several tons of pine logs packed inside a warm kiln to dry. Everyone worked frantically and the wood was saved, but it brought back memories of similar disasters at Abiko and St Ives.[102]

At the request and expense of the Takashimaya department store Leach joined Yanagi, Hamada and Kawai on a journey south and on to the island of Kyūshū to select country crafts. To their amazement, standing in fields at Naeshirogawa, they found pots that preserved the traditional Korean character, glazed in shades of black and 'not a bad one amongst them'.[103] In all some 20,000 objects were purchased, which sold out in three days and the same amount ordered again. Although sensing the work's commercial potential and the role of the Mingei movement in heightening awareness of it, the store had little warning of its great popularity. Leach also purchased fine quality Japanese handicrafts such as tea strainers, lacquer spoons and toys for Dartington and for Muriel Rose's Little Gallery off Sloane Street in London. Diminutive and short-sighted but a passionate advocate of handmade work, Muriel Rose[104] was a key figure in the crafts and an influential figure in Leach's life. She had a reputation for showing fine if conventional work and obtaining tasteful interior furnishings for a discriminating and often distinguished clientele. Rose hoped that Leach would persuade Hamada to exhibit at the Little Gallery.

Despite the full itinerary, which included a radio talk in Japanese, there were ample opportunities for reflection, none more so than when visiting his and Muriel's old friends Harold and Winnie Spackman, who knew nothing of his personal difficulties. Early in the new year he spent a week with them at Karuizawa and again enjoyed the spectacle of the snow-covered mountains 2,000 feet above sea level, grateful for their generous hospitality and space to spread out his things. News from home arrived erratically and at one point he bemoaned in his diary 'No letter from Laurie for five weeks'. One entry,

recorded as 'Laurie's confessional letter', probably brought details about which he had mixed feelings. Inevitably Laurie felt rejected by Leach's decision to go to Japan and, given all the complications of his emotional, artistic and business life, doubted whether they had a future together. Also she had had to deal with her pregnancy without his support. Feeling emotionally bereft, she formed a series of intimate attachments that included Harry Davis and Bernard Forrester. Following their earlier agreement to be truthful to each other, the fact that she felt it necessary to tell Leach, and that she continued to work at the Pottery, suggests that despite all she still had hopes of retaining their relationship, though her confession may have included an element of revenge. When Leach subsequently wrote to Leonard Elmhirst he remarked cryptically that he 'had strong reasons' for not involving Forrester in a particular job, suggesting that Laurie had indeed 'confessed' to the turbulent state of her emotions. Referring to this difficult period in *Beyond East and West* Leach darkly admits that he 'put work before human relationships', and confessed to 'deeds I cannot defend'[105] but did not offer further details. Despite, or because of, Laurie's 'confession', Leach wrote regularly to Davis, who was running the Pottery, mostly of pottery matters rather than personal issues. Nevertheless, Davis was relieved to receive the letters and appreciated his apparently civilized attitude, saying 'it opens up unique opportunities for truth and friendship'.[106]

Letters from Muriel confirmed her ignorance of the true nature of Bernard and Laurie's relationship. She sent Christmas presents for the Spackmans and their Japanese friends, and gently chided Leach for the infrequency of his letters. Hers were full of family activities, describing visits from or to relatives, illnesses and the demands of the children, especially Betty, for whom professional help was sought. In one heartfelt letter she described a journey to see relatives, writing admiringly of the countryside that she and Leach had visited, suggesting that when he returned they could perhaps have another honeymoon. In another she reminded him of their silver wedding anniversary, all stabbing reminders of family intimacy, duty and responsibility.

This news of family life only fuelled Leach's anxiety about the difficult emotional situation that he would have to face on his return. In response to Muriel's effusive and loving accounts Leach was more impersonal and guarded, often focusing on the reality of being a guest in a foreign country. He bemoaned the long working hours usually in unheated pottery workshops, the discomfort of buildings too small for his tall lanky frame, the endless sitting on the floor, which made his legs stiff, and the lack of a regular base. Far from relaxing, he implied it was somewhat of a hardship. One postcard outlined his frenetic schedule, listing visits to six potteries in as many days.

News from David was troubling. While working at Dartington building a slightly more efficient wood-fired kiln and investigating various raw materials, he had become better acquainted with the Elmhirsts, discussing among

other topics the new venture. What had rapidly become clear was his limited technical knowledge. Both he and the pottery, it was suggested, might benefit from a period of technical training in Stoke-on-Trent, to which he agreed. Accordingly, in September 1934, leaving Bernard Forrester to take over his teaching, he enrolled on a three-year pottery managers course at North Staffordshire Polytechnic. Leach was furious about not having been consulted and dismayed that David had agreed to study in what he described as the 'commercial scientific graveyard' of Stoke, believing that it would 'do him more harm than good'.[107] As an alternative he proposed that David spend a year in Japan to acquire a wider understanding of pottery. David, however, had now committed himself, recognizing that a thorough technical grounding would not be forthcoming from his father but would enable the Dartington pottery to develop on a more secure foundation. He welcomed the opportunity to study ceramic technology, thinking that aesthetic understanding would follow. Leach took the opposite view believing, like William Blake, that ideas should come first and technique second. To Leach's protests Leonard Elmhirst remained cool pointing out the advantages of 'a sound scientific background', and that David had decided what 'seemed best from his own point of view'.[108] The galling reality was that however much Leach hated the idea there was nothing he could do.

Michael was also exploring new territory having become deeply involved at Cambridge with the Oxford Group, a fundamentalist Christian organization set up in the 1920s by Frank Buchman[109] and later renamed Moral Rearmament, whose members were sometimes referred to as Buchmanites. With no temples, endowments, membership, subscription, badge, rules or definite location, the group was made up of Christians who declared they had surrendered their lives to God, advocating the essential basis of all Christian faith as absolute honesty, purity, unselfishness and love. Ideas were discussed at meetings known as House Parties and campaigns were planned to spread the word as part of Christian evangelism. For Michael, the Oxford Group became a way of life in which both his mother and David became actively involved, with Muriel writing to Leach saying how helpful she found the early morning gatherings largely conducted in silence when each could listen to God's voice. Such fundamentalist belief held no attraction for Leach who found the approach too hard line, narrow and doctrinaire. It appealed neither to his spiritual needs nor to his circumstances, and he suspected that its advocates would neither understand nor condone his more emotional sexual desires.

News from Turvey was not good. Despite endless repairs the new house remained damp, his investments in Kenya were falling, and in November A. R. Orage,[110] editor of New Age and founder editor of New English Weekly, died leaving a void no one so far had filled. There were also cryptic references to wanting to 'clear off all the fog and mistrust',[111] a veiled reference to a continued tension in their relationship.

After spending some months with Teng Kwei studying Chinese calligraphy Tobey arrived in Japan but instead of immediately seeking out Leach spent a month in a Zen monastery in Kyoto practising meditation and studying Zen Buddhism. So involved was Leach in his crowded schedule it was a relief not to have to deal with Tobey's inexperience of the country and its ways, though he did wonder what had happened to him. For a few days Tobey did appear, when they 'talked endlessly' and Leach filmed him watching Minagawa decorating teapots. However, after the high expectations and excitement of China, Tobey found Japan not 'suitable for his needs' and, much to Leach's regret, he left suddenly for America and an exhibition of his work at the Seattle Art Museum.

In an extraordinary fifteen months, Leach held successful exhibitions in Tokyo, Kobe, Osaka and Kyoto, travelled the length and breadth of the country looking at rural crafts and lecturing on subjects as diverse as aesthetics and home cooking. On one occasion he even demonstrated how to make a complete meal, which included banana ice cream. His advice was sought on designs for furniture and textiles, even picture frames. 'I have gained in confidence', he wrote, working 'amongst the potters in nine potteries has taught me a lot technically about the handling of clay, pigments, glazes, kilns etc, and I have been able to discuss many of the difficulties we have encountered during the last 14 years in England'.[112] He had also started work on ideas for his major text, *A Potter's Book*. The highly productive if cosseted potting and lecturing Leach enjoyed in Japan led him to speculate on the possibility of involving himself more with the country by setting up a central training school near Tokyo. If this was successful he even considered whether 'the time [had] come to think of winding up St Ives'[113] and moving production to Dartington under David's direction. In a letter to the Elmhirsts he again broached the idea of his son spending a year in Japan, but they remained non-committal, biding their time to see what developed.

At Yanagi's invitation Leach contributed several articles to the May issue of *Kōgei* (Crafts). These included 'Thoughts on Japanese Crafts', 'Impressions of Japan After Fourteen Years', and 'A Letter to England', detailing his experiences and his dislike of growing westernization while feeling deepening admiration for old Japan. Sensitive topics such as the extensive political changes and militaristic development were avoided though Leach had personal experience of both, in particular the growing military activity of the country, which he recorded at some length. By the side of Lake Shinji he heard the crack of rifle practice and the 'pom pom' of distant machine guns as the army trained and became expert at German military tactics. The rise in Japan's martial spirit Leach rationalized as an example of what he called 'nervous energy', arguing that they had some justification in asserting their international rights. 'Here is Japan alone amongst the Eastern peoples with nervous energy . . . preserving her freedom and realising full self-responsibility and

consciousness.' In assessing Japan's growing role within international power relations he was acutely aware of the Japanese government's desire to increase its control over China, commenting 'From us she has learnt the process of exploitation with us she is competing in China'.[114]

Within the wider political outlook Leach was doubtful of any long-term hope of peace between Japan and China. 'Any unification and organisation of Chinese resources on industrial and military lines', he wrote, would offer 'the greatest possible threat to further Japanese security unless such a development be brought about on terms of friendship and fair give and take'. In reconciling Japan's imperial ambitions Leach cited the example of Britain's own position of power with regard to India and Gandhi's increasing demands for independence, arguing 'we run a danger of being virtuously hypercritical now we are being forced to loosen our grasp'.[115] Although deeply critical of Japanese international policy and the government's determination to modernize at all costs to compete in world markets, Leach had nothing but praise for the hard-working population. He did however regret their blind acceptance of authority and their apparent willingness to believe all they read in the newspapers.

On 10 June 1935 Leach said goodbye to his friends and sailed for Korea with Yanagi, *en route* for England. As seventeen years earlier, they landed at Pusan and travelled to the capital by train. In the intervening years the Japanese had consolidated and increased their power but many Koreans were still prepared to speak out against the occupation, even at the risk of fierce retribution. An exhibition of Leach's pots made in Japan was held in an old palace set up as a museum in Seoul, where, as he put it rather naively, 'Japanese and Koreans could enjoy love of beauty without rivalry or politics'.[116] During a talk in which Leach praised Yanagi's attempt to preserve some of the 'arts of the people', a fearless young Korean student reproved Leach's pleading for beauty when the suppression of Korea by Japan put life at stake. For once Leach was silenced and in retrospect, knowing how ruthless the Japanese could be in squashing opposition, feared for the student's safety.

In the capital they admired the Imperial collection of pots. Leach's attention was particularly caught by the grey-green celadons of the twelfth and thirteenth centuries, many delicately inlaid with white and black patterns, their soft colour recalling that described as 'the colour of the sky after rain'. However, it was the plain white, or blue and white porcelains, influenced by Ming China that he came to admire more. His purchases included a twelfth- or thirteenth-century Yi dynasty wine cup with a gold lacquer repair indicating it was greatly prized, and a magnificent sixteenth-century vessel moon vase with a matt, creamy-white glaze.[117] These were packed in a fine, iron bound chest and duly shipped to St Ives.

At the invitation of an old and distinguished nobleman, Leach and Yanagi attended a party at his village guest house. After travelling some miles they

were carried across a fast-flowing river on palanquins by strong men wading through the shoulder-high cold water. On a low table a traditional meal was served presented in Yi dynasty porcelain bowls consisting of delicious salted preserve of onions, garlic, pine-kernels, cabbage, cut up pears and apples. In the unfamiliar surroundings Leach mistook the beautiful young woman sitting next to him to be the host's daughter but much to his bemusement discovered that she was a geisha, a professional entertainer, a mistake he would never have made in Japan.

The final few days were spent in the Diamond Mountains in the north, walking, talking and admiring the traditional architecture of the buildings with their beautiful curved roofs. During a visit to a pottery workshop, Yanagi pointed out that the throwing wheel wobbled as it rotated, the unevenness not seeming to bother the potters. 'This state of mind,' claimed Yanagi 'is the very foundation from which the beauty of the Korean pots flows out.'[118]

At Mukden Leach boarded the Trans-Siberian express for the thirteen-day journey through Russia, Germany and France, giving him the opportunity to contemplate the events of the past fifteen months, which had involved over 4,000 miles travel and great artistic acclaim. It was a painful journey not only for the anticipation of his reception back in England but because the poor food brought on severe stomach cramps and for several days he survived on boiled milk purchased at station stops. The train arrived in Moscow three days late, and Leach explored the city, although he appeared to be either unaware, or chose to ignore, the political tension of the country, then in the grip of Stalin's terror, dramatically highlighted in a series of spectacular 'treason' trials.

In Red Square he peered at the famous churches, too sweet and pineapple-like for Leach, and queued to gaze at Lenin's embalmed body in a glass coffin. An exhibition of paintings by young artists confirmed his opinion of the low standard of Soviet art, seeing it as 'second-class academy' or too Socialist Realist. He did however enjoy a performance of *Prince Igor* by the Russian ballet and the opportunity to observe such details as the shoes, clothes and jewellery of the audience. Though not entirely unsympathetic to what was still widely regarded as the Soviet experiment, Leach was most struck by the air of poverty and deprivation and wondered whether communism was an effective system of government. As the train moved further west he began to feel himself in more familiar territory, Berlin station reminded him of London's Paddington and the Gare du Nord in Paris seemed positively English, though the homecoming filled him with doubt and trepidation rather than pleasure.

COMMERCE, SCIENCE AND ART

England

1935–1945

Muriel came to meet Leach in London, delighted to see him, to hear news of Japan and to return with him to Carbis Bay. Leach, however, wanted to see Laurie and was cool and distant, leaving Muriel feeling both confused and upset, for she still knew nothing of the relationship. After a fifteen-month absence, Leach had finally decided his marriage was over and that he must tell his wife. Inevitably such an emotional upheaval impacted on virtually all aspects of Leach's life: his wife of twenty-six years, his sincere but often traumatic affair with Laurie, his wavering commitment to the new pottery at Dartington, and the still uncertain financial future of the Pottery at St Ives. Like a house of cards, all seemed interdependent.

Leach's announcement that he wanted to end the marriage was a devastating blow for Muriel as her feelings for him were unchanged. When she was told that the relationship with Laurie had been going on for four years virtually under her very nose, she felt, not surprisingly, humiliated, hurt and angry. David, who had known of the affair for some time, was to some extent prepared and was therefore able to offer his mother support, but in a family in which intimate feelings were not freely expressed this was not an easy task. Muriel, while outwardly calm and seemingly able to deal with the situation, did on occasions give vent to her feelings of anger and resentment – in one dark moment beating the iron stove in the kitchen with a poker in a fit of impotent rage. It was not a happy homecoming.

When Leach finally saw Laurie they found that, despite their confused feelings and the tensions of their relationship, they wanted to be together but recognized that this would be impossible at St Ives. In Leach's absence she had settled into Pottery Cottage but both felt it was too difficult for him to join her there. Ironically, it was Harry Davis who came to the rescue; despite his previous liaison with Laurie he offered Leach temporary accommodation at his cottage at Nancledra. Following Forrester's move to Dartington, Davis had left the house at Ninnis Bridge for a cottage reached via a bridge over a stream where Leach stayed for several months. Davis continued as the mainstay at the Pottery.

Writing to the Elmhirsts Leach referred in an understated way to 'difficulties back home of a personal nature',[1] explaining that he would give details in person. In the same letter he felt it appropriate to pass on Tomimoto's request to come to England for six months, implying that the Elmhirsts might find his project worthy of support.

With Muriel and Laurie likely to meet accidentally in the town and Davis offering only a temporary refuge, remaining in St Ives was fraught with both emotional and practical problems, and if Leach and Laurie were to live together a more permanent solution would have to be found. Following the example of Augustus John a caravan seemed to offer a romantic vision of freedom and both warmed to the idea, its unconventionality reflecting their mood of exploration and discovery. The caravan they selected was no rustic gypsy home but one of the latest models, a streamlined Car Cruiser built in Kent by a small, progressive manufacturing company. Neat, compact, well designed and spacious, Car Cruisers were seen as the Rolls-Royces of the caravan world. Accommodation comprised a double bed and two singles, a cooking galley, with the de luxe version, priced at £245, including a bath set in the floor and a chemical closet. Laurie chipped in £150, Leach the rest, and they travelled to Kent to specify various modifications to the fixtures and fittings. A powerful, 18h.p. Humber or a Lanchester was purchased to tow the caravan. First stop was near Ditchling, where the caravan was parked in a protected spot halfway up Ditchling Beacon overlooking flat land behind the South Downs.

Here they enjoyed the intimacy of domestic life. Visits were made to Ethel Mairet and Edward Johnston in Ditchling, and to Havelock Ellis, then in his late seventies, in nearby Wivelsfield. They found him with 'a charming French companion', sunning himself in a revolving garden outhouse. Ellis's groundbreaking writing on the psychology of sex with its detached, guilt-free accounts was still highly controversial and it is tempting to speculate on the reassurance Leach may have found in these meetings.[2] For both Leach and Laurie it was an idyllic interlude. They gathered fruit in an old orchard, and explored the magnificent rolling downs between Lewes and Chanctonbury Ring, taking with them Laurie's wire-haired fox terrier, Peter, who, like Leach's dog Pan, could cause problems, becoming particularly fearsome with other dogs.

It was, Leach wrote, 'a happy life, ideal for both drawing and writing'.[3] Drawings made at this time, often with soft, sepia washes of colour with pen-drawn detail, evocatively suggest the rolling landscape and the often-changing moody and brooding English weather, some recalling the intensity of the Neo-Romantics. One of the most effective, carried out on the South Downs, is also one of the more psychologically engaging, its depiction of a round pool, with its white reflective surface appearing both seductive and engulfing, its prevailing mood one of stillness and silence.

At one point in their travels, which included a visit to Henry Bergen in Chiswick, they moved to Winchcombe in Gloucestershire, arriving in the late autumn,[4] parking the caravan in Michael Cardew's apple orchard and staying for a month. Cardew and his wife, Mariel, accepted their relationship without question. Despite their different approaches to the craft, Leach and Cardew were great friends. Cardew preferred the warmth of English slip-decorated red earthenware with its naive, often lively decoration, and was suspicious of too much oriental influence, which he felt was alien and cold. In spite of his success with slip-decorated plates in Japan, Leach responded more to the sophisticated elegance, muted colours and austere beauty of high-fired stonewares and porcelain, and felt no inhibition in adapting established shapes and glazes. Although a dedicated and industrious potter, Cardew had a wide range of artistic interests, which included playing the recorder, folk-dancing and learning Chinese calligraphy, activities that held little interest for Leach. His more single-minded ambition was to be acknowledged as an artist for his work as a potter. Yet the two men got on well, each speaking and recognizing the other's language. 'Whenever you meet Bernard Leach the conversation begins to talk about something real immediately,'[5] noted Cardew warmly.

At Winchcombe, Leach took the opportunity to reflect on his time in the East, writing a long 'letter', 'Christ in Japan', which attempted to assess contemporary attitudes to Christianity in the country. In it he came to the conclusion that while there was a difference between the Christian and Japanese approaches to religion, he decided 'there is no conflict',[6] suggesting that while individuals might be respected and accepted, Christianity per se was not likely to become widely established. His view, which reflected his involvement with individual Christians rather than the work of the Church as a whole, was probably a reasonable assessment.

In December 1935, Leach and Laurie moved to Dartington, settling at Shinner's Bridge in a cider-apple orchard above the small pottery studio that had been built at the north end of the inner quarry. With the caravan set up, a studio to hand and active involvement in the activities of the school and its artistic community, they soon established their new life, though the intimacy of a caravan brought a new awareness of each other's strengths and foibles. Although in many ways independently minded, Laurie wanted what she considered a fair share of Leach's attention and interest, while he sought a partner who while supporting and encouraging him, would not tie or smother him in any way. Unlike Muriel, Laurie wanted to be involved in Leach's work, a demand that he respected in theory, but in practice found more difficult to deal with.

On his fiftieth birthday Leach reflected on his life and achievements. Little progress had yet been made in developing the pottery at Dartington and although now settled he returned regularly to St Ives to keep an eye on the

business. The caravan, although well designed and efficient, proved small and cramped. The roof began to leak, damp was a problem, the windows and door stuck, the metalwork started to rust and in the cold weather the small stove proved inadequate. There were also problems with the brakes and electric lights. In the warmer weather it was pleasant but when it rained the noise was virtually unbearable as the drops beat relentlessly on the thin metal skin of the roof. In addition the chemical toilet did not appeal to Leach's fastidious nature. Some of the difficulties were outlined in a letter to Leonard together with a less than tempting invitation to come for a meal to 'test the horrors of our primitive life'.

As an alternative Leach secured permission to construct a wooden, single-story dwelling on the site – variously described as the cabin, hut or ark. The simple building, designed by Leach with arts and crafts zeal and constructed at low cost, combined truth to materials with an emphasis on function rather than decoration, ideals reflected in such details as the efficient rustic wooden door latches, still in use sixty years later. Built by one of the old workers from Stavertons, the Dartington builders, the cabin lacked any pre-tension. The basic layout consisted of a kitchen, a decent sized living-room with an iron stove and a bedroom and bathroom. It was simple enough but after the constrictions, cold and damp of the caravan Leach described the dwelling with uncharacteristic understatement as 'great'. To complete the arts and crafts effect curtains were made from a length of 'Loo Choo Island' linen. Eventually an anomaly over ownership had to be settled, for although built at Leach's expense it was on the Dartington estate, a situation that ran counter to the Dartington policy of owning everything on its land. After endless nego-tiations the Elmhirsts agreed to purchase the building for £250 and lease it back to Leach at a modest annual rent of £15. The outbreak of war delayed the sale of the caravan but it was eventually sold in late 1939, as was their powerful car.

During Leach's absence in Japan and David away in Stoke-on-Trent, the Pottery at St Ives suffered a lack of direction. Laurie, who acted as secretary, had neither the talent nor inclination for management, and a period of demor-alization, boredom and time wasting began when 'bobbing' or flicking pellets of clay became part of the curious blend of horseplay and high culture that infused the atmosphere. Both Davis and Nance were appalled by the general inefficiency of basic processes being carried out by hand without even the assistance of minimal equipment to carry out menial, repetitive, tiring tasks. Disillusioned by such aimlessness, Dicon departed leaving Davis and Laurie who, taking matters into their own hands, used Leach's car to successfully tour craft shops to acquire sufficient orders to keep them busy until Christmas. All was going well until, for some reason, the pots started to come out of the kiln blackened and burnt, the glaze spoilt beyond repair. With growing desperation, kiln load after kiln load was ruined. The problem was

finally solved by allowing in more air to enable the wood to burn freely. Frantically Davis worked virtually non-stop to remake pots to complete the orders on time.

Despite the set-back with the kiln, Davis introduced many technical improvements. In addition to being a fast and accurate thrower, he was also an efficient organizer with a sound understanding of clays and glazes. Through daily use he observed that the tablewares, made in red earthenware, chipped easily, the slip and glaze often peeling off edges making them unsightly and unhygienic. By adjusting the body he made it stronger and more durable and by altering the mix of the slip made it a tighter fit on the body. A more effective method of packing the kiln was also devised, which required fewer shelves so allowing more space for pots, with lower firing losses. As a result the Pottery began to operate more efficiently, even yielding a small profit, a situation that however modest, allowed Leach to report to the Elmhirsts that 'the St Ives Pottery finances are more satisfactory than they have been for some years . . . For the current year our combined turnover . . . will be in the neighbourhood of £1,000 and our expenditure not more than £700'.[7] Such news, though hardly a basis for great optimism, was a move in the right direction, giving Leach additional leverage in his negotiations with the Elmhirsts. With Leach back in England, the short courses, suspended during his absence, began again either at St Ives or Dartington.[8]

Soon after Leach's return an attractive young potter named May Scott[9] introduced herself to him at a Red Rose Guild exhibition in Manchester and asked to be taken on. Always on the lookout for new recruits who were prepared to commit themselves for a reasonable time, he was impressed by her sincerity and agreed to her becoming a full-time paying student for a year. Serious, independently minded and deeply committed, she settled in a caravan at the foot of Rosewall Hill and became an industrious member of the crew. Although soon aware of the complexities of Leach's relationship with Laurie and Davis's own involvement with her, she had no wish to become embroiled in such personal matters but rather concentrated on becoming a skilled potter. She was also unwilling to listen to what she called Leach's 'heart-to-hearts', when 'he would expose his innermost feelings'[10] and expect them to do the same. Far from feeling flattered by his confidences they had the effect of making her shut up like a clam as did Leach's occasional theatrical outbursts when describing pots or agonizing during the firing of the large kiln when, metaphorically, he would tear out his hair or sit with his head in his hands in tragic despair. Yet for all her aloof single-mindedness Leach admired her spirit, capturing her youthful good looks and strength of character in a delicate pencil drawing.

Relations between Leach and Davis, however, remained tense. While Davis disagreed with many of Leach's attitudes about the importance of individual rather than functional pottery, and his non-businesslike approach, he found

that as he got to know him better his admiration increased. When the two were alone Davis found they could communicate and had much in common, but in company he thought Leach an impossible posturing exhibitionist. For his part Leach, while acknowledging Davis's technical abilities, could not forget the man's liaison with Laurie which came at a time when his own behaviour towards her had been distinctly shabby. Leach found it difficult to like or respect him and feelings of shame for his treatment of Laurie added to his resentment of Davis. He also felt out of sympathy with Davis's austere and what he judged to be hard-line attitudes, believing that he lacked any real artistic understanding of either form or decoration. Davis's anthropomorphic theory of design was based on a belief that shapes should be derived from the human body and as such should be rounded and full rather than angular, an approach that Leach thought mechanical and simplistic. He was also riled by Davis's criticisms of the organization and working methods at the Pottery, however well founded, yet was reluctant to appreciate or acknowledge the value of his contribution in stabilizing its finances. Notwithstanding Davis's hard work and loyalty, Leach viewed him as little more than a skilled and able technician.

In return for his dedication and industry during Leach's absence in Japan, Davis hoped to secure a permanent position either at St Ives or Dartington. Eighteen months after Leach's return little apparent progress had been made, and Davis was anxious about his future. Having spent over four years at the Pottery and contributed to its efficiency, he quite reasonably expected to be involved in any future plans. He supported the idea of producing a range of functional wares for domestic use rather than individual pieces at Dartington, believing that 'it could do the world of contemporary ceramics an incalculable amount of good',[11] but it was an attitude hardly likely to endear him to Leach. Perceptively Davis recognized that there was too much procrastination from both Leach and Dartington for real progress to be made, reflecting a reluctance on both sides to make a serious commitment.

With his future uncertain and with David Leach due to return, Davis decided to take a year's break to explore other possibilities while keeping open the option to return. For a time he joined May Scott, with whom he had become romantically involved, in South Kensington, London, where she had set up a pottery studio. Despite leaving St Ives he maintained a lively if somewhat acrimonious correspondence with Leach. 'You and I have hurt each other so deeply and struggled in the past to discard hatred and jealousy despite it that in a cooler world of thought and action I took a more generous attitude for granted,'[12] wrote Leach. Davis was contrite but unrepentant: 'Convey my greetings to Laurie and tell her I'm hoping to meet her with amicable feeling as changes have been wide and many in my mental make-up.'[13] Clearly Davis's affair with Laurie continued to rankle and as the weeks and months passed it became evident that however valuable his contribution,

Leach would not be asking him to rejoin the team. In an effort to find a solution, Leach wrote to Cardew, admitting his difficulties with Davis but still recommending him as a skilled potter and asking if Cardew had an opening for him,[14] which he had not. With no prospects of returning to the Leach Pottery, Davis investigated the idea of setting up a pottery in the north of England and invited two former St Ives potters – Dicon Nance and Douglas Zadak[15] – to join him. Aware of the financial risks of potting, and with a desire to contribute to the wider application of pottery skills, he applied for and was offered a post on what was then known as the Gold Coast (now Ghana) as 'ceramic instructor to Native potters in West Africa'.[16] As a parting gift and to show there were no hard feelings, Davis posted Leach a set of bowls bought in a Chinese shop in London's East End shortly before sailing for Ashimota College, Accra.

At Dartington Leach had to sort out the complicated accounts for his Japanese trip. During his nine exhibitions he had sold pots and drawings to the value of £640, an impressive amount by any standard. Half was for new pots that could be set against Dartington's investment, the remainder was for pieces already in the country and therefore went directly to Leach. In total, the cost to Dartington of the visit to Japan was over £700 plus passage. Purchases of an odd assortment of traditional Japanese handcrafts (a term Leach had come to prefer over handicraft) intended either for sale in the Dartington shop, for the permanent collection, or for Muriel Rose's Little Gallery[17] were a matter of some dispute. These included children's toys, bamboo tea strainers, lacquer spoons, lengths of stair carpet (too narrow, declared Muriel Rose) and prints.

Leach began his official duties at Dartington in the spring term of 1936. The modest pottery studio at Shinner's Bridge was now equipped with a small if not particularly efficient earthenware kiln, and although the site for the larger pottery had been selected no building work had started. In David's absence at Stoke-on-Trent, Bernard Forrester had successfully taken over his teaching at Foxhole School and having found the repetitive nature of much of the work at St Ives too reminiscent of his time in industry, had no desire to return. Forrester went on to develop pots that owed little to Leach's influence, while continuing to teach at Dartington. David found the pottery managers course of mixed value, for while industrial production methods were of little relevance, the sound scientific understanding of clays, glazes and firing were broadly applicable to the small-scale production at St Ives. David did enjoy his contacts with the local Oxford Group, with which he became deeply involved. Holidays were spent mostly at St Ives keeping an eye on the Pottery.

To move forward the setting up of a production pottery at Dartington specific decisions and actions were required by both the Elmhirsts and Leach, not the least of which was a genuine demonstration and commitment to

the enterprise, and Leach continually stressed the time and investment required before any profit could be achieved. At least the possibility of ample funding enabled a well thought out workshop to be planned, a situation in which Leach held great power. He had written from Japan expressing doubts about the new venture paying its way for at least the first five years, and stressed the need for adequate allowance for deficit funding. As with many of his financial calculations Leach was adept at whisking figures out of the blue and basing a rationale on them to suit his own purpose. To sustain a *'maximum* output of 40,000 pots per annum at an average price of 5/-' he argued, would require 'capital of £10,000, a working staff of a dozen and total running expenses of £4,000'.[18] Such substantial sums, compared to the output at St Ives and the predicted turnover, were astronomical, a fact that did not escape the sharp eye of Slater who continued to be highly sceptical of the whole venture.

The new building, estimated to cost £1,000, was planned to start in May 1936 and be completed by autumn of the same year when the Pottery at St Ives would be closed and the business transferred to Dartington. Full production would begin after Leach had spent a further year in Japan. As usual Leach's rough calculation of the cost was estimated very much from his own perspective. This involved a payment to him of £500 for tools, stock and goodwill, £1,750 to buy the land and buildings, which would enable him to pay off the mortgage of £1,500, leaving him with a total of £750. In view of this he suggested that Dartington should pay him a final settlement of £1,000. While discussion on this went ahead and he returned to Dartington full time, it was agreed that Leach would receive half his full salary of £350. Though not lavish, it at least guaranteed him a reasonable income quite apart from any earnings at St Ives.

Following further discussion, Leach proposed abandoning the idea of producing porcelain at Dartington, which would be expensive to make and market, in favour of slipware, which in some romantic, authentically English way he suggested would usefully connect the pottery to traditional wares made in Devon. Such work could also tap into an already existing market. At the 'International Exhibition of Industrial and Decorative Art' in Milan his tiles had been awarded a gold medal and he proposed increasing output at Dartington through the use of blanks made at Candy & Co. in Newton Abbot. Production would also include glazed bricks 'an article not yet on the English market, but one that meets both the practical and aesthetic need of people with quite ordinary good taste'.[19] Once operational a yearly salary of £300 was proposed for himself and £175 each for the workers at the pottery as part of a total expenditure of £1,310. Sales of £575 were estimated in the first year, sums Leach claimed were based on a comparison of the yearly balance sheet at St Ives. As a new business venture it was hardly an alluring proposition.

Despite the difficulties over constantly changing proposals, more fundamental battles about artistic freedom had still to be resolved. Although largely carried on between Leach and Slater, they also reflected the Elmhirsts' intention to set up all businesses on a sound business footing, including the pottery. Early in 1936 Leonard sternly reminded Leach that any Dartington enterprise had to have 'commerce, science and art to be well and solidly established'.[20] Nevertheless, feeling that his position was strong, Leach stated that his vision was 'to step out from the studio, shall I call it, towards the small factory where quality of design and material is preserved, whilst science and organisation are put to the service of the artist and craftsman'.[21]

While Slater continued to insist that the pottery had to aim towards financial viability Leach's prime concern was to ensure that he retained his independent status in an enterprise in which art rather than commerce was the driving force. 'I also want,' he told Slater, 'an absolute assurance that in the matters of technical methods and artistic control I shall be free.'[22] Privately Slater secured Leonard's backing for his hard line, writing 'You will realise that it is impossible to give him the freedom on design and technique which he requires. To do so would be merely acting as patron to a studio . . . You cannot control finance in a business where the products are not related to the market'.[23] Continuing to doubt the overall financial success of the pottery, Slater proposed deferring the start of the building work and wrote to Leach accordingly saying that expenditure on other arts projects had been heavy, but failed to indicate when the scheme would finally go ahead.

Given Leach's continuing involvement in St Ives, procrastination at Dartington and the emotional upheavals in his private life, it was perhaps inevitable that the relationship between Bernard and Laurie should often be traumatic and stormy. Writing to Michael Cardew he reported that they were content with life 'save when the dark mood shaddows [sic] us', but added that they were 'learning slowly how to tackle it and each our own selfishness'.[24] Such difficulties were observed at first hand by the quixotic St Ives-based poet and artist Sven Berlin who occasionally accompanied Leach to Dartington. He thought Laurie 'a highly intelligent, intense, dark haired person who sought perhaps domestic peace and love for her own sake as a pre-requisite to happiness',[25] a desire in which she felt continually frustrated. Despite protesting that he had changed, Leach was still largely a conventional, conservative man, forced to adapt to rather than choose his apparent bohemian way of life. Yet, in addition to enjoying the security of domestic routine he craved activity and excitement. Laurie felt excluded from many of his activities, realizing that to a large extent they both sought different things. He wanted a partner who was willing to take on the accepted role of carer and home-maker while also being totally involved with and supportive of his career. She looked for something more balanced, equal and shared. Laurie certainly created a warm and supportive home, helping to organize his time, suggesting that he work part of

the day in the pottery making pots and carrying out experiments for *A Potter's Book*, and part of the day writing. But there was friction, with Laurie feeling increasingly resentful and neglected. The painter Elizabeth Collins, then part of the Dartington community, noticed Leach had an eye for the ladies, possessed endless charm, and was someone who liked things to happen.

A major crisis developed in their relationship in July 1939. Much to Laurie's disapproval, under the continuing influence of Mark Tobey and Reggie Turvey, Leach had become more involved in the Bahá'í faith. She had a distrust of all religions and saw Leach's increasing commitment as yet another distraction both from her and from his work as a potter. She also saw Leach as advocating one set of principles about love and care while she experienced something different. When Leach was invited to attend the Bahá'í summer school at Hoddeston to talk on 'the place of beauty in life', Laurie threatened that if he accepted she would leave him, not return and provide no forwarding address. Despite this ultimatum, Leach did attend, and Laurie did leave him. Writing to Tobey, Leach told him that 'love is not dead – there was no third party',[26] indicating that the differences between him and Laurie were not about any flirtatious behaviour on his part, but what they wanted from, and were willing to give, each other. The episode was a dismal reminder of the difficulties of sustaining relationships, reflecting the need for a painful balance of independence and commitment. Their often-tempestuous partnership seemed to Leach to echo the growing international tensions as war hung ominously in the air, writing 'The clouds are grey, the atmosphere heavy, the colours green and black'.[27] Laurie was persuaded to return, but the friction remained.

Far from withdrawing from the Bahá'í faith, Leach became more involved, and in 1940 declared his commitment at a public meeting in Torquay. After Hasan Balyuzi, the distinguished Bahá'í historian, said it was sufficient to consider Bahá'u'lláh a 'spiritual genius', Leach felt able to accept the central figures of the faith.[28] 'I found myself convinced', he wrote, 'almost against my will that the absence of self implied the presence of Truth – the Universal "I am that I am"',[29] suggesting that the mystical aspects of the faith were as significant as the practice of the religion.

Leach also had to consider the feelings of Muriel, and while relations between them were often strained they developed a working understanding. From time to time he stayed at the Count House, seeing the children and spending time with Betty. Increasingly Leach began to feel that the separation had, paradoxically, dissipated some of the bitterness that had built up over the years, and enabled them to communicate more effectively. Whether Muriel shared this view is a matter of debate. As a mark of the changed relationship Leach now tended to refer to Muriel as mother, a role in which to some extent he had always seen her. Their improved relationship did not, however, overcome Muriel's reluctance to grant Leach the divorce for which he continued to press, for while she was prepared to be friendly for the sake of Betty and

the family, she remained fierce in her opposition to his request. This was less for the social undesirability of the proceedings than because of the deep resentment, hurt and anger she continued to feel. Nevertheless Leach was insistent and the case inched slowly and painfully ahead. In an attempt to divide up their estate, lists were drawn up to establish the value of the Pottery and identify the monies that Muriel had invested. Though some had been credited to her, no proper record had been kept and given the financial circumstances they were in any case unlikely to be repaid. Sorting out the grisly financial details was both testing and distressing, and in a gesture of neutrality the deeds of the house were deposited at Barclays Bank.

The children had strong views about the separation. Michael, in particular, with his powerful allegiance to the Oxford Group and the sanctity of the marriage vows, thoroughly disapproved of his father's behaviour and made little secret of his support for his mother.[30] The situation for David was more complex. Like Michael he was involved with the Oxford Group and supportive of his mother but he had some sympathy for his father with whom he was deeply committed to working. The two girls also sympathized with their mother, yet they loved their father who saw to it that they spent little time with Laurie. They were allowed to stay with their father but only when Laurie was away.

During a visit to Dartington in 1937 David Leach met Elizabeth Facey, known to her family as Bubby, the sister of one of the employees on the estate. They soon became engaged and were married a year later. With David's future appearing to centre on St Ives they planned to move into Pottery Cottage after the building had been extended and modernized. A loan of £400 was arranged with the bank to cover the cost and in 1938 the move was accomplished. A year later Elizabeth gave birth to their first son John Harry, Leach's first grandchild.

David returned to St Ives with plans for a major reorganization. Although the Pottery's finances had continued to improve, its overall situation remained weak. Frances Horne was still owed £1,500, lent as mortgage at 5 per cent on the land and buildings, and various vague but substantial sums were owed to Bernard and Muriel. With Harry Davis gone and Leach mostly in Devon, David proposed a series of far-reaching technical, artistic and administrative changes intended to make the enterprise viable and effective. These included the installation of electricity, the purchase of a small amount of machinery to carry out mechanical tasks, a radical overhaul of the kiln that involved converting it from wood to oil and the introduction of a new range of wares. To fund the changes a proposal was put forward for help from Dartington. The Elmhirsts, impressed by David's sound grasp of business and technical understanding acquired during his study in Stoke-on-Trent, warmed to his plans and agreed to fund the programme of modernization, providing £1,000 annually over a period of three years to cover salaries, running expenses and capital

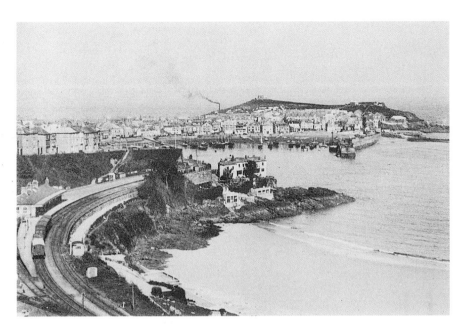

A view of St Ives from above Draycott Terrace looking across the harbour to the island, 1923. The smoking chimney indicates that industrial activity still took place. The station lies bottom centre left. (Private collection).

The Leach family standing outside Count House shortly after acquiring it in 1922. Hamada stands on the left, Muriel is holding Michael; David is on the bicycle. (Private collection).

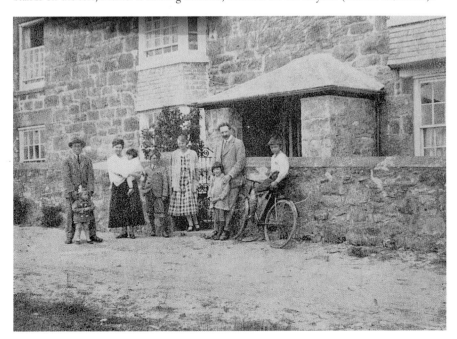

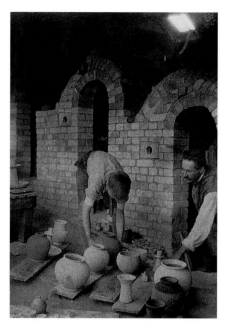

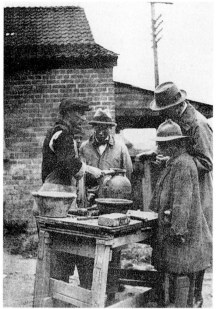

Bernard Leach supervising the packing of the climbing kiln, designed and built by Matsubayashi. The assistant may be his son David. The newness of the kiln indicates a date of around 1924 when David would have been thirteen. (Photograph A. Guthrie).

Hamada Shōji, wearing bow-tie, Bernard Leach and David Leach, wearing a scout hat, watching the potter pulling a handle on a jug at Lake's Pottery, Truro, early 1920s. After seeing this demonstration Leach's handles improved enormously, and he subsequently adopted this method. (Private collection).

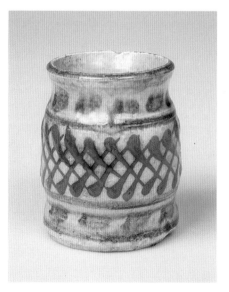

Bernard Leach, pot, 1925. Raku, thrown with brushed decoration in blue, green, yellow and brown; h. 7.5 cm, d. 6.6 cm. During the 1920s Leach produced a limited amount of raku, which was fired in the top part of the earthenware kiln. Its bright colours were in great contrast to the earthenware and quiet colours of the stoneware. The designs were often based on Dutch delftware. (Leach archive).

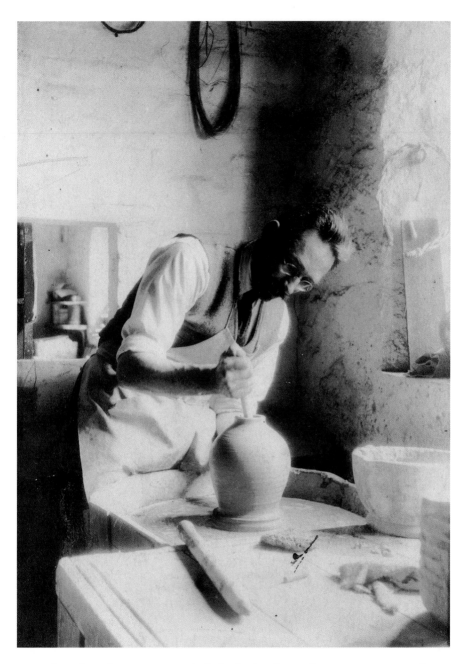

Bernard Leach working on a pot on the kick wheel at the Leach Pottery, *c.* 1925. Leach is wearing, as usual, a white shirt and woollen tie, possibly designed and woven by Ethel Mairet, with a waistcoat beneath his apron. (Family archive).

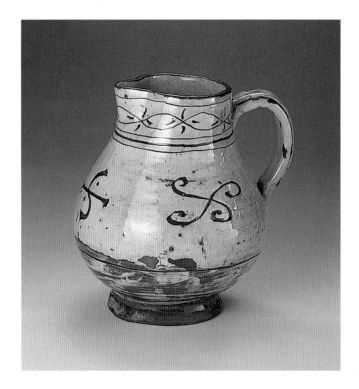

Bernard Leach, pitcher, 1922. Earthenware, thrown, with white slip and incised decoration under galena glaze; h. 18.8 cm, w. 14.5 cm. A strong, traditional jug form made at St Ives as part of the range of tableware. The cross motif was used by Leach in many variations. (Courtesy Ohara Museum of Art, Japan).

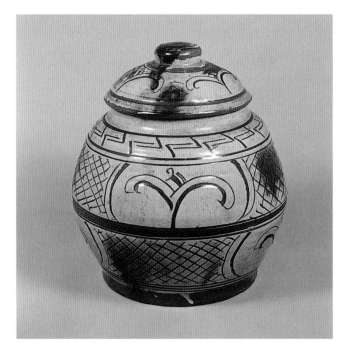

Bernard Leach, covered jar, 1924. Earthenware, thrown, with pattern carved through white slip, galena glaze with areas of green from copper; h. 25 cm, d. 22.2 cm. The strong form, which combined aspects of western and eastern influences, was typical of Leach's work at this time. (Courtesy Ohara Museum of Art, Japan).

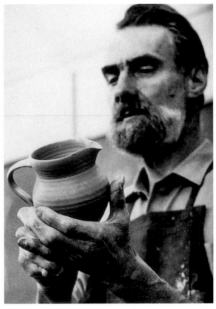

A single-head stamp fitted up at the Leach Pottery by Dicon Nance for pounding grog; George Dunn stands in background, *c.* 1927. (Family archive).

Harry Davis making a jug, Leach Pottery, *c.* 1933. Although Leach admired Davis's technical skill, he thought his approach to form too mechanical and unfeeling. (Leach archive).

Bernard Leach and Michael Cardew at the weekend with Gordon Russell when Cardew was to demonstrate throwing, 1926. They were to build and fire a kiln, possibly for a raku firing. Neither potter found himself in agreement with Russell's move towards greater use of machine processes. (Private collection).

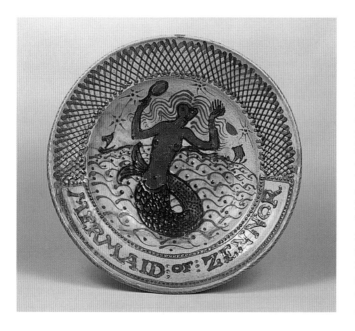

Bernard Leach, Mermaid of Zennor, 1925. Earthenware plate; h. 10 cm, d. 48 cm. Leach made a range of these handsome, slip-decorated plates; this one was based on a carving in Zennor church. These plates were modern interpretations of Staffordshire Toft slipware. (Courtesy Ohara Museum of Art, Japan).

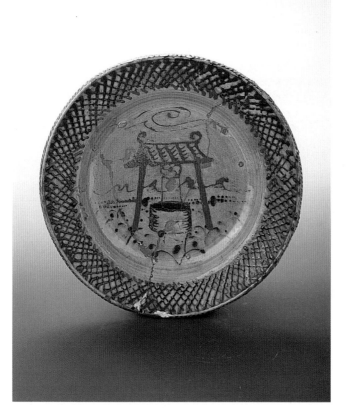

Bernard Leach, Well-head, c. 1926, Earthenware plate with slipware decoration; h. 8 cm. d. 41.5 cm. The trellis border, reflecting the work of English potters such as Toft, contrasts with the well-head, which is inspired by oriental design. This dish exploded during the firing; it was subsequently repaired and remained in the Leach family. Signed BL. (Collection of David Leach OBE).

Bernard Leach, panel of tiles, c. 1929. Stoneware, fire-clay body with painted decoration; 84 cm square. In the 1920s Leach started production of tiles. They were ideally suited to his graphic skills, the brushwork being softened by the glaze. These tiles include many of Leach's recurring motifs. (York City Art Gallery, The Milner-White Collection).

Bernard Leach with Dorothy Kemp (left), and Laurie Leach (centre), standing outside the showroom at the Leach Pottery, c. 1947. A panel of tiles decorated by Leach can be seen in the background. (Photograph Mary Boyd Adams).

Bernard Leach, breakfast set, 1928. Earthenware. This image appeared in the December issues of the *Studio* and *Pottery and Glassware*, 1929, and was intended to promote the new range of tableware Leach was producing at St Ives. The flowing, relaxed design and simple colour combinations have not dated.

Mark Tobey, c. 1950. Leach met Tobey in 1932 at Dartington, and the two became lifelong friends. Tobey introduced Leach to the Bahá'í faith, and Leach declared himself a Bahá'í in 1940. (Leach archive).

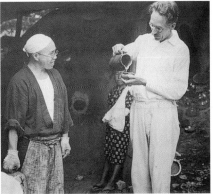

Bernard Leach with Hamada Shōji at the opening of the kiln shared by the two potters at Mashiko, during Leach's visit to Japan in 1934. (Leach archive).

Bernard Leach discussing their pots with the two Ono brothers, Sokeshi, Matusui, March, 1935. (Leach archive).

Bernard Leach thowing a pot on a hump of clay during his 'five strenuous days and nights' in Kurashiki during his visit to Japan in 1934–5. Leach, wearing collar, tie and waistcoat, working on a Japanese kick wheel, protects only his trousers from splashes. The stick to turn the wheel head lies on the left. (Leach archive).

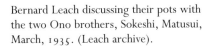

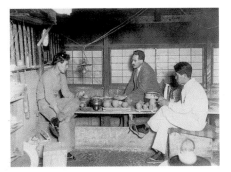

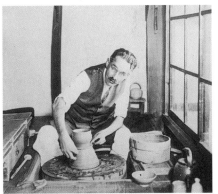

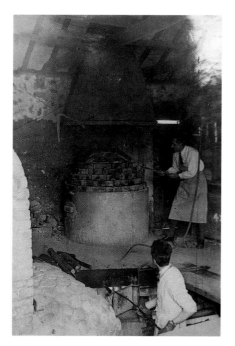

Bernard Leach with Bernard Forester firing the kiln at Dartington, c. 1933. The kiln, which never worked well, was rebuilt several times. After working in Stoke-on-Trent Bernard Forester moved to the Leach Pottery but found the repetitive tasks too reminiscent of industrial production, and preferred to remain in Dartington. (Leach archive).

Bernard Leach, coffee set, 1933. Earthenware, with black slip and dot decoration in bright honey yellow; coffee pot h. 14.3 cm, d. 14.3 cm. Made in the small pottery at Dartington, possibly as prototypes, which were never followed up. Impressed mark BL. (Leach archive).

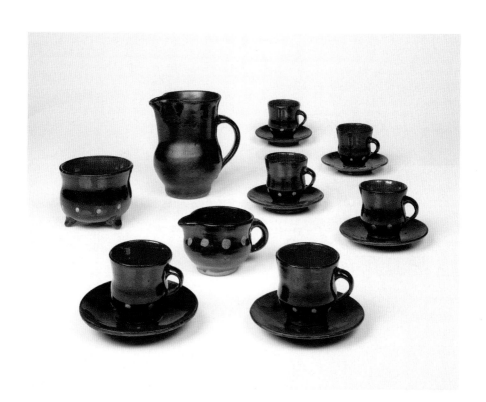

Bernard Leach, incense container, 1935. Porcelain; h. 4.3 cm, w. 6.5 cm. Leach enjoyed decorating these lidded, press-moulded boxes. The swallow pattern, rendered in cobalt blue, was based on a drawing. Made in Japan. (Courtesy Ohara Museum of Art, Japan).

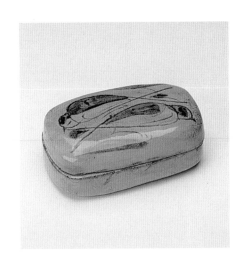

Bernard Leach, vase, 1935. Stoneware, thrown, with slip and wax resist decoration of a fox and rabbit design set among abstract landscape; h. 37.5 cm, d. 32.2 cm. Made in Japan. (Courtesy Ohara Museum of Art, Japan).

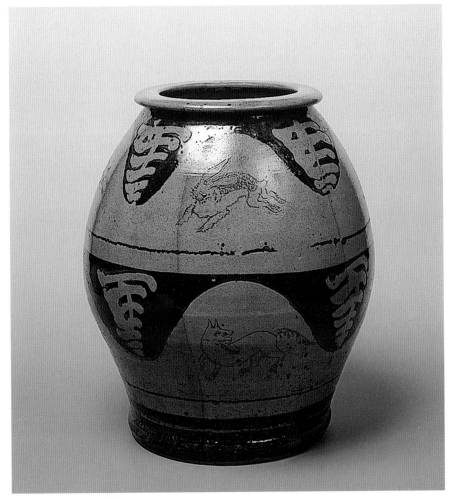

Bernard Leach with friends and potters outside the Berkeley Galleries, 1946, attending an exhibition celebrating twenty-six years of the Leach Pottery. Standing, right to left, unknown, Bernard Leach, Harry Davis, Sylvia Fox-Strangeways, Jessamine Kendall, Delia Heron, Aileen Newton, Dorothy Kemp, Kenneth Quick, Bunty Smith, Patrick Heron, unknown, Laurie Leach, unknown, Marianne de Trey, William Ohly, unknown, Sam Haile, Margery Horne, unknown, Annamarie Fernbach. Sitting, right to left, Michael Leach, Valerie Bond, unknown, Meriel Cardew, Margaret Leach, Frank Vibert, Dick Kendall, Dicon Nance. (Private collection).

Bernard Leach (centre), in front of the corner fireplace at the Leach Pottery discussing the finer points of making a jug with Mary Gibson Horrocks (left), Valerie Bond and David Leach, 1947. (Leach archive).

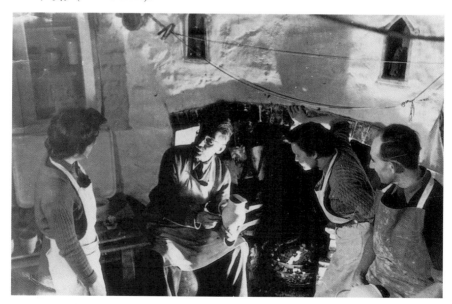

Bernard Leach, house list with sketch of lidded pot, *c.* 1944. Pencil on paper; 28 × 11.5 cm. Leach enjoyed making lists; here he details the tasks to be carried out by the shared household, in addition to sketching a lidded pot. (Private collection).

Bernard Leach in his study above the showroom at the Leach pottery, drawing a pot, *c.* 1948. Leach felt at ease with the brush, whether working on paper or the surface of clay. (Private collection).

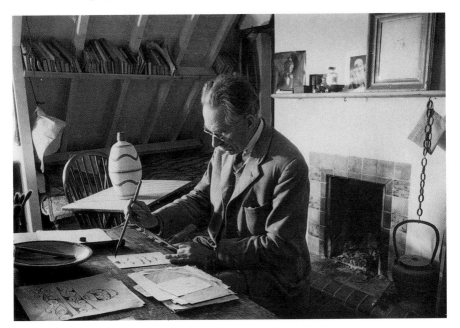

Potters at the Leach Pottery, *c.* 1946.
Clockwise from left, Bernard Leach,
Kenneth Quick, David Leach, Joe Benny,
Horatio Dunn, Aileen Newton, centre
Mary Gibson Horrocks. (Leach archive).

Bernard Leach, centre, with the Spanish
potter Jose Artigas and Lucie Rie at the
Dartington International Conference,
1952. It was Artigas who coined the phrase
'To Leach or not to Leach', in reference to
Leach's unsympathetic attitude to the
ceramic industry. (Leach archive).

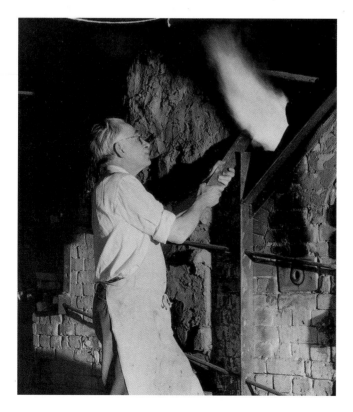

Bernard Leach
checking the kiln
during a firing, St
Ives, *c.* 1950. The
size of the flame
emanating from a
spy hole suggests
that reduction was
in process and the
firing coming to an
end. (Photograph
Mary Boyd
Adams).

Bernard Leach, dish, 1936. Stoneware, thrown, with design of simplified sun, mountains and fish in a stylized landscape; d. 25.5 cm. The contrast between the clay body and the glazed areas may have been influenced by Leach's experience working in country potteries in Japan 1934–5. (Leicester City Museums; photograph Stephen Brayne).

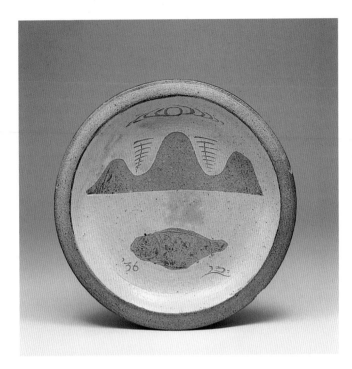

Bernard Leach, square dish, 1954. Porcelain, press-moulded, enamel decoration in black, red and green; w. 15.5 cm, depth 3 cm. An example of Leach's work with enamel decoration on a simplified design of a house with mountains in the distance. Signed BL 1954. Made at Kutani, Japan. (Leach archive).

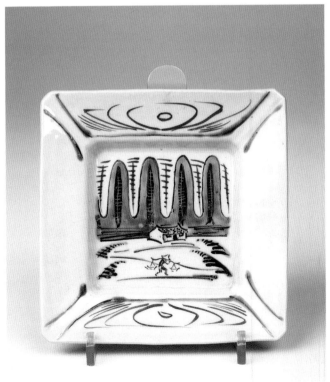

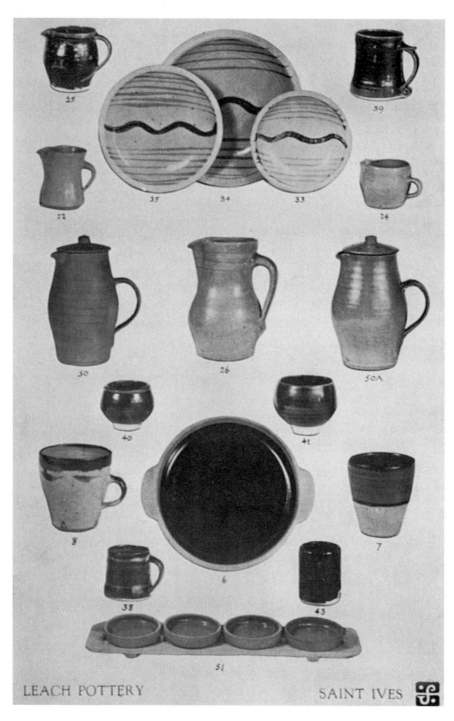

LEACH POTTERY SAINT IVES

Leach Pottery Standard Ware, 1946. A catalogue insert showing jugs, plates, mugs, bowls and serving dishes. The range remained remarkably consistent over nearly forty years.

outlay. Slater, ever the shrewd observer, recognizing that there was little hope of recouping such sums, proposed that the funding be given as a donation on the strict understanding that it was the total sum available and no more money would be forthcoming. From the point of view of the Pottery it enabled David's radical reform programme to go ahead.

In addition to what seemed like a sound business plan for St Ives, the increasingly tense international situation and the prospect of war convinced the Elmhirsts that this was not the moment to embark on a complex new business venture and the further development of the pottery at Dartington was quietly dropped. Still the Elmhirsts remained loyal patrons, and on their return from a visit to the United States in 1942 they commissioned five beautiful pots, but as Leach had only one or two large ones he sent a total of eight the remainder made up of smaller pieces, no doubt hoping they would keep them all, which they duly did.

Although Leach held the view that wood was the only fuel able to achieve the sort of qualities he wanted in high-temperature firing, it was costly in terms of labour and difficult to find in Cornwall. David's proposal to modify the firebox to take oil burners and introduce wood only at the end to 'toast' the body was grudgingly accepted by Leach. Although oil was used widely in industry, little was known about using it to fire a three-chamber studio-pottery kiln and a certain amount of trial and error was required. Firing with oil, though noisy and smelly, speeded up the process, making it less tiring while yielding good results.

To sustain regular production of high-quality wares, David reasoned that a skilled permanent workforce, organized in a more businesslike way, was required. For years the Pottery had relied on a stream of students and trainee potters, who once trained quickly left to pursue individual styles and careers. Reviewing the situation David proposed a system of apprenticeships whereby school leavers who showed practical aptitude rather than artistic talent were taken on and trained along professional lines. Adopting William Morris's theory that art and skill are ready to be drained out of the least superficially promising of people, several youths were invited to visit the Pottery to see whether it appealed to them.[31] In 1938 William (Bill) Marshall and George Whittaker were taken on, eager to learn the preparation of clay and glazes, throwing and turning pots, and kiln packing and firing, all geared to professional production rather than leisure time or artistic activity. Bill Marshall became a highly skilled potter, proving to be a mainstay at the Pottery, where he produced standard ware and in the 1950s his own pots, remaining until 1977. Over the years other apprentices were accepted for an initial three years and it proved to be an effective way of establishing a regular and skilled workforce. Students still came, but were less essential for day-to-day production. In 1937 George Dunn retired and was replaced by Horatio, one of his sons.

Under Leach's direction David devised a range of pots for use on the table,

in the kitchen or even in the oven, which were made to a measured shape and size from a known weight of clay. The wares were designed in the tougher more hardwearing stoneware, virtually bringing the production of earthenware to an end. Leach first drew the shapes and David made prototypes, which were discussed and the final forms agreed. The dimensions, weight and shape of each pot were recorded as a guide for future reference. The range included egg bakers, salt, pepper and mustard pots, beakers, casseroles, ashtrays, jam pots, small pots, plates and jugs. With the outbreak of war, Jimmy James[32] a self-employed salesman recommended that they add a soup jug and bowls to the range, with the idea that hot food could be served in air raid shelters. David designed a tall lidded jug, unglazed on the outside, which was successful and was produced as a standard item. The pots, sufficiently uniform to enable them to be ordered from a catalogue, became known as Leach Standard Ware and with modifications continued in production until Leach's death in 1979. The clay body was also adjusted to make it more workable and reliable as well as more attractive.

By March 1938 Leach was able to write to the Little Gallery offering samples of the new stoneware. Having learnt to appreciate the quality of unglazed clay from his time in Japan, most were glazed only on the inside with either a creamy white, a pale green celadon or a deep black-brown *temmoku*, leaving the rich toasted body on the outside. This subtly contrasted the smoothness of glaze with the texture of the clay body. Decoration was minimal, though some jam pots were painted with a flowing design, while one in porcelain had an incised pattern of an oak leaf on the lid. Fruit or cereal bowls thrown with a turned foot were covered with a creamy-white glaze and decorated with three iron brushstrokes in the form of a 'z' carried out by the team, a motif which could be read as the Japanese character *kō*, meaning craft. Prices ranged from under a shilling for a small jug to fifteen shillings for a large. A series of bulb bowls made by Candy & Co. and glazed at the Pottery were deemed inelegant, while Muriel Rose thought a blue glaze not quite right. The general impression was of sound, practical design incorporating a feel for clay, the earthy, subdued colours suggesting wholeness and health with a suitable degree of restraint.

Producing such a wide range of standard ware called for a greater degree of organization. Although tableware had been made for some time, and Leach recognized that it could be a useful part of 'bread and butter' production, making had been largely piecemeal with limited attempt at regulation. Alongside the standard wares that now formed the bulk of production, Leach and other throwers made individual pieces, all of which were fired in the large kiln. These were then sold under the name of the maker and the Pottery. Such a system became the model for many studio potters throughout the world, and continues to be accepted as a sound, workable basis, amalgamating art and skill, spanning the gallery and the craft shop.

Throughout the 1930s Leach's output of individual pots in England was small, but the influence of working at Dartington and his tour of country potteries in Japan was reflected in the pieces he made. A stoneware dish, nine inches (25 cm) across has a silhouette design of a mountain range and a fish through white slip with incised decoration, framed with an unglazed rim and dated 1936. Its muted colours of ambers, greys and rich browns and highly stylized pattern suggest a new awareness of texture and material. At Dartington Leach made slip-decorated tableware and few individual pieces. In consequence most invitations to show work were refused and even the offer of an exhibition at the Little Gallery was declined, with Leach citing Laurie's view that he had too many other commitments. However, an invitation to take part in an international exhibition in Paris was accepted, and in mid-1938 he and Laurie visited the city partly for a short holiday and partly to see the British Pavilion at the International Exhibition of Arts and Crafts. At the Rouard Gallery in addition to his own work, there were pots by among others Murray, the Vyses, Pleydell-Bouverie, Braden, Cardew and Dalton.[33]

Feeling somewhat more settled, Leach began serious work on *A Potter's Book*, the project he had been dreaming of since 1920, the outcome of over twenty-five years involvement with the craft. Part philosophical observation, part technical and part inspirational, the book was a deeply felt exposition on the importance of pots in everyday life, offering an appreciation and enjoyment of ceramics far beyond practical and functional concerns. Although aimed at students, collectors and enthusiasts who were taken through various making, decorating and firing processes, it was also meant for the more general reader in explaining the methods and procedures of making pots, with the aesthetic appreciation of pots woven into the text.

Given the book's ambitious aims it is not surprising that it took over four years to complete. Although various publication dates were agreed, Richard de la Mare at Faber & Faber was wary of rushing and thereby spoiling the book, and at times it seemed that it would never be finished. Laurie offered practical support and encouragement, for not only did she have useful secretarial skills and some knowledge of the processes, but put forward constructive ideas about the book's structure. However, the overall advisor was Henry Bergen, who, with his meticulous classical background, Marxist politics and knowledge of pottery, was a stern critic of writing he considered vague, general and patronizing. Against this Richard de la Mare was keen that the book should retain its human qualities, urging Leach to keep 'a few high spots' and not 'allow Bergen to cut out your titbits'.[34]

The tortuous writing process involved sending chapters to Bergen and Cardew for advice, comments and rewriting. Bergen was scathing in his attacks on what he saw as the pretentious and shoddy, expressing scorn for Leach's early drafts of his key chapter 'Towards a Standard', in which Leach laid out the basis of his approach to pots. Bergen challenged its notion of the Sung

standard as exemplary for contemporary potters. 'Sung pots can never be a standard for mass-produced wares,' he pointed out, 'they do not correspond in form to the functional requirements of today.'[35] Sung dynasty ceramics, Bergen argued, were produced in a situation vastly different to modern conditions and he remorselessly accused Leach of idealizing the past. To Bergen the text was 'too rhetorical and excited'[36] as well as badly written. He also charged Leach with confusing the 'humanistic and intuitive work done in a traditional manner . . . by individual potters' and 'the rational and abstract (sometimes harmonic) work done by a designer who is today most properly an architect and carried out by a machine or some other reduplicating process', adding 'each has its own virtues'.[37]

Other equally profound ideological differences surfaced, particularly over the value of mass production. Against what he saw as Leach's ill-informed criticism Bergen felt it necessary to defend industrial production in meeting the practical needs of the population, telling him not to sneer as 'the factories . . . are bound to produce what they can sell, otherwise they can't exist'. Mass production, he pointed out, is here to stay and he urged Leach not to confuse his nostalgia for 'the little workshop in China and Korea and Japan' with the reality of the virtues of mass-produced tableware, which was 'much more practicable in use than any peasant ware'.[38] 'Good, well-designed mass-produced pottery is not only better but a thousand times better than the work of 75% if not more of studio potters,'[39] he added. In despair Bergen occasionally rewrote Leach's text rather than engage in long and, to his mind, often futile correspondence, ruthlessly reshaping early drafts before declaring them 'simpler and less turgid'.[40]

In an attempt to force Leach to think both more analytically about what it was he wanted to say and the most effective way of expressing it, Bergen recommended Edward Johnston's book *Writing, Illuminating & Lettering*. To broaden Leach's outlook he directed him to the writing of modernist architects Le Corbusier, Gropius and Frank Lloyd Wright where he would 'see that such men have the greatest respect for tradition and far more knowledge of it than most artists'.[41] On other subjects Bergen advised him to read Nikolaus Pevsner on architecture, and Herbert Read for writing on pottery, both of whom Leach quoted in the published version of 'Towards a Standard'.

Bergen also objected to autobiographical references in a book of this nature, claiming comments such as 'my friend Hamada', were unnecessary and suggested a homely rather than analytical text. With regard to the practical writing Bergen had fewer concerns, but insisted that an introductory paragraph on kilns should be cut to eliminate the 'cackle and prancing'. 'Who wants to know that the burning of pots in ovens is a mystery or that the making of pots on a "spinning wheel" (too much like spinning-wheel) is a miracle,' he questioned, adding 'Don't write as if your readers were fools.'[42]

While accepting many of Bergen's arguments and rewrites, the book retained a powerful sense of individual vision that left the personality of the writer intact. Eventually the first and most difficult chapter, 'Towards a Standard', was completed and, more than any other of Leach's writing, is now perceived as a major statement in dealing with the aesthetics of studio pottery and the role of the potter within modern society. In searching for a common standard of 'fitness and beauty' Leach proposed, 'without hesitation', the Sung standard as an ideal while insisting that this does not mean 'imitating particular Sung pieces' either in form or glaze. Rather it was a profound acceptance of a way of working that involves employing naturally occurring materials and 'a striving towards unity, spontaneity, and simplicity of form and in general the subordination of all attempts at technical cleverness to straightforward, unselfconscious workmanship'. Aesthetics for Leach were a matter of certainties rather than doubts, clarity rather than confusion, decision rather than hesitation. 'It is true,' he declared, 'that pots exist which are useful and not beautiful and others that are beautiful and impractical, but neither of these extremes can be considered normal: the normal is a balanced combination of the two.' In its range and confidence, 'Towards a Standard' is a *tour de force*, taking into account 'beauty and vitality' and poetic vision.

In addition to a series of line drawings illustrating tools and various pottery processes, Leach selected seventy-seven black and white illustrations, which were a personal choice rather than a catholic survey of ceramic history. They include a bonfire firing in Nigeria and historical and modern pots that he particularly admired. Pride of place is given to Chinese pots, including Sung jars, which had been much admired at the 1935 'Chinese Exhibition' at Burlington House and acknowledged as inducing a 'seismic tremor of great art'. Others ranged from Japanese tea-bowls, a Korean jar, a Kenzan raku dish to a Staffordshire slip-decorated charger and a German salt-glazed bottle. In addition he included pots by former assistants such as Cardew, Braden and Pleydell-Bouverie, as well as pieces by Murray, whose work he continued to hold in high regard.

In spite of the endless delays and receiving the chapters one at a time, Richard de la Mare went out of his way to accommodate Leach's requests. He agreed to have the four colour plates printed in Japan from already existing blocks to save costs, to include additional drawings and black and white photographs, to select a typeface in keeping with the subject and to pay particular attention to the orange-terracotta colour chosen for the dust jacket. Bergen was unable to write an introduction due to a severe attack of shingles, and Cardew produced a preface and Yanagi a glowing introduction. While de la Mare judged the latter to be 'a little adulatory' he approved, but initially it was not shown to Bergen as Leach feared he would 'go off in hysterics'. To everyone's relief Bergen did endorse Yanagi's piece as not 'too eulogistic'.

The complete manuscript was finally delivered in June 1939. The declaration of war caused de la Mare to toy with the idea of postponing production, but in the lull of the 'phoney war' he decided to go ahead and it was published a year later[43] priced twenty-one shillings. Complimentary copies were sent to, among others, Laurie's parents in Earl's Court.[44] Although not on the face of it a propitious moment to issue such a volume, *A Potter's Book* was a steady success from the start. Numerous reprints were required and it was translated into many languages. It is still in print.

Dedicated 'to all potters', the book is Leach at his strongest and most focused, speaking from undisputed personal knowledge both as a potter and commentator on pots in modern society. One of its great strengths is that it calls on Leach's direct experience of potting in the East and West, experience that few other artist potters had at this time. Oriental techniques and processes are presented with western understanding, whether in describing the aesthetics that informed the pots or the practical methods used. Under guidance from Bergen and Cardew the book effortlessly combines ideas and opinion in elegant and spare prose. Stimulating and inspirational, the account of the work and life of the potter is a philosophical discourse on quality and integrity, a technical manual that includes kiln plans and glaze recipes, and most tellingly a personal diary in which work and play seem intimately combined. This imaginary account interwoven with real letters from such friends as Tomimoto placed the reality of the life of a potter at the core of the book.

Critical response was generally laudatory. Recognizing Leach's experience in the Far East and in England, the *Times Literary Supplement* declared that while the 'author's aesthetic judgements may scarcely command universal acceptance', his 'output combines the best of both worlds'.[45] In *Time and Tide* the critic Maurice Collis thought it 'the soundest and most detailed book which has ever been written on the subject'.[46] Some writers did point out the narrowness of Leach's perspective, objecting to his intolerance, quoting for example his remark that 'Italian ma[i]olica is generally weak, ornate and closely allied to third-rate Renaissance painting'.[47] This attitude clearly caught the attention of the reviewer in the *Burlington Magazine* who declared that in the book, Leach 'pronounces judgement with an almost arrogant dogmatism', adding 'and this is hardly made more impressive by a knowledge of ceramic history which is, to say the least, somewhat defective'.[48] While *A Potter's Book* offered a clear vision of the work of studio potters, some viewed it as dogmatic and oppressive in denying the possibility of other ways of working. Even Herbert Read, a great admirer of Leach, and full of praise for the book, could not help pointing out that 'Art is various, even the art of pottery'. The *Listener* took issue with Leach's comments on mass production as being 'hard, cold, mechanically perfect'. Industry, the reviewer pointed out, provides 'the ground and conditions for an entirely new sort of ceramic

achievement', and suggested that Leach had failed to 'perceive that his own self-conscious and backward looking sophistication may obstruct the growth of a new tradition of mass-produced pottery'.[49] Despite these criticisms, *A Potter's Book* was overwhelmingly regarded as magisterial in its ambition and was quickly hailed as the 'Potter's Bible'.

The troublesome subject of mass production, endlessly thrashed out by Leach and Bergen and discussed in 'Towards a Standard', was a theme that engaged many others in the craft world, with Leach often taking on the role of keeper of the faith in opposing any recognition of machine-made work. As a member of the Arts and Crafts Exhibition Society (ACES) he was usually the most vocal in speaking against any shifts to kowtow to mass production or the over-use of machine techniques. Minutes of the ACES meetings in the 1930s reveal anxious soul-searching, much of it often sparked by Leach insisting that individuality not soulless production should be the prime concern of the craft world. Relentlessly he argued that industry must come to the craftsman, not the craftsman to industry. For many it remained a problematic area and Leach's own dogmatism in refusing to brook any compromise could be difficult to deal with. At one point, enraged by views he did not approve of, Leach resigned and was besieged with requests to rejoin. Like Murray he objected to the policy of including machine-made goods in ACES shows.

This issue came to a head with a proposed 'International Exhibition' in Paris when W. B. Honey, of the department of ceramics at the Victoria and Albert Museum, invited Leach to submit a collection of slipware 'traditional English in character, made for use, rather than large decorative dishes'.[50] The restriction in what he could submit 'astounded' Leach, who wrote back protesting that stoneware 'has more "potential" for the future of pottery in general'. The crux of the problem was that the original intention of the 'International Exhibition' had been to show industrial work as part of an export drive, and only after much protest was a small studio section added, which furthermore was limited to functional work to keep it in line with other exhibits. Following further complaints from Leach and others individual stoneware pieces were grudgingly allowed.

Artist potters and the ceramics industry, on the whole, viewed each other with suspicion. This mutual lack of trust was not helped when one or two manufacturers in Stoke-on-Trent commissioned artists to prepare designs for existing shapes with a view to limited production.[51] Leach, while thinking this would be 'useful up to a point', doubted whether such artists would 'know and feel their medium',[52] and was annoyed that the experience of studio potters was ignored.[53]

Craft societies such as the Red Rose Guild were also riven over whether or not to include industrially made objects in their exhibitions, however well designed they may be. Harry Norris,[54] one of the leading lights of the guild, was particularly vehement in his disapproval, and deplored the way some

craftsmen appeared preoccupied with industry, going as far as to claim that 'Industry can not be called human – in fact it is a degrading – dehumanising force'.[55] Such vehemence demonstrated Norris's loyalty to the guild but it could also appear unwavering and hard line. In typical forthright manner he dismissed the work of both ACES and the Art Workers' Guild as 'overloaded with personalities and half dead meat'[56] and other societies he judged as too parochial, doctrinaire or commercially motivated. In his view the Red Rose Guild was the only body that could adequately introduce the crafts to a wider audience. While Leach shared Norris's desire to promote crafts he shrank from his extreme views and abrasive attitude and far from collaborating amicably they spent much of their time in dispute. At one point Leach accused Norris of being an 'insular provincial'; in turn he dismissed Leach as one of the 'cosmopolitan travellers'. Infuriated, Leach resigned and rejoined only after long deliberations. In fact Leach showed something of a flair for resignations, also withdrawing from the St Ives Society of Artists. In 1938 he did however join the National Register of Industrial Art Designers under the chairmanship of Charles Tennyson (later Sir), which sought to develop practical links between studio and factory.

A regular stream of visitors to Dartington kept Leach in touch with events in London. These included Dorothy Kemp,[57] usually known only as Kemp, and the Viennese-born potter Lucie Rie-Gomperz.[58] Having fled from Austria shortly after the Anschluss when Germany annexed the country in 1938, Lucie Rie had recently arrived in London with her husband, he to continue on to the United States, she to remain and establish a pottery. Small, elegant with fine features and a delicately pointed face and dark hair, Rie rented a modest house in a quiet mews near Marble Arch in London,[59] setting up a studio on the ground floor and an attractive one-bedroomed flat above, where she was to live until her death. In Vienna her sensitive bowls and vases in earthenware had gained her an international reputation but in England her work was still virtually unknown. In an attempt to establish her career in England, she sought as many contacts as possible. She knew of Leach's reputation, but he knew nothing of her success. In both style and intention their work was very different; hers was part of an awareness of and response to the austerity of European modernism that drew more on Scandinavian minimalism than oriental sources. Some early pieces such as teasets in terracotta left without glaze on the outside had a finely honed simplicity. Others, like individual cylinder vases and bowl forms often finished with thickly applied and textured glaze, were more decorative.

Rie and Leach first met briefly at the Little Gallery, and she subsequently wrote expressing a wish to visit him, show him her pots and seek advice. He did take paying students at Dartington, particularly in the summer, and Rie happened to write when one of his students, a German-Jewish refugee Annamarie Fernbach, was away. Rie was invited to fill the vacancy for

which she paid the nominal charge of £2 for one week. Leach showed her how to pull traditional handles and prepare clay by spiral wedging and each day they would chat over tea in a café on the bridge. Typically Leach made little effort to conceal his criticisms of Rie's pots, which seemed to him too thin and paper-like, but he liked her, again disproving his theory that the pot is the person. An enduring, lifelong friendship was established and, promising to help with her application for a permit to work as a potter, Leach wrote to various bodies including the Board of Trade, but at this point without success.

Under the influence of Leach's persuasive arguments about the virtues of high-temperature firing and his charismatic charm – and there are suggestions that he was physically attracted to her – Rie felt the need to rethink her pots. She considered moving from earthenware to stoneware, though outbreak of war and the lack of a permit prevented her carrying out any decision. Despite limited space in her mews house, Leach became a regular visitor often staying at what became known as Lucie's hotel, his trips seeming to coincide with terrific air raids giving rise to jokes that the bombers were after Leach. At his request, Rie collected two pots, a German Bellarmine bottle and a white Korean jar some two foot high[60] that he had brought back with him in 1935 and which he had left with Jean Milne,[61] 'the best weaver of carpets in these islands',[62] who lived in Kensington. Leach was fond of Milne who, after studying as a sculptor carving stone, had worked with the sculptor Mestrovic with whom she formed a lifelong relationship. After admiring Macedonian textiles in Belgrade she became a weaver and was commissioned by the Elmhirsts to contribute work to Dartington Hall. Leach was pleased that Rie and she become friends and in his letters to Rie often spoke of his respect and affection for Milne, who suffered from depression, and of the need to maintain balance through 'sunlight in ones inner life'.[63]

As the war gathered momentum it rapidly became clear that Leach would have to abandon plans to visit Japan. In any case Japan was waging its own war, having invaded China in 1937, much to the disapproval of Yanagi who deplored the action, recognizing that his country was becoming involved in the 'biggest war she had ever had'.[64]

In Britain, as the implications of war became a reality, the outlook for craftsmen and women in all disciplines was bleak; the supply of many raw materials was controlled and skilled workers were conscripted. In the face of the impending conflict craft seemed a low priority, forcing many small specialist sales outlets to go out of business. At the Little Gallery Muriel Rose reported a serious dearth of customers and held a closing sale in October 1939.[65] As the realities of war slowly became more apparent Leach considered accepting orders for such diverse wares as acid bottles, crucibles, fireproof ware or even false teeth in an effort to support the war. He even toyed with the idea of producing insulators and other high temperature porcelains but, on reflection, thought them too specialist.

The changes initiated by David in the Pottery were effective. Firing the kiln by oil, though still tricky, worked, shortening the firing time by 20–25 per cent. A new celadon glaze proved attractive and reliable. A more efficient system for mixing the clay body was successful, and making schedules for the throwers based both on fulfilling orders and the most economical way to fill the kiln, resulted in a steady stream of saleable pots. Unlike Dartington, where most of the regular staff were too old to be conscripted, all members of the team at St Ives, other than Leach himself, were eligible for military service. The ending of the Elmhirst funding in 1940 forced the Pottery to become self-sufficient, and to maintain viability David, aware that new outlets for the pots were required, tenaciously searched London. With all decorated industrially produced pottery shipped to America as part of the export drive there was a lack of distinctive ceramics. As a consequence useful orders were obtained from department stores such as Liberty, Peter Jones and Heal's, shops that hitherto would not consider taking their pots but were now keen to fill empty shelves. Sales at the Pottery for the quarter covering Christmas totalled £126 10s 9d, an improvement on the previous quarter and the same period a year earlier. Although modest, the sum was considered 'reasonable', and if maintained over twelve months would make the Pottery self-sufficient.

Britain's declaration of war on Germany in September 1939 was a severe challenge to Leach's pacifist views. Many artists, including Leach, had joined forces to oppose Fascism in countries such as Spain and Italy and supported the anti-Fascist, pro-Soviet organization Artists International Association (AIA),[66] which had been set up in 1933, helping to organize a craft exhibition that resulted in a net profit of £70. Leach also attended a meeting of the British Artists' Congress and sent work to Nell Vyse's fund-raising events at Whistler's old house in Cheyne Walk, in aid of medical services. Unlike the First World War, when he was in the Far East, Leach was now in the thick of it. While continuing to regard himself as a pacifist, and being in any case well above the age when he could enlist, the horror of invasion, a hatred of 'Hitler and his gang, and the rousing voice of Churchill' proved overwhelming and at the age of fifty-two he joined the Home Guard, rationalizing this decision as one of defence. Manoeuvring in the hills around Dartington at night and witnessing enemy aircraft bombing Plymouth twenty-two miles away, an action that destroyed the square mile of the city centre, confirmed his horror of war but also vindicated the decision to play his part in resisting Nazism.

The reality of the conflict was vividly brought home on 25 January 1941 when a landmine fell on the Pottery. In its position above the town the Pottery proved an ideal lookout and was designated an air-raid warden post. On the evening in question David was on duty with a small team waiting for the all clear. Leach, recovering from an attack of quinsy, was temporarily staying at Count House as the difficulty of obtaining supplies of bottled gas made

remaining in the cabin at Dartington impossible in the cold weather. Hearing a tremendous explosion at around nine o'clock in the evening he rushed out to identify the cause. Over a poor telephone line David excitedly told his father that a half-ton bomb had landed in the vegetable garden. The gable end had been blown off Pottery Cottage and Penbeagle Cottage severely damaged. Fortunately George Dunn's widow, Martha, and her children escaped with their lives, although Martha did sustain a fractured collarbone. The pottery roof was also damaged but the supporting granite walls withstood the blast. With Pottery Cottage rendered uninhabitable David, Elizabeth and their son moved to Count House, which was once again divided to enable them to have a separate establishment.

Apart from regular patrols with the Home Guard, Leach's only other direct experience of war in St Ives occurred in August 1943 when two stray German planes circled the town aimlessly machine-gunning before dropping a series of bombs, one of which hit and destroyed the gasworks overlooking Porthmeor beach, killing a woman. Incensed, Leach fired several shots at the planes as they made their escape.

A temporary awning enabled production to continue. With two firings yielding some 2,500 pots, many of which were orders, Leach was convinced that they were 'well on the road to recovery'.[67] Conscription rather than enemy action proved more effective at restricting production as one by one the regular team was called up, Horatio Dunn to the Royal Naval Reserve and Bill Marshall to be an army driver. But it was David's call-up in September 1941 that looked set to seriously affect the viability of the Pottery and led to Leach permanently returning to St Ives. Although David was inclined towards pacifism, and even considered joining the Cotswold Bruderhof community,[68] he failed to avail himself of the conscientious objectors tribunal and was ordered to report for duty to the Devon and Cornwall Light Infantry at Dorchester. After much protest he rationalized that a Christian could also be a soldier, donned the uniform and spent the war training recruits.[69] With no deep-seated pacifist beliefs, Michael served with the Pioneer Corps in East Africa.

New assistants were found, though not all were a great success. Betty Hope, who arrived at the beginning of the war, either could not or would not settle, threw tantrums and disrupted work. Others proved more successful. Margaret Leach (no relation to Bernard), who arrived in July 1942, turned out to be a competent thrower who was very soon making tablewares. After Betty Hope, who engendered feelings of unease with her 'unreasonable suspicions', Margaret Leach contributed to the working rhythm of the Pottery introducing 'a very different and co-operative hard working and unselfish spirit'. She not only threw, glazed pots and helped fire the kiln but also found ingenious ways of eking out the meagre war rations. Aileen Newton, wife of Eric Newton the art critic, arrived shortly after to complete the team.

For three years Pottery Cottage remained uninhabitable. Substantial claims for war damage were allowed and Leach went to great lengths to ensure that these were as comprehensive as possible. Under wartime regulations only essential work was permitted and, anxious to prevent the buildings being condemned and demolished, Leach put pressure on his London contacts for permission to proceed with repairs, so enabling it to be reoccupied. In the meantime he and the assistants lived in various houses in nearby Hellesvean. Life with Leach could be something of a trial for he fussily insisted on keeping the place clean and tidy, often pinning up notes reminding everyone to leave things as they found them, although his minimal arrangements of flowers or twigs, carried out in the ikebana style, were greatly appreciated. Occasionally they visited the cinema or listened to classical concerts on the wireless. During a broadcast of Beethoven's Mass in D minor, Leach found the 'swells & bursts' so moving that he had to pause when writing a letter to David to recover himself.

With Pottery Cottage again habitable life became simpler. By making use of the upstairs loft, which had its own external staircase, Leach had more privacy. In both the Pottery and in the cottage the crew were driven by a powerful sense of purpose and a strong community spirit developed. This not only involved a great deal of hard work in maintaining production, but also resourcefulness in scrounging food and a degree of improvisation to satisfy healthy appetites from minimal rations. They took turns to cook, with Leach's efforts judged the most tasty. Cauliflower au gratin was a favourite, and bread fried in dripping was another. With foresight Leach had hoarded a huge sack of rice, which became a useful basis for many meals. Much to the amusement of the locals Margaret Leach successfully cultivated vegetables in the Pottery garden, regularly fertilizing them with the contents of the Pottery closet and fending off local 'advice' such as suggestions that she plant leeks upside down. In the morning break, known as crib, Cornish crib cake[70] was eaten, and after lunch there was usually a game of cricket in the yard and the deserted road outside. Still a fair bat Leach liked to demonstrate the elegance of his strokes. With Leach back in Pottery Cottage Laurie occasionally visited St Ives, sometimes appearing at the Pottery window to offer cakes but she rarely came inside and was wary of bumping into Muriel in the town. The friction of Laurie living in Dartington and he in St Ives added to Leach's feelings of loneliness, but he reassured himself with the thought that this was perhaps self-indulgent when a more important concern was with 'one's inner life – the degree to which one achieves God's will'.[71]

In David's absence Frank Vibert was taken on full-time as general manger. For some years Vibert had been employed as the Council Rating Valuation Officer but his widely expressed pacifist views were not well received and the move to the Pottery may have been propitious. Vibert inaugurated a more useful accounting system, typed Leach's letters, took charge of sales and

attended firings. He also expounded his ardent pacifist beliefs to an unsympathetic public on the quay, his listeners often threatening to toss him in the sea. As a member of the Magic Circle, under the pseudonym of Wu Chang, Vibert performed on stage and at children's parties, an aspect of his character that greatly intrigued Leach.

In the course of the war potting was declared a reserved occupation, which enabled Leach to employ conscientious objectors who, among others, included the painter Richard (Dick) Kendall and the artist and critic Patrick Heron. Some conscientious objectors tribunals were thought to be more liberal than others and Kendall, who had been a student at Leach's old art school, the Slade, was advised to apply to Bristol where about 60 per cent of applications for exemption were granted. At the Pottery he became a more than competent thrower and a potter of integrity and sensitivity, later marrying Leach's daughter Jessamine.[72] Heron, who had been brought up near St Ives and knew the Leach family, met Kendall at the Slade and he also successfully applied to the Bristol Tribunal. He suffered from a weak chest and eventually got permission to work at the Pottery, arriving in Cornwall shortly before the West Country was sealed off in preparation for the Normandy landings in 1944. Like Kendall, he became a decent thrower making small standard items such as lidded jam pots while also amusing the crew by his quick wit and effective mimicry. As pacifists their greatest indignity was walking in the town to taunts of 'Leach's sissies', their presence adding to the resentment of what seemed like an alien bohemian lifestyle at the Pottery. The more gullible believed that the kiln was used to signal to German bombers, even after it had taken a direct hit.

During the war Leach became one of the unofficial spokesmen for the crafts. He was invited by the Ministry of Labour to assist a national committee of craftsmen in the preparation of a report on how men maimed in the war could be trained in hand-work, writing to many potters asking for their views. The committee's recommendation that special centres be established with trained instructors was duly noted though nothing was done. In 1943 Leach was invited to sit on a joint committee of the Arts and Crafts Exhibition Society and the Red Rose Guild, set up under the auspices of the Central Institute of Art and Design (CIAD), headed by T. A. Fennemore. The Joint Committee, as it was known, sought to establish a closer relationship and collaboration in matters relating to government regulations or other questions of national application and importance to crafts with a view to helping improve the situation during the war and afterwards. Meetings, held in the echoing deserted rooms of the National Gallery in London, involved Leach travelling to the capital at his own expense. Kenneth Clark, director of the National Gallery, was an admirer of Leach's pots and they became good friends.

More controversially Leach was one of the few craftsmen invited to Windsor Castle to take part in the selection of work for a major exhibition

'Modern British Crafts', which opened at the Metropolitan Museum of Art, New York, on 20 May 1942. Assembling a show across all craft disciplines proved an almost impossible task and not surprisingly the final choice did not meet with universal approval. Despite what was often perceived as an Olympian manner Leach again became embroiled in the bitterness of craft politics. Because of his close association with the Red Rose Guild he became the target for his old adversary Harry Norris, who was angry that neither he nor the guild had been involved, arguing that Leach had not represented the guild as he should.[73]

The feud was part of a continuing disagreement, and at one point Leach travelled to Manchester in an unsuccessful attempt to resolve their differences. As guild secretary Norris demanded that Leach should be loyal to its aims and seek to promote them whenever possible. He also accused Leach of using the National Gallery meetings to further his own career and those of other potters. When discussion of a chairman arose, Norris was adamant that in view of Leach's prejudices he would make an incompetent chairman. The implication was unjust as Leach had already twice refused to take the chair, but he was stung into charging Norris with behaving like another Hitler. Feeling hurt and misunderstood Leach resigned from the guild committee and urged Margaret Pilkington[74] to resume real leadership. Such rancour and bitterness made him wary of further involvement, but advising and discussing was a role he found impossible to resist.

At weekends he often travelled by train to Dartington to stay with Laurie, his tall, lean figure resembling that of 'a travelling Chinese monk'. Dressed in a loose overcoat, wearing a Trilby hat and carrying over his shoulder a leather bag on the end of a long leather thong and a net basket containing a change of shirt and writing materials, he had the air of an oriental sage. Incredibly, on board the train, no matter how dramatically the carriage swayed, Leach wrote legibly and intelligently, often completing thumbnail sketches or drawing pots that he wanted to make.

On one visit in 1941 Leach arrived to discover Laurie caring for Maurice, a wild two-year-old London evacuee. A group of children from the city had arrived at Totnes station to be housed locally, and this child was the only one remaining after homes had been found for the rest. Taking pity on the child Laurie agreed to care for him. Evacuated from a large extended family in London's East End, Maurice appeared out of control, seemingly unresponsive to care and constantly snivelling from cold. They discovered that the family had spent six awful weeks in the London Underground during the Blitz. Laurie was confident that with love, care and a proper diet he would thrive. In Leach's view the child had the effect of enabling Laurie to 'haul herself out of the slough' and forget herself, but he was less sure about his own feelings, seeing the child as a rival for Laurie's affection. With five children of his own he had no desire to raise another, but given the loss of Laurie's child in 1934

he perhaps felt in no position to disagree and Maurice was taken in as a member of the family. Slowly he began to thrive, and Laurie became firmly attached to him, alert to any sign of childhood illness, which caused her much anxiety. When the boy suffered an acute attack of tonsillitis in 1943 she feared he might loose his hearing but Maurice was operated on in time and soon recovered.

After protracted negotiations, and after Muriel agreed not to contest it, so avoiding hateful and painful disclosures in open court, the divorce was made absolute in February 1943. Muriel's reluctance, the onset of war, endless delays and Leach's own lack of urgency had made it a drawn-out process, but then Bernard and Laurie did not marry until nearly a year and a half later. A marriage service at the Bahá'í Centre in Victoria Street, London, on Empire Day[75] was followed by an official ceremony at Totnes Register Office.[76] Laurie wore a dress specially made from fabric block printed by the textile artists Phyllis Barron and Dorothy Larcher. Following the marriage, Laurie pursued the idea of officially adopting Maurice, to which Leach agreed, but the child's father, who constantly changed his mind, thwarted their plans. The emotional tug-of-war did not seem to unduly perturb Leach, but he recognized that it was hard for Laurie 'making life more unsettled than ever for both of us'.[77] Although now married, Leach remained at St Ives, intending to review the situation at the end of the war when he planned to ask David or Michael whether either wanted the Pottery 'vigorously', in which case he would consider settling in Dartington.

In a long letter to David written towards the end of the war, Leach attempted to set out his feelings about Muriel, the importance of his marriage to Laurie, and his commitment to the Bahá'í faith, pointing out aspects of the faith important to him. These included the acceptance of divorce on the reasoning that greater harm ensued from fundamental disharmony. It was a persuasive letter, not least because while acknowledging his affection and respect for David, it outlined the basis of their business relationship within the Pottery and Leach's intention to make David a partner. Leach also sought to explain his motives behind a naive attempt at reconciliation between Muriel and Laurie. He had hoped that Muriel would feel able to recognize their relationship, but shortly afterwards when Laurie accidentally met Muriel on Tregenna Hill in St Ives and stretched out her hand in a welcoming gesture it was ignored.

The refusal of her hand was a great disappointment to Laurie who, after the ten-year separation, hoped that the tension might have dissipated. She was further saddened to hear that when Leach had mentioned the meeting to Muriel, she, far from being disturbed, claimed to have felt easy and relaxed, even promising to arrange a proper meeting, though no definite plans were made. To Leach, Muriel's behaviour seemed unnecessarily cool and aloof, appearing to revel in 'a certain strength and integrity in self-entertainment'.[78]

Certainly she could be seen to occupy the moral high ground, a fact that Leach did not particularly relish. Selfishly he saw the display of hurt and pride only from his own point of view and accused Muriel of having 'a large frozen area inside which for our sakes needs thawing'.[79] Although Bernard and Muriel now had 'friendship and memory and kindness', he wanted acceptance on his terms, which he hoped meant 'sharing our inner lives'.[80] His lack of understanding of Muriel's feelings did not bode well for his relationship with Laurie.

A WORLD CRUSADE

England Scandinavia USA

1946–1952

W ith hostilities finally brought to an end in August 1945 by the drop-
ping of atomic bombs on Japan, Leach's optimistic hope was that,
despite personal, family and business pressures, peace would settle
not only around the world but more particularly at St Ives. The success of *A
Potter's Book* was establishing him as an authority not only on the practical
aspects of potting but also as someone who had a contribution to make on the
role of craft in postwar renewal, a worldwide mission he saw as requiring cru-
sading passion. Leach secured David's early release from the army at the end
of 1945, and made him a partner the following year. With some restriction
on the control of materials slightly relaxed, David initiated improvements that
included slightly extending the building and acquiring an electrical blunger
for mixing the clay slip and an electric pugmill for help with clay preparation.
A little later an electric kiln was purchased for biscuit firings.

David's return as Pottery manager suited Leach for he was a capable potter
with a sound head for business, efficiently handling day-to-day running and
the training and organization of the workforce. Leach relied entirely on his
good sense. An indication of the Pottery's growing reputation was the increas-
ing number of students wanting to work there. Over a three-year period in
the late 1940s well over a hundred applicants were turned away.[1] With David
in charge Leach was able to pursue his writing and other activities. Having
publicly declared himself a Bahá'í, Leach was prepared to help spread the word
and secure recruits to the faith, and he wanted to devote time and energy to
this.

In the winter of 1945 Leach broached the possibility of setting up a modest
workshop at Dartington, suggesting that it should come within the Art Section
rather than under the control of Central Office, 'in order to fall into a
Dartington pattern'.[2] In other words he wanted to avoid direct contact with
Slater and operate more as a studio than as a business, as an artist rather than
artisan. The idea, not taken up by the Elmhirsts, was quietly dropped.

With the Pottery set to remain at St Ives, Bernard and Laurie had to decide
whether to live in St Ives or Dartington. They also had to find ways of easing
the tensions between them, a symptom of which was their reluctance to come

to an amicable decision over this important matter. In St Ives Leach had become distanced from the activities at Dartington, which had in any case been severely curtailed by the war, and the pottery studio had become a useful store for his possessions. The kiln at Dartington was temperamental and inefficient and though requests came from potters wanting to make use of it, Leach was adamant that it was not practical. Save for short periods with Laurie his base, to all intents and purposes, had again become Cornwall.

Characteristically, Leach addressed the problem of where to live by drawing up lists 'for' and 'against' remaining in Cornwall or returning to Devon. David had already made his feelings clear a year earlier when he wrote to Leach telling him he could not see 'how remote control or collaboration from Dartington Hall will be very satisfactory'.[3] For his part, Leach noted that Dartington was damp and bad for his rheumatism; they would need a new house and professionally there would be the challenge of setting up a new pottery and establishing a market. As Laurie was already living at Dartington the advantages of moving permanently to Devon were mostly on her side, she had a circle of friends, and Maurice attended a local school. The biggest attraction for them both was its distance from St Ives, which precluded embarrassing chance meetings with Muriel. By contrast, St Ives offered many benefits for Leach. With David as manager/partner, he was able to make individual pots with access to a skilled workforce, regular kiln firings and within an environment in which he was the undisputed head. While trying his best to be open-minded, the advantages for Leach of staying at St Ives far outweighed the disadvantages. Absent from his analysis was any real understanding of Laurie's point of view and the difficulties of integrating a new wife into what was now a family business. Sven Berlin, identifying some of Laurie's difficulties, believed that she would find a move to St Ives difficult to deal with, and thought Leach 'completely naïve about women and had not the faintest notion what they were about and what they wanted'.[4]

Despite Leach's persuasive arguments, Laurie was steadfast in refusing to move, her obstinacy largely fuelled by the possibility of bumping into Muriel. She was also reluctant to deal with the family at such close quarters and face their disapproval of someone who was inevitably viewed as a 'marriage breaker'. Another growing cause of friction involved Leach's commitment to the Bahá'í faith and his often dogmatic manner. By early 1946 an impasse had been reached with both remaining adamant. Laurie's eventual decision to move may have been prompted by a dramatic incident in which Maurice inadvertently set fire to a shed containing three tons of straw. Having watched the driver of a steamroller make a small fire by placing a quantity of straw on two or three glowing embers on a shovel he emulated his action. Inevitably, the fire rapidly blazed out of control and though Maurice was not in danger the shed caught alight resulting in an inferno that not only destroyed the building but also threatened to burn down the cabin. Leach's embarrassed apologies

to the Elmhirsts sought to make light of the incident but it did suggest that at the very least Maurice required greater supervision. By July, Laurie and Maurice had joined Leach at Pottery Cottage in readiness for the child to start school in the autumn term.

At the Pottery the team that had worked so well in the war years was rapidly disbanding. Dick Kendall, uncertain whether he wanted to pursue a career in ceramics, but in Leach's view a first-class potter, left at the end of 1944 and Patrick Heron shortly after. Margaret Leach, who had proved not only to be a sound potter but a strong cohesive personality, left in 1946 to care for her mother. Aileen Newton, Mary-Gibson Horrocks and Valerie Bond remained, and Bill Marshall and Horatio Dunn returned to take up their old jobs the following year. Like many other businesses, the shortage of materials and the need for permits, which continued in the early postwar years, affected the Pottery, but sales of the standard ware remained buoyant. Between them the four or five throwers working at the three kick wheels averaged some 2,000 to 3,000 pots a year. The 1946 catalogue invited customers to place orders by post from the illustrated range. With most industrial wares continuing to be sent for export, regular bulk purchases for standard ware continued to be placed by large London department stores. Despite the imposition of purchase tax[5] on pots, which increased prices considerably, demand continued to rise, though the changes in levels of tax prevented accurate price lists being issued. Order books were full and demand high, though profits remained modest.

Given the hard work and devotion of the Pottery crew, Leach was greatly irritated by an article in *Time and Tide* by Patrick Heron on the role of the artist craftsman, prompting him to write protesting against Heron's suggestion that 'we would be better advised to have devoted our energies to design for mass-production'.[6] The Leach Pottery, he pointed out, with a crew of five full- and three part-time workers produced a total of 17,000 domestic pots a year at an average net price of three shillings. While wages were low, the value of the enterprise he argued was in its ability to offer an alternative to 'soulless' industrial production. Given that the huge output of industry was to meet the needs of the majority of the population, it was naive to even hint that studio pottery was a viable alternative.

Under David's management the Pottery had, for the first time, what would later come to be known as a sound business plan. The working day began at eight and finished at five with breaks for crib, lunch and tea. Saturday was a half-day when visitors were welcome to see pots being made. Wages were modest and to supplement their income and development as individual potters, throwers were encouraged to make one-off pots in their own time, which could be sold in the showroom, the potter receiving a third of the selling price. A loose system of profit-sharing was introduced to encourage and reward hard work. Slowly the Pottery began to operate on a reasonably

financial even keel, enabling the loan to Mrs Horne to be repaid. Two more local lads Kenneth Quick, nephew of Bill Marshall, and Joe Benny were taken on as apprentices. Benny never mastered the technique of throwing and concentrated on mixing and applied glazes. Kenneth Quick, slight of build and sharp, proved to be an excellent and sensitive potter, keen to learn and develop his style. His fondness for practical jokes such as on one occasion substituting the ice cream on Leach's cornet with white clay, made him a likeable and popular member of the crew. Both were called up for National Service in 1950 and a new apprentice, Walter Firth, accepted. The final apprentice, Scott Marshall,[7] was taken on a year later at the age of fifteen. He eventually left with Richard Jenkins, a student at the Pottery, to set up the Boscean Pottery at St Just.[8]

Visitors to the Pottery included Augustus John and his wife, Dorelia who, wearing a gypsy skirt and red sandals, again struck Leach with her beauty. After buying pots John spotted a pen and wash drawing and asked to purchase it. Confused but delighted Leach offered it as a gift but John insisted on paying. Despite the hard-won if modest success of the Pottery, both Leach and David were alarmed when Harry and May Davis set up the Crowan Pottery at Praze in Cornwall in 1946, producing a well-made range of tablewares fired to stoneware temperatures, which seemed to directly rival Leach Standard Ware. Furthermore, because of the Davises' anti-élitist beliefs, their pots were sold at what seemed ridiculously low prices. During a visit to Crowan Pottery Leach unwisely responded to May's invitation to comment on the pots, describing them in no uncertain terms as 'dead' and 'lousy'. Davis took great exception, writing to Leach 'I am all too conscious of an overwhelming domination of your ideas in my evaluation of pots. I therefore do not want to subject myself more than I can help to further impressions from you'.[9] Davis was even more scathing of Leach's plan to set up a guild of Cornish potters, which he saw as Leach seeking to extend both his influence and his narrow views. 'Your teaching to students and those working under you are so authoritarian', he wrote, 'as to be very destructive of the creative impulses of such people', adding 'and this was what I felt so very strongly when you were here last'. It was open war, with Leach's residual resentment of Davis's relationship with Laurie playing a part in the battle.

On his discharge from the army Michael Leach returned from Africa and rather than pursue a teaching career decided he wanted to work at the Pottery. With little experience of production potting, both his brother and father were reluctant, believing him to be unsuitable for either the role of manager or worker. While serving in Kenya he had tried to set up a pottery producing essential ware but this had proved impractical. In Africa he married Myra Lea-Wilson, the daughter of a tea planter, and they returned to England with their two-year-old daughter, Alison. When Leach first met Myra at a family meal he served corn-on-the-cob, a crop grown in abundance locally,

which in some curious way he thought would have special appeal given her time in Africa.

For a time Michael worked throwing plant pots at the long established Wreccelsham Pottery in Farnham before moving to Stoke-on-Trent and the studio of Bullers factory to assist Agnete Hoy[10] in making individual pieces of porcelain. In the late 1940s he moved to St Ives and settled in Penbeagle Cottage, George Dunn's old house. His work in the Pottery was combined with teaching at Penzance Art School, taking classes that had been started earlier by Leach and David under the principal Edward Bouverie-Hoyton. Because of what was seen as Michael's inexperience his role within the Pottery was never fully resolved, a member of the family but one with little practical knowledge of small-scale production. Eventually he set up a space to experiment with porcelain in his own 'search for perfection'.[11] When David and Leach were away he took charge, though not always successfully for his manner could be abrupt and his advice was often seen as interference. Living in Penbeagle Cottage with their now rapidly growing family, Michael and Myra were immediately adjacent to the Pottery and occasionally were called upon to accommodate students, something that proved difficult with a young family.

Students came for longer or shorter periods to gain practical experience, their training involving group discussions particularly after a firing, when losses, failures and gains were considered. Leach's favourite theme for the discussion, 'What is a good pot?', touched on the choice of materials, the use of appropriate texture, colour and pattern and the balance of form as well as such details as the size of the foot, the thickness of the rim and shape of a handle. In such a milieu Leach was in his element, with a cigarette firmly held between his fingers he waved his arms with great energy to make his point, occasionally illustrating his ideas on the blackboard while talking endlessly about his experiences in Japan. An excellent mime, in an attempt to allow the students to 'see', Leach created an imaginary form in the air and followed the lines flowing off the pot. Historical pieces were passed around to illustrate a point or enliven the discussion, including a small shallow twelfth-century Korean porcelain cup with a delicate engraved design under a pale celadon glaze, which Leach believed showed the successful marriage of form and decoration. A salt-glaze jug was admired for its ingenious integration of the influence of metalwork. Henry Hammond,[12] a student of Murray's before the war, visited every day for two weeks, discussing the pros and cons of the individual as opposed to the group workshop.

Requests to work at the Pottery came from, among others, two young American potters Warren and Alix MacKenzie[13] in 1949. Having taken up potting after the war they had been profoundly influenced by *A Potter's Book* and travelled to St Ives with the idea of seeking an apprenticeship. After looking at their pots Leach and David exchanged covert glances and tactfully

declared there were no vacancies. However, given the distance they had travelled they were invited to visit each day during their two-week stay and learn as much as possible by observation. Impressed by their evident commitment if not their pots, Leach suggested they accompany him one evening as he supervised the firing of the kiln. This not only provided a much-appreciated audience, for Leach rarely tired of talking, but gave him an opportunity to get to know them. Subjects ranged over politics, art, social structure, ambition and economics rather than pots and at the end of the night Leach declared that he had changed his mind and offered to take them on at the Pottery.

To mark the return to full production of the Leach Pottery William Ohly,[14] who ran the Berkeley Galleries in Mayfair, a space usually devoted to African and Oceanic artefacts, invited Leach to have his first major postwar show in London.[15] Symbolically the exhibition was a restating of the power of Leach's creative output; more practically it demonstrated the survival of the Pottery, then celebrating its twenty-sixth anniversary. In all some twenty-two packing crates containing 500 pieces of standard ware, tiles and individual pots, as well as thirty drawings, were dispatched to London.

Individual pieces included a number of nine-inch-square (22.8×22.8cm) tiles mounted and framed, many decorated with landscapes that were pictorial rather than decorative in style, recalling the sort of pastoral imagery that appeared in Leach's poems. There was also on display a magnificent fire-screen made up of stoneware tiles mounted in a wrought iron frame built by the Cornish blacksmith Alex Carne of Truro. The tiles were decorated with a reworking of the design Leach had produced for the cover of the *Shirakaba* Blake issue, bearing the poet's words 'Tyger Tyger Burning Bright, In the forests of the night', here retaining Blake's spelling. The scene, of a large tree below which lay a tiger, set in a landscape with a naked child, is virtually unchanged from the original cover.[16]

Equally impressive was a full, rounded stoneware vase, some thirteen inches high (32 cm), bearing a painted and incised design in iron slip of the tree of life beneath which figures worked the land. The motif, which Leach repeated in different variations, was drawn, he said, from a Han dynasty tomb carving. 'The subject is derived from very old traditions and may be regarded as symbolic',[17] he wrote. Although never indicating what the symbols meant to him, he did suggest that in some ways it implied God 'which is *thusness* to the Buddhist'.[18] Large, assured and confident, the design is sensitively related to the swelling volume of the pot. The boldness of the piece marked a new phase in his work as potter. The high technical quality probably owed much to David's making and firing skill. It was purchased by the Very Reverend Eric Milner-White, by now Dean of York and presented to York City Art Gallery.

Sales of pots were good but, disappointingly, few drawings sold, reflecting a widespread resistance in England to an artist making both pots and

drawings. To publicize the show Leach took part in a recorded radio discussion on English pottery, and the BBC arranged a private showing of a film about the Pottery directed by Malcolm Chisholm.[19] To mark the closing of the exhibition the Pottery workers[20] organized a lunch at a Chinese restaurant in Soho, sending out a beautifully printed invitation by the highly inventive St Ives-based typographer and printer Guido Morris designed in the style of Chinese script. The occasion was recorded by David in a group photograph showing some thirty potters and friends outside the gallery.

The exhibition was a welcome sign of survival and renewal, a theme Leach sensed in the capital where the bomb-sites, 'the toothless holes', burst into life with wildflowers, reflecting his own buoyant and hopeful mood. The first large postwar public exhibitions were also a welcome indication of the return of a full cultural life. At the Victoria and Albert Museum a show of sculptures dating from the time of Henry VI were, Leach wrote, 'as fresh as when they were chiselled in the fifteenth century'.[21] More modestly the museum housed a memorial exhibition of calligraphy by Edward Johnston, who had died in 1944, the flowing confidence of the line and the strong sense of composition again striking Leach by its combination of austerity and generosity.

Paintings by Picasso and Matisse proved more perplexing. Leach was willing to consider modern and challenging art on its own merit but was profoundly wary of anything that appeared superficial or pretentious. In *A Potter's Book*[22] Leach described Picasso as 'perhaps the most creative artist alive', suggesting a willingness to look sympathetically at his new work. The artist's bold colour and abstract compositions seemed to assert a new spirit in keeping with the mood of renewal and expansion. After seeing little or nothing of developments on the Continent during the war the exhibition had a profound effect on many British artists.[23] However much Leach pondered the qualities of the paintings what really engaged him was the response of visitors all keen to see and assess the controversial art. During his visit the gallery was crowded with both admirers and detractors 'like a pack of hounds in full cry',[24] some openly shocked and appalled by the work on view. One elderly retired admiral became more and more angry, mopping his red neck and resting on the shoulder of his wife who urged him to 'be calm, be calm – if you're not you'll have an attack of apoplexy'.[25] The show became a symbol of the profound, and for many, terrifying attitudes of the postwar world. On one occasion Diana Holman Hunt, daughter of the Pre-Raphaelite artist William Holman Hunt, jumped on a table and harangued the crowd for supporting the exhibition by their very presence. Leach was torn between genuine interest and suspicion of work with which he could not feel altogether in sympathy.

He had less hesitation in deriding the highly decorative and colourful pots Picasso produced at Vallauris in the late 1940s, which were radically different to his own use of clay and his idea of what constituted beauty. Leach's dislike of Picasso's ceramics can be seen as the beginning of a serious split

with a radical younger generation wanting more independence, whether in the use of colour or freedom to model figures and animals, all well outside the cannon prescribed by Leach or Murray. Leach made little attempt to conceal his contempt, describing Picasso as 'the Catelan bull-fighter of the modern arena', adding 'great acrobat that he is, I cannot call him a potter',[26] finding little subtle or seductive in the way the artist played about with the concept of the vessel. Furthermore he recognized Picasso's potential influence on young potters and feared that they might 'ape his brilliance of invention and verve of draughtsmanship and colour', which he believed to be 'unfortunate for them and for us'.[27] Picasso's influence on a new generation of potters focused mainly around the Central School of Art and Craft in London, who Leach dubbed dismissively as Picassiettes.[28] Dora Billington,[29] one of the potters who favoured the 'new look', disliked the 'aura of solemnity and preciousness' of neo-oriental ceramics, preferring the bright colours of earthenware.

With the cabin and pottery studio at Dartington now vacant Leach put forward Sam Haile, a graduate of the Royal College of Art, 'the best Murray product', as someone suitable to take over the accommodation and studio. The intention was that Haile, whose ceramics were described by Patrick Heron as 'the first modern pots that bore any relation to contemporary painting',[30] would work as an individual artist rather than attempt to set up a production workshop. Haile was married to another potter Marianne de Trey, whom Leach 'could recommend on all scores'.[31] As part of his role as unofficial spokesperson for the crafts Leach had become friendly with Haile towards the end of the war through the activities of the Joint Committee of the Central Institute of Art and Design (CIAD). This had been set up with the purpose of representing the interests of artists and craftsmen in wartime and to secure adequate recognition of the arts in national life. While still a serving soldier Haile became concerned about the conditions potters and other craftsmen and women would face after the war and put forward practical proposals for assessing their needs. Haile, along with T. A. Fennemore (secretary of CIAD), Sir Charles Tennyson (CIAD chairman) and painter Cosmo Clark of the Rural Industries Bureau, asked Leach to draw up a list of minimum and essential demands on behalf of potters to meet any threat to their survival. This was later to form part of a wider move to establish a national centre for the crafts in London once the war was over, where the best work could be seen.

At the instigation of Hugh Dalton,[32] Sir Thomas Barlow became the first chairman of a new British government agency, the Council of Industrial Design formed in 1944 to promote good design in British industry with Gordon Russell representing the interests of craftsmen and women. Other moves were afoot. The wood engraver and advocate for the crafts, John Farleigh, was in the process of turning the Joint Committee of the Arts and Crafts Exhibition Society and Red Rose Guild into a federation of five craft

societies[33] that would eventually become the Crafts Centre of Great Britain, a plan in which Leach played a central part. Yet, despite such widespread concern for craft in the immediate postwar period, when the empty galleries of the Victoria and Albert Museum became host to the 'Britain Can Make It' exhibition in 1946, crafts were largely ignored. Five years later the situation had radically altered, for with Gordon Russell in charge of selection at the Festival of Britain the crafts were well to the fore. In the Festival's Country Pavilions Leach's work included stem cups, jugs and tall mead bottles that celebrated some self-conscious idea of Englishness. Individual pots by Leach were shown in 'The British Craftsman' and 'Nature' in the Lion and Unicorn Pavilion. Demonstrating the extent of Leach's influence, the majority of potters included in the Rural Crafts section had been taught by him.

A modest grant from the Board of Trade, a landmark event in government recognition of the crafts, enabled the Crafts Centre of Great Britain to be set up in 1947 with its headquarters and gallery (opened in 1948) in Hay Hill, London. Within the various bodies and groups Leach enjoyed a formidable position as spokesman, sitting on committees and giving talks and lectures on the current state of the crafts. In an article published in the *Listener*[34] and broadcast on the BBC Far Eastern Service, Leach set out the background to his work as a potter, reiterating his view of what made a 'good pot'. Little credence was given to studio pottery produced in Scandinavia, France, America and China, which were casually dismissed as 'lacking in life'. The essential ingredient, 'vitality', Leach saw only in the work of a small number of like-minded potters in England and Japan.

Similar themes were taken up in a talk to the Royal Society of Arts in London,[35] with W. B. Honey in the chair. Leach's topic, 'The Contemporary Studio-Potter', was an ideal platform for him to be at his most expansive, addressing broad areas of activity, paradoxically supporting progressive thought while hankering after the romantic idyll of a pre-machine age. His combination of acutely observed personal experience counterbalanced with wide generalizations was highly arresting if at times perplexing. In conversational mode Leach put his finger on one of the attractions of the life of the studio potter identifying 'craftsmanship as an experience – as a way of life'.[36] In the alternative world of the 1960s and 1970s this crucial concept was to become the hallmark for artist craftsmen and women seeking a meaningful unification of work and leisure. Leach also elaborated on the importance of 'the close contacts between maker and consumer, between heart and hand, man and material, art and life'. In this Morrisian mood he pinpointed the essential contribution of craftsmen in 'clarifying and fighting for the basic principles of work – that work which is at one and the same time recreation and labour, and in which use and beauty are inseparable'. It was a stirring message, reflecting his crusading role in promoting a particular sense of wholeness and unity. In contrast his broadside on various aspects of modern society was

more controversial and reactionary, whether it was an attack on mechanical reproduction and industry as 'largely anti-social', or a more general swipe at 'evils of our age'. These he listed as 'the anaesthetic of heartless repetition . . . the Bedeaux system[37] . . . "music while you work" . . . jazz . . . cinema and wireless,[38] and all the dope which clogs the release of healthy talent'.

On a more international note Leach touched on his ambiguous relationship with the defeated enemy, speaking of 'the terrible apparition of Japan which war has brought to the mind of the West'.[39] This, he pointed out, contrasted sharply with his own experiences in the country and his fifteen-month stay in the 1930s, which he described as 'the fullest and most rewarding of my life'. Although relieved that the war had been brought to an end, the dropping of two atom bombs caused him great anguish:

> Is it possible to believe that by so terrible an act we can achieve so great a good as real peace? My artist and craftsmen friends in Japan whom without exception were anti-militarists, will look upon this with bitter disillusion. What can I say to them? . . . We are content to call the Japanese sub-human. My experience in Japan is quite to the contrary and I fail to be convinced that under like circumstance we would have behaved very much better . . . the greatest scientific discovery of the age has been un-necessarily baptised with blood.[40]

Re-establishing communication with Japan had to wait until full postal services had been restored, and it was nearly a year before a letter arrived from Yanagi.[41] His wife and all their friends were well, he told Leach, two of his sons had married and the Nihon Mingeikan museum had survived, although conditions in Tokyo were totally changed and he thought the future looked bleak. Two-thirds of the city lay in ruins, there was a scarcity of food such as sugar and meat, inflation was rampant and morals 'much degenerated'. In Yanagi's view, defeat had, however, put an end to militarism and 'ultra-nationalistic' ideas, and brought a renewed interest in 'liberty, truth and peace', but despite the note of optimism, the prevailing tone of his letter was of sadness and regret, though hopeful for renewal and change. Nevertheless, it was a sign that Leach was not forgotten, that his links with Japan were still alive and at some point it would be possible for him to return.

A year later a letter from Tomimoto, breaking a silence of over ten years, brought news that his marriage had finally broken down and he was living the life of a travelling hermit. Although he felt free and his children were well, he did not know quite what to do. He had, however, decided to disassociate himself from Yanagi and the Mingei movement, accusing Yanagi of turning Mingei into an art form that stressed beauty over function. In 1947 he even set up his own organization, the Shinshōkai (New Craftsman Association). Repeating his pre-war wish of wanting to come to England, he again pleaded for Leach's assistance, showing little appreciation of the difficulties this posed,

either in the reality of him making a living as a potter or the inevitably hostile reception he would receive so soon after the ending of the war.

Within the rapidly growing artistic community in St Ives, Leach was widely perceived as something of a father figure, respected and sagacious but also lively and active. During the war leading artists had settled in the town, attracted by its timeless beauty and also its distance from the Blitz suffered by London and other major urban centres. Many of them stood at the forefront of the modern movement, and for a few decades the small Cornish town became the centre of some of the most progressive art in Europe. The painter Ben Nicholson and his wife, the sculptor Barbara Hepworth, arrived with their triplet children a week before war broke out, and were followed by the painters Adrian Stokes and Margaret Mellis, and the diminutive but charismatic constructivist sculptor Naum Gabo and his English wife, Miriam. As fellow members of the Home Guard, Leach struck up a particularly close friendship with Gabo, who despite their involvement with different art forms (Gabo preferred synthetic materials such as plastics to create abstract form) shared a common belief in 'works that express harmony with beautiful reason'.[42] In 1943 they collaborated on making a clay model for a Jowett car[43] as part of the Design Research Unit's efforts to link art and industry.[44]

These artists lifted St Ives out of what had been a largely parochial milieu into one of national importance. Friendships were soon made, and Leach modelled a horse for Stokes to place on his roof as an emblem of good luck. Nicholson's concern with painting that 'is not necessarily representational or non-representational, but is both musical and architectural, where the architectural construction is used to express a "musical" relationship between form, tone, and colour',[45] found some resonance with Leach. According to Sven Berlin, Leach was reputed to have first met Barbara Hepworth one night on the mainline St Erth station when both alighted from the same train and she offered him a lift to St Ives in her waiting taxi. Along with the friendship came conflict and jealousy. When Gabo publicly accused Barbara Hepworth of plagiarism for stealing his 'egg', a Perspex oval built on a curve with intersecting threads which he claimed he had produced before the war, sides had to be taken, and Leach expressed support for his former Home Guard comrade. Shortly afterwards Gabo left St Ives for America. Younger artists also arrived in the town, including Wilhelmina Barns-Graham, who struck up a lifelong friendship with Leach.

With so many talented artists there was inevitably much discussion of the best way to show art in the town, with many calling for a suitable gallery in which to exhibit. There were also endless debates of the greater or lesser importance of representational and abstract art, in which Nicholson and Hepworth, by now dubbed the King and Queen of St Ives, played a central role. Of particular concern to Leach were the real and imaginary distinctions between fine art and craft. In consequence the town's art politics were often

heated and divisive, and when the old St Ives Society of Artists, already riven by conflicting supporters of traditional and modern work, decided in 1949 to put all exhibition works to a jury, it collapsed. Shortly afterwards the Penwith Society of Arts in Cornwall, popularly known as the Penwith, was set up in a renovated potato loft in Fore Street. Leach was a founder member and Herbert Read president. Headed by Hepworth and Nicholson the Penwith was far more liberal, dividing art into figurative, non-figurative and craft, each with its own jury. The modest craft section included Leach, an embroiderer and Dicon and his brother Robert Nance who had taken up furniture making. Six years later the categories were abolished as they were considered disruptive to the harmony of the society.

David Lewis, curator of the Penwith, recalls Leach at this time as 'gaunt and stooping, with hair and moustache like dried grass and small laughing eyes'.[46] Lewis, a regular visitor to the Pottery, often joined in the games of cricket played in the yard. On one occasion he was particularly taken by Leach's skill when with his first ball he bowled out George Wingfield Digby, keeper of textiles at the Victoria and Albert Museum. Digby was an enthusiastic supporter of studio pottery[47] and Lewis wondered whether such a display of bowling prowess was inopportune. So enthralled was Wingfield Digby by Leach's work that he experienced an almost mystical feeling when visiting the Pottery, saying that 'entirely different principles' informed the work there, referring to its concerns for function and beauty rather than pure commercialism, which resulted in the 'human quality of the Leach wares'. Wingfield Digby went on to acquire a large collection of Leach's pots.

During the war Alfred Wallis, then one of St Ives' lesser known artists, died in the workhouse, his so-called naive or primitive paintings of ships, the harbour and seascapes appreciated only by a small if highly influential number of people. These included Ben Nicholson, who along with the artist Christopher Wood, had 'discovered' Wallis before the war. On Nicholson's recommendation Jim Ede, a curator at the Tate Gallery purchased work by Wallis for the collection. To rescue Wallis from a pauper's grave Sven Berlin, a great admirer, agitated for proper recognition of his artistic status and persuaded Adrian Stokes to purchase a plot of land in Barnoon Cemetery[48] with, as Barbara Hepworth wryly observed, 'a sea view'. Berlin initiated a collection for a gravestone, and Leach was commissioned to make and decorate a set of golden stoneware tiles for the grave, edged with glazed bricks. He produced a design of a lighthouse, a symbol of both hope and salvation frequently used by Wallis, which covered much of the length of the grave, and included the words 'Into thy hands O lord'.[49]

Once Laurie and Maurice were settled in Pottery Cottage, Leach pursued his allegiance to the Bahá'í faith vigorously, and attempted to persuade others to join. Much to Laurie's disapproval, his determination to live the life of a Bahá'í was reflected in the day-to-day events at Pottery Cottage. Each

morning at 7.45 Leach was joined by Ursula Newman, an illustrator of plant and gardening books and a Bahá'í, who carried out secretarial duties, and by David who was an interested but non-committed believer, for a few minutes of prayer and meditation. In the lunch hour Leach reread *The Dawn Breakers: Nabil's Narrative of the Early Days of the Bahá'í Revelation*,[50] an account of the events of the heroes and martyrs of the earliest days of the faith. In the evenings occasional open meetings or 'firesides' were held in the cottage, when readings would be given and aspects of the faith discussed. On one occasion an impressive twenty-five guests attended, including Naum Gabo. A dramatic reading of Hasan Balyuzi's *Bahá'u'lláh, King of Glory* was given, which Leach thought very moving, and afterwards Ursula produced 'wonderful food'. Feeling sufficiently confident to publicly proclaim his faith Leach joined Ursula and a small group of Bahá'í in public speaking on the wharf. Occasionally Leach mounted the soapbox and somewhat surprisingly, given his own unconventional life, proceeded to denounce immorality. Marion Hocken, a student of the artist and teacher Arthur Hambly,[51] was also a regular at the meetings. Despite the shouts and catcalls of the fishermen or more usually the general indifference, Leach persisted. It was the start of a battle that was both literal and spiritual between Leach the man of God anxious to proselytize and recruit, and Leach the distinguished potter keen to further his artistic career.

In a letter to Tobey written on Christmas Eve, 1947, Leach reflected happily on his new life and its material needs. His health, he reported, was good, he was well cared for and in reply to Tobey's enquiries about the deprivations of postwar Britain he reassured him that although rations of basic foodstuffs such as sugar, bacon and eggs were tightly regulated they were in no real need. What did trouble Leach, however, was what he called 'money morality', which included greed and no 'just price', and a general concern with material rather than spiritual values of life.

Despite his reassurances to Tobey, relations with Laurie continued to be difficult. Although she had seemed 'really herself and happy'[52] in the three weeks they had spent together in London during the Berkeley Galleries exhibition, this was an exception rather than the rule. Laurie was contemptuous of what she saw as Leach's hypocrisy in espousing values that she believed he did not follow in his own life – especially in the way he related to her. There were endless disagreements over his observance of the Bahá'í faith, and she complained about having to reorganize their lives to accommodate fasts, holy days or host fireside meetings. Far from expressing interest in becoming a Bahá'í, Laurie continued to regard it as yet another rival for Bernard's affection. It was an issue on which neither would relent. With Maurice boarding at Dartington School she had more time on her hands, but despite living in Pottery Cottage, she had little involvement with the Pottery, which only added to her sense of isolation and non-involvement in Leach's

life. Their often tempestuous and traumatic relationship suggests that Berlin's observation about Leach's lack of understanding of women was fairly near the mark.

In Leach's view Laurie had 'the devil of a pride',[53] and was unwilling to accept the complexities of his life. Occasional chance meetings with Muriel only added to the strain. One evening they bumped into her outside the cinema, an incident that embarrassed all three. As a result, whenever they were out in public, he avoided taking Laurie's arm in case they again met Muriel, a situation that did little to reassure Laurie of his devotion. Maurice also continued to cause them worry. The child seemed neither to like nor feel comfortable in the highly privileged and liberal atmosphere of Dartington School and was transferred to Frensham Heights, a boarding school in Surrey. Contact with his natural family in London may have added to his restlessness. Continual wrangles, mostly over what Laurie perceived as Bernard's selfish behaviour, led to her either leaving him for a period or withdrawing in some other way. There were constant separations with Laurie walking out vowing never to return, leaving Leach to contemplate the 'utter hopelessness about our continued life together'.[54]

Following the success of A Potter's Book Leach proposed the idea of a new volume, A Potter's Portfolio, which would further elaborate some of his ideas. With an eclectic selection of high-quality illustrations of pots selected from different cultures at various points in history the book was both an exemplar of fine pieces of work and a way of looking at and appreciating the richness of ceramics. Comments on form and analysis of shape further amplified Leach's concept of the 'good pot' and the book was intended to be a wide-ranging and thoughtful exploration of the aesthetics of ceramics as opposed to its philosophical and practical aspects. A Potter's Portfolio[55] was issued by the fine art publisher Lund Humphries in 1951. The main section was a compilation of Leach's favourite pots illustrated in colour and black and white. These ranged from a black-top pre-dynastic Egyptian vessel, an Arkansas Indian black jar, Middle-Eastern tin glaze wares, and Chinese, Japanese and Korean stonewares, to slipware by Michael Cardew and examples of his own pots, with a commentary on each. The historical span and the diverse aesthetic qualities of the pots reveal a surprisingly catholic taste, with long captions discussing their manufacture and aesthetic success. The introductory text took up many familiar themes deploring, for example, the self-conscious qualities of modern American pots and the conservatism of British potters whom he saw as tending to look 'towards the past and so fail the insistent needs of the present'. At the same time he reiterated his belief that 'the pot is the man; his virtues and his vices are shown therein – no disguise is possible'. While generally well received, Norah Braden was one of the few to comment unfavourably on the choice of illustrations, and despite their friendship, Leach found it difficult to forgive her.

With a growing reputation as both a maker and commentator, Leach was invited overseas to give his views. This began with an invitation to exhibit pots and drawings and to lecture in Scandinavia. Although far from enthusiastic about Scandinavian (and French) pottery, writing in 1946, 'the pots which come from these two sources strike me, and most of my fellow English and Japanese potters, as lacking life, for all their smoothness and conscious control',[56] he felt there was work to be done and he accepted the invitation. Given such views, his Scandinavian tour had a strong element of missionary zeal in which, as he saw it, he was offering aesthetic understanding to audiences in need of guidance.

Despite their continuing disagreement, Leach persuaded Laurie to accompany him and under the auspices of the British Council they left London's St Pancras station for Tilbury in the spring of 1949[57] to sail to Gothenburg in western Sweden. They were guests of the Röhsska Museum, the country's only museum of arts and crafts. Seventy-five pots were asked for but ambitiously Leach packed 137[58] in two packing cases with a total retail value of £246 1s 6d. The crossing was uneventful until the ship dramatically changed direction and took on an alarming tilt that caused tables and chairs to slide furiously to one side and, much to her annoyance, resulted in a cup of tea being split down Laurie's dress. The incident did little to curtail Leach's enjoyment of the ship's food that included a dish of stewed young spring rhubarb, a 'semi-medical and so often over-tart, fibrous vegetable'.[59]

In Sweden his talk, 'My experiences as an artist and potter in the Far East and in England',[60] was greeted enthusiastically. From Gothenburg they travelled to Leksand, Dalarna, where for five days they were guests of the mother and stepfather of Anne-Marie Backer,[61] a student of Leach's at St Ives and who accompanied them on much of their tour. In Stockholm they were shown over the Crown Prince's impressive collection of mostly Chinese ceramics by Dr Palsmgron, which they much appreciated, but King Gustav V was ill and unable to meet them.

In Norway Leach was particularly taken by the long boats in the Ship Museum in Oslo, noting the shape of one made from black oak, which he was later to use as a design on tiles. At dinner, in the absence of meat, they were served a fine dish of halibut and were told stories of wartime resistance to the German occupation. They arrived in Copenhagen on 5 April and his exhibition opened four days later in Den Permanente, a co-operative gallery run by craftsmen and women. Following the opening a dinner was held in his honour at the baronial home of Paul Michelson, president of the Danish National Arts and Crafts Association, where after ample food came loquacious speeches, the event lasting six hours. The busy days included visits to the Royal Porcelain Factory, where the director, Christian Christensen, assembled all his staff and invited technical questions; Saxbo, where they met among others the eminent potter Nathalie Krebs,[62] as well as a tour of Bing and Gondahl's

showroom and a lecture at the Applied Arts Museum. At the annual exhibition of the Royal Danish Craft Society, which included Leach's pots, he was slightly overawed to be introduced to Queen Ingrid, the daughter of the ceramic-collecting Crown Prince of Sweden and a great-granddaughter of Queen Victoria. The meeting reminded him of doffing his cap to the queen as she drove in Windsor Great Park during his school days.

Although Leach was welcomed as an honoured guest, with audiences listening attentively to what he had to say, there was no enthusiasm for his standard wares. The subdued colours, unglazed surfaces and restrained form met with a distinctly muted response. While admiring his sensitivity to the qualities of the materials, the Scandinavians found the work too sombre and rough, preferring the cleaner, simpler lines and brighter colours of Bauhaus modernism. Press response was also mixed, with some critics complaining about what they saw as an invasion of British crafts and several commenting on the coarse and unpleasant texture of many of the pots. Nevertheless his pieces sold well and were stoutly defended by Kurt Ekholm, director of the art school. In contrast to Britain, where studio potters worked on their own or in small groups, Scandinavian potters had studios within ceramic factories, a practice totally unfamiliar to Leach and, given his deep suspicion of industry, one he viewed with some misgiving. While recognizing that potters gained access to first-class technical facilities, and factories were able to draw on creative talent informed by sound knowledge of the materials, he judged it to be too stifling a relationship for real individuality.

During the tour the differences between Bernard and Laurie were to some extent forgotten, and the mere fact of them travelling together suggests a mutual willingness to sustain their relationship, but it was a short-lived reunion. Things between them came to a dramatic head in October 1949 when as Leach solemnly recorded 'This day I parted from Laurie at St Ives in great sorrow'.[63] It was a virtual repeat of earlier incidents when friction reached boiling point and Laurie could cope no longer. It was a tough and painful break and they were apart for over a year.

With their separation all but complete, there was no possibility of Laurie accompanying Leach on a ten-week lecture and demonstration tour of the United States. Arranged by Robert Richman, director of the Institute of Contemporary Art in Washington, DC, this ambitious trip involved 12,000 miles of travel and about a hundred seminars. Over three weeks were spent at Alfred University, New York State College of Ceramics, the leading institution for both industrial and studio techniques. An exhibition of two to three hundred of his pots toured independently to various museums. After spending a few days with Lucie Rie, in February 1950 he set sail on the much-lauded brand new liner SS *Ile de France*. To Leach's eye the French ship appeared 'a vast emporium full of passages and snaky [sic] neon light lighting – pseudo modern French décor'[64] though he appreciated the 'wonderful grub'. His luggage

included a film of Hamada's pottery and subscription leaflets for his forthcoming *A Potter's Portfolio*, for which he subsequently received 2,000 orders or promises.

While many travellers may have found the 'man-made canyons of architecture' of New York or the vast open spaces and huge distances daunting, for Leach they were a challenge, part of 'a crusade from coast to coast',[65] In what Leach described as the 'land of money and speed and gadgetry',[66] he became aware of missing 'the old, tap-rooted inbred intimacies of a small country'. Whether in Washington or at Alfred University,[67] his first major stop, he was not averse to speaking his mind on the subject. Alfred, situated some eight hours from New York, had a reputation for its all-embracing ceramics course that ranged from industrial production and ceramic technology to more craft-based processes and concerns, though its main aim was to meet the needs of industry. The full programme planned for Leach's visit by Charles Harder,[68] head of the college, involved practical sessions in the morning and talks and lectures in the afternoon. The mostly male students, many of whom had served in the war, wanted to get on with their own projects and some did not take kindly to the disruption.[69] Nor were they made more amenable when, despite freezing weather, Leach insisted on first opening all the windows to let in fresh air before demonstrating basic and familiar processes such as making dishes by laying clay slabs in moulds and slip-trailed decoration. Projects on the wheel were more popular, with the students throwing six to eight pieces for Leach to comment on. He also worked with raku. Leach's holistic and rounded approach cast a warm craft glow over the ceramic department, which was in great contrast to the more anonymous industrial approach, his ideas and methods attracting a small but dedicated number of students.

Casually dressed and informal in their attitude, the students were respectful but questioning, though many were mystified by the muted qualities and restraint of an aesthetic based on oriental forms and glazes. Most preferred the simpler lines and brighter colours of Scandinavian work and the more modern feel of Bauhaus design. Dressed in neat, formal white shirts, hand-printed ties and tweed sports jacket, Leach appeared like a quintessential Edwardian gentleman. They did respond to Leach's good humour and generous open manner finding him quaintly old-fashioned. His relaxed way of throwing, in which the clay would be centred as part of the opening up process, and his habit of nodding his head as he watched the pot turn on the wheel, was thought highly entertaining.

For Leach the students were a continual source of fascination. Despite insisting on the importance of understanding rather than imitation, they persisted in asking for glaze recipes rather than explanations. At breakfast Leach was often astonished by the students' behaviour as they enacted various initiation rituals. One male student appeared wearing a woman's feather hat and

dragging a pram containing a doll attached to his waist by a ribbon. Such escapades, he discovered, were known as 'hazing'. The social life involved attending the St Patrick's parade and grand ball where the dancing, which consisted of either slow shunting or fast jitterbugging, left him perplexed, although he gamely took part.

A particular friendship was struck up with Minni Negoro, a student with Japanese parents, who had been interred as an alien during the war and after the terrible actions of Japan felt confused about the country and its culture. Feeling much sympathy for her, Leach spoke positively and movingly about the country and its people, the special quality of its art and the unique nature of Japanese ceramics in an attempt to help Negoro recognize the value and richness of Japanese culture. Another student, Susan Peterson, was deeply taken by Leach's work and ideas, and invited him to talk and demonstrate at the Chouinard Institute on his next visit to the US.

During a brief trip to New York City while at Alfred he was guest of Aileen Osborn Webb,[70] one of the great patrons of modern craft in the United States, a 'tall, authoritative, yet strangely shy'[71] figure, who combined a regal presence with genuine humility and an idealistic commitment to the crafts. She had helped found the American Crafts Council, was chairman of the Board of Managers, director of the School for American Craftsmen, and president of the American Craftsmen's Cooperative Council Inc., which published the magazine *Craft Horizons*. Such generous support and enthusiasm for contemporary craft was in sharp contrast to Leach's experience in England where private patronage was modest and the government reluctant to accept financial responsibility. Yet his admiration for her support for the crafts was muted by what seemed to him a lack of understanding of 'craft values'.

From Alfred he travelled by train to Toronto in Canada to teach at the Central Technical School. He also gave a broadcast and talked about 'East and West' to the local Bahá'í group. To Leach, the crafts in Canada seemed undeveloped and 'rather lost'.

At Wichita, Kansas, as a selector of a national crafts exhibition, he found to his surprise that he was largely in agreement with the other two judges in both their assessment of the work and in awarding the national prize to a ceramic sculpture by Tony Prieto. In Detroit, John Foster, a potter with only one hand, gave him hospitality and in Ann Arbor he stayed with Jim Plumer who knew many of Leach's friends in Japan. At a dinner during a workshop at the University of Wisconsin Leach talked to the potter David Shaner, but found they had little in common. When Shaner mentioned with enthusiasm the work of the experimental Japanese potter Rosanjin, Leach was clearly not impressed and merely remarked: 'He's dead'.[72] Rosanjin was a potter who clearly did not figure in Leach's image of Japan. During the tour the American Ceramics Society presented him with the Binns Medal for Ceramics, the highest such award in the country. The fact that the society

was mainly concerned with industrial production and this recognition was for studio pottery tickled his egotism, though he did decline an honorary Ph.D.

In Minneapolis he stayed with the MacKenzies, lecturing and demonstrating at St Paul's School before flying to San Francisco. On the west coast the work of local potters seemed even more inclined to exaggeration, and made a less than favourable impression on Leach. In Seattle he spent two weeks with Mark Tobey and his partner Pehr Hallsten, an artist working in a naive style, who in Tobey's opinion 'paints wonderful attractive little paintings' and had 'a remarkable natural colour sense.'[73] Their large house, even to Leach's acquisitive nature, seemed too crammed with objects. Mark and Pehr's relationship was a complex combination of love and aggression, in which affection would be interspersed with much snarling and snapping, and was fully accepted by Leach as a part of Tobey's life, though to what extent he recognized its homosexual nature is not clear. What he did find difficult was Mark's obsession with bric-à-brac and the endless shopping expeditions, which at one point left Leach so exhausted that he sat down on the pavement and demanded to be left alone.

The tour ended in the middle of June and Leach, accompanied by Alix and Warren MacKenzie, who were coming to spend two years at the Pottery, sailed home from New York.[74] The seven-day crossing, with warm sunny weather, provided an opportunity for Leach to put down his thoughts on the visit and, bearing in mind the experience of what he had seen, muse on the role of the potter in contemporary society. If the pots failed to gain even the slightest approval, the people he found almost without exception polite and charming, generous in their hospitality and greatly enthusiastic for the craft. Across the length and breadth of America he was met with every conceivable kindness, and experienced first hand the life of prosperous Americans.

His opinion of American ceramics, some of which he included in *Beyond East and West*, is Leach at his most pompous and aloof. The pots, he wrote, were often badly conceived, many of which he dismissed as ugly and grotesque with little sense of restraint. One round, full, balloon-like shape with a tiny neck, made by several potters, he thought stretched the form to the point of distortion. Practical criticisms included 'handles which are obviously stuck on and do not grow from within as branches grow from a tree-trunk' and 'jug lips which will not pour without dripping; teapot spouts which are either goiterous or camel-like; hollow knobs on covered pots which contradict the formal rhythms of the rest of the shape'.[75] But his myopia was at its most extreme when reflecting on the connection of pots with life, writing 'when society is in confusion or decay the artist and the potter have to seek what truth and beauty they can find for themselves'. In his view both America and western civilization were 'at a crossroads in art as in life . . . in its suicidal pursuit of external at the cost of the internal and spiritual and artistic values'.[76]

Returning to a familiar theme he stressed again that 'the qualities of the man may be seen in the pot'. His confidence, he argued, was justified in his advocacy of 'standards'.

While Leach did little to conceal his disapproval of American ceramics, some American commentators were less than enthusiastic about Leach and his achievements. The influential potter and teacher Daniel Rhodes was clearly out of sympathy with Leach's enthusiasm for eastern ceramics. While acknowledging his importance in 'turning the attention of potters to Chinese and Japanese values in pottery', he thought that in his own work Leach had not developed 'a truly personal style, or a pottery which seems in keeping with any dynamic Western tradition'.[77]

While ready to identify the weaknesses and problems of the realities of pottery in America, the difficulties of Leach's own life were far from resolved. Despite implying in his account of his visit that he had found solutions to 'primary values' many fundamental issues remained. There was his reliance on David's willingness to continue as manager, despite the impact on his development as a potter in his own right. There was also the problem of resisting, or at best controlling, his son Michael's attempt to join the Pottery. The troubled state of his relationship with Laurie continued to bother him, notwithstanding their separation. During his absence Laurie had settled in Wolland House (or Cottage), Old Romney, Kent, and had occasionally written to Leach. In one 'rather terrible letter' she had, in Leach's view, twisted 'the memories of the past into a caricature of truth'.[78] A letter from David saying that he had received a telegram from Laurie asking for immediate repayment of the £500 that she had loaned the Pottery, added to his worries. The demand took David completely by surprise for although he was a partner the arrangement had been made without his knowledge, and embarrassed him because he had no way of repaying the debt. With much effort he scraped together £100, but as the bank had not been formally informed of his partnership they refused to make a loan. David also mentioned other financial matters that had to be sorted out, including the complexities of income tax and bonuses to the crew.

Although a partner, David was left to run the Pottery without all the necessary power to take decisions. In this particular instance he did not direct his anger at his father who had not informed him about the loan, but at Laurie, who may have needed the money to pay for her move, though she may also have felt disinclined to continue with the loan given the poor state of her relationship with Bernard. To David, Laurie further blackened herself in the eyes of the family by defiantly defending in court a woman named Elizabeth Prowse. While working as a 'domestic servant'[79] for Muriel and Myra Leach, Prowse had systematically stolen small but valued items of jewellery worth £240. When brought to court Laurie was outspoken in her defence of Prowse and as a result, much to David's annoyance, the accused was bound over rather

than given a prison sentence. During the trial Laurie stayed with Helga, Sven Berlin's wife, rather than in Pottery Cottage.

On his return to England Leach immediately went to see Laurie in an attempt to reconcile their differences, but, given their fundamental incompatibility, with no success.[80] He could not or would not relinquish his Bahá'í faith, which had become a symptom of their disagreements rather than its cause. Neither was he able to adapt sufficiently to settle the storms between them, which continued even after they had agreed to part. As a tacit recognition of the ending of his marriage, and as he disliked being by himself, he invited the MacKenzies to live with him in Pottery Cottage, where they effectively became part of his family. Initially overawed by close proximity to such a god-like figure, it took time before they felt able to call him Bernard instead of Mr Leach. They marvelled at the way he drew ideas for pots on scraps of paper over breakfast before making them in his studio. In the evenings guests were entertained or they sat round the fire reading and discussing books such as *Kindergarten Chats* by Louis Sullivan[81] and listened as Leach compared his training in Japan with the progress of the young architectural student. The MacKenzies quickly became useful members of the crew.

The Pottery, as Leach recorded at the time, 'involved a team of twelve, open consultation and profit-sharing, a production of about 20,000 pots a year about 3,000 of which are expensive, selected, individual pieces'. Many of these were 'sold direct to customers by means of a catalog [*sic*] covering about thirty varied domestic pots'.[82] Such a picture of an ordered, directed and motivated team may have had more than an element of romantic idealism, for as the MacKenzie's discovered, the reality of daily life at the Leach Pottery was far from perfect. The members of the crew were paid barely subsistence wages, hence their keen interest in bonuses. There were also personality clashes and problems with Michael's continuing demands to be given an established role and David's growing restlessness. With the MacKenzies' help, David virtually rebuilt the three-chamber kiln, which was in poor shape, more efficiently adapting it to oil firing.

In addition to working in the Pottery, the MacKenzies proposed making a film of the Pottery from a potter's point of view, which the Elmhirsts agreed to fund. The twenty minute black and white film is a model of clarity in following the progress of the making and firing of a pot; it shows clay being prepared, pots thrown on the kick wheel, the speed and dexterity of brush decoration, glazing pots and the large kiln being packed and fired. The tensions of the firing are suggested by the potters peering anxiously into the kiln as ominous black smoke billows out of the chimney. The fired pots are shown being unpacked and scrutinized, with the best ones put to one side. Leach's commentary, spoken in his most precise English, focuses on both the practical aspects of running a studio pottery and the aesthetics of handwork. Despite its vaguely romantic almost idyllic approach, the film is a vivid record

of a working pottery, suggesting both the hard physical tasks and the satisfaction of the potter's life. It was perfect for Leach to show on his tours.

With the ending of the war Muriel Rose, now on the staff of the British Council, showed no enthusiasm for reviving the Little Gallery, but others recognized a potential market. In 1946 Henry Rothschild[83] opened Primavera, a small craft shop and gallery in Sloane Street, London, selling contemporary craft, high-quality textiles and imported folk art. In quest of stock he visited Leach and after picking out a number of pieces was complimented on his good taste but then informed that all the ones he selected were not available. Declining the pots that were available Rothschild left with nothing, an inauspicious start to what was to prove a long and productive relationship as Leach regularly held exhibitions at Primavera and his pots were on permanent display there. Primavera, together with the British Crafts Centre in Hay Hill, and Heal's in Tottenham Court Road, was one of the major London outlets for serious contemporary craft at the time.

With Muriel Rose, Leach flew to Paris in September 1951,[84] mostly to meet traditional French potters but also in the hope of re-establishing contact with Vera Milanova, who he had not seen for many years. After booking into the Hôtel d'Alsace on the rue des Beaux Arts, they went to Les Deux Magots in the hope of finding an old waiter who might know of Vera or her husband René Daumalx. Barely had they sat down when by an odd coincidence Vera entered and seeing Leach called out his name and threw her arms around him. In her flat in Montparnasse they reminisced about mutual friends, Leach hearing of the death of her husband from consumption, and more of the life, teaching and death of Gurdjieff, who had lived in Paris, and of whom she was a devoted follower. Leach told her of his own problems and the split in his 'inner life' since his American tour, which she identified as the pull between the 'I and the all'. Recognizing his allegiance to the Bahá'í faith, she did not attempt to draw him into Gurdjieff's orbit but sought common ground, agreeing that 'many roads lead to the mountain'. Vera attempted to teach Leach to relax 'on all three planes' so that the habit would become part of his daily life.

At the Musée de l'Art Moderne Leach found few contemporary pots worthy of regard. Apart from one made by the Catalan potter Llorens Artigas and decorated by the Spanish Surrealist artist Joan Miró 'there was not a real potter to be found', he wrote. 'Applied Art as such appears to be a failure in France. It is simply riddled with self defeating self-consciousness . . . They are all half baked or just downright poor',[85] was his uncompromising verdict. What he saw as the artificiality and self-regarding qualities of French studio pottery contrasted poorly with the vitality of traditional work. They greatly admired 'a lovely exhibition of the folk art of Brittany, excellently done in which a large section was devoted to Les Potieres [sic] de St Jean La Poterie, Morbihau, near Vannes, Brittany. Every detail of materials and tools, plans of kilns, photos history, admirably set forth.'[86]

A few days were spent in the historic city of Bourges where the magnificent soaring lines of the ancient cathedral of St Etienne with its flying buttresses and dazzling thirteenth-century stained glass was as impressive as they hoped. 'This' wrote Leach 'is one of the great gothic and romanesque works. It is magnificent outside and in. Dwarfing all our present individualistic efforts in art. Here was a great overall expression of faith and life and art.'[87] Noting their admiration, a townsman explained that parts of the building had buttresses of heavy stone as the foundations had to be prevented from sliding towards the sandy riverbed.

From Bourges a bus jolted them over Roman or military roads to the sixteenth-century town of Henrichemont from where they walked the three and half kilometres to the tiny village of La Borne, passing through light woods where they picnicked under an oak. At the village they were welcomed by the wife of one of the potters, Madame Lerat, and given coffee before being shown the workshop and the vast old stoneware kiln. A firing was in progress in which only hardwoods including long slivers of silver birch were used. Quiet and unassuming, Jean-Louis Lerat continued the artisan tradition dating back 400 years, making pots mainly for local sale. These included bottles for storing walnut and olive oil, pots for pickling hams or holding grain or butter, all glazed with a mixture of wood ash and clay or feldspar. This gave rich but quiet glazes in pale blues and greens with attractive iron speckles. Lerat's strong pots and his sensitive understanding of the artisan tradition, which was rapidly dying out, impressed both visitors who deplored the lack of public interest in his work. Another potter in the village astonished them with his virtuoso throwing skills as, leaning over a wheel set at near ground level, he swiftly made a fifteen-inch (38 cm) pot in only two minutes. During the walk back they gratefully accepted a lift and duly offered to buy the driver a drink, an offer he declined. This, he explained, was because as a connoisseur he could not abide what was served in the local cafés. Instead he invited them to his home where he plied them with delicious home-produced wine.

One day they visited Mehun-sur-Yèvre to see the eleventh–twelfth-century church and the fourteenth-century château, of which only the twin towers remained, soaring to an impressive 300 feet. Dutifully they toiled up the spiral stone staircase managing to fight off swarms of gnats clustered around the top to admire the grand view with Bourges just visible on the horizon. It was, thought Leach, an absolutely perfect warm autumn day, the trees were full of ripening apples and pears, and orange pumpkins were mellowing on window-sills.

On their final day they visited the Musée du Berry, Hôtel Cujas, to see the excellent collection of old La Borne stoneware, all of which was wood-fired. These included modelled figures, mainly religious in character, which were often placed in graveyards, by the sides of roads or at junctions as a reminder to travellers of the eternal presence of God. In addition there were many old

pots to admire, the vigorously thrown practical forms geared to farm and domestic use, the quality of the deep, matt, iron-speckled glazes and the unglazed areas bearing the effects of the flame, made a deep impression on the visitors. Leach drew the pots and learnt something of the history of the industry. Muriel Rose purchased a catalogue of an exhibition that had been held some time earlier.

In preparation for the trip Leach had drawn up a list of French studio potters and on the spur of the moment on their return to Paris they decided to visit Emile Decoeur,[88] an eminent studio potter then in his seventies who lived at Fontenay-aux-Roses just outside Paris. Although frustrated by being given conflicting travel instructions they finally arrived at Decoeur's studio.[89] This he had set up nearly fifty years earlier and here he made porcelain and stoneware, successfully experimenting with *flambé* glazes on shapes often derived from vegetables, with minimal decoration. Although cordial greetings were exchanged their unannounced arrival proved to be inconvenient and the visit was brief, but Decoeur did look politely at photographs of Leach's pots. Despite Decoeur's international reputation, Leach found his pots too much like 'blueprints carefully drawn, precise and without vitality, rather than organic, wheel-thrown forms'.[90]

The realization that his marriage to Laurie had ended meant a profound review of his life. Part of Leach's long-term strategy was to make an extended visit to Japan where he felt he was more respected as an artist and his work better understood, appreciated and perhaps most importantly bought. In a complex combination of altruism and practicality Leach took the dramatic step of distributing his property amongst his children on the understanding that each would pay him £50 a year, to provide him with an income. It was an arrangement that meant that his family could benefit from his property while he was alive rather than wait until he was dead and at the same time free him from the responsibility of ownership. David got the Pottery premises lock, stock and barrel, though Leach retained Pottery Cottage, and a half share of the business itself. On Muriel's death the house at Carbis Bay was to be divided between Eleanor who got the Count House and Jessamine who was given Providence House. Michael received Penbeagle Cottage, though Myra was dubious about an arrangement that meant they had to go on paying for something that had been given to them. Book royalties were made out to Betty. Despite generally enjoying good health Leach began to suffer from minor ailments, most associated with ageing, and this may have further prompted him to sort out his affairs. In 1952 an enlarged prostate was diagnosed but he was reassured that it was 'part of the male menopause and 50% of men are affected'[91] and unless the condition worsened no further action would be required.

Aware of the absence of a society of potters, Leach supported proposals to set up a potters' guild and sought to enlist the help of the potter Heber

Mathews, who was teaching at Woolwich Polytechnic. Little progress was made, however, and many potters preferred integration into multi-discipline craft societies rather than single craft groupings. After a pot by Michael Cardew was rejected for an exhibition, the pitfalls of selection and the wider questions about 'standards' caused much confusion and the guild idea was quietly dropped. More in keeping with Leach's international ambitions was a bold and radical proposal to hold a ten-day conference on pottery and textiles at Dartington Hall, reinforcing his notion of a 'world-wide outlook'. Its broad scope also fitted in with his plans to visit Japan. The idea grew out of a visit to Dartington in the summer of 1950 during an exhibition 'Made in Devon', which included Leach's work, organized by an ambitious and energetic young arts administrator Peter Cox. During the associated conference, Leach and Muriel Rose proposed a similar show featuring the best textiles and pottery from 1920 to the present.

From this grew the idea of an international conference and exhibition with the broad aim of considering the role of the craftsman and woman in the postwar world, and to offer a global perspective that would consider practical, aesthetic and educational issues. Muriel Rose and Dorothy Elmhirst made use of their North American connections and Leach his friends in Japan to ensure its international remit. The conference also looked to alert a new generation of the hard-won interwar achievements. 'Many young people were coming into the world of craftsmanship,' Leach told Mairet, 'without knowing the best that we had produced between the wars, or, indeed, where they are going.'[92]

Unlike contemporary painters and sculptors, who tended to look to America for modern developments, makers of woven textiles turned to Scandinavia, while potters, at least those of concern to Leach, looked East, and this was how the programme was drawn up. Members of the advisory panel included the textile designer Marianne Straub, George Wingfield Digby and Cecilia, Lady Semphill.[93] The international twelve-day conference, and accompanying exhibition, which subsequently toured Britain, was ambitious and wide-ranging. Over a hundred delegates came from the USA, Europe, Asia and Africa as well as Yanagi and Hamada from Japan, most of whom were housed and fed at Dartington. The detailed programme of lectures, debates and practical demonstrations of pottery and weaving allowed plenty of time for social exchange. This daunting administration involved many hours of detailed discussions about finance and protocol.

Ingeniously, the event blended entertainment, stimulation and information, when potters and weavers discussed shared objectives, considered new developments and the uneasy relationship between craft and industry. The eminent chemist, engineer and part-time potter Edward Burke demonstrated the qualities of a type of clay called bentonite, ten times more plastic than ordinary ball clay, by adding it to a porcelain body so making it highly elastic

and throwable. To gasps of astonishment, an unidentified Belgian potter used this modified clay to throw a fifteen-inch (38 cm) diameter bowl, which he then successfully shaped into a bottle. Hamada illustrated his expertise by swiftly making a small side-handled teapot or saucepot with, as Marianne de Trey recalled, 'awe inspiring fluidity'.[94] It was later glazed and fired by David Leach. Michael Cardew and the weaver A. S. Southern spoke about their experiences of craft in Africa. Discussions on geology involved much poring over maps, examination of specimens and even field trips. Yanagi's two talks addressed the work of the Mingei movement, and the value of the work of the 'anonymous' maker and its unselfconscious beauty. As Yanagi discussed the qualities of functional craft in the culture of old Japan it was almost as if the terrible events of the war had not taken place. He also deplored the West's stress on individualism, its tendency to over-intellectualize, and its neglect of its craft tradition. The still vivid memories of the war were graphically brought home when Yanagi and Hamada had difficulties in booking a London hotel; they stayed with Rie, where they insisted on rearranging the furniture. Myra Leach was given Yanagi's kimono to wash, a task she resented given the difficulties of dealing with such a complex garment.

In an introductory address, 'The Contemporary Potter', Leach reiterated his belief in the importance of the contributions from England and Japan to studio pottery and in a familiar, and for him crucial refrain, stressed the need for employing head, heart and hand in the making of good work. In putting forward his belief in an East/West synthesis, Leach urged the audience 'to become citizens of the human race rather than merely citizens of one culture'. While respectfully received, not all the debates went Leach's way. Despite their friendship, Lucie Rie felt uneasy at Leach's proselytizing, as did the potter Hans Coper,[95] then working with Rie. Several delegates did not see industry as the enemy, arguing that the individual maker and industrial producer could productively exist alongside each other, and some were vocal in their opposition to what they saw as Leach's narrow views. The outspoken German-born potter Marguerite Wildenhain from America, who had studied in the Bauhaus and designed for industry, argued that craftsmen required training in both handmaking and mass production on the grounds that once understood they can be used 'with discernment, efficiency, expediency and without emotional conflict'.[96] Others too thought that collaborations between industry and studio potters could be useful and that they should have a role as designers. The running conference joke, whether 'To Leach or not to Leach', focused principally around the anti- or pro-industry issue. To outside observers the conference seemed more archaic than relevant, a view expressed by Robert Melville in the *Architectural Review*: 'The general effect is of an ethnographical exhibit of the remains of a lost civilisation, of a village and town community of highly aesthetic peasants.'[97]

For Leach, Patrick Heron's talk 'The Crafts in Relation to Contemporary Art'[98] must have been one of the most satisfying. In addition to acknowledging the value of his fourteen-month involvement with the Leach Pottery, Heron put forward an enlightened analysis of the pots of Leach, Hamada and Cardew, describing them as having 'submerged form, submerged rhythms'. 'Form,' he argued, 'is essentially fluid in Hamada or Leach . . . We feel a powerful pulse in their pots: a rhythm that seems at its most emphatic just below the glazed surface.' In its poetic and vivid description Heron saw the pots like human figures, 'where the structural form is *below* the surface of the flesh — the bone is under the muscle'. But his greatest assertion was that their pottery was 'utterly contemporary: the exact counterpart, in ceramic terms, of the sculpture of Henry Moore or the paintings of Braque'. For Leach, the conference was a huge success. His persuasive tone, rational arguments and deep-felt commitment to the making of whole work was for many inspiring, a clear voice at a time of uncertainty and change.

With David firmly in charge at the Pottery, and encouraged by Yanagi, Leach planned an extended visit to Japan. Yanagi saw the tour as important publicity for the rapidly expanding Mingei movement, of which he was the undisputed head. Knowing the popularity of his slip-decorated earthenware in Japan, Leach decorated a series of large red earthenware dishes made by David, very much in the style of those made in the 1920s. The large thrown platters measured eighteen inches (44 cm) in diameter, the press-moulded rectangular dishes with rounded corners a sizeable thirteen and a half inches (35.5 cm) in length. All displayed greater technical understanding and control than the earlier pieces. On some Leach simply drew his fingers through a layer of slip to create a willow-tree design, on others he trailed animals such as a mountain goat or a mountain range with a winding road that can be seen as symbolizing Leach's own path in life. Because of their size they were fired in the large kiln, one of the few occasions when earthenware was made at the Pottery after 1937. The combinations of warm reds, oranges, creams and browns were as powerful as those made thirty years earlier, but the greater control gave them a professional quality the earlier pieces lacked.

Discovering that Leach, Yanagi and Hamada intended to travel to Japan via America the MacKenzies proposed a lecture-demonstration tour. This would be at a much steadier pace, over a longer period of time and to fewer centres than the 1950 tour, with all the arrangements made by the MacKenzies. All three saw it as an opportunity to put their ideas to a new audience, and a chance to see the country. For Leach it held the promise of a new beginning.

THE SPIRIT AND THE BODY

USA Japan

1952–1954

'All my life', wrote Leach, 'I have been a courier between East and West',[1] a task that took on a new reality with the extended tour of the United States and long visit to Japan. The idea of a fresh start was very appealing and any doubts about being away from the Pottery for such a long period, and concerns over David's growing restlessness,[2] were quickly brushed aside. In the 1952 Leach Pottery pamphlet Leach indicated his confidence in his son, saying that in his absence David would assume charge with 'the opportunity to develop it in his own way now rather than later'.[3] Paradoxically this both liberated David from, and bound him to the Leach mould.

With Hamada and Leach's joint London exhibition a success and the general acclaim of the Dartington Conference still ringing in their ears, Leach, Hamada and Yanagi, dubbed 'the three Musketeers' by Leach in a letter to Lucie Rie,[4] set sail for American on the SS *Mauritania* in October. Their four-month coast-to-coast tour promised to be financially rewarding, the well planned itinerary covering much more than expenses. Hearing of Leach's plans to keep a diary the Japanese Mainichi Press offered to pay his fare in exchange for permission to publish his detailed 'comments, and even frank criticisms'[5] of his time in Japan.

In Washington, their first stop, they stayed with Robert Richman and as usual had to sort out a muddle over financial arrangements before travelling south through the Blue Ridge Mountains to their inaugural seminar at the experimental, interdisciplinary Black Mountain College, Ashville, North Carolina. The setting, at 2,500 feet, was magnificent. The mountains were clad in brilliant autumn colours and amongst the trees and falling leaves swallow-tail butterflies, black with blue sheen, flitted, seemingly undisturbed by the great highways and fast traffic. The crisp air, sharp nightfall temperatures and wooded surroundings brought a pleasant reminder of Karuizawa, the Japanese mountains where Leach had spent many happy holidays.

Black Mountain, led by practising artists and craftsmen and women and developed along liberal lines by the artist Josef Albers[6] in the 1930s, was renowned for its broad spectrum of the arts forming the core of the college

curriculum. Two recent Alfred graduates, David Weinrib and his wife, Karen Karnes, were in charge of the pottery but in their absence Marguerite Wildenhain was hosting the two-week session. Thirty-five enthusiastic students and potters had enrolled for a programme of films, slides, demonstrations, lectures, parties, excursions and social events. All three lecturers quickly fell into the roles they were to retain throughout the tour. Leach the 'articulator, the innovator . . . who coupled standards with form' talked endlessly, gesticulated freely and made a few pots. Hamada the doer, who 'wrote in visual language' and who spoke only Japanese despite having good English, silently threw on the wheel and assembled a teapot in a matter of minutes. Yanagi, 'the master of Zen aesthetics',[7] lectured on Buddhist theories of beauty and Zen and Shin − 'the road of the few and the road of the many'[8] − difficult concepts that often went above the heads of their audience. Topics such as 'The Responsibilities of Criticism' sought to get to the heart of their approach. Clamours for copies of Yanagi's talk suggest that many students required time and thought to digest its ideas and concepts.

Three successful stoneware and earthenware firings were held. A high manganese glaze was used over black and white slips for the earthenware, and the stoneware body was enlivened by adding a local iron-bearing sand. At the end of the two weeks the pieces produced by Leach and Hamada were sold for $235, a sum they contributed to the badly depleted college funds. One Leach pot, about seven inches (17 cm) tall, had a typical willow tree design incised through a dark slip under a white glaze.[9]

The twin themes of tradition and theory dominated discussions at Black Mountain, as they did throughout the entire tour. With zeal they freely criticized attitudes to the crafts as well as pots, often with what seemed at times brutal frankness, in an endeavour to enlighten, inform and provoke. Critiques tended to be hard, often with little attempt to comprehend the ideas behind them. Although they constantly stressed the need to understand the broad base of their aesthetic ideas and philosophical approach, from their first demonstrations there was resistance to their preference for soft, muted earth colours and harmonious shapes. Instead students preferred 'recipes, tricks and dodges' rather than serious discussion about the sort of pots they liked. As a way of demystifying their approach and stressing the value of local materials, Hamada explained how attractive stoneware glazes could be made from combinations of rock and wood ash, and demonstrated how bundles of grass could be bound to make useful brushes. Through patient explanation Leach felt that 'at the end there was frank and sincere conversation',[10] though only a small number responded to their ideas.

The need for a tradition, or 'tap root', a topic articulated by Leach at great length two years earlier, was a recurring theme. 'America as a new amalgam of races does not provide a craftsman with traditions of right making born on its own soil',[11] was Leach's view, an authoritative opinion that implied a known

path and a single solution. Few students responded to such observations, and many dismissed his analysis as a failure to understand the nature of American culture. When bewailing the absence of 'tap roots' at a workshop and seminar at Chouinard Art Institute, Los Angeles, Susan Peterson, the potter in charge, recalls thinking that 'none of the three men could comprehend the melting pot nature of the United States'.[12] In search of 'roots' at Black Mountain College, group expeditions were organized to the summit, 6,000 feet, and to a traditional pottery run by Mr Brown, 'an old, dry, lean, humorous American' with his son and grandson. The flower pots, casseroles and jars they produced met with the visitors' approval, their simplicity having 'comparatively little modern vulgarity'.

The most significant meeting at Black Mountain was with the Texan-born potter Janet Darnell.[13] Having read and been impressed by the sense of wholeness and unity in A Potter's Book, and having heard Leach lecture two years earlier in New York, she wanted to know more about his approach and philosophy, and travelled 700 miles from New York state, where she was then living. Strong minded and determined, she had a clear vision of her needs and capabilities. With striking angular features and a mop of dark, curly hair, Susan Peterson remembers her as 'wiry, boney, thin with deep-set eyes . . . fun-loving and happy'.[14]

To Janet's surprise it was not Leach but Hamada who impressed her, and she watched spellbound as the Japanese potter sat cross-legged patting and pulling the clay on the wheel to bring out its sensual, generous qualities. 'He was making the richest and warmest pots I have ever seen. He was like a child, almost as if he were playing patty cake . . . Hamada's way on the wheel was gentle and easy.'[15] By comparison Leach, sitting upright on a wheel, seemed stiff and formal, his pots tight and controlled. In the evenings lively discussion about pots and national culture continued with Janet arguing fiercely about what she saw as Leach's lack of comprehension of the country's cultural make-up. Few Americans, she pointed out, appreciated his concept of tradition and far from revering the past as a virtue many equated it with old-fashioned fuddy-duddy habits unrelated to modern needs. Through such vigorous debate, interspersed with dancing, a friendship was struck up, with Leach finding 'her mind alive and intelligent'.[16]

Deeply impressed by watching Hamada make pots and the glimpse of a different, living pottery tradition that seemed fulfilling and meaningful, Janet decided that she must experience this at first hand. This was a challenge not only because of her own limited financial resources but because women were rarely trained as potters in Japan. Richard Hieb,[17] another student at the seminar, was equally enraptured and without hesitation successfully approached Hamada with a view to working at Mashiko. Fearing a refusal Janet made no mention of her own desire for such a trip, but aware of establishing a rapport with Leach she subsequently wrote begging to be allowed the

opportunity. Nothing was resolved and for a time she doubted if her request had been taken seriously.

In New York City, Leach's programme involved a lecture at New York University on 'The Contemporary Potter', visits to amongst others the Metropolitan and Brooklyn museums, and sitting for photographic portraits by Trude Fleischmann,[18] a friend of Lucie Rie. Twice they visited Yanagi's teacher and great exponent of Zen Buddhism, Dr Suzuki Daisetz, now aged eight-two, and his secretary Okamura Mihoko. In his tiny flat overlooking the Hudson River Dr Suzuki impressed them with his quiet wisdom and understanding as he expounded on such tenets of Buddhist philosophy as jiriki-dō (or jirikido), the individual development path towards enlightenment and tariki-dō (or tarikido), the broad path towards enlightenment for the many. The latter, said Suzuki, 'may be compared to going to sea in a sailboat; the former, to walking on land',[19] causing Leach to ponder which path he followed. On broader themes Yanagi talked to Leach about the Buddhist concept of thusness, the state of being in which there is the need to 're-establish art in relationship to The Tree of Life, to God'.[20] A central aspect of Buddhist thought was the idea of non-duality, the recognition of the wholeness of creation in which heart and mind were united as one. Such qualities Yanagi saw in the work of Blake, an artist who believed that God was in everything and lay within rather than without, giving special significance to his concept of the 'human form divine'.

After a lunch party in Greenwich Village given by Mrs John D. Rockefeller they went to marvel at the new United Nations building, gazing at its immense glass front before travelling by high-speed lift to the top. Overawed by the modernity of the huge transparent box and the broad sweep of the Hudson River below, they were brought back to earth by Dr Suzuki asking quietly 'and who cleans the windows?'[21]

Their tour took them on to Boston where they renewed contact with Langdon Warner, and Leach saw Naum and Miriam Gabo in Woodberry, Connecticut. Other stops were made at Worcester, Ann Arbor, Detroit and St Paul where they stayed with the MacKenzies for a two-week Midwest Craftsmen's Seminar at the St Paul Gallery and School of Art, Minnesota.[22] Thick snow and blizzards curtailed some activities, including a Bahá'í meeting, but for Thanksgiving they celebrated at a lakeside chalet some miles away where they met again the Austrian-born painter Oskar Kokoscha whose work Leach admired. At the Archie Bray Foundation[23] in Helena, Montana, in mid-December they met the gifted young potters Peter Voulkos,[24] one of the resident potters and recent masters graduates, and Rudy Autio.[25] Voulkos kicked the footwheel for Hamada's demonstration allowing the potter to sit cross-legged on a folded blanket on a table, throwing much as he did in Japan. At such close quarters the young potter had the opportunity to admire Hamada's easy technique and relaxed brushwork, which he found 'rhythmical and dancelike in movement and gesture'.[26] The visitors, however, were highly

critical of Voulkos's tableware, believing it was more decorative than functional. With a powerful sense of his own work producing strong, simple forms, but already concerned with pushing at the boundaries of conventional craft, Voulkos was taken more by their ideas than by their opinion of his pots. The concept of head, heart and hand, and its implied unity he saw as related to the Abstract Expressionist movement, which he later sought to express in ceramics. Despite the cold, at Hamada's request the young potter drove him to the hills to paint water-colours; to Hamada's delight the water froze producing interesting effects on his paper. Whenever possible Leach also drew and sketched, making studies of the landscape, some light and impressionistic, others more detailed and many serving as starting points for decoration on pots and tiles.

After what seemed like a surfeit of studio pots, in search of American Indian pottery they flew to Santa Fe in New Mexico where Leach stayed with Miss C. F. Bieber, known as Beibah, who was a friend of both Langdon Warner and Muriel Rose. At four museums they admired old hand-built pots and woven and printed textiles as well as genuine primitive Spanish religious paintings. So enamoured were Hamada and Yanagi by the intensity and power of the paintings that they spent virtually all their earnings acquiring pieces. They were all impressed by the Indian Pueblos of San Domingo and Taos. At San Ildefonso they wandered around looking for the renowned potter Maria Martinez,[27] whom they found raking pots out of an ash heap. Black and shining from being fired with horse dung, the pots gleamed and sparkled and for once all three nodded their approval. Greatly honoured by their visit Maria Martinez arranged a special firing, an event recorded by the Santa Fe-based photographer Laura Gilpin.[28] For their lectures and demonstrations at the International Museum of Folk Crafts, Maria Martinez honoured them by wearing her best blankets, necklaces of coral, jet, silver and turquoise. Appropriately Leach's subject was 'The Integration of the Craftsman', a theme also taken up by Yanagi who spoke on 'Responsibility of the Craftsman'. Santa Fe, described by Leach as 'much the size of Penzance', appeared half-Spanish, half-Indian. At 7,000 feet above sea level the low pressure made him short of breath and tired.

At the railway town of Gallop and the Zuni Pueblo at the edge of Navajo country they saw more dramatic landscape and marvelled at an extinct volcano, ancient lava flows, gigantic ramparts of rock, erosion, scrub, and slopes dotted with evergreen piñon. 'I have never seen a place which excited me more',[29] enthused Leach. The mile deep, many coloured Grand Canyon was all they had imagined, and with a light covering of snow appeared even more impressive. Its 'scintillating opalescent light and incredible formations of ramparts, pinnacles, castles, bastions and slopes of water-worn rocks and far, far below glimpses of the thin thread of the Colorado River',[30] for once overawed Leach. In his drawings Leach captured in a few deft lines the quality

of the landscape, a pen and ink wash drawing of the Arizona desert evoking the vastness, heat and drama of the landscape.[31] The sepia-coloured study contrasts with a drawing in black ink wash, *Snow and Pines, USA*, which greatly simplified the hills and trees to great effect.[32]

As a great privilege, a Miss Wainwright, founder of the Navajo Museum, arranged for them to attend the annual religious *Shalako* dance, an important occasion when *Anglos* were tolerated. Following long delays the ancient ceremony, deeply complex and symbolic of Zuni belief and tradition, dealing with 'life and death, good and evil, rain and corn, Gods, spirits, man, and in this case procreation',[33] began. After what seemed an interminable procedure, they returned to their hotel to find their chauffeuse ill and in their bedroom in a deep sleep from which she could not be awakened. They had the discomfort of spending the freezing cold night in the car unsuccessfully attempting to sleep in the cramped and icy conditions.[34] Leach subsequently developed a severe cold.

The final leg of their tour was Los Angeles and the Pacific Palisades, where Leach remained indoors nursing his cold. Hamada stood on the cliffs by the ocean gazing longingly over the Pacific towards Japan. On Christmas Eve they enjoyed a good meal in Chinatown and spent much of Christmas morning opening presents, seeing friends and driving into the Santa Monica mountains to admire its greenness and beds of blooming flowers, a great contrast to the more arid countryside of New Mexico. For Leach it was a time of reflection and sadness, of remembering his family in England, his failed marriage but still loved wife, Laurie, and feeling 'terribly far away'.[35] Anxiously he looked for letters but few arrived, a fact duly recorded: 'My 66th birthday and no letter from home.'[36] News did come of the death of Ethel Mairet and at last a letter from David.

The final stops were Scripps College, Clairmont, where Richard Peterson was in charge, Mills College, where Tony Prieto was making ceramics, and a two-week workshop at the Chouinard Art Institute in Los Angeles with Susan Peterson. Respectfully the audiences watched as Leach and Hamada threw several score of pots ranging from modest marmalade jars to large urns, and again Hamada neatly assembled a teapot with a few rapid motions. One demonstration was watched by a hundred students and recorded by no fewer than four movie cameras, adding to the showman-like quality of the seminars and further massaging their egos. Their pieces were sold at the end of the two weeks. A talk at the Los Angeles County Museum of Art had a record audience of 1,000 and, as Leach gleefully noted, 200 were turned away. In San Francisco, as guests of the Japanese Consul General they stayed in his 'posh and ugly' house overlooking Golden Gate Bridge. The massive 600-yard span linking the bay and the Pacific made a great impression on Leach. San Francisco he found 'beautiful, hung like a necklace on the throat of the Pacific'.[37] One night was spent in the remarkable gorge in central California at Yosemite,

then covered in snow, to see the redwoods and the *Sequoia gigantea*, upwards of 4,000 years old, and the magnificent granite masonry of Half Dome.

Both Leach and Hamada were great admirers of the innovative American designer Charles Eames[38] and went to visit him and his wife, Ray. Eames's openness to both hand and machine work, and his readiness to respond to East and West 'open hearted, accepting and recreative' about furniture and design in general seemed to successfully combine the traditional and the new. Eames's radical new fibreglass moulded chair, exhibited at the Museum of Modern Art, New York, to wide acclaim, seemed so far from their handcrafted pots both in spirit and appearance that it is difficult at first to see the connection. At Marguerite Wildenhain's studio at Pond Farm, Guerneville, California, they encountered a similar involvement in the technology of the machine and hand-work. Recalling her vocal opposition to many of his ideas at Dartington, particularly about his resistance to and engagement with industrial production, she seemed to Leach to be 'capable but too outspoken for American taste'.[39] In Germany Wildenhain had gained a reputation for well-designed, modern looking industrial tableware and believed that the ceramics industry and studio potters could work productively together. While remaining critical of Leach, especially his comments on American craft and his failure to come to terms with the different nature of American culture, she did approve of the way both he and Hamada 'make the pot a human affair and not one of technique'.[40] With her thorough European education and long years of study, her complaints about the shallowness of American students who expected to learn pottery in six weeks, fell on receptive ears.

Accounts of their tour in *Ceramics Monthly*[41] singled out in particular Leach and Hamada's unenthusiastic response to American ceramics, quoting Leach's view that 'strong digestive capacities' were required to absorb influences as diverse as Pre-Columbian Indian and the contemporary abstract idiom, a feat that Leach thought few could achieve. Hamada did offer some hope saying 'the history of studio pottery in America is as yet quite green, but the unflagging endeavour of many honest artists certainly promises well for the future'. Various correspondents strongly rejected what they saw as their patronizing attitude.[42] Far from respecting Leach's work, one described his pots as 'stuffy, heavy; and mid Victorian . . . and incredibly dull'. In *Craft Horizons*[43] Wildenhain joined the many critical voices, contending that they were starting from the wrong premise. Again the crux was tradition and roots, with Wildenhain insisting that to look for a single root was misconceived as the country had many sorts of cultures and therein 'lies its uniqueness, its grandeur'. She also pointed out that such qualities were an intrinsic part of its make-up. Taking a side swipe at Leach's espousal of oriental styles, she pointed out that 'American potters cannot possibly grow roots by imitating Sung pottery or by copying the way of life of the rural population of Japan', comments echoing the East versus West debate.

While highly critical of American pots, all three acknowledged some merit in the openness of potters to a wide variety of influences. This was particularly evident in work they judged for a national competition, but they nevertheless concluded that the pots lacked 'the virtue of restraint and the support of tradition'.[44] All three were full of praise for the openness and generosity of the people who entertained them in their homes and facilitated their tour. As guests in such houses the 'three wise men' experienced at first hand the life of wealthy Americans. The modern home, Leach wrote,

> really took ones breath away with the sense of another life . . . the conveniences especially in the kitchen. Even Y and H said they could accept it 80% . . . warmed (very) screened against insects (mosquitoes bad) warmed floors, deep freeze storage, enormous windows with double insulating glass, hidden lights, lights in ovens, good floors, washing machines, garbage destroyers (grinders) out of sinks, trap doors for dirty clothes, and every kind of arrangement to save labour and give life, space and light.[45]

While fascinated by many of the modern innovations there were other, more fundamental aspects that Leach strongly disliked, which much to his horror were rapidly being taken up by Japan. These included 'rampant and universal' materialist values, 'mass-production, speed, size, and the dollar criterion', as well as 'advertising, juke boxes, chewing gum habit, and white, tasteless blown up bread'. But he freely acknowledged the generosity of the people, and admired the 'eager open mind and energy of a young people in a vast and varied land'.[46] Although a slightly patronizing tone informed many of Leach's comments, he was a willing and 'friendly visitor', anxious to find out for himself, keen to see as much as possible, to meet potters and offer a heartfelt if narrow response. The impact of their tour was variable, ranging from a few who totally accepted the visitors' ideas, to those doubtful of their relevance to modern life. Warren MacKenzie, who set up his pottery in Minnesota, espoused many of Leach's concepts and became an influential teacher. When Leach subsequently wrote about the hundreds of potters in the Midwest, despite the fact that many had been inspired by the work of the MacKenzies, he observed 'the seed has fallen on good earth in my lifetime',[47] but overall the numbers remained small.

In late January they flew to Honolulu, *en route* for Japan. The lush trees and rich vegetation of the tropical Hawaiian islands reminded Leach of Singapore and Penang. References to Pearl Harbour[48] on the island of Oahu were discreetly avoided. Honolulu seemed idyllic, and they relished two weeks to relax and enjoy the easy atmosphere. As guests of the pottery section of Hawaii University they lectured and talked to potters, visited friends and met admirers of Yanagi. They also explored the volcanic islands, even fitting in a morning on the famous Waikiki beach. Despite feeling 'fat and old and rather

ashamed of the flabby middle-aged spread',[49] Leach was persuaded to take a ride on a double surf board and race 150 yards towards the shore on the white crest of a huge wave. Unfortunately, when they reached shallow water he gashed his foot on the coral and though not serious it reddened the blue sea with alarming speed. For all three one of the great pleasures was the sight of Hawaiian girls wearing green-leaf skirts dancing the hula on grass beneath coconut palms that leaned longingly across the white Pacific surf. It was, they thought, a successful 'inter-racial Garden of Eden', a 'Pacific playground of mixed races'.[50] The welcoming smiles seemed happy and genuine, and were an agreeable escape from growing international tensions between the USA and China over Korea. At a final farewell supper twelve friends[51] gathered to feast on joints of roast beef and Yorkshire pudding, traditional English fare specially chosen for Leach.

After an eighteen-hour flight they landed at Tokyo's Haneda airport, little prepared for the huge welcome awaiting them from both the press and their friends. The warmth and size of the reception set the mood for Leach's two-year visit. Astonishingly, they were mobbed by press photographers, news-paper reporters and radio interviewers pestering for opinions, impressions and plans, treatment usually reserved for film stars rather than craftsmen and writers. Leach basked in the warm glow of the unquestioning adulation of this enthusiastic welcome. As honoured guests they were waived through customs and escaped to the calm of Yanagi's house opposite the Nihon Mingeikan.

Since the end of the war the country had changed greatly. Buildings of poor quality and design, evidence of the rapid intention to modernize, had replaced vast urban areas destroyed by bombing. The centre of Tokyo was now packed with noisy, brightly lit *pachinko* halls, the slot and pinball machines attracting large numbers of people, while blaring loudspeakers in streets and shopping centres competed for the sale of goods. American occu-pation had introduced western ways and attitudes that had been taken up at an alarming rate, an impression confirmed by endless loud renditions of jazz variations of Yankee Doodle Dandy. Many Japanese now chewed gum and adopted Americanisms in a desire to acquire or emulate the American way of life. Even the blonde and blue-eyed mannequins in shop windows were based on the ideal western stereotype. Western conventions were often little under-stood and on one occasion Leach was appalled when press photographers invaded the stage to take pictures by flash during a performance of Okinawan dance, a particularly disturbing intrusion given the delicate eroticism of the movements.

More fundamentally, the adoption of the western way of life and American values seemed to challenge concepts of loyalty and duty, two basic tenets of Japanese culture, which to Leach threatened to denude the country of its essential qualities. Even characteristic aspects of Japanese life such as the

woven mats, *tatami*, were fast becoming regarded as too old fashioned or a luxury, while simple charcoal stoves, *hibache*, were no longer thought adequate for modern needs. Many Japanese sat on chairs rather than on the floor, symbolic of a rejection of traditional life. In the streets Japanese men and women walked hand in hand, with no signs of disapproval, so breaking the conventional taboo on men touching women in public, and even more startling was the sight of American GIs strolling about hand in hand with Japanese women. The traditional role of feminine modesty, humility and subservience was beginning to be seriously questioned, and while Leach and Yanagi were generally supportive of the concept of equality, they often retreated from it in reality. 'The man's world is the outer and woman's the inner,' noted Leach, 'and it is only recently that this is being questioned.'[52] A visit to see the film *Moulin Rouge*, based on the life of the nineteenth-century French artist Toulouse-Lautrec, served as a further reminder of the difference between the sexes in East and West.

The Japanese disregard for privacy, however, had not changed. When staying in a top-class hotel Leach was horrified when his bedroom was suddenly filled with other guests wanting to see the rooms without regard for his presence. No disrespect was intended, but Leach continued to find such customs irritating. Progress did bring benefits. Dr Horiuchi, the son of the dentist who had administered to Leach's grandparents and father sixty years earlier, provided Leach with a set of well-fitting dentures and would accept only pots as payment. Given that the general cost of living was now very similar to that in the West, with an exchange rate of nearly 1,000 yen to the pound, Dr Horiuchi's generosity was much appreciated. In 1909, Leach recalled, a pound was worth about 10 yen and 17 yen in 1934.[53]

Many of Leach's doubts about the role of tradition in new Japan were symbolized by the tea ceremony. Although he enjoyed the highly conventional and mannered rituals, admiring the specially made vessels, appreciating the poise and economy of movement, the tea ceremony had become synonymous with the fashionable and stylish, seen as offering little more than a training ground in deportment for young women. It also epitomized both a deep concern with, and ossification of, the past. However tightly tea masters sought to maintain traditional ways, when set against the rapidly changing nature of society, particularly in cities and large towns, the old rituals appeared far too rigid and stilted for modern life. In an effort to address such issues the Tea Reform Society had been set up to simplify the essential qualities of the ceremony, without losing them altogether. Yanagi, regarded by Leach as a modern master of tea, attempted to break through conventional rigidity. In seeking to preserve its essence, against a 'background of degeneracy and anachronism'[54] he practised few ceremonials, but simply proclaimed the basic principles. Yanagi's attitude was complicated by his involvement in the Mingei movement, which had an uneasy relationship with the rituals of the tea ceremony. While

welcoming many of the qualities of objects admired by tea masters, Mingei was generally wary of contrived effects, preferring the beauty of 'naturalness and health'.

While some tea masters continued to insist on traditional rites, their power as arbiters of taste and aesthetic appreciation was fast disappearing as the adherents of tea rapidly dwindled. With no one to take their place and offer guidance, Leach thought the concept of 'taste' was without either a traditional or modern structure, and Japan, like the West, was now subject to fashion, commercial forces, and media pressure. The ancient art of Japanese flower arranging, *ikebana*, was also suffering badly, with many practitioners aping without understanding the modern movement in sculpture and painting to grotesque effects. 'Japan,' observed Leach, 'is like a mask with two faces, War and Peace – The Sword and the Tea-bowl', adding 'I have been concerned mainly with the latter.'[55]

Reassuringly, the Nihon Mingeikan, the Japanese Folk Craft Museum, was all that Leach hoped for. The sensitive displays and the selection of objects won his approval. The building had escaped damage in the war and great efforts by Beth Blake, head of the Red Cross, had saved it from American occupation. At Takumi, Tokyo's craft shop, little of the quality of the carefully selected work on show at the Nihon Mingeikan was evident. Although it was filled with objects drawn from many parts of the country, the quality was poor, with 'standards of material, workmanship and design . . . deteriorating'.[56] Yet, despite reservations, Leach did hold an exhibition there.

Major recognition came with an invitation to include work in a commemorative Kenzan-Kōrin exhibition, at the Mistukoshi Gallery,[57] Tokyo. This important show was part of a renewed concern with aspects of national culture and a reappraisal of the work of traditional artists. Unlike in the West, large department stores in Japan played a crucial role in mounting historical and contemporary art and craft exhibitions. The Kenzan-Kōrin exhibition included paintings by Sōtatsu, one of Japan's greatest traditional artists, and artists of the Rimpa school of which Kenzan was a part. Leach and Tomimoto, as the two living representatives of Kenzan, following their nomination by their teacher Urano Shigekichi, forty years earlier, were greatly honoured to be asked to contribute. The invitation acknowledged their status as living exponents of a greatly respected tradition.

Hitherto both potters had placed no great importance on the title, seeing it as little more than a gesture. Yanagi, who was aware of the increasing value given to tradition in the cultural regeneration of the postwar period, encouraged Leach to take the Kenzan lineage seriously. It may have been at his instigation that Leach's pots were included, both as recognition of his artistic status and as a way of attracting publicity for the Mingei movement. The Kenzan lineage, sketchy and often speculative and with little meaningful connection between the historical and modern aesthetic approaches, nevertheless offered

an association with a long and noble tradition that added to Leach's status and his qualifications to speak about the importance of a living tradition. 'The whole exhibition introduced me to fresh pastures in art,' he wrote, 'about which I hope to compile a book whilst I am in Japan.'[58]

In order to consolidate his new-found role as representative of the Kenzan tradition Leach employed a young poet and art historian Mizuo Hiroshi to assist him in becoming more familiar with Japanese art history, in particular the Kenzan heritage, and possibly contribute to it. With his limited Japanese Leach relied heavily on the broad art historical survey *Epochs of Chinese and Japanese Art* (1912) by Ernest Fenollosa,[59] a book that had 'rescued' the Kanō heritage, and for which Fenollosa was awarded the title *Eitan*. Taking to heart Fenollosa's remark that the Kenzan Rimpa school 'had suffered from possessing no historian who had preserved biographical and other facts striking to the popular imagination',[60] Leach saw this as justification for his own research and his role as arbiter of Kenzan's work.

Featured in the Kenzan-Kōrin exhibition were representative works tracing the long Kenzan tradition, but doubts were raised over the authenticity of some pieces. Individual pots attributed to the first Kenzan seemed to Leach either deliberate fakes or produced by little known followers. Because traditional craftsmen were highly skilled in making excellent copies, the task of detecting forgeries was often difficult. Japanese artists, unlike those in the West, thought it perfectly acceptable to reproduce copies of highly regarded pieces as tribute to the status of the artist without intending to mislead, and were accepted as 'originals'. With little reliable art historical evidence as to provenance, or scientific tests to assess age, identifying genuine pieces involved the highly subjective assessment of what Leach called 'intrinsic character and merit'.[61]

With a newly acquired pride in his Kenzan inheritance, Leach embarked on serious research for a book provisionally entitled *Koyetsu-Kenzan Tradition*, on the basis that it was the great artist Koyetsu,[62] sword expert, calligraphist, lacquerer and potter, who inaugurated this 'essentially Japanese movement'. The book aimed to make use of new material, referring to original texts including Kenzan's two sets of pottery notes. To his satisfaction Leach discovered that the artist had regarded himself as creating not merely objects but environments, ordering the human and technical resources to express them, manipulating ideas as well as clay. Such a view, tying in with his own creative approach, was one with which he fully identified. As part of his research Leach sat in Kenzan's rooms at the Ninnaji Temple, removed from Omura, and walked to the site of his kiln at Marutaki, where with little regard for scholarly archaeological rigour they scratched up shards, enjoying the sensation of direct contact with the artist. The book was eventually published in Japan in 1960, and six years later in England as *Kenzan and his Tradition: the lives and times of Koetsu, Sotatsu, Korin, and Kenzan*.

Old friendships were renewed with Yanagi's wife Kaneko, Hamada's wife Kazue, Kenzan's daughter Nami (or Namiko), Tomimoto, Kawai and Takamura, who at seventy was a respected critic, poet and sculptor. There were lectures, radio talks and articles and most importantly tours of the country either looking at or collecting folk craft and raising awareness of a tradition that was rapidly disappearing, or working at country potteries. Here he demonstrated techniques, commented on work and made and/or decorated pots, which were shown in a series of exhibitions hosted by large department stores. Underlying all these activities was Leach's intention of assessing the possibility of settling in the country, and he wanted to gauge the sort of reception he would receive as a semi-permanent resident rather than as an occasional visitor.

Much of the tour is elegantly detailed in Leach's book *A Potter in Japan*, a record of what was in many ways a pioneering journey. Commissioned and published by a major Japanese newspaper, the account is both personal and subjective in giving his response to the current state of craft. Its vivid descriptions of the countryside and the people and potters he met are lovingly if romantically drawn, their solidity and stability contrasted with the uncertainties of a rapidly changing society that had little regard for much of the work they admired. Detailing old customs and rituals, Leach is full of praise for the refinement and charm of old Japan, which lay behind the noisy, brash and ugly exterior of new Japan, and is often critical of the neglect of tradition. Although written in the form of a diary *A Potter in Japan* gives few personal or intimate details, but its opinions and ideas paint a sharp and often honest, if selective, picture. He is, for example, disarmingly frank about the generosity and sensitivity of the American occupation in respecting Japanese traditions and customs, pointing out that if the Japanese had been victorious they would have imposed their ideas with brutality and ruthlessness.

In the course of the extensive tour Leach, Yanagi, Hamada and often Kawai, usually accompanied by Mingei enthusiasts, moved as a group, authoritative, respected and patrician. They spoke about the Dartington conference and the relevance of the Mingei movement today to craftsmen eager to hear their views, but not always without opposition. At Takamatsu on the island of Shiku, a 'young individual potter' at the traditional pottery village of Tobe, keen to explore new ways of working, protested that their advice to stick to 'good old traditions' was cramping. 'Be modest,' they advised, 'these results of wild experiment show indigestion, launch out into the new only as you can understand it and feel it.'[63] At Shigaraki, the unsentimental, down-to-earth potters hardly reciprocated the interest of the visitors, whose character Kawai captured astutely in the imaginary persona named Shigaraki Tōrō. For Leach it was the more sanctioned 'folk art' products that caught his eye, such as the green-striped tea jars and the 'landscape' teapots rather than early unglazed pieces and the *namako*-glazed *hibachi*.[64]

During one talk a young Japanese journalist fearlessly questioned Yanagi's aesthetic ideas, asking 'What has it got to do with us today, in a machine age?'[65] In reply Hamada spoke quietly of their visit to see Charles Eames in America. Although generally thought of as a radical, modern designer who seemed to have little regard for the past, Hamada pointed out that Eames drew heavily for his ideas on traditional design from East and West, implying that such ways of working had still much to offer. The enthusiasm for the minimalist aesthetic of Eames was not awarded to the exhibition of Bauhaus design Leach saw in Tokyo a year later. Here he met the founder of the movement, Walter Gropius. Gropius had proclaimed in 1919 that 'Architects, painters, sculptors, we must all return to the crafts! . . . There is no essential difference between the artist and craftsman',[66] but despite these shared sympathies, to Leach the Bauhaus work seemed hard and unfeeling. Its machine-like qualities led Leach to sum it up as 'Bauhaus versus Sung'.

At Okayama, 350 miles south on the Inland Sea, they met Mr Ōhara, whose father Ōhara Sōichirō founded the Ōhara Museum of Art in 1930. Mr Ōhara, owner of a successful rayon factory, like his father, was also an important patron of the arts, helping to establish the local folk museum. In honour of Leach's visit an exhibition of his early work was set up, though some of the pots Leach found he could willingly have smashed. Here he lectured, admired the austere beauty of the tearoom, found time to draw and was again impressed by the extensive collections of European art, recalling shamefully how little interest Europeans showed in Japanese work. Throughout they were treated like feudal lords, a perception reinforced when he and Hamada were given a room with a raised floor area that was formerly used by eminent visitors including the emperor. But, as Leach pointed out in a letter to Muriel,[67] in the postwar period the imperial family were no longer seen as having god-like status, and by modern standards many were comparatively poor; one or two, he claimed, were even unable to afford cars. Under the American occupation all aristocratic titles were eliminated, a decision the Japanese government chose not to rescind.

Many of the country potteries visited eighteen years earlier were revisited; some they discovered continued to make pots that retained many of their traditional qualities, though often without the vigour of the old ware, but changing lifestyles threatened their existence. In the village of Tachikui, in the province of Tamba, an area with a pottery tradition stretching back over 800 years, they were amazed by the sight of twenty-five old type Korean climbing kilns, which illustrated the long pottery connection with that country. Pots, 'comparatively unspoilt', were laid out for their inspection, and in one workshop they watched the trailing of white slip lettering made with a bamboo tool. At Tamba, nearly twenty years earlier, Leach had shown the potters how to pull handles and make spouts for their ewers, forms that continued to be made. Although the majority of the pots were still largely traditional in form

and decoration, Leach detected disturbing evidence of elaboration, what he described as qualities of 'showmanship' and 'intricacy'.

In the smoky city of Seto, the Japanese equivalent of Stoke-on-Trent, where 2,000 kilns were in operation and the river ran white with clay washings, the majority of the pots were industrially produced and Leach thought poorly designed. They did inspect and marvel at a surviving enormous old domed, climbing wood-fired *maru-gamma* (round kiln) that took a fortnight to fire and was capable of holding a quarter of a million pots. Arakawa's workshop in Tajimi, high in the pinewoods, with a simple updraught kiln, seemed the most promising pottery.

Twice Leach spent time at Yamashiro Onsen, or Spa, near Kanazawa, in the heart of Kutani, an area renowned for its enamel-decorated porcelain. In addition to decorating prepared shapes he advised on the design of a range of table-wares such as tea and coffee sets intended for the western market. Most of the modern work at Kutani, while appearing to follow tradition, seemed to Leach to have lost its finest qualities. A white, dead looking industrial body had replaced the more interesting greyish local clay, and the traditional, spontaneous, boldly painted enamel designs had given way to meticulous, easily repeatable lifeless patterns. Why, pondered Leach, when surrounded by magnificent examples of old work, in which shape and decoration had been refined over many years by tradition and convention rather than by personality or fashion, did modern potters produce such dull and poor work?

The quality of the old wares even led him to feel dissatisfied with his own pots, the over-refined body and harsh enamel colours appearing crude and lacking subtlety, while his designs seemed too sweet and soft when a stronger, harder approach would be more effective. During his second visit Leach decorated some 250 pots made in his absence to his design, on this occasion confining himself to traditional clays, glazes and a limited palette of black, blue-green and red, learning how to control the unsympathetic pigments which resisted his more spontaneous approach. Square and round porcelain dishes were decorated with over-glaze enamels, the designs kept simple with a minimum of detail. Motifs included eastern and western patterns such as a weeping willow and an onion seller as well as a reworking of an earlier design of a landscape with tall mountains. One dish, based on a sketch of Lake Shinjiko with three boats and a mountain, was minimal and sensitively abstract in feeling.[68]

After the disappointing industrial production of Kutani, Yanagi, Hamada and Kawai were particularly insistent that Leach should appreciate the 'simple and unspoilt life'[69] of the potters of the remote village of Onta (or Onda) on the southern island of Kyūshū. As an enticement the Onta potters, who worked as both potters and rice farmers, offered to build him a western bed, prepare foreign food and install a tiled bathroom. Production at Onta had changed little over the years, the long communal stoneware kilns still

stretched to the roadway and the traditional process of clay preparation retained its great simplicity.[70]

During his twenty-day stay Leach learnt the potters' techniques of producing chattering patterns using a springy curved metal tool held against the pot as it turned on the wheel, and brush decoration involving white slip over the local red clay. It is, wrote Leach 'the purity of the link between man and nature that these potters have not lost. This purity gives them a warmth that is reflected in the beauty of their pots'.[71] Under his direction the potters made plates, jars, bread-pans and big pots, which he patterned with brush and slip, and with combs and gravers. One large dish about sixteen inches (41 cm) across was decorated with a flying bird incised through white slip with a characteristic 'chattered' rim decoration.[72] Others were decorated with such designs as a frog or owl. On the jugs Leach pulled and attached handles in the English-medieval way, a technique that subsequently became part of Onta style. Over the three-week period he decorated an astonishing 300 pots, many large in size, which were subsequently well fired. During his high-profile stay at the remote village, reporters and photographers recorded his every move. This helped to make 'Onta ware' more widely known, resulting in a great increase of visitors as part of what came to be known as the '*Mingei* boom',[73] which was to change the work irrevocably.

As in other workshops, Leach was greatly disconcerted to discover the potters, thinking they were honouring him by emulating his work, proudly reproducing his shapes and patterns without any awareness of infringing artistic rights. Far from understanding or following his advice to absorb outside influence slowly, many sought to imitate his work with little understanding of what he was trying to achieve. The results of this copying were brought alarmingly home when his pots, made at the Maruzan Pottery, were put on exhibition at Takumi in Tokyo. To his horror, he discovered that almost exact copies made at Fujina, Matsue, were on sale on the first floor at about one-third of the price – some even bearing the BL signature. Yet far from seeing this as a deception the Japanese regarded it as a compliment, illustrating the vast gap between the concept of the individual pot and its associated value and the production work of the country potter.

Given his knowledge of the prevailing situation, in thinking that his much-respected pots with their high prices would not be copied, Leach was perhaps unduly naive. While insisting on the cultural value of traditional pots he overlooked fundamental changes taking place within the market, where functional 'plain' wares were giving way to more decorated and individual work able to command higher prices. At the same time Leach was well aware of the dilemma of encouraging traditional potters to continue with long established practices in a rapidly changing society knowing that they would remain poor and that the market was likely to contract. Onta and other such country potteries he knew could not be preserved as artificial enclaves, but must adapt

and change if they were to survive financially and be more than working museums. He was equally sceptical of advocating too strongly the Mingei concept of humility and 'a subordination of over-stressed individualism, which would be even more alien and indigestible'.

During several long stays with Hamada at Mashiko[74] he made and decorated pots, battling to come to terms with the notoriously short sandy clay and the restrictions of a Japanese wheel. In the past twenty years Hamada had prospered, running a highly successful pottery and establishing an international reputation. Keen to preserve the best of the past he had built up his estate, which now consisted of several acres on which stood five beautiful old buildings he had purchased and re-erected, creating a sense of timeless history. They also provided comfortable and generous accommodation.[75]

Richard Hieb was gradually fitting into Hamada's team, though he complained about finding the language impossible to learn or speak. To Leach's relief he was not attempting to make pots like Hamada but sought to develop his own style. Among all the activities of the pottery and the regular stream of visitors, Leach was again amazed by Hamada's ability to centre himself, to focus on throwing or decorating pots no matter what activity was going on around him. In one marathon session Leach decorated a hundred-odd pots that were intended for exhibition. Speed, however, did not always help, for when fired he thought the designs too niggly and tight.

In Kyoto, Leach saw Tomimoto, who was now a professor at Kyoto City University of Arts, and his new partner, Fukie Ishida, in their 'tiny bird's nest', and admired the clarity and elegance of his painting. As a mark of the outstanding artistic achievement of Hamada and Tomimoto, both had been honoured with the Order of Living National Treasure, one of the highest awards given to artists. Each had great respect for the other. Hamada regarded Tomimoto as the best artist potter, and he in turn saw Hamada as the finest craftsman potter. Unlike Hamada's pots, Leach found it difficult to be a great advocate of Tomimoto's work despite the fierce passion with which they were made, for while admiring the technical virtuosity he thought them too hard and cold. In Tomimoto's porcelain, decorated with blue and white enamels, he found a 'tight sharpness' that seemed to reflect the difficulties he had been through in his personal and artistic life, particularly during the war. Kawai, 'a warm & vivid & good man'[76] who accompanied them to many potteries during the tour, Leach found equally perplexing. In many ways commendable and loveable, and a potter with enormous skill and knowledge, something seemed to Leach to have gone wrong with his pots, some twist had occurred resulting in his shapes and brushwork becoming too flamboyant and exaggerated.

A reminder of home came with an invitation to a Coronation dinner at the British embassy to celebrate the crowning of Queen Elizabeth II.[77] To his disappointment and disapproval, national pride was threatened when thick slices

of beef and a leaden Yorkshire pudding were served on cold plates eaten at small tables on a lawn. Yet even this unappetizing collation proved more palatable than slivers of raw horsemeat or cooked young bees he was offered on various official Japanese occasions. Letters from home brought mixed news. Lucie Rie, a regular correspondent, kept him informed of craft events and the activities of personal friends including Joan Kennedy, one of Leach's recent flames. She was feeling more cheerful, Rie reported, presumably recovering after Leach's absence; later Rie wrote about the death of the weaver Jean Milne.

Infrequent letters from David brought news of the Pottery and of his acceptance of the post of pottery lecturer at Loughborough Art School, further indicating his conscious or unconscious distancing from full-time involvement at St Ives. Following a poor report of the pottery teaching at Loughborough by Her Majesty's Inspector Mildred Lockyer,[78] the principal, Jack Divine, invited David with his practical training to take over the department. Although David had limited teaching experience he saw this as a welcome opportunity to broaden his ideas. A great attraction was that the pay was three or four times more than he was earning as a potter and he agreed to take the position for a year. The day-to-day running of the Pottery, allowing it to 'find its own feet', was left in the collective hands of his brother, Michael, Bill Marshall and Frank Vibert. It was a situation that David realized was far from satisfactory but he felt that Michael still lacked sufficient management experience and tact to be left in sole charge. As he was only to be absent during term time, David intended to assume control in the long holidays. It was not a scheme Leach liked as he thought that as manager David should have a full-time presence, but again there was little he could do about it. David's year at Loughborough, culminating with a highly acclaimed exhibition of his pots alongside student work at Heal's in London, was thought a great success. A favourable review in *Pottery Quarterly*, focusing on David's pots, declared that they had 'flowered and grown in stature',[79] affirming his decision to go to Loughborough.

At this time David's wife, Elizabeth, converted to Catholicism and following her lead David, nominally a member of the Church of England, also converted, mostly out of respect for his wife and convenience for his family, although he remained an active and committed member of the Oxford Group. Leach, having rejected Catholicism fifty years earlier, was deeply suspicious of organized religion and found such a decision unthinkable. 'Your wife needs a kind master not a kind servant',[80] was his uncompromising view, indicating his own edgy relationship with his daughter-in-law and something of his own fraught relations with women in general. David's restlessness was further illuminated by accepting an invitation to set up a pottery workshop producing tablewares for the Carmelite Friars at Aylesford in Kent.[81] The offer came from Father Malachy Lynch, an imposing god-like figure with a beaked nose

and white shoulder-length hair, who was a keen supporter of Arts and Crafts ideas. In addition to establishing a pottery he instigated a printing press, which was also intended to be a creative activity for the Brothers. Setting up the pottery involved building an oil-fired kiln and designing a range of tablewares that could be made by the friars, used in the friary and sold to the many visiting pilgrims to raise funds. The scheme again meant long periods when David was away from the Pottery, adding to management problems.[82]

A more poignant reminder of his family came when Leach visited a school and hospital in Tokyo that cared for 160 children, aged between ten and sixteen, with cerebral palsy. With his daughter Betty in his mind Leach was amazed by the progress achieved, discovering that when the children entered the clinic few could stand or walk but with skilled teaching many were able to do so, some even gaining sufficient control to take up semi-independent lives. Despite limited funds, the school was equipped with bars for exercise, walking frames and bicycles, and had classes in carpentry, weaving, pottery and painting, with boys and girls working happily alongside one another, all unthinkable in Leach's experience. The positive approach and creative atmosphere, in which sentiment was replaced by self help and shared mutual support, was highly effective. The head teacher, Mr Matsumoto, had firm views, believing that to develop fully children needed to be away from home, as often the very love of their parents stood in the way of encouraging them to do things for themselves. 'It made me so sad,' Leach wrote to Muriel, 'that we never had the advantage of such a place for Betty, her whole life could have been changed, developed and given an objective.'[83]

What was particularly significant was to hear that the latest medical theory believed that the condition was not hereditary but usually occurred when too much pressure was placed on the child's brain during birth causing blood vessels to break. Other factors were extra pressure in the womb, especially in the case of twins, too narrow a birth canal, or too quick a delivery. After years of anxiety and feelings of guilt for having married his cousin, it was greatly reassuring to be told that this was not the 'cause' of Betty's condition. Sadly the treatment was too late to help Betty. As gifts for his daughter the children gave him a blue-pink shawl and red knitted cap.

A series of regular exhibitions of his pots, drawings and designs for interiors were a great success. His first one-person show of 119 pots and nineteen new drawings sent out from England, held at the Matsuzakaya department store, sold out in three days. Eminent visitors included the emperor's younger brother and his wife, Prince and Princess Takamatsu, who subsequently invited him for tea. The royal couple struck Leach as thoughtful, intelligent and genuinely interested in modern craft. Subsequent shows at Nagoya and Osaka featured work made in Japan. Unlike England, where the general attitude was that he should concentrate on making pots, his drawings, which in Leach's view ranked alongside his pots, were enthusiastically received.

One of Leach's collaborative projects was a book involving Hamada, Kawai and Yanagi, provisionally entitled *Way of the Potter, East and West*, which combined practical information on kilns, clays and glazes with broad philosophical ideas around making. To continue work on the book and escape the August heat, Leach, Hamada and Yanagi moved to the central mountains of Shinshu, the Japanese alps and the luxury of the Kazanso Hotel. Situated in the beautiful valley of Matsumoto, at 3,000 feet it was 'cool, quiet, comfortable & glorious'.[84] For part of the time they were joined by Kawai, who proved a mine of information having extensive knowledge of making and firing. In the city of Matsumoto, nine miles away, Leach collaborated with a small group of 'keen & intelligent' woodworkers on the design of chairs and tables basing them on a 'lovely old N. England light Windsor chair. It's fantastic, if I make any suggestion on a scrap of paper in two days it is carried out'. Excursions included a visit to Kashiwabara to see the last home of the famous haiku poet Issa, where the poet had died in poverty 120 years earlier. They admired the spartan austerity of his single room with a tiny window. Learning of Issa's unhappy childhood and cruel stepmother, Leach was sufficiently stimulated to attempt to translate some of his couplets.

As Leach's renown spread, so he was invited to take part in a wide range of artistic and educational events. At the last moment Trevor Thomas, the British organizer at the Tokyo UNESCO conference on the subject of craft in education, asked Leach to be the official British observer. Apparently a letter had been sent to England but had not yet reached Leach. Much to his surprise neither Hamada nor Yanagi were invited, nor was the Nihon Mingeikan represented. The organizers, he discovered, knew nothing of the Mingei movement or its work in fostering the crafts, the Japanese Ministry of Education having failed to draw their attention to it. As in old Japan, government bodies distrusted independent institutions, preferring to exercise total control. At the conference, bristling with international delegates, Leach was in his element. Seizing the opportunity he decried the attempt 'to inject a dose of crafts' into 'a Western kind of education born of the machine age',[85] and proposed an education programme that took account of the head, heart and hand. Appointed chairman of a sub-committee to look into the possibilities of preparing a 'how to do it' book of crafts, views were heard from representatives of several eastern countries. After three days of deliberations the committee turned down the project, saying that a single book was not only impractical but also undesirable as it would fail to recognize the qualities of individual cultures. Instead they recommended that each country should investigate its own crafts and report back to UNESCO.

Throughout his time in Japan Leach searched out fellow Bahá'ís, as he did in every country he visited, attended as many meetings as possible and generally sought affirmation of his own ideas among other adherents. He was able to remind them that the pioneer Bahá'í Agnes Alexander, who had been born

in Hawaii and travelled to Japan to spread the faith, had introduced him to its ideas forty years earlier. Wide-ranging discussions included difficult subjects such as concepts of God and Bahá'u'lláh's planning of world peace, topics that seemed especially relevant as they heard American bomber aircraft flying to Korea. With his views on education much respected he was invited to serve on the teaching committee of the faith in Japan. As a proclamation of his own thought he wrote 'My Religious Faith', a personal statement 'giving my belief and the cause of it', which he had printed in English and Japanese and issued as a leaflet. Copies were sent to Muriel for her to distribute among friends and acquaintances.

Just as in England, few of his Japanese friends were sympathetic to his Bahá'í beliefs, and many were openly suspicious of what they saw as a new religion, mistrusting its commitment to the concept of a Commonwealth of Nations. Like Laurie they also saw it as in competition with Leach's artistic vocation. Yanagi in particular was deeply sceptical demanding to know 'what in the Bahá'í teaching is greater than Buddhism?' In Leach's enthusiasm to talk to or entertain fellow Bahá'ís, few of whom he knew, old friends were often ignored. The Horiuchis in particular felt hurt and slighted when brushed aside in favour of Bahá'ís, especially after he had willingly accepted their warm-hearted Christian hospitality, enjoyed excellent homemade western food and a western-style bed.

With a full programme of visits to look at pots, work with potters, lectures to large groups of people and attendance at cocktail and dinner parties, at times Leach felt slightly smothered and homesick. Although always treated as an honoured guest, there was the physical discomfort of living in rooms too small for his large frame, sitting cross-legged on the floor without the support of a backrest and endlessly taking off his shoes to enter houses. With no settled base he tired of having to live out of suitcases and rarely had the opportunity to put out all his belongings. He also felt lonely. 'This world of half under-standing & half speech leaves a warm part of oneself cold,' he wrote to Lucie Rie. 'The easy emotional contact with women – womanhood is lacking . . . one does not get from the society of Japanese women the same response, at least I don't, although they have emerged much in eighteen years.'[86]

There were other difficulties, in particular his relationship with Yanagi, one of his oldest and most respected friends, which were both personal and ide-ological. With the Nihon Mingeikan now firmly established and the Mingei boom in full swing, Yanagi was accepted as the head of a major new move-ment in Japan, able to look to the past, the present and the future. Yet Yanagi's enthusiasm to embrace such 'revivalist', but individual, makers as Hamada, Tomimoto and Kawai within the Mingei movement presented Leach with pro-found problems. They were not, or ever claimed to be, 'anonymous crafts-men', a concern which lay at the heart of Mingei, and Leach had difficulty in reconciling these apparent contradictions.

Such ideological differences paled into insignificance in the face of what Leach saw as Yanagi's personal duplicity. While advocating the importance of the religious and non-individualistic attitude to work, and playing down the importance of the ego, far from living modestly by such ideals Yanagi seemed to relish power and authority, often disregarding the needs of others. Even Kaneko, his wife, was pushed aside and her needs overlooked resulting in much unhappiness. To Leach Yanagi appeared to be 'growing unchecked into irresponsibility, selfishness and pride',[87] his hypocrisy making it 'more difficult to see and love Yanagi the man'.[88] In addition to his swaggering confidence and neglect of his family, there were also financial issues. In the mid-1930s Leach had left funds for Yanagi to purchase a plot of land, none had been acquired but requests for their return went unheeded. Neither were loans repaid nor were monies for pots sold. As a further complication Leach was aware of accepting and enjoying Yanagi's hospitality.

Nevertheless, as an old and trusted friend he felt duty bound to express his thoughts, deciding to explain his misgivings during a long walk. It was a tense discussion, but having started he felt he must continue. Taking as his starting point his own unhappy past, he expressed his concerns about Yanagi's coolness towards Kaneko's emotional and practical needs. 'The gradual division', he noted in his diary, 'the repeated aggravation of the drop of water which always falls in the same place – the mounting and mutual hatreds – the attraction to other women following or the isolated whirlpool of self unconscious of its egocentricity'[89] was how he saw Yanagi's behaviour. It was an observation little short of an acute self analysis. Aware that by raising such sensitive issues Leach risked accusations of interfering, particularly given his own fraught emotional relationships, after initially brushing aside his remarks Yanagi listened. It was a tribute to their mutual respect that they parted with no apparent ill feeling, remaining good friends and continuing to travel and work together.

In addition to experiencing a contradiction between theory and practice, between what Yanagi taught and what he did, Masu Minagawa,[90] now in her eighties, shook his belief in the inherent satisfaction of handwork. The much lauded decorator of teapots, who had worked for over seventy years at Mashiko, was praised as an example of an 'authentic' country potter and Mingei artist who found full satisfaction in her work. When casually asked by Hamada if she had liked her job she retorted 'No I did not. I can't read or write my own name – I only lived by repetition'.[91] Far from confirming a romantic notion of the enlightening value of making by hand, her comments were a severe jolt to the reassuring concept of simple fulfilment and intrinsic joys of anonymous craft work.

On Christmas Day 1953, like the previous year, Leach reflected on his friends, family and career, lit candles on a tree and gave presents. Yet, despite eating dinner with fourteen friends he felt lonely and recalled other, happier Christmases. Far from the reassuring support of home, he wrote one of his

most poignant poems 'Romney Marsh'. The brief but revealing lines offer insight into his profound sense of isolation at the failure of his relationship with Laurie, who had settled with Maurice on Romney Marsh, the final three lines in particular evoking his sense of loss and sadness.

> Sheep are nibbling the grass
> On Romney Marsh,
> Would I had a pillow
> On Romney Marsh
> Where flat winds blow through willow.
> Love's door is shut on Christmas Day,
> My heart is full on Christmas Day
> Of what has been, great seas between.[92]

Little though he knew it at the time, love's door was not to remain closed for long, and a new and important relationship was about to shape the remainder of his life.

BODY AND SOUL

Japan England USA
1954–1961

Two letters, beautifully typed, arrived from Janet Darnell repeating her request to work in Japan. In them she further outlined her experience of living in a Steiner community,[1] her involvement with anthroposophy, and her search for some sort of meaning and feeling in her pots. Janet had decided to type her letters believing that the Japanese judge character by handwriting and doubtful that hers would meet with approval. Leach, remembering their lively conversations, her alert and intelligent mind as well as her warm personality, became convinced of her sincerity, and Hamada agreed not only to sponsor her but also offer her accommodation in the gatehouse.[2] Noting her skilled typing, Leach hoped that she could type for him. A regular correspondence ensued in which he described modern Japanese society as outwardly 'so ugly, noisy and vulgar, the reverse of the picture of old Japan',[3] but, he added reassuringly, in the area of the handmade old and new did overlap.

On 3 June 1954 Janet arrived at Yokohama on the cargo boat *Canada Mail*, and as arranged travelled by taxi to meet Leach at the Takumi craft shop in Tokyo. For the next week Leach took her on a whirlwind tour of the capital's crowded streets, showed her old buildings and escorted her around the Nihon Mingeikan. He introduced her to some of his friends such as the Livingstons, through whom she met the painter Donatienne Lebovitch who subsequently offered Janet the use of her studio in Tokyo. She went on to Mashiko[4] leaving Leach to supervise the installation of an exhibition of work by himself, Tomimoto, Kawai and Hamada at the Takashimaya department store. Although this sold well, he thought the work, including his own, below par.

Mashiko proved more difficult than Janet had imagined. Although she had been attracted to Japan by Hamada, and never ceased to admire his ability to combine traditional and modern elements in his work, she sensed he was reluctant to take her as a student. He suggested that she observe rather than participate and seemed disinclined to talk to her. There was also jealousy from Richard Hieb whom Janet suspected viewed her as an unwelcome rival. Given this frustrating experience she readily accepted Leach's offer that she accompany him as his secretary on his tour. She had the necessary skills and with

Leach she could meet potters and see something of the country. She also sensed his loneliness and his need for female company.

During their travels she told Leach more about herself, her escape from what she described as a stiflingly narrow Methodist home in Grand Saline, Texas, to live with relatives first in Dallas and then Houston. In her late teens, determined to pursue a career as a sculptor, she and a friend scraped together sufficient funds to travel by Greyhound bus to New York where she became a sculptor's assistant. During the war she qualified as a certified welder at Bethlehem Steel, and worked in a dockyard. As a symbol of her independence and emancipation she rode a motor cycle that she named 'Dude'.

After the war, aware of the problems facing women sculptors in a male-dominated world, she started to work with clay and immediately felt that the material was right for her. For a time she taught at Rockland State Mental Hospital and subsequently in a pottery. Passionately egalitarian she committed herself to the communist cause for a time but eventually baulked against its unrelenting demands and party discipline. Following 'the Christian impulse in which love was brought into the world',[5] she became a potter in a Steiner community at Threefold Farm in Spring Valley, New York state. However, the two weeks at Black Mountain College had opened her eyes to other ways of working with clay and she had no hesitation in wanting to study in Japan. To raise funds she frantically made terracotta birdhouses and other commercial pieces, in ten weeks earning an impressive $1,000. Despite this she travelled by the cheapest cargo boat.

In the heat of August they escaped to the luxury of the Kazanso Hotel, Matsumoto, to enjoy the cool mountain air and to work on various manuscripts including Leach's Japan diary and the Kenzan book. Hamada, Kawai and Yanagi came to discuss their book on pottery,[6] and one afternoon Kawai produced the equipment for ceremonial tea, *matt-cha*. He attempted to teach Janet the elegant rituals, but decided that until her 'soul was attuned' her efforts would inevitably lack the required grace and beauty. She subsequently retreated into the more mundane work of typing the chapters of the books Leach was steadily writing.

Yet far from remaining a purely business arrangement Leach and Janet quickly became close friends and subsequently lovers, spending increasing amounts of time together, often experiencing the pleasure of finding themselves in complete agreement about what they wanted to do. They wandered the hills admiring the grasses and pines of the steep slopes with their orange and pink flowers; they sat and watched the dragonflies and listened to the chirping of the crickets or *semi*. They marvelled at the simplicity of the life of an old hermit nun who lived in a white hut in the mountains, accepting her gift of a Buddhist rosary. In the seclusion of the mountains they felt able to speak openly of their past lives, their hopes and ambitions, with Leach confiding the problems of his marriage, of the Pottery, the possibility of

settling in Japan, the importance of his faith and his proposed visit to meet the Guardian of the Bahá'í faith at Haifa, Israel.

After the peace and seclusion of the mountain retreat, touring Kobe, Kyoto, Tamba and the area north of Mashiko, meeting potters and looking at pots, involved more mundane matters such as finding suitable hotels where they could maintain a degree of privacy. In addition, in traditional Japanese hotels Janet found the toilet[7] arrangements worryingly primitive. Guests had to supply their own toilet paper, and the floor hole, usually an oblong slit some three feet long and one foot wide, was far too small. Only in western-style hotels did they feel safe from inquisitive eyes.

The affair with Janet, passionate, loving, accepting and physical, threw Leach into confusion for he had come to Japan still hoping for an eventual reunion with Laurie and he regularly dreamt about 'her pale face and dark eyes'.[8] Although greatly flattered by Janet's attention and concern, and appreciating her understanding and powerful physical presence, he still felt unable to declare his love. Some time later he wrote to her of this period, telling her 'you wanted me to light the candles of love and I did not'.[9] He was also aware of his commitments to the Pottery, for although he had given David the building, they were equal partners in the business with responsibilities on both sides. With the possibility of a serious relationship with Janet, his planned visit to Haifa took on even more importance in helping review his future, his work as a potter and his devotion to the Bahá'í faith.

They did, however, make tentative plans for their future. One idea was for Leach to return to Japan within a year, marry Janet in Hong Kong and then settle permanently in Japan where they would buy a house and set up a pottery. As a first step he gave Janet £500 to purchase a suitable property near the old capital Kyoto, which, apart from being a good distance from Tokyo, had the added attraction for Leach of an active Bahá'í group. He encouraged Janet to read about the faith, hoping that she would discover its meaning and value, but she remained cautious and uncommitted.

Leach worked at Mashiko for his final and largest exhibition, at the Mitsukoshi department store, in November.[10] This included 250 pots, a hundred drawings and fifteen scrolls or *kakemono* in addition to six sets of chairs and tables he had designed and a model western room that he had furnished. At the opening the crowds flocked to pay homage to the esteemed visitor, and an astonishing 90 per cent of the work was sold on the first day, resulting in takings of over £1,000. Royal visitors included Prince Mikasa, Prince Takamatsu and Princess Chichibu. When the time came for farewells several small private gatherings were arranged, including one with Kame-chan's seventy-eight-year-old mother. Kame-chan, Leach had been told, had died of consumption and no one knew what had happened to the body. At a much larger party held at the Nihon Mingeikan, Leach once more upset many of his old Japanese friends by favouring Bahá'ís, most of whom he hardly knew.

At the airport Janet,[11] along with some forty friends, came to wish Leach goodbye. Following Leach's departure Hamada suggested that Janet work at Okinawa, which would be warmer in the winter months, but having visited Tamba in the mountains and admired its austere wares, she was determined to brave the bitterly cold weather and work there. She came to an agreement with the Ichino family of potters to study traditional making and firing techniques as well as make her own pots, and hoped to learn Japanese from the children.[12]

As arranged, *en route* to Europe Leach spent ten days at the World Centre of the Bahá'í faith at Haifa on Mount Carmel in northern Israel. Symbolically positioned halfway between East and West, and so bridging the two aspects of his life, he looked forward to meeting Shoghi Effendi, great-grandson of Bahá'u'lláh, Guardian of the faith and 'the expounder of the words of God'. His intention, he told Janet, was to go as 'near naked as I can'[13] without any preconceptions about whether to pursue his career as a potter or commit his life to the faith. Planning what he wanted to say, he noted in his diary 'I believe that you represent Bahá'u'lláh and are guided by Him, and that He was and is the creative mind of the age of the unity of man — use me if you can'.[14]

The centre overlooked the port of Haifa 600 feet below and was an extravagant combination of elegance, splendour and calm. The rococo gardens, created out of a barren hillside by ingenious irrigation, were strewn with eagles and peacocks made in lead and many plinths bearing Italianate urns that Leach thought unnecessarily showy. Recalling that pivotal religious figures such as Zoroaster, Moses, Jesus and Muhammad as well as Bahá'u'lláh had trodden there, he found the ten days intensely moving. At the Tomb of Báb, with its magnificent, reflective golden dome, he slipped off his shoes and entered the vaulted chamber, where, he recorded, 'I fell to the floor and poured out my heart with irrepressible tears'.[15]

Each day Leach talked with Shoghi Effendi and with his lively Canadian-born wife Rúhíyyih Khánum.[16] The Guardian, noted Leach, was short of stature, clear in speech and thought and without prejudice. Although he did not strike Leach as a great personality, he believed him to be utterly dedicated and 'great in the powers of reflection, his soft brown eyes taking in things and people, looking through rather than at'. His response to Leach's earnest questions was tantalizingly enigmatic. When Leach asked about settling in the East or West, he was told that he was needed at both ends, and received much the same answer to his enquiries about whether he should work as an artist or devote his life to the benefit of the faith. The reply that they need not be separate but could be united effectively left Leach to decide his own future. The Guardian did drop his enigmatic approach to stress that Leach's international status as an artist was of great value to the faith, and in discussing Leach's possible remarriage, assuring him that a four-year separation was considered

sufficient evidence of the ending of a relationship. Other topics discussed included the design of Bahá'í public buildings. Here both hoped for a new and universal style that would reflect the spiritual content of Bahá'u'lláh's vision rather than one that adapted existing religious architecture.[17] Leach considered the ten-day visit to have been 'a turning point in my life. This was Reality – no dream'.[18]

On leaving Israel Leach flew to Paris for a three-day visit to see Mark Tobey, who had been to Haifa some twenty-eight years earlier. In England Leach stayed a few days with Laurie and Maurice. After their long separation much of Laurie's anger and frustration appeared to have dissipated, and while Leach thought her still 'full of nervous tension', when discussing their relationship it rapidly became clear that Laurie had long given up any hope of rescuing their marriage. They also talked of Maurice who, Laurie complained, occasionally reacted violently, and Leach promised to help care for him from time to time. The calm atmosphere was rudely shattered when Leach spoke of Haifa and his discussions with the Guardian. Laurie, still adamantly opposed to his beliefs, refused even to speak about them and during one particularly angry flare up, before walking out, accused him of hypocrisy in preaching one thing and doing another.

They did speak of divorce. Laurie agreed in principle, but whenever it was subsequently raised she repeatedly threatened to withdraw consent out of feelings of anger and resentment at what she perceived as Leach's selfish behaviour. When Leach offered to pay her a modest weekly sum of £2 she finally gave her permission. The petition, on the grounds of adultery, was filed in September 1955 and made absolute on 19 March 1956.

There were problems of a different kind with Muriel. She had been unwell for some time and cancer of the bladder was eventually diagnosed. Despite two operations and repeated blood transfusions her condition continued to deteriorate. Betty, who had lived with and been cared for by Muriel was reluctantly placed in a home, a traumatic event that served only to reinforce Leach's feeling that he 'had failed her needs'.[19] Muriel's death on 17 July 1955 was a great sadness to Leach, the family ties, children and shared experience running hand in hand with unresolved guilt about the collapse of their marriage and the unhappiness he had caused her. Perhaps because of this he insisted on being a pallbearer at her funeral, a gesture that would have been less well received had the family known he was contemplating a third marriage. In her will Muriel provided a measure of financial independence for the five children but slightly to Leach's chagrin left him nothing.

To add to his worries, things were not going well at the Pottery. With David often away in Loughborough, Michael had directed the crew with only limited success. Kenneth Quick, one of the most skilled and experienced potters, had left after a disagreement and set up Tregenna Hill Pottery in the town, though he found it hard to make a decent living and suffered from severe

migraines.[20] Other members of the crew also threatened to leave. Although Bill Marshall kept a sharp eye on the standard ware, concern was mounting about overall direction. Leach's return did have a calming effect and while he spent only short periods at the Pottery his presence seemed to raise morale. Various apprentices, including Peter Wood, assisted the regular crew of Bill Marshall, Horatio Dunn, Scott Marshall, Frank Vibert, Joe Benny and Dinah Dunn.

After the comforting physical and affectionate intimacy provided by Janet, Leach felt lonely in England, his isolation exacerbated by the decision not to reveal to his family his plans to marry for a third time. Furthermore, he sensed that his absence in Japan had led to a feeling of separation from the family. Sometimes he had the impression of being viewed like a loved but inanimate piece of old furniture, something to be put in its place and walked around rather than cherished. Equally depressing was the suspicion that in England he had gained a reputation for being 'an old fossil', something he had never experienced in Japan. A sense of drift informed Leach's mood, and even the annual New Year fancy dress Penwith Arts Ball did little to lift his spirits.[21] Now he felt that Ben Nicholson's and Barbara Hepworth's work was 'lacking warmth, blood and heart',[22] and the art at the Penwith filled him with despair.

In long, passionate letters to Janet he poured out his feelings about their relationship, the Pottery, his family, friends, and his deepening conviction that they should marry and settle in Japan.[23] Her replies were often frank and revealing, with Janet writing directly about their 'fucking' and love making in a manner that both shocked and delighted him in equal measure. She related a story about Richard Hieb who, at Hamada's suggestion, had worked with potters on the Okinawa Islands. After living like a native he returned to Mashiko enthusing over the Okinawans whom he saw as so natural and unin-hibited that they relieved themselves anywhere, even on the footpaths. 'Got to shit in the path to be a good potter',[24] was Janet's dry and unenthusiastic response, an anecdote Leach gleefully repeated to close friends.

Japanese sanitation proved something of a hobby-horse to Janet and when writing to friends in America she was equally forthright in giving detailed and amusing descriptions of Japanese toilet arrangements and the problems these posed for westerners. She also commented on the habit of Japanese men peeing in public and, while claiming never to have seen a Japanese penis, speculated that they must be more than adequate judging by the number of children around. That aside, her greatest annoyance were the newspaper reporters, intrigued by an American woman working in a remote country pottery, who constantly pestered her for interviews and photographs.

The correspondence between Leach and Janet tells of a growing love and devotion, a physical desire allied to emotional and intellectual commitment. Leach confessed to her his own feelings of profound guilt at leaving Laurie

in 1934 to go to Japan knowing she had conceived his child, one of the few surviving references to the traumatic event. She in turn gave details of her failed marriages, the first at the age of twenty the other when twenty-three, and suggested that they both needed to learn how to love before they could build anything for themselves. To her amazement and not a little concern he told her of his increasing involvement with spiritualism, of his efforts to make contact with the dead and his desire to look into the future. A young doctor, he reported, who usually worked 'dealing with the mentally defective', had read his palm, describing him as 'very sensitive, intuitive emotional type but also intellectual'. That, added Leach 'set my life problem. That the intuitive was uppermost, warm and generous, almost a missionary!'[25]

Other subjects in the letters ranged from endless discussions of the Bahá'í faith, which Janet was still keeping at arm's length, to whether or not Leach was still fertile, a theme she did not want to pursue. Although nearly twice Janet's age, Leach had proved an active lover who, she believed, 'could still put a couple of Texas boys I used to know to shame'.[26] Leach made her feel relaxed and at ease. He, in turn, believed that he had found a richness and naturalness 'on two plains – the spirit and the body',[27] and they finally agreed to marry and settle in Japan. After his experiences in America and his poor view of American pottery, Leach may also have felt able to guide Janet both artistically and spiritually, and in some ways saw her as much a student as a lover. This, however, was not Janet's view. As a forceful and often outspoken personality, she saw herself as an independent potter and someone with her own political and spiritual beliefs.

In the meantime, Leach accepted invitations to tour. In March he travelled to Scotland where he spoke to 'responsive and warm' audiences; he lectured in Manchester and in London, speaking at the Institute of Contemporary Art (ICA) on 'Impressions of Japan',[28] and to the Oriental Ceramic Society on 'Japan Re-visited: The First Kenzan'.[29] In May, Mark Tobey, 'older and more casual and untidy and grumbling and self-centred on the surface but underneath very loveable and penetrating',[30] arrived in England for three weeks, much of which they spent together. In August, Leach attended the Bahá'í summer school where amongst others he met Gertrude Scott, known as Trudi, whom he described as a 'plain but honest Bahá'í'.[31] Born into a Jewish family in Manchester she was still recovering from a failed marriage to a bullying husband. A warm friendship developed, and Leach told her much about his private circumstances.

Leach's long-term plans were thrown into confusion when friends in Japan began to question the wisdom of him moving there permanently. In addition Yanagi had many misgivings about Leach's intended marriage, suspicious of what he perceived as a pushy American woman. He feared that the relationship would have a negative effect on Leach's work, and quoted other friends who thought Janet was not 'a woman for you'.[32] Even Hamada was cautious,

and although he had supported Janet in her endeavour to study and learn, he had done so probably only at Leach's request, and maintained a distant attitude to her personally. Janet quickly became aware that Hamada believed Leach should remain in England and manage his own Pottery. On the equally pressing question of Leach taking up residence in Japan, a letter from Yanagi[33] was greatly disturbing. Written, Yanagi said, after great deliberation among Leach's close friends in Japan, he obliquely warned Leach that there would be problems if he sought to change his status from a revered and respected foreign visitor to making his home there, and proposed that Leach stay in England. While Japanese etiquette prevented him spelling out such concerns explicitly, the meaning was clear.

Recalling his disillusionment with Yanagi's behaviour and their subsequent discussion Leach questioned his motives for writing such a letter. He concluded that Yanagi, while wanting to continue to use his name and prestige to promote the Mingei movement, feared his move to Japan could threaten his own authority. He also felt that the overwhelming exposure from the sixteen exhibitions mounted during his visit had been largely created by Yanagi, seemingly forgetting his own financial gain. In the end there seemed no alternative but to accept Yanagi's advice to remain in England; Leach cancelled his plans to return, the search for property was abandoned and Janet agreed to come to St Ives and to be his wife.

Such a drastic change of plan meant a fundamental reassessment of their relationship. In Japan Janet and Leach had got on well and her letters contained numerous expressions of love for him and respect for his work, but moving to St Ives and dealing with his family had not been part of the original proposal. Equally, while admiring Leach's pots, she saw Hamada as her natural teacher and by living in England contact would be broken. That she consented to such a radical change in their plans implied both love for Leach and a desire to spend her life with him, though in some people's eyes her decision was based on ambition; many of Leach's friends in Japan suggested both at the time and subsequently that Janet had 'set her cap at him', marrying a respectable and highly esteemed artist principally for mercenary and career reasons. Some of her own close friends also believed that Leach should have been told about her unconventional sexuality, the fact that she was attracted to women as well as men, before they agreed to marry.

Although David knew of his father's plans to divorce Laurie, Leach only told his son about the proposed marriage to Janet and their intention of settling in St Ives after accepting Yanagi's advice to stay in England. This came as a terrible shock to David, for when his father had left in 1952, not only had he given his son the property but also hinted strongly that the Pottery was now in David's charge. Although part of him had been wary of assuming the role of leader and manager, David had nevertheless been attracted by it, and had risen to the challenge, and he felt 'an instinctive negative reaction'[34] to

the news. In practical terms he doubted if such an arrangement would work and emotionally he was reluctant to share the Pottery with another potter who was so closely involved with his father. In the face of his father's decision he felt he had no option but to leave and establish his own pottery. The move would also enable him to set up his own home, which with two children and a third expected, both he and Elizabeth felt was timely. Using his mother's inheritance he acquired a handsome Edwardian house with a pottery studio in Bovey Tracey in south Devon,[35] but in view of Elizabeth's pregnancy decided to delay their departure until after the birth. In contrast, Michael was keen to remain at the Pottery, despite his father's proposed marriage, but Leach decided against him staying, principally on financial grounds, and Michael also left to set up his own pottery in north Devon.

David's departure was traumatic. Loosing such an able and loyal partner had not been part of Leach's plan, and he believed that David was being unduly influenced by his wife who was attempting to secure their marriage, which was then experiencing difficulties, rather than making a rational decision. Any possibility of Dick Kendall taking over as manager was ruled out when disseminating sclerosis was diagnosed, a progressive condition for which there was no cure. Given all the problems Leach had little choice but to take charge of the Pottery for the first time in nine years. When he told the crew about his forthcoming marriage, Bill Marshall, the most senior of the potters, diplomatically replied that it was Leach's business. Most of the crew's anxieties were of a practical nature, concerned with job security, wages, the bonus scheme, the impact of any debt to David and, given Leach's age, the long-term future of the Pottery. Although naturally apprehensive, they seemed ready to accept Janet and while suspicious of her motives in marrying a famous potter, hoped she had a sound business sense that would ensure the Pottery's viability. This was being affected as much by external forces as by changes of personnel, for the imposition by the government of a flat rate of 30 per cent purchase tax drastically increased prices and depressed sales to the extent that Leach wrote a letter of complaint to *The Times*.[36] He also had to come to an acceptable financial settlement with David for his share of the business and his ownership of the Pottery buildings. This proved to be difficult and the problem rumbled on for many years.

Apart from occasional prostate problems and what he called losses of memory, Leach was in robust physical health and had few anxieties about his relationship with Janet, seeing her as 'experienced, capable, hardy and a deeply sincere woman'.[37] However, managing the Pottery proved a more demanding task than he had imagined and he confessed to Janet that he was struggling, an admission that must have alerted her to the role she would be expected to fulfil. Sensing that in a situation where Leach was well established and she a stranger, she broached the possibility of them setting up home together before committing themselves to marriage. Even though they had lived together in

Japan, Leach rejected the idea, arguing that as a devout Bahá'í this would be wrong.

To his credit, Leach did try to prepare Janet for life at St Ives. He outlined the responsibilities of running the Pottery, his problems with David and Michael, and the difficulties of his protracted divorce from Laurie. Leach's belief that his children would be less hostile to Janet than they had been to Laurie because she was not breaking up the family was at best only partly true. His daughters, although surprised by their father's decision to marry again and to a woman nearly thirty years his junior, supported him, but David and Michael objected on religious grounds, though when challenged reluctantly agreed that their father could not be bound by their own moral scruples.

Janet's ship docked at Dublin on 6 January 1956, the day after Leach's sixty-ninth birthday. She then travelled to Liverpool to be met by Trudi Scott, who Leach told her had an 'interesting plain face' and would be wearing 'an off white coat, a pale green hat and will carry a large red handkerchief'.[38] Maurice, who Leach was taking care of over the Christmas holiday, was put in the care of friends so that Leach could meet Janet at London's Euston Station. Until their marriage Janet lodged in St Ives with Mrs Richards, 'kind and talkative and elderly', who had taken pottery students for thirty-four years, but she took her meals at Pottery Cottage. In preparation for her arrival Leach tried to tidy up the cottage, which had been greatly neglected after being occupied by a variety of students and visitors. To Janet it seemed dark and crowded with objects and furniture, the curtains were in shreds, and the whole place was desperately in need of an overhaul. As a great hoarder Leach kept volumes of letters, books and papers, so while being sincere in wanting to create a home for them both, he was reluctant to allow anything to be changed or thrown away, making it difficult for Janet to feel any sense of ownership or give the cottage the imprint of her own personality.

They were married at Penzance Register Office on 26 March 1956[39] witnessed by Leach's eldest daughter Eleanor Nance and by Margery Horne. This was followed by a three-day honeymoon spent touring round the Lizard peninsula in a Hillman car bought for £250. It was an opportunity for Leach to enjoy his new wife's 'insight and integrity', and as he wrote explicitly to Mark Tobey 'Janet has a body and soul and we meet on both planes'.[40]

When the honeymoon was over Janet had to begin to establish herself as both an individual potter and a manager. This, as she suspected, proved far from easy. She had no experience of organizing a team of potters or supervising regular production, and her understanding of the processes involved was distinctly patchy. There were inevitably many teething problems. The cardboard guides to the shape and size of the items of standard ware were unaccountably found to be missing and had to be redrawn with the co-operation of experienced hands such as Bill Marshall. Each week a 'make list'

was drawn up of items in the catalogue that were required to fulfil orders and replenish stock as well as suit the packing requirements of the kiln. This involved keeping a close eye on the order book, an understanding of the complexity of each piece and what each thrower could be reasonably expected to make in a week. With her limited experience, Janet's lists tended to be light rather than demanding, a change not always welcomed by the throwers who wanted the Pottery to succeed and were anxious to earn bonus payments. It was not a promising start.

However inexperienced, Janet was soon instigating changes. The working day was retimed to begin at nine rather than eight, and both she and Leach felt they needed a new clay body. Preparation of clay was a lengthy, labour intensive process, and after working with country potters in Japan Leach started talking about wholemeal bread instead of puffed up white and wanted a body with more character. Alternatives were investigated, modifications made and eventually a more textured clay, dug by Joe Dobble, a farmer in St Agnes, became the standard body.

Throwers, encouraged to develop individual styles, had been allowed to put one pot of their own, no bigger than six to eight inches (15–20 cm), in each kiln, which if well fired was sold in the showroom, the potter receiving a third of the selling price. Janet thought this restriction impossibly mean and discouraging, and the number was increased. A pot book was introduced to record what was being fired, but there were still disputes about what should go in the kiln. On one occasion Leach found his pots had been left out and Janet remonstrated with Bill Marshall and the kiln packers to ensure that in future Leach's pots should go in first and in the most favourable position. The packers, resenting her peremptory tone, took their revenge by so arranging a pile of saggars that it appeared as if her pots had been ruined, a reminder to Janet of the importance of team work and of how much she had to learn about effective management.

Despite the difficulties she pressed on, persuading Leach that the standard ware needed rethinking, arguing that it had become 'too careful – measured – weighted – waxed – calculated' and desperately needed bringing up to date and loosening up. The shapes, developed before or immediately after the war, seemed in the late 1950s old fashioned or inappropriate. They were, for example, still producing a soup jug that she believed was unrelated to modern life. The plates she found too small and mean, while the narrow bases of the casseroles not only made them unstable but also impractical as all the juice stood at the bottom. In a move 'towards freer and more living expression'[41] she persuaded Leach to redesign and simplify the range, making, for instance, only three types of jug, and generally adapting the forms to suit the demands of modern life.

An indication of the extent of the 'loosening up' process and the profound change in approach it represented was succinctly expressed in a letter Leach

wrote to his grandson John Leach,[42] popularly known as Johnny, who wanted to spend a year at the Leach Pottery. 'This is the day of the artist craftsman not of the journeyman potter,' wrote Leach. 'Any young person taking up a craft today as a vocation only justifies himself or herself by finding something to voice or say. That is life or true character, extended into his pots . . . Thus your main objective should be aesthetic – to know good pot from bad pot and to be able to find your own way with your own clear connections.'[43] It was a valiant clarion call, far-sighted, enlightened and challenging. Johnny was to be paid £5 a week, a sum slightly more than his peers.

Janet, meanwhile, was encountering problems with the existing workforce. She had a tendency of trying to mask her uncertainty and lack of managerial experience by an aggressive and rebarbative manner. Frank Vibert, the manager/bookkeeper left after a series of disagreements, as did Dinah Dunn, a skilled thrower, and Richard Batterham, a promising student who had studied pottery at Bryanston School.[44] Others took their place but the popularity of well-funded ceramic courses at art schools and a system of generous grants now meant that many would-be students preferred their more liberal approach to the disciplined and directed workshop training. Furthermore, education grants were only available to students on recognized courses and not available for study at places like the Leach Pottery, where after an initial trial period students were paid only a nominal wage of £3. To boost the number of trained potters Kenneth Quick was persuaded to return. Miraculously, once back at the Pottery, his migraines cleared up though not his habit of wearing rings on his fingers, which got in the way when he was throwing. Talented, adept, and amusing, he was seen as a future manager.[45]

In the light of changes in art school education, the policy of taking apprentices was dropped in favour of accepting students, mostly from overseas, who had secured government funding, on a one- or two-year work trainee basis. In the mid- and late 1950s these included Len Castle and Peter Stichbury from New Zealand, Anna Kjaersgaard from Denmark, Gwyn John[46] from Australia, Hamada's son Atsuya, Helena de Silva from South America, Pierre Culot from Belgium, and John Reeve[47] a French Canadian who came with his heavily pregnant partner Donna Balma. Reeve and Balma, together with Byron Temple[48] from the United States, who arrived in 1961, Glenn Lewis[49] from Canada who came a year later followed by Michael Henry,[50] were especially welcomed by Janet as fellow North Americans. English assistants included Derek Emms and Robin Welch. To provide cheap accommodation Janet bought Anchor House, a small property in the centre of the town, which she turned into flats. At the time the crew, including bookkeeper and packers, usually consisted of around eleven or twelve.

The students brought a variety of individual skills and a range of experience. Hamada Atsuya, fiercely independent, argued endlessly with Leach but was an expert mould-maker and suggested that some of the individual pots

could be produced in a mould and then finished and decorated by Leach. One such item was a tall squared bottle (17–18 in; 43–6 cm high), the model made from a thrown form beaten into a square shape. Once the body was cast a neck was thrown and added to finish the piece. Many such bottles were covered with a *temmoku* glaze.

Amongst the students Leach was generally accepted as sage and font of wisdom. As before the war he talked during morning crib or afternoon tea about the students' pots. He drew diagrams on the blackboard to illustrate the angle of a foot ring in relationship to the neck, and insisted that if the inside of a pot was correct the outside would take care of itself. His criticisms as usual were expressed using the language of the body, and any weakness in the pot he indicated by shaking or scratching that part of his own body that he felt corresponded to it, often doing a sort of hula dance round the Pottery. Amused at his own antics he often let out a hybrid laugh, somewhere between a snort and a whinny, wiggling his large white moustache independently of his lips. In the evenings students were entertained either individually or in groups for a meal and conversation, and they were invariably invited to select favourite pots to eat off, Janet insisting that they should be put to practical use no matter who made them. It was one way of appreciating Leach's dictum that 'you can understand with your gut the adjective *shibui* – the recognition of "truth and beauty . . . joy and utility meeting" '.[51] Broken pots were carefully repaired by Leach with gold or red lacquer, adding both to their useful life and to their overall beauty.

A favourite discussion topic was Hamada's maxim on the need to 'loose ones tail', the search for anonymity and unselfconsciousness, the state when 'true' pots could be made. 'He touched his head', recalled one student, 'smoothed back his hair with long fingers, pointed one of them like a gun to his temple. His voice was melodic, rhythmic and energetic and he could talk uninterrupted for hours'.[52] Not all students were enraptured or convinced by the constant evoking of his personal belief system, some finding it repetitive and the call for sacrifice a little hard to swallow given the minimal wages on offer. Janet preferred practical topics such as American politics, pottery and shop business to the accompaniment of strong fresh coffee, cigarettes and Johnnie Walker Red Label Whisky.

The favourite esoteric concerns of the Leaches were interrupted by real-life drama one evening when Donna Balma declared she was about to give birth. The breaking of her waters accompanied by rapid contractions had John Reeve and Janet rushing around trying to contact the midwife. Recalling the births of his own children, Leach combined a cool head with affectionate concern. Seeking to distract the anxious and frightened mother-to-be he 'very tentatively, and gently, put his hand on my shoulder and said "Now my dear, tell me about yourself" '.[53] The baby girl was safely delivered and later christened Hannah Bernardette.

Through a shared interest in Zen Buddhism John Reeve and Leach struck up a close friendship, and endlessly discussed its significance for the potter. Although more instinctive in his approach than Leach, and as much concerned with feeling his way with clay as planning the shapes he wanted to make, Leach declared that in many ways Reeve was his 'rightful heir'.

Among the crew discussion reflected the alternative mood of the times. In an attempt to understand eastern thought Herrigel's Zen in the Art of Archery,[54] was studiously read, the dog-eared and battered copy earnestly devoured and seriously considered. They also debated the proposal to set up the Craftsmen Potters Association,[55] a self-help organization that sought to promote high-quality studio pottery by opening a shop and gallery in London's West End. Leach refused to join on the grounds that the association had no plans to select members, conveniently disregarding that only a few years earlier he had actively tried to set up a potters society or guild.[56] There were also debates about the various alternative, anti-establishment movements, with several of the crew taking part in the Ban the Bomb march from Aldermaston to London. Yanagi's philosophy and concept of beauty were endlessly discussed as were their relationship to the work of the studio potter, with 'new words . . . slipped into the conversations – yunomi, Mingei, and (ah) shibui.'[57] In contrast to the refined peasant porcelain wares of Korea on which Leach spoke so eloquently, the students were more impressed by the qualities of the great leathery-looking jars from Tamba, which Janet showed them.

The days fell rapidly into a pattern. In the mornings Janet checked the Pottery, attended to the house, wrote letters, organized any shopping, and pre-pared lunch. In the afternoon when Leach took a siesta Janet made her own pots. Supper was planned in advance with Janet devising a variety of casseroles that could safely be left in the oven. Both smoked heavily, drank a little wine and Janet more than a little whisky mixed with water, which could sometimes get out of hand. Her rib-cracking coughing fits could be terrifying while drink made her voice lose its ring of natural sincerity and take 'on a conspiratorial edge and gradually slurred its way south until she sounded like a tough, Texan pioneer woman'.[58]

Preferring to work independently, Janet took over a corner of the down-stairs communal workshop as her studio, rejecting Leach's offer to have a wheel in his upstairs room. Nor did she show interest in following any Leach 'style', either in her forms or techniques. Many of her pots were hand-built or made on the wheel using soft clay in a combination of coiling and throwing, a process that often resulted in an organic asymmetry. Inspired by the Japanese Bizen-Tamba tradition,[59] Janet combined careful control with an easy, relaxed approach. To achieve textural surface effects she built a small experimental kiln which allowed for more frequent firings and for trying out various sorts of processes, including salt-glaze. The students, encouraged to experiment in the small kiln, wrapped pots in seaweed and straw and

threw in shovels full of sawdust at top temperature to create mock Bizen effects.

Given Janet's strongly stated creative and personal independence, her decision to use Leach's name created controversy and much cynical comment. It linked her with a well established and highly respected potter and virtually ensured her a particular status within the pottery world. Defending herself, Janet claimed that Leach had insisted she use her married name, asking 'Isn't the name Leach good enough for you?', but in the end was prepared to accept both its advantages and the inevitable drawbacks. In any case her strong and distinctive pots were always recognizably her own.[60]

The first acknowledgement of Janet's work in Britain came when Henry Rothschild invited her to share an exhibition with Bill Marshall at Primavera.[61] At this and later shows Leach had to face the challenge of publicly acknowledging Janet's artistic independence and while he was to describe her work as having 'great force of character',[62] the pots were never sufficiently in the 'Leach' mould to allow him to admire them wholeheartedly. On one occasion, when he arrived at one of Janet's private views, he simply walked by her pots with barely a sideways glance and passed the time 'holding court' surrounded by a group of his admirers. To Janet his behaviour seemed appallingly insensitive and a public demonstration of how little genuine respect he had for her work.

The endless wrangling with David over financial arrangements continued to worry and upset Leach. With some justification David felt that he should be adequately compensated not only for giving up the Pottery but also for the 'good will' he had created and his contribution in ensuring it remained a financially viable business during his father's absence. Leach took a different view, arguing that having set up the Pottery any 'good will' should be two-thirds in his favour as opposed to only half. A further source of aggravation was a reluctance to agree a settlement for the improvements David had made to Pottery Cottage prior to his marriage. This, David insisted, should reflect current values rather than the sum he had paid some fifteen years earlier. Leach was convinced that David's wife, Elizabeth, was continually pushing him to demand more. As they remained living in the Count House until their third child was born, David was for a time a regular visitor to the Pottery and seemed to Leach and Janet to be casting a critical eye over the changes they had instigated.

The disagreement came to a head in late 1957 when after a long and heated discussion David became so enraged by what he saw as his father's obstinacy and unreasonableness that he struck him, knocking him to the ground. In the process he blacked his eye and sent his glasses flying across the room. Janet was furious, and concerned that the continuing dispute was adversely affecting Leach's pots, and she demanded that a solution be found. As Leach and Janet had insufficient capital to purchase the Pottery a monthly rent was

agreed, an arrangement that held until they were able to buy the property outright in 1972. Fortunately, the Elmhirsts provided funding through their Elmgrant awards to help tide them over a difficult period.[63]

In his studio Leach threw smaller pieces and decorated, but anything of any size or complexity was made under his direction by Bill Marshall and subsequently finished by Leach. As Marshall threw in western style with the wheel going anti-clockwise and Leach the reverse, it is often possible to tell which of them made the different parts by examining the direction of the spiral. It was important that he settle down to making as he had an exhibition scheduled for April 1956 at the London department store of Liberty, his first in England for four years. For a time Dinah Dunn helped make porcelain forms using a new white plastic translucent body that included bentonite, which David had devised after seeing the dramatic demonstration at the Dartington conference. Unlike the St Ives standard porcelain body, which though vitreous was opaque, the new body was not only more plastic but acquired a seductive translucency when fired. Leach made small pieces with engraved decoration to be finished with a pale blue 'Ying Ching' glaze. In the West porcelain was expected to be both white and translucent, but this was not so in the East. As a precedent Leach looked to Korea where porcelain was often heavier and more intense in character and not necessarily thinly potted. Nor, as Leach pointed out, was it as white or shiny, being closer in quality to jade and marble. The usual St Ives porcelain lay somewhere between Korean and early Chinese, which when finished with a pale, silky celadon glaze, was one of Leach's favourite materials.

Through purchasing various artefacts for Liberty in Japan, Leach had established a good working relationship with the store, and they offered generous terms for his exhibition, agreeing to show 150 pots, mount a full window display and charge only 25 per cent commission as well as cover publicity and carriage costs. In addition to Leach's pots, it included standard ware and individual pieces by David Leach and Bill Marshall. Sales were good, apart from the porcelain, which in the opinion of *Pottery Quarterly*[64] was still in the early stages of development. The Victoria and Albert Museum acquired a large, flat *temmoku* bottle ingeniously assembled from two thrown shallow bowls joined together, with an added foot and neck. A thin, hard-fired *temmoku* glaze over the combed and cut surface brought out the variegated effects of the patterning, the glaze, a deep black breaking rust-brown on the edges, added to the majesty of the form. In Leach's view this was one of the best pieces,[65] a view reflected in the high price of £30. Other exhibitions were less successful. Pots sent to Johannesburg at the suggestion of Reggie Turvey failed to appeal, and a travelling exhibition arranged by his friends the Diamonds in the United States received only a lukewarm reception. This confirmed John Reeve's remark that in the United States Leach's pots were liked but not well liked.[66] A group of Leach's pots sent to an international exhibition at Syracuse

Museum of Fine Arts, New York, arrived too late to be included in the judging. *Time*, reporting on the exhibition, declared that if his pots had been there earlier 'he would certainly have won a prize'.[67] Reassuringly, an exhibition sent to New Zealand sold out immediately.

A one-person show at Primavera,[68] 'Stoneware and Porcelain', included salt-glaze, which *Pottery Quarterly* thought 'not to be sufficiently dry thrown, clean and profiled' for what it described bluntly as a 'rather starved glaze'.[69] More liked was the 'new St Ives porcelain', consisting mostly of shallow bowls, some with finely incised decoration and some with a delicate cobalt wash and brushwork. Leach and Henry Rothschild were delighted that the exhibition attracted about sixty visitors a day. Despite the high regard in which his work was held in England, Leach's exhibitions were rarely an instant sell-out. This was well contrasted with the concurrent exhibition of pots by Hamada at the Crafts Centre. Brought over by his son Atsuya to help pay for his time at the Leach Pottery, the pots virtually sold out on the first day.

For their first Christmas together Leach and Janet's cottage was adorned with a twisted bough of blackthorn decorated with silver and red candles. Eleanor and Dicon Nance who had been on holiday in Thailand were welcomed back and they all attended midnight service at the parish church. A full programme of events and exhibitions in 1957 was typical of their busy schedule. Conferences included a Society for Education through Art meeting at Chichester, chaired by Henry Hammond, then teaching at Farnham School of Art,[70] and a two-day conference of the Red Rose Guild in Manchester. Despite being under 'Henry Norris's realistic but bitter chairmanship', it was productive and 'some practical result[s] were achieved'.[71] There was also a one-week potters' seminar at Pendley Manor,[72] near London organized by Murray Fieldhouse[73] where, among other topics, Leach spoke about Zen, Tea and Pottery, and Janet on her time at Tamba and Mashiko. During leave from Nigeria, Michael Cardew held a geology course for potters at his pottery at Wenford Bridge, Cornwall, in September, which Janet and John Reeve attended. Donna Balma agreed to remain in St Ives to look after Leach, discovering he had a taste for 'spicey dishes, lots of meat and cheese, brown bread, good chocolate and salads'.[74] Leach also attended the Bahá'í summer school at Buxton.

Doggedly Leach worked on his book on Kenzan but his limited Japanese meant that progress was slow. Recognizing the need for an independent view, draft chapters were given to the 'mad poet' and satirical writer Arthur Caddick who lived in St Ives. Faber & Faber agreed to publish an English version of *A Potter in Japan: 1952–1954* but suggested that it might benefit from an introduction, which would include an account of the Dartington conference and the 1952–3 tour of the United States. The book was finally published in 1960, the text interspersed with many atmospheric sketches and photographs of landscape, pots and people. Notices were respectful, *Pottery Quarterly*

concluding that the book was full of 'humanity and humility', but qualified its praise by adding 'no one writes a diary without a modicum of vanity'.[75] *Craft Horizons* devoted nearly two and half pages to the book, deciding that it was 'exceptionally rich on many levels'.[76] Leach fondly quoted one unnamed reviewer who described him melodramatically as a 'tetchy and curious recluse writing from an ivory tower tea room'.[77] Although vivid in its descriptions of Japan and the apparent conflict between the urge to modernize and respect for traditional skills, *A Potter in Japan* was in essence a clarion call for traditional standards, a look back rather than forward.

The unexpected death of Shoghi Effendi, on 5 November 1957 came as a severe blow to devout Bahá'ís, particularly as there was to be no successor. Leach joined with some 400 mourners weeping and kissing the ground in which he was buried in New Southgate Cemetery, north London, and was pleased to be asked to make four vases for his grave.[78] Being a Bahá'í signified for Leach a living religion and an acceptance of prophesies made a hundred years earlier, which seemed particularly relevant in an increasingly tense world. The horrors of events such as the 1956 Suez Crisis, the U2 incidents, the growing conflict between Cuba and the USA, and the turmoil in the Congo and Laos Leach saw as fulfilling Bahá'í forecasts of disaster and catastrophe before peace could be found. 'My own conviction,' he wrote to Warren MacKenzie, 'is the same and does not lessen. We have gone so far towards materialism that without the scourge we will not come back to unity and the spirit.'[79]

In October 1960 Leach and Janet flew to Stockholm for an exhibition of his work. Janet had her black, wavy hair cropped short, wore a three-quarter-length brown sheepskin coat, low-heeled shoes and borrowed a demure 'little black number' from Barbara Hepworth. Uncharacteristically she added a smear of lipstick. As usual when travelling abroad Leach became very English, donning his finest homespun suit, a tweed greatcoat and highly polished brown shoes. Unlike his earlier show in the country there were no loud dissenting voices and the exhibition was an acclaimed success. They returned via Denmark where Leach took to his bed with a cold suffering what Janet called 'a post-exhibition relapse', a typical occurrence for Leach after an exhibition. Fully recovered he gave the opening address at the exhibition 'Engelse Pottenbakkers' (Forty Years of British Studio Pottery), which included forty-one of his own pots, at the Boymans-van Beuningen Museum, Rotterdam.[80] Beautifully set out in the garden gallery and two adjoining rooms, the work was shown in specially lit cases. The theme of his talk, 'East and West in Art, The Contemporary Stoneware Tradition', was familiar but still inspiring; he spoke about his own background, the work of Kenzan, Hamada and Yanagi, showed films, and as ever discussed the concept of 'the good pot'.

Rather uncharacteristically, Leach and Janet took a short holiday in Seville in southern Spain. The weather was good, Leach got sunburnt, and they

enjoyed the countryside 'with its olive groves, cacti, cork trees, white villages . . . on hills, droves of pigs, black or rusty, sheep, horses'. 'Seville,' noted Leach, 'is a noble city and the architecture of the normal homes solid, well proportioned and with delightful tiled patios and the best wrought iron I have ever seen.'[81] Entertainment included an evening of Flamenco music and dance, which Janet, who had some distant Spanish blood, particularly enjoyed. Leach, unused to being a tourist and not being the centre of attention, was restless. While full of admiration for the architecture and countryside he thought they had seen no decent pots, and only one notable painting, an El Greco in Cadiz.

Although Leach wrote to Mark Tobey of his marital happiness, there were growing problems, some of them depressingly familiar. Like Laurie, Janet complained that far from acknowledging her as his partner Leach regarded her primarily as his wife, often failing to ensure, for instance, that when he was invited to social occasions she was also included. She also complained about being at the receiving end of a stream of generally unwanted advice on anything from buying groceries to making pots, which she found increasingly irritating. 'I live,' she wrote 'with the constant nightmare that sometime a party of guests will arrive for dinner without my being aware of their coming.'[82] Leach complained that her manner could be hectoring and bullying, and had become seriously concerned about her excessive drinking. A fierce row broke out when, after witnessing and then celebrating the marriage of John Reeve and Donna Balma, Leach accused her of not being in complete control of the car as she drove them home.

The Bahá'í faith was a further source of friction. Reluctantly Janet had gone through a Bahá'í marriage ceremony in London and attended a Bahá'í summer school in North Wales, but she did not respond to the Bahá'í way of life or thought, her ideas and belief lying 'somewhere between Christian mysticism and Zen'. While Leach had some sympathy for her 'dislike of anything like organised religion',[83] he felt that as the Bahá'í had no churches or a priest-hood they were altogether different. Unfortunately Janet disliked most of the Bahá'ís she met, finding them to be as persistent and aggressive as Jehovah's Witnesses in pressing their ideas and seeking recruits. Her reluctance to embrace the faith made Leach feel that in some undefined way her non-belief curtailed his own practice. At one point he pushed her so strongly on the issue that in exasperation she asked him whether he wanted to be a Bahá'í missionary or a potter, something that he often asked himself. Reggie Turvey advised patience, reassuring Leach that 'there is no doubt about the truth and importance of it'.[84]

For Janet, Leach's 'mission' was simple: it was to make pots, a view that combined an element of pragmatism – his individual pieces helped ensure the viability of the Pottery – with a belief in him as a great potter. 'What' she demanded 'does the Bahá'í faith do towards pots – they are your obvious job.'[85]

Such a confrontation between the production of art and the pursuit of faith brought Leach face to face with an old dilemma, the conflict between spiritual commitment and artistic practice. 'What is the use of talking about virtuous Bahá'í,' he wrote in anguish to Mark Tobey, 'without possessing them – being them. Hell and damnation! How is one to be an artist and a Bahá'í at one and the same time?'[86] Tobey's growing international acclaim – he was awarded the international painting prize at the Venice Biennale in 1958 – brought him up against similar problems. Leach, amazed by the increased value of Tobey's work, obtained his permission to sell a painting he had given him, receiving through Harold Diamond in the United States the astonishing sum of $1,000.

Occasional contact was maintained with Laurie. Each Christmas Leach sent her a cheque for £50, fretting if it was not acknowledged at once. Laurie had been debating whether to sell Welland House, Old Romney, but having bought a small car decided to remain where she was. Maurice, however, was still unsettled and a great source of anxiety. After leaving Frensham Heights he had become involved with a girl at the school. A pregnancy ensued but fortunately, as Leach noted, 'the girl's parents are decent folk' and they were duly married. At the age of nineteen Maurice became the father of a son.[87]

In 1960, with Leach's approaching anniversary of fifty years of potting the following year, various celebrations were planned. These included a BBC film about the Leach Pottery directed by John Read, son of Herbert, to be broadcast to coincide with an Arts Council retrospective of his work. At first, knowing that it would disrupt production, Leach was reluctant to collaborate especially when he needed to make pots for a series of exhibitions, but on reflection he saw the benefits. After viewing the completed film, entitled 'A Potter's World', he was appalled by the sight of his 'head shaking on a stalk and hands clumsy on the clay',[88] but Read's sensitive documentary was widely acknowledged as an artistic and critical success.

Academic awards included an honorary doctorate of art from Manchester College of Art, received alongside fellow recipients James Laver, Oliver Messel and Marie Rambert. On 9 May 1961, Exeter University honoured him, along with the crime writer Agatha Christie, with a doctorate of literature. The ceremony appealed to Leach's sense of the theatrical as it involved processing in a velvet Tudor hat, hood and gown. He was pleased to note that guests at a subsequent celebration dinner included the Duchess of Devonshire, a former German president, several lord mayors and various bishops. He had to wait another ten years before he was awarded an honorary doctorate by the Royal College of Art, an honour that was particularly welcome given his disappointment at not being asked to take over the ceramics department in 1925.[89]

On his seventy-fourth birthday in 1961 the retrospective exhibition 'Bernard Leach: 50 Years a Potter' opened at the prestigious if modest Arts

Council premises in St James's Square, London, before touring to Bradford and Newcastle. In celebrating the work of a potter rather than a painter or sculptor the Arts Council was bestowing a great honour. Both Bernard and Janet worked diligently to select and catalogue some sixty drawings, prints and *kakemono*, together with 180 pots ranging from his first raku piece to pots made the previous year. An intelligent catalogue introduction by art critic Paul Hodin outlined Leach's development as a potter and concluded that his work had 'become simpler, more "essential" and consequently grander . . . a seeker after truth rather than amusement . . . dignity and quietude in the sense of Zen or Tao, which is contemplative, austere and serene'.[90]

For three weeks Leach stayed in London with Lucie Rie, attended parties, met friends and potters at the exhibition and conducted a group of sixty-two from the Craftsmen Potters Association round the show.[91] It was, thought Leach, 'a curious experience to see one's old work and to take stock of fifty years effort and struggle.'[92] Many reviewers found the show a revelation. John Mander in the *New Statesman* came to the conclusion that the 'craftsmen of the future will have the Leach standard to aspire to'.[93] On the BBC radio programme *Today*, Peter Rawsthorne, who described Leach as a 'tall man of 73 with grey swept-back hair and . . . grey moustache, small brilliant eyes and brown tweed jacket smelling of wood smoke', was equally laudatory.[94] In *Pottery Quarterly* the potter Geoffrey Whiting wrote of the work 'growing like a great oak, really putting out shoots from the unshakeable main stem',[95] while Eric Newton thought that 'nowhere in the exhibition does one feel that a set of alien idioms has been imposed on a British artist'.[96] Over 10,000 people visited the show.

Coinciding with the retrospective was a solo exhibition of recent pots at Primavera.[97] Shortly afterwards Leach and Janet sailed for an ambitious eight-week lecture and exhibition tour of the United States, with all the detailed preparation and planning, including seminars in thirteen different centres, made by Janet. As so often in the past there was a muddle over finances. Robert Richman had secured funding from the wealthy Ford Foundation[98] and, Leach assumed, this would cover his costs. To his frustration this was not the case and each of the venues had to meet the $500 fee. Janet, in typical forthright manner demanded that Warren MacKenzie find out if Richman was 'crooked'. Eventually the problem was sorted out.

In an effort to keep down costs, they made use of Janet's American citizenship to import luggage without customs and freight charges and bought a large Ford station-wagon to allow them to travel easily and stay at motels so avoiding expensive airfares. To cope with the different exhibition venues Leach devised a scheme of first drawing and then making pots of a certain type so that those sold could be replaced. By January, Leach was able to report that 'the pots are made thank God'. In preparation for the American visit, Leach, at John Reeve's suggestion, read *Dharma Bums* by the American beat

writer Jack Kerouac to give him an alternative view of the country. Pottery
Cottage and their cat Cho Cho were left in the care of John Reeve and Donna
Balma.

Aboard the RMS *Ivernia*, which sailed on 22 February 1961, Leach took the
opportunity to respond to an article 'Towards a New Standard' by potter and
teacher Paul Brown in *Pottery Quarterly*,[99] which was largely a reassessment of
Leach's chapter 'Towards a Standard' in *A Potter's Book*. Brown tentatively sug-
gested that a broader approach might now be needed. Leach, in his response,
quoting from his recently published *A Potter in Japan*, agreed that 'another gen-
eration should assess the ideas which I put forward twenty years ago', point-
ing out that 'good taste' was 'an incidental and secondary virtue'. '*Vitality*,' he
added 'is the primary criterion of the good pot.'[100]

The tour began in New York with an exhibition at the small but exclusive
department store of Bonniers on Madison Avenue. This was at the invitation
of Goran F. Holmquist through an introduction by Lucie Rie. Leach thought
it was very well arranged, sales were good and further pieces were ordered,
including twenty of Janet's pots. Meetings and events in the city ranged from
public talks to what seemed like an endless round of dinner parties including
one at Aileen Osborn Webb's handsome penthouse apartment. At the Museum
of Indian Art they had lunch with the 'sophisticated, but sincere, daughter of
one of the Sioux chiefs and her American husband'[101], and talked about pots.
There was also a photographic session with Trude Fleischmann. More con-
troversial was Peter Voulkos's exhibition of painting and sculpture at the
Museum of Modern Art. As they peered uncomprehendingly at Voulkos's con-
structions in clay Janet wondered 'Where has pottery failed this man'.[102] The
large, bold, energetic sculptural pieces with their references to Abstract
Expressionism, though technically skilled, were not to their taste, and they
were convinced that had Voulkos made pots rather than semi-abstract forms,
his work would not have been shown.

On two occasions they were entertained to lunch by Miss Gordon, editor
of *House Beautiful* at the Four Seasons, thought to be the world's most expen-
sive restaurant, where 'glass icicles fell from a heaven 50' above in cascades,
the carpets were thick and silent, the food very good'.[103] To Leach's amaze-
ment Miss Gordon had, 'caught Zen and "shibui"' and wanted to hear about
it in great detail from someone she believed understood it. The August 1960
edition of the magazine had been devoted to the idea of *shibui*. 'It astonishes
me,' Leach wrote, 'that a popular magazine in America should have the insight
and courage to attempt to bring the austerities of Zen Buddhist taste to the
multitudes of the West. Straw, straw, where blows thy wind?'[104]

In a talk at the New York Donnell Public Library, Leach expounded his
views on the ceramics he had seen in the States, questioning among other
topics the value of prizes, which he believed forced potters to 'play a certain
acceptable game'.[105] He did acknowledge the readiness of American potters

to experiment, though as usual he could not resist identifying what he saw as evidence of poor design, reiterating comments made during earlier visits about ugly teapot spouts and the tendency to exaggerate rather than under-state. At a seminar at the University of Wisconsin he recommended vigorous action against pieces that do not hold 'a quiet assurance', advising 'occasional rock throwing at your pots when you're dissatisfied'.[106]

During the tour Leach not only introduced his pots and ideas to new audi-ences but also discovered more about Janet and her life in America. At Three-fold Farm they were warmly welcomed, despite residual resentment at what some perceived as Janet's disloyalty in abandoning the community. From New York they drove to Baltimore for a two-day stop to teach '29 nice, normal, eager beaver amateur but keen women students'[107] before driving 1,850 miles to Dallas and Grand Saline to stay with Janet's parents and meet her relatives. Although her mother disapproved of the marriage, for no specific reason other than a general disapproval of her daughter's behaviour, she got on well with Leach, and he enjoyed watching Janet play dominoes with her father, both, he noted, soon reverting to their private, well-established language.

In Dallas, Leach gave talks and demonstrations. One student described him as 'a lanky old man in a baggy tweed suit',[108] an outfit that Leach proudly explained had belonged to his father, indicating that the old was neither bad nor useless. Before beginning his demonstration on the wheel he further impressed his audience by producing a handsome wooden lacquer toolbox 'embedded with a sort of mosaic of colored bits of eggshells'.[109] Although well smattered with clay, the box added an element of finesse and style. As he worked Leach explained his techniques and methods, pausing only to com-plain about the sticky Texan clay. During lectures he spoke enthusiastically about the work of potters like Cardew and Hamada and their awareness of tradition. This 'warm, affable and opinionated potter-draftsman-philoso-pher'[110] went down well, despite Leach telling one would-be potter that his pot looked like 'a top-heavy ballerina about to tip over on a too narrow foot'.[111]

During the long drives Leach either wrote letters or lay flat out fast asleep. At the motels Janet organized clean shirts and sorted out the next leg of the journey. As they criss-crossed America into Canada they were constantly amazed by the dramatic climatic changes and the breathtaking landscapes including, north of Michigan, fascinating 'glacid creek pine and silver birch'. 'I have never felt the grinding push of the last ice age so charmingly. The white stocks of birch are so lovely at dusk,'[112] noted Leach. Vermont he thought 'beautiful – nature not spoiled by man . . . good varied farm land', though at one point they hit and killed a dog and had to placate an angry farmer. They were also stopped for speeding. In Wichita, Leach sat on the jury for the Fifteenth Annual National Decorative Arts-Ceramics exhibition, again dis-covering that the jurors were in 80 to 90 per cent agreement.

At Michigan University in Ann Arbor they stayed with Jim Plumer and interviewed an earnest young potter named Byron Temple,[113] who had written asking to work at the Pottery. Temple arrived at their motel bearing several bags of pots, which he carefully unpacked, and both Leach and Janet approved of this serious man and his strong sense of purpose, agreeing that he could start at the Pottery later in the year. At St Paul, Leach was delighted to spend time with the MacKenzies, though his habit of treating them as students rather than mature potters continued to grate. He was particularly critical of what he saw as Alix's lack of understanding of pattern. 'Decor, rhythm, repeat pattern' he pointed out 'are secondary to the pattern idea – the little dance – the little melody which picks up the form of a pot and completes it.'[114] Alix thought it typical of Leach that he made no effort to appreciate her experimental exploration of design. Just as during his previous visit, Leach was highly critical of the pots he saw and Alix's were no exception.

The 10,000-mile journey, which would have taxed a man half Leach's age, was in many ways a success. Critical reception was respectful, though as Janet observed they did not 'meet many of the leading potters',[115] and she could not help noticing that audiences tended to be enthusiasts rather than respected professionals. Sales, however, were excellent with the pots realizing the not inconsiderable profit of £1,000. On familiar territory Janet felt at ease and although driving vast distances and making innumerable arrangements she and Leach were together, virtually without a break, and it seemed to work. As on previous visits Leach responded to the warmth and generosity of the many individuals they met, but he did not accept America easily, suspicious of its modernity and consumer-orientated values. Janet, like many others, thought Leach made no real attempt to appreciate either the American way of life or their approach to making pots.

The financial success of the tour meant that they had sufficient funds for them both to visit Japan, but much to Janet's dismay Leach announced that he intended to go alone, and simply assumed that she would stay to run the Pottery. Janet was enraged; feeling neglected and used she angrily demanded half of the tour profits which, somewhat shamefacedly, he handed over. Leaving Janet to run the Pottery was certainly convenient but in her view it completely failed to acknowledge her own interest in and involvement with Japan. No matter how distinguished he was, to Janet they were equals but to Leach she was his wife and could be left when he thought appropriate.

ART AND LIFE

England Japan Australia New Zealand USA
1961–1964

The late 1950s and early 1960s saw Leach produce some of his most assured work. Perhaps drawing on Janet's enthusiasm the pots grew in strength and clarity, losing much of their fussiness to acquire new vigour and energy. At their strongest they are understated and fluid with minimal decoration. Leach was aware of this positive development, telling his son Michael that they were 'more plastic, more clay-like . . . better than in any previous year'.¹ Some of this vigour was certainly the result of an increased reliance on Bill Marshall's skilled throwing, for as he became older Leach made greater use of this talented potter. In effect Marshall became Leach's right-hand man, with Leach drawing the shapes and then directing their making. In addition to the forms taking on greater clarity the decoration became livelier and freer. Many of the more symmetrical, ordered patterns of the 1940s and early 1950s gave way to looser, greatly simplified designs such as incised birds that seemed to move effortlessly round the shape, and fluted lines that successfully integrated form and surface.

Certain silhouette motifs were repeated by making use of cut paper stencils, the final effect depending on the subtle contrast between a dark brown slip and a rich *temmoku* glaze. One such image created on the inside of flat dishes included a flying bird surrounded by angled lines that suggest freedom and movement. Another was the solitary figure of a pilgrim or monk holding a begging bowl and carrying a staff setting out to cross an uncharted landscape. Illustrating the Buddhist concept of the universe – a circumference-less circle with a centre anywhere – it was an image that in many ways reflected what Leach saw as his own independent and lonely aesthetic quest. The tree of life, sometimes known as the tree of knowledge from the tree planted by God in the Garden of Eden,² was also used in various forms. The motif echoed some of the flowing qualities of William Morris's plant designs and the ancient idea of the labyrinth, the symbolic representation of the journey through life. The limited range of slip-cast forms included a tall, squared-off bottle, a square tea caddy with a domed lid, and a flattened square bottle with an added pedestal foot and thrown neck. Like his thrown pieces Leach decorated these by either

painting, drawing his fingers through glaze, or with trailed decoration in a rich orange tan.

Leach's search for the 'good pot' went relentlessly on but as ever seemed tantalizingly elusive. On one occasion he carried a large, first-class piece, newly unpacked from the kiln, to Pottery Cottage and placed it alongside an old Korean pickle jar. Taking off his glasses, he put his head on one side and compared the two, muttering 'Damn, damn, damn! I'll never be able to do it'.[3]

The disagreement between Bernard and Janet over his proposed visit to Japan signalled a profound change in their relationship. Japan was Leach's second home but not one that he was willing to share, partly because he knew that many of his friends there still did not approve of the marriage and partly because he wanted to keep it for himself. Janet saw sharing such experience as part of their relationship and while willing to care for Leach, to shop, cook and even run the Pottery, she felt there had to be compromise and exchange. Given their initial plan to settle in Japan and her love for Japanese ceramics, she believed that she should have the opportunity to make regular visits. When she realized that Leach was unable to compromise she felt that he had not honoured their partnership and she was therefore justified in establishing a degree of independence in their relationship.

Running parallel to their personal problems there were also difficulties for Leach over Janet's work. Strong and independent, Janet's pots showed no direct influence from Leach, something that he both admired and resented. Almost instinctively he was drawn to the classics of the East, taking as his models the high-fired and glazed wares of China, Japan and Korea. In contrast Janet admired the sixteenth- and seventeenth-century rustic-looking wares from Bizen, Karatsu and Iga, pots that were often irregular in form, with little glaze, the body often bearing the marks of the flame and smoke from the long firing. Furthermore, Janet's making methods were different and she did not welcome interference. When aware of Leach hovering about to give advice when she was working she would tell him in no uncertain terms to go away. 'Don't you want my criticism?' he would ask. 'No,' was the emphatic reply, 'not until the pot is finished and fired.'

Always outspoken and direct, Janet could be frighteningly confrontational whilst Leach, when challenged or crossed, tended to be reticent and evasive when faced with conflict, often retreating into a sulky silence. Rather than state his grievances openly he would leave notes, a habit which incensed Janet more than the actual complaints. They continued to share a bed but their once ardent lovemaking had become more functional and perfunctory, and Janet often felt used rather than loved. Despite his protestation to the contrary he retained conventional views about the role of a wife, and had to be continually reminded to involve her in his activities.

Partly as a measure of self-defence Janet developed a more exclusive relationship with Barbara Hepworth. They shared an involvement in sculpture and

saw each other regularly, spoke frequently on the telephone and developed a bond that was partly anti-men, partly female solidarity and partly a shared sympathy on the plight of being a female artist in a male-dominated world. Hepworth, encouraged by Janet, found solace in whisky and they often indulged in long drinking sessions. At one point, either recognizing or sensing Janet's bisexuality, feeling that people may suspect them of having a lesbian relationship, Hepworth felt that they were appearing to get too close and sought to distance herself.

Hepworth and Leach were also friends and he would often drop in to see her around teatime for a chat and to catch up with the local gossip, but the relationship had none of the intensity of that with Janet. Leach, while admiring Barbara's drawing, was less enthusiastic about her sculpture, and on one occasion was seen to lean casually against one of her large forms, cigarette in hand while talking about Japan. The Leaches were often invited to Barbara's dinner parties when London visitors had to be entertained.

At Barbara's suggestion a group of her friends spent a 'working holiday' at a splendid new hotel on the beautiful island of Tresco in the Scillies, enjoying its exotic vegetation and, as there were no motor vehicles, the silence. It proved to be a bizarre break. In addition to Barbara and the Leaches, the party included the composer Priaulx Rainier,[4] who with great seriousness announced that the birds were singing more clearly than in London, and the writer Frank Halliday[5] with his wife, Nancie. In keeping with their Christian Scientist beliefs, the Hallidays refused to drink alcohol and to everyone's amazement spent the time walking round and round the small island. To Janet's despair, Leach spent much of the week sitting in the hotel foyer with his back to the window and the glorious view outside planning his forthcoming visit to Japan, a trip from which she was excluded. Determined that nothing should disturb the silence, Hepworth insisted that the hotel lawns should not be mowed as the noise was too disturbing, but in spite of all her efforts a week 'of sun and waves, puffins, seals, oyster-catchers and islets, also flowers and rock-crashing waves'[6] was not, declared Leach, to his taste.

Some of the difficulties Janet experienced with Leach were, she believed, not helped by the behaviour of his friend Lucie Rie whom Janet thought hopelessly spoilt him and behaved like the conventional wife he seemed to want. Leach invariably stayed with Lucie whenever he visited London, and on these occasions she gave up her bedroom, dropped all other engagements and tried to please him by baking Japanese cakes, preparing special meals and generally waited on him hand and foot. Naively Leach hoped she and Janet would be friends, and on the face of it they seemed to get on well but Janet resented the secondary role she was forced to adopt during these London visits and was annoyed that Lucie was automatically included in their outings. Things came to a head on one occasion when just as Leach and Janet were setting off for lunch at a pub on the Thames, Lucie insisted that he return to her house

so that he should not miss his afternoon rest. Furious at what she saw as inter-
ference Janet moved into a small hotel on the Bayswater Road and never stayed
with Rie again. Having established her independence, from this point on their
relationship improved.

With preparations well in hand for Leach's visit to Japan a telegram arrived
in May 1961 with the news that, after four years of illness and following a
third stroke, Yanagi had died.[7] It was a heavy blow for Leach. 'We had 50 years
of close friendship,' he wrote, 'and it took his death to make me realise my
debt to him . . . Japan has lost a great mind and I a lifetime's companion.'[8]
Yanagi's death, following on from the sudden deaths of Jim Plumer in Ann
Arbor and the teapot decorator Minagawa, who died at the age of eighty-
seven, were all reminders of his own mortality. 'The scythe reaps as one gets
older,'[9] he reflected sadly.

However difficult Leach had found some of Yanagi's attitudes in later years
he had held him in high regard both for the challenge of his original thought
and as leader and instigator of the Mingei movement. 'Yanagi', he wrote, is
'an example constantly by me'.[10] Even in the final years of his life and already
ill Yanagi had helped arrange the sale of Leach's drawings in Japan, ensuring
that no commission was charged. At Yanagi's funeral service in the Nihon
Mingeikan, attended by over 1,000 people, one speaker after another broke
down in tears despite the Japanese convention that public displays of grief
were unseemly. Only Hamada remained steady and spoke without a break in
his voice.

Shortly before leaving for the East in August there was other, far more dis-
turbing news that threw his life into total crisis, echoing in some awful way
the traumatic news of Laurie's pregnancy received shortly before he was due
to sail for Japan in 1934. Walking along Fore Street in St Ives one evening a
woman rushed up to him and told him in no uncertain terms that Janet was
bisexual and having affairs with women, adding that as everyone else knew
she thought he should be told. The talebearer may have been one of Janet's
former drunken girlfriends jealous of not receiving her undivided attention,
or a friend of Leach's who felt he was being cheated. It was a distressing and
a quite unexpected revelation that left him feeling betrayed and because of
his ignorance somewhat foolish. Although keenly aware that their relationship
had its problems, not least of which was Janet's frightening addiction to
whisky, the news of her bisexuality and her infidelity came as a great shock.
Despite the difficulties of their marriage Janet had restored his faith in his
ability to form an enduring and loving relationship, now thrown so dramati-
cally into doubt.

Janet maintained that for the first few years of their marriage she had been
'a good wife', and that her relationships with women only began in earnest
following Leach's decision to travel to Japan without her. From that point on
she more or less decided that as Leach seemed willing to selfishly jeopardize

their marriage, then she felt she had a right to look elsewhere for her sexual and emotional needs. The result was a series of clandestine relationships, often with women who worked at the Pottery, and inevitably gossip was soon rife even if it escaped Leach's ears.

Writing to Mark Tobey of his anguish and confusion Leach was, he said, 'moving through these last days as though through a nightmare'. Without spelling out the exact cause of the 'nightmare', he wrote of receiving news from an 'utterly unexpected third party intervention of which I an unfree to write. It is nothing to do with me really though to Janet's mind I am generally responsible and constantly nagged at for shutting her in the prison of my shell' adding 'No, it is not a man'.[11] He had for some time toyed with the idea that they should spend some time apart 'to gain perspective and internal quietude',[12] but this traumatic incident cast any separation in a new light and placed a question mark over their entire future together. Equally conscious of tensions Janet had earlier suggested that they should buy an adjacent property that had come up for sale where Leach could work in peace and quiet and which would give them both a degree of independence. She was well aware that in a small town like St Ives people would quickly pick up on the irregularities of individual behaviour and given that she did not want her marriage to end she was wary of setting up a long-term relationship with a woman.

The effect of the disclosure on Leach was profound. After a period of withdrawal during which he felt unable to discuss the problem with his family and could make only veiled references to close friends such as Mark Tobey, it seemed to have brought a new awareness of what was going on around him. Despite or because of the shattering news, Leach felt that he had no alternative but to continue as planned his four-month overseas tour to Japan, Australia and New Zealand. Again Japan offered an escape, a refuge, a safe haven where respect and affection seemed unconditional, somewhere he could have time to reflect. The visit was also an opportunity to assess the effect of Yanagi's death on the Mingei movement as well as pursue research for his Kenzan book. It also coincided with an exhibition of fifty thirteenth- and fourteenth-century medieval pots from London's Guildhall Museum at the Nihon Mingeikan,[13] an idea first proposed by Yanagi in 1929. The city fathers, persuaded by Norman Cook, director of the London museum, agreed to loan pots unearthed by wartime bombing, which were to tour four venues. In the catalogue Leach wrote about the jugs as fine examples of strong, functional ware, tempting him to ponder the eternal question of 'a good pot? In life: in art?'[14] When the exhibition opened he was gratified that the 'men of tea' thought the jugs and pitchers the finest pots they had seen out of Europe, reaffirming to Leach 'the possibilities of the beauty of roughness'.[15]

A series of successful exhibitions of his work reaffirmed his popularity. At Mitsukoshi, the biggest and oldest department store in Tokyo, large areas were

devoted to ceramics. One floor housed an exhibition of Hamada's work that included 'broad, easy, natural' pots covering a period of forty years, and on the floor below a show of Leach's recent pots and drawings. To his gratification 95 per cent sold on the first day. There was also a retrospective of his work in Osaka. Receptions, parties and engagements kept him occupied, with Mitsukoshi putting a large car at his disposal.

The country offered the usual series of paradoxes. The novelty of colour television, on which he made several broadcasts, was a classic example of new Japan moving rapidly into the technological age, and of the huge number of different stimuli on offer.[16] In *Japan Quarterly* he wrote how rejuvenated he felt by renewed contact with the East but went on to deplore 'the concrete-box, shapeless skyline of new Tokyo'. The energy of postwar recovery and expansion, and the speed of change made him anxious, though the concept 'Art as part of life, not extra',[17] continued to enthral him. Yet some aspects of Japan still appalled him. Sitting at a table one day a praying mantis flew in through the window and he watched in horror as a Japanese man tore it into pieces and laughed as it lay wriggling on the table, leaving Leach to conclude 'art is not enough'.[18]

As autumn was about to break Leach travelled in the mountains of central Japan, meeting craftsmen, looking at craft and sketching what seemed to him idyllic landscapes. 'Mists,' he noted 'wreathe amongst the conical, pine-clad peaks in the early sunlight of an autumn day.' The timeless scene with 'patient oxen ploughing, the rice crop hanging in ranks to dry, stubble-burning, blue smoke, ripe persimmons on bare branches and under thatched eaves, water running white'[19] made a deep impression, such solidity a huge reassurance after the emotional torment of St Ives.

In Mashiko, Leach was again taken by the sense of unity and completeness that Hamada had created with the sensitively restored buildings and the carefully planted trees and shrubs complementing the ordered rhythm of the workshop. Hamada's son Atsuya, now back after his time in St Ives and a year travelling, welcomed him. At mealtimes, laid out on a long refectory table, there was excellent home-cooked food lovingly prepared by Hamada's wife who had devoted her life to ensuring her husband's happiness, often diligently preparing dishes they had enjoyed overseas. It was in sharp contrast to his own tense domestic arrangements. In the pottery Leach was made to feel equally at home and given every possible help. Among other forms he decorated a series of fifteen-inch (38 cm) tiles based on memories of the landscape he had seen during his time in the mountains.

At Leach's request it was arranged that he and Hamada would visit the Ryukoin sub-temple of the Daitokuji, not only to see two famous paintings but the fine building constructed by the Kouroda family, who had built a pottery for Leach in 1919. After serving tea the abbot brought out the paintings and after a little while asked which Leach preferred. Leach's liking of

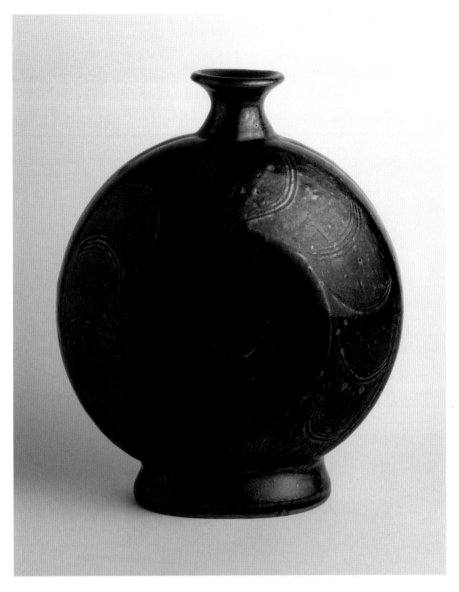

Bernard Leach, pilgrim bottle, c. 1952. Stoneware, thrown in sections and assembled, incised decoration and temmoku glaze; h. 26.9 cm, d. 24.5 cm. The shape is derived from the flattened bottles carried by pilgrims. Impressed marks BL and SI. (The Board of the Trustees of the Victoria and Albert Museum, London).

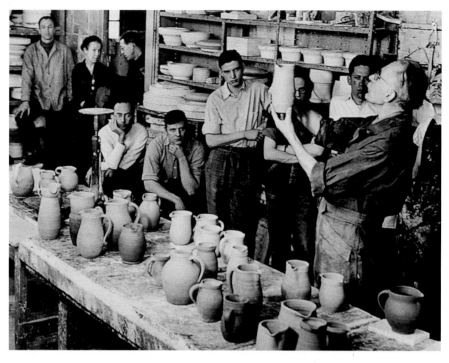

Bernard Leach discussing the merits of thrown pots with students at Alfred University, 1950. The jugs were made as part of a project set by Leach. (College Archives, New York State College of Ceramics at Alfred University).

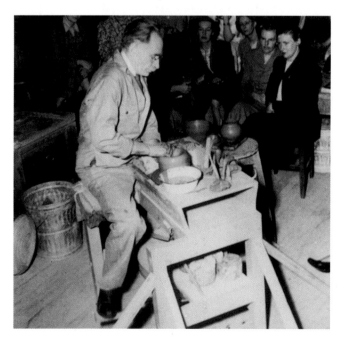

Bernard Leach demonstrating to the Canadian Guild of Potters, 1950. Leach was welcomed in many countries across the world. (Leach archive).

Left to right, Yanagi Sōetsu, Bernard Leach, Rudy Autio, Peter Voulkos and Hamada Shōji at Archie Bray Foundation, 1952. On account of his expressionistic form, Voulkos went on to become one of the most significant ceramic artists in post-war America. (Archie Bray Foundation).

Bernard Leach, Hamada Shōji and Yanagi Sōetsu with Maria Martinez at San Ildefonso, New Mexico, 1952. To demonstrate her method to the visitors Maria Martinez arranged a special firing of her pots in a bonfire. (Leach archive).

Bernard Leach with Dr Suzuki Daisetz, the acclaimed expert on Buddhism. (Leach archive).

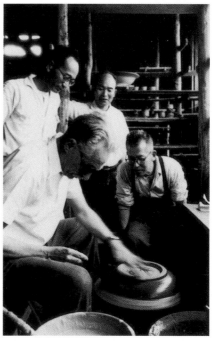

Bernard Leach surrounded by reporters on his arrival in Japan, 1953. (Leach archive).

Bernard Leach painting slip or glaze onto the outside of a bowl, watched by Yoshino Harutu, Fujina Pottery, during his tour of Japan 1953–4. (Leach archive).

Bernard Leach with Janet Darnell, Japan, 1954. (Private collection).

Bernard Leach and Hamada Shōji admiring an early English medieval pitcher, Japan, 1961. (Leach archive).

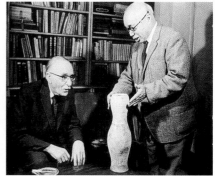

Bernard Leach drawing on the dunes at Tattori, Japan, 1953. Wherever he went, Leach found time to draw, on occasions standing under an umbrella held by a friend in order to make a quick sketch. (Leach archive).

Bernard Leach with Morikawa Kanichiro, the extraordinarily bearded collector and connoisseur of old Japanese art, Japan, 1967. (Leach archive).

Bernard Leach, bottle, c. 1956. Stoneware, thrown with Tree of Life design carved in dark brown slip, showing the intertwined branches, birds, agriculture and animals; h. 29 cm. (Leicester City Museums, photograph Stephen Brayne).

Bernard Leach, Francine del Pierre and President Valencia at a reception in Bogota, during their visit to South America, 1966. (Leach archive).

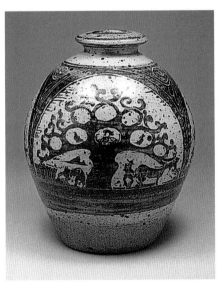

Bernard Leach with Rúhíyyih Khánum, known as Madame Robbani, the Canadian-born wife of the Guardian of the Bahá'í faith, c. 1976. (Private collection).

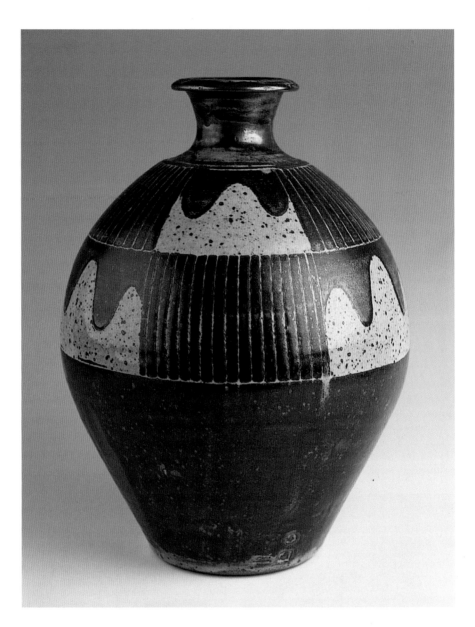

Bernard Leach, bottle, *c*. 1965. Stoneware, thrown, a full, rounded form with mountain
design alternating with incised lines in iron slip; 36.5 cm. This was a design to which Leach
returned many times, making the most of the balance between positive and negative space.
Impressed BL and St Ives seal. (Private collection).

Bernard Leach, St Ives, *c.* 1960. In the background is a bottle with a variation of the mountain design cut through slip. (Leach archive).

(Below) Bernard Leach unpacking a kiln after a firing, *c.* 1957. The spacious chambers were tightly packed, with some pots placed inside saggars to protect them from the flames. (Private collection).

Bernard Leach, drawing of a bottle, showing a design of mountains and trees engraved through black slip, 1946. Pencil. (The Board of the Trustees of the Victoria and Albert Museum, London).

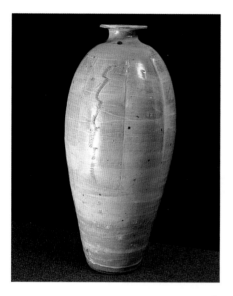

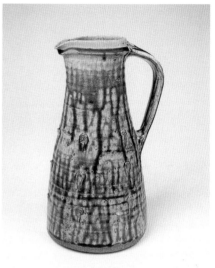

Bernard Leach, bottle, *c.* 1960, Stoneware, thrown in two parts, painted in a thin layer of white slip, the sides divided into six panels, with combed wave decoration under a semi-clear glaze; h. 42 cm. (Courtesy Cleveland Craft Centre, Middlesbrough).

Bernard Leach, jug, *c.* 1960. Stoneware, thrown; h. 31.75 cm, w. 16.50 cm. Leach greatly admired English medieval jugs and pitchers and based this shape on them. (Leach archive).

Bernard Leach finishing the neck of a bottle on the wheel, Leach Pottery, St Ives, *c.* 1965. (Leach archive).

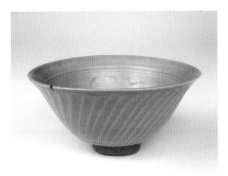

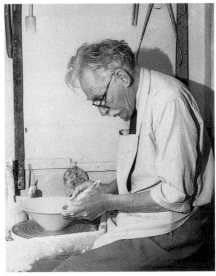

Bernard Leach, bowl, *c.* 1960. Porcelain, thrown with fluted decoration on the outside and incised pattern on the inside, pale blue celadon glaze; h. 7.9 cm. d. 23 cm. Impressed marks BL and SI. (Buckinghamshire County Museum).

Bernard Leach working on the inside of a porcelain bowl, *c.* 1955. (Leach archive).

Bernard Leach, bowl, *c.* 1960. Stoneware, thrown and turned with incised decoration on the inside and fluted decoration on the outside of a silky-smooth celadon glaze; h. 10.15 cm, d. 12.85 cm. Based on Chinese Sung form, Leach liked to play with the balance between the width of the rim and foot. Impressed marks BL and SI. (Leach archive).

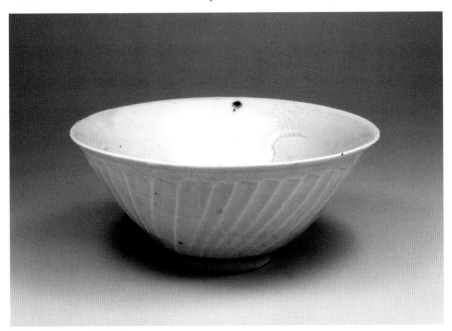

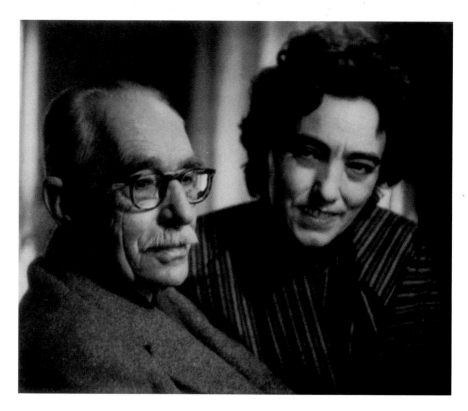

Bernard and Janet Leach, a portrait by Trude Fleischmann, New York, 1960. (Leach archive).

Trudi Scott and Bernard Leach, *c.* 1977. Scott, a fellow Bahá'í who befriended Leach in the last two decades of his life, acting at various times as his housekeeper and secretary. (Private collection).

Left to right, Lucie Rie, Bernard Leach and Janet Leach, *c.* 1970. Leach hoped that Janet would share his friendship with Rie. (Private collection).

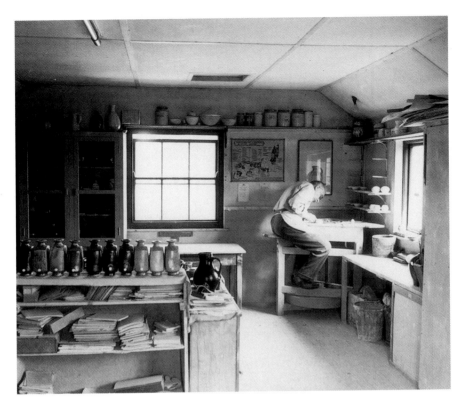

Bernard Leach working on the wheel in his studio at the Leach Pottery, St Ives, *c.* 1963. (Photograph Glenn Lewis).

Bernard Leach assessing a pot thrown on the wheel, Leach Pottery, St Ives, *c.* 1970. (Leach archive).

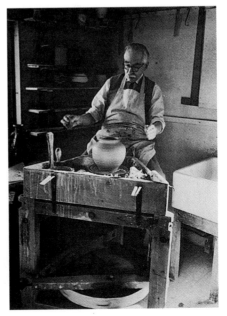

Bernard Leach watching John Reeve throw on the Leach kick wheel; Leach and Reeve shared a deep interest in Eastern religions and Leach saw Reeve as 'his natural successor'. (Leach archive).

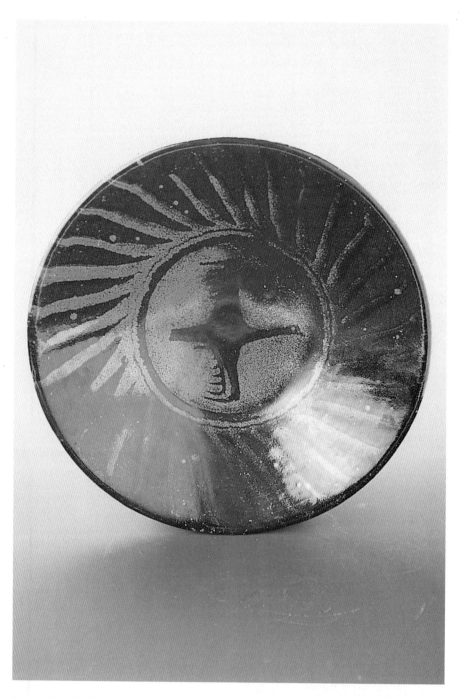

Bernard Leach, dish, *c.* 1966. Stoneware, thrown, with stencilled bird decoration in iron slip; h. 7 cm, d. 35 cm. The flying bird, suggesting freedom, was a favourite motif for many of Leach's dishes. (Collection David Leach OBE).

Bernard Leach, bottle, *c.* 1959. Stoneware, thrown with vertical ribbing and temmoku glaze; h. 36.3 cm, d. 29.7 cm. Impressed marks BL and SI. (The Board of the Trustees of the Victoria and Albert Museum, London).

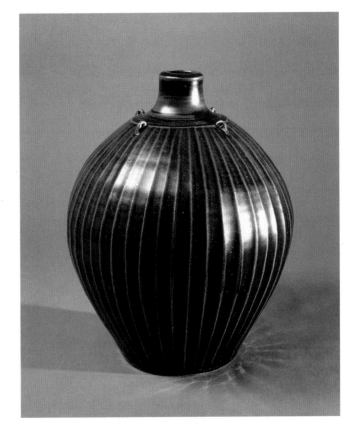

Bernard Leach at the retrospective exhibition 'The Art of Bernard Leach' at the Victoria and Albert Museum, 1977. Janet Leach stands on the left, the author stands behind Leach to his right. (Times Newspapers).

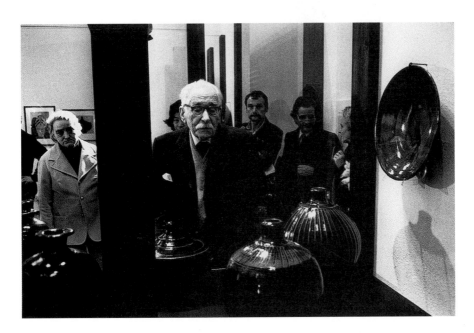

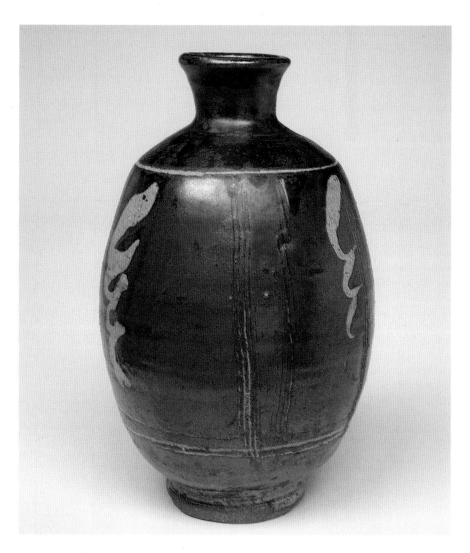

Bernard Leach, bottle, *c.* 1966. Stoneware, thrown with design in wax resist and brown/red slip under a semi-clear glaze; h. 24.7 cm, d. 17 cm. This was the bottle selected by the Royal Mail to use on a postage stamp to celebrate the art of pottery. The other three potters chosen were Lucie Rie, Hans Coper and Elizabeth Fritsch. (Leach archive).

Bernard Leach Memorial, Abiko. Made of polished granite, it bears the silhouette of a travelling monk, one of Leach's favourite designs. (Photograph Kazuno Mori).

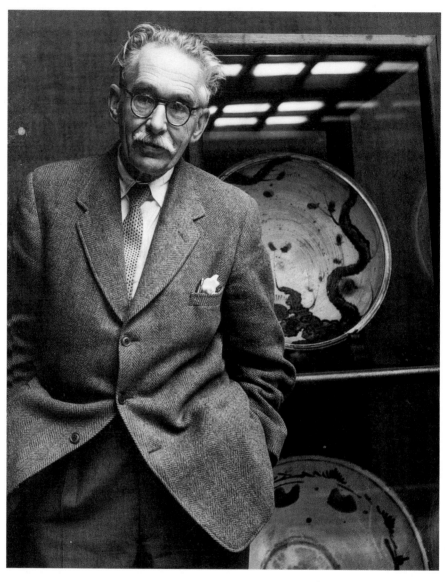

Bernard Leach in a museum in Japan, *c.* 1965. (Family archive).

them both was not what the abbot thought appropriate and he repeated his inquiry. Sensing the tone of a Zen question, Leach sidestepped it by asking about enlightenment and its importance for the artist. 'There cannot be art without enlightenment',[20] was the abbot's reply, and this led to an easy conversation in which Leach was accepted without further interrogation. On departing he was given a handwritten poem: 'Amidst mountain peaks no place for measured time', which seemed to accurately encapsulate his months in Japan. When reflecting on his various stays in the country he concluded that they were 'some of the richest and happiest years of my life'.

The visit certainly provided an opportunity for spiritual regeneration and time to regain a sense of inner peace. Increasingly Leach became aware of how Yanagi's death had deprived him of coming to a fuller understanding of his old comrade, and he spoke at length about the loss of a friend, an original thinker and leader of the Mingei movement. By 1961 the latter had grown to include a paying membership of about 2,500 but actively encouraging the work of traditional country craftsmen whilst also supporting selected contemporary artist craftsmen working in a 'revivalist' style raised familiar ideological issues for Leach. Travelling round the country he not only came to realize the extent of the differences between the two types of work but also the changes in so-called traditional craft. Much of this, he saw, was now 'produced by educated, modern Japanese rather than artisan craftsmen, who are not simple or religious-minded like their forebears'.[21] As such it could no longer be usefully described as folk art. In daring to suggest that a rethink was needed, Leach proposed the term Mingei-style to describe such work. 'The age of folk-arts is over – or almost over – everywhere', he wrote, attempting to come to terms with the changing conditions of the modern world. 'We have', he continued, 'launched into another world of individualism, science and the machine, and we cannot go back. We must go forward into the next age',[22] a comment that seemed equally relevant to his own life.

In pursuit of his Kenzan studies he collected photographs, talked to experts, looked at manuscripts and visited sites where Kenzan lived and worked, consolidating his reputation as an 'expert' on the poet and painter. Shortly before the end of his visit his research was dramatically accelerated by an urgent request from Mizuo Hiroshi to see a recent discovery of over a hundred pots and three diaries thought to be by the first Kenzan.[23] Tempted by vanity, curiosity and scholarly interest Leach travelled to Kyoto in January 1962 to see them. Tomimoto, who had also studied the work of Kenzan, declined, knowing that Japanese etiquette would prevent him giving an honest opinion and any criticism would be taken as a personal attack on the host. As a foreigner Leach felt no such inhibition.

The owner of the pots, Morikawa Isamu, hosted a luncheon party at which the objects were presented. Distinguished guests included Leach's friend Horiuchi, curators of the Kyoto and Tokyo national museums,[24] and Ogata

Nami, one of the sixth Kenzan's two daughters, who had become a potter. Leach was fond of Nami, describing her as 'a nice quiet middle-aged woman who has never married'[25] and he advised her on what pots to show. When the three bound notebooks or diaries, together with the pots, were brought in Leach was so 'astonished' by their quality that he stopped eating to gaze at them. Without hesitation he accepted them as genuine, despite knowing of the existence of excellent fakes and aware that potters continued to produce 'Kenzan' pots almost identical to the originals. The lead-glazed raku pots with over-glaze and under-glaze decoration in black, reds, greens, yellows and blues in Rimpa-based themes of natural form such as flowers and grasses seemed to Leach to convey 'unequalled mastery'.[26] 'Not only do I think that they are genuine at first sight,' he commented, 'but also that they are the finest group of Kenzan pots that I have ever seen.'[27] The diary notebooks he found equally fascinating, the handwriting distinctively that of Kenzan. When translated, the short, evocative poems revealed, in Leach's opinion, much about the final years of Kenzan's life and his undiminished creative output.

In allowing himself to be placed in a position where, with little substantiating evidence, he was expected to verify the genuineness of the pots and diaries, Leach assumed an unwarranted belief in his powers of detection. Determined to be seen as an 'authority' he put trust in 'feeling' rather than a rational assessment of evidence. Recalling his affection for his teacher, he may also have wanted to please Nami, and to generally impress the distinguished gathering with his knowledge. The tremendous blossoming that Leach was convinced took place in Kenzan's life in his seventies, to some extent echoed his own undiminished creative energies in feeling that his pots remained as strong, if not stronger, than ever. In asserting this work by Kenzan so fiercely, Leach could easily have been speaking about himself.

The episode, which became known as the New Sano Kenzan affair (because the pots were claimed to have been retained by old, long-established families in the village of Sano, in what is now Tochigi Prefecture, north of Tokyo where Kenzan worked towards the end of his life), made front page news. Leach's enthusiasm knew no bounds, and he was convinced that the diaries explained Kenzan's 'late flowering in Sano and the circumstances surrounding his fifteen months there with the Tea and Poetry group who supported him'.[28] As a tribute he translated extracts from the notebooks, and several haiku were included in *Beyond East and West* (1978), including the spare but evocative

> A priest sweeps pine-needles
> In cold autumn rain.

Three exhibitions of the Sano finds, in Tokyo, Osaka and Tochigi province, divided experts and public between those who accepted them and others who vehemently doubted their authenticity. Doubts rested not only on the

improbably large number of pieces found but also on what appeared to be a florid, over-decorated style. Technically the pieces were also questionable, the decoration appearing to have made use of oxides such as chromium and selenium that were not in general use when the pots were supposed to have been made. Other worries included the resemblance of certain pots to illustrations that were produced long after Kenzan's death, by inconsistencies in dates, and by the overall impression of crude rather than sensitive forms. In an effort to persuade Tomimoto, Leach himself sent photographs but he remained unconvinced; Hamada 'raised the strongest objections', considering the shapes poor and the decoration too ornate. It was a dispute that was to dog Leach for the rest of his life, though he never wavered in his view. Following the convention of *mokusatsu* or 'murder by silence', the affair was allowed to die down as if it had never happened. Before leaving Japan, Leach accepted as a gift one of the tea-bowls he most admired on the condition that he present it to the Victoria and Albert Museum.

Correspondence brought details of home. 'Cheerful' letters from Janet at least helped to maintain contact and were reassuring, though the news that the talented young American, Byron Temple, was leaving the Pottery after only a few months was unexpected. Despite having initially committed himself to a period of a year or more, Temple found the atmosphere tense and attitudes too precious.[29] Writing to Lucie Rie[30] Leach pondered the reason, wondering if Janet may have been responsible, although it transpired that while Temple experienced the mood at the Pottery as negative and unfriendly rather than creative and stimulating, it was Bill Marshall rather than Janet he found particularly overbearing. He also resented what he saw as Leach's narrow and confining attitudes. In his place came other overseas students including Mirek Smísek[31] from New Zealand, and later Clary Illian[32] from Iowa.

In the same letter to Rie, Leach wrote of his disapproval of the arrest and imprisonment of the distinguished philosopher Bertrand Russell who had taken part in the Campaign for Nuclear Disarmament peace protests. 'So law is more important than freedom. I swore!' he wrote, indicating his own continuing pacifist commitments. From Barbara Hepworth came letters assuring him that he was greatly missed, and in return he sympathized with her over the tragic death in an air accident of her friend Dag Hammarskjöld,[33] Secretary-General of the United Nations. 'It was as if a light had gone out,' she told Leach.

From Japan, Leach flew via Manila to Sydney, Australia, and a warm reception at the University of New South Wales. A few days were spent with Ivan McMeekin, a potter who, after working in England with Michael Cardew, had set up a workshop in Australia. Among others, McMeekin had taught Gwyn Johns, a gifted potter whose work at the Leach Pottery was much admired. One of the country's pioneers of reduction-fired porcelain and stoneware, McMeekin had a great admiration for and knowledge of classic Chinese glazes

and, inspired by Cardew's example, he devised Chinese-type bodies and glazes from indigenous Australian raw materials. In a radio broadcast Leach took up familiar themes, speaking of 'the man behind the pot', and identifying a profound change of status of the potter who, he said 'has been forced into the same position as the artist. During my lifetime something has happened, bringing about a new set of values – an expanded consciousness of what is true and beautiful in life. The task before us [is] to discover how to use this new perception'.[34] It was a paradigmatic shift that reflected the huge changes he was experiencing.

At Wellington, New Zealand, Leach was met by Terry Barrow,[35] a friend and anthropologist at the Dominion Museum. When undertaking his studies at Cambridge University, Barrow had visited potters in England, including Leach with whom he had established a great rapport. He himself also made pots from time to time. During Leach's four-week tour of the islands,[36] Barrow was a constant companion, facilitating meetings and showing him the beautiful countryside, which seemed to Leach like a semi-tropical England with 'sheep all over a magnified Salisbury Plain'. In Auckland Leach spent time with Len Castle, a former St Ives student, at his house built on tall stilts taking it to treetop level and enabling Leach to gaze in awe at giant ferns and other strange formations unique to the country. The mayor honoured him with a civic reception, and he gave a public lecture at the City Art Gallery where he showed films including Read's *A Potter's World*, one on Tomimoto and slides of Korean pottery. One of the more exciting excursions involved hiring a small-float aquaplane to visit Barry Brickell at Coromandel. After the dramatic take-off across water Leach was thrilled when at one point the pilot allowed him to take control of the joystick. Brickell's house and huge plot of land proved as beautiful as he had been told. Leach was particularly intrigued by a small drip-feed oil-fired test kiln with a biscuit chamber attached that reached stoneware temperature in four to five hours, wondering about its possible use at St Ives.[37] When visiting another former student, Peter Stichbury at Ardmore, Leach again could not resist taking on the role of teacher and gave his pots a frank and not altogether flattering appraisal. At Dunedin on South Island he spoke to an audience of 300, perceiving the usual warm welcome. Patricia Perrin arranged a visit to Leon Cohen's joinery, where high-quality kick wheels were built based on the Leach design.

The days were filled with lectures, broadcasts, parties and official receptions, including one given by the Japanese ambassador. There were also pots to look at, potters to meet and pottery groups to talk to, as well as meetings with Bahá'ís. The tour was exhaustive and exhausting, but with his circus-horse instinct Leach was always entertaining, witty and erudite, charming his audiences wherever he went. In his role as distinguished guest he was often entertained in 'high quarters' by such luminaries as the High Commissioner of New Zealand Sir Francis Bruce and the Vice Chancellor of

Sydney University,[38] when he took the opportunity to stress the importance of nurturing the blossoming studio pottery movement. To cultural bodies such as the Arts Advisory Council he emphasized the seriousness and quality of the work produced.

During his stay Leach met many of the 500 or so potters in New Zealand, 'a few pretty good' and was given hospitality in ten different homes. The pots he found 'far less showy and "different" . . . than in America',[39] though in his farewell message he took up his familiar line by opining that the pottery 'has not got, as yet, a definite character of its own'.[40] Yet, despite his criticisms, Leach was warmly, often enthusiastically received, and he felt that he 'helped other people to greater clarity'.[41] As in America it was the potters themselves with their genuine respect and generous hospitality that made the greatest impression rather than the pots.

On his last day in Wellington Leach, accompanied by Terry Barrow and his wife, Joy, visited the architect Ernst Plishke and his wife, Anna, friends of Lucie Rie from pre-war Vienna. Their modernized old house in the hills above the city offered a breathtaking view of the sweeping harbour. In addition to talking about Lucie Rie and the quality of her pots, they also touched on more philosophical questions. In an edition of *New Zealand Potter*[42] Plishke had written of the need to digest the stimuli of the past as a step forward to the future, a view that reflected Leach's own thoughts.

During the visit Leach received tragic news from Warren MacKenzie that his wife, Alix, had died after a brave fight against cancer. With two young children, Shawn and Tamsin, it was a devastating blow and Leach was greatly upset by the loss of a friend and the impact on her family. He wrote to Warren:

> Tears rose as I looked out over the tops of the tree ferns towards the setting sun over the green semi tropical alley. Oh my dear Warren if this is grief to me what is it to you? I believe in the continuance of conscious life, so prayed that Alix could make the passage from this to that in the hand of God and that you and the children could find the way to go on in this life, rightly and therefore quietly and steadily. God grant it for the test is severe.[43]

On the return journey to St Ives Leach flew first to Japan then Seattle in the United States, to discuss with John Reeve his problems in convincing the Canadian authorities of the viability of setting up a well-equipped school of pottery. From Seattle he travelled to Minnesota to spend a few mournful days with Warren and offer what solace he could before flying to England and 'back to my problems'.[44]

Taking stock during his six months away Leach had come to the conclusion that whilst not wanting his marriage to end he needed to find ways of making it at least workable and the partnership effective. He also realized that he needed to distance himself from Janet in some way, possibly by moving out of

the cottage. They now slept apart, and as Leach told Tobey 'I carry on as best I can, the alternative is too destructive and fearsome'.[45]

Despite her consumption of alcohol Janet managed the Pottery more or less successfully. Order books were full and apart from the comings and goings of the crew and residual resentment at Janet's occasionally abrasive manner there was a sense of purpose and direction. As a means of providing reasonably priced student accommodation and also to ensure a measure of financial security she invested in more property, acquiring eight flats and two shops. With a friend Mary Redgrave, known as Boots, she opened the New Craftsman, a shop in the centre of St Ives.

Bearing in mind his plan of living apart, Leach was prompted into action by the opportunity to acquire a flat in a recently completed block known as Barnaloft, situated on the edge of Porthmeor Beach. Designed by local architect Henry Gilbert, the flats, on two levels, were spacious with large picture windows overlooking the Atlantic. Despite the reasonable price of £2,000 buyers were slow to come forward. Barbara Hepworth, struck by the quality of light, acquired one as a refuge where she could draw in peace. Inspired by her example Janet quickly followed, negotiated a private loan, and planned to let it in the holiday season and live in it the remainder of the year. With other flats still available Leach was approached independently and decided that flat number four would suit him fine, and without consulting Janet – who organized their finances – courageously arranged his own funding through their accountant Tony Williams.

The first Janet knew of Leach's decision was finding him measuring items of furniture with a view to installing them in his new premises. Although Leach intended to spend only weekends in the flat the move did not altogether meet with Janet's approval for though both found the cottage too small she resented having to repay the loan on property that would produce no income. More importantly, she thought that living in the flat would take Leach away from his work as a potter. While their relationship had changed drastically and they were still in the process of working out a modus operandi, she retained her respect for Leach as a potter and wanted him to be able to work freely. For Leach being able to spend time at Barnaloft represented liberation from Janet's control and as soon as it was furnished he spent weekends there, taking the opportunity to become more involved with the Báha'ís and entertain members of his family away from Janet's disapproving gaze.

At the Pottery Bill Marshall kept an eye on the production of standard ware, and was a stern critic of pieces he considered weak. Although Leach often referred to him as the foreman, and he certainly was Leach's right-hand man in making many of his pots, he never took over as manager. Marshall made his own pots, which, rather than reflecting the refined qualities of Leach, showed the more rugged influence of Hamada and that of the anarchic

Japanese potter Rosanjin Koitaoji,[46] a figure rarely mentioned by Leach and his circle of Japanese friends. In conversations with Matsumoto Sono, a friend of the Leach family and a regular visitor, Marshall learned about this highly individual potter.

New students, especially those from overseas, brought fresh ideas and suggestions for additional shapes. In keeping with the times, tea-bowls, sake cups and rice bowls, based on a Korean shape, were introduced. Ichino Shigeyoshi, son of the pottery family from Tamba devised the last two, which for many students were 'most rewarding and difficult'.[47] Further moves were made to free up the forms made and produce more individual work. Experimental firings were carried out in the small stoneware kiln resulting in innovative pieces that were beneficial to both the Pottery showroom and the development of personal ideas. 'Each potter must be allowed and encouraged to "do his own thing",' argued Janet, 'to develop his individual expression in pots alongside his development in throwing standard ware.'[48]

There were also changes to the regular crew, in particular the unpopular dismissal of Horatio Dunn who was responsible for clay preparation and pot packing. Dubbed 'the Artful Dodger', his regular series of scams involved the private sale of seconds – pots considered not of first quality – and charging the Pottery twice for packing cases. Feeling that such fraudulent practice had a demoralizing effect on the crew and had been going on for too long, Janet dismissed him, accusing him of 'constant stealing, lying and bad work, heavy drinking'.[49] The crew, led by Leach's grandson Johnny who thought Dunn's many years of loyalty and service should be recognized, protested vehemently but Janet was unrepentant arguing that he had become a liability rather than an asset and reluctantly Leach had to agree.

With Kenneth Quick, known as Kenny, and described by Leach as 'the life of the place',[50] on a working visit to Japan, the remaining crew was stretched to meet orders. Quick was regarded not only as skilled and talented, 'the warm solvent of our group',[51] but as a potential Pottery manager. His own pots included quiet but subtle variations of *unomis*, or tea-bowls, with understated brush decoration. Having heard so much about Japan, Quick was keen to see the country and work at Mashiko, and Leach, perhaps recalling his failure to send David, secured a £500 Elmgrant from Dartington to cover costs. In the event Japan did not quite live up to Quick's expectations. Although full of admiration for the magnificent countryside, the 'picture postcard houses' and the 'strange but interesting' food, he saw little in the kiln at Mashiko to excite him, finding much of the ware 'over decorated and tight'. In truth, though pleased to see the country, he was homesick and began to wonder if he was 'the right person to have this opportunity because such a large part of me is still there in St Ives'.[52]

Tragedy struck only weeks before Quick was due to return to England. When swimming with friends at Kumihama-chōyoung bathing beach on the

Inland Sea, the police, warned about the imminence of a typhoon and strong tides, insisted the bathers come ashore. Quick, last seen waist deep in the water laughing and waving his arms about, disappeared. Fearing that the back-wash or strong undertow had swept him out to sea, boats immediately set out to search for him but the rough seas caused by the typhoon rendered the task impossible. Two days later his body was found along the coast. The news of Quick's death,[53] at the age of thirty-four, was a terrible shock. In St Ives Bernard and Janet, the first to be given the news, had the unenviable task of telling his widowed mother. Despite the presence of her other children she could not be consoled and irrationally blamed the Leaches for securing the money for the trip. Quick's mother wanted her son's body returned but this proved impossible and his ashes were flown home and, after a mournful service in the Methodist church, buried locally. In Mashiko the pottery workers, car-rying sticks and incense, attended a brief Buddhist ceremony at Hamada's house, and his pots were later glazed and sent to England.

A further sad blow came with the death of Tomimoto[54] at the age of seventy-seven. For some time he had been suffering from lung cancer, too weak for an operation. The year before his death he had built a new house in Yamashina, Kyoto, for himself and his mistress Fukie Ishida, but soon afterwards became ill. His mistress, Leach was told, had kept the seriousness of his illness from him, and failed to notify his friends or family for some days after his death. In addition she had inherited £30,000 to £40,000 from the estate, leaving Tomimoto's family with very little. All this, heard second hand, caused Leach great distress. Reflecting on his enduring friendship, Leach recalled their shared interests in art, their common training as potters, and their close comradeship when they were 'like brothers, perhaps better than many'.[55] 'With his young vitality and sharp fine perception of beauty',[56] Leach acknowl-edged that Tomimoto 'opened new doors of understanding'. One of his chief regrets was that he had been unable to help his comrade work as a potter in England. 'This mysterious, unknown gate-way – death,' meditated Leach, 'how shall we look it in the face, positively, fearless.'[57]

In addition to the deaths of friends and the 'difficulties and tensions' of life with Janet, Leach was alarmed to discover that the manuscript and illustra-tions for the book he was preparing on Kenzan and his school had been lost. When leaving Japan it had inadvertently been packed up for storage at Inter-national House and did not turn up again for two years. This was in addition to the loss by another publisher of the plates of *A Potter's Portfolio*.[58] 'Fate' observed Leach, 'is hitting me hard and I am in a fearful tangle from which I cannot run.'[59]

The Barnaloft flat offered some escape. Through its huge windows he could watch the rise and fall of the Atlantic, 'the sun sets across the waves'[60] and the fishing boats bobbing beyond the rocks. A poem, 'Barnaloft',[61] suggests some of its pleasures:

My room so warm,
My window so large,
At the sea edge.
The dried foam
Blows
Along the sand,
Rolls
Into nothingness.

Here there was the opportunity for 'licking his wounds, getting some peace, reading, a little drawing'[62] and at the beginning of 1963 Leach contemplated a permanent move. In his diary he drew up a list detailing the rights and wrongs of his relationship with Janet. In it he looked at the past and towards the future, considered independent friends, loyalty, disloyalty, and ended on a practical note about car repairs. He also listed the ten names of the Pottery crew.[63] Shortly afterwards he moved permanently to Barnaloft, insisting that although in his late seventies he could live alone and care for himself. At various times housekeepers were appointed, though he resented paying their wages, and on one occasion one walked out when there was a disagreement over the preparation of a steak and kidney pie. Janet also moved into her flat, where she could entertain her own friends away from the prying eyes of the Pottery crew and at the same time be on hand should Leach need her.

The first major public event following his return from Japan was the investiture at Buckingham Palace when Leach was created Commander of the Order of the British Empire (CBE), the ceremony having been deferred until he was back in England. Pleased and flattered, Leach the royalist found Queen Elizabeth II 'human and charming'. Later in the year there was a summer banquet for artists and scientists at the Mansion House in the City of London, a splendid affair 'full of drums, trumpets, choirs, loving cup rituals and halberds',[64] all of which Leach greatly enjoyed. Other distinguished guests with whom he chatted included T. S. Eliot and Henry Moore. While such awards were unsolicited, Leach wrote to Warren MacKenzie 'I did not say "no"'.[65]

However welcome such public recognition, it did not quell his endless questioning of whether to commit himself to working for the Bahá'í faith or continue as a potter, a decision that became more meaningful now that he had his own flat. 'Hamada says my work is good to live with, Yanagi believed in it, they say it is *sunao*. I know there is a spark in me that is "not me", it is more than me, but I also know how often I have failed it both in art and in life.'[66] Although art and life were inextricably combined at St Ives, free from Janet's disapproving and sceptical gaze, Leach increased his involvement with the Bahá'í. At regular Sunday evening fireside meetings attendance varied from three to twenty. Prayers were read and various aspects of the faith discussed, but much to his regret, few recruits were secured, leading Leach to complain

that 'artists are hard nuts to crack, they hang on to their precious individ-
ualism'.[67] However, he became even more convinced that 'our way of life –
industrial materialism . . . will have to receive a blow before our conceit is
pricked, and people listen'.[68]

A major Bahá'í event was a huge public celebration of faith at the First
World Congress at the Albert Hall, London, in 1963 when some 6,000 Bahá'ís
from round the world gathered to celebrate the 100th anniversary of the
'Ascension of Bahá'u'lláh' to the Throne of His Sovereignty'. To mark their
long friendship and their shared beliefs, Leach, Mark Tobey and Reggie Turvey,
who had returned to South Africa in 1940, planned a reunion around the con-
gress. Now seventy-nine Turvey was gaining wider recognition as an artist in
his own country but remained poverty stricken and in poor health. Tobey and
Leach agreed to meet the cost of Turvey's travel. Tobey suffered from a series
of ailments but with increasing fame his greatest dilemma was whether to
remain as a tax exile in Switzerland or to return to the United States. In
London Turvey and Leach stayed with Guy Worsdell, a painter friend, before
moving for a week to Barnaloft, where Janet helped prepare meals and care
for them, though because of Turvey's severe deafness she found communica-
tion difficult. The two old friends slowly walked the streets of the town, both
aware that they were unlikely to 'meet again over brown earth'.[69]

Setting up meetings with Tobey proved tricky for he seemed reluctant to
actually agree a time and place, and once after visiting Dartington Hall he,
typically, disappeared. This, Leach suspected, was because of Tobey's fear of
any involvement in his marital problems. Eventually they did all get together
and Tobey was as generous with his hospitality as Leach was cautious. 'I was
short of cash and let you pay disproportionally',[70] he wrote apologetically. All
three made a pilgrimage to Shogi Effendi's grave in New Southgate Cemetery,
north London and pondered the future. At the Albert Hall, despite a lack of
a common language, Leach was aware of a shared faith and love. At one point
Rúhíyyih Khánum spoke movingly about Shoghi Effendi, at the end of which
the Africans present started singing gently until everyone joined in.

Having seen Leach at the World Congress 'looking old and doddery and
talking about death',[71] Trudi Scott decided she must offer practical help in
caring for him. Since standing as a witness at Leach and Janet's Bahá'í wedding
she felt responsible in some way for its partial disintegration and decided
to move to St Ives to be near Leach, even applying for a job in the New
Craftsman. Unfortunately for Trudi, Janet did not want what she saw as
interference in her relationship with Leach and she had also become pro-
gressively more antagonistic to Bahá'ís and no job was forthcoming. Recalling
her own unhappy marriage, Trudi encouraged Leach to stand up to Janet,
which only added a further strain to his marriage. She also helped Leach
entertain what seemed like a non-stop series of Bahá'í visitors, all of whom
Janet complained kept him from making pots.

Inspired by the example of the American Bahá'í Jack Davis who gave up his job and possessions to 'cry the name of Baha'u'llah amongst the thieves and murderers in the prisons of the Philip[p]ines',[72] and who succeeded in bringing 24,000 into the faith, Leach, with Trudi's support, agreed to speak in public about his belief. With true pioneering spirit he felt ready to talk about the faith with 'understanding, conviction and clarity' as part of his commitment to recruit new members. Notices of the meetings were posted round the town, though he was put out when some visitors assumed that this would be about Zen Buddhism. Occasionally the Salvation Army hall was booked but attendance was disappointing. Encouraged by Trudi, a part of him was drawn to full-time involvement with the faith, but remembering the advice of the Guardian of the faith to 'do your work and teach when you can'[73] he was reluctant to stop potting. While observing that 'most of my work is done', a vital part of him still felt the need to make pots.

Most days Leach would drive up to the Pottery, parking the car in the yard, though rarely without scraping it against the wall. With a full exhibitions programme, including two in Paris, a show of new stoneware and porcelain at Primavera in October,[74] and a visit to Japan in 1964, his making time was fully occupied. Janet was also consolidating her individual reputation with a show in June at Primavera. With major exhibitions generally taking about six months of concentrated work they devised a scheme of making three rather than one of any new shape, two for exhibition, one for the St Ives showroom, to meet all their commitments.

In Paris, Leach's pots, along with pieces by Hamada, were given pride of place in a prestigious international exhibition at the Louvre, inaugurated by the French minister of arts, André Malraux. The invitation had come following the intervention of the French potter, Francine del Pierre, whom Leach had met through Henry Rothschild. Much to Rothschild's delight, after Leach had admired her pots at Primavera and knowing that he genuinely liked the work of few modern potters, he arranged for them to meet. Flattered, Francine took the opportunity to cook a classic French meal that Leach greatly appreciated and their friendship was cemented.

Later in the year Leach was in France for two combined exhibitions. The first, 'Exposition Internationale du Grés à Ratilly',[75] was at the invitation of the French foreign minister and Monsieur Pierlot at the magnificent Château de Ratilly, the thirteenth-century castle some 180 kilometres from Paris. Pots by Leach, Francine del Pierre and Jeanne and Norbert Pierlot, who ran the pottery at the château, were on show. This was followed by an exhibition at Galerie de France[76] in Paris, shared with Hamada, who joined him in the city and Fance Franck,[77] the American-born potter with whom del Pierre shared a studio in the rue Bonaparte, Paris.[78]

A strike of electricians the following day prevented the gallery from opening and Leach and Hamada, recalling their visit thirty-four years earlier,

suggested a visit to Chartres to marvel again at the soaring architecture of the cathedral and ponder its creative spirit. To Leach the building was not only a great work of art but more importantly an expression of profound belief. Walking slowly up the nave with Francine he was suddenly aware that 'the spirit of the place was upon me' and asked to be left alone for a short time. Although the magnificent building had no direct contact with the Bahá'í, he found himself overwhelmed by memories of his own religious childhood and the evidence of faith that surrounded him. The sight of worshippers in the Virgin chapel silently kneeling each holding a candle, the only light other than the sun flooding in through the ancient stained glass window, he found intensely moving. In the cloisters, on one of the earliest arches, Francine pointed out a carving of a potter's wheel, an illustration of the Creation carried out at a time when few could read.

The exhibition coincided with a talk by Leach to the staff of UNESCO[79] in which he outlined the history of the 'stoneware pottery movement', beginning first by acknowledging the work of Morris and his followers who gave birth to the concept of 'the artist craftsman'. He went on to pay fulsome tribute to Yanagi's contribution in recognizing the folk art of Japan and Korea. 'My belief', he concluded, 'is that we are slowly feeling our way towards a criterion of the good pot corresponding more or less to those unwritten principles by which we judge other forms of art',[80] and that enlightenment comes from the East – 'ex oriente lux'.[81]

In London a show of Hamada's pots at the Crafts Centre was opened by the Japanese ambassador, Katsumi Ohno, and almost immediately sold out, attracting an astonishing 1,000 visitors a day. Leach entertained Hamada and his wife in London by exploring the cosmopolitan cuisine of the capital. In chop houses they ate traditional English food and, by contrast, tasted hot curries and spicy dishes in Indian restaurants, all of which they greatly enjoyed. In St Ives, the Hamadas stayed in Janet's Barnaloft flat, where they discussed among other topics a six-month visit by Leach to Japan in early April with the primary intention of completing the book on Kenzan and beginning a translation of Yanagi's writings. To her chagrin Janet was again not included.

Despite its growing acclaim the Crafts Centre was going through one of its periodic financial and ideological crises, with the Board of Trade hinting that it would not renew its annual grant of £5,000. Although modest, the sum would have ensured that the centre could remain afloat and focus on the best rather than the most commercial work. Angry at the philistine decision Leach wrote to the *Daily Telegraph* drawing attention to the meagreness of the amount and pointing out that 'the handicrafts of England are historically something to be proud of'.[82] Endless meetings were arranged and proposals put forward, with the craft world divided between various factions. Cyril Wood, energetic and persuasive, a former BBC producer and founder of the South West Arts Association, was introduced by Gordon Russell as a possible saviour and was

eventually appointed director of the Crafts Centre. However, Leach did not trust Wood, a judgement well founded when Wood eventually declared the Crafts Centre a 'lost cause' and recommended its closure. After several years of bitterness, proposals and counter-proposals Graham Hughes, art director at Goldsmiths' Hall, took over as chairman and oversaw the relocation of the centre[83] to an old banana warehouse in Covent Garden. The area, still recovering from the loss of the fruit and vegetable market,[84] was noted for its low rents and although considered unfashionable and off the beaten track, was seen as full of potential.

On issues he thought important Leach could be fearless in giving his opinions, and as with his view on the Kenzan pots, often relied as much on instinct as knowledge. At the Fourth Craft Conference, organized by the Society of Education through Art,[85] he had little positive to say about modern education, which in his view was largely unfeeling and remote. The sizeable audience, mainly made up of teachers and practising craftsmen and women involved in education, were meeting to delve more deeply into the possibilities, processes and problems facing the crafts, and to acquire knowledge of other crafts from distinguished 'experts'.

The full programme included kiln-building, spinning, textile and natural dying, slide shows and films of potters in Japan and St Ives. Recalling the UNESCO conference, Leach took the opportunity to challenge the 'very basis of our Western education, post-industrial, education', with its 'over-stress on intellect and, sequentially, upon theory before practise'. In conclusion he quoted the Chinese philosopher-statesman Liang Shi Yi who, when discussing the relative values of Chinese and western culture, said 'Your civilisation is outside in, ours is inside out'.[86] Such a profound critique by so distinguished an artist created quite a stir on the day but little subsequent action.

The year ended with Leach more or less successfully able to juggle the different parts of his life into some workable whole. Discussions with Janet on how Christmas was to be spent proved difficult and at one point she silently walked out, a highly uncharacteristic and somewhat alarming response. Slowly they did establish a means of working together, though Leach's observation in his diary was far from optimistic:

> From emptiness into fullness
> And back into emptiness.

In the end a compromise was reached whereby they agreed to spend Christmas Day together and have dinner with Barbara Hepworth and Priaulx Rainier, and reserve Boxing Day for his family, a means of coexisting that was to continue until his death.

THE DESIRABLE TRUTH

Japan England

1964–1969

On Good Friday 1964, before leaving for his sixth visit to Japan, Leach wrote a poem for Trudi Scott, indicating the important role she had come to play in his life. It described in terse, short lines some of the mental and practical preparations for the journey, inquiring in some metaphysical way 'What lies ahead?'[1] In Hong Kong he changed planes for Okinawa, largest of the Ryukyu Islands, though he preferred the more romantically sounding old Chinese name of Liu Chou Islands, where he was to meet Hamada. Aware that it was here that the American troops had landed in 1945, the islands were a reminder of the terrible conflict and his loyalty to both England and Japan.[2] Although much of Naha, the Okinawan capital and one of the loveliest cities on the islands, had been destroyed in the war, the pottery workshops had survived without damage. Hamada had worked here on his return from St Ives and had visited regularly ever since.

Both potters took part in the annual meeting of the Japanese Association of Folk Craft, when fifty or sixty leading craftsmen gathered for the two-week event. Under Hamada's direction the potters had not only made dishes for Leach to decorate but had also prepared a range of pigments for his use. The wheels, low on the ground, were awkward for Leach, fast approaching his eightieth year, but the pots were decorated and successfully fired.

For ten days Leach and Hamada travelled the semi-tropical islands enjoying the lush vegetation and warm weather. They welcomed the revival of the traditional weaving industry, appreciated the individual style of dancing and savoured the local food.[3] Remote parts of the island, unaffected by the ravages of war, retained a timeless quality and under a baking sun they explored distant coral islands with fine white sandy beaches, tasted delicious, freshly cut pineapple, drank local wine and admired strange, unfamiliar butterflies. Despite his age Leach was fit and energetic but he did notice that Hamada, having become fatter, was slowing down. Before moving to the mainland they hired a plane to visit the Yaeyama group of islands, five hundred miles further south off the coast of Formosa (Taiwan), and Quemoy Island, named Jinmen by the Chinese, where sporadically war still continued.[4]

In the following eight months Leach, usually accompanied by Hamada and various assistants, toured the length and breadth of Japan 'from Yaeyama to Hokkaido, crossing the country from coast to coast three times'. As they travelled up the western watershed and down the eastern, 'almost like following a twisting stream', Leach was reminded of the country's spectacular geography, which required incredible feats of engineering to construct the excellent roads. Craft centres were visited and numerous potters spoken to at endless meetings and lectures. They also went to the ancient pottery area of Seto, where some years earlier Leach had lectured at the pottery school, the equivalent of the Stoke-on-Trent technical institute. The smoky city with its 2,000 kilns was a far cry from its ancient origin as one of the old so-called six kilns of Japan,[5] most famous for decorated pots, including dishes with the *uma-no-me* or 'horse-eye' painted decoration. They sought out the surviving traditional potters and admired a 'fine almost unspoiled workshop with a grand climbing kiln half packed with simple straightforward bowls and plates made of the excellent local clay. The four chambers were about 7'6" inside, packed to the top of the arches'.[6]

In Shimane Province they spent time with the Shussai (or Shusai) Brotherhood, a visit undertaken partly to fulfil Yanagi's suggestion that the brotherhood might benefit from the guidance of an experienced maker sympathetic to their work. The group of Buddhist potters, who had no pretence to be artists, where attempting to deal with the problem of adapting their traditional understanding and working methods to the needs of the modern world. After being invited to comment on their pots, Leach silently watched them throw, showed them how to pull handles and how to make a lip. He also drew the pots they made and indicated what he saw as weaknesses in their forms, and suggested that they would benefit by having a creative artist as a leader, preferably someone from among themselves to guide and direct. At first they doubted if anyone in their group would be suitable, but during the discussion they were joined by Funaki-Kenji, a young artist potter, who quietly threw a series of forms based on English medieval-style jugs. Rather than produce mere copies Funaki-Kenji's shapes were alive and the potters recognized the transformation. 'Something new had happened, a pot was born alive', observed Leach, it was a meeting of '"individual and community"'.[7]

Touring Japan without the company of Yanagi and Tomimoto was often an unsettling experience, as Leach recalled the warmth of their friendship and the visits they had made, and he felt that they and Kenzan were constantly at his shoulder urging him on. This impression was heightened when he began his book based on Yanagi's writing, and his old friend often seemed to be 'sitting next to me in spirit'.[8] This was even more so when Hiroshi Mizuo, acting as Leach's secretary, or Sonoe Asakawa of the Nihon Mingeikan read aloud Yanagi's writing whilst Leach 'wrote down his thoughts in English'.[9] The

more Leach studied Yanagi's ideas, the more he admired them, coming to the conclusion that the Indian critic Ananda Coomaraswarmy[10] was the 'only one creative critic of religion and art of the East and West with whom I can compare Yanagi'.[11] Both thinkers seemed to Leach to open the way to the next stage in the evolution of 'total human life'.

Translating Yanagi's writings to make them accessible to Western readers while doing full justice to the complexity of the Eastern concepts he put forward proved not only a linguistic challenge but inevitably involved Leach in questioning his own perception of the role of the artist. As part of their attempt to understand Yanagi's Buddhist aesthetic of beauty, in long conversations Hamada and Leach discussed his ideas on the role of artists and craftsmen in the modern world. They also sought to follow Yanagi's studies on the teaching of the three great exponents of Buddhism – Honen, Shinran and Ippen Shonin – and the relevance of their ideas to concepts of beauty.[12]

Central to Yanagi's thought was the belief that artists should utilize intuition as much as intellect and attempt to transcend individualism and thereby attain what he called the Round Table of Heavenly Beauty, something that was beyond relativity and all assessments of above and below. In putting forward such far-reaching concepts Yanagi's hope was that they would encourage a society in which co-operative rather than individual work was 'the life-expression of all'.[13] The breadth of such concepts and their apparent denial of the importance of the individual creative force, together with Yanagi's 'condemnation of the self-centredness of so much individual art', caused Leach to ponder long and hard. To achieve such a state, he felt, was beyond the power of most artists except on a modest scale, and to succeed such a movement would require immense authority and the strength found only in the leaders of a world religion such as Buddhism or Christianity. Far from encouraging Leach to become a Buddhist, it seemed only to confirm his adherence to the teachings of Bahá'u'lláh, 'which includes and relates to all the great religions of mankind on a world scale'.[14]

By the law of karma, Leach understood, 'good' or skilled acts yield pleasant results and 'bad' or unskilled acts unpleasant ones, and that creating fine work was in itself an expression of faith. Yanagi's ideas, he realized, required a profound re-evaluation of 'correct thought' and he wondered what artist craftsmen would make of it in the West, especially in America. 'The broad idea,' he wrote to Glenn Lewis, 'is based on Christianity as well as Buddhism, that the craftsman and the artist, in search of truth and beauty, has got to get rid of self, and self expression, in the egotistic sense.'[15] The Korean rice bowl was cited as an example of an object simply and unselfconsciously made by artisan potters that was transformed by tea masters into a tea-bowl, 'a paramount example of work done by man in complete harmony with the creative process in nature. No swank at all'.[16] The concept of the 'real' or authentic

work produced by anonymous makers was one that stood in opposition to Leach's as an individual artist.

A recurring theme in Leach's books on Kenzan and Yanagi was the importance of tradition to an understanding of the present. Both Leach and Hamada, while regarding the past as important, agreed that it offered only a limited solution, and thought that modern artists must get rid of at least two centuries 'of junk' if they were to find true inspiration in historical wares. Nevertheless, they felt it important that they identify the relevance of Kenzan and Yanagi to new generations of artists. Both the way of 'humble tradition' and the way of the individual artist could lead to the same 'hill top' but were not accessible to modern artists, claimed Hamada, unless they lost what he called their 'tail', an inevitably agonizing procedure because modern artists and society had their values upside down. Paradoxically, however strong the obligation of the artist craftsman to society, both thought that it need not preclude the possibility to be either hermits or pariahs.

Whenever possible Leach attended meetings with fellow Bahá'ís to exchange ideas and plan for a better future. He agreed to use his privileged position as a distinguished artist and foreign visitor to make the Bahá'í views known to Emperor Hirohito and negotiate a mass of red tape to present the emperor with a copy of the Declaration of Bahá'u'lláh. Leach also wrote a long piece about his faith in which he detailed his personal commitment to bringing together East and West, and he also spoke to a large audience of Bahá'ís at a convention in Tokyo, the speech being simultaneously translated into Japanese. Two years later he was to visit Agnes Alexander who had been nominated a Hand of the Cause[17] in recognition of her pioneering work in Japan. Although feeble and confined to bed in hospital, she 'still chirrups and sticks her tongue out',[18] reported Leach.

In Tokyo Leach invariably stayed in the relative comfort of International House, a sort of club with a membership system set up after the war by Aileen Osborn Webb to accommodate Europeans and Americans who had come to teach in the universities. Here Leach enjoyed privileged status and was referred to as 'Master'. One warm day in May, after many hours writing, he escaped into the Japanese garden, which while not large, was beautifully laid out. It encompassed a bluff with trees and winding paths that crossed stone bridges over an artificial riverbed in which were placed large water-worn rocks and small pebbles to evoke the suggestion of mountain streams. A large pool had pike rising. The carefully chosen and arranged rocks had been partly concealed under leafage to enhance the 'natural' effect. Azalea bushes in full bloom added splashes of exotic colour. Below the garden lay the roofs of the city. Only the distant hum of traffic, construction work and the enthusiastic shouts of baseball players broke the silence. Lafcadio Hearn's observation that 'a Japanese garden is a landscape garden, yet its existence

does not depend upon any fixed allowance of space'[19] came back to him. The garden seemed to Leach a fine example of the way the Japanese expressed the intimate relationship between nature and art, and a perfect place to contemplate his own bringing together of East and West. The paradox of enjoying such a peaceful and elegant refuge in the midst of a gigantic built-up conurbation of thirteen million people, where the value of each unit of land, like the cost of living, was the highest in the country, did not escape him.

It was at International House that Leach struck up a warm friendship with a young English painter and designer, Theyre Lee-Elliott, whose work he liked and with whom he often played chess. They met regularly in England and Japan and maintained a lively correspondence. In one letter Lee-Elliot reported that he had discovered that they were distantly related, a coincidence that excited Leach, who declared himself 'delighted, and astonished, and as pleased as Punch . . . I've always felt a strong bond with you of background and kinship . . . and strangest of all, this love and knowledge of Japan'.[20] In his letter Leach wrote the lines

> Ghosts whisper in the undergrowth,
> We are what our fathers were,
> Who are you, and who am I
> In all this panoply?

In the summer Leach and his entourage escaped from the steamy, oppressive heat of Tokyo to the cool mountain air and comfort of the traditional Kazanso hotel, which was now run by the original owner's widow. Magnificently situated 3,000 feet up the side of a valley on the great saddle-back plain of Matsumoto across the middle of Honshu, the hotel faced the alps, which soared to 10,000 feet. Widow Nakamura, the maids and the whole staff welcomed the honoured guests, ushering them into rooms that had previously been occupied by the emperor. Having stayed there many times, the hotel was full of memories for Leach, and the bath-boy greeted him like an old friend, which was a further reminder of the humanity of 'old Japan'. Full of gossip, the bath-boy described at length the endless preparations for the recent visit of the emperor and empress; the road to Matsumoto, a distance of seven or eight miles, had been repaired, which was generally approved of, but the old wooden bridge across the stream had been replaced with an ugly concrete structure without any sense of line or beauty. In addition the austere interior of the traditional hotel had been ruined by red carpets laid along all the passageways, and every window double-blinded and kept shut. While ensuring privacy, it prevented the royal party from gaining a breath of fresh air or appreciating the magnificent setting. The hotel, overlooking an expanse of paddy-fields, was surrounded by heavily wooded slopes through which appeared slowly wreathing and swirling mists, which the Chinese called

the breath of the mountains. Leach could only feel sorry for the 'Poor Emperor'.

During a three-day intensive meeting with a hundred craftsmen who travelled to see them from all over Japan, many topical issues were raised, including the role of the craftsman in new Japan. Such huge, demanding events were as thrilling as they were exhausting, and though Leach emerged 'feeling he had a hole in his head from ear to ear', he revelled in being the centre of attention. However, not all the audiences were welcoming and uncritical. At Hashokan they talked to a group of about thirty craftsmen and journalists on the importance and relevance of Mingei to modern potters. A keen young journalist began firing questions at Hamada, claiming to be speaking on behalf of the young generation who, he said, were increasingly suspicious of Mingei. An old doctor tried to hush the protagonist but an unperturbed Hamada answered with understanding and warmth. In effect he agreed saying that he too was as sick of the word Mingei as he was of the opposed word *saka*, meaning the current individual or artist craftsman, pointing out that they were equally misconceived. Spellbound the audience listened intently until the questioner fell silent and quietly thanked Hamada. Despite their reassurances the questioning underlined the profound problems facing the Mingei movement and what many saw as a lack of relevance to the craftsmen of new Japan.

During the day Leach and his translators worked steadily, nurtured by Anglo-Japanese breakfasts of eggs, toast, butter and bean soup and by occasional walks along the new mountain road to admire the view over the stream and the climbing paddy-fields. Despite the temptation to draw, especially when the clouds lifted and the view became panoramic, Leach battled on with the translation. By August, after four months translating and writing, many sections were completed and much of the manuscript typed, allowing Leach a little space to polish the draft and to draw.

The New Sano Kenzan affair continued to rumble. Arguments waged vigorously, with leading dealers still doubtful and complaining bitterly that such a large number of pieces had upset the market. Leach remained adamant that the pots and notebooks were genuine. Two chapters of his Kenzan book, devoted to discussion of the finds, detailed his investigations, all of which stressed their authenticity as beyond doubt. 'I believe,' wrote Leach, that 'these sixteen notebooks, diaries with their lovely drawings, their humanity, and their wealth of detailed information, glow with such an internal light and honesty as to convince the most sceptical critic of their truth.'[21] Despite this assurance from an author regarded by many as an expert on Kenzan, he failed to convince those 'sceptical of the truth'. 'It will be,' he wrote to Tobey, 'a bigger affair than the Van Meegerens.'[22]

Further 'discoveries' two years later dispelled any hope that the matter would be allowed to settle. A Mr Aoyagi from Nigata Province invited Leach,

his former assistant Mr Mizuo, the archaeologist Mr Ishizuka and the Morikawas to see 'a superb Sano Kenzan tea-bowl'. This, together with half a dozen paintings and other documents, he claimed to have bought in Sano some years before the Morikawas came on the scene.[23] Again Leach had no hesitation in declaring them to be genuine.

Leach, together with Mr Ishizuka, a historian who had devoted himself to the unravelling of the Sano Kenzan story, was lavishly entertained in an exclusive Japanese hotel in the geisha quarter of Kyoto by Morikawa Isamu the owner of the Kenzan pots. Morikawa's father, Kanichiro, invited them to visit him in Nagoya and stay as his guest at the Hasho Kan, a beautiful Japanese inn regarded by Leach as 'the best hotel I ever stayed in'.[24] Although now retired, Morikawa Kanichiro was acknowledged as one of the great masters of tea and the invitation was deemed a great honour. After some difficulty they eventually identified the house by two syllables on the entrance, *mori* and *kawa*, meaning forest and river. A trembling voice in Japanese invited them to come to the veranda so they could meet without ceremony. With Morikawa's reputation of being *ganko* (or self-willed and difficult), the visit was undertaken with some trepidation, but Leach found the tea master gentle and considerate, full of old world courtesy.

A year older than Leach, his aquiline face topped by a high domed skull and his waist-length white beard, kept most of the time in a tidy white bag looped to his ears, Morikawa seemed to epitomize the finest qualities of old Japan. Convinced by Leach's sincerity Morikawa slowly prepared tea so allowing his guests to look round the room, which they thought plain but good. In a recess, and clearly placed for Leach to appreciate, was a picture of a spray of rice by the thirteenth-century Chinese artist Gassan and a single camellia bud placed in a green celadon bottle. Leach correctly identified a tea-bowl as being by Kōetsu,[25] which, because of its intense hue, was known as *shigure*, meaning 'approaching storm', the result, he thought, of an accident in the firing.

Slowly Morikawa brought out treasures such as inscribed boxes, tea utensils, old calligraphy, paintings, lacquer and textiles, commenting on them to nods of appreciation. The meeting seemed a cross between the quiet of a Buddhist assembly and the coming together of a Quaker gathering. After a hot bath at their hotel they returned for supper and talked long into the night. The following day they were offered *koi cha*, a special thick kind of tea served in a bowl that was passed from hand to hand, lip to lip, interpreted as a 'kiss' of intimacy. After inspecting and cleaning all the utensils Morikawa put at least eight times the usual amount of green powder tea into the dark, austere tea bowl, poured on the boiling water and whisked up the brew. Such quiet ritual seemed to Leach a salutary reminder of how much Japan was losing in the urge to modernize, rejecting a past that was slow and contemplative, privileged and rare. As a final parting Leach was handed a poem that he found deeply moving:

Here we part
I pray for a reunion
Frost is on the leaves

The poignant lines came to mind two years later when Leach, with Mr Ishizuka, again visited Morikawa Kanichiro and his son Isamu, spending the afternoon admiring his treasures and taking tea. With due ceremony they had *koi cha* using Kōetsu's magnificent *shigure* bowl. Their conversation ended on the meeting place of the 'me' and 'not me', *satori* or the land of Mu, where there is no measurement of time and place. Despite the calming rituals and courtesy, Leach could not help but be shocked by how frail and slow the tea master had become, subsequently learning that his heart was weak and that he did not have long to live. On the fast train home Leach travelled much of the 300 miles in silence, contemplating the impact and meaning of their discussion.

Letters brought news of home. Barbara Hepworth wrote urging him to return, 'St Ives very beautiful now – come back soon',[26] and reassured him that Janet's 'problem', probably a reference to her drinking, was much better. Muriel Rose, though now retired and living in the country, kept him up to date with the intricacies of craft politics in London, which continued to be riven by rival factions. A letter from Reggie Turvey reminded him of the increasing frailty of his friend who was suffering from severe giddiness and was haunted by fears that he and Leach would not meet again. The vulnerability of the body, wrote Leach, was something that 'has to be faced and without self pity in fact with faith and assuredness',[27] reaffirming his own belief as well as that of his friend. 'We come naked and we should be prepared to go naked and if possible with gladness of spirit',[28] was his advice, adding that he felt that he himself had 'not got there yet but see it as the truth and the desirable truth'.[29] Turvey's premonition was correct. His health continued to deteriorate and he died shortly afterwards. After sixty years of friendship his death, while not unexpected, was a blow and Leach added his name to the thirty he prayed for each morning.

Settling back into St Ives after an absence of nearly ten months proved more difficult than he had anticipated. After the reassurance and loyalty of the Japanese, England seemed particularly difficult, testy and unwelcoming, giving rise to a post-Japan depression and sense of anticlimax, which saw Leach retreat to bed for a few days to recover. The excitement and speed of Japan made St Ives seem dull and quiet, but he was convinced that his move to Barnaloft had been wise.

The days were more or less divided between making pots and fitting together the 'jig-saw puzzle over the last chapter of my Kenzan book – the translation of his sixteen diaries written in 1737 at the age of 75',[30] and struggling with Yanagi's Buddhist aesthetic. It left him with the impression

that he still had 'one leg in Japan'.[31] With his limited Japanese the books were a true labour of love, the difficult translation endlessly slowing down the project.

After twelve long years in preparation *Kenzan and his Tradition*[32] was published in England in December 1966. It was, Leach made clear, a personal book, written as a pupil of the sixth Kenzan, and one that attempted to draw a picture of these men 'living in the magnificent setting around the Genroku Post-Renaissance at the close of the seventeenth century'. Regardless of the controversy surrounding the New Sano Kenzan work, about which Leach was convinced that he made a 'clear case', the handsome volume, with its many illustrations, was largely responsible for introducing the work of Kenzan to the West. The *Times Educational Supplement*, summing up the generally positive response to the re-evaluation of Kenzan's work, wrote that even those 'who remain unconvinced about the Sano pots cannot fail to warm to the character of their champion' and was prepared to overlook 'minor inaccuracies, and large assumptions'.[33]

At Barnaloft Leach lived 'an almost independent life', though Janet was often on hand in her flat entertaining her own and mutual friends. One such was the French-Egyptian artist Donatienne Lebovich, who had befriended Janet in Japan in 1954. Now living in Paris, Donatienne was intelligent and also alert to the nuances of oriental art, but not concerned with its reproduction. Both Leach and Janet liked her, and were appreciative of her understanding of the issues of East and West and her uncritical acceptance of their relationship in Japan.

With Pottery Cottage more or less empty, Janet proposed turning part of it into a small museum to house a collection of Leach's work as a further attraction for the increasing number of visitors. However, with the question of payment for the improvements to the cottage still not settled, David was concerned about the idea of major structural change and the idea was dropped. Still receiving what he regarded at best as only a modest rent, David continued to feel that he had not been adequately compensated for the improvements he had made to both buildings, and while Leach was now more 'understanding', nothing was resolved.

During his absence in Japan an exhibition of Leach Pottery pots had been held at the Crafts Centre in May,[34] and individual and standard work sent to Copenhagen. This was part of a mixed show that also included work by Janet Leach, Lucie Rie and Hans Coper,[35] the German-born potter who had shared Lucie's studio from 1947 until 1958. Leach admired, without ever quite liking, the qualities of Coper's vessel-based forms, ingeniously assembled from thrown pieces, finding them too cerebral and dry for his taste. Because of his close friendship with Rie he made efforts to respond to Coper's vessels and to respect his integrity and seriousness. On one occasion Janet drove Leach to Coper's studio at Digswell, Welwyn Garden City, where after looking at

and discussing his pots for some time, Janet admired a particular piece, an approval echoed by Leach. Much to her annoyance, she subsequently discovered that Coper had given the piece to him when she felt it more rightfully belonged to her.

In an attempt to catch up with making pots Leach made fewer visits to London, a decision that caused him to miss an exhibition by John Reeve at Primavera in February.[36] In June, Janet successfully exhibited at the same gallery showing pieces made from a newly devised body with a dark, almost black texture often enhanced by poured slashes of white glaze that Leach thought highly effective.

Involvement in the narrow politics of the craft world did little to reassure him of its healthy state. Even the continuing debacle around the uncertain future of the Crafts Centre in London and the power struggle between apparently opposing forces failed to make him feel involved, although it was a cause in which he believed passionately. Local art politics proved more engaging. Artists and craftsmen at the Penwith Art Society continued to be divided over dealing with figurative and non-figurative work, with younger artists favouring the more radical approach of making no distinction at all, although the old ABC system of dividing up members into figurative, non-figurative (or representational and non-representational) and craft had been dropped in 1958. Leach found the atmosphere uncongenial, with younger members dismissive of older artists such as Barbara Hepworth, and in Leach's eyes 'picking over Barbara's bones before she is dead',[37] a reference as much as anything to her poor health that was not helped by copious smoking and whisky drinking. Weighing less than six stone, Hepworth was painfully thin and was often cared for by Janet who visited her regularly.

Despite a full commitment to making pots, Leach did accept speaking invitations, whether to fellow Bahá'ís or to pottery groups. In the autumn he spoke to a gathering of about fifty Bahá'ís at John Ruskin's house on the banks of Coniston Water in the Lake District, a building noted more for its magnificent views across the lake rather than its architecture.[38] The event went well and he told his audience of his youthful interest in Ruskin when as a schoolboy he devoured and thoroughly enjoyed *Modern Painters*. In November he was in Stoke-on-Trent, the heartland of the pottery industry, to open an exhibition of studio pottery and to give a talk to factory managers and directors. Conscious of a hundred years of feuding between studio and factory Leach saw it as an opportunity to at least bury the hatchet and to declare a truce if not become actual friends. Standing before the audience of industrialists and managers Leach was at his wittiest and most disarming, generous in his recognition of the achievements of the ceramics industry but insistent on extolling the virtues of studio pottery. In conversational mode he began by posing a series of questions outlining the present mood of antagonism, asking: What do we suppose you think of us? What do I suppose we think of you?

What might you think of us? What would we like to think of you? Although defining a 'you' and 'us' rather than a 'we' position, he sketched out areas of overlaps such as a concern for good design and the sensitive use of materials that opened up a way forward. In addition he spoke about his early days in Japan and how enriching the meeting of East and West could be. As a reminder to industry to pay attention to the popularity of craft work he pointed out that there were estimated to be 100,000 studio potters in the USA, an indicator perhaps of future developments in Britain.

The future was also the indirect theme of a talk he gave shortly afterwards to students on the recently opened studio pottery course at Harrow School of Art.[39] Under the energetic direction of Victor Margrie and Michael Casson, the syllabus was based on the workshop system, with an emphasis on practical skills such as throwing, glazing and firing pots that were functional rather than decorative. In many ways the course was an art school interpretation of Leach's own belief in education through discovery, with students being taught by practising potters, learning by doing rather than debating, a method Leach fully approved of. It was a perfect opportunity for him to sing the praises of the potters and pots of the East, which to general nods of approval, he did with great enthusiasm. In combining the production of well-designed functional wares with individual pieces many of the students took the Leach Pottery as their model, and felt greatly privileged by his visit. In the garishly lit and newly painted canteen Leach, confident and relaxed, sat and ate cakes specially made in his honour, surrounded by admiring students, entertaining them with his experiences in Japan.

The visit went well, particularly for Margrie who wrote saying that it had been 'a landmark in the life of our potters . . . a cleansing of the soul . . . a search for oneself'.[40] After the talk Michael Casson took Leach aside to explain the use of Carbon 14 and thermoluminescence[41] as a means of discovering the true age of ceramic material. These, he thought, could be useful in authenticating the New Sano Kenzan pots, and as requested he posted on details of the processes involved. Typically Leach filed the information but was privately disdainful, preferring to trust his 'instinct' rather than science.

An equally indulgent but engaging talk was given to the Craftsmen Potters Association. Although disappointed by his initial refusal to join in 1958, the CPA nominated him an honorary life member,[42] which he accepted, though he was reluctant to follow David's urging to do more than give lip-service and support the shop by sending individual pots. The enthusiastic audience met to hear about Leach's recent visit to Japan but he began by explaining why he had not joined the CPA at its inception when his name and prestige would have been of great benefit in awarding status to the fledgling organization. While confessing to admiring its spirit of co-operation it was, he said, the policy of non-selection that deterred him and he expressed approval of the recent introduction of selection for membership.

With explanations over he went on to sketch in briefly his early years in Japan, his training with Urano and his friendship with Yanagi and Hamada. He also spoke about the 'three friends, the brush, the ink and the ink-slab'[43] and outlined the various methods used to make brushes in Japan. Hair, he explained, was carefully selected from the back of the neck or on top of the tail where it had been subjected to least friction – be it deer, badger, cat, dog – and shaped to form different sorts of brushes. Always an able speaker and expert teller of stories, he combined his own experience as a potter and observer to paint vivid pictures of potting in Japan, and the way pots were an integral part of everyday life. His genuine belief in the value and importance of handwork and the individual qualities of the potter fitting in well with the craft movement's counter-cultural position of the mid-1960s.

Leach enjoyed a similar success when he spoke to about a hundred members of the Cornwall Craft Association at Fowey some years later. Speaking without notes he touched on his training in Japan, the setting up of the Pottery at St Ives and his frequent return visits to his 'second home', constantly stressing that 'intellect must serve the imagination, because intellect alone is a bad master'.[44] For two hours, reported a newspaper, he held the audience 'spell-bound'. After the showing a film of a traditional Japanese pottery one member of the audience did suggest that the breathtaking rapidity with which designs were put on the pots really represented a type of mass production because the finished products all appeared much the same. Undeterred by what seemed like a critical remark Leach cleverly agreed saying 'Yes they do seem alike, but so do leaves. None are exactly alike. The important thing is the sense of life and individuality'.

Other public occasions included participation in a World Craft Council (WCC) conference at the Victoria and Albert Museum,[45] an organization that had been founded by Aileen Osborn Webb and Margaret Patch in 1962. Committed in principle and practice to the international craft movement, Leach fully supported the WCC's aims and objectives, readily agreeing to speak at the London conference. Henry Rothschild, appointed secretary of the British section, succeeded in filling the museum's lecture theatre with a range of young and enthusiastic people, keen to identify with the international movement. Speakers included Aileen Osborn Webb, president of the WCC and John Pope-Hennessy, director of the Victoria and Albert Museum. The activities of the WCC, thought Leach, were a 'significant moment in the history of the craft' and 'a necessary step in cultural evolution', as the 'young craftsman of any country inherits the cultures of all countries'.[46]

At the fourth WCC meeting in Dublin, Leach and Hamada were honoured for their life's work and international contribution to crafts. Aileen Osborn Webb presented each of them with a beautiful box in slate, cut by Inigo Jones from his quarry in Wales and carved with lettering designed by David Kindersley.[47] Hamada declined to speak, so, holding his hand, Leach replied

for them both, talking about their work together, their friendship with Yanagi and the importance of 'the exchange of the ideas and methods leading towards global standards',[48] bringing the audience 'close to tears'.[49]

Pots were required for a series of shows in England and abroad. In London there was a one-person show 'Stoneware and Porcelain' at Primavera,[50] and, gratifying his desire for wider international recognition, a string of overseas exhibitions included one shared with Francine del Pierre and Hamada in South America. Del Pierre also secured requests for Leach and Hamada to take part in shows in Venezuela and Colombia in April 1966. The highly prestigious government invitations came through del Pierre's friendship with Fina Gomez, granddaughter of Juan Vicente Gomez, president of Venezuela from 1910 until his death in 1935. Fina Gomez was diligent in introducing art from abroad into the country and in promoting the work of Venezuelan artists overseas. Ever adept at tapping funding sources, Leach persuaded the British Council to sponsor the tour, though curiously they declined to fund his subsequent visit to Japan even though the government there was to honour him with a national award.

Despite the long flight to South America Leach relished the visit seeing it as an opportunity to introduce and talk about his work to new audiences, establish contact with Bahá'ís and help consolidate the faith. As Hamada could not join them the party consisted of Francine, her friend Fance Franck and Leach, all of whom were entertained as honoured guests. At Caracas airport they were met by Luz Valencia de Uruburu, director of the Institute of Popular Culture, Popayan, sister of the President of Colombia, and a group of Bahá'ís. Luz had taken up the craft after having read *A Potter's Book* and, inspired, arranged for Leach to visit her country. The exhibition opened at the Museo de Bellas Artes in Caracas where, under the director Miguel Arroyo, the pots were sensitively displayed with John Read's BBC film discreetly projected onto a screen. Virtually everything sold immediately. Pieces by contemporary Venezuelan ceramists were also in the exhibition, which to Leach's astonishment included stoneware in a country where earthenware was the tradition.[51] This he believed indicated the extent of the 'new stoneware movement'. At the Esculea de Artes Plasticas, under the direction of Alejandro Otero, who had studied with Francine in Paris, an enthusiastic audience gathered to hear them speak and see them make pots. 'Art and artists are the messengers for the East and West', said Leach, outlining his belief in the necessity for mutual understanding. 'If we in the western world do not feel the oriental world in our hearts, we cannot obtain peace.'[52]

In contrast to the oil wealth and the relatively settled political situation of Venezuela, Colombia was poor and the political situation distinctly uneasy. They were made well aware of this in Bogotá when a military escort took them outside the city to the Club Militar reserved for army officers, which with guards at the gate and bugles at dawn was remarkably like a prison.

Their anonymous, stuffy and airless suite, recently occupied by Prince Philip, had plush, wall-to-wall carpeting and seemed coldly modern, such blandness and formality all the more noticeable after the relaxed family comforts of Caracas. Leach found the altitude of nearly 9,000 feet exhausting, but the stunning views of the Andes were more than compensation. Ancient pots were admired in an archaeological museum, and a trip was made further up the valley for lunch with the president at a country house where hot springs watered the luscious, colour-filled garden. Jack Troy, a young American who was teaching English and making pots in a local studio, was one of the guests. Echoing Leach's experience in Japan, he discovered that the studio owner had made moulds of his pots and produced slip-cast replicas, offering them for sale at half the potter's asking price. Troy remonstrated but to little avail.[53]

For the opening of the exhibition at the Valencia National Museum they and a group of pottery enthusiasts flew in the president's plane to Popayan for a three-day visit, Leach staying in Luz's old family home beside the Cauca River. At the museum the two potters showed slides and films, demonstrated their skills and talked about their work. Pot lovers, keen to see the exhibition and meet them, packed the town, attracted by the specially arranged cheap travel and hotel rates. With the presidential election due the following week and a possible change of leader, the increasing political tension dashed hopes of either showing their pots and drawings in the capital or of them being there. As a substitute the British Council representative John Gale, a 'helpful Yorkshireman', arranged for a set of photographs to be enlarged and shown instead.

The round of official engagements included a cocktail party at the British embassy to celebrate the Queen's birthday (21 April), where among others Leach talked to a young playwright who invited him to see his avant-garde play, which he duly did. On the final night some twenty Colombian Bahá'ís gathered in Leach's room along with Luz and twenty of her friends to spend a quiet time in prayer and thought. Luz proved an intriguing figure, older than Leach had first assumed, a complex combination of feeling and intuition, sensitive and highly strung, but capable, devoted and sincere.

Bearing in mind his forthcoming visit to Japan and the fact that Hamada had been unable to come to South America, Leach bought him a gift of a long tube of basketry, which could be contracted and expanded to a length of six feet. The curious animal-like form was originally intended to hold boiled manioc or cassava[54] but its intriguing appearance with no readily identifiable purpose provoked much discussion. At customs, faced with endless questions about the object, he invented various stories including one that it was the dried skin of a pet boa constrictor that had lost its tail.

At the invitation of Dave Stannard, who had worked at St Ives in the early 1950s, Leach flew to the USA for a brief visit before flying to Honolulu and

then Japan. After a cramped fourteen-hour flight he was given hospitality by a welcoming Bahá'í before going on to Portland to be met by Marian Bowman, associate professor of art at Oregon State University and a Mr Wiprud who drove him seventy miles inland to Corvallis. Potters from many parts of the state joined the students for a day of talks, film shows and slides. Despite the limited time they managed to squeeze in a trip to Mount Washington to marvel at the tall pine woods extending to the snow line, with the snow-clad peaks above. At Honolulu Terry and Joy Barrow met him and together with Francis Haar and his wife they had a leisurely lunch overlooking Waikiki beach, very different to the views of the grey Atlantic he usually saw through his window at St Ives.

In Japan a major retrospective in Tokyo coincided with the Japanese government's award of the Order of the Sacred Treasure 2nd Class, the highest decoration that could be given to a non-Japanese. It was particularly gratifying to be presented with such a great public honour in a country where in many ways he felt more at home and respected than in England. Amid great ceremony Fukuda Shigeru, the vice-minister of art and learning handed over the award in acknowledgement of his significant contribution to the art of pottery. At a dinner given by the Anglo-Japanese Society to mark the occasion, the Japanese ambassador to Britain, Katsumi Ohno spoke eloquently and generously about Leach's and his understanding of East and West.

No sooner had Leach returned to St Ives than the powerful Mainichi Newspapers invited him to contribute to a series of essays, 'East and West', which they were commissioning from respected foreigners. Each was to consist of ten articles of around 550 words for the not inconsiderable fee of 20,000 yen, about £200. The topic could not have been closer to Leach's heart and publication would more or less coincide with a double exhibition of his work in Tokyo planned in November, for which he had again agreed to be in the country. Although asked to write on any topic, Leach refrained from making a broad commentary but sought to explain his position as 'an artist and potter' who for more than fifty years had worked in the East and West. 'Art', he concluded 'is the key to life, and that if, even a potter, puts his eye to the keyhole his view is almost without limit'.[55] As an afterthought he added 'not for nothing have the archaeologists written that "the history of man is written in clay"'. It was combative in putting forward the case for the art of clay, and trenchantly restated his belief in the potential of ceramics.

The death of the Buddhist scholar Suzuki Daisetz, at the age of ninety-six, was a further reminder of mortality. Although Suzuki was regarded with suspicion by some, both in the East and West, not least by the editor of *Pottery Quarterly* in England who thought him a 'laughing-stock . . . and something of a wily phoney',[56] many regarded him as a distinguished commentator. Earlier in the year Leach had shown Suzuki a photograph from an English newspaper depicting a man hanging upside down on the glass façade of the

United Nations building in New York – a solution to his question 'Who cleans the windows?'

In the last fifteen years of his life Suzuki had been cared for by a Okamura Mihoko, who served as his secretary, companion and pupil. Mindful of her close attention and noting her devotion, Leach was intrigued to discover that she was born in Los Angeles of Japanese parents and was not only fully bilingual but had a profound understanding of Buddhist thought. Frustrated by the lack of progress on the Yanagi book, he asked her to assist him. A close collaborative relationship developed and she not only worked with Hamada and Leach in Japan but also visited St Ives for periods of several months at a time, battling with crucial chapters of Yanagi's writing such as 'The Gate of Beauty' and 'The Heaven of Beauty'.

The 'Potter's Paradise'[57] of Japan again wrought its usual magic when he returned in November, enabling him to find what he described as 'an aesthetic elixir from this soil and friendships'.[58] A show of his pots from St Ives astonished him by selling out on the first day. A major retrospective exhibition of work produced since he arrived in the country in 1909, drawn from Japanese collections, held at the Mitsukoshi department store,[59] included not only pots but also brush paintings, sketches for pots, and furniture. Throughout the day Leach was constantly on his feet, showing VIPs around, signing books and catalogues, meeting old friends and being filmed. In the afternoon there was a large reception at which he made a speech in Japanese. Throughout Leach was 'quite amazing: active, indefatigable, his hand and eye . . . as steady as ever'.[60] The celebrations culminated with a formal dinner that went on until 1 a.m.

A large format, handsomely illustrated monograph/catalogue on his work coincided with the retrospective. In the foreword, Leach wrote optimistically, expressing the belief 'that we are at the threshold of a world culture and a world order, long foreseen, but now possible for the first time'. This theme was later taken up in a contribution to the BBC programme 'Doubts and Certainties – the religious interplay between East and West'. The broadcast provided an ideal opportunity to talk about his belief and its importance in uniting both sides of the world.

On a sadder note Leach went to see Kawai 'on his death bed'. Although too ill to speak, Kawai did manage to signal that he recognized his old comrade, and in silence they gently held hands in mutual appreciation and respect as they bade each other farewell. At a final quiet supper with Hamada and his wife at a restaurant they discussed the possibility of an exhibition of the work of Lucie Rie and Hans Coper in Japan, and speculated on how it would be received. On the eve of his departure, reflecting on the deaths of old friends, Leach wrote a short poem 'Maple Leaf',[61] using nature as a metaphor for sombre thoughts on mortality, which despite its use of archaic language captures his reflective mood:

Brief autumn leaf.
Three days
And thou art gone!
Thou hast burnt
My heart withal.

In London Janet came to meet him and they returned to St Ives in time for Christmas. Although their relationship remained difficult and it was often 'hard to reach a peaceful solution',[62] they found ways of working and communicating, and for his eightieth birthday she arranged several days of ambitious celebrations. These included a family gathering of twenty-five, a dinner for sixty-four with speeches and a Pottery party with a birthday cake bearing eighty candles, which he was able to extinguish in one puff. There was also a tea party in Barbara Hepworth's studio, plus an exhibition and film show. After all the celebrations and congratulations the week ended with a minor disaster when Leach fell down the stairs in his flat, hitting the refrigerator and sustaining a black eye and a sore hand.

With further exhibitions planned in Britain and in Japan, a holiday with Janet in the south of France as guests of Francine had to be postponed. Beginning to feel the need to slow down Leach visited the Pottery less often, relying more on Bill Marshall to throw his shapes. He continued to work on the smaller shapes, add the finishing touches to larger pieces, and carry out the decoration. After working together for so long Marshall understood the nuances required and without difficulty threw to Leach's design a series of handsome bottles commissioned for Truro town hall, some of the largest that Leach ever produced.

The Sunday evening Bahá'í fireside meetings at Barnaloft with Trudi Scott continued with only moderate success, though Leach became ever more convinced that 'our way of life – industrial materialism . . . will have to receive a blow before our conceit is pricked, and people listen'.[63] Attendance varied from three to twenty, prayers were read, but much to Leach's regret few recruits were secured.

To Leach's amazement and dismay, a group show of the Leach Pottery in Manchester provoked a half-page feature in the *Guardian*[64] entitled 'Feet of Clay?' by Francis Howard. The semi-veiled attack on what the journalist perceived as Leach's negative influence on English crafts implied that he was partly to blame for the 'fuddy-duddy' image of the modern potter. It seemed to Leach 'the inevitable denigration in old age insofar as it had truth in it',[65] but he was sufficiently rattled to reply. Letters by Michael Casson and Hans Coper as well as Lord Queensberry, head of ceramics at the Royal College of Art, were published asserting Leach's positive achievements and opposing Howard's views. The series of letters ended when, perhaps fearing further establishment wrath, a sort of apologia was published from Howard. As if to

compensate, a month later Fiona MacCarthy, the *Guardian*'s design corre-
spondent, penned a feature 'Crafts alive-o',[66] lauding the work of potters such
as Leach, Coper and Rie. Although Leach shrugged off the *Guardian* attack, it
seemed typical of the cool level of indifference and even hostile reception of
his work and ideas among many in his own country.

The intense programme of pot-making, travelling, writing and public
speaking proved too much for Leach and in April 1967 he collapsed with a
slight heart attack and mild pleurisy. A course of antibiotics was prescribed
but recovery was slow, confining him to his flat and leaving him feeling weak
and helpless. A May visit to Japan was postponed until October. First he was
cared for by Janet, then his daughter Eleanor and for the following weeks Trudi
Scott and other Bahá'í friends who seemed mysteriously to have appeared at
the right time. They helped take him, he felt, into new worlds of under-
standing that had put him on what he called the 'Third Path', and made him
realize and accept that age was beginning to tell. He believed conversations
about his faith were a great help in ridding him of an element of self-
centredness, a state he had sought for many years. His recovery was not helped
by a catastrophic incident at Land's End, when thousands of gallons of thick
crude oil leaked into the sea from the oil tanker *Torrey Canyon*. Much of the
oil settled on the beaches around St Ives filling the air with a sickening smell.
Gloomily Leach watched as giant bulldozers attempted to remove the sticky
black sludge in an attempt to protect the wildlife and restore the sands for the
expected holiday trade.

As his strength returned Leach began work for a large London show at the
Crane Kalman Gallery, London,[67] a gallery known for specializing in naive
painting and the work of L. S. Lowry. It was a welcome return to the fine art
as opposed to the craft world and was timed to coincide with a major new
publication *A Potter's Work*, published by a friend Tony Adams. This illustrated
sixty drawings and over seventy pots, twelve in colour, with extensive cap-
tions describing how pieces were made, with a commentary by Leach on their
aesthetic qualities. With the majority of the illustrated pots dating to the
1960s, the book is a useful survey of his work at this time. The pots, varia-
tions of familiar shapes such as bottles, lidded forms and bowls, are crisp and
uncluttered in feel. Some make effective use of the drama and intensity of the
classic Chinese/Japanese black-brown *temmoku* glaze, applied over minimal
decoration. Designs range from an abstracted willow to a bird with out-
stretched wings in full flight sensitively positioned on the form. The orientally
inspired shapes and the soft, restrained decoration characterize a coming
together of qualities of East and West, representing Leach at his most lean,
spare and majestic, suggesting some sort of resolution in which fussiness and
detail were avoided in favour of a crystallized essence of the natural world.
The deep, sombre glaze was a reflection of his serious and introverted
thoughts. A biographical note and a brief chapter on 'Pottery Drawings and

Patterns' were followed by two substantial essays 'Bernard Leach and the Modern Movement' and 'The Work of Bernard Leach' by the critic and art historian Paul Hodin with whom Leach had become friendly in St Ives. The book was an instant success.

International shows included an exhibition with Hamada, Francine del Pierre and Fance Franck shown first at the Museum für Kunst und Gewerbe, Hamburg,[68] before it moved to Cologne. Leach and Janet attended the opening. For the catalogue he contributed two essays, one focusing on Hamada and the other on the humanitarian nature of pots as 'human expressions'. A month afterwards came the news of Francine's death at the age of sixty-eight, when for Leach 'a light went out'.[69] Although they had known each other for only a relatively short time he liked her and genuinely admired her pots, which, he felt, seemed to capture the substance of oriental work without in any sense seeking to reproduce its appearance. She had given him one of her small lidded boxes in the form of a persimmon, which he kept on the Korean chest in his living-room.

In contrast to his warm admiration for Francine and her work, his feelings about Lucie Rie's pots were more complex. To Leach they seemed too refined and spare, lacking the richness and depth of reduction-fired work and its qualities of robustness. Despite this they were close friends and confidants for nearly thirty years, and she was a loyal colleague, supporting him unhesitatingly. 'Without Bernard Leach we would not be here,' she said. He greatly valued their friendship and he relied on her understanding and advice, often revealing to her details of his private life that he told no one else.

The ambivalence he felt about Rie's ceramics was highlighted when the Arts Council of Great Britain invited him to write the catalogue essay for a retrospective exhibition of her work at their London headquarters in St James's Square. Fully approving the decision to honour her, he agreed to write the catalogue essay, regardless of his own reservations. In the event he wrote generously, acknowledging her qualities and originality. In his praise for her achievements as a potter who had established her own individual style, he was unstinting in recognizing what he called the 'feminine' qualities of her work before going on to take up his usual theme of 'the pot is the man (or woman)'. Although the exhibition contained a number of older pieces, the majority had made in the previous few months, with Rie confining herself to a limited palette of deep matt blacks and a variety of whites, which even Leach confessed to finding 'truly beautiful and enlightening'.[70]

A similar dilemma had faced Leach when David had his first solo exhibition in London in 1966.[71] After initially producing slip-decorated earthenware at Bovey Tracey, David had gone on to make tableware and individual pieces in stoneware and porcelain, which, while owing much to his father, had evolved a distinctive style of their own. The venue for David's exhibition was

the gallery and shop opened by the Craftsmen Potters Association[72] in central London, which promoted both functional wares as well as more sculptural pieces. Commenting on David's pots, Leach was far from generous, describing them as 'pretty good . . . though rather reflective'.[73]

Since its inception the CPA had flourished to become a national focus for potters, selling members' work, mounting exhibitions, arranging talks and meetings as well as issuing a lively newsletter. This carried reports on events in the pottery world, discussed technical developments and occasionally raised such philosophical issues as what constitutes 'the good pot', a debate to which Leach was only too willing to contribute. For him there was little doubt of the criteria, though his emphasis on some sort of moral concept as well as aesthetic quality seemed for many too mystical and narrow. The 'good pot', wrote Leach, had nothing to do with newness or size but was a reflection of the 'depth of truth in the maker', insisting that 'we have to trust the intuition'.

Murky waters were stirred in a series of articles on the question of 'seconds', pots which though aesthetically acceptable were technically slightly flawed. Gwyn Hanssen (née John), who was then producing wood-fired stoneware in La Borne, France, put forward a 'council of perfection' arguing that any pot not perfect should be destroyed. David Leach responded with a more pragmatic view, pointing out that there were important distinctions between technical and aesthetic imperfections, and that many so-called seconds were perfectly acceptable.[74] Leach saw the issue in a more philosophical light. In *A Potter's Book* he was at some pains to indicate that 'technique is a means to an end', pointing out that 'some of the most beautiful pots in the world are full of technical imperfections'.[75] This, he argued, should not be confused with the way some Japanese went too far in making pots 'with deliberate imperfections and overstatements'. In the CPA newsletter and in a letter to David he advocated a broader, more abstract approach that addressed concepts of perfection, suggesting that this 'depends on standards of truth obtained from the accumulated and highly selected past corroborated by the living present'.[76]

The question of 'technical flaws' posed both practical and aesthetic dilemmas for Leach. In the early years the Pottery had been dogged by technical problems whether in formulating suitable clay bodies that could withstand the high stoneware temperatures or in successfully firing the kiln. Failure often resulted in pots developing lumps known as bloating, which though technically a fault may not have necessarily detracted from the unity of form, glaze and decoration. As such, while the pieces could accurately be described as seconds, Leach considered them acceptable and pots with such 'faults' were often purchased for museum collections. Some split pieces were painstakingly repaired with lacquer in the Japanese style by Leach, thereby celebrating the imperfection and incorporating it into the piece.

In the summer Leach shared an exhibition at Primavera[77] with Janet and Lucie Rie, and a hundred pots were sent to Japan. A further bout of pleurisy kept him at home but, once recovered, he was soon making pots and drawings,but an offer by UNESCO to send him to Japan, all expenses paid, was turned down because of pressure of work and anxiety about his health. In addition to continuing to work on hisYanagi book, Leach did find time to write poems, sometimes experimenting with what he called 'free verse' in a style reminiscent of his near contemporary Ezra Pound. These, he insisted, were intended primarily for his own and his friends' enjoyment rather than for publication. He also readAldous Huxley's *The Perennial Philosopher*, which he found 'a positive book, wide, deep and clear',[78] recommending it to MarkTobey and Lucie Rie as 'one of the books of the century'.[79]

Recognition of his international acclaim came from St Ives in September 1968 when the town council bestowed on their two most distinguished artists – Leach and Barbara Hepworth – the rare honour of Freedom of the Borough.[80] Leach was described as 'Master Potter of theWestern World'[81] and Dame Barbara 'the world's leading woman artist'.[82] Amid great ritual and ceremony the presentation included speakers praising Leach for his 'humanity, dignity and quietude', and for his work in the 'creation of a cultural bridge between East and West'.[83] Norman Reid, director of the Tate Gallery, opened an exhibition of work by both artists in Guildhall concert hall, St Ives.

The question of when – or whether – Janet would go with Leach to Japan continued to hang in the air, but his recent illnesses were reminders of his fragility and it became obvious that it would not be sensible for him to travel alone. Janet was as ever keen to go with him, but Leach remained unsure despite Hamada suggesting that she should travel with him. The matter was finally resolved when Janet was offered an exhibition in Tokyo (possibly arranged by Hamada), which coincided with one showing work by Leach, Hamada and Kawai at the Daimaru department store in Osaka. The fact that the two shows were in different cities finally persuaded Leach that he could at last 'share' Japan with his wife and they flew together for the first time to Japan in October 1967. It marked a significant change in their relationship. Although Janet went as the wife of Leach and travelled around with him, she was at last to have a major one-person show in Japan and to establish her reputation as an independent potter.

It was a strange occasion for them both. 'It has not been easy living in tandem' reported Leach to Lucie Rie 'but I have done my uttermost to avoid difficulties and we certainly have been able to enjoy many experiences.'[84] What struck Janet most forcibly was the realization of how relaxed and expansive Leach was in the supportive, welcoming atmosphere, where he was respected and admired; he was virtually a different person. In England, overburdened by anxieties and doubts, he appeared to shrink and close up, which explained to some extent his collapse with either a cold or depression whenever he

returned from Japan. In addition to helping organize Leach's days and protect him from what seemed like an endless series of visitors, Janet's broken, often colloquial Japanese was far more effective than his eloquent but old-fashioned language.

Both their exhibitions were a financial and critical success, with Leach selling all his work including forty drawings (which he thought of as pocket money), and Janet nearly all 116 pots. Royal visitors included Princess Chichibu, sister-in-law of the emperor, who acquired a pot by Janet. Although cautious in acknowledging either Janet's artistic independence or the quality of her work, and too scrupulous to laud her pots insincerely, Leach was genuinely surprised by their positive reception. 'Men (and women) of Tea,' he noted, 'sit and contemplate her pots for their Western revival, or restatement of glaze textures and qualities. They seem to find a new life in her pots absent in most Japanese pots.'[85]

At times each went their separate ways. With much still to be done on translating Yanagi's writing, Leach pursued his research and also met fellow Bahá'ís. In Kyoto they both got terrible colds and stayed at a 'posh' Japanese-style hotel, in a room called 'No 7 under the sun', on the seventh floor. Mr Morikawa often entertained them and they heard about recent developments in the New Sano Kenzan affair. Leach was reassured to learn that there had been no open attacks on the translations of his book on Kenzan or on the detailed account of the notebooks. To Janet, after a gap of twelve years, the country struck her as more internationalized, wealthy and extravagant, and they enjoyed the excellent hotels and restaurants. Although Leach confessed to feeling less inclined to 'go running around the world', he was pleased to see his Japanese friends again with their 'warmth and steadfastness'.

Buoyed by their success further major exhibitions were planned. In March 1969 they returned to attend openings that included a show at the Osaka Daimoru department store, breaking their flight for a few days in Hong Kong to meet Hamada and his wife. At the airport they were welcomed by three representatives from the local branch of the store who attended to their every need and entertained them lavishly. Aware that age was beginning 'to put out its claws, faculties failing, legs, ears, eyes and memory',[86] Leach took the opportunity to research family history and to look for his mother's grave. Although he had been to Hong Kong many times since his childhood, this was the first occasion that he had wanted to find the grave. Wandering among the imposing but badly weathered tombstones of Happy Valley Cemetery proved a frustrating experience as he discovered that the grave, number 4933, had been destroyed during the Second World War when massive bombing wiped out large areas of the cemetery. The destruction was a further reminder of the uneasy relationship between his two beloved nations and the difficulties in negotiating peace and gaining acceptance for different ways of life. In the cemetery Leach 'stood there in silence alone amongst all those other marbles,

on that lovely morning, without a point of focus'.[87] 'Hamada's murmured sympathy', was the only consolation.

At Okinawa the four were greeted at the airport like celebrities with floodlights, cameras and reporters, setting the mood for the visit. Under the relentless gaze of movie cameras and press photographers the few days spent at the established Tsuboya pottery were a source of endless public interest. The pots produced by the workshop still retained much of their vigour, and were noted for the liveliness and the warmth of feeling of the patterns, whether in the sgraffito designs cut through white slip or its over-glaze enamels on stoneware. Leach decorated two dozen plates, his every move watched by enthusiastic reporters keen to capture the distinguished octogenarian at work.

Leach's pots and drawings, judged by admirers to be his best work yet, 'severer, maturer',[88] amidst an unprecedented and undignified scramble, sold out in eight minutes. In Osaka Janet's show, although slower, also did well. In Bizen and Tamba Janet investigated traditional kiln-firing methods with Kawai's nephew Takeichi. The pottery had an international feel, with the New Zealand potter Len Castle, a former Leach Pottery student, 'one of the best', according to Leach, spending a year studying traditional and modern making and firing techniques.[89] In addition to translating Yanagi's writing, Leach agreed to write a long piece on Hamada, who he thought was 'at the crest of his powers. Broad, wise and very human'.[90] A dinner at a Chinese restaurant with ten friends on the eve of his departure was an agreeable farewell following a hectic but highly successful visit.

Back in England Leach watched spellbound the drama and excitement of the moon landing on television. Neil Armstrong's prophetic words 'That's one small step for man, one giant leap for mankind', seemed a positive omen for the future.[91]

After all the excitement and activity of Japan, making pots, travelling, translating and writing, Leach felt utterly exhausted and in August 1969 collapsed with a third and far more serious attack of pleurisy. Janet, still recovering from a gall-bladder operation, attempted to nurse him but care had to be handed over to his daughters Eleanor and Jessamine. With no improvement Leach was admitted to St Michael's Hospital, Hayle, where for forty-eight hours he fought for his life. Wretchedly weak and tired he finally pulled through and the slow recovery process began. Old age was putting out its claws with a vengeance.

INNER VISION

England Japan England

1970–1979

Informed by what he called his 'brush with death', the past, present and future became inextricably linked in the final decade of Leach's life. Although his sight was beginning to fail, and by the mid-1970s he was almost blind, his mind remained as sharp as ever while his commitment to work – which slowly changed from potting to writing – deepened, as did his Bahá'í faith. His relationship with Janet veered between feeling overwhelmed by her 'domineering smoking and drinking'[1] to a belief that they had at last 'found peace.'[2] To provide accommodation for a resident housekeeper, whom Leach could contact in emergencies via a bell, Janet left her flat and moved back to Pottery Cottage.

As the winter cold gave way to warmer weather and 'the sap started to rise' Leach returned to his established routine. When feeling sufficiently strong, which was most days, he drove to the Pottery in the afternoons to discuss ideas for pots with Bill Marshall. If unable to do so Janet gave him news on the telephone and alerted him to impending visitors. In the evening he entertained students, friends or visitors at Barnaloft.

For the opening of an exhibition of his pots at Den Permanente, which also included pieces by Lucie Rie and Hans Coper, he and Janet travelled to Copenhagen. He thought the exhibition 'beautifully arranged', and was delighted at the enthusiastic critical reception it received. Despite his recent illness, he declined the use of a chair and microphone when speaking to a large gathering of craftsmen and women and, although invited as a 'severe critic', wisely avoided talking directly about other potters' work, preferring to range over areas specific to his own concerns and experience. Expansive and eloquent, Leach touched on the nature of individuality, deploring what he saw as the production-line approach of many art schools and stressing the increasing need for potters to work 'from the heart'.[3]

Fru Koch, the Danish minister for the arts, described by Leach as 'a wild grey haired woman who smokes cigars from sleep to sleep',[4] listened entranced and then spoke about Leach's contribution as both potter and thinker, finally proclaiming that the audience had 'heard the truth'. Her enthusiasm for her guests knew no bounds and despite the severe winter weather

drove them thirty miles through snow-covered landscape to the famous Louisiana Gallery outside Copenhagen to see paintings by Marc Chagall. Moved by the dream-like images that combined religious intensity with a naive folk style, Leach lived in his own fantasy for an hour or two, enjoying the visionary quality of the artist's work. Following the success of his exhibition and the four days in Denmark, Leach and Janet were invited to contribute to a mixed show of English and Danish potters a year later.

The book on Yanagi's Buddhist aesthetic slowly moved forward. In addition to accurately rendering difficult concepts in English, there was the more personal challenge of resolving what Leach saw as 'a conflict of thought . . . a clash between Tariki and Jiriki and of intuition and intellect – unresolved, but of solution nearly and of absolute import, containing resolution of difficulties but also attainment of "peace of mind" '.[5] A continuing dilemma, but fundamental in making Yanagi's ideas relevant to the West, was 'the artists true and free action'[6] and the individuality of the artist. Equally problematic were more abstract concepts such as 'What is the meaning of the sign for Infinity O? Full or empty?' and questions like 'How does Buddhism dovetail with Christianity?' and 'What am I with engagement of opposites, even in my pots?'[7]

Despite the difficulties, and recalling Yanagi's enduring support, their long friendship and mutual respect, Leach was deeply committed to illuminating the often complex concepts. No matter how challenging he was determined to press on. Okamura Mihoko proved both a stalwart helper and a stern critic, particularly of Leach's translation, arguing that it failed to get to the heart of Yanagi's ideas and needed to be rewritten. During four months in St Ives progress was made but she had to return to Japan, where she now lived, before the book was completed. Her parting comment 'eventually you must kill all Buddhas',[8] was a reference to Leach's elevated view of his own state of 'enlightenment' and of his understanding of Yanagi's ideas, which she saw as interfering too much in the translation – one of many paradoxes with which he struggled. *The Unknown Craftsman: A Japanese Insight into Beauty* was eventually published in a de luxe edition in 1972,[9] bound with special handmade mulberry-bark paper (*momigami*) and handmade endpapers. The heart of the book 'The Buddhist Idea of Beauty', put forward the view that everyone has the possibility to reach the state of enlightenment, and so is capable of becoming a Buddha. 'The final objective of Zen Buddhists is . . . liberation from all duality: good and evil, true and false, beautiful and ugly.' Although Leach was wary of such all-embracing concepts, the book 'was a dream come true',[10] and he felt that it was 'bound to make a deep and long impact'.

At much the same time that Leach struggled to complete *The Unknown Craftsman*, the American potter Susan Peterson was writing a book on Hamada. Rather than attempt an objective historical account she focused on her friendship with Hamada, and to this end spent several months at Mashiko at his

pottery, watching him work and taking photographs. To balance her more personal approach she suggested that Hamada and Leach collaborate on a book about their friendship and early life in Japan and England, which would also include a selection of Hamada's writings. Kim Schuefftan of Kodansha International, was keen on the project, suggesting that for Leach to move from 'Yanagi's aesthetics to Shoji Hamada's action'[11] seemed a short distance, and that the book would be quite different to Peterson's. Given the long and fruitful friendship it was a project that again lay close to Leach's heart.

Organizing a collaboration between Leach and Hamada proved more difficult than anticipated and eventually they agreed to tape-record long conversations that would form the core of the book. Over a period of three months they met in a Tokyo hotel room to talk about their early meetings, their time together in St Ives and their long association. Meeting Hamada was a good reason to spend time in Japan and also be with Okamura Mihoko, who simultaneously translated both languages. Although both potters spoke English and Japanese they appreciated being able to converse in their native tongue to bring out the subtleties of thought and nuance that might otherwise be missed. Throughout the often tortuous process Janet gave unfailing support, partly because she had great respect for Hamada whom she regarded as the finest living potter, and also because she felt that a serious book by Leach on Hamada was long overdue.

Although often regarded as a 'country potter', an image Hamada to some extent encouraged, his long artistic and technical education had made him as sophisticated an artist as Leach. The quality and quantity of his writing, whether on Eric Gill or English Windsor chairs came as something of a surprise to Schuefftan. To cope with the large amounts of translation Schuefftan employed another translator, John Bester, who dutifully transcribed and carefully edited the long, rambling conversations of 'the two old men' into written text. The transcript was heavily annotated with requests for precise dates and details of the people mentioned in an effort to give it a tighter structure. The dialogue records their work in establishing the Pottery at St Ives in an engaging series of reminiscences rather than by analytical or factual comment, either of the practical tasks they faced or of their quest to establish an identity for studio potters. One of the most effective accounts is of the evolution of the idea of Mingei in the 1920s and early 1930s when Yanagi and Kawai formulated the idea of a museum to house historical and modern work. When asked directly about the relationship of the modern potter to Mingei Hamada avoided a direct reply preferring instead to talk about potters looking to their own character.

With two books due to be published and concern expressed about possible confusion it was agreed that Peterson's be called *Shoji Hamada: A Potter's Way and Work,* and issued in 1974, followed a year later by a fine edition of Leach's book *Hamada: Potter.* After two successful exhibitions, Leach left Japan

in June 1973, waved off by a huge crowd at the airport, some travelling as far as 600 miles to say farewell, reaffirming his widespread support.

Leach's 'brush with death' had curious offshoots, including a deeper involvement in seances and spiritualism, assisted and encouraged by Trudi Scott for which, wrote Leach to Tobey 'she has capacity'.[12] In seeking to make direct contact with the dead he consulted Naomi Long, a medium living in Paignton, Devon, who was also a Bahá'í, and generally thought to be a somewhat domineering character. In Leach's view she proved so successful in putting him in touch with his parents that he was sure they 'were in my room. Oh. So wonderful'.[13] Contact with his parents was also made through automatic writing, after which he announced that they were 'now in the next world'. At various sessions Leach wrote down much of what his parents said, claiming to have learnt a great deal about their early life, but disappointingly the surviving notes are little more than a series of generalized platitudes.

Such dabbling with the occult, although echoing the activities of distinguished writers such as John Ruskin and the Irish poet W. B. Yeats, met with disapproval from an unlikely alliance of Janet, his children and close friends such as Lucie Rie. While reassuring them that temperamentally he was sceptical, he found 'the message was real enough'.[14] With increasing age, the after-world seemed to him very vivid and he fully believed in the possibility of communication between the living and the dead. Although such activities were not a part of orthodox Bahá'í practice he did not see them as conflicting with his beliefs. Life, Bahá'ís believe, continues 'on the other side', and that while those who had passed over could seek to make contact with the living, the living should not consciously seek to communicate with them. Yet, despite his avowed scepticism, Leach found the sessions greatly reassuring. He not only claimed to have established meaningful touch with figures such as the first Kenzan but also to have come to a fuller understanding of departed friends, saying for example that he had got to know 'Yanagi better after he had gone over'.[15] Throughout his final years Leach was convinced that seances and spiritualism were part of preparations for his own death, writing to Tobey 'Let's look forward to meeting on the other side. I do . . . in eternity'.[16]

With Tobey suffering from arterio-sclerosis, which involved loss of oxygen to parts of the brain, Leach's reference to 'the other side' reflected a new awareness of mortality. As a result of his illness Tobey was often unable to recall names of friends, cities or continents, but still painted and occasionally expressed himself verbally with fluency and pith. His memory lapses meant that writing was difficult and he could not travel alone. As a consequence there were only occasional letters and even these took days to decipher. Although Leach disliked making telephone calls and preferred to discuss ideas and his various projects in letters he nevertheless enjoyed Tobey's calls, even if they were distressingly difficult as he sought to find the words, on one occasion

endlessly repeating 'I don't know who I am'. Following one telephone conversation, in a letter to Tobey, Leach quoted his lines,

> You stirred your cup
> Before you left last night
> The tea leaves would not settle
> I could not sleep![17]

Poignant memories of their early friendship were recalled when Leach visited Dartington in March 1972 with Ben Nance, one of his grandsons, to spend time with Leonard Elmhirst, which brought to mind his time in south Devon in the 1930s, and his friendship with Dorothy. Four years had passed since she had died in 1968 and this was an opportunity to talk about their times together with Leonard. 'Dorothy's ashes are under quite a beautiful statue (old) in the upper gardens, now open to all and sundry,' he wrote to Tobey, 'the most beautiful I know in all England.'

During his time in hospital a visitor had casually suggested that Leach should publish a book of his poems, an idea that initially he rejected but on reflection decided to pursue. Since adolescence he had written poetry, sending some to friends, but without any intention of publishing it. As 'an amateur'[18] he was therefore flattered that they might be thought worthy of publication, and saw such a book as a means of placing his drawing and poems within the context of his Bahá'í faith. In accepting the idea that acts of creation, whether potting, drawing or writing were also expressions of belief, he saw his art as part of a wider search for 'truth'. In this he found great reassurance in Bahá'u'lláh's view that the true pursuit of beauty was the equivalent of prayer, taking 'prayer in the sense that he uses the word as a rule as pure joyful worship'.[19]

Publishers, however, proved to be somewhat wary of poetry books. Kim Schuefftan, his enthusiastic editor at Kodansha International, thought that without a substantial order of something like a thousand copies from his fellow Bahá'ís it would have little chance of commercial success and declined to publish it. After the success of *A Potter's Work*, Tony Adams of Adams & Dart was interested, though he too was concerned about the logistics of making the book financially viable, but in 1973 he finally agreed to issue a limited edition of 500 copies in a fine, cloth-bound edition. Its success led to a republication four years later with thirteen additional poems but in a cheaper format with a dust wrapper.[20]

In the introduction to *Drawings, Verse & Belief*, Leach wrote movingly about the need for unity rather than duality, whether with 'intellect and intuition', or 'the head and the heart, and man and God'.[21] One of the most revealing passages is Leach's description of the initial difficulty he had had in accepting the Bahá'í faith. Although introduced to and in sympathy with it in the early 1930s he continued to struggle with the concept of Bahá'u'lláh's claim to be a manifestation of God. Much of the preparation for the book was carried out

while he was still deeply involved in writing about Yanagi's Buddhist aesthetics and inevitably he drew comparisons between Buddhist beliefs and the Bahá'í faith. 'The difficulty I experienced in accepting the World Faith of Bahá'u'lláh lay in the apparent curtain hung between normal man and prophethood, which to Buddhists is anathema,' he wrote. 'To them a Buddha is a fully enlightened man, in other words a selfless being',[22] adding 'as every Buddhist knows, Heaven is half-hidden behind any leaf, or stone, or human face, or even artifact'.[23] Such ideas were not fully in accord with Bahá'í beliefs and like artist-poets such as Khalil Gibran,[24] Leach found it hard to accept the need for an intermediary between God and man.[25] What finally persuaded him was the 'quality of inspired selfishness in the lives of the three Persians of our time',[26] referring to the three principal figures of the faith.

Although revealing and deeply felt, such searching passages do not altogether resolve the acceptance of an external God, which for Leach constituted a duality. Yet the world order of Bahá'u'lláh, with 'its unity, its roots in justice, universal education, balance of religion and science, marriage of East and West, recognition of art, of the equality of men and women, the need of a common language, the abolition of both great wealth and great poverty, and to these ends, of a universal parliament of man'[27] Leach found gave shape and meaning to his life.

In the book each poem was placed opposite a black and white drawing, be it a pot, portrait, landscape or kiln; these were not intended as illustration or even as reference but as part of what Leach saw as a wider search for 'truth and beauty'.[28] The attempt to integrate the visual with the verbal, as independent but linked concerns often employing the medium of earth, literally and metaphorically, as a common aesthetic, worked surprisingly well. Many of the poems seem born out of weathered clays, roughage of the earth as distinct from the emotions or the recesses of the mind. 'This Clay' is placed opposite two landscape drawings, *Passage Through the Hida Mountains* and *Pinnacle Rock, Karuizawa*, all three having an origin in earth. In another example the poem 'Thirst' is set against an image of Californian sea birds, each alluding in its own way to water. Pictures and poems share a sensibility, an awareness informed by the minimalism associated with *shibui*, often seen as quiet, modest, unassuming.

The earliest verses date to 1907 when Leach was twenty, the latest were written in 1973 and are a maturing vision rather than a changing style, many inspired by aesthetic, social or religious ideas. Starting in the first decade of the twentieth century, in the twilight of the Romantic tradition, Leach's lines, refreshingly free of conventional form, seek neither to be trendy nor literary, their frugality of style avoiding easy or glib repetitive rhymes and flat movement. Early poems are pacifist-lyrical, anti-war in feeling, sharing an affinity with poets such as Wilfred Owen and Siegfried Sassoon, whose work he almost certainly would not have known. Concerns about history, danger and the

growth of monetarist rather than humanist policies as advocated by Montagu Norman[29] are crisply expressed in 'Coffin of England' with lines such as

> Oh John Bull
> Your head does rest
> Upon a bag of gold,
> And Mr. Norman
> To his foreman,
> Well may say,
> Take one away.
>
> Beware, beware!
> The end is near,
> The wind is at the door.[30]

In later poems he moved from social concern to applied religio-moral aesthetic and mystical references, with mentions of such elusive concepts as the 'spirit', 'Inscrutable God', and 'Him the Lord God'. Close observation of nature, whether in references to 'dark white wave' or descriptions like 'Flat wind blows through willow', and 'Cut away / The thorns / The briar' and 'Earth upon which we stand / Of which we are made / Of which we make pots'[31] bring together central concerns in his own life. Lapses into Georgian felicities, clichés and *longueurs* such as 'Nought but thine', 'furled . . . world',[32] 'Oh! Sweet pain' and 'Thou Essence of all Being . . . Without thy burrowed eye', look back to earlier forms. Yet despite this, there is an individual voice, an all-encompassing vision that forms part of Leach's philosophy. Lines such as 'Perfume of God's genitals / In a flowering tree',[33] and 'A lion lies / With cat's paws / Stretched along the ground',[34] are clear, refreshing images that are part of Leach's broadly humanistic vision, as is the poem 'Premonition' (1967):

> Old age
> Trod upon my toe
> Last night.
> Stumbling
> Up the lane
> I saw a light
> And entered in;
> Of blackberries
> I laid a bowl
> Before my friend,
> Wiping my glasses
> Before his fire.
> 'Keep them for this respite
> On this premonitory night.

With an emphasis on narrative and description, the poems echo his great hero

Blake, though rarely achieve the sharp imagery and melody in which Blake so dazzlingly excelled. In the introduction Leach acknowledged his debt to Blake, quoting his lines 'Sheep are nibbling the grass/On Romney Marsh', and drawing a parallel between his own 'imperfect rhyme' and that of Blake in the belief that the vision was more important than the form. The book's layout, in combining the art of the studio with that of the study, brings together acute observation and lived experience, which if it at times seems too didactic has the richness and finesse of his pots. Some of the strongest are Leach's translations of Japanese poems that ring true as works in themselves.

> Waking towards dawn
> In a country inn.
> The lonely wind
> Combing the pines.[35]

As the publication of *Drawings, Verse & Belief* drew near, Leach wanted to discuss the project with Tobey, his fellow Bahá'í, for 'it's core is the Faith of Bahá'u'lláh', as he planned to dedicate the book to him. 'It was,' he wrote to Tobey, 'through you that I reached my Faith in Him as the prophet standing between East and West.'[36] Accordingly, accompanied by Theyre Lee-Elliot, Leach spent three days in Switzerland with Tobey reading and talking about the poems, which the painter fully approved of.

Concepts of 'truth and beauty', central concerns in *Drawings, Verse & Belief*, took more concrete form in the 'International Ceramics' exhibition at the Victoria and Albert Museum in 1972. After looking at the experimental sculptural ceramics as well as pots, Eileen Lewenstein,[37] one of the organizers, was surprised by Leach's non-judgemental approach. 'Ten years ago,' he told her 'I would have dismissed it out of hand, but now I am curious. I want to know why people are making pieces like this.'[38] This generosity of spirit, which he had showed to Lucie Rie, was also reflected in a letter he wrote to a distant cousin, Alan Caiger-Smith, a potter who made highly decorated maiolica with painted lustre and in-glaze decoration, inspired by Middle-Eastern ceramics. Caiger-Smith, along with Leach, had work in the exhibition 'The Craftsman's Art', also at the Victoria and Albert Museum.[39] 'Your pots sang out in the show' Leach wrote, 'and though your language is not my language, you do it very well.'[40]

One of his most cherished honours was the Companion of Honour (CH), an award that he was pleased to note ranked above that of knight although, to his private disappointment, it did not carry a title. During the presentation,[41] made personally in a twenty-minute private audience, Leach inadvertently tripped on a thick carpet and was helped to his feet by the Queen. Recovering his composure he spoke of his faith, promising to send a copy of *Drawings, Verse & Belief*, and of his fifty-four-year-old friendship with Hamada, telling her about his award of an honorary doctorate by the Royal College of Art in 1972.

The Queen delighted Leach who enjoyed 'the nature of our sincere, direct, and quite informal conversation', adding 'the contact was real – pots were not mentioned'.[42] Following the presentation at Buckingham Palace a party was held for fifteen friends and relatives at the Coburg Hotel, Bayswater, where 'good salmon and champagne' were served.

In recognition of his lifelong association with Japan, Leach had attended a banquet given in honour of the emperor and empress of Japan at Guildhall on 6 October 1971 during their state visit to Britain.[43] It proved a highly controversial visit as many people in Britain felt that the emperor was responsible for the Japanese atrocities during the war and therefore should not have been invited. In the event the crowds lining the official route from Victoria Station to Buckingham Palace received Hirohito and his wife in stony silence. Leach disagreed, and as a peacemaker and builder of bridges hoped the visit might alleviate bitterness and promote understanding. When asked to supply royal gifts for the Queen to present to the imperial couple during her state visit to Japan in the spring of 1975, a 'pilgrim' dish was selected for the emperor and an etching *Lagoon of Teganuma, Abiko* for the empress.

In Japan, Leach was now treated with almost god-like reverence. Popular enthusiasm for both him and his work knew no bounds, and he continued to go regularly and hold major shows at department stores until 1974, when he made two visits. In his honour the Osaka Royal Hotel even named a bar the Leach Bar. A retrospective of his pots, at the Tenmaya department store, Okinayama, in April 1971, accompanied by a fine catalogue, he considered 'a great and unsought honour'. The show, supported by Hamada, was opened by the British ambassador, Sir John Pilcher. During the visit Kim Schuefftan initiated an excursion to Wajima, a coastal town on the Noto peninsula, with a group that included the Hamadas, Mihoko and Barbara Adachi, an American writer on crafts for whom Leach had great respect. The area, some of the most beautiful, isolated and untouched countryside of Japan, was renowned for its fine lacquer work. In the relatively unspoilt town the fishing families lived on one side of the river, the lacquer-makers and merchants on the other. Leach was delighted to find that 'Old Japan still seemed alive in this remote peninsular',[44] but wondered how long it would survive.

The lacquer-makers of all ages were keen and vigorous, but all spoke of the uncertain future and were anxious to hear the views of the distinguished visitors. After looking at the modern work, Janet, much to Leach's surprise, forcefully questioned the importance placed on constantly honing their skill. Holding up one of the wooden cores on which they were working she pointed out that it was so thin that when lacquered it became almost translucent, and as such aimed for a false standard of refinement. This, she insisted, had nothing to do with the best traditional work, backing up her argument by indicating a lacquer soup bowl made fifty or a hundred years ago, which they all admired. Although it did not have the same degree of thinness it was, she said, the most

beautiful thing they had seen that day. After an animated debate the visitors left, with the lacquer-makers declaring 'This discussion has been a miracle. It has set us all aflame'.[45]

In Tamba, where they stayed with the Ichino family, the Leaches were reminded of similar problems facing traditional potters. Bordered by abrupt mountains 2,000–3,000 feet high the pottery offered a magnificent view across the twenty-mile-long valley running due north and south. Much to Leach's pleasure the morning sun threw the wooded slopes into dramatic shadow, the spectacle accompanied by the song of the Japanese nightingales. The sense of timelessness, the tranquillity and rhythm of the ancient work-shops belied the difficulties of adjusting to the modern world. With Ichino Tanso, a follower of Yanagi and Mingei, and his son Shigeoshi, who had spent two years at the Leach Pottery making western-style tableware and indi-vidual pots, they talked long into the night. Could such a true tradition of communal craftsmen ever be preserved in a meaningful way, asked Leach, or must the solitary artist craftsman inevitably replace it? Was there, he won-dered, the possibility of a slower, more natural transition for traditional craftsmen to move into the modern world?

Leach was now approaching his mid-eighties and despite weakening sight had a full exhibition programme, including solo shows in 1971 and 1973 at a new London venue, the Marjorie Parr Gallery in the King's Road, Chelsea.[46] After initially dealing only in antique furniture, the gallery, encouraged by Janet, had expanded into contemporary visual arts, including pottery and sculpture.[47] Bill Marshall continued to throw many of his pieces but Leach still made porcelain bowls and lidded pots, which are among some of his finest works. Thickly rather than thinly potted, the Sung-inspired bowls with their narrow foot and generously opening curve often have minimal incised deco-ration on the inside and carved fluted decoration on the outside. Carried out in a single stroke without correction or hesitation, the slanted, slightly uneven lines give the shape rhythmic controlled movement. A pale blue or green, semi-matt glaze enhanced the pieces. The lidded so-called incense pots with three small feet are modest rather than monumental. The shape, Leach said, had 'evolved over many years from the sight of tiny rice-straw stacks which border the paddy fields of Japan in autumn and winter'.[48] These finely bal-anced, resonant forms, confident and quiet, are some of the last pots Leach made. As his sight deteriorated he became less concerned with pots and at one point rejected a series of large bottles Marshall had made for him. While still able to read large script and write with a black, felt-tipped pen, his hand-writing, usually so clear and well formed gradually became large and sprawl-ing.

Two days after the private view at the Marjorie Parr Gallery in 1973,[49] Leach and Janet flew to Japan for further exhibitions in Tokyo (15 May) and Okayama (1 June). In Tokyo dealers' runners bought the entire show in less

than one minute – a situation unknown in England – and then cheekily offered it for sale at increased prices. Leach thought this 'nasty'. Princess Chichibu invited them to her 'lovely new small palace' for a private tea party where 'good English tea' was served in a room filled with pots and drawings. A sensitive and thoughtful patron of the arts, the princess also made pots. During their conversation she mentioned, much to Leach's surprise, how she admired the poems of Takamura and he told her about their meeting in 1908 and of their long friendship. To her astonishment and pleasure he quoted lines of Takamura's poetry that referred to Chichibu, the name of the province that shared her name:

Chichibu oroshi no samui kaze	Cold winds blow fierce
Konkororin to fuite koi.	From the wild mountains of Chichibu.
	Konkorin the sound of their voice.[50]

Further recognition of Leach's esteem in his adopted country came with the erection of a stone monument at Abiko on the banks of Tega Lake to commemorate his pottery there sixty years earlier.[51] The tranquil setting on the slope down to the water below Yanagi's old house, with the continuing presence of three oak trees, seemed to suggest the staying of time, an apt spot for the memorial. The impressive monument consisted of a four-ton pedestal of Tsukuba stone supporting a rectangular slab of black granite from India. At Leach's suggestion the front was carved with his image of the wandering monk or pilgrim, a motif Leach employed on many of his dishes and drawings, along with the prophetic text, 'I have seen the marriage of East and West. Far down the Halls of Time, I heard a childlike voice How long? How long? Bernard Leach'. Inscribed on the back was 'Abiko Rotary Club erected this monument'. Encouraged by Hamada the club had raised the funds over several years.

A further honour came in 1974 when the Japan Foundation awarded Leach the equivalent of the Nobel Prize, and he was flown first class to Tokyo where he was to be handed a cheque for 5,000,000 yen the equivalent at the time of £7,127. This was in recognition of Leach's 'immeasurable contribution to cultural exchange as the leading transmitter of Japanese influence to the Western world in the field of ceramics'.[52] The other distinguished recipient of the award was the US Senator William Fulbright.[53] The event was memorable not only because of the great honour and accompanying financial award, but because of the profound respect with which Leach was treated. On the second day of his visit and still feeling jet lagged and confused, Leach gave a live television interview at 7.30 in the morning before receiving the award at noon. Janet was amazed at his composure and confidence and wrote to Richard de la Mare of how he 'rose to a magnificent peak and did a magnificent performance, turning to the camera and using professional hand movements. I don't know how he did it but he found the reserves out of his love

for Japan.'[54] Hamada, ill in hospital with prostate trouble, was to Leach's sadness unable to be present.

It proved to be Leach's final visit to Japan, for on his return he suffered a sudden and frightening deterioration in his eyesight. Glaucoma was eventually diagnosed and an operation performed. He retained some peripheral vision but lost the sight of his right eye and therefore decided that he could no longer make pots. This acute reminder of his fragility prompted him to stop smoking, quite an achievement as he had smoked heavily throughout his life, even when working on the wheel. Because of the hazardous internal stairs in his flat, and temporarily without a housekeeper, Leach went into a nursing home to recuperate. At much the same time the death of his son-in-law Dick Kendall, following a prolonged, painful and debilitating illness, came as a relief with Jessamine saying 'I saw Infinity and light bright light entering it. I wanted to celebrate; no black edges; flowers and fronds of young beech in church'.[55] Unable to attend the funeral Leach wrote to Tobey that he 'would like to have such a passing'.[56]

The reality of death as a release from physical pain was brought home again with the news that Mark Tobey had fallen into a coma and was being kept alive by intravenous infusion. Dramatically Leach sent a telegram 'I am with you in spirit'[57] and a huge bouquet of red roses as a celebration of their long and deep friendship. Tobey died six weeks later on 3 May 1976. Stirred by the death of his close friend Leach investigated burial sites, and discovered that as a Bahá'í he could not be buried alongside Christians. In an area designated for non-Christians, he selected a secluded plot under trees in Longstone Cemetery, Carbis Bay.

In these final years Leach defined himself as a poet and writer and just as he had sought recognition for his pottery, now wanted acknowledgement for his writing and regretted that the Companion of Honour had been awarded solely for his achievements as a potter. Far from finding his limited sight a problem Leach thought it sharpened his mind and spoke of 'new worlds to conquer'.[58] During visits to the Pottery and New Craftsman, Janet's shop in Fore Street, he held pieces and caressed them to assess their strengths and weaknesses, often sighing over what he thought were rudimentary and unnecessary handles on Janet's pots.

When invited by the radical educationalist Simon Nicholson,[59] son of Barbara Hepworth, to take part in an Open University programme about the Japanese tea ceremony Leach readily agreed saying 'I think I can usually talk with clarity . . . especially since my sight has nearly gone. One is driven inward, and inner vision gives the answer'.[60] The successful programme led to the publication of a book entitled *Kizaemon-Ido*, giving the background to the common rice bowl made in the fifteenth century in Korea. Produced in great quantities as an ordinary food bowl with minimal decoration by unknown potters, such pieces had been praised by the tea masters of Japan

who judged that the modest vessels possessed all the necessary qualities of humility, quietness and austerity appropriate to the tea ceremony. The bowl, thought Leach, was likely to strike dismay in the heart of a viewer because it is so ordinary, so simple,[61] while modern work, made by more knowing potters, could never be as free or relaxed.[62] This sense of the choices open to artists was elegantly expressed in a letter to the American potter Sally Bowen Prange. 'I never aim to copy nature in the shape or pattern of my pots,' Leach wrote, 'that way disaster, but we are nature plus choice. The choice of beauty or ugliness, good and evil . . . The coin of reality has two faces. The lotus grows in the mud.'[63]

Although no longer potting, Leach resisted attempts by others to relegate him to history, adamantly opposing an initiative led by John Lane of Dartington and the restaurateur and supporter of the crafts David Canter[64] to set up a Leach museum on the Dartington estate, which was to combine commercial and educational elements. Despite a promise that 'your life and achievements will be traced with word panels and photographs, a collection of your pottery shown . . . and a full-scale replica view created looking into part of your workshop',[65] he refused to be involved dismissing it as 'a Madame Tussaud's exhibition'. Dartington also asked to borrow some of his historical pots to put on show, a request that he again declined. Apart from the few in his flat, his collection was on display at the Leach Pottery or had been bequeathed to either the Penwith Art Society[66] or a brand new venture, the Crafts Study Centre, to which he left his books, papers and drawings.[67] To Janet the proposal reeked of the cliché 'Bernard Leach slept here', but with hopes of creating her own Bernard Leach museum at St Ives she had an element of self-interest.

More surprising was Leach's refusal to become involved in the proposal to set up the Dartington Training Workshop,[68] in particular to approve their idea of basing their shapes on Leach Standard Ware. When visiting David, who was involved in setting up the project, Leach cautiously welcomed the principle of a training workshop where a regular team of professional potters would produce a range of standard tablewares and trainees would learn the skills of making thrown functional wares, but did not like the idea of the Leach Standard Ware being copied. 'Influence', he wrote, 'is natural – copying an error'.[69] Again, Janet was adamantly against the scheme for far more practical reasons. Producing pots similar to Leach Standard Ware would have led to Dartington becoming a direct competitor and thereby undermine the Pottery's market. With the Pottery often failing to maintain quality the proposal may also have been a hint that the new workshop could take over the production of well made standard ware, again a suggestion that Janet saw as a threat to the Leach Pottery's finances.

The skills of the potter made engrossing television and Leach, a natural performer, could outline in a few words complex concepts about his work

and what he was trying to do. An American, David Outerbridge had met Leach when exhibiting at Bonniers, New York, and was a great admirer. He directed *The Art of the Potter* in 1971 in which Leach made and fired pots. Shortly afterwards Westward Television produced *The Potter's Art*,[70] again featuring Leach at work on the wheel and one of the last recordings of him throwing and decorating pots. The film made grandiose claims in seeking 'to capture the qualities which make Bernard Leach not only a great potter but an outstanding human being'.[71]

A 1974 BBC programme, also entitled *The Art of the Potter*, focused more on Leach's ideas than his practice, setting these alongside those of Hamada. It included shots of Leach, who after being stick-thin all his life had put on considerable weight, sitting in his Barnaloft flat, looking patrician and Buddha-like, reminiscing about the East and what makes a 'good pot'. This was intercut with old footage of him in the Pottery by the kiln, and included shots of thick black smoke emanating from its chimney. Interviews with Leach were contrasted with Hamada in Mashiko, shown sitting cross-legged effortlessly throwing and decorating pots in what seemed like a timeless manner. Ingeniously, the film brought together their different working methods and shared concerns to suggest a creative interchange between East and West and the richness of the international language of ceramics. The programme inspired Michael Cardew to write saying that he was 'greatly moved by the simple and beautiful way you were able to gather up in a few words all the teaching you have done in the past 50 or 54 years here in Britain'.[72]

Not all brushes with television were a success. On one occasion Leach agreed to be interviewed by a 'horrible bitch by the name of Miss Makamura . . . wearing outlandish jewellery'[73] who after what seemed like endless negotiation succeeded only in rubbing up Janet the wrong way. Much to Janet's disgust Miss Makamura booked herself into a first-class hotel while her cameraman and director had to make do with a modest bed and breakfast.[74] Miss Makamura's programme usually featured celebrities and was broadcast in Japan.

At David Outerbridge's initiative a new and expanded edition of Leach's 1951 book *A Potter's Portfolio*, aimed specially at the American market, was prepared and published as *The Potter's Challenge*.[75] In a smaller format than the original and with additional new material, the text incorporated edited transcripts from a series of interviews Leach made with Outerbridge in 1973. Here he stressed the need for a thorough understanding of materials and the 'joy' of the handmade object that 'serves a starved heart both in the maker and the user'.[76] In addition to illustrations of historical wares, images featured recent pots by Leach including a fish bottle, a *temmoku* vase and a fluted porcelain bowl. A year later a second impression of Paul Hodin's book *A Potter's Work*,[77] first published in 1967, was issued and again sold well. Unfortunately the new pink cover framing one of Leach's earliest and most untypical pots —

a raku copy of a Delft drug jar – did not meet with the approval of Janet, Kim Schuefftan or Leach. All felt the 'pukey pink' totally unsuitable and out of tune with Leach's ideas. Despite good sales the squabble brought to an end their friendship with the publisher Tony Adams.

A Potter's Book, in print in England without a break since being first issued in 1940, provided a regular income for both publisher and author. After thirty years it continued to be bought and translated by overseas publishers, appearing in France in 1972, in Germany in 1974[78] – where it quickly ran into three editions – and Sweden in 1977.[79] By the early 1970s the English language edition had been reissued by Faber & Faber so many times that the type was literally wearing out and the colour, printed from plates supplied from Japan thirty-five years earlier, was thought unsatisfactory. Bearing in mind the continued interest, Richard de la Mare contemplated a new edition and invited Leach to look at the line drawings and colour images with a view to proposing alternatives.

No new edition was produced but Faber replaced the hardback with a paperback in a slightly smaller format, giving it a cramped and mean look with little of the elegance of the first edition. The majority of the pages were reproduced photo-lithographically from the original publication, though some were reset to incorporate footnotes updating specific information, which served only to give the book a disjointed, cheap appearance. A brief endnote pointed out that many of the firms mentioned in the original had changed name or gone out of existence. A postscript, dated 1975 headed 'The Leach Pottery', briefly outlined the history of the pottery acknowledging the contribution made by David, Michael and Janet Leach. For this, the fifteenth edition, all the colour plates were removed and rendered in poor quality black and white.

Successful exhibitions in Japan helped put financial affairs on a firm footing. After years of wrangling with David over finances, and still paying the rent negotiated in 1956, in 1972 ownership passed jointly to Bernard and Janet for the sum of £10,000 following an independent valuation. With the premises secure Janet initiated a series of improvements, the first of which was to install a smaller gas-fired kiln. The three-chamber oil-fired kiln was too large for the more modest rate of production and needed 'too much labour, work and expense for standard ware alone'.[80] It also bellowed black smoke during firings, which various remedies such as burning a gas poker in the third chamber had failed to solve, resulting in complaints from people living in nearby houses, particularly on Mondays when washing was hung out to dry. With North Sea Gas now piped to St Ives, Janet contemplated converting from oil to gas but decided in July 1974 on a smaller, more efficient gas-fired kiln, which could produce similar results to those from the old kiln with a great deal less bother. In addition, its smaller size would enable a more rapid turnaround of pots.

New buildings included a proper showroom for the increasing number of visitors, a shed housing a fine collection of Leach's pots, a packing area and clay store. The old showroom in Pottery Cottage was converted into a studio for Janet, and the cottage extensively altered into two self-contained flats, one upstairs with its own staircase on the outside of the building, another on the ground floor occupied by Janet. In her studio Janet spent more time on her own pots, experimenting with various firing processes such as placing small pots in the firebox of a small wood kiln to create highly textured markings.[81] She also tried out salt-glaze with Ian Gregory, a potter in Devon. With Leach no longer making pots and only rarely visiting the Pottery the crew were encouraged to make more individual pieces to maintain interest for visitors. Despite cutting back on the production of standard ware the quality remained variable and stores such as Heal's regularly returned pots they thought not up to the required standard.

To oversee production Janet decided that the Pottery desperately needed some sort of leader or manager. Temperamentally she was neither qualified nor wanted to act as manager, her own health was not good and the extent of her addiction to whisky meant that in the mornings she was somewhat slow to get going, though she usually remained sober until the afternoon. The person required would have to be committed to the Pottery and what it stood for, be familiar with the pots, able to oversee production and maintain and improve the quality of the standard ware. Bill Marshall, although well qualified by experience and ability, either did not want or was not invited to take a managerial position and so a letter from Donna Balma in Vancouver proved timely. Donna and her husband, John Reeve, with their two daughters, were having family problems and, thinking that a move might help, she wrote asking about any possible openings. A long correspondence ensued and although there were lingering doubts about Reeve's willingness to tackle the bread and butter aspects of production Janet invited them to return, with Reeve taking over as manager.

Having made the decision Janet embraced the new arrangement with enthusiasm, writing 'there is a gaping hole here that only John could fill . . . Bill [Marshall] retreats and retreats so that he is carrying no responsibility at all – not even to look in the kiln – or to properly show anyone how to throw a soup bowl'.[82] Confident that any initial teething problems could be quickly and easily resolved, she confided to Reeve that she had long seen him as 'Bernard's successor', and then added the final inducement of a promise to amend her will to leave him her half share of the Pottery. Leach supported his return for he was fond of Reeve whom he described as 'gentle, modest, loveable',[83] a man with 'a soul behind the searching eyes, a mixture of poet and priest',[84] but, unlike Janet, he was not unaware of 'a wandering waywardness in his make-up'.[85]

Since working as an assistant fourteen years earlier Reeve had maintained

contact with Leach through a series of taped letters, and while having great respect for Leach had little for Janet or her pots despite her support and encouragement. Problems arose almost immediately as Reeve and Janet attempted to establish a working relationship without either properly listening to what the other wanted or required. Janet, while expecting Reeve to provide some of Leach's 'spiritual leadership'[86] within the Pottery, basically wanted him to take a hands-on role in managing the workshop and in making the larger items of standard ware, in effect to more or less pick up from where Reeve had left off. However, in the intervening years Reeve had established a reputation in Canada for his individual pots and had little interest in repetition wares. In taking over Leach's studio his intention was to make his own pieces and even use his own glazes, defining his duties as manager as selecting students and generally overseeing the quality of the standard ware rather than actually making it. It was not a recipe for success.

Still in sympathy with Leach's ideas Reeve spent many evenings discussing their shared beliefs in spiritual matters. Donna dutifully tagged along, eating supper prepared by Trudi or a housekeeper and listening to Leach reminisce about his years in Japan or his involvement in the Bahá'í faith. Pots were the focal point of these talks and Leach would turn them over 'running his fingers around the foot, the belly, shoulders and lip, saying "Ah, yes", or "this is weak"'[87] before handing them over for comment. Because of his infrequent visits to the Pottery and limited sight, Leach felt left out of developments and looked to Reeve to keep him informed with what was happening. Reeve spoke frankly from his own perspective about what he saw as the declining standard of work and the low morale of the crew, attributing much of the problem to the fact that Leach was no longer 'at the helm'.[88] Such comments were intended primarily to reassure Leach that he still had a vital contribution to make, and to seek some way of improving the situation, but they only served to make Leach feel more isolated and troubled. Inevitably they also put a strain on his relationship with Janet. When Leach confronted her, Janet accused Reeve of disloyalty and meddling, and deeply resented the time and effort required dealing with Leach's endless anxious enquiries.

As a manager Reeve also failed to impress Janet. She considered him unfocused and too much of a dreamer, and her repeated demands that he give more attention to day-to-day production rather than his individual pots appeared to fall on deaf ears. Disagreements over money did not help, with Janet disputing what had been agreed on the basis that he was not producing enough pots. Their basic incompatibility was further exacerbated by their working patterns: Reeve's day began early and finished at three; Janet never appeared until late morning. By the mid-afternoon she had started to drink and for a short time would became jovial and conspiratorial, but as her speech became slurred, her Texan accent more pronounced and her cough more violent, it became impossible to understand what she said. Reeve's strategy to deal with this was simply

to avoid her as much as possible. By contrast Donna established a good working relationship with Janet, finding her when not drunk 'more real, more accessible and more direct as a person than BL'.[89] The complications of working at the Pottery were not helped by problems within the Reeves' own marriage or by their two daughters experiencing difficulties adjusting to the English education system.

At the Pottery the situation went from bad to worse with Janet and Reeve hardly communicating, while Donna was caught in the middle, enjoying making pots in Janet's studio, which sold well in the showroom, but at the same time feeling disloyal to her husband. The tensions could not be repressed. A row broke out when Donna 'arrogantly challenged the legitimate sincerity of her and BL's marriage',[90] the argument culminating in Janet hurling a wet pot at her and forbidding her to return to the studio. It was the beginning of the end of the partnership. Communication broke down completely and Reeve felt he had no alternative but to resign. This, coinciding with the Watergate trials making headline news, prompted the Reeve family to chant in unison 'Impeach Mrs Leach'.

Although Leach knew a little of the personal tensions of the Reeves' marriage, he was saddened by their decision and felt that the Pottery was slipping further from his grasp. Financially the Reeves were destitute. Having taken out a mortgage they had little hope of any financial return and had no funds for their passage to Canada. Feeling that 'justice must be done'[91] Leach wrote them a cheque for £500 to cover their fares, a gesture that amazed Janet for he was notoriously cautious with money. Such a gift was doubly generous as he had no hope of repayment, but for him it was between what he saw as spiritual values and the 'hard outwards facts of life – justice on the one hand, and disarming defencelessness in ones own self-defence'.[92]

With Reeve departing, Janet sought to maintain a team of competent throwers, which included Trevor Corser,[93] John Bedding[94] and Jason Wason,[95] all of whom had studied at the Pottery. American students included Jeff Oestreich[96] and Jeffrey Larkin[97] from Minnesota and Robert Fishman[98] from Rhode Island, all of whom were deeply committed to the Pottery. For Oestreich the atmosphere was one of extremes, with intense periods of stress 'balanced by periods of harmony'.[99] Still with no one in overall charge the quality of the standard ware was uneven, and shops continued to complain.

To add to their problems, Reeve's departure coincided with Barbara Hepworth's horrific death in a fire, probably the result of drinking and smoking in bed, and with Bill Marshall's announcement that he was leaving to set up his own studio, bringing to an end a forty-year association. Janet and Marshall had rarely been in sympathy and they maintained a spiky relationship, but as a highly skilled potter he was a central and valued member of the team and Janet knew he would be impossible to replace. His decision to leave

in 1977 came while Janet was on an emotionally difficult five-week visit to Texas to see her dying father and console her mother, and it seemed to her like a betrayal.

In acknowledgement of Marshall's long and invaluable contribution a letter written by Bernard and Janet was circulated to many previous employees notifying them of his departure and suggesting that there might be opportunities for employment. The American Byron Temple was immediately interested. Since leaving St Ives in 1961 and then working with Colin Pearson, he had returned to the United States where he successfully produced a range of wood-fired tablewares and individual saggar-fired pots with a dark, intense-coloured body. Despite a degree of success, Temple was attracted by the idea of a change to his usual routine and the opportunity to manage what he regarded as an important Pottery workshop. Terms were agreed and he arrived in late August 1978.

On paper, having trained potters and run his own successful production team, Temple was much better qualified to take over the position of leader-manager than Reeve but like his predecessor he quickly ran into difficulties with Janet. Even the modest monies agreed were not forthcoming and far from working with what he assumed would be a skilled crew he thought the throwers badly trained and the pots of poor quality. Without profound changes he believed there was little prospect of improvement. Although he knew of and thought he could handle Janet's fondness for whisky, it was only at close quarters that he saw the scale of the problem. Ironically, one of his tasks was to stock up with crates of her favourite brand, Johnnie Walker, bought from a discount supermarket.

Like Reeve, Temple spent many evenings at Barnaloft listening to Leach talk about pots, the importance of his Bahá'í belief, and regret over his failed marriages. Leach had been particularly distressed by Laurie's death two years earlier, acknowledging that despite the passion they had 'never been able to bridge the gap'[100] and admitted that 'Bernard the potter and Bernard the husband are two different folk'.[101] In reply to Leach's anxious enquiries about the Pottery, Temple, like Reeve, related its shortcomings as he saw them, describing how on one occasion Janet staggered around with a whisky bottle in her hand intimidating the crew, an accusation she denied vehemently when challenged by Leach. What particularly alarmed Temple was the continued production of pots bearing Leach's personal seal. Although made to Leach's design at the Pottery, technically they could be defined as fakes. Unsure what to do Temple contacted David Leach. When they confronted Janet she offered lame excuses but, significantly, production came to an end. In an endeavour to initiate meaningful change, Leach discussed making Temple a partner in the Pottery, but the idea was firmly squashed by Janet. Feeling unable to effect improvements, Temple, much to Leach's disappointment, left after less than a year.

It was against this background of seemingly endless problems at the Pottery that Leach became deeply involved in two major projects. One was his memoirs, eventually published in 1978 as *Beyond East and West: Memoirs, Portraits & Essays*,[102] the other was a major retrospective at the Victoria and Albert Museum, London, to mark his ninetieth birthday with an accompanying illustrated book published a year later. Apart from the Arts Council's relatively modest exhibition 'Fifty Years a Potter' in 1961, no serious critical attention had been devoted to Leach's work in the United Kingdom, which even those out of sympathy with his ideas thought shameful given his great international standing and major exhibitions and retrospectives in Japan. As a further example of the high regard of the Japanese, the Seibu department store in Tokyo planned a collective exhibition of his individual pieces and that of the Leach Pottery, the first time the work was shown together in Japan.

On December 1975 Carol Hogben of the department of regional services[103] at the Victoria and Albert Museum wrote to Leach discussing a touring exhibition, but gradually this evolved into a full-scale retrospective entitled 'The Art of Bernard Leach'. As the only craftsman to be made a Companion of Honour, it was assumed that it would tie in with the Queen's Silver Jubilee celebrations of 1977 as well as Leach's ninetieth birthday and would, promised Hogben, look 'at your thought and its development'.[104]

From the start, the Victoria and Albert exhibition was dogged with wrangling over costs and uncertainty. The museum, like many others at the time, had severe funding problems which inevitably restricted what could sensibly be achieved. With limited time and resources to research or borrow pieces from collections overseas, selection could only be made from work in Britain, which set immediate restrictions. Hogben had also to manoeuvre a complicated path between Leach, often advised by Trudi, Janet and David, all of whom had differing views of what should be included. Understandably the museum wanted to include a cross-section from all periods, but were occasionally inclined towards what Janet described as 'trivia', unrepresentative pieces such as a coronation mug and a fancy jug that she deemed quirky and unusual rather than good.

While acknowledging the need to be comprehensive, Janet pointed out that most of Leach's best pots from the 1920s were in Japan and that in the 1930s his output was small as he had spent little time at the Leach Pottery, thus making chronological coverage difficult. She favoured concentrating on the better, later, maturer pots arguing that they would make a stronger exhibition. Janet also objected to the inclusion of pieces of inferior quality, pointing out, for example, that a small hare plate was an imperfect 'second' that had been sold cheaply and suggested, to Hogben's amazement, that if required a better one could be made. As a general policy Janet urged Hogben to note the three groups of work made at the Pottery – pieces thrown by Leach, individual pots made under his supervision, and repeat ware made to his design.

The last group, if included at all, should, she thought, be shown separately and clearly labelled as Leach Pottery pots rather than by Bernard Leach. The exhibition eventually included nearly 200 pots plus drawings, prints and working studies.[105]

At one point a wider selection of Leach's output was considered, including a three-legged chair, an oil painting of Poole Harbour dated 1908, and a self-portrait, though in the end none made it to the final show. Apart from David and Janet, the proposed final selection, which ranged from Leach's first pot decorated in 1911 to his last in 1973, was agreed by, among others, Lucie Rie, Henry Rothschild, Marjorie Parr, Guy Worsdell, Sibyl Hansen, Muriel Rose, Victor Margrie, the art critic Edwin Mullins[106] and the collector W. A. Ismay, all of whom found it balanced and impressive. Despite what was generally thought to be too cramped a space, Ivor Heal produced roomy showcases with a slightly Japanese look.

Financial pressures also dogged the exhibition catalogue. Initially the intention was for a fully illustrated publication but the museum felt that this could only be achieved with the collaboration of a commercial publisher. Kodansha toyed with the idea but decided that a publication with ample colour would not be ready for the opening. After what seemed like interminable indecision it was agreed that the exhibition itself would be accompanied by a modest black and white catalogue that would sell for thirty-five pence, and this would be followed a year later by a book of the exhibition. The catalogue would list the exhibits, carry only four black and white illustrations and include an essay by Victor Margrie, then director of the Crafts Advisory Committee.[107] When Margrie failed to deliver, John Houston, also connected to the Crafts Advisory Committee, was commissioned to write a wide-ranging contextual piece that thoughtfully combined history, chronology and comment.

On the day before the exhibition opened[108] Leach insisted on attending a three-hour press show in the morning and a two-hour private view in the evening. Janet, constantly by his side, told him who was present, to whom he was speaking and generally tended to his needs. Far from shrinking from the crowds he relished being the centre of attention and enjoyed the occasion. The following day an informal seminar 'Towards A Standard', organized by the Crafts Advisory Committee, was held in the lecture hall of the Royal Geographical Society, near to the museum. Over 500 craftsmen and women, friends and colleagues gathered to hear David Leach, Janet Leach, Edwin Mullins and Victor Margrie pay homage to Leach's achievements. But the star was Leach himself. After showing parts of Warren MacKenzie's 1952 film of the Leach Pottery and John Read's BBC film A Potter's World, he spoke vigorously about his work as a potter, his time in Japan and the importance of his friendships with Hamada and Yanagi.

On more topical themes he discussed the terror of the 1962 Cuban Missile Crisis and the need for international understanding, reminding his audience

that crafts now operated in a world where the old continuity of values no longer existed. Questions from the audience ranged from practical issues about art school versus workshop education and approaches to decoration to the thorny topic of 'bad men who make good pots'. With great aplomb Leach acknowledged that it was the good side of a person's character that made the pot, whilst the rest was of no importance. As a speaker his skills were as persuasive as ever. To the delight of the audience he also referred to some of his mistakes, concluding 'The craftsman's real search is for true values in living – in which an artist is not a special sort of man, but everyone is a special sort of artist.'[109] Far from looking or acting his ninety years he stood to give his talk, appearing lively, witty, mentally alert and totally on top of the occasion. It was, reported the *Yorkshire Post*, 'one giant birthday party'.[110]

Press response to the retrospective was generally laudatory. Marina Vaizey in the *Sunday Times*[111] thought the exhibition 'a marvel, encapsulating over sixty years of work in a superb anthology', achieving 'that dream-like balance between artisan and artist'. In *The Times*[112] Ian Bennett argued that the pots were not 'about function but about art. These are sculptural objects springing from the mind and hands of a graphic artist of great talent'. By contrast Stephen Bailey in the *Listener*[113] found the show far from illuminating, complaining that it did 'little to explain Leach's pots to us'.

One of the most penetrating reviews appeared in the *New Statesman*[114] where, rather bravely, John Spurling sought to deal with the philosophy informing the pots, which, in his view, 'promote a strong idea of usefulness . . . the moral atmosphere . . . is inescapable'. Sticking to his theme he added 'Bernard Leach is not just a good potter, but is a man who believes that good pots are made by a quality he translates as *thusness*, thusness is what everybody can contribute to life in his own way'. It was maybe not quite how Leach would have put it, but it was a welcome discussion nevertheless. One of the more brutal assessments came from Paul Atterbury in an opinion piece in *Ceramic Review*.[115] This drew attention to the growing anti-Leach movement, particularly within some art schools that saw his influence as deadening, lifeless and dogmatic. 'For many, long lean years, craft and industrial potters have been blinded by the image of Leach, which has lain heavy and oppressive over potters like the clouds of smoke that used to lie over Stoke-on-Trent', wrote Atterbury, adding, 'I hope and pray that we can turn our backs on this gloomy period in English ceramics, and, having given Leach his honourable discharge, can look forward to better things'. It was a damming indictment but it did not prevent the exhibition doing well, attracting nearly 4,000 visitors a week, some 35,000 in total.

The dithering over the catalogue caused Leach much confusion. Believing a substantial volume was planned he handed over large amounts of illustrative material to the museum on the assumption that it would be used for the

exhibition or the official publication. When he discovered that a commercial publication was planned, possibly using such material, Leach, Janet and David, while not having any fundamental objections, thought they had not been properly consulted and that the whole enterprise had been handled in an underhand way. The fully illustrated book, also entitled *The Art of Bernard Leach*, edited by Carol Hogben and based on the exhibition, was a lavish production. It included a thoughtful essay by Edwin Mullins, excerpts from writings on Leach by Hamada and Yanagi, and many colour and black and white illustrations. Given the recent spate of books by or about Leach such as *Hamada: Potter*, *The Potter's Challenge* and *A Potter's Work*, as well as the pending publication of *Beyond East and West*, the need to avoid repetition proved difficult. The book, published in 1978,[116] included only brief excerpts from Leach's previous writing.

The preparation of his memoirs involved a more personal scrutiny of his life, his beliefs and his work as a potter. For many years Leach had recorded impressions and ideas in his diaries and these, along with a large archive of letters, were a central part of the book. Writings by friends such as Yanagi were also included. *Beyond East and West* was in no sense a straightforward autobiography, for as he points out in the preface 'much concerning my private life I have omitted',[117] but he did include sufficient biographical detail to create a strong narrative, and the book is Leach at his most readable and accessible. His account is often touching, and while sometimes unintentional in revealing his pomposity and arrogance, it is informed by a desire to be true to his art and to his lifelong search for 'truth' in both his art and his life. The memoirs outline the main events of his life in roughly chronological order, beginning, in a short preface, with his childhood in the East, his time as an art student in London, his move to Japan at the age of twenty-two and his work in China. It describes the setting up of his pottery in St Ives with Hamada, his involvement at Dartington and subsequent visits to Japan, America and other parts of the world.

In telling the story of his life, Leach's account is often self-deprecatory and includes wry anecdotes such as his confusion and modesty over the Japanese bath or the dubious honour of being stared at and questioned in Japan. Disarmingly, he also wrote about such major misjudgements as his commitment to Dr Westharp in China. In mapping out his life he did refer in broad outline to his three marriages, using telling phrases to suggest the anguish of personal relationships such as when leaving England to go to Japan in the spring of 1934. Without detailing his failed marriage to Muriel or his involvement with Laurie, the book merely records how he 'was exceedingly sad at the parting and stood alone in the stern of the cross-Channel boat saying farewell'.[118] It was hardly an explanation of the turmoil of his emotions when, on the point of visiting his beloved 'second home', he had taken the traumatic decision to end his twenty-three-year-old marriage.

In addition to outlining his experiences as a potter, one of Leach's main aims was to write about his belief in and commitment to the Bahá'í faith, and to tie this in with his involvement in the East and the West. The final page, headed 'East and West', and written in Leach's hand, repeats his cry for a 'marriage of East and West', and was signed in barely legible script 'Farewell BL', summing up the contents as a reflection on his life. It was, he wrote, 'like a "grand confession", an examination of conscience over the years'.[119] Typically he thought it would be his best contribution – 'truest, least egotistic'.[120]

Preparation for the book began in the early 1970s, and was slowly completed with the help of several secretaries. These included Alan Bell, who he met at a Bahá'í summer camp at Tiverton, Devon, and who shared Leach's love of the orient. Bell helped with Leach's writing and his Bahá'í activities. As Leach's sight deteriorated the text had to be read aloud and edited, with additional pieces written in large script. Initially Janet was dismissive for she saw it as yet another project keeping him away from pots, for notwithstanding his growing fragility, she still hankered to get Leach to supervise the making of his pots. An element in her hostility was undoubtedly that she felt excluded, which probably accounts for her view that the book was far too long and rambling; contrary to her opinion, both Kodansha and Faber expressed interest. Leach's loyalty was to Faber for consistently supporting him since 1940, despite endless complaints about their poor distribution, particularly in the United States where there was still a healthy demand for *A Potter's Book* but few copies in the shops. *Beyond East and West*,[121] published a year before his death with sixty-two black and white illustrations of photographs and drawings in a handsome hardback edition, was reissued in paperback seven years later.

Press response varied, though the general view was that it was a great success, many considering it 'enchanting, stimulating';[122] Frank Hermann in *The Times*[123] confessed to finding it 'a long, difficult but infinitely rewarding book . . . of his pilgrimage through life'. In the *Sunday Telegraph*[124] the writer Rebecca West was one of the few to take issue with some of Leach's specific metaphysical points, in particular his global view that the 'Universe is One'. She failed, she said, to comprehend Leach's observation 'No one, no two, or three, or multiplicity. Q.E.D', saying 'this is an argument hardly bearable to many of us even when it is carried on within a philosophical framework', adding 'that is lacking here'. She was also critical of Leach's skills as a draughtsman, finding the drawings 'flabby and uninteresting'.[125] Other reviewers were more sympathetic. Writing in the magazine *Resurgence*, John Lane thought the section on the nature of dualism 'engrossing', but regretted that it was not developed in other parts of the book.

For his ninetieth birthday the celebrations involved three nights of festivities and hundreds of visitors. On 5 January there was a party at the Penwith,

with the mayor of St Ives in attendance, but for Leach the most enjoyable was the family party on the eve of his birthday when a cake was prepared bearing an astonishing eighty-nine candles. The evening was rounded off by three of his grandchildren playing a musical piece they themselves had composed. A fireside meeting at Barnaloft with fellow Bahá'í's completed the celebrations.

At his flat Leach continued to entertain visitors; these included Warren MacKenzie, Bill Marshall and others, many of whom read to him aloud, often from his own writing. Under pressure from his family, his Bahá'í friends and from Janet he constantly rewrote his will. In the final draft his share of the Pottery was left to Janet including the museum collection of pots, and Pottery Cottage for her use during her lifetime after which it was to pass to his five children, who also received various bequests in the form of book royalties. Betty was left the Barnaloft flat. Other bequests were made to Trudi Scott, the Bahá'í Spiritual Assembly, his grandchildren and Maurice.

A shadow was cast over the celebrations for Leach's ninety-first birthday by a telegram announcing Hamada's death. After being ill for some time Hamada had passed into a coma and shortly afterwards died of acute pneumonia. There were two funerals. The first, in Mashiko three days after his death, involved a private ritual at his family home followed by a public ceremony, conducted by the mayor, in the town's large sports stadium. Undeterred by a chilly, cloudy sky it was attended by an estimated 1,000 mourners. The second, on 26 January, was in the Kawasaki area where Hamada had spent his childhood and where his ashes were buried at the Soryuji Temple. In a tribute in *The Times*[126] Leach wrote 'I have never come across any other potter who had such a balance between head, heart and hand – his pots actually resembled him. Like him', he added 'they stand four square upon the ground'.

At the Pottery Janet decided that, with no more individual pots from Leach and a general decline in the market for standard ware, tough decisions were required. As she pointed out to Susan Peterson,[127] overheads were not reduced just because there were no Bernard Leach pots to sell. Production was slimmed down. Her financial predicament had odd resonances with Hamada's situation, for during the last years of his life he had not attended to the pottery and following his death it faced severe financial problems requiring drastic measures. 'I wish he had stayed home more often and made more pots', commented Janet, a view that could well have applied to Leach. She also suffered a series of illnesses including a peptic ulcer and bouts of acute vertigo caused by low blood pressure, on one occasion falling flat on her face with a total loss of balance, putting her out of action for five days. This, plus excessive drinking and smoking, caused her and those around her great anxiety.

In April 1979 Leach was admitted to St Michael's Hospital in Hayle suffering from a weak heart. The regular use of a 'popper'[128] had helped his

breathing but his general lack of energy and increasing pain were sufficiently severe to require hospital care. Although initially agitated by his prolonged stay in hospital he slowly became 'very much at peace and happy during the last ten days', enjoying simple pleasures such as having his hair brushed and the smell of lilies of the valley brought in by his daughters. Bahá'u'lláh's quotation 'I have made death a messenger of joy, wherefore doest thou grieve?' suddenly seemed more meaningful.[129] Gradually sufficient strength returned to enable him to write short letters to close friends, including Lucie Rie. After enquiring about her health, to indicate he was feeling livelier he added 'Some God put a little bit of gold dust on my tail this morning'.[130]

It proved to be only a temporary reprieve. On a sunny morning, feeling slightly better, he was helped out of bed to sit by the open window when he suddenly complained of feeling faint and was put back to bed. Shortly afterwards he died peacefully in the presence of his daughter Eleanor at 11.30 a.m. on 6 May 1979. His death certificate, registered by Janet, 'widow of deceased', recorded him suffering from cardiac arrest, ischaemic heart disease and bilateral bronchopneumonia. Four days later Leach was buried in a simple elm coffin in Longstone Cemetery, Carbis Bay, after a private ceremony for family and close friends conducted by Philip Hainsworth of the National Assembly of Bahá'ís, which some of those present thought would never end. The following day a memorial service was held at St Ives parish church. Hymns included 'The King of Love My Shepherd Is' and 'Now Thank We All Our God', music by J. S. Bach played on the cello by Richard Lester and violin by Krysia Osostowicz and a Bible reading by George Wingfield Digby (Isaiah 55: 6–13). In his address Michael Cardew sensitively combined aspects of personal knowledge with a warm assessment of Leach's achievements, finishing with lines by Edmund Spenser:

Sleep after toyle, port after stormie seas.
Ease after warre, death after life doth greatly please.

The obituaries fulsomely acknowledged Leach's achievements. The *Guardian*[131] described him as 'probably the greatest potter Britain has produced' and 'a world renowned craftsman'. *The Times*[132] asserted that 'he had a greater influence on potting in England than any potter since Josiah Wedgwood', a claim that would have delighted Leach for his qualities were the opposite of the great eighteenth-century leader of the ceramic industry. The obituary went on 'Leach insisted that the natural qualities of the clay should be allowed free expression. The play of fire, the extrusion of minerals through the glaze, even the potter's thumb-marks, could be left to speak for themselves'. Less convincingly *The Times* claimed that 'so far there has been no conspicuous reaction against Leach's ideals of simplicity and "truth to material"'.[133]

In the *Spectator*[34] Michael Cardew took the opportunity to develop some of the themes he had touched on in his farewell address to paint a loving but more complex picture of Leach's achievements. While agreeing that Leach had in his time 'done more to change the lives of potters in Britain than anyone since Josiah Wedgwood', he placed this within a global movement of studio potters. When Leach set up his Pottery with Hamada in 1920, they were contributing, Cardew pointed out, to a 'quiet, benign, non-violent revolution in the potter's art, which has been gaining converts ever since'. Unlike *The Times*, which claimed that there was no adverse critical response to his work, Cardew acknowledged that 'some critics react[ed] strongly against the extreme sobriety of his potting style and have represented Leach's influence as retarding and constricting, as designed to de-bar bright students from access to the pleasures of self-expression'. Still, he concluded, 'many young potters coming newly to the art still seem more inclined to pursue the new avenues which Leach was the first to open'. It was a balanced, loving and fitting tribute to a great potter and teacher.

AFTERWORD

In his will Bernard Leach left his share of the Pottery to Janet Leach but with no instructions as to its future direction. Following Leach's death Janet almost immediately ended production of the standard ware, reasoning that it was something that Leach and David had evolved and was not what she wanted or was able to continue. From a team of around ten the number of potters at the Pottery rapidly declined and within a short time only Janet and Trevor Corser remained. They, together with occasional help from short-term workers, made individual pots. Feeling freer to experiment Janet produced loosely thrown pots fired in an anagama-type process in which form and surface were intimately combined.

Following Janet's death in 1997 Pottery Cottage returned to the Leach family, while Mary Redgrave, the friend with whom she had opened the New Craftsman shop in St Ives, inherited the Pottery, its buildings and contents. Recognizing the importance of the Leach Pottery as part of Britain's cultural heritage, the external building structure was given class B protection as a listed property. In 1999 Alan Gillam, a local hotelier, bought the Pottery and Pottery Cottage and is in the process of restoring the buildings and converting the cottage into a showroom and Leach museum. Trevor Corser continues to work at the Pottery (2002).

In the article written for the *Spectator* after Leach's death, Michael Cardew had referred to a significant change in the approach towards making ceramics, with a move towards what he called 'self-expression'. In so doing he identified the beginnings of an increasing ground swell in the West that was out of sympathy with Leach's work and ideas, though this was often levelled more at his followers rather than at Leach himself. Although still widely acknowledged as 'the father of studio pottery', Leach's work and ideas were largely seen as irrelevant by the new generation of potters. Throughout the late 1970s but more significantly in the 1980s many potters moved towards brighter colours and an increased concern with decorative and sculptural pieces and away from the quiet, subtle qualities of reduction-fired stoneware and functional work. The certainties that Leach had expressed with such confidence rapidly fell apart in the general move towards more anonymous, hard-

edged design and industrial ceramics. Equally, there was a reaction to what many saw as the 'good' or 'moral' pot in favour of a wider, more eclectic approach that was part of the iconoclastic nature of post-modernism that influenced the applied as well as the fine arts.

While the new generation of potters felt it had little in common with Leach's ideas and philosophy, the market for his work, particularly in the saleroom, boomed with one piece fetching the record sum of £4,200.[1] Such unprecedented success for studio pottery established its commercial potential and some unscrupulous potters saw this as an opportunity to tap into a buoyant market. In 1980 Vincent Mason, an inmate in Featherstone Prison, near Wolverhampton, studied Leach's pots in books and magazines and then made use of the pottery facilities to produce vases, dishes and bowls in his style.[2] All carried the SI seal indicating that the pot had been produced at St Ives, and even more importantly the vital BL seal denoting that the pot was the work of Bernard Leach, apparently authenticating the pot as genuine. These fake Leach pots were offered to leading London auction houses and were accepted without reservation as genuine by dealers eager to meet increasing demand. Only when two virtually identical pots with an unusual green glaze came up for sale were buyers suspicious and the fraud exposed. Given the poor technical and aesthetic quality of the pots it is surprising that the forgeries progressed as far as they did, with pieces passing through virtually all major London auction houses.[3] Subsequently, in an attempt to protect the market, all pots offered for auction were verified as genuine by a member of the Leach family, but it took ten years or more before prices began to recover.

In Japan, where many potters still worked in traditional ways, Leach continued to be revered, both in the respect and status he was given as a westerner who attempted to understand oriental ways and by exhibitions of his work. The Japanese admired him both as an artist working within a wide range of disciplines and also for his dedication to understanding Japanese art and culture. In Yanagi's view, Leach's influence on Japanese art was profound, and he attributed to Leach much of the energy and life of the modern movement in Japan, declaring 'those who wanted to become potters found a leader in him'.[4]

The late 1990s brought a serious re-evaluation of Leach's career in the West. Within the fine art world Leach's contribution to modernism was acknowledged in a new installation of twentieth-century art at Tate Britain, which opened in 2000. This included two of Leach's iconic works – a tall stoneware jug based on medieval forms and a large slipware dish with a lively griffin motif – shown alongside work by artists of the modern movement in Britain. In the United States a series of exhibitions looked at his work as a potter, focusing particularly on the integration of eastern and western cultures. In San Francisco 'The Quiet Eye'[5] brought together the work of Bernard

Leach and Hamada Shōji. 'The Leach Tradition' showed pots by Leach and twenty-six former apprentices of the Leach Pottery.[6] In Japan a major retrospective 'Bernard Leach: Potter and Artist', was commissioned and toured to six major museums in the country[7] before being shown in London at the Crafts Council Gallery (December 1997–March 1998). Curated by Oliver Watson, head of the ceramics department of the Victoria and Albert Museum, the large, comprehensive exhibition offered a fresh assessment of Leach's work as a potter and draughtsman as well as his key role within twentieth-century modernism. A handsome, well-illustrated and annotated catalogue traced the development of his pots, helping to re-establish him as a major figure within the visual arts. Another major exhibition, 'Content and Form: Bernard Leach', curated by Emmanuel Cooper was initiated by Penlee House Gellery and Museum, Penzance, and subsequently toured to Middlesbrough, London, Farnham and Cardiff, 2002–3. This exhibition looked at the wide range of Leach's achievements and included drawings, furniture, textiles and jewellery, as well as ceramics.

The Leach legacy lives on, not least within his own family. Although never consciously setting out to do so, Leach founded a family dynasty of potters. David Leach set up his own workshop, Lowerdown Pottery, in south Devon where, after initially making slip-decorated earthenware, he went on to produce reduction-fired tableware and individual stoneware and porcelain pieces, evolving a distinctive style, which, while based on that of his father, is recognizably his own. His three sons have all become potters. John (Johnny) Leach is known for high quality wood-fired tableware and unglazed, saggar-fired individual pieces; his brother Jeremy assists his father and also makes his own pots; and David's third son, Philip, experiments with raku as well as producing high-fired tablewares. Michael, Leach's second son, set up a pottery in north Devon, again making reduction-fired tableware and individual pieces, and his son Philip runs a pottery with his wife, Fran, making red earthenware, also in north Devon.

For potters, collectors and admirers it is the integrity of Leach's approach and his search for vitality – a major driving force in his life and work – that makes his work of enduring interest.

NOTES

Material has come from many sources, including extensive Leach family archives; these are indicated by the initials FA. The majority of the papers, which include books, letters, drafts of manuscripts, diaries and photographs, are in the Leach Archive, Craft Study Centre, Surrey University College of Art and Design, Farnham, marked LA, and are followed by their Leach catalogue number. Dartington archives are DA. Rie archive material, much of which is now in the Crafts Study Centre, is indicated as RA. Papers in the collection of the Cardew family are marked CA. Papers in private collections are marked PC.

INTRODUCTION

1 Bernard Leach, letter, *Bernard Leach: Essays in Appreciation*, edited and collected by Terry Barrow, The New Zealand Potter, Wellington, New Zealand, 1960.

2 The sixth Kenzan made figurines, food dishes, decorative objects in what was known as the Rimpa style based on that of the first Kenzan.

3 Bernard Leach, *A Potter's Book*. Faber & Faber, London, 1940, p. 1.

4 Bernard Leach, *A Potter in Japan, 1952–1954*. Faber & Faber, London, 1960, p. 161. 'Backwards we cannot go' wrote Leach, 'a greater consciousness is our birthright; our difficult task is consequently one of deepening consciousness towards a new wholeness.'

5 This useful phrase is used by Tanya Harrod in her book *The Crafts in the Twentieth Century*. Yale University Press, New Haven and London, 2000. In a wide-ranging discussion about the relationship of crafts to modernism (pp. 10–11) Harrod identifies how the wider reading of modernism since the 1980s has embraced hand-work, work by women and theatre design in Paris in 1910.

6 Other artists who had worked with clay included Maurice Vlaminck and André Derain, the latter having such pieces shown in the 1910 Post-Impressionist exhibition organized by Roger Fry at the Grafton Galleries in London.

7 The Sung dynasty (960–1279), characterized as peaceful and restrained, produced some of the most beautiful ceramics ever made. Encouraged by court patronage, potters developed new skills and processes for both stoneware and porcelain.

8 One of the first major exhibitions of early work was 'Early Chinese Pottery and Porcelain' at the Burlington Fine Arts Club in 1910. Collectors such as George Eumorfopoulos were acquiring

early wares revealed by the construction of railways in China at the turn of the century.

9 From an article Murray wrote entitled 'Pottery and the Essentials of Art' and quoted in Malcolm Hasland, *William Staite Murray*. Crafts Council/Cleveland County Museum Service, London, 1984, p. 71.

10 Bernard Rackham and Herbert Read, *English Pottery: Its development from early times to the end of the eighteenth century*. Ernest Benn, London, 1924, p. 4.

11 Sir Francis Rundall, 'Bernard Leach Mitsukoshi Retrospective Exhibition', November 1966. LA1479.

12 Thomas Toft was one of a group of potters working in Staffordshire around 1670–1730 producing dishes with trailed slip decoration, often with a trellis border bearing the name of the maker or recipient.

13 See for example Oliver Watson, *Bernard Leach: Potter and Artist 1887–1979*. Crafts Council, London, 1997.

14 Edmund de Waal, *Bernard Leach*. Tate Gallery Publications, London, 1999.

15 This was a concept often considered by Leach; see for example the chapter 'Stepping-Stones of Belief' in *Beyond East and West*, p. 305.

CHAPTER ONE

1 Bernard Leach document, 9 March 1969. LA11266.

2 *Ibid*. A new airport has now superseded Kai Tak Airport.

3 Conducted between Britain and China, 1839–42, following the Chinese government's attempt to stop importation of opium from India. China was compelled to cede Hong Kong and open five ports to foreign trade.

4 Bernard Leach discovered that one of the earliest references to his 'Leach pedigree' was in 1737 when the family lived in Bedford.

5 1760–1834.

6 Bernard Leach document, 9 March 1969. LA11266.

7 Ibid.

8 1757–1827. English artist, philosopher and poet, and a great influence on Leach.

9 William Blake, 'The Marriage of Heaven and Hell, The Voice of the Devil'.

10 Bernard Leach, An English Artist in Japan. Privately printed, Japan 1920, p. 41.

11 Ibid., pp. 41–2.

12 Established as a 'Free Grammar School for the education institution and instruction of boys and youths in grammar at all times, for ever, to endure'.

13 Entered in 1872. See the entry in V. Sillery (ed.), St John's College Biographical Register 1775–1875. Oxford, 1987. The entry gives an incorrect date of birth.

14 Nellie Leach letter to her parents, 22 March 1885. LA328.

15 An Anglo-Indian term usually referring to lunch.

16 According to Bernard Leach the will was such that it was in the hands of the solicitors for over five years after his uncle's death. About £50,000 went in legal fees after two daughters of his eldest brother Edmund Fletcher Sharp, Ellen Bentham and Harriet Wells, disputed it. They lost but the estate paid all costs.

17 The hospital eventually opened in 1904 and was later merged with the War Memorial Hospital.

18 A society for the promotion of cremation, with Sir Harry Thompson as president, was set up in 1874 in England, and the first crematorium opened in Woking, Surrey in 1885.

19 A full account is given in the Hong Kong Daily Press, 24 August 1893.

20 A round-the-world scientific cruise, 1872–6, investigating life in the Atlantic, Pacific and Antarctic oceans. Recording the research took fifteen years.

21 Death certificate. The child, who died on 6 December 1854, had been named Marion Edith.

22 Dr Hartigan was notable for putting forward more liberal provision for European employees of the bank, suggesting that summer accommodation should be provided for them on the Peak, so taking them out of the oppressive heat of the town.

23 Elizabeth Massey Sharp diary. FA.

24 Ibid.

25 Ibid.

26 Annette remains something of a mystery, but she may have been a distant relative.

27 Elizabeth Massey Sharp diary. FA.

28 These included Episcopalians, Presbyterians, Baptists, Methodists, Reformed, Lutherans, Church of England, Russian Orthodox, Quakers, Unitarians, and Universalists, which must have been confusing for the Japanese. See George N. Curzon, Problems of the Far East, Japan, Korea, China. Longmans, Green & Co., London 1894, p. 58.

29 Elizabeth Massey Sharp diary. FA.

30 Ibid.

31 Quoted in Tomoko Sato and Toshio Watanabe, Japan and Britain: An Aesthetic Dialogue 1850–1930. Lund Humphries, London, in association with the Barbican Art Gallery, London and the Setagaya Art Museum, Japan, 1991, p. 58.

32 Ibid.

33 Joseph Hardy Neesima (1843–90) was born into a samurai family and travelled to America to escape the feudal system in Japan. He came to believe that the best way to establish the new Japan was to train Japanese youth in the 'furnace' of a Christian college.

34 A letter from Hamilton Sharp to Neesima Joe outlining this transaction, 1 February 1888, is in the archives of Doshisha University, Japan.

35 Elizabeth Massey Sharp diary. FA.

36 Sir Edward Arnold (1832–1904), poet, wrote among other works The Light of Asia on the life and teachings of Buddha and other poems coloured by his experience of the East. Arnold travelled widely in the East, married a Japanese woman and lived for more than a year in Japan.

37 The marriage records were destroyed in the Second World War, and the exact date of the marriage is not known, but was probably in 1891.

38 1862–1955.

39 Bernard Leach, Beyond East and West. Faber & Faber, London, 1978, p. 38.

40 Bernard Leach document. FA.

41 'Official Guide to Japan', quoted in Bernard Rudofsky, The Kimono Mind. Charles E. Tuttle & Co., Tokyo, 1971, p. 103.

42 Bernard Leach recollection, no date. FA.

43 Bernard Leach letter to Dr Shikiba Ryūzaburō, 7 August 1933. LA12013.

44 Bernard Leach memories of his father, 1955. FA.

45 Ibid.

46 A memoir by Roland St John Braddell. FA.

47 Bernard Leach memories of his father, 1955. FA.

48 Ibid.

49 Bernard Leach, Bernard Leach: A Potter's Work. Evelyn, Adams & Mackay, London, 1967, p. 31.

50 Bernard Leach, The Potter's Challenge, edited by David Outerbridge. Souvenir Press, London, 1976; first published by E. P. Dutton, New York, 1975, p. 35.

51 The school still exists in the original building.

52 Beyond East and West, p. 30.

53 It was the custom to appoint a rector for only three or four years.

54 Bernard Leach in conversation with Peggy Archer, Craft Potters Association archives, Aberystwyth, tape no. 18, cat. no. VA042, no date.

55 Written in 1966. LA11369.

56 Joyce's book Portrait of the Artist as a Young Man, first published in 1916, is a semi-autobiographical account, which describes his school days.

57 At the time the King of Spain, Alfonso XIII (1885–1941), had seven old Beaumont boys in his government. King Alfonso was grandfather to the present Spanish King, Juan Carlos I.

58 Letter dated 26 July 1902. FA.

59 Prefects' Journal, Beaumont, 25 October 1902. Jesuit Archives, Mount Street, London.

60 *Beaumont Review*, March 1902, p. 250. Jesuit Archives, Mount Street, London.

61 Son of the poet Coventry Patmore.

62 This was debated in 1901.

63 *Beaumont Review*, October 1902, pp. 398–9. Jesuit Archives, Mount Street, London.

64 'Beaumont Debating Society', *Beaumont Review*, December 1902, pp. 37–40. Jesuit Archives, Mount Street, London.

65 *Beyond East and West*, p. 27.

66 William Blake argued that 'Nature has no Outline, but imagination has'. M. Butlin, *A Catalogue of the Works of William Blake*. Tate Gallery, London, 1957, p. 769.

67 'Modern Side Academy', *Beaumont Review*, July 1903. Jesuit Archives, Mount Street, London.

68 According to David Leach, Bernard Leach developed a 'soft spot' for Hilda, but she went on to marry a schoolteacher.

69 Andrew Leach letter to Bernard Leach, Parker's Hotel, Naples, 9 March 1903. FA.

70 Andrew Leach letter to Bernard Leach, Penang, 26 July 1902. FA.

71 Andrew Leach letter to Bernard Leach, 26 April [no year] probably 1902. LA329.

72 The first volume of *Modern Painters* was published in 1843, the second in 1846, the third and fourth 1856, and the final volume in 1860.

73 Bernard Leach. Craft Potters Association Archive, Aberystwyth, tape no. 19, cat. no. VA 036, no date [c.1960].

74 Bernard Leach lecture, Craft Potters Association archives, Aberystwyth, tape no. 19, cat. no. VA036, no date [c.1960].

75 Andrew Leach letter to Bernard Leach, Penang, 22 August 1902. FA.

76 Andew Leach letter to Bernard Leach, Penang, 4 November 1902. FA.

77 Andrew Leach letter to Bernard Leach, Penang, 16 July 1902. FA.

78 Like his father, Bernard Leach was a heavy smoker until forced to give it up in his eighties after a severe illness.

79 Andrew Leach letter to Bernard Leach, Penang, 26 July 1902. FA.

80 Andrew Leach, letter to Bernard Leach, 4 December 1902. FA.

81 Andrew Leach letter to Bernard Leach, Parkers Hotel, Naples, 24 February 1903. FA.

82 *Beyond East and West*, p. 23.

CHAPTER TWO

1 This tended to be virtually instant selection or rejection, with Tonks nodding yes or no.

2 At the Slade John was regarded as the most brilliant student of his day.

3 Bernard Leach, draft document, 1915. LA11163.

4 Francesco Squarcione (1394–c.1468), tailor, painter, and probably art dealer, active in Padua in the middle of the fifteenth century, who traditionally has been seen as a centre of new interest in ancient art, and as in some way, the founder of the Padua School or the Paduan style. Leach's mention of Venice was probably a slip for Padua.

5 Bernard Leach, draft document, 1915. LA11163.

6 Joseph Hone, *The Life of Henry Tonks*. William Heinemann Ltd, London 1939, p. 77.

7 *Ibid.*, p. 41.

8 The Slade was one of the few established schools that accepted women students.

9 Bernard Leach, *Beyond East and West*. Faber & Faber, London, 1978, p. 27.

10 Bernard Leach letter to Dr Shikiba Ryūzaburō, 7 August 1933. LA12013.

11 Joseph Hone, *The Life of Henry Tonks*, William Heinemann Ltd, London, 1939, p. 44.

12 Bernard Leach, ' The Contemporary Studio-Potter', *Journal of the Royal Society of Arts*, 21 May 1948, pp. 356–72.

13 *Beyond East and West*, p. 28.

14 Bernard Leach notes. LA11381.

15 Reginald Ernest George Turvey (1882–1968), painter, born in Ladybrand, South Africa.

16 *Beyond East and West*, p. 27.

17 Bernard Leach, draft of eulogy of Turvey, 1966. LA11369.

18 Gordon Leith (1885–1965) worked on the War Graves Commission before returning permanently to South Africa in 1920.

19 He was probably referring to Lord's Cricket Ground, St John's Wood.

20 Reginald Brundrit (1883–1960) went on to the become an Associate of the Royal Academy, and subsequently a Royal Academician.

21 *Beyond East and West*, p. 28.

22 Inscribed on the back 'From Hampstead Heath while at the Slade' (9.7 × 13.1 cm), Collection of Hitomi Museum, Japan.

23 These lines were not electrified until the 1920s.

24 Cat's meat referred to meat sold for cats, but Frank Brangwyn recalled hearing this cry and discovered that choice cuts of cat's meat were sold to fashionable ladies who used to go to bed with such slices of meat on their faces. Quoted in William de Belleroche, *Brangwyn's Pilgrimage: The Life Story of an Artist*. Chapman and Hall, London, 1948, p. 27.

25 Scottish-born doctor (1844–1922), practised medicine in the East, became medical advisor to the Colonial Office and helped found the London School of Tropical Medicine.

26 *Beyond East and West*, p. 28.

27 Bernard Leach, draft of eulogy of Turvey. LA11369.

28 Brundrit eventually settled in Skipton, and with a break during the First World War, when he

served on the Italian Front, lived all his life in Yorkshire.

29 Carol Hogben, *The Art of Bernard Leach*. Faber & Faber, London, 1978, p. 190.

30 Quoted Tomoko Sato and Toshio Watanabe, *Japan and Britain: An Aesthetic Dialogue 1850–1930*. Lund Humphries, London, in association with the Barbican Art Gallery, London and the Setagaya Art Museum, Japan, 1991, p. 47.

31 Bernard Leach, quoted in Lowell Johnson, *Reginald Turvey: Life and Art*. George Ronald, Oxford, 1986, p. 2.

32 Now part of Dorset.

33 Bernard Leach, notes for *Beyond East and West*, 1972–8. LA805.

34 Grave number ZZ49.

35 His death certificate gives as cause of death 'Carcinoma of the liver and Asthenia cardiac syncope', the certificate signed by Ralph J. MacDermot MB.

36 Bernard Leach letter to Dr Shikiba Ryūzaburō, 7 August 1933. LA12013.

37 In 1904 the college gained independent status to become part of Manchester University.

38 *Beyond East and West*, p. 30.

39 *Ibid.*

40 Bernard Leach letter to Dr Shikiba Ryūzaburō, 7 August 1933. LA12013.

41 *Ibid.*

42 For a full account see Keith Clements, *Henry Lamb: The Artist and his Friends*. Redcliff Press, Bristol, 1985.

43 *Beyond East and West*, p. 30.

44 See, for example, P. G. Wodehouse, *Psmith in the City*. A. & C. Black, London, 1923.

45 P. G. Wodehouse, 'My Banking Career', *Hong Kong Bank Group Magazine*, summer 1975, pp. 12–16 (HSBC Group Archives, PU1. 6).

46 Bernard Leach letter to Dr Shikiba Ryūzaburō, 7 August 1933. LA12013.

47 For a time at 39 Bramerton Road, Chelsea.

48 James Abbott McNeill Whistler (1843–1903), had lived in Cheyne Walk.

49 *Beyond East and West*, p. 31.

50 For a full account see Michael Holroyd, *Augustus John: The New Biography*. Chatto & Windus, London, 1996.

51 Bernard Leach, draft of 'sketch' of Augustus John. LA11163.

52 Quoted in Michael Holroyd, *Augustus John*, p. 102.

53 The distance from London to Bournemouth is about 105 miles.

54 Omar Khayyám, fourth edition, xiviii, translation Edward Fitzgerald.

55 From Robert Browning's *Abt Vogler*, section ii, line 6, the long poem written in honour of Abt Vogler, credited with inventing the violin, first published 1864.

56 Written in 1966. LA11369.

57 Bernard Leach letter to Dr Shikiba Ryūzaburō, 7 August 1933. LA12013.

58 Dated 6 April 1906.

59 Bernard Leach, *An English Artist in Japan*. Privately printed, Japan, 1920. FA.

60 *Beyond East and West*, p. 32.

61 Bernard Leach letter to Dr Shikiba Ryūzaburō, 7 August 1933. LA12013.

62 Bernard Leach notes for *Beyond East and West*. LA805.

63 *Beyond East and West*, p. 33.

64 *Ibid.*

65 Although resembling a tin mine, this must have mined lead or zinc, as tin was found only in Cornwall.

66 This was later given to his grandson Philip Leach as a wedding present.

67 Other family trees were also lost. In a letter to Robin Fletcher (23 September 1970), Bernard Leach says 'I did inherit Sharp family trees going far back, but these were destroyed, or thrown away, by a strange forgetfulness on my first wife's part.'

68 The area has now been built on to form the Northmore Estate. A surviving oil painting of a farm building may be Northmore Farm.

69 *Beyond East and West*, p. 34.

70 Bernard Leach, tape recording [c. 1971]. FA.

71 Bernard Leach diary, 1908. LA10874.

72 No exact date is recorded, but it was probably January 1908.

73 For a lively account of the life and work of Sir Frank Brangwyn see Rodney Brangwyn, *Brangwyn*. William Kimber, London, 1978.

74 Prospectus of the London School of Art for Men and Women, 1908–9. LA10218.

75 Born in Bruges, Belgium.

76 Founded by William Anderson and other Japanophiles to hold meetings and issue publications for those who had diplomatic, commercial or cultural ties with Japan.

77 For a fuller discussion see Ellen P. Conant, 'Bernard Leach, Frank Brangwyn, and Japan', *Studio Potter*, June 1999, vol. 27, no. 2, pp. 15–20.

78 She had been trained as a nurse in a north London hospital.

79 Tomoko Sato and Toshio Watanabe, *Japan and Britain*.

80 Quoted Tomoko Sato and Toshio Watanabe, *Japan and Britain*, p. 47.

81 Correspondence from John Adams in South Africa, 1916–20. LA2297–2313.

82 See Lowell Johnson, *Reginald Turvey: Art and Life*. George Ronald, Oxford, 1986, p. 64.

83 *Ibid.*

84 *Beyond East and West*, p. 36.

85 Etching is a method of engraving in which a design is scratched through a wax-like layer on a metal plate and bitten into with acid; the lines are then filled with ink and printed on paper by putting it through a press.

86 A copy is in the National Museum of Wales, Cardiff, accession number 24.121, registration number 1623.
87 A copy is in the National Museum of Wales, Cardiff, accession number 24.121, registration number 1624.
88 Takamura Kōtarō (1883–1956), Japanese sculptor, poet and critic.
89 Bernard Leach, 1 July 1974. LA5569.
90 Now Tokyo School of Fine Arts and Music.
91 Takamura Kōtarō, 'Twenty-Six Years Ago'. LA1575.
92 *Ibid.*
93 *Ibid.*
94 Hamilton Sharp was not well and died a year later in London on 19 September 1908, aged 79.
95 1907.
96 1894.
97 Bernard Leach letter to Dr Shikiba Ryūzaburō, 7 August 1933. LA12013.
98 Lafcadio Hearn, *Japan, An Attempt at Interpretation*, quoted in Bernard Rudofsky, *The Kimono Mind*. Charles E. Tuttle & Co., Tokyo, 1971, p. 151.
99 *Beyond East and West*, p. 36.
100 Bernard Leach letter to Dr Shikiba Ryūzaburō, 7 August 1933. LA12013.
101 See Frances Spalding, *Vanessa Bell*. Weidenfeld & Nicolson, London, 1983, p. 56.
102 Quoted by James Beechey in 'The Friday Club', Michael Parkin Gallery, London, 1996.
103 *Ibid.*
104 Bernard Leach letter to Dr Shikiba Ryūzaburō, 7 August 1933. LA12013.
105 LA108704.
106 Arriving, according to his diary, on 22 March. LA108704.
107 *Beyond East and West*, p. 35.
108 Probably by the thirteenth-century Italian sculptor Arnolfo di Cambi. St Peter is shown holding the keys of heaven.
109 The composer Berlioz had similar feelings when in 1831 he watched a peasant kiss the big toe of St Peter writing 'You believe, you have hope . . . What will you be looking for when you go out of here? A patch of shade to sleep in. The wayside shrines are yours, you will find it there. What are your dreams of wealth? The handful of piastres necessary to buy a donkey or get married; three years savings will achieve it. What is a wife for you? Someone of a different sex. What do you look for in art? A means of giving tangible form to the objects of your worship, making you laugh or providing something to dance to.' Quoted in David Cairns, *Berlioz: Volume One: The Making of An Artist 1803–1832*. Cardinal, Sphere Books, London, 1989, p. 434.
110 *Beyond East and West*, p. 35.
111 Staying at 21 rue Valette, Pantheon.
112 November 1910.
113 *Beyond East and West*, pp. 34–5.
114 *Ibid.*, p. 35
115 *Ibid.*, p. 36.
116 Bernard Leach, *A Review 1909–1914*. Privately printed, Tokyo, 1914, p. 2.

CHAPTER THREE

1 Takamura letter to Bernard Leach, 11 February 1909. LA11571.
2 *Ibid.*
3 *Ibid.*
4 36 Bedford Place, London, WC1. As a student at the Slade, Leach had become friendly with Mr Kimber, maintaining contact for many years. Mr Kimber's daughter became a schoolteacher, and when the school was evacuated to St Ives in the Second World War she often visited the Leach Pottery.
5 The etching process had in fact been introduced into Japan in the late nineteenth century along with other European printing techniques.
6 Sir Rutherford Alcock, *Capital of the Tycoon*. Longman, London, 1892, p. 10.
7 Lafcadio Hearn, *Glimpses of Unfamiliar Japan*. Charles E. Tuttle & Co., Tokyo, 1976, p. 8.
8 Monsignor Count Vay de Vaya and Luskod 'How to see Tokio', 1902, in Michael Wise, *Travellers' Tales of Old Japan*. Times Books International, Singapore, 1985, pp. 187–8.
9 Quoted in Bernard Leach, *The Unknown Craftsman: A Japanese Insight into Beauty: Yanagi Sōetsu*. Kodansha International, Tokyo and Palo Alto, 1972, p. 92.
10 Bernard Leach letter to Dr Shikiba Ryūzaburō, 7 August 1933. LA12013.
11 *Ibid.*
12 Sir Edward J. Reed, *Japan: Its History, Traditions and Religions*, vol. II. John Murray, London, 1880.
13 Quoted from the official 'Narrative of the Expedition' in Bernard Rudofsky, *The Kimono Mind*. Charles E. Tuttle & Co., Tokyo, 1971, p. 16.
14 Bernard Leach, *Beyond East and West*. Faber & Faber, London, 1978, pp. 39–40.
15 Sir Edward Reed, *Japan, Its History, Traditions, and Religions*, vol. II, pp. 281–2.
16 *Beyond East and West*, p. 40.
17 *Ibid.*
18 Takamura Kōun (1852–1934), distinguished Japanese sculptor in wood.
19 'Narrative of the Expedition of an American Squadron to the China Sea and Japan, under the Command of Commodore M. C. Perry', 1852, quoted in Bernard Rudofsky, *The Kimono Mind*, p. 157.
20 In *Shumi* (Taste), Bohusha, June 1909. LA906.
21 Two new movements were emerging, *Shin-Hanga* and *Sosaku Hanga*. Printmaking only became part of the syllabus of the school in 1935.
22 The great potter Ogata Kenzan lived here in 1731, as, much to his satisfaction, Leach was to discover later.

23 *Beyond East and West*, p. 42.

24 'Narrative of the Expedition of an American Squadron to the China Sea and Japan, under the Command of Commodore M. C. Perry', 1852, quoted in Bernard Rudofsky, *The Kimono Mind*, p. 158.

25 Sumié Seo Mishima, *The Broader Way*, 1953, quoted in Bernard Rudofsky, *The Kimono Mind*, p. 170.

26 The address was 40 Sakuragi-cho, Ueno, Tokyo.

27 For a useful introduction to western art in Japan see Shuji Takashina 'East Meets West: Western-Style Painting in Modern Japanese Art', Tomoko Sato and Toshio Watanabe (eds) *Japan and Britain: An Aesthetic Dialogue 1850–1930* Lund Humphries, London in association with Barbican Art Gallery, London and the Setagaya Art Museum, Japan, 1991, pp. 67–76.

28 13 November 1909.

29 Bernard Leach diary, 1911–12. LA10875.

30 *Beyond East and West*, p. 50.

31 Leach often spelt Japanese names differently. O Mya San was one such that occurred in various forms. Leach's spellings have been retained. In Japanese San is an honorific roughly the equivalent to Miss or Mrs (or today possibly Ms). O Mya San could more properly be written as Omiya-san.

32 Pierre Loti, 'Japoneries d'automme', quoted in Ian Littlewood, *The Idea of Japan: Western Images, Western Myths*. Secker & Warburg, London, 1996, p. 93.

33 Bernard Leach diary, 1908. LA10874.

34 Bernard Leach diary, 1911. LA10875.

35 *Ibid.*

36 *Ibid.*

37 *Ibid.*

38 Bernard Leach, memoir, post 1972. LA11295.

39 *Ibid.*

40 Henry Hawley Crippen (1861–1910) murdered his wife and the variety artist Belle Elmore. He was arrested on board ship with his mistress Ethel le Neve trying to escape to the USA, following a radio signal, the first criminal to be so captured. Executed at Pentonville Prison, London.

41 A progressive group of artists formed in 1886, as rival to the Royal Academy, to promote naturalistic painting under the strong influence of contemporary French painting.

42 Lowell Johnson, *Reginald Turvey: Art and Life*. George Ronald, Oxford, 1986, p. 18.

43 Turvey's letters to Bernard Leach are included in *ibid.*

44 *Beyond East and West*, p. 50.

45 Tomimoto Kenkichi (1886–1963) Japanese architect and potter.

46 This was the predecessor of today's Tokyo National University of Fine Arts and Music.

47 No exact record has come to light of Tomimoto's study programme.

48 The property built 1859–60 by William Morris, in conjunction with Philip Webb, embodied many of the early ideas of the Arts and Crafts movement.

49 Lowell Johnson, *Reginald Turvey*, p. 23.

50 *Ibid.*

51 This involved two teams sitting opposite at a table; one has a sixpenny piece and the intention was to spot the member with the coin. The team without the coin could call out various instructions including 'Up Jenkins' when the other team had to hold up their hands, and 'down with the creep' when they had to bang their hands on the table, or 'down with a camel' in the hope that the coin would be dislodged.

52 Not listed by the British Film Institute [2001].

53 *Beyond East and West*, p. 47.

54 Leach used various spellings for this name. Chan is a Japanese honorific roughly equivalent to master.

55 Bernard Leach diary, 1911. LA10875.

56 This was probably Kenzan.

57 See Ellen P. Conant, 'Leach, Hamada, Yanagi: Myth and Reality', *Studio Potter*, vol. 21, no.1, December 1992.

58 Satomi Ton (1888–1983), founding member of Shirakaba, youngest brother of Arishima Takeo, one of the most respected novelists of modern Japan and Arishima Ikuma, a highly regarded Western-style painter who had studied in Europe.

59 Kojima Kikuo (1887–1950), became a well known historian, noted for his writing on Leonardo da Vinci.

60 Bernard Leach memoir, post 1972. LA11295.

61 Kishida Ryūsei (1891–1929), painter influenced by Impressionism and Post-Impressionism.

62 Bernard Leach, Craft Potters Association archives, Aberystwyth, tape no. 19, catalogue no. VA066, transcript, no date [c. 1966].

63 *Ibid.*

64 Yanagi Muneyoshi (1889–1961), later known as Yanagi Sōetsu, critic and writer, founding figure of the Japan Folkcraft Movement.

65 Daisetz Teitaro Suzuki (1870–1966), leading world authority on Zen Buddhism.

66 Bernard Leach memoir, n. d., post 1972. LA11295.

67 Paul Signac.

68 Bernard Leach diary, 1911–12. LA10875.

69 *Beyond East and West*, p. 75.

70 6th–4th century BC Chinese philosopher generally regarded as the founder of Taoism.

71 Latinized name of the Chinese sage K'ung Fu-tzu, (c. 550–478 BC) whose name is given to Confucianism.

72 Chinese philosopher and essayist (c. 330–c. 275 BC), and leading thinker of the Taoist school.

73 Bernard Leach, *The Unknown Craftsman: A Japanese Insight into Beauty*. Kodansha International, Tokyo and Palo Alto, 1972, p. 91.

74 Bernard Leach, *The Unknown Craftsman: A Japanese Insight into Beauty*. Kodansha International, Tokyo and New York, revised edition 1989, p. 88.

75 See Kikuchi Yūko, 'Yanagi Sōetsu and Korean Crafts Within the *Mingei* Movement', *Papers of the British Association for Korean Studies*, vol. 5, 1994, pp. 23–38.

76 Tea masters who led the tea ceremony were traditionally seen as arbiters of taste and refinement.

77 *Beyond East and West*, p. 62.

78 Bernard Leach diary, 1911–12. LA10875.

79 Bernard Leach, Craft Potters Association archive, Aberystwyth, tape no. 19, cat. no. VA036, transcript p. 3. no date [c. 1966].

80 Autumn 1913.

81 *Beyond East and West*, p. 77.

82 See Kikuchi Yūko, 'The Myth of Yanagi's Originality: The Formation of *Mingei* Theory in its Social and Historical Setting', *Journal of Design History*, vol. 7, no. 4, 1994, pp. 247–66.

83 Between 1910 and 1917 the Shirakaba organized eight exhibitions showing new and progressive work.

84 *Shirakaba*, published monthly between 1910 and 1923, had no acknowledged publisher, editor, or fixed date of publication or price. Its main aim was to introduce western ideas and fine art.

85 Exceptions are no. 10–7, 1919 on 'Japanese Art'; no. 11–2, 1920 on 'Korean Buddhist Art'; no. 11–7, 1920 on 'Japanese Buddhist Art'; no. 13–9, 1922 on 'Korean Pottery'; no. 14–7, 1923 on 'Chinese art'.

85 November 1911.

87 Interestingly, the design is reminiscent of one of the images illustrating stages of Zen discipline on the road to enlightenment. Many variations were made, but in the *Ten Oxherding Pictures*, no. 6, 'Unimpeded', shows the boy-beast contentedly idling his time away, while the boy sits leisurely under a pine tree. These are illustrated in D. T. Suzuki, *Manual of Zen Buddhism*. Rider & Co., London, 1974, pp. 128–9.

88 Takamura Kōtarō letter to Bernard Leach, 18 October 1910. LA11573.

89 Bernard Leach diary, 1911–12. LA10875.

90 Bernard Leach diary, September 1910. LA10875.

91 Bernard Leach diary, 1911–12. LA10875.

92 *Kagaku to Jinsei* (Science and Life), published in 1911, included a study of Cesare Lombrosso's *After Death —What?* and Sir Oliver Lodge's *The Survival of Man*.

93 Bernard Leach diary, 1911–12. LA10875.

94 *Ibid.*

95 *Ibid.*

CHAPTER FOUR

1 On 15 February 1911.

2 Bernard Leach, *Beyond East and West*. Faber & Faber, London, 1798, p. 63.

3 Bernard Leach diary, 1911–12. LA10875.

4 *Ibid.*

5 *Ibid.*

6 *Ibid.*

7 *Ibid.*

8 *Ibid.*

9 *Ibid.*

10 *Beyond East and West*, p. 64.

11 *Ibid.*

12 Bernard Leach diary, 1911–12. LA10875.

13 *Ibid.*

14 This poem ends on Keats's immortal lines '"Beauty is truth, truth beauty" – that is all/Ye know on earth, and all ye need to know', a sentiment that came to be a major concern in Leach's life.

15 Bernard Leach diary, 1911–12. LA10875.

16 *Ibid.*

17 The sculpture, in the form of a sphinx, was for Wilde's memorial at Père Lachaise cemetery, Paris.

18 Bernard Leach letter to William Hoyle, 11 January 1913. National Museum of Wales, Cardiff.

19 22 June 1911.

20 Leach and Morita visited the gallery on 18 February 1911. *Beyond East and West*, p. 55.

21 Recent theories suggest that raku may have been brought to Japan by Korean potters.

22 Bernard Leach diary, 1911–12. LA10875.

23 Bernard Leach, interviewed by Peggy Archer for a radio broadcast, no date. Craft Potters Association archives, University of Wales, Aberystwyth, tape no. 18, cat. no. VA042.

24 *Beyond East and West*, p. 55.

25 Bernard Leach, interviewed by Peggy Archer for a radio broadcast, no date. Craft Potters Association archives, University of Wales, Aberystwyth, tape no. 18, cat. no. VA042.

26 *Ibid.*

27 Bernard Leach diary, 1911–12. LA10875.

28 Quoted in Elisabeth Cameron, *Encyclopaedia of Pottery and Porcelain: The Nineteenth and Twentieth Centuries*. Faber & Faber, London, 1986, p. 271.

29 Bernard Leach, 'Notes on the Making of Raku', 1923. LA55.

30 *Beyond East and West*, p. 56.

31 *Ibid.*

32 Bernard Leach diary, 1911–12. LA10875.

33 1851–1923.

34 Masako Shimizu 'Japan and St Ives: Friendship between East and West', in *St. Ives*, exhibition catalogue, Setagaya Art Museum, the Japan Association of Art Museums, the Yomiuri Shimbun, Japan 1989, p. 114.

35 Miura Ken'ya had led a fascinating life as an engineer and potter, helping to construct the first Japanese steam-engined iron ship, and when doubting critics questioned its viability, he convinced them by floating a metal saucepan.

36 1662–1743.

37 Bernard Leach, *Kenzan and his Tradition*. Faber & Faber, London, 1966, p. 160.

38 For a full account of the genealogy of Kenzan, see Richard L. Wilson, *The Art of Ogata Kenzan: Persona and Production in Japanese Ceramics*. Weatherhill, New York and Tokyo, 1991.

39 Quoted in, *St. Ives*, exhibition catalogue, p. 150.

40 *Kenzan and his Tradition*, 1966. p. 160.

41 A style of painting and design in which the major elements were simplification, selective formal exaggeration, serial repetition of elements and explicit interest in materials. For a full description of Rimpa with regard to ceramics, see Richard L. Wilson, *The Art of Ogata Kenzan*.

42 Bernard Leach, radio script, 11 April 1947. LA533.

43 *Ibid.*

44 *Ibid.*

45 *Beyond East and West*, p. 57.

46 *Kenzan and his Tradition*, p. 160.

47 Quoted in *St. Ives*, exhibition catalogue, p. 150.

48 In the collection of the Victoria and Albert Museum, London.

49 Bernard Leach, interviewed by Peggy Archer for a radio broadcast, no date. Craft Potters Association archives, University of Wales, Aberystwyth, tape no. 18, cat. no. VA042.

50 Charles J. Lomax, *Quaint Old English Pottery*. Sherratt & Hughes, London, 1909.

51 *The Far East*, 20 December 1913, pp. 491–6. An English language weekly based in Tokyo.

52 Bernard Leach letter to William Hoyle, 11 January 1913. National Museum of Wales, Cardiff.

53 *Beyond East and West*, p. 57.

54 This pot was later given to Leach who presented it to the Victoria and Albert Museum, London.

55 The bowl is illustrated in *Kenzan and his Tradition*, plate 94.

56 When Leach's pottery at Abiko burnt down the Densho was destroyed, but Kenzan replaced it with another, now in the Leach Archives, Craft Study Collection.

57 Bernard Leach diary, 1913. LA10876.

58 *Ibid.*

59 *Ibid.*

60 Bernard Leach diary, 1911–12. LA10875.

61 At Sankaido Reianzaka Shita, a gallery 'just below American Embassy', 16–25 February 1912.

62 Tomimoto Kenkichi, *Zuan Jimusho*, 1914.

63 Bernard Leach diary, 1911–12. LA10875.

64 *Ibid.*

65 *Ibid.*

66 See Tomimoto Kenkichi, 'Takushoku Hakurankai no Ichiaichi' (One day in the Takushoku Colonial Exhibition) in *Bijutsu Shinpō* (Art News), 12–2, 1912. See also *Kikūchi Yuko Journal of Design History*, no. 7–4, 1994, p. 262.

67 *Beyond East and West*, p. 54.

68 April 1911. The Gorakuden was built in Kyōbashi, Tokyo, c. 1911, by Gorakukai, a society for art school teachers. Illustrations of Gorakuden, the exhibition site, Leach's curtains and Tomimoto's chairs are in *Bijutsu Shinpō*, 10–7, 1911, pp. 207–17.

69 *Beyond East and West*, p. 63.

70 Edward Carpenter (1844–1929), poet and social reformer, dealing with 'spiritual democracy', and the march of humanity towards 'freedom and joy', much admired by Leach. Carpenter also withdrew from city life to set up a smallholding in the country.

71 Bernard Leach diary, 1911–12. LA10875.

72 *Ibid.*

73 It opened on 16 April 1911.

74 *Beyond East and West*, p. 64.

75 This was the most prestigious government sponsored art exhibition, it began in 1907 following the model of the French salon.

76 Letter, *The Japan Advertiser*, 17 October 1912. LA972.

77 Kouroda (1866–1924) had studied in Paris with the *plein-air* artist Raphael Collin, and was gaining recognition as an accomplished western-style painter who introduced Impressionism to Japan. His stepfather was a prominent official and briefly prime minister. In 1896 he was appointed professor of western-style painting at Tokyo Art School.

78 Bernard Leach diary, 1913. LA10876.

79 Bernard Leach diary, 1911–12. LA10875.

80 See Kikuchi Yūko, 'The Myth of Yanagi's Originality: The Formation of *Mingei* Theory in its Social and Historical Context', *Journal of Design History*, vol. 7, no. 4. pp. 247–66.

81 'Shitsunai Sōshoku Mangen' (Rambling Talk on Interior Design) *Bijutsu Shinpō* (Art News), vol. 10, no. 10, 1911.

82 *Beyond East and West*, p. 68.

83 *Ibid.*, p. 70.

84 *Ibid.*, p. 72.

85 Illustrated in Oliver Watson, *Bernard Leach: Potter and Artist*. Crafts Council, London, 1997, p. 33.

86 *Beyond East and West*, p. 71.

87 *Beyond East and West*, p. 67.

88 *Ibid.*, p. 67.

89 *Ibid.*, p. 67.

90 *Beyond East and West*, p. 66.

91 *Ibid.*, p. 62.

92 *Ibid.*, p. 66.

93 Reported in Morita Kamenosuke, 'Shinshin Sakka Shōhin Tenranka' (An exhibition of small works by Young Artists), *Bijutsu Shinpō*, vol. 10, no. 7, 1911, pp. 207–17. LA1615. Much to Leach's delight the medium evaporated leaving no fringe of oil on the absorbent handmade paper whilst preserving the bloom of the paint.

94 Bernard Leach diary, 1911–12. LA10875.

95 *Ibid.*, August 1912.

96 Bernard Leach diary, 1911–12. LA10875.

97 Bernard Leach, *Bijutsu Geppō* (Art Monthly), 13 March 1920. LA916.

98 Bernard Leach memoir, 25 October 1961. LA11227.

99 Bernard Leach diary, 1911–12, November 1911. LA10875.
100 Bernard Leach diary, 1911–12. LA10875.
101 Ibid.
102 The Far East, 20 December 1913, pp. 491–5.
103 Ibid.
104 Ibid.
105 Bernard Leach diary, 1911–12. LA10875.
106 Ibid.
107 Beyond East and West, p. 87.
108 Italian educationalist (1870–1952) who published her ideas in Montessori Methods, 1912.
109 Beyond East and West, p. 87.
110 Quoted by Leach in 'Chinese Education and the Example of Japan', Anglo-Chinese Friendship Bureau, Peking, 1916.
111 Alfred Westharp, 'Regeneration through Education', a lecture delivered at the World's Chinese Students' Federation, dated Shanghai, 21 April 1913. LA10710.
112 Beyond East and West, pp. 102–3.
113 Ibid., p. 103.
114 Alfred Westharp, 'The Renaissance of the Geisha Through Japanese Music', The Far East, 20 December 1913, pp. 520–1.
115 Delivered at the World's Chinese Students' Federation, Shanghai, 21 April 1913.
116 Quoted in Alfred Westharp, 'Education through Freedom', paper read in Shanghai, May 1913, p. 2.
117 Bernard Leach, Chinese Education and the Example of Japan, Anglo-Chinese Friendship Bureau, 1916. LA11312.
118 Alfred Westharp 'Education through Freedom' given to the American Woman's Club, signed Shanghai, 4 May 1913. LA10711.
119 Westharp was particularly critical of Dr Montessori for removing children from their home when she set up her residential school.
120 Alfred Westharp, 'Education through Freedom'. LA10711.
121 Alfred Westharp, 'Regeneration through Education', p. 5. LA10710.
122 Westharp correspondence, 11 March 1912. LA11672.
123 Alfred Westharp, 'Education through Freedom'. LA10711.
124 Ibid.
125 No record of Westharp has been found in the Freud archives in either London or New York to date.
126 Bernard Leach diary, 1914. LA10877.
127 Ibid.
128 Ibid.
129 Ibid.
130 Ibid.
131 Most notably in Milton; discussed in Peter Ackroyd, Blake. Sinclair-Stevenson, London, 1996, p. 313.
132 Bernard Leach diary, 1914. LA10877.

133 Ibid.
134 Miyagawa Kōzan (1842–1916), born Miyagawa Toranosuke, attached to the Imperial court, was an expert in copying old work. He produced highly intricate ceramics and was made a member of the Japanese Royal Academy in 1896.
135 BBC radio broadcast, 12 December 1946. LA531.
136 William Blake, 'Jerusalem'.
137 Bernard Leach diary, 1913. LA10876.
138 4 August 1914.
139 Sir Norman Angell (1874–1967), writer on politics and economics, Nobel prize-winner, knighted in 1933.
140 Bernard Leach diary, 1911–12. LA10875.
141 Beyond East and West, p. 70.
142 Bernard Leach diary, 1914. LA10877.
143 20 October–1 November 1914.
144 24 October 1914.
145 This is now in the possession of the family.
146 Quoted in Edmund de Waal, Bernard Leach. Tate Gallery Publications, London, 1999, p. 15.

CHAPTER FIVE

1 Westharp letter to Bernard Leach, 26 October 1914. LA11700.
2 In Beyond East and West Leach says that he left Japan for China in spring 1914, but this conflicts with his exhibition which did not open until 20 October and ran until 1 November, and his diary entries for 1914.
3 Bernard Leach diary, 1914. LA10877.
4 In a letter to Leach dated 1 June 1914 Yanagi specifically requested Dr Westharp to refrain from making 'any reference more to the thought of Japanese people in his writings before he knows the ideas of the young Japanese generations really and thoroughly'. LA11599. In a later letter he decided he would not accompany Leach to China but was keen to hear 'the detail of Dr Westharp's plans'. LA11600.
5 Ibid.
6 Probably Yixing ware, Jiangsu province. These small unglazed teapots continue to be made in red clay following traditional methods.
7 Bernard Leach diary, 1914. LA10877.
8 Ibid.
9 Westharp letter to Bernard Leach, 15 June 1914. LA11683.
10 Bernard Leach diary, 1914. LA10877.
11 Ibid.
12 Westharp letter to Bernard Leach, 15 June 1914. LA11683.
13 Bernard Leach, Beyond East and West. Faber & Faber, London, 1978, pp. 89–90.
14 Bernard Leach diary, 1914. LA10877.
15 Ibid.
16 Ibid.
17 This was probably a reference to the Mexican dollar, which was a common currency at the time.

Chinese currency was highly complex. For an illuminating account see *Money in the Bank and the Hong Kong Bank Money Collection*. Hong Kong and Shanghai Banking Corporation, London, 1987, chapter one.

18 *Ibid.*
19 *Ibid.*
20 *Beyond East and West*, p. 89.
21 *Ibid.*, p. 102.
22 Bernard Leach diary, 1914. LA10877.
23 *Ibid.*
24 *Ibid.*
25 *Ibid.*
26 *Beyond East and West*, p. 90.
27 *Ibid.*, p. 92.
28 *Ibid.*
29 Bernard Leach diary, 1915, LA10878.
30 Bernard Leach diary, 1914, LA10877.
31 *Ibid.*
32 Westharp letter to Bernard Leach, 2 January 1915. LA11701.
33 One such book was a two-volume treatise on the method of oriental brushstroke.
34 Bernard Leach letter to Muriel Leach ,16 February 1915. FA.
35 Bernard Leach letter to Muriel Leach, 12 February 1915. FA.
36 Bernard Leach letter to Muriel Leach, 18 February 1915. FA.
37 Bernard Leach letter to Muriel Leach, 7 April 1915. FA.
38 *Ibid.*
39 *Ibid.*
40 *Ibid.*
41 *Ibid.*
42 *Ibid.*
43 Bernard Leach diary, 1915. LA10878.
44 *Ibid.*
45 *Ibid.*
46 *Ibid.*
47 *Ibid.*
48 *Ibid.*
49 *Ibid.*
50 *Ibid.* Probably a reference to some sort of psychoanalytical process carried out by Westharp to free Leach from his inhibitions.
51 *Ibid.* Liberty was established in London to sell imported artefacts from India and the Far East.
52 *Ibid.*
53 *Beyond East and West*, p. 98.
54 Bernard Leach letter to Muriel Leach, 7 April 1915. FA.
55 *Ibid.*
56 Bernard Leach diary, 1915. LA10878.
57 First published in 1914 putting forward the concept of 'Significant Form', which held that form, independent of content, was the most important element in a work of art.
58 Bernard Leach diary, 1915. LA10875–10879.
59 Bernard Leach diary, 1915. LA10878.
60 Bernard Leach letter to William Hoyle, 21 June

1915. LA2291.
61 Muriel Leach letter to her parents, 7 July 1915. FA.
62 So called because it was close to the great drum tower known as Gulow or Gu Low containing an immense drum beaten to announce the watches of the night.
63 Bernard Leach, diary 1915. LA10878.
64 Muriel Leach letter to Bernard Leach, 13 July 1915. FA.
65 The name given to groups of Chinese nationalists who in 1900 besieged the foreign legations in Peking, and murdered European missionaries and thousands of Christian converts. An international force was dispatched and the city was recaptured.
66 Bernard Leach, 'Notes on Peking', January 1916. LA11382.
67 Muriel Leach letter to her parents, 31 July 1915. FA.
68 Muriel Leach letter to her parents, 8 August 1915. FA.
69 *Ibid.*
70 Muriel Leach letter to her parents, 2 August 1915. FA.
71 *Ibid.*
72 *Ibid.*
73 *Ibid.*
74 Muriel Leach letter to her parents, 8 August 1915. FA.
75 Muriel Leach letter to her parents, 24 August 1915. FA.
76 *Ibid.*
77 *Ibid.*
78 Westharp letter to Bernard Leach, 15 September 1915. LA11723.
79 Bernard Leach diary, 1915. LA10878.
80 *Beyond East and West*, p. 95.
81 Muriel Leach letter to her parents, 5 September 1915. FA.
82 *Ibid.*
83 *Ibid.*
84 Muriel Leach letter to her parents, 30 September 1915. FA.
85 *Beyond East and West*, p. 97.
86 39 Santiao Hutung, Tung Tan Pai lo.
87 Westharp letter to Bernard Leach, 19 September 1915. LA11728.
88 Bernard Leach letter to Westharp, 28 October 1915. LA11729.
89 *Ibid.*
90 Muriel Leach letter to her parents, 26 October 1915. FA.
91 *Ibid.*
92 *Ibid.*
93 *Ibid.*
94 *Ibid.*
95 *Ibid.*
96 Muriel Leach letter to her parents, 5 November 1915. FA.
97 Muriel Leach letter to her parents, 14 November 1915. FA.

98 Ibid.
99 Sometimes spelt Pechili.
100 Outline constitution of an East and West society, 4 September 1910. LA10805–10806.
101 Bernard Leach, c. 1915. LA11164–11165.
102 Bernard Leach diary, 27 November 1915. LA10878.
103 Bernard Leach diary, 24 November 1915. LA10878.
104 Ibid.
105 Bernard Leach dairy, 1 November 1915. LA10878.
106 Bernard Leach diary, 27 November 1915. LA10878.
107 Bernard Leach diary, 1 November 1915. LA10878.
108 Bernard Leach diary, 11 May 1916. LA10880.
109 See 'Chinese Education and the Example of Japan', Beyond East and West, p. 105.
110 Bernard Leach, notes on Chinese education, 1916. LA11166.
111 Ibid.
112 Bernard Leach, notes on Confucius. LA11170.
113 Ibid.
114 Ibid.
115 Ibid.
116 Ibid.
117 Ibid.
118 'Confucius', Beyond East and West, pp. 102–11.
119 Beyond East and West, p. 102.
120 The full text of the letter is given in Beyond East and West, pp. 103–4.
121 Dated 22 July 1915, quoted in Beyond East and West, pp. 78–9.
122 Dated 8 November 1915, quoted in Beyond East and West, pp. 79–82.
123 Ibid.
124 Ibid.
125 Yanagi letter to Bernard Leach, 19 November 1915, quoted in Beyond East and West, pp. 82–3.
126 Ibid.
127 Beyond East and West, p. 83.
128 Chosŏn blue and white porcelain was much admired in Japan at that time. See Kikuchi Yūko, 'Yanagi Sōetsu and Korean Crafts within the Mingei Movement', Papers of the British Association for Korean Studies, vol. 5 (1994) pp. 23–38.
129 Yanagi letter to Bernard Leach, 13 September 1916. Yanagi Sōetsu Zenshū (Collected Works of Yanagi Sōetsu). Chikuma Shobō, Tokyo, 1981, vol. 21, part 1, pp. 35–6.
130 Beyond East and West, p. 97.
131 Ibid.
132 This is the period recorded in Leach's 1916 diary, though he gives the period as a month in Beyond East and West.
133 Yanagi letter to Bernard Leach, 23 October 1916, Yanagi Sōetsu Zenshū (Collected Works of Yanagi Sōetsu). Chikuma Shobō, Tokyo, 1981, vol. 21, part 1, p. 657.
134 Quoted in Beyond East and West, p. 130.
135 Beyond East and West, p. 98.
136 Ibid.
137 Ibid.
138 Yanagi letter to Bernard Leach, 23 October 1916, Yanagi Sōetsu Zenshū (Collected Works of Yanagi Sōetsu). Chikuma Shobō, Tokyo, 1981, vol. 21, part 1, p. 655.
139 Yanagi letter to Bernard Leach 23 October 1916 Yanagi Sōetsu Zenshū (Collected Works of Yanagi Sōetsu). Chikuma Shobō, Tokyo, 1981, vol. 21, part 1, pp. 336–7.
140 Ibid.
141 For a full account see Beyond East and West, pp. 98–9.
142 Bernard Leach diary, 1916. LA10880.
143 Beyond East and West, p. 100.

CHAPTER SIX

1 Bernard Leach essay, 'The Introduction of Etching'. LA11175.
2 Ibid.
3 Ibid., p. 113.
4 A member of the Seitōsha (blue stocking).
5 Bernard Leach, Beyond East and West. Faber & Faber, London, 1978, p. 114. Here, inaccurately, Leach identifies her bridal kimono as white.
6 Tomimoto established himself in the middle of a rice field, building a 'peasant' home equivalent to Morris's Red House, following plans approved by Leach, with a studio and kiln next door.
7 The Japanese equivalent of picnic food, consisting of rolls of cold boiled rice flavoured with cooked vegetables, and a variety of pickles covered with delicate slices of seaweed or raw fish.
8 Beyond East and West, p. 113.
9 Ibid.
10 The address was 209 Harajuku, Aoyama.
11 Letter to Bernard Leach, 6 January 1917. LA2318.
12 'Dead London', in Bernard Leach, Drawings, Verse & Belief. Adams & Dart, Bath, 1973, p. 14.
13 This was recorded by Leach as:

 Nen nen yo/Nen nen yo/Mother carried you on her back/Good children do not cry/Nen nen yo/Nen nen yo/

 Nen nen yo/Nen nen yo/Mother cradles you in her arms/Good children do not cry/Nen nen yo/Nen nen yo/

 Nen nen yo/Nen nen yo/From mother's breast you take your food/Good children do not cry/Nen nen yo/Nen nen yo/

 Nen nen yo/Nen nen yo/Dream happy dreams my pet/Good children do not cry/Nen nen yo/Nen nen yo.

14 Muriel Leach letter to Bernard Leach, 1917. LA344.
15 Ibid.
16 Ibid.
17 J. W. Robertson Scott, The Foundations of Modern Japan: Notes made during journeys of 6,000 miles in

the rural districts as a basis for a sounder knowledge of the Japanese people. John Murray, London, 1922, p. 105.

18 Brian Moeran, Folk Art Potters of Japan: Beyond an Anthropology of Aesthetics. Curzon, Richmond, Virginia, 1997.

19 J. W. Robertson Scott, The Foundations of Japan. John Murray, London, 1922, pp. 98–9. The chapter 'The Idea of a Gap' is devoted to a discussion of Yanagi and his views.

20 E. E. Speight to Bernard Leach, 19 April 1919. LA2327–2328.

21 Beyond East and West, p. 117.

22 Ibid., p. 112.

23 Beyond East and West, p. 115.

24 In 1925 Yanagi came up with the term mingei, which means 'art of the people'.

25 For a full discussion see 'Buddhist Idea of Beauty' in Bernard Leach, The Unknown Craftsman: A Japanese Insight into Beauty: Yanagi Shōetsu. Kodansha International, Tokyo and Palo Alto, 1972.

26 Although in a 1946 broadcast Leach claimed to have found the book on Yanagi's bookshelves this conflicts with his account given in Beyond East and West, written some thirty years later; it ties in with the sort of pots he began to be aware of at that time.

27 Charles J. Lomax, Quaint Old English Pottery. Sherratt and Hughes, London, 1909. p. viii.

28 Illustrated in Shikiba Ryūzaburō, Bernard Leach Biography, Tokyo, 1934, plate 4.

29 Illustrated in Bernard Leach, 'Ten Years in Japan' (written in Japanese), Bijutsu Geppō (Art Monthly), 1921. LA916.

30 Produced in the last firing at Abiko. Illustrated in the magazine Bijutsu Shashin Gahā and given to Yanagi, now in the collection of the Japan Folk Craft Museum, Tokyo. 21.3 cm diameter.

31 A drinking cup with two or more handles.

32 All nature listens silent to him/and the awful sun stands still upon/the mountain looking on the little bird/mounting up the wings of light into the/great expanse, reaching against the/lovely blue and shining heavenly skies.

33 Bernard Leach, Hamada: Potter. Kodansha International, Tokyo and New York, 1975, p. 100.

34 Technically the smoke resulted in a kiln atmosphere starved of oxygen, known as a reducing atmosphere, which caused the small amounts of iron in the glaze to turn from cream-yellow to blue-green giving the characteristic celadon glazes.

35 Takamura to Bernard Leach. LA1580.

36 Hamada: Potter, p. 26.

37 Quoted in Bernard Leach, An English Artist in Japan. Privately printed, Japan, 1920.

38 Hamada: Potter, p. 96.

39 Japan Advertiser, 1919, quoted in Edmund de Waal, Bernard Leach. Tate Gallery Publications, London, 1999, p. 22.

40 This is illustrated in Bernard Leach, An English Artist in Japan.

41 Cutting from an untitled periodical, dated by Leach March 1919. LA914.

42 Bernard Leach, notebook, c. 1934. LA11341.

43 Scheduled for the March 1919 issue.

44 Bernard Leach essay, 'To save a noble Corean building'. LA11289.

45 Leach's account of his first visit in Beyond East and West, p. 22, is brief but enthusiastic.

46 The Far East, 29 May 1915.

47 The Unknown Craftsman, p. 98.

48 For a full discussion see Teiko Utsumi 'Mingei and the Life of Sōetsu Yanagi', Studio Potter, vol. 25, no. 1, December 1996, pp. 1–7.

49 This collection can now be seen in the National Central Museum, Seoul.

50 See Kikuchi Yūko, 'The Oriental Orientalism of Yanagi Sōetsu and Mingei Theory', in Obscure Objects of Desire: Reviewing the Crafts in the Twentieth Century. Crafts Council, London, 1997. 'Hybridity and the Oriental Orientalism of Mingei Theory', Journal of Design History, vol. 10, no. 4, 1997, pp. 343–54.

51 The Unknown Craftsman, pp. 97–8.

52 Ibid., p. 98.

53 Ibid.

54 A few years later Yanagi was instrumental in saving the Chosōn-period Kwanghwa-mun, the front gate of the Kyongbok-kung Palace from demolition as part of a scheme to clear a space for a new western-style building for use as the colonial government office.

55 George N. Curzon, Problems of the Far East: Japan, Korea, China. Longmans, Green & Co., London and New York, 1894, p. 95.

56 Beyond East and West, p. 200.

57 Beyond East and West, p. 201.

58 Ibid.

59 Bernard Leach, An English Artist in Japan.

60 Ibid.

61 Ibid.

62 Ibid.

63 Quoted in a BBC programme in 1947. LA533 (p. 21).

64 Ibid.

65 1894–1978. The visit was April 1919.

66 Hamada: Potter, p. 20.

67 Quoted in Hamada: Potter, p. 21.

68 Ibid.

69 Itaya Hazan (1872–1963) was the most respected potter of the establishment and leader of the ceramics section of the academy. His pots were elegant and intricate, and included large pieces.

70 During a visit to Itaya's home Hamada admired a teapot, which turned out to have been made in Mashiko, and when considering setting up his studio in 1924 remembering this pot he visited the town and established his pottery there.

71 Kawai Kanjirō (1890–1966) was an artist potter who spent most of his adult life in Kyoto, where

his kiln and traditional Japanese house are now a museum. At the Tokyo Institute of Technology one of Kawai's projects was to recreate the copper-red effects of the Sung and Yūan dynasties. Having seen only book illustrations, it was by examining such pots in a fine art dealers that he was able to deduce how the glazes were achieved, illustrating the technical approach of the course.

72 During visits to see Kawai in Kyoto, Hamada travelled around traditional pottery centres such as Tajimi in Gifu Prefecture, Nagoya to visit Seto and Tokoname, and Yokkaichi and Shigaraki, admiring pots made much as they had been produced for hundreds of years. He also visited Tomimoto.

73 Draft of *Hamada: Potter*. LA747.

74 *Ibid.*

75 26 May 1919.

76 On this occasion Naka behaved well but when Yanagi wrote to him several times shortly after Leach had left Japan he received no reply. He asked for permission for a young Indian potter, Singh Gurcharan (1898—1996), a friend of Leach, Tomimoto and his, to use the kiln at Kōgai-chō, forcing Yanagi to conclude that he was 'a sheer materialist'. Singh was a distinguished Indian potter who established the Blue Delhi Pottery, and wrote *Pottery in India*. Vikas Publishing House, New Delhi, 1979.

77 Aza Kami Uma, Komazawa mura. LA936.

78 Bernard Leach, papers on Hamada Shōji. LA739.

79 For useful background to Father Kelly's work see Society of the Sacred Mission, Hamilton Kelly, 1860—1950. *S. S. M. An Idea Still Working*. Society of the Sacred Mission, Milton Keynes, 1980.

80 *Ibid.*, p. 2.

81 *Ibid.*, p. 25.

82 The drawing is now in the possession of the Society of the Sacred Mission, Willen Priory, Milton Keynes.

83 Bernard Leach, papers on Hamada Shōji. LA739.

84 *Beyond East and West*, p. 119.

85 *Hamada: Potter*, p. 24.

86 The Skinners lived in a house more or less opposite the site where Leach was to built his pottery.

87 'St Ives Handicraft Guild', *St Ives Times*, 16 May 1919.

88 *Hamada: Potter*, p. 34.

89 *Ibid.*, p. 34.

90 These were: Iseki Sōzan, a follower of Zen, who had lived for a time in a Zen monastery before becoming a lawyer. His slow manner of speaking gave great weight to what he said, his words tended to be sharp like those of a Zen Master; Hamada's father, who had run a factory manufacturing ink on the banks of the Sumida River in Tokyo; and the third, Mr Okada, proprietor of the Heiandō, a firm producing the best calligraphy and artists' brushes in the city.

91 Twenty later years, when Hamada insisted on repaying the money, he discovered that Iseki was still paying interest on it.

92 *Hamada: Potter*, p. 35.

93 For full details see *Hamada: Potter*, pp. 29—34.

94 1—7 June 1920.

95 4 June 1920.

96 A Yorkshire man living in Japan teaching and lecturing. He visited Leach at Abiko and was a great admirer. See LA2327—2328 for full correspondence.

97 E. E. Speight, 'The Drawings of Bernard Leach', *Japan Advertiser*, 6 June 1920.

98 13 March 1920, published in Japanese in *Bijutsu Geppō* (Art Monthly). LA916.

99 *Hamada: Potter*, p. 100.

CHAPTER SEVEN

1 Bernard Leach, draft of speech 'The Craftsman and the Machine', 21 October 1925. LA11340.

2 Bernard Leach, *Hamada: Potter*. Kodansha International, Tokyo and New York, 1975, p. 37.

3 Named Tom, Harry, Eileen and the youngest Kathleen, much the same age as David.

4 *Hamada: Potter*, p. 37.

5 Sir Leslie Stephens, quoted in Quentin Bell, *Virginia Woolf*. Paladin, London, 1976, p. 30.

6 A track from Paddington, London to Penzance had been opened by Great Western Railways in 1876 and a connecting branch line to St Ives two years later.

7 *Hamada: Potter*, p. 37.

8 Bernard Leach, *Beyond East and West*. Faber & Faber, London, 1978, p. 138.

9 *Ibid.*

10 For a fuller account of the artists working at St Ives see Marion Whybrow, *St Ives 1883—1993: Portrait of an Art Colony*. Antique Collectors' Club, Ltd., Woodbridge, 1994.

11 They spent the summers with their daughters Virginia and Vanessa and sons Thoby and Adrian in St Ives until Julia's death in 1895. Virginia Stephen would later be a regular visitor, during one visit staying at Trevose House, Draycott Terrace, the row in which Leach lived.

12 In *Hamada: Potter* Hamada gives this date as 24 August, but this is unlikely as the Leach's twin daughters were not born until 28 August.

13 Reminiscences by Margery Horne, in the collection of Dr Roger Slack.

14 *Beyond East and West*, p. 137.

15 *Ibid.*, p. 139.

16 Some years later Frances Horne presented Jessamine with a cabinet of small stones and shells gathered in the Far East where, with her husband, she had been a regular visitor.

17 Hamada in *Hamada: Potter*, p. 38.

18 Report in *St Ives Times*, 16 May 1919.

19 Edgar and Edith Skinner lived at Chyan Street, St Ives, according to the Leach Pottery Visitors Book. LA2047.

20 *St Ives Times*, 29 October 1920.

21 *Ibid.*, 19 November 1920.

22 Michael Cardew, *A Pioneer Potter*. Collins, London, 1988, p. 31.

23 *Ibid*.

24 Ceramic boxes used to hold pots and protect them from the flame and ash.

25 A photograph shows Hamada standing inside the partially built firebox, assembling the individually shaped bricks.

26 A diagram of the kiln appears in Leach's *A Potter's Book*.

27 *Hamada: Potter*, p. 43.

28 *Ibid*., p. 42.

29 So called because a lump of it was stuck on the helmets of miners to hold a candle and so give light.

30 This vase was purchased for 30 guineas by Eric Milner-White from a London exhibition in 1931, and is now in York City Art Gallery.

31 17 August 1923.

32 *Beyond East and West*, p. 141.

33 Katharine Pleydell-Bouverie, 'St Ives in the Early Years', in *Bernard Leach: Essays in Appreciation*, edited and collected by Terry Barrow. The New Zealand Potter, Wellington, New Zealand, 1960, p. 29.

34 *Ibid*., pp. 29–30.

35 *Hamada: Potter*, p. 40.

36 Katharine Pleydell-Bouverie, 'St Ives in the Early Years' in *Bernard Leach: Essays in Appreciation*, p. 29.

37 Around 1927.

38 1862–1925. Leach made a set of nine tiles for his grave in Barnoon Cemetery, St Ives, bearing the motto 'He went through life with outstretched hand of help'.

39 Katharine Pleydell-Bouverie, 'At St Ives in the Early Years' in *Bernard Leach: Essays in Appreciation*, p. 30.

40 *Hamada: Potter*, p. 88.

41 *Ibid*., p. 56.

42 Katharine Pleydell-Bouverie, 'At St Ives in the Early Years' in *Bernard Leach: Essays in Appreciation*, p. 46.

43 *Hamada: Potter*, p. 46.

44 Common lead ore in partially refined state, which when combined with a small amount of clay and other materials yields a rich, unctuous clear glaze often tinted a warm honey colour.

45 Bernard Leach in John Farleigh, *The Creative Craftsman*. London, 1950, p. 69.

46 *Hamada: Potter*, p. 50.

47 Illustrated in Shikiba Rhyūzaburō, *Bernard Leach: Biography*. Tokyo, 1934, plate 47.

48 Illustrated in Carol Hogben (ed.), *The Art of Bernard Leach*. Faber & Faber, London 1978, plates 11 and 12.

49 1877–1951. Wells later made stoneware.

50 For a full account see Philip Hill, 'Back to the Yard: A Tribute to the Craftsmen of Lake's Pottery, Truro', Royal Cornwall Museum Galleries, Truro, 1995.

51 Illustrated in Bernard Leach, *Bernard Leach*. Ashi Shimbun Publishing Company, Tokyo, 1966. Published on the occasion of a retrospective of Leach's work drawn from collections in Japan.

52 Illustrated in Carol Hogben (ed.), *The Art of Bernard Leach*, plate 57.

53 Hamada, papers on the subject of *Hamada: Potter*, 5–8 April 1964. LA731.

54 In the collection of the York City Art Gallery.

55 Draft copy of Hamada manuscript. LA802.

56 James Dunk, 'The Artist-Potter of St Ives', *Western Morning News*, 5 October 1926.

57 Bernard Leach, manuscript, a notebook 'on the making of simplest oriental pottery', 1923. LA514.

58 Bergen was a great admirer and loyal friend of potters, working with Leach at St Ives, Michael Cardew at Winchcombe (opened in 1926) and William Staite Murray in London. At St Ives Bergen laboriously carved lettering through slip-covered surfaces and helped fire the kiln, including the first firing of the new kiln.

59 Michael Cardew, *A Pioneer Potter: Autobiography*. Collins, London, 1988, p. 94.

60 Yanagi letter to Bernard Leach, 11 September 1921, in *Yanagi Sōetsu Zenshū* (Collected Works of Yanagi Sōetsu). Chikuma Shobō, Tokyo, 1981, vol. 21, part 1.

61 2–30 April 1921.

62 Catalogue of exhibition by the Friday Club, 2–30 April 1921. LA1381.

63 'Home arts and Industries Exhibition', Drapers' Hall, Throgmorton Street, London, first week in November, *Pottery and Glass Record*, n.d. LA1382.

64 59 Frith Street, 16–30 November 1922. Catalogue in Leach archive. LA1383.

65 9 October 1922.

66 The General Press Cutting Association and Durrant's Press Cuttings.

67 3 December 1927.

68 Bergen to Bernard Leach, 31 January 1923. LA11882.

69 Now the Society of Designer Craftsmen.

70 Founded 1920–1.

71 Sidney Kyffin Greenslade (1866–1955), architect and designer of the National Library of Wales; an enthusiastic and knowledgeable collector, he had met the Martin brothers (pioneer studio potters who worked in Southall making pots and grotesque owls) in 1898. In the 1920s and 1930s he selected contemporary art, including studio ceramics, for the University of Wales at Aberystwyth, now in the Arts Centre. The collection includes early pots by Bernard Leach. The Pottery had a series of distinguished visitors in the early years, including the artists John Piper, Edward Bawden and Eric Ravillious, and the writer Angela Brazil, all of whom signed the visitors book. LA2047.

72 *Beyond East and West*, p. 151.

73 Katharine Pleydell-Bouverie, 'At St Ives in the Early Years' in *Bernard Leach: Essays in Appreciation*, p. 30.

74 Blueprint of 'The Leach Pottery Japanese Style of [climbing] kiln design by T. Matsubayashi', June 1953. LA2250–2251.

75 1901–83.

76 *Hamada: Potter*, p. 62.

77 Specially contributed, 'An Art Pottery in Cornwall', *The Pottery Gazette and Glass Trade Review*, December 1920, p. 1661. Probably written by Leach. LA1629.

78 Michael Cardew, *A Pioneer Potter*, p. 24.

79 *Ibid.*, p. 25.

80 Michael Cardew, 'Bernard Leach – Recollections' in *Bernard Leach: Essays in Appreciation*.

81 *Ibid.*

82 *Beyond East and West*, p. 147.

83 Bernard Leach letter to Michael Cardew, 24 January 1923. LA6540.

84 Curious to find out more about the world into which he was planning to move Cardew visited London galleries mentioned by Leach and was far from impressed. Leach's pots at the Artificers' Gallery he found 'strange and difficult, and also expensive'. More alarming was an overheard telephone call in which price was equated with quality, a sentiment with which he had no sympathy and an aspect of the arts and crafts world that to him 'emitted a stink . . . something old and stuffy, over-upholstered and decaying; cobwebby, sticky and contaminating', a self-conscious preciousness he found alien.

85 Michael Cardew, *A Pioneer Potter*, p. 31.

86 Acquired July 1922, a 1921 6 h.p. machine, registration number N7C 4498.

87 Quoted in Michael Cardew, 'Bernard Leach – Recollections', in *Bernard Leach: Essays in Appreciation*, p. 23.

88 *Hamada: Potter*, p. 67.

89 April 1923.

90 Henry Bergen letter to Bernard Leach, 31 January 1923. LA11882. Bergen gives a detailed description, including the fact that there were six show cases, also an octagonal centre case and two other cases.

91 The pots were recorded by Leach as 'Tessha, Kaki, Yüan splendid, Kaki and Tenmoku good'. Technical notes. LA2097.

92 1895–1985. For an account of her life see, *Katharine Pleydell-Bouverie: A Potter's Life 1895–1985*. Crafts Council, London, 1986.

93 Michael Cardew, *A Pioneer Potter*, p. 34.

94 Set up in London by Roger Fry 1913–1919 employing artists to design objects for the home, products included furniture, textiles, pottery, tiles, puppets and many more.

95 *Ceramic Review*, no. 58, July–August, 1979.

96 Unidentified cutting. LA1385.

97 *Beyond East and West*, p. 150.

98 The actual terms were a short trial period, a £26 premium to cover six months at £1 a week, followed by six months without pay, and one year at a salary of £1 a week. If the agreement was for a period shorter than two years, the premium would have to be higher or the pay less. Letter to Katharine Pleydell-Bouverie, 20 January 1923. LA6540.

99 *Ibid.*

100 Michael Cardew, *A Pioneer Potter*, p. 35.

101 For an account of Cardew's time at Braunton Pottery see *ibid.*

102 Quoted in Garth Clark, *Michael Cardew: A Portrait*. Faber & Faber, London, 1978, p. 9.

103 *Beyond East and West*, p. 149.

104 Quoted in Michael Cardew, 'Bernard Leach – Recollections' in *Bernard Leach: Essays in Appreciation*, p. 22.

105 *Ibid.*, p. 23.

106 Barley Roscoe in *Katharine Pleydell-Bouverie: A Potter's Life 1895–1985*. Crafts Council, London, 1986, p. 8.

107 *Beyond East and West*, p. 152.

108 Bernard Leach, *A Potter's Outlook*. New Handworkers' Gallery, London, 1928, p. 38.

109 Michael Cardew, *A Pioneer Potter*, p. 43.

110 Russell was later made director of the Council of Industrial Design.

111 Quoted in Katharine Pleydell-Bouverie, 'At St Ives in the Early Years' in *Bernard Leach: Essays in Appreciation*, p. 32.

112 *Ibid.*, p. 32.

113 Quoted in Michael Cardew, 'Bernard Leach – Recollections' in *Bernard Leach: Essays in Appreciation*, p. 22.

114 Bernard Leach, quoted in Oliver Watson, *Bernard Leach: Potter and Artist*. Crafts Council, London, 1997, p. 81. The bowl, measuring 18.8 cm across, is illustrated plate 76.

115 *A Potter's Book*, p. 204.

116 One such Bellarmine is illustrated in *Monthly Pictorial*, December, 1926, p. 6.

117 Between April 1909 and January 1910.

118 Keeper of ceramics at the British Museum.

119 1881–1962.

120 Principal of Camberwell School of Art and Crafts.

121 1881–c.1955. Daughter of the potter Richard Lunn who became head of ceramics at the Royal College of Art and set up the ceramics course at Camberwell School of Art.

122 Charles Vyse (1882–1971) with his wife Nell (1892–1967) set up a studio in Cheyne Walk, London in 1919 making high-fired stoneware with oriental glazes.

123 1877–1951. Set up his kiln in the King's Road, Chelsea, London in 1919, creating *chün*-glazed pots in the style of Sung dynasty.

124 Founded around 1928, it held its first exhibition at the Grieves Art Gallery, 22 Old Bond Street.

See *The Times*, 28 June 1928, and *Liverpool Post*, 25
June 1928.

125 Modelled figures in earthenware and porcelain
often based on traditional London characters.
W.B. Dalton was appointed president the follow-
ing year.

126 Bernard Leach letter to Yanagi, 6 February 1928.

127 Leach quotes one pot 'Ra' as being offered for sale
at 150 guineas. *Hamada: Potter*, p. 62.

128 In 1927 Murray was the only potter member of
the 7 & 5 Society, showing alongside Ben and
Winifred Nicholson and Christopher Wood,
among others.

129 Quoted in Malcolm Haslam, *William Staite
Murray*, Crafts Council, London/Cleveland
Museum Service, London, 1984, p. 17.

130 *Spectator*, 15 November 1924.

131 *Beyond East and West*, p. 144.

132 *Ibid.*

133 Leach thought that Murray had only ever seen ori-
ental pots in museum collections and so had never
been able to look carefully at the base and observe
the foot-ring.

134 *Hamada: Potter*, p. 62.

135 On 1 September 1925. For a full account see
Malcolm Haslam, *William Staite Murray*.

136 This may have been influenced by Murray's friend-
ship with Rothenstein's brothers, the painter
Albert Rutherston and the collector Charles (who
had Anglicized their names during the war). Leach
suspected a conspiracy.

137 *Hamada: Potter*, p. 62.

138 Malcolm Haslam, *William Staite Murray*, p. 25.

139 Frank Rutter, *Christian Science Monitor*, Boston, 14
December 1925.

140 *Hamada: Potter*, p. 67.

141 7 Chelsea Embankment.

142 Quoted in Sarah Riddick, *Pioneer Studio Pottery:
The Milner-White Collection*. Lund Humphries,
London in association with York City Art Gallery,
1990, p. 7.

143 *Ibid.*, p. 59.

144 Quoted in Malcolm Haslam, *William Staite
Murray*, p. 36.

145 She was a pioneering hand weaver. For a full
account of her life see Margot Coatts, *A Weaver's
Life: Ethel Mairet 1872–1952*. Crafts Council,
London, 1983.

146 *Hamada: Potter*, p. 59.

147 For which Eric Gill designed the masthead.

148 The pottery had been set up on the site of
medieval and Tudor potteries producing earthen-
ware for domestic and farm use. William Fishley
Holland (1889–1970) took over from his grand-
father, but he sold out to a Staffordshire firm in
1912. He also set up other potteries in north
Devon.

149 *Hamada: Potter*.

150 Hamada 'A Visit to Gill', *Cage*, no. 31, August
1933. LA760.

151 This involved acquiring a property Skidden
House on Skidden Hill, with each member taking
shares.

152 The spelling of the gallery varies: was also written
as Kyukyodo. I have adopted the most common
spelling.

153 Yanagi letter to Bernard Leach, 20 March 1929.
Yanagi Sōetsu Zenshū (Collected Works of Yanagi
Sōetsu). Chikuma Shobō, Tokyo, 1981, vol. 21,
part 1.

154 Yanagi letter to Bernard Leach, 2 November
1925. *Yanagi Sōetsu Zenshū* (Collected Works of
Yanagi Sōetsu). Chikuma Shobō, Tokyo, 1981,
vol. 21, part 1.

155 Bergen letter to Bernard Leach, 16 December
1923. LA11902.

156 Bernard Leach letter to the Elmhirsts, 2
December 1931. DA.

157 F. C. Thorpe letter to Bernard Leach, 22
November 1925. LA11934.

158 Yanagi letter to Bernard Leach, 2 November
1925. *Yanagi Sōetsu Zenshū* (Collected Works of
Yanagi Sōetsu). Chikuma Shobō, Tokyo, 1981, vol.
21, part 1.

159 1901–2001. At the Leach Pottery 1924–7.

160 Bernard Leach letter to Yanagi, 16 January 1926.
LA353.

161 Bernard Leach copy letter to Norah Braden,
1934. LA2594.

162 *c.*1900–74.

163 David Leach, 'My Life in Pottery', *David Leach: A
Potter's Life: With Workshop Notes*, edited by Robert
Fournier. Fournier Pottery, Lacock, Wiltshire,
second edition, 1979.

164 Michael Cardew, *A Pioneer Potter*, p. 36.

165 Rosseter was killed when leaning out of a school
bus window and was hit by a lamp post.

166 His health continued to deteriorate, and he died
in February 1926.

167 Tomimoto and Yanagi letter to Bernard Leach, 13
October 1922. LA11629.

168 1 September 1923.

169 *Hamada: Potter*, p. 69.

170 *Ibid.*, p. 70.

171 This was mainly because collectors had started to
buy furiously following the destruction of their
collections.

172 28 December 1923.

173 27 April–2 May 1923.

174 Yanagi letter to Bernard Leach, 5 May 1923.
Yanagi Sōetsu Zenshū (Collected Works of Yanagi
Sōetsu). Chikuma Shobō, Tokyo, 1981, vol. 21,
part 1.

175 Quoted Edmund de Waal, *Bernard Leach*. Tate
Gallery Publications, London, 1997, p. 35.

176 Quoted in Oliver Watson, *Bernard Leach: Potter and
Artist*. Crafts Council, London, 1997, p. 19.

177 'Summary of Leach Pottery Balance Sheets
1921–1931'. DA.

178 Quoted in a letter to Bernard Leach from Margarita C. Lucas, 8 August 1926. LA2421.

179 30 November 1929.

180 Bernard Leach letter to Yanagi, 27 June 1924, quoted in Edmund de Waal, *Bernard Leach*. Tate Gallery Publications, London, 1997.

181 Bergen letter to Bernard Leach, 26 April 1926. LA2392.

182 Visitors' responses to the pots is recorded by Bernard Leach in *Hamada: Potter*, p. 49.

183 *Hamada: Potter*, p. 50.

184 30 May–3 June 1925.

185 Yanagi letter to Bernard Leach, 2 November 1925. LA11634.

186 *Ibid.*

187 *Ibid.*

188 *Ibid.*

189 *Ibid.*

190 *Beyond East and West*, p. 157.

191 Bernard Leach letter to Yanagi, 16 January 1926. LA6538.

192 Possibly written *en route* to England. LA2363.

193 Social credit was a complex system that involved retailers selling goods below cost to bolster the economy, the losses, plus commission, being credited to them by the bank.

194 Philip Mairet letter to Bernard Leach, 19 May 1926. LA11938. Mairet saw the singing of Blake's 'Jerusalem' as some triumphal festivity, reminding him of the celebrations after the ending of the war when a field gun had been wheeled into the crossing at St Paul's Cathedral, a bitter irony that 'never seemed to anyone as significant'.

195 *New Age*, no. 1806, vol. XL, no. 25, Thursday, 21 April 1927, p. 293.

196 *Ibid.*

197 For a fuller account of the Grig, or Grigg, family see Alison Symons, *Tremedda Days: A View of Zennor 1900–1944*. Tabb House, Padstow, 1992.

198 Dreolin is Irish for wren.

199 *Beyond East and West*, p. 139.

200 Hamada, 'Chairs and Myself'. LA727.

201 The dish measures 46 cm in diameter. Such a dish was illustrated in *Studio*, vol. 90, no. 392, 14 November 1925.

202 Nicolo Bernard Walke was vicar at St Hilary from 1913 to 1936. His book, *Twenty Years at Hilary* (Methuen, London, 1935), gives a vivid account of his years in the parish.

203 *Beyond East and West*, p. 159.

204 *Ibid.*

CHAPTER EIGHT

1 Bernard Leach, *A Potter's Book*. Faber & Faber, London, 1940, p. 11.

2 'Excellent Work by Mr Bernard Leach', *Morning Post*, 26 March 1927.

3 8 Holland Street, London W8.

4 'Excellent Work by Mr Bernard Leach', *Morning Post*, 26 March 1927.

5 The original building, at 14 Percy Street, one of a row of Georgian houses, has been demolished, and a Japanese restaurant occupies the site [2002].

6 Margery Kenton quoted in Margot Coatts, *A Weaver's Life: Ethel Mairet 1872–1952*. Crafts Council, London with Crafts Study Centre, Bath, 1993, p. 110.

7 These included Philip Mairet's own 'The Idea Behind Craftsmanship' and A. Romney Green's 'Instead of a Catalogue (The Apologia of a Furniture Maker)'.

8 After Philip and Gwendoline formed a passionate attachment both the gallery and the Mairets' marriage fell apart.

9 Bernard Leach, *A Potter's Outlook*, Handworkers' Pamphlet no. 3, 1928. The text is reproduced in Carol Hogben, *The Art of Bernard Leach*. Faber & Faber, London, 1978, pp. 189–91.

10 Bernard Leach, *Beyond East and West*. Faber & Faber, London, 1978, p. 145.

11 *Ibid.*

12 Bernard Leach notes for *A Potter's Outlook*. LA563.

13 *A Potter's Outlook*, p. 27.

14 *Ibid.*, p. 29.

15 *Ibid.*, p. 39.

16 1 Bruton Place. With Christmas in mind December was a popular time for exhibitions of pots, prompting one critic to remark 'Hark hark the critics do bark / The potters are coming to town'. 'The Potter's Craft', *Morning Post*, 28 November 1929.

17 Harry Trethowan, *Studio Year Book of Decorative Arts*. Periodical Publications, London, 1929.

18 December 1928, p. 338.

19 16 December 1928.

20 Leonard Elmhirst 1893–1974; Dorothy Elmhirst 1887–1968.

21 *Beyond East and West*, p. 162.

22 Quoted in Michael Young, *The Elmhirsts of Dartington: The Creation of a Utopian Community*. Routledge and Kegan Paul, London, 1982, p. 196.

23 Bernard Leach letter to the Elmhirsts, 14 March 1927. DA.

24 Katharine Pleydell-Bouverie letter to Bernard Leach, June 1930. LA2492–2520.

25 5–22 May 1926.

26 These included the beauty of naturalness, of tradition, simplicity, functionality, plurality, inexpensiveness, selflessness and beauty of health.

27 Paradoxically, Yanagi's concept of Mingei embodied Confucian principles, which were discussed in a different context by Japan's nationalist leaders at this time, and Mingei was often seen as highly politicized and indicative of the new wave of nationalism. For a fuller discussion of this see Brian Moeran, *Lost Innocence: folk craft potters of Onta, Japan*. University of California Press, 1984, pp. 24–5.

28 1 Bruton Place, London W1, 9–27 July 1929, catalogue with introduction by Hamada. LA521

29 Yanagi letter to the Elmhirsts, 29 August 1929. DA.

30 *Ibid.*

31 Letter from Yanagi to Bernard Leach, 12 April 1930. LA11640.

32 *Ibid.*

33 Bernard Leach, *Hamada: Potter.* Kodansha International, Tokyo and New York, 1975, p. 92.

34 In his diary Leach noted down the names of such leading French studio potters as Decoeur, Delaherche, Chaplet, Cazin and Carries, the first three of whom were still alive, but there is no record of any visits.

35 Father Kelly letter to Bernard Leach, 1930. LA11969.

36 See *St Ives Times*, 20 March 1931.

37 As Muriel Lanchester she set up the St Anne's Pottery at Malvern, her brother-in-law was the film actor Charles Laughton who purchased many of Leach's finest pieces.

38 1908–90.

39 Bernard Leach letter to the Elmhirsts, 11 December 1931. DA.

40 Consisting of George Dunn, Bernard Forrester, and Dicon Nance who worked part-time. At the Pottery Leach was referred to as B Leach, a modest concession to the more formal 'Mr Leach'.

41 17 September 1895–17 March 1976.

42 Laurie Cookes letter to Bernard Leach, n.d. [c.1933–4]. LA446.

43 *Ibid.*

44 *Ibid.*

45 Laurie Cookes wrote a book *A History of the Cookes Family.* Privately published, 1967. One of her ancestors Sir Thomas Cookes founded Worcester College, Oxford.

46 Laurie Cookes to Bernard Leach, n.d. LA446.

47 *Ibid.*

48 Bernard Leach letter to the Elmhirsts, 11 December 1931. DA.

49 Catalogue, Burlington Fine Arts Club. LA1519.

50 Leonard Elmhirst letter to Bernard Leach, 4 December 1931. LA5832.

51 Bernard Leach, 'Notes from a letter to Tomi', December 1931. LA11984.

52 Bernard Leach letter to the Elmhirsts, 2 December 1931. DA.

53 Bernard Leach letter to the Elmhirsts, 11 December 1931. DA.

54 Leonard Elmhirst letter to Bernard Leach, 25 December 1931. LA5833.

55 This is the present site of Dartington Pottery.

56 Topsy Turvey letter to Bernard Leach, c.1935. LA2611.

57 1910–86.

58 Bean, then in his seventies, had worked for Doultons of Lambeth making Stephen's ink bottles, often throwing 1,800 per day.

59 Bernard Leach letter to Harry Davis, May 1933. LA12013.

60 1890–1976.

61 Bernard Leach 'Mark, Dear Mark', *World Order*, Spring 1977, pp. 28–30.

62 Founded in the nineteenth century, Bahá'í's claim that the faith incorporates what they consider best in all religions, and is based on the belief in successive revelations of God, none of which is final. It has three central figures: the Forerunner Ali Mohammed who adopted the title Báb; the Founder, who took the name Bahá'u'lláh; and Abdu'l-Bahá, the Interpreter.

63 *Beyond East and West*, p. 164.

64 Bernard Leach, *My Religious Faith.* Privately printed, 1953. LA28.

65 Yanagi letter to Bernard Leach, 12 April 1930. LA11640.

66 2–5 December 1933.

67 Bernard Leach letter to Dr Shikiba Ryūzaburō, 7 August 1933. LA12013.

68 Bernard Leach letter to the Elmhirsts, 14 June 1933. LA12013.

69 Bernard Leach letter to Mrs K. Starr at Dartington, 20 December 1933. LA2542.

70 Leonard Elmhirst letter to Bernard Leach, 20 June 1933. LA5932.

71 Reggie and Topsy Turvey letter to Bernard Leach, 3 August 1933. LA12006.

72 *Ibid.*

73 Bernard Leach letter to Dorothy Elmhirst, 9 January 1934. DA.

74 *Beyond East and West*, p. 170.

75 Bernard Leach postcard to Michael Leach, 9 March 1934. PA.

76 Bernard Leach letter to Laurie Cookes, 7 March 1934. LA5969.

77 Interview, Warren MacKenzie, Tate Gallery Archives, TAV 263 2/4, p. 15.

78 Georges Ivanovitch Gurdjieff (1866–1949), Russian-Armenian mystic and philosopher. His basic teaching is that human life is lived in waking sleep; transcendence of the sleeping state requires a specific inner work, which is practised in private quiet conditions, and in the midst of life with others, leading to otherwise inaccessible levels of vitality and awareness.

79 In the collection of the Louvre, Paris.

80 Bernard Leach letter to Muriel Leach, 9 March 1934. FA.

81 Bernard Leach, impressions of sea-voyage to Japan, 1934. LA522–523.

82 *Ibid.*

83 *Ibid.*

84 *Ibid.*

85 *Ibid.*

86 Bernard Leach draft letter to Norah Braden, 1934. LA2594.

87 For a full account of his life see Sam King, *Tiger Balm King: Aw Boon Haw.* Times Books International, Singapore and Kuala Lumpur, 1992.

88 *Beyond East and West*, p. 173.

89 First agreed in 1921 and rescinded in 1934 when the Japanese government refused to accept any new naval agreement except on the basis of parity with Great Britain and the USA.

90 Bernard Leach, 'Travels in Southern Japan', 17 February 1935. LA11179.

91 *Beyond East and West*, p. 194.

92 *Hamada: Potter*, p. 100.

93 'Some reminiscences of Mr Leach's rough sketches by Mr Hamada', 11 September 1934. LA1567.

94 Now in the collection of Ōhara Museum of Art, Kurashiki, Japan.

95 Atsuya was later to work at the Leach Pottery in St Ives, 1957–8.

96 *Beyond East and West*, p. 184.

97 *Ibid.*, p. 183.

98 Bernard Leach, 'Travels in Southern Japan', 17 February 1935. LA11179.

99 The Nihon Mingeikan opened on 24 October 1936.

100 *Beyond East and West*, p. 195.

101 Bernard Leach, 'Travels in Southern Japan', 17 February 1935. LA11179.

102 The incident is fully described in *Kōgei* (Crafts), a monthly magazine chiefly devoted to oriental handicrafts, edited by Yanagi Sōetsu, Tokyo, May 1935.

103 *Beyond East and West*, p. 191.

104 1897–1986.

105 *Beyond East and West*, p. 192.

106 Harry Davis letter to Bernard Leach, n.d. [c. September–October 1934]. LA2597.

107 Bernard Leach letter to the Elmhirsts, 24 August 1934. LA5952.

108 Bernard Leach letter to the Elmhirsts, 15 January 1935. DA.

109 An American Lutheran minister.

110 See Alan Powers, 'A. R. Orage', *Crafts*, 1996, pp. 18–19.

111 Reggie Turvey letter to Bernard Leach, 2 February 1935. LA2598.

112 Bernard Leach, 'Travels in Southern Japan', 17 February 1935. LA11179.

113 Bernard Leach letter to the Elmhirsts, 24 August 1934. LA5952.

114 Bernard Leach, 'Travels in Southern Japan', 17 February 1935. LA11179.

115 *Ibid.*

116 *Beyond East and West*, p. 200.

117 Following the death of Janet Leach the vase was sold at auction for £330,000 in 1999, and the chest stood in Leach's living-room throughout his life. The pot is currently on show in the Korean Gallery, British Museum [2002].

118 Nick Pearce, 'The Rise of the Mingei Movement' in Yanagi Sori (ed.), *Mingei: Masterpieces of Japanese Folkcraft*. Kodansha International, Tokyo and New York, 1991, pp. 23.

CHAPTER NINE

1 Bernard Leach letter to the Elmhirsts, 18 January 1936. DA.

2 Among other books Ellis wrote *Studies in the Psychology of Sex*, seven volumes, 1897–1928.

3 Bernard Leach, *Beyond East and West*. Faber & Faber, London, 1978, p. 211.

4 This is often credited as 1936, but was more likely 1935.

5 Michael Cardew, interview, Tate Gallery Archives, TGA269 AB.

6 The full text is included in *Beyond East and West*, pp. 205–9.

7 Bernard Leach letter to the Elmhirsts, 20 November 1936. DA.

8 Fees charged were 5 guineas for one week, 8 for two and 10 for three with tuition in the morning and practice in the afternoon.

9 1914–95. See May Davis, *May Davis: Her Story*. Nelson, New Zealand, 1990.

10 *Ibid.*, p. 20.

11 Harry Davis letter to Bernard Leach, 10 November 1936. LA3114.

12 Bernard Leach letter to Harry Davis, 10 August 1937. LA3119.

13 *Ibid.*

14 Bernard Leach letter to Michael Cardew, 15 March 1937. CA.

15 Douglas Zadak (b. 1913), studied with Otto Lindig at the Bauhaus before moving to Britain in 1934.

16 Harry Davis letter to Bernard Leach, 8 August 1937. LA3118.

17 The Little Gallery moved from 3 to 5 Ellis Street in 1935.

18 Bernard Leach letter to the Elmhirsts, 4 December 1934. DA.

19 Bernard Leach letter to William Slater, 19 September 1935. DA.

20 Leonard Elmhirst letter to Bernard Leach, 15 January 1935. DA.

21 Bernard Leach letter to William Slater, 19 September 1935. DA.

22 *Ibid.*

23 William Slater letter to Leonard Elmhirst, 3 December 1935. DA.

24 Bernard Leach letter to Michael Cardew, 15 March 1937. CA.

25 Sven Berlin, *The Coat of Many Colours: Autosvenography*. Redcliffe Press, Bristol 1994, p. 234.

26 Bernard Leach letter to Mark Tobey, 5 June–27 July 1939. PC.

27 *Ibid.*

28 For a full outline of Bernard Leach's commitment to the Bahá'í faith see Robert Weinberg (ed.), *Spinning the Clay into Stars: Bernard Leach and the Bahá'í Faith*. George Ronald, Oxford, 1999.

29 Bernard Leach, 'My Religious Faith'. Privately printed.

30 Belief was such a powerful force for Michael that at one point with war looming he wrote to his father saying that he felt 'this war is a mistake, that we have nothing to fear of Hitlerism if we put our faith in God', though he did enlist when war was declared. Michael Leach letter to Bernard Leach, 14 September 1939. LA384.

31 William Morris employed boys from the Industrial Home for Destitute Boys in Euston Road, London. See Fiona MacCarthy, *William Morris: A Life for Our Time*. Faber & Faber, London, 1994, p. 175.

32 Jimmy James was a general craft salesman with many contacts working for the Leach Pottery 1939–40.

33 W. B. Dalton (1868–1965) head of Camberwell School of Arts and Crafts who initiated the setting up of the pottery department at the school.

34 Richard de la Mare letter to Bernard Leach, n. d. LA2943–3113.

35 Henry Bergen letter to Bernard Leach, n.d. LA3201.

36 Henry Bergen letter to Bernard Leach, 29 July 1937. LA3180.

37 Henry Bergen letter to Bernard Leach, n.d. LA3201.

38 Ibid.

39 Henry Bergen letter to Bernard Leach, 7 September 1937. LA3186.

40 Bernard Leach diary, 1968. LA317–3212.

41 Ibid.

42 Henry Bergen letter to Bernard Leach, 7 September 1937. LA3186.

43 6 June 1940.

44 25 Weatherby Mansions, Earls Court Square, London.

45 6 July 1940.

46 15 June 1946.

47 Bernard Leach, *A Potter's Book*. Faber & Faber, London, 1940, p. 120.

48 November 1941, pp. 169–70.

49 6 August 1940.

50 W. B. Honey letter to Bernard Leach, 19 August 1938. LA2856.

51 These included Kenneth Murray who produced designs for objects and Eric Ravilious patterns for existing shapes for Wedgwood. The Stoke firm of E. Brian & Co. invited designs from Vanessa Bell, Duncan Grant, Barbara Hepworth and Ben Nicholson, among many artists, but without any notable commercial success.

52 *A Potter's Book*, p. 21.

53 Inspired by Bergen's Marxist views and feeling some more meaningful link should be established, Michael Cardew volunteered to collaborate with industry at his own expense, spending some weeks in 1938 making teasets out of Spode body at the Copeland factory in Stoke in an effort to deal with form as well as decoration: (one of his Spode teacups is on show in the Potteries Museum and Art Gallery, Stoke-on-Trent [2001].) Disappointingly, his efforts aroused no interest

from industry leaving Cardew feeling that nothing was going to soften the hearts of people at Copeland, who he thought 'too self-satisfied'. Like Leach, he bewailed their neglect of studio potters in favour of 'artists like Ravilious with apparent reverence, as designers for pottery whereas it doesn't occur to them that a potter could make designs for them'. See Michael Cardew letter to Bernard Leach, 13 December 1938. LA2940.

54 See Margaret Pilkington 'Harry Norris', *Pottery Quarterly*, vol. 9, no. 35, pp. 92–4.

55 Harry Norris letter to Bernard Leach, 13 November 1936. LA2923.

56 Harry Norris letter to Bernard Leach, 6 September 1936. LA2921–2923.

57 1909–2001. A teacher at Ecclesfield Grammar School, Chapeltown, Sheffield, she later wrote a practical book on slipware.

58 1902–95. Gomperz, her maiden name, was soon to be dropped.

59 18 Albion Mews, London W2.

60 Lucie Rie retained the jar and after her death it passed to Janet Leach. See note 117, chapter eight.

61 1875–1953. As a weaver, Milne's textiles based on Bushongo woven raffia textiles of the Congo were much admired. Milne attended the Dartington Craft Conference in 1952.

62 Bernard Leach letter to Lucie Rie, 29 May 1943. RA.

63 Ibid.

64 Correspondence between Yanagi in Tokyo and Leach, 20 August 1937 – 31 August 1938. LA3259–3264.

65 Muriel Lanchester found the gallery like a mausoleum, with Muriel Rose looking like 'a personification of Jan Austin [sic] only minus the bustle'. Muriel Lanchester letter to Bernard Leach, 9 December 1939. LA3485.

66 Among the many craftspeople Leach contacted to support the AIA, Ethel Mairet was non-committal and Dora Billington replied with a complaint about 'subtle communist propaganda'. Bernard Leach letter to Michael Cardew, 15 March 1937. CA.

67 Bernard Leach letter to Muriel Rose, 29 May 1941. LA289.

68 An international community movement rooted in Anabaptist and early Christian traditions, committed to non-violence, justice, and fellowship.

69 A reluctant recruit, he twice refused to wear military uniform and was hauled in front of a military commander who, having just returned from Dunkirk was full of fury for Nazi Germany and felt totally unsympathetic to David's pleas sentencing him to twenty-eight days detention. On his release the order to wear uniform was repeated and again refused, resulting in three months in military prison. With neither civilian clothes nor army uniform he eventually returned to the camp shrouded only in a blanket to the

taunts of 'Gandhi'.

70 Cornish crib cake can still be bought in pastry shops in St Ives [2000]. Possibly named after crib, which is the Cornish for break. There is also a suggestion that a game of crib was played in the break.

71 Bernard Leach letter to David Leach, 7 April 1943. Quoted in full in Justin Howes (ed.), *Craft History One: Celebrating the Centenary of the Arts and Crafts Exhibition Society*. Combined Arts, Bath, 1988, pp. 69–72.

72 Kendall (1917–74), worked at the Leach Pottery from 1942 to 1944. He was head of the ceramics department at Camberwell School of Arts and Crafts in London, 1949–71, appointing Lucie Rie as a part-time lecturer, among other distinguished potters on to the staff.

73 For a full account see James Noel White, 'The Unexpected Phoenix: The Sutherland Tea Set' in Justin Howes (ed.), *Craft History One: Celebrating the Centenary of the Arts and Crafts Exhibition Society*. Combined Arts, Bath, 1988.

74 1891–1974. A wealthy supporter of the crafts and principle founder of the Red Rose Guild in 1921.

75 24 May 1944. Married according to the rites of the Bahá'í faith according to the will of Bahá'u'lláh.

76 7 July 1944.

77 Bernard Leach letter to Dorothy Elmhirst, 5 March 1945. DA.

78 Bernard Leach letter to David Leach, 21 July 1944. LA726.

79 *Ibid.*

80 *Ibid.*

CHAPTER TEN

1 A large number of applications came from ex-servicemen seeking more challenging and meaningful work. Leach received so many letters at this time that he had a postcard specially printed: 'I am receiving so many letters which are irrelevant to my job of making pots that I am forced into silence. Please do not misunderstand. Yours sincerely, Bernard Leach.'

2 Bernard Leach letter to the Elmhirsts, 7 November 1945. DA.

3 David Leach letter to Bernard Leach, 8 November 1944. LA400.

4 Sven Berlin, *The Coat of Many Colours: Autosvenography*. Redcliffe Press, Bristol, 1994, p. 234.

5 Purchase tax was introduced on various goods in 1940 and its level varied from time to time. It remained until replaced by Value Added Tax (VAT) in 1973.

6 Bernard Leach letter, 23 December 1946. LA982.

7 Like Kenneth Quick, Scott (b. 1936) was a relative of Bill Marshall. Scott Marshall pots at St Just, Penzance [2002].

8 Inspired by a fervent desire to produce pots in quantity that could be sold cheaply and so reach a wide market, they sought to make what later

became known as the 'one dollar pot', rapidly thrown and finished, but occasionally with a rough finish.

9 Harry Davis letter to Bernard Leach, 15 February 1949. FA.

10 1914–2000. Danish-born potter living in England who pioneered a collaboration between studio pottery and industry.

11 Michael Leach letter to Bernard Leach, 16 May 1950. LA404.

12 1914–89. For a full account see Barley Roscoe (ed.), *A Fine Line: Henry Hammond 1914–89: Potter and Educationalist*. Holburne Museum and Crafts Study Centre, Bath, 1992.

13 Warren MacKenzie b. 1924; Alix MacKenzie 1922–62. For a full account see David Lewis, *Warren Mackenzie: An American Potter*. Kodansha International, Tokyo, New York and London, 1991.

14 William Ohly was a painter and sculptor and also a German refugee. He set up the Berkeley Galleries at 20 Davies Street, London after the war. He knew Lucie Rie and this might have been the connection through which Leach was offered the exhibition. A short obituary appeared in *Pottery Quarterly*, Autumn 1955, no. 7, p. 117. Ohly had trained as a sculptor in Germany and, sympathetic to studio pottery, set up a pottery at the Abbey Art Centre at New Barnet where younger artists could work.

15 4–30 June 1946.

16 Illustrated in Oliver Watson, *Bernard Leach: Potter and Artist*. Crafts Council, London, 1997, plate 103.

17 Quoted in Oliver Watson, *Bernard Leach: Potter and Artist*. Crafts Council, London, 1997 (*Work*, no. 35), illustrated as plate 125.

18 Bernard Leach, *The Unknown Craftsman: A Japanese Insight into Beauty: Yanagi Sōetsu*. Kodansha International, Tokyo and New York, 1972, p. 88.

19 This was first broadcast on television in 1951. No copy has been identified in the BBC archives.

20 Listed as Bernard Leach, David Leach, Horatio Dunn, Frank Vibert, Aileen Newton, Valerie Bond, Mary Gibson Horrocks and Kenneth Quick, and dated 29 June 1946.

21 Bernard Leach, *Beyond East and West*. Faber & Faber, London, 1978, p. 224.

22 *A Potter's Book*, p. 14.

23 These included Victor Pasmore. He worked in the sombre Euston Road style of figurative work and for a time followed Whistler's freer approach, but after attending the Picasso exhibition he began seriously to experiment with abstraction, and was subsequently invited to visit St Ives by the progressive artists of the town.

24 *Beyond East and West*, p. 225.

25 *Ibid.*

26 Bernard Leach, 'American Impressions', *Craft Horizons*, vol. 10, no. 4, winter 1950. LA931.

27 *Ibid.*, p. 238.

28 These included Margaret Hine, William Newland, Nicholas Virgette and James Tower.

29 Head of the ceramics department at the Central School of Art and Craft.

30 Patrick Heron, 'Round the London Galleries', *Listener*, 13 September 1951, p. 428.

31 Bernard Leach letter to the Elmhirsts, 24 November 1945. DA.

32 President of the Board of Trade and later Chancellor of the Exchequer in the Labour administration.

33 The Red Rose Guild of Craftsmen, the Arts and Crafts Exhibition Society (now the Society of Designer-Craftsmen), the Society of Scribes and Illuminators, the Society of Wood Engravers and the Senefelder Club.

34 2 January 1947.

35 21 May 1948. Published by the Royal Society of Art, vol. 96.

36 21 May 1948. Published by the Royal Society of Art, vol. 96, p. 357.

37 System devised by Charles Bedeaux on time and motion.

38 Radios were only introduced to the Leach Pottery workshop when Leach had more or less ceased to be a regular visitor.

39 21 May 1948. Published by the Royal Society of Art, vol. 96, p. 367.

40 Bernard Leach, document, 6 January c.1946. LA14176.

41 Yanagi letter to Bernard Leach, 5 May 1946. LA11646.

42 Quoted in David Lewis, 'St Ives: A personal memoir, 1947–55', *St Ives 1939–64: Twenty-five years of painting, sculpture and pottery*. Tate Gallery, London, 1985, p. 23.

43 A company started by the Jowett brothers in 1901 which produced stylish and much admired saloons, sports and utility vehicles until 1954.

44 The design was never taken up, but illustrates Leach's willingness to collaborate with industry. For a brief discussion and illustration see Robin Kinross 'Herbert Read and Design' in David Goodway (ed.), *Herbert Read Reassessed*. Liverpool University Press, Liverpool, 1998, pp. 151–2.

45 Ben Nicholson, 'Notes on "Abstract" art' in *Ben Nicholson: A Retrospective Exhibition*. Tate Gallery, London, 1955.

46 David Lewis, 'St Ives: A Personal Memoir 1947–55' in *St Ives 1939–64: Twenty-five years of painting, sculpture and pottery*. Tate Gallery, London, 1985, p. 28.

47 The Wingfield Digby Collection of Leach pots (together with pieces by Hamada, Cardew and others associated with St Ives) is on loan to and displayed in the Tate St Ives.

48 Adjacent to the Tate St Ives, which regularly shows Wallis's work.

49 Leach also produced a set of tiles for the grave of Edgar Skinner, also buried in Barnoon Cemetery.

50 By Muhammad-i-Zadarandí (Nabíl-I-A'zam), translated from the Persian by Shoghi Effendi. The book is still regarded as a crucial text.

51 Headmaster of Redruth and Cambourne Art Schools, and later head of art teaching for Cornwall.

52 Bernard Leach letter to Mark Tobey, 4 July 1946. PC.

53 Bernard Leach letter to David Leach, 21 July 1944. LA6550 [726].

54 Bernard Leach letter to Reggie Turvey, 25 September 1948, quoted in Lowell Johnson, *Reginald Turvey: Life and Work*. George Ronald, Oxford, 1986.

55 Bernard Leach, *A Potter's Portfolio: A Selection of Fine Pots*. Lund Humphries, London, 1951. The book was reissued with additional writing in 1975 under the title *The Potter's Challenge*, edited by David Outerbridge.

56 *Beyond East and West*, p. 227.

57 Left 12 March 1949, returned to Northholt 10 April.

58 This probably included a proportion of standard ware.

59 *Beyond East and West*, p. 262.

60 The fee was 200 Swedish kronor.

61 b. 1929. Leach Pottery 1948–50.

62 1895–1978.

63 Bernard Leach, personal note. LA14087.

64 Bernard Leach postcard to Lucie Rie, 8 February 1950. RA.

65 Bernard Leach letter to Lucie Rie 10 March 1950. RA.

66 *Ibid.*

67 6–25 March 1950.

68 1889–1959. Head of the design department, who made salt-glazed domestic stoneware.

69 See Susan Peterson, 'Reflections: Part 1 – Leach at Alfred', *Studio Potter*, vol. 9, no. 2, June 1981.

70 1892–1979. The American Crafts Council grew out of Aileen Osborn Webb's efforts during the Depression, with America House established in 1940, the magazine *Craft Horizons* set up in 1943, the American Craftsmen's Co-operative, and later the School for American Craftsmen, the Museum of Contemporary Craft (1956) and the World Craft Council (1964).

71 For accounts of Aileen Osborn Webb see Rose Slivka, 'Our Aileen Osborn Webb', *Craft Horizons*, June 1977, pp. 10–13, and see Rose Slivka, 'Aileen Osborn Webb, David Campbell: A Reminiscence', *Craft Horizons*, August–September 1993, pp. 133–41.

72 David Shaner 'Shaner's Red', *Studio Potter*, December 1999, vol. 28, no. 1, p. 12. In fact Leach was inaccurate (Rosanjin did not die until 1959), unless the meeting took place during Leach's 1960 visit to the USA.

73 Mark Tobey letter to Bernard Leach, 4 April 1958. LA12239.

74 19 June 1950.

75 Bernard Leach, 'American Impressions', *Craft Horizons*, vol. 10, no. 4, winter 1950. LA931.

76 *Ibid*. Leach issued several 'impressions', all much in the same spirit.

77 Daniel Rhodes, *Stoneware and Porcelain: The Art of High Fired Pottery*. Pitman Publishing, London, 1978 (first published 1959), p. 39.

78 Bernard Leach letter to Lucie Rie, 10 March 1950. RA.

79 Report in *St Ives Times*, 10 February 1950.

80 15 August 1950. LA14087.

81 Louis Henry Sullivan (1856–1924), leading American architect, whose maxim 'form follows function' appealed to Leach.

82 Bernard Leach, 'American Impressions'.

83 B. 1913. For a full account see Tanya Harrod, *Primavera: Pioneering Craft and Design*. Shipley Art Gallery, Tyne and Wear Museums, 1995.

84 The fare cost £11.

85 Bernard Leach document, 26 September 1951. PA. Leach recorded the price of their hotel as '450 francs, tout compris, 9/- per day'.

86 Bernard Leach document, dated 27 September. PA.

87 *Ibid*.

88 1876–1953.

89 Accounts of the visit vary. One describes how Decoeur had just returned from an official engagement and was dressed in formal clothes before having to leave for another.

90 Bernard Leach, *Bernard Leach: A Potter's Work*. Evelyn, Adams & Mackay, London, 1967, p. 16.

91 Bernard Leach letter to Lucie Rie, 29 February 1952. RA.

92 Bernard Leach letter to Philip Mairet, 27 June 1952. LA 6497.

93 Cecilia Dunbar, later Lady Semphill, ran Dunbar Hay Ltd, a shop-gallery in Kilburn selling folk crafts and modern craftwork in the 1930s. Also on the panel was a representative of the Arts Council of Great Britain, Philip James (chairman), Her Majesty's Inspector and calligrapher Robin Tanner, Alec Heath the exhibition designer, and Peter Cox of the Dartington Trust. The dates were 17–27 July 1952.

94 Margo Coatts, 'The Dartington Conference of 1952' in David Whiting (ed.), *Dartington: 60 Years of Pottery 1933–1993*. Dartington Cider Press, 1993, p. 39.

95 German émigré (1929–81) who developed thrown and assembled thrown forms that are among some of the most important in the twentieth century.

96 Margo Coatts, 'The Dartington Conference of 1952', p. 41.

97 *Architectural Review*, vol. 112, November 1952, p. 344.

98 Included in Peter Cox (ed.), *The Report of the International Conference of Craftsmen in Pottery and Textiles July 17–27, 1952*. Dartington Hall, Devon, 1954. DA.

CHAPTER ELEVEN

1 Bernard Leach, 'Belief and Hope', *Fifty Years a Potter*. The Arts Council, London, 1961, catalogue.

2 David had spent six weeks helping Hans Peter Pfeiffer set up a pottery at Kjerringvik on the coast south of Sandefjord, Norway.

3 Bernard Leach, *Leach Pottery 1920–1952*. Pamphlet, St Ives, 1952. FA.

4 4 November 1952. RA.

5 Bernard Leach, *A Potter in Japan 1952–1954*. Faber & Faber, London, 1960, p. 25. Mainichi agreed an advance of 8,500 yen, 8 per cent royalty on the first edition and 10 per cent on subsequent editions. The account was published in Japan in Japanese in 1955 and in London in English in an extended form five years later.

6 Albers directed the programme from 1933 to 1949.

7 Susan Peterson, 'Bernard Leach: Two Recollections', *Studio Potter*, vol. 8, no. 1, 1979–80, p. 3.

8 Bernard Leach, 'The American Journey with Yanagi and Hamada', n.d. PC.

9 In the collection of the Nihon Mingeikan, the Japan Folk Craft Museum, Tokyo.

10 Bernard Leach letter to Janet Darnell, 'The American Journey with Yanagi and Hamada', n.d. PC.

11 *A Potter in Japan*, p. 34.

12 Susan Peterson, 'Bernard Leach: Two Recollections', *Studio Potter*, vol. 8, no. 1, 1979–80, p. 3.

13 1919–97.

14 Interview with author, 21 March 1997.

15 Janet Leach, 'Janet Leach: American Foreigner', *Studio Potter*, vol. 11, no. 2, June 1983, p. 77.

16 Bernard Leach, *Beyond East and West*. Faber & Faber, London, 1978, p. 245.

17 Born 1931.

18 She was born in Vienna in 1895 and moved to the USA in 1940, establishing a reputation as a portrait photographer.

19 Bernard Leach, *The Unknown Craftsman: A Japanese Insight into Beauty: Sōetsu Yanagi*. Kodansha International, Tokyo and Palo Alto, 1972, p. 132.

20 *Ibid*., p. 88.

21 Bernard Leach, 'The American Journey with Yanagi and Hamada', n.d., p. 4. PC.

22 17–29 November 1952.

23 The Foundation had been set up by Archie Bray on the property of the Western Clay Manufacturing Company two years earlier to provide facilities and advance ceramic studies in the state.

24 1924–2002. One of the most influential and significant potters of postwar America.

25 Autio (b. 1926) remained at Archie Bray until 1956.

26 Quoted in Rose Slivka and Karen Tsujimoto, *The Art of Peter Voulkos*. Kodansha International, Tokyo, 1995. This was a turning point in Voulkos's life as shortly afterwards he was invited to teach at

Black Mountain College where he came into contact with the ideas of the Abstract Expressionist painters stimulating him to produce more abstract sculptural forms in ceramics.

27 1884–1980.

28 For a full account of the visit see Susan Peterson, *The Living Tradition of Maria Martinez*. Kodansha International, Tokyo, New York and London, 1977.

29 Bernard Leach, 'The American Journey with Yanagi and Hamada', n.d., p. 6. PC.

30 *Ibid.*, p. 8.

31 1952. In the collection of the Victoria and Albert Museum.

32 1950. In the collection of the Nihon Mingeikan, Tokyo.

33 Bernard Leach, 'The American Journey with Yanagi and Hamada', n.d., p. 7. PC.

34 They later discovered that she was ill with a diabetic coma rather than exhaustion.

35 Bernard Leach, 'The American Journey with Yanagi and Hamada', n.d., p. 9. PC.

36 *Ibid.*

37 *Ibid.*, p. 10.

38 Charles Eames (1907–78) worked with his wife Ray (1912–88), and many ideas were developed together.

39 *Beyond East and West*, p. 248. Wildenhain could be contentious. She publicly cancelled her subscription to *Craft Horizons* because of the magazine's 'offensive' partisanship of Abstract Expressionist gestural works. Aileen Osborn Webb stood up for the magazine, but later underwrote the costs of publishing a book on Wildenhain's ceramics to show there was no ill will.

40 Marguerite Wildenhain letter to Bernard Leach, 17 December 1950. LA3875.

41 E. James Brownson, 'Midwest Craftsmen's Seminar', *Ceramics Monthly*, March 1953, pp. 10 and 28.

42 *Ceramics Monthly*, March 1953; April 1953. LA1728.

43 May–June 1953, pp. 43–4.

44 *A Potter in Japan*, p. 37.

45 Bernard Leach letter to Muriel and Betty Leach, 26 November 1952. FA.

46 Bernard Leach, 'The American Journey with Yanagi and Hamada', n.d., p. 6. PC.

47 Quoted in Nicole Coolidge Rousmaniere, 'Yanagi's America', *Studio Potter*, December 1996, vol. 25, no. 1, pp. 10–12.

48 US naval base scene of the Japanese attack in 1941 that destroyed much of the base and many of aircraft and warships, precipitating the US to enter the Second World War.

49 Bernard Leach diary, 14 February 1953. LA312.

50 *Beyond East and West*, p. 250.

51 Listed as the Horans, McVays, Sofos and Yanamoto. LA312.

52 *A Potter in Japan*, p. 80.

53 Bernard Leach letter to Muriel Leach, 6 March 1954. FA.

54 *A Potter in Japan*, p. 67.

55 *Ibid.*, p. 27.

56 *Ibid.*, p. 44.

57 A major department store. April 1953.

58 *A Potter in Japan*.

59 American professor (1853–1908), devotee of the Nō theatre and Buddhism, was a crucial figure in laying the foundations for a historical approach to art that would enable Japan's heritage to be evaluated and classified.

60 Quoted in Richard L. Wilson, 'Bernard Leach and the Kenzan School', *Studio Potter*, vol. 27, no. 2, June 1999, pp. 9–14. This article usefully discusses the relationship of Leach and the Kenzan tradition.

61 *A Potter in Japan*, p. 71.

62 This was later spelt as either Kōetsu or Koyetsu.

63 *A Potter in Japan*, pp. 88–9.

64 See Louise Allison Cort, *Shigaraki Potters' Valley*. Orchard Press/Kodansha International, Tokyo and New York, 2001, p. 295.

65 Bernard Leach, *Hamada: Potter*. Kodansha International, Tokyo and New York, 1975, p. 118.

66 Quoted in Yanagi Sori, *Mingei: Masterpieces of Japanese Folkcraft*. Japan Folk Crafts Museum. Kodansha International, Tokyo and New York, 1991, p. 15.

67 Bernard Leach letter to Muriel Leach, 9 August 1953. FA.

68 Illustrated in Bernard Leach, *Bernard Leach: A Potter's Work*. Evelyn, Adams & Mackay Ltd, London, 1967, plate 45.

69 *A Potter in Japan*, p. 194.

70 After being hewn from the hillside as hard rock the clay was pounded into powder by large wooden stamps operated by a mountain stream running into a bucket at one end that caused the stamp to lift. When full the bucket tipped over and emptied causing the stamp to fall, gradually crushing the clay rock to dust. When mixed with water the dust formed a good plastic body. The ingenious system, which harnessed natural forces and operated twenty-four hours a day, provided sufficient material for the potters' needs. Some years earlier, in an attempt to encourage the potters to modernize, officials had installed power-driven machinery that had proved costly and too efficient, swamping the potters with clay. Eventually, without being oiled or cared for the machinery had seized up and the traditional system was reintroduced and equilibrium restored.

71 Quoted in Brian Moeran, *Lost Innocence: Folk Craft Potters of Onta, Japan*. University of California Press, Berkeley, Los Angeles and London, 1984, p. 121.

72 In the collection of Asahi Beer Oyamazaki Villa Museum.

73 For a detailed account of this visit see Bernard Leach, 'Onda Diary', *Pottery Quarterly*, winter 1955, no. 4, pp. 3–11.

74 Around 80 miles from Tokyo. Then 300 men and

women were occupied in pottery work in some forty workshops. Hamada employed his own team and had his own kiln.

75 With his team of potters Hamada produced four distinct types of ware: pots thrown and decorated by him, those made to his design and decorated by him, and pieces made and decorated by assistants under his supervision, all of which he would put his name to. The fourth group consisted of pots produced at the pottery in his style but without his supervision.

76 Bernard Leach letter to Muriel Rose, 23 August 1953. FA.

77 Crowned 2 June 1953.

78 Mildred Lockyer had worked at the Leach Pottery after studying at the Royal College of Art. She recommended that a practical potter be appointed to run the ceramic department.

79 'Pottery from Loughborough College', Pottery Quarterly: A Review of Ceramic Art, winter 1955, no. 4.

80 Bernard Leach diary entry, 16 June 1953. LA312.

81 Starting September 1953.

82 Colin Pearson and his wife Lesley were appointed as assistants to run the pottery, but when their left-wing views were discovered by Lynch they were dismissed and potters brought over from Portugal.

83 Bernard Leach letter to Muriel Leach, 13 August 1954. FA.

84 Bernard Leach letter to Muriel Rose, 23 September 1953. FA.

85 Bernard Leach letter to the Elmhirsts, 10 April 1955. DA.

86 Dated 6 March 1953. PC.

87 Bernard Leach letter to Janet Darnell, 10 October 1954. PC.

88 Bernard Leach diary, 9 January 1954. LA313.

89 Bernard Leach diary, 28 February 1954. LA313.

90 1871–1954.

91 Bernard Leach diary, 24 January 1954. LA313.

92 Bernard Leach, Drawings, Verse and Belief. Adams & Dart, Bath, 1973, p. 22.

CHAPTER TWELVE

1 Rudolph Steiner (1861–1925), Austrian founder of anthroposophy. He evolved a study of spiritual concerns opposed to conventional occultism, his educational theories of using the arts therapeutically were widely influential.

2 February 1954, agreeing she could arrive in the summer.

3 Bernard Leach letter to Janet Darnell, 8 August 1953. PC.

4 For a full description of pottery-making at Hamada's pottery see Janet Leach, 'With Hamada in Mashiko', Pottery Quarterly: A Review of Ceramic Art, autumn 1956, no. 11, pp. 97–102, with illustrations.

5 Janet Darnell letter to Bernard Leach, 12 November 1955. PC.

6 Planned as an account of the beauty and techniques of pottery from all over the world, the book was never completed for Yanagi had a disabling stroke shortly after Leach's return to England, though he was able to work on other projects.

7 Colloquially known as benjo.

8 Bernard Leach diary, 23 February 1954. LA313.

9 Bernard Leach letter to Janet Darnell, 19 September 1954. PC.

10 16–21 November 1954.

11 Departed 26 November 1954 by BOAC for Cyprus.

12 For a full account see Janet Leach, 'Tamba', Pottery Quarterly: A Review of Ceramic Art, spring 1957, no. 13, pp. 8–17, with illustrations.

13 Bernard Leach letter to Janet Darnell, 24 September 1954. PC.

14 Bernard Leach diary, 26 November 1953. LA312.

15 Bernard Leach, Beyond East and West. Faber & Faber, London, 1978, p. 302.

16 Born Mary Sutherland Maxwell, married Shoghi Effendi in 1937, appointed a Hand of the Cause in 1952.

17 At the 1955 Bahá'í summer school, Leach was asked to suggest an architect for the Temple at Kampala and put forward the name of Maxwell Fry. Unfortunately Fry's design was totally unlike his usual style and sought to speak in what he imagined was a Bahá'í idiom. The result was considered disastrous.

18 Beyond East and West, p. 303.

19 Bernard Leach letter to Janet Darnell, 25 June 1955. PC.

20 Tregenna Hill Pottery is illustrated in Pottery Quarterly: A Review of Ceramic Art, autumn 1957, vol. 4, no. 15. Quick made well designed tablewares with a light oatmeal glaze and rust-coloured brush decoration.

21 At the first Penwith Arts Ball in 1950, Leach, dressed as a Ben Nicholson drypoint, had won a prize for best costume.

22 Bernard Leach letter to Janet Darnell, 12 December 1954. PC.

23 Janet Leach retained many of Leach's airmail letters to her and carbon copies of hers to him.

24 Bernard Leach letter to Mark Tobey, 28 November 1956. PC.

25 Bernard Leach letter to Janet Darnell, 14 April 1955. PC.

26 Janet Leach letter to Betty Diver, Threefold Farm, n.d., [c. January 1955].

27 Bernard Leach letter to Janet Darnell, 23 September 1954. PC.

28 23 March 1955.

29 4 May 1955.

30 Bernard Leach to Reggie Turvey, 18 June 1955, quoted in Lowell Johnson, Reginald Turvey: Life and Work. George Ronald, Oxford, 1986.

31 Bernard Leach letter to Janet Darnell, 21 September 1955. PC.

32 A letter from Yanagi quoted by Bernard Leach to Janet Darnell, 22 May 1955. PC.

33 23 June 1955. *Yanagi Sōetsu Zenshū* (Collected Works of Yanagi Sōetsu). Chikuma Shobō, Tokyo, 1981, vol. 21 (part 3), p. 610.

34 Interview with author, 31 October 1996.

35 This had previously been occupied by the Ehlers, who were friends of Lucie Rie.

36 12 November 1955. LA12124.

37 Bernard Leach letter to Laurie Leach, 21 December 1955. Divorce papers.

38 Bernard Leach letter to Janet Darnell, 3 December 1955. PC.

39 Married under the name of Janet Darnell Roland, of Buena Siesta, Upper Stennack, St Ives, father Charles Walter Darnell, bread company agent, previous marriage dissolved. Roland remains a mystery, but may have been the name of a previous husband.

40 Bernard Leach letter to Mark Tobey, 24 April 1956. PC.

41 Bernard Leach letter to John Leach (grandson), 26 June 1960. FA.

42 Eldest son of David, born 1939.

43 Bernard Leach letter to John Leach, 26 June 1960. FA.

44 Richard Batterham and Dinah Dunn were married shortly after.

45 Quick lived in St Ives and had a friend Norman Stocker, a car mechanic with a wooden leg, who sometimes worked for Barbara Hepworth.

46 Gwyn John (b.1935) planned to marry her Australian fiancé at St Ives, all preparations were made and Janet baked a cake, but on the wedding eve Gwyn cancelled the wedding and subsequently married Louis Hanssen, a poet who later became a potter. See *Studio Potter* (USA), December 1991, pp. 46–50.

47 B.1929. Paid a wage of £2 10s od (£2.50) a week.

48 1933–2002.

49 B.1935, Leach Pottery 1961–3.

50 B.1939, Leach Pottery 1963–5.

51 Quoted in Gwyn Hanssen Pigott, 'Autobiographical Notes', *Studio Potter*, December 1991, p. 48.

52 Donna Balma, unpublished autobiographical account.

53 Quoted in Donna Balma and Scott Watson, 'Bernard Leach and his Vancouver Students', *Ceramics*, 1946–59, (Canada), pp. 102–7.

54 Eugen Herrigel, *Zen in the Art of Archery*, first published 1953. Herrigel's book expounds the idea that archery is not merely a sport or form of self-defence, but an art and a religious ritual, and one of the many paths to enlightenment.

55 The Craftsmen Potters Association (now Craft Potters Association) was set up in 1958 as a co-operative Friendly Society.

56 1952. See LA4386–4387, 4147. Bernard Leach was later made an honorary member and the Leach Pottery joined in the early 1970s.

57 Gwyn Hanssen Pigott, 'Autobiographical Notes', pp. 46–50. *Yunomi* is a tea-bowl, *shibui* refers to

quiet, imperfect beauty, described by Yanagi as the 'infinite mysteries of beauty'. Bernard Leach, *The Unknown Craftsman: A Japanese Insight into Beauty*. Kodansha International, Tokyo and Palo Alto, 1972, p. 184.

58 Donna Balma, unpublished autobiographical account.

59 Bizen and Tamba were two of the oldest pottery sites in Japan. The pots produced here were characterized by long slow firings with wood, taking several days, which coloured and textured the surface of the pots giving them an earthy, organic quality.

60 One national museum did, however, attribute one of her early slab-built pots to Bernard Leach, despite it bearing no resemblance to his usual work.

61 14–24 October 1959.

62 *Beyond East and West*, p. 258.

63 Bernard Leach letter to the Elmhirsts, 18 March 1957. DA.

64 'Leach Pottery', *Pottery Quarterly: A Review of Ceramic Art*, summer 1956, no. 10, p. 77, with illustrations.

65 'Pilgrim bottle' (h. 28 cm). Victoria and Albert Museum (c.498–1956). For the exhibition review see 'Leach Pottery', *Pottery Quarterly: A Review of Ceramic Art*, summer 1956, no. 10, p. 77, with illustrations.

66 The comment was usually applied to the plays of Arthur Miller.

67 *Time*, 16 February 1959, pp. 80–1. The exhibition went to three other venues including the Metropolitan Museum of Art, New York.

68 4–14 March 1958.

69 *Pottery Quarterly: A Review of Ceramic Art*, spring 1958, vol. 5, no. 17, p. 34, with illustrations.

70 Now the Surrey Institute of Art and Design University College.

71 Bernard Leach letter to Lucie Rie, 10 September 1957. RA.

72 27 December 1957–3 January 1958. The conference also included visits to the collection of Sir Alan and Lady Barlow at their Arts and Crafts-style house, Boswells, near Wendover, in the Chilterns, and the British Museum.

73 B.1925. Potter and editor of *Crafts Review* and *Pottery Quarterly: A Review of Ceramic Art*.

74 Donna Balma unpublished autobiographical account.

75 *Pottery Quarterly: A Review of Ceramic Art*, vol. 7, no. 26, 1961, pp. 75–7.

76 M. C. Richards 'Leach: East and West', *Craft Horizons*, July–August 1960, pp. 36–8.

77 Quoted by Leach in letter to Warren MacKenzie, January 1960. PC.

78 The order was later cancelled as impractical.

79 Bernard Leach letter to Warren MacKenzie, 20 August 1960. PC.

80 The show included pots by Michael Cardew (3), Katharine Pleydell-Bouverie (9), Norah Braden (5), William Staite Murray (11), T. S. Haile (5),

Dan Arbeid (3), Ian Auld (5), Hans Coper (13), Ruth Duckworth (3), Janet Leach (6), Peter O'Malley (3), William Marshall (4), Helen Pincombe (4), Lucie Rie (21), James Tower (3), Harry and May Davis (3), David Leach (3), Leach Pottery (14), Marianne de Trey and Geoffrey Whiting. With over half the exhibitors having had a direct association with the Leach Pottery, the show illustrated the extent of Leach's influence at the time.

81 Bernard Leach letter to Mark Tobey, 18 March 1958. PC.

82 Janet Leach letter to Dorothy Elmhirst, 1959. DA.

83 Bernard Leach letter to Mark Tobey, 28 November 1956. PC.

84 Reggie Turvey letter to Bernard Leach, 30 May 1958. LA12144.

85 Bernard Leach letter to Mark Tobey, 30 July 1957. PC.

86 Ibid.

87 Three years later Maurice and his family emigrated to Australia, later returning to England.

88 Bernard Leach letter to Lucie Rie, 25 October 1960. RA.

89 The award was made on 7 June 1972. Hamada was awarded an honorary doctorate a year later, 6 July 1973.

90 P. J. Hodin, Introduction in Bernard Leach: 50 Years a Potter. Arts Council of Great Britain, London, 1961, p. 14.

91 13 January 1961. Such a large number astonished the Arts Council, and at the end of the visit members had to wash up.

92 Bernard Leach letter to Mark Tobey, 14 February 1961. PC.

93 20 January 1961.

94 5 January 1961. LA4664.

95 Geoffrey Whiting, 'Bernard Leach – Fifty Years a Potter', Pottery Quarterly: A Review of Ceramic Art, vol. 7, no. 26, 1961, pp. 65–6. Whiting was a distinguished potter working in the 'Leach tradition'.

96 Eric Newton, 'The Pottery of Bernard Leach', unidentified cutting. LA1467.

97 9–23 January 1961.

98 The foundation had resources of $125,000 to assist visiting lecturers from Europe.

99 Pottery Quarterly: A Review of Ceramic Art, vol. 6, no. 23, 1961, pp. 79–83.

100 Bernard Leach, 'In Reply to Paul Brown', Pottery Quarterly: A Review of Ceramic Art, vol. 6, no. 24, 1959, pp. 121–6.

101 Bernard Leach letter to Lucie Rie, 16 March 1960. RA.

102 Janet Leach, 'A Few Impressions of Current American Pottery', Pottery Quarterly: A Review of Ceramic Art, vol. 7, no. 25, 1961, pp. 12–16.

103 Bernard Leach letter to Lucie Rie, 16 March 1960. RA.

104 Bernard Leach letter to Warren MacKenzie, 16 March 1960. PC.

105 'Leach in the USA', Craft Horizons, July–August 1960, p. 38.

106 Ibid.

107 Bernard Leach letter to Lucie Rie, 16 March 1960. RA.

108 John P. McElroy, 'A Visit from Bernard Leach', Studio Potter, December 1958, vol. 27, no. 1, pp. 18–19.

109 Ibid.

110 Ibid.

111 Ibid.

112 Bernard Leach letter to Warren MacKenzie, 8 August 1960. PC.

113 1933–2002. Leach Pottery 1959–62, 1978–9. Made pots at Lambertville, New Jersey.

114 Bernard Leach in letter to Warren MacKenzie, 16 May 1960. PC.

115 Janet Leach, 'A Few Impressions of Current American Pottery'.

CHAPTER THIRTEEN

1 Bernard Leach lettercard to Michael and family, 20 December 1957. FA.

2 Genesis 2: 17.

3 Quoted in Donna Balma and Scott Watson, 'Bernard Leach and his Vancouver Students', Ceramics, 1946–59 (Canada), pp. 102–7.

4 1903–86. South African-born composer of modern music.

5 Distinguished writer on Shakespeare and on Cornwall.

6 Bernard Leach to Donna Balma, 24 May 1961. PC.

7 3 May 1961.

8 Bernard Leach letter to Mark Tobey, 17 May 1961. PC.

9 Bernard Leach letter to the MacKenzies, 29 August 1960. PC.

10 Bernard Leach letter to Richard and Jessamine Kendall, 10 October 1961. PC.

11 Bernard Leach letter to Mark Tobey, 17 August 1961. PC.

12 Ibid.

13 July 1961.

14 Bernard Leach draft of essay, c. 1960. LA11225.

15 Bernard Leach talk to the Craftsmen Potters Association, [c. 1964], Aberystwyth, no. VA. 036(b)F, tape no. 22.

16 Bernard Leach 'Hail and Farewell', 20 November 1961. LA1021.

17 Bernard Leach letter to Lucie Rie, 24 September 1961. RA.

18 Ibid.

19 Bernard Leach, Beyond East and West. Faber & Faber, London, 1978, p. 269.

20 Ibid., p. 274.

21 Ibid., p. 269.

22 Ibid., p. 270.

23 For a full account of this incident see Richard L. Wilson, The Art of Ogata Kenzan: Persona and Production in Japanese Ceramics. Weatherhill, New

York and Tokyo, 1991, pp. 192–9.

24 Fujioka Ryōichi and Hayashiya Seizō respectively.

25 Bernard Leach letter to Lucie Rie, 24 September 1961. RA.

26 *Beyond East and West*, p. 275.

27 Bernard Leach, *Kenzan and His Tradition*. Faber & Faber, London, 1966, p. 96.

28 *Beyond East and West*, p. 275.

29 In search of a more fulfilling experience he went to work for Colin Pearson, the potter who after taking over from David Leach at Aylesford Priory had set up his own pottery in the town of Aylesford producing a range of straightforward, high-quality tableware.

30 24 September 1961. RA.

31 Leach Pottery 1963–4.

32 B. 1940. Leach Pottery 1964–5.

33 18 September 1961.

34 *Beyond East and West*, p. 277.

35 B. 1923 in New Zealand, helped set up the Japan Society of New Zealand.

36 23 January–24 February 1962.

37 Leach remembered seeing Brickell's small gauge railway, but this was built subsequent to his visit, though the potter did make use of a steam engine. Barry Brickell discusses his small kiln in 'Drip Kiln – Further Hints', *Pottery Quarterly: A Review of Ceramic Art*, vol. 6, no. 23, 1961.

38 Bernard Leach letter to Lucie Rie, 27 February 1962. RA.

39 Bernard Leach letter to Warren MacKenzie, 5 February 1962. PC.

40 Bernard Leach, 'To New Zealand Potters', *New Zealand Potter*, vol. 5, no. 1, August 1962, pp. 5–7.

41 Bernard Leach letter to Lucie Rie, 27 February 1962. RA.

42 'Thoughts from an Architect', *New Zealand Potter*, vol. 1, no. 2, December 1958, pp. 7–9.

43 Bernard Leach to Warren MacKenzie, 5 February 1962. PC.

44 Bernard Leach letter to Mark Tobey, 8 March 1962. PC.

45 *Ibid.*, 29 November 1963. PC.

46 1883–1959 A potter who thought the tea ceremony tedious and found inspiration in such unlikely forms as auction catalogues.

47 Jeff Oestreich (student at the Leach Pottery 1969–71), letter to author 1997.

48 Janet Leach, *Ceramic Review*, no. 18, November–December 1972.

49 Bernard Leach letter to Mark Tobey, 23 January 1963. PC.

50 Bernard Leach letter to Warren MacKenzie, 6 July 1962. PC.

51 Bernard Leach letter to Mark Tobey, 29 November 1963. PC.

52 Kenneth Quick letter to Bernard Leach, 14 March 1961. LA4691.

53 22 July 1963.

54 8 June 1963.

55 Bernard Leach letter to Horiuchi, 10 June 1963. LA12382.

56 *Ibid.*

57 Bernard Leach letter to Reggie Turvey, 20 June 1963. Quoted in Lowell Johnson, *Reginald Turvey: Life and Art*. George Ronald, Oxford, 1986.

58 Edited by David Outerbridge. Published in the USA by E. P. Dutton & Co., and in the UK by Souvenir Press Ltd, London, 1976.

59 Bernard Leach letter to Mark Tobey, 23 January 1963. PC.

60 *Ibid.*, 26 May 1963. PC.

61 Bernard Leach, *Drawings, Verse and Belief*. Adams & Dart, Bath, 1973, p. 3.

62 Bernard Leach letter to Mark Tobey, 29 November 1963. PC.

63 Jack Worseldine and wife, Marylyn, Archie Peters (clay), Brian Ilsley (packing), Micky Henry, Patricia Ashmore, Mireck Smirsek, Bill Marshall. The names of Glenn Lewis, Jean Mallick and Joan Thums were crossed out.

64 Bernard Leach letter to Warren MacKenzie, 10 June 1962. PC.

65 *Ibid.*

66 Bernard Leach, memoir, written in Kyoto, 10 November (1962?). LA11228.

67 Bernard Leach letter to Mark Tobey, 24 August 1966. PC.

68 *Ibid.*

69 *Ibid.*, 26 May 1963. PC.

70 *Ibid.*

71 Trudi Scott letter to Lucie Rie, 5 June 1979. RA.

72 Bernard Leach letter to Reggie Turvey, 24 June 1964. Quoted in Lowell Johnson, *Reginald Turvey: Life and Art*.

73 *Ibid.*

74 'Stoneware and Porcelain', 29 October–9 November 1963.

75 23 May 1962.

76 November 1963, 3 rue de Faubourg, Saint Honoré.

77 For an account of her career see Jacqueline du Pasquier, *Fance Franck: Poteries et Porcelains*. Musée des Arts Décoratifs de la ville de Bordeaux, catalogue, 1976.

78 In the visitors' honour Francine threw a party, offering among other delicacies twenty-six different French cheeses. When the guests had left at 2 a.m. she took Leach and Hamada to a seafood restaurant where Leach ate, and enjoyed, sea urchins, a delicacy he had hitherto declined. This prompted Hamada to accuse him of 'English conservatism' in being unwilling to taste the dish before.

79 Place de Fontenoy, Paris 7e, 7 November 1963.

80 Bernard Leach, 'Potter's Voices from East and West', UNESCO, November 1963. LA11366.

81 Light out of the East.

82 20 November 1963.

83 In 1972 renamed the British Crafts Centre and later Contemporary Applied Arts.

84 For a full account see Tanya Harrod, *The Crafts In Britain in the Twentieth Century*. Yale University Press, New Haven and London, 1999.

85 Bishop Otter College, Sussex, 24 August–6 September 1962.

86 Bernard Leach, 'Education and Art', August 1963. LA11240.

CHAPTER FOURTEEN

1 Bernard Leach, poem to Trudi Scott, 1964. LA14214.

2 Over 100,000 Japanese and nearly 50,000 US soldiers were killed in the encounter.

3 For a full account of Okinawan arts and crafts see Bernard Leach, *The Unknown Craftsman: A Japanese Insight into Beauty*. Kodansha International, Tokyo and Palo Alto, 1972, pp. 158–70.

4 The island was occupied by the Nationalist Chinese when they were driven from the mainland by Chinese Communist forces in 1949. Matsu Island, Quemoy, was heavily bombarded from the mainland in 1958, an incident that caused the redeployment of the US 7th Fleet and provoked an international diplomatic crisis.

5 The others are Tokoname, Shigaraki, Tamba, Bizen and Echizen.

6 Dated 29 April 1964. LA11394.

7 Bernard Leach, 'My farewell letter to craftsmen in Japan', 24 November 1964. LA11244.

8 *Ibid.*

9 *Ibid.*

10 1877–1947, Indian writer, mainly on the arts, and prominent in the revival of Indian culture.

11 Bernard Leach, 'My farewell letter to craftsmen in Japan', 24 November 1964. LA11244.

12 Honan taught that all that was needed for salvation was the invocation of Amida; Shinran said that the mercy of Amida was so extensive that it embraced all that is known as sin and so invocation was unnecessary; Ippen Shonin bridged the apparent difference between Jodo and Zen Buddhism by insisting upon the principle of Immanence, that is man in Amida or God, who created a paradise for his followers and was sometimes known as Amitabba.

13 Bernard Leach, *Beyond East and West*. Faber & Faber, London, 1978, p. 300.

14 *Ibid.*

15 Bernard Leach to Glenn Lewis, 24 August 1964. PC.

16 *Ibid.*

17 Bahá'í emphasis is on group leadership, but some individuals are recognized for their spiritual capacities, foremost among whom are the 'Hands of the Cause of God', of whom only forty-seven have been appointed.

18 Bernard Leach to Mark Tobey, 5 July 1966. PC.

19 Lafcadio Hearn, *In a Japanese Garden*.

20 Bernard Leach letter to Theyre Lee-Elliott, 13 July 1966. FA.

21 Bernard Leach, *Kenzan and his Tradition*. Faber & Faber, London, 1966.

22 Bernard Leach letter to Mark Tobey, 13 June 1966. PC. Henricus Anthonius Van Meegeren (1889–1947) painted a series of fakes of seventeenth-century Dutch artists, such as Vermeer, which at the time many art historians and connoisseurs argued were genuine, though they were poorly done.

23 Possibly dated 4 June 1966. LA10990.

24 For a full description of this hotel see Bernard Leach, *A Potter in Japan*, Faber & Faber, London, 1960, p. 56.

25 1558–1632. Calligrapher and arbiter of taste, founder of an artistic community at Takagamine.

26 Barbara Hepworth letter to Bernard Leach, 18 September 1964. LA12405.

27 Bernard Leach letter to Reggie Turvey 24 June 1964, quoted in Lowell Johnson, *Reginald Turvey: Art and Life*. George Ronald, Oxford, 1986.

28 *Ibid.*

29 *Ibid.*

30 Bernard Leach letter to Mark Tobey, 8 January 1966. PC.

31 Bernard Leach letter to Warren MacKenzie, 22 February 1965. PC.

32 *Kenzan and his Tradition.*

33 *Times Educational Supplement*, 13 January 1967.

34 Review in *Times Educational Supplement*, 5 June 1964.

35 1920–81.

36 Stoneware by Marianne de Trey and John Reeve, February 1965.

37 Bernard Leach to Warren MacKenzie, 22 February 1965. PC.

38 Ruskin moved there in 1872 and remained until his death in 1900.

39 24 November 1965. LA 11359.

40 Victor Margrie letter to Bernard Leach, 30 September 1965. LA 5119.

41 Robert Boyle (1627–91) observed in 1663 that if subjected to natural or artificial radiation many minerals emit energy in the form of light when stimulated by thermal agitation, an effect that provides a convenient way of measuring radiation dosages and of estimating the age of archaeological specimens.

42 29 July 1965.

43 Bernard Leach talk to the Craftsmen Potters Association [c. 1960] Aberystwyth, tape no. 19, cat. no. VA.036.

44 Frank Wintlew, 'The Bridge Builder from St Ives', unidentified newspaper cutting, 1975. LA13771.

45 18 March 1967. LA 13881.

46 WCC meeting, 18 March 1967. LA13881.

47 The box was inscribed 'Bernard Leach, potter, World Crafts Council, Dublin, 1970. In grateful recognition of his inspiration to craftsmen throughout the world'.

48 Bernard Leach letter to Mark Tobey, 19 June 1974. PC.

49 Bernard Leach, private papers dated 14 August 1970. PC.

50 22 March–2 April 1966.

51 These were Ruben Nuñez, Mercedes Pardo, Cristina Merchan, Alejandro Otero, Maria Luisa Zuloaga de Trovar, Tecia Tófano, Rema Herrere, and Thekla and Gottfried Zielke.

52 *Daily*, 24 April 1966.

53 For a full account see Jack Troy, 'Bernard Leach: An Earnest Presence', *Studio Potter*, June 1999, vol. 27, no. 2, pp. 28–30.

54 When full the basket was hung and pulled with both hands to squeeze the paste into a bowl, the residue being eventually baked to make a sort of bread.

55 6 October 1966. LA12421.

56 Murray Fieldhouse letter to Bernard Leach, 16 October 1959. LA12346.

57 A term coined by Yanagi and quoted in the introduction by Leach to the monograph/catalogue of his retrospective in Japan in 1966.

58 Bernard Leach letter to Mark Tobey, 5 July 1966. PC.

59 November 1966.

60 Oscar Oeser, letter to friends, Tokyo, December 1966. LA12422.

61 Bernard Leach letter to Lucie Rie, 1 December 1966. RA.

62 Bernard Leach letter to Mark Tobey, 24 August 1966. PC.

63 *Ibid.*

64 19 April 1967.

65 Bernard Leach letter to Mark Tobey, 12 May 1967. PC.

66 3 May 1967.

67 Old Brompton Road.

68 1 December 1967–7 January 1968.

69 *Beyond East and West*, p. 286.

70 Bernard Leach to Glenn Lewis, 17 August 1967. PC.

71 November 1966.

72 Recently moved from Lowndes Court, Carnaby Street, London W1 to a new building at 7 Marshall Street, W1.

73 Bernard Leach letter to Glenn Lewis, 5 November 1966. PC.

74 Most potters sent pots regarded as 'firsts' to shops, galleries and exhibitions, and often sold 'seconds' from their own workshop or studio clearly labelled as such. The problem with this was that when they had left the studio, the potter had no control over their labelling and the pots may subsequently be labelled as 'firsts'.

75 Bernard Leach, *A Potter's Book*. Faber & Faber, London, 1940, p. 24.

76 Bernard Leach letter to David Leach, 4 January 1968. PC.

77 7–22 June, 1968. Primavera had by then moved to Walton Street, behind Sloane Street.

78 Bernard Leach letter to Mark Tobey 8 September 1968. PC.

79 Bernard Leach letter to Lucie Rie, n.d., 1968. RA.

80 The honour was also offered to Ben Nicholson but given the bitterness of his relationship following his divorce from Barbara Hepworth he declined as one of the conditions was that it had to be collected in person.

81 *St Ives Times and Echo*, 27 September 1968. LA1760.

82 *Ibid.*

83 *Ibid.*

84 October 1967. RA.

85 *Ibid.*

86 Bernard Leach letter to Mark Tobey 7 July 1968. PC.

87 Bernard Leach letter to Mark Tobey 9 June 1969. PC.

88 *Ibid.*

89 For a full account of this visit see Janet leach, 'A Letter from Japan', *Pottery Quarterly: A Review of Craft Pottery*, vol. 9, no. 36.

90 Bernard Leach letter to Mark Tobey 9 June 1969. PC.

91 Moon landing 20–1 July 1969.

CHAPTER FIFTEEN

1 Bernard Leach, 'A Reaction to the Unknown Craftsman', 30 September 1972. LA807.

2 Bernard Leach letter to Mark Tobey, 15 April 1970. PC.

3 Bernard Leach, *Beyond East and West*. Faber & Faber, London, 1978, p. 265.

4 Bernard Leach letter to Mark Tobey, 15 April 1970. PC.

5 Bernard Leach, 'A Reaction to the Unknown Craftsman', 30 September 1972. LA807.

6 *Ibid.*

7 Bernard Leach letter to Lucie Rie, 21 April 1970. RA.

8 *Ibid.*

9 Kodansha International, Tokyo and Palo Alto, 1972.

10 Bernard Leach letter to Kim Schuefftan, 4 June 1972. LA5545.

11 Bernard Leach, *Hamada: Potter*. Kodansha International, Tokyo and New York, 1975, p. 15.

12 Bernard Leach letter to Mark Tobey, 29 August 1972. PC.

13 Bernard Leach diary, 17 March 1970. LA319.

14 Bernard Leach letter to Lucie Rie, 21 April 1970. RA.

15 Bernard Leach letter to Mark Tobey, 19 June 1974. PC.

16 *Ibid.*

17 Bernard Leach letter to Mark Tobey, 19 March 1972. PC. A slightly different version of this poem appeared in *Drawings, Verse and Belief*, 'Tea-Leaves', p. 68.

18 Bernard Leach, *Drawings, Verse and Belief*. Adams & Dart, Bath, 1973, p. 6.

19 Bernard Leach letter to Philip Mairet, 30 March 1974. LA5641.

20 Bernard Leach, *Drawings, Verse and Belief*, second edition, Jupiter Books, London, 1977. This edition was eventually remaindered, much to Leach's annoyance, and he wrote to the publisher complaining about poor distribution.

21 *Drawings, Verse and Belief*, p. 8.

22 *Ibid.*

23 *Ibid.*

24 Lebanese-American philosophical essayist, novelist, mystical poet, and artist (1883–1931). Gibran's works were especially influential in American popular culture in the 1960s.

25 I am grateful for discussions with Dermod Knox pointing out some of the difficulties Leach experienced.

26 *Drawings, Verse and Belief*, p. 9. Leach was probably referring to the three great Bahá'í leaders: Báb, the Prophet-Founder of the Faith; Bahá'u'lláh, Prophet-Founder of the Faith and the Manifestation of God for this Day; and his son Abdu'l-Bahá.

27 *Ibid.* 'The universal parliament of man', was used by Tennyson in 'Locksley Hall'.

28 I am greatly indebted to the poet Dr Frederick Grubb for illuminating discussions on Leach's poetry.

29 Montagu Collet Norman (1871–1950), financier, director of the Bank of England in 1907 and governor 1920–44, often portrayed as a sinister figure and the archetypal financier of the First World War.

30 *Drawings, Verse and Belief*, p. 16.

31 'This Clay', *Drawings, Verse and Belief*, p. 24.

32 'When I read the rhymes furled/world or breath/death I reach for my gun', wrote the critic Cyril Connolly, echoing Goering's remark about culture: 'When I hear anyone talk of Culture, I reach for my revolver.'

33 From 'The Five Senses', 1924. Unpublished.

34 'Thirst', *Drawings, Verse and Belief*, p. 60.

35 Honami Koyetsu (first artist craftsman, 1558–1637). *Drawings, Verse and Belief*, p. 108. The artist's name is now written as Hon'ami Kōetsu.

36 Bernard Leach letter to Mark Tobey, 4 October 1971. PC.

37 B. 1925. Potter, co-editor, with Emmanuel Cooper, of *Ceramic Review* until 1998.

38 Quoted in Eileen Lewenstein, *Ceramic Review*, July–August 1979, p. 21.

39 The show was at the initiative of the Crafts Advisory Committee, and was a celebration of the thriving work of contemporary craftsmen and women, 1973.

40 Anecdote from Alan Caiger-Smith. When Caiger-Smith decided to become a potter he wrote to Leach asking for advice and received the emphatic reply, 'Don't'. For a full account of his life as a potter see Alan Caiger-Smith, *Pottery, People and Time*. Richard Dennis, Shepton Beauchamp, Somerset, 1995.

41 8 August 1973, 11.50 a.m.

42 Bernard Leach letter to Mark Tobey, 12 September 1973. PC.

43 6 October 1971.

44 Bernard Leach, 10 June 1973. LA777.

45 *Ibid.*

46 285 King's Road.

47 Amongst other artists the gallery showed sculpture by John Milne, a former assistant of Barbara Hepworth, who lived in St Ives and was a friend of the Leaches.

48 Bernard Leach, *Bernard Leach: A Potter's Work*. Evelyn, Adams & Mackay, London, 1967, p. 50.

49 Leach liked to note his sales but these records have not come to light. One of few to survive is for his exhibition at the Krane Kalman Gallery, 178 Brompton Road, London, in 1967, held to coincide with the first publication of *A Potter's Work*. Out of the 117 pieces of porcelain and stoneware on show only thirteen remained unsold.

50 Quoted in *Beyond East and West*, p. 295. See also Bernard Leach letter to Tanabe Sanna, 2 August 1974. LA5569.

51 Unveiled 30 June 1974.

52 Awarded 2 October 1974. LA5592.

53 James William Fulbright (1905–95), Democrat, expert in international affairs.

54 Janet Leach letter to Richard de la Mare, 28 October 1974. LA5329.

55 Bernard Leach letter to Mark Tobey (quoting Jessamine), 1 June 1974. PC.

56 *Ibid.*

57 Bernard Leach telegram to Mark Tobey, 10 March 1976. PC.

58 Janet Leach letter to John Reeve and Donna Balma, 5 September 1973. PC.

59 Simon Nicholson was a devoted modernist, who when leading a course at the Open University encouraged students to produce 'bum prints' by pressing their posteriors on the wall. In an effort to 'break personal boundaries; releasing the inner child' an impromptu choral act was performed in a local launderette in 'random acts of senseless beauty'.

60 Bernard Leach letter to Simon Nicholson, 12 August 1974. LA5571.

61 'It is just a Korean food bowl, a bowl moreover that a poor man would use every day – commonest crockery,' wrote Leach in *The Unknown Craftsman*.

62 For a full discussion of the significance of the rice or tea bowl see Yanagi Sōetsu, translation Bernard Leach, 'The Kizaemon Tea-bowl' in *The Unknown Craftsman: A Japanese Insight into Beauty*. Kodansha International, Tokyo and Palo Alto, 1972, pp. 190–6.

63 Bernard Leach letter to Sally Bowen Prange jr, 2 January 1969. LA5396.

64 One of the founders of the Cranks chain of health food restaurants, which served food on hand-thrown pottery.

65 Letter, September 1975. LA93.
66 In January 1976 Leach donated eighteen pots to the Penwith Art Society, St Ives.
67 This new organization, set up to conserve the archives of craftsmen and women, was then housed in the Holburne of Menstrie Museum, Bath. In January 1976 Leach donated ninety pots to the Crafts Study Centre, which opened later that year. Robin Tanner, Muriel Rose and others set it up as part of an initiative for studying the history of craft. The Crafts Study Centre moved in 2000 to the Surrey Institute of Art and Design University College, Farnham.
68 This proposal was to set up a pottery producing a range of standard ware with trainees working alongside experienced potters in premises at Dartington once occupied by Leach. The Dartington Training Workshop, advised by David Leach, was set up and a range of tableware produced. It now operates as Dartington Pottery [2002].
69 Bernard Leach letter to David Canter and John Lane, 23 September 1975. LA5638.
70 Written and presented by Clive Gunnell, produced and directed by Derek Fairhead. They also made a film on Barbara Hepworth.
71 Westward TV publicity catalogue.
72 Michael Cardew letter to Bernard Leach, 18 February 1974. LA556.
73 Janet Leach letter to Kim Schuefftan, 6 June 1974. LA5304.
74 The programme was broadcast 30 June 1974.
75 The Potter's Challenge was published in the USA by E. P. Dutton & Co., 1975, and in the UK by Souvenir Press Ltd, 1976, and sold out within a few weeks.
76 The Potter's Challenge, p. 19.
77 Published by Adams & Dart, Bath, 1967 and 1974.
78 Werner Hörnemann Verlag.
79 ICA Bokförlag, Stockholm.
80 Janet Leach letter to John Reeve and Donna Balma, n.d. [c.1973]. PC.
81 After Hans Coper's death in 1981 she acquired his Continental-type wheel.
82 Janet Leach letter to John Reeve and Donna Balma, 5 September 1973. PC.
83 Beyond East and West, p. 249.
84 Ibid.
85 Ibid.
86 Donna Balma letter to author 25 March 1997.
87 Ibid.
88 Ibid.
89 Ibid.
90 Ibid.
91 Bernard Leach letter to Mark Tobey, 15 September 1974. PC.
92 Ibid.
93 B. 1938, Leach Pottery 1966 to present.
94 B. 1947, Leach Pottery 1969–71.
95 Leach's 1978 diary lists the pottery employees as John Bedding, Trevor Corser, Jason Wason, Robert Fishman, Judy Gardiner, Kim Perry and Jeffrey Larkin, with Jenny Galloway and Mary Yates acting as secretaries. LA327.

96 B. 1947, Leach Pottery 1969–71.
97 B. 1950, Leach Pottery 1976–8.
98 B. 1952, Leach Pottery 1976–8.
99 Jeff Oestreich, Curator's Statement, Leach Tradition 1923–1987, catalogue St Louis, USA, 1987.
100 Bernard Leach letter to Michael Leach, 29 March 1976.
101 Byron Temple interview with the author, January 1995.
102 Faber & Faber, London 1978.
103 Previously the Department of Circulation responsible for travelling shows. It was disbanded because of financial pressures and the ceramics taken into the ceramics department.
104 Carol Hogben letter to Bernard Leach, 7 January 1977. PC.
105 At one point three members of the ceramic department at the Victoria and Albert Museum – Carol Hogben, David Coachworth and John Mallet – visited Leach in St Ives where they were entertained to supper at Barnaloft. This consisted of Cornish pasties accompanied by copious amounts of Bristol Cream Sherry.
106 Son of Gwen Mullins who set up a trust to help young craftsmen. Leach served on its committee.
107 Now the Crafts Council and part of the Arts Council of England. Arts Councils in Scotland, Wales and Northern Ireland have their own arrangements for the crafts.
108 The official dates were 3 March–8 May 1977.
109 Reported in Yorkshire Post, 14 March 1977. LA1492.
110 For a full report see Carol Hogben, 'Towards a Standard', Crafts, May–June, no. 26, 1977, p. 12.
111 13 March 1977.
112 26 March 1977.
113 17 March 1977.
114 18 March 1977.
115 'Off Centre', Ceramic Review, no. 47, September–October, 1977, p. 7.
116 Carol Hogben (ed.), The Art of Bernard Leach. Faber & Faber, London, 1978.
117 Beyond East and West, p. 24.
118 Beyond East and West, p. 170.
119 Bernard Leach letter to Mark Tobey, 19 June 1974. PC.
120 Ibid, 15 September 1974. PC.
121 Published by Faber & Faber in the UK and in Japan by Nippon Keizai Shimbun Sha, Tokyo.
122 Western Morning News, 5 May 1978.
123 24 June 1978.
124 7 May 1978.
125 Rebecca West had strong views on pottery, declaring that she would not serve food to a dog on a Bloomsbury plate.
126 7 January 1978.
127 Janet Leach letter to Susan Peterson, 6 September 1978. LA5811.
128 A form of amyl nitrate.

129 Trudi Scott letter to Lucie Rie, 25 May 1979. RA.
130 Trudi Scott letter to Lucie Rie, n.d. [c.June 1979]. RA.
131 7 May 1979.
132 19 November 1979.
133 Other obituaries included *Burlington Magazine* (June 1979) and *Daily Telegraph* (12 May 1979).
134 12 May 1979.

AFTERWORD

1 Cited in Barrie Penrose and Simon Freeman 'How to make pots of money in prison: throw your own', *Sunday Times*, April 1983. Unidentified cutting. LA14761.
2 Another prisoner at Featherstone, William Boardman, with permission from the prison governor, passed the pots to antique dealer John Excell who put them into the hands of the auction houses.
3 One is in the fakes collection of the British Museum.
4 Preface to Dr Shikiba Rhyūzaburō, *Bernard Leach Biography*, Tokyo, 1934. LA1613.
5 Carole Austin and Jo Farb Hernandez, 'The Quiet Eye: Pottery of Hamada Shōji and Bernard Leach', Monterey Museum of Art, California, 1990.
6 Jeff Oestreich, 'The Leach Tradition: The Work of Bernard Leach: Potter-Teacher and Work by Former Apprentices of the Leach Pottery, St. Ives, Cornwall, England', Pro-Art, St Louis, 1987.
7 Odakyu Museum; Tochigi Prefectural Museum of Arts; Kasama Nichido Museum of Art; The Hiratsuka Museum of Art; The Shigaraki Ceramic Cultural Park, The Museum of Contemporary Art; Naha City Traditional Art Gallery, all 1997.

BIBLIOGRAPHY

PUBLICATIONS BY BERNARD LEACH

A Review: 1909–1914. Privately printed, Tokyo, 1914.

An English Artist in Japan. Privately printed, Tokyo, 1920.

A Potter's Outlook. Handworkers' Pamphlet No. 3. New Handworkers' Gallery, London, 1928.

A Potter's Book (introductions by Yanagi Sōetsu and Michael Cardew). Faber & Faber, London, 1940; second edition 1945, third edition 1975.

A Potter's Portfolio. Lund Humphries & Co., Ltd, London, 1951.

A Potter in Japan: 1952–1954. Faber & Faber, London, 1960.

Kenzan and his Tradition, the lives and times of Koetsu, Sotatsu, Korin, and Kenzan. Faber & Faber, London, 1966.

Bernard Leach: A Potter's Work, with introduction and biographical note by J. P. Hodin. Evelyn, Adams & Mackay Ltd, London, 1967. Second impression Adams and Dart, Jupiter Books, Bath, 1974.

The Unknown Craftsman: A Japanese Insight into Beauty. Translated and adapted from the work of Yanagi Sōetsu. Kodansha International, Tokyo and Palo Alto, 1972.

Hamada: Potter. Kodansha International, Tokyo and New York, 1975.

The Potter's Challenge, edited by David Outerbridge. E. P. Dutton, New York, 1975; Souvenir Press Ltd, London, 1976.

Drawings, Verse & Belief. Adams and Dart, Bath, 1973; revised edition Jupiter Books Ltd, London, 1977.

Beyond East and West: Memoirs, Portraits and Essays. Faber & Faber, London, 1978.

SELECT BIBLIOGRAPHY

BARROW, TERRY (ed.), *Bernard Leach: Essays in Appreciation.* Special issue of the New Zealand Potter, Wellington, New Zealand, 1960. Nine contributors including three essays and chronology by Bernard Leach.

Bernard Leach: Fifty Years a Potter. Arts Council of Great Britain, London, 1961. Catalogue of retrospective exhibition, introduction by J. P. Hodin, with 'Belief and Hope' essay by Bernard Leach.

BIRKS, TONY and WINGFIELD DIGBY, CORNELIA, *Bernard Leach, Hamada and their Circle, from the Wingfield Digby Collection.* Marston House, Marston Magna, Yeovil, Somerset, 1992.

BROWN, DAVID (ed.), *St Ives 1939–64: Twenty-Five Years of Painting, Sculpture and Pottery.* The Tate Gallery, London, 1985. Catalogue produced in conjunction with the exhibition of the same name.

VIVIENNE BROWNING, *St Ives Summer – 1946: The Leach Pottery.* The Book Gallery, St Ives, number five in the occasional series of Book Gallery monographs, 1995.

CARDEW, MICHAEL, *A Pioneer Potter.* William Collins and Sons & Co., London, 1988.

CRAFTS COUNCIL, *Katharine Pleydell-Bouverie: A Potter's Life 1895–1985.* Introduction by Barley Roscoe, Crafts Council, London, 1986.

DE WAAL, EDMUND, *Bernard Leach.* Tate Gallery Publications, London, 1999.

DIGBY, GEORGE WINGFIELD, *The Work of the Modern Potter in England.* John Murray, London, 1952.

FARLEIGH, JOHN (ed.), *Fifteen Craftsmen on their Crafts.* Sylvan Press, London, 1945. With an essay by Bernard Leach.

HARROD, TANYA, *The Crafts in the 20th Century.* Yale University Press, New Haven and London, 1999.

HOGBEN, CAROL (ed.), *The Art of Bernard Leach.* Faber & Faber, London and Boston, 1978.

JOHNSON, LOWELL (ed.), *Reginald Turvey: Life and Art*. George Ronald, Oxford, 1986.

LANE, ARTHUR, *Style in Pottery*. Oxford University Press, London, New York and Toronto, 1948.

LEWIS, DAVID, *Warren MacKenzie: An American Potter*. Kodansha International, Tokyo, New York and London, 1992.

RIDDICK, SARAH, *Pioneer Studio Pottery: the Milner-White Collection*. Lund Humphries in association with York City Art Gallery, London, 1990.

ROSE, MURIEL, *Artist Potters In England*. Faber & Faber, London, first edition 1955; second edition 1970.

SATO, TOMOKO and WATANABE, TOSHIO (eds), *Japan and Britain: An Aesthetic Dialogue 1850–1930*. Lund Humphries, London, in association with Barbican Art Gallery and the Setagaya Art Museum, 1991.

SHIKIBA RHYŪZABURŌ (ed.), *Bernard Leach: Biography*. Tokyo, 1934.

The Art of Bernard Leach. Victoria & Albert Museum, London, 1977. Catalogue of a retrospective exhibition, foreword by Roy Strong, introduction by John Houston.

WATANABE, TOSHIO (ed.), *Ruskin in Japan 1890–1940: Nature for Art, Art for Life*. Ruskin Museum, Sheffield Arts and Museums, Sheffield, 1997.

WATSON, OLIVER, *Bernard Leach – Potter and Artist*. Crafts Council, London, 1997.

WATSON, OLIVER, *British Studio Pottery: The Victoria and Albert Museum Collection*. Phaidon/Christies in association with the Victoria and Albert Museum, Oxford, 1990.

WHITING, DAVID (ed.), *Dartington: 60 Years of Pottery 1933–1993*. Dartington Cider Press, Dartington, 1993. Eight contributions.

WILSON, RICHARD L., *The Art of Ogata Kenzan: Persona and Production in Japanese Ceramics*. Weatherhill, Inc., New York and Tokyo, 1991.

WHYBROW, MARION, *St Ives 1883–1993: Portrait of an Art Colony*. The Antique Collectors' Club, Ltd., Woodbridge, Suffolk, 1994.

WHYBROW, MARION, *The Leach Legacy: St Ives Pottery and its Influence*. Sansom & Company, Bristol, 1996.

YANAGI, SŌETSU, *Yanagi Sōetsu Zenshü* (Collected Works of Yanagi Sōetsu). Chikuma Shobō, Tokyo, 1981.

YANAGI, SŌRO (ed.), *Mingei: Masterpieces of Japanese Folkcraft, Japan Folk Crafts Museum*. Kodansha International, Tokyo and New York, 1991.

YOUNG, MICHAEL, *The Elmhirsts of Dartington: The Creation of a Utopian Community*. Routledge and Kegan Paul, London, 1982.

INDEX